THE PALACE OF
CHARLES V
IN GRANADA

THE PALACE OF CHARLES V
IN GRANADA

EARL E. ROSENTHAL

PRINCETON UNIVERSITY PRESS

PRINCETON, NEW JERSEY

All Rights Reserved
Library of Congress Cataloging in Publication Data
will be found on the last printed page of this book
ISBN 0-691-04034-6

This book has been composed in Linotron Bembo
Design by Janet Tingey

Clothbound editions of Princeton University Press books
are printed on acid-free paper, and binding materials
are chosen for strength and durability

Printed in the United States of America by
Princeton University Press
Princeton, New Jersey

CONTENTS

TEXT FIGURES

PLATES

ABBREVIATIONS

AA	Archivo de la Alhambra
AGPM, SCR	Archivo General del Palacio Real, Madrid, Sección Casas Reales
AGS	Archivo General de Simancas
AGS, CM1	Contaduría Mayor, primera época
AGS, SCR	Sección de Cédulas Reales
AGS, CSR	Casas y Sitios Reales
AGS, PR	Patronato Real

ACKNOWLEDGMENTS

THIS MONOGRAPH is dedicated to my friends in Granada who encouraged, facilitated and contributed to my study of the palace of Charles V. Foremost among them is Jesús Bermúdez Pareja, the Director Emeritus of the Museo Arqueológico on the Alhambra. He invited me to study the palace and, with the approval of the Patronato de la Alhambra, granted full access to its archive of documents and to all parts of the palace itself; in many conversations through the years, he shared his considerable knowledge of the history of the Moorish citadel and its palaces and fortifications. The archivist of the Alhambra, María Angustias Moreno Olmedo, gave me transcriptions of pay ledgers for 1537 to 1540 which she had undertaken at the request of Manuel Gómez-Moreno y Martínez, and she generously helped me with difficult passages in the documents I transcribed in the Alhambra archive.

The conservator, Francisco Prieto-Moreno y Pardo, and his staff answered my questions on materials and structural techniques and made available measured drawings of various parts of the palace. I suspect that no architectural historian has ever had better circumstances than those provided me by the officials and staff of the Alhambra.

Many other friends in Granada contributed to this monograph. From the very beginning of my archival research in Granada I have had the unfailing help and encouragement of Lolita Ibarra Guil, now subdirector of the Archivo de la Real Chancillería de Granada, and through the course of this study, she has proofread many of my transcriptions and has promptly provided information needed to resolve problems that arose when I was far from Granada. I also benefited from the expertise of many scholars at the University of Granada, whose precise contributions will be noted in the proper place in this monograph. Most notable among them are José Manuel Pita Andrade, Emilio Orozco Díaz, Antonio Marín Ocete, José Cepeda Adán, Domingo Sánchez Mesa, Asunción Linares, Concepción Félez Lubelza, Carmen Villanueva, and Antonio Gallego Morell. To this Granadine group I should add René Taylor, long a resident of Granada and student of Spanish architecture.

Spaniards outside Granada also aided in this study. José Gudiol Ricart in 1962 arranged for four hundred photographs of specified parts of the palace, and he and Montserrat Blanch de Alcolea facilitated my use of the photographic collection of Spanish architecture in the Archivo Mas in Barcelona. Research in the archive of the Palacio Real in Madrid was aided by Fernando Navarro, and at the Archivo General de Simancas, by Ricardo Magdaleno, Amalia Prieto, and Concepción Alvarez. Isabel Mateo Gómez of the Instituto "Diego Velázquez" in Madrid has been a great help to me not only when I used that library but also in responding to my letters requesting information about scholars and publications. For various kindnesses and points of information to be cited subsequently, I am grateful to Juan José Martín González, Fernando Chueca Goitia, Diego Angulo Iñiguez, Francisco Iñiguez Almech, Xavier de Salas, Vicente Lleo Cañal, Cristina Gutierrez-Cortines Corral, and Luis Sánchez Belda.

In Italy, my interest in the relation of Spain and Italy in the arts and specifically my study of this palace was first encouraged by Roberto Longhi, my professor at the University of Florence, by Ulrich Middeldorf, with whom I discussed the sculptural ornament of the palace, and by Wolfgang Lotz, who gave me the benefit of his extensive knowledge of Cinquecento architecture.

Among scholars in the United States, I am especially indebted to Helen Nader of the Department of History, Indiana University, for sharing her knowledge of the Mendoza family and for giving me transcriptions of unpublished letters that reveal their interest in architectural projects previous to the building of the palace of Charles V. For his willing help in the translation of difficult passages in Latin sources, I am most grateful to my friend, Edward L. Basset, Professor Emeritus, Classics Department, University of Chicago. Aid of various kinds was extended to me by Priscilla E. Mueller, Theodore S. Beardsley, Jr., Harold E. Wethey, George Kubler, John Hoag, Richard Pommer, Beverly L. Brown, Helmut Nickel, René de Costa, and Catherine Wilkinson.

This study was initially supported by Guggen-

heim and Fulbright Fellowships in 1964–1965 and supplemented by the University of Chicago in various ways since then. Research funds of the Division of the Humanities paid for the photographing of the palace by José Gudiol in 1962 and for additional photographs of buildings and sculpture elsewhere, while the Center for Latin American Studies at the University of Chicago has funded a review by Orlando Ocampo of the Spanish documents quoted in the footnotes and the appendix of this monograph and also the proofreading of the entire book by Sonia Csaszar.

INTRODUCTION

THE PALACE of Charles V on the Alhambra in Granada is of equal interest to historians of both Italian and Spanish Renaissance architecture because it pertains to a theoretical Italian type first realized in Spain: the block-design residence with a porticoed round courtyard. Unlike most buildings designed in the Renaissance style outside Italy, it is surprisingly up-to-date. Scholars describe it as "High Renaissance" or even "Mannerist," though formal incongruities would seem to contradict both classifications. Because of its patron, the palace pertains to a rare iconographic type: the regal or imperial palace. It also offers the only record of the architectural style of its designer, Pedro Machuca. About him we know only that he was born in Toledo and, after a trip to Italy, returned to Spain in 1520 as a painter in the Raphaelesque style. Six years later, with no known architectural works to his credit, he was commissioned to design a palace for Emperor Designate Charles V.[1]

Several fortunate circumstances facilitate the study of this unique palace. Because it was never finished and never used (until the mid-twentieth century), it was never altered to serve later residents or new functions. Equally fortunate is the great number of original documents that have survived in the archive of the palace itself, the Archivo General de Simancas, and the Palacio Real in Madrid. Several scholars, starting with Simón de Argote in 1807, claimed to have reviewed the documents on the Alhambra, but they sought little more than the dates of execution for major parts of the palace. In 1775, the documents were sorted into 120 bundles,

called inventory A, but those bundles were undone when the documents were ransacked during the subsequent French occupation by authorities in search of titles that pertained to the Royal Patrimony. When the French were through, the documents were dumped into a warehouse in the city. They remained there until Manuel Gómez-Moreno y González in 1876 brought them back to the Alhambra and sorted them out into a new set of bundles, known as inventory B. In doing this, he simply identified the subject of a document and, when he found one that dated a part of the palace, made a note of it or, in a few cases, transcribed it. In 1885, on the basis of these documents, he wrote a small monograph on the palace of Charles V. That monograph and the transcriptions were used by his son, Manuel Gómez-Moreno y Martínez, for the 1941 study of Pedro Machuca as one of *las águilas* of the Spanish Renaissance. Shortly after, George Loukomski is said to have searched through the documents in the Alhambra archives, but his article of 1944 seems to have been based more on intuition than documentary evidence. During several campaigns, beginning in 1964, I transcribed selected documents on the palace in the three archives cited above. About two thousand were transcribed (from one-line payments to eight-page Work Rules) and notes were taken from several thousand more.[2] In the main, those included in the appendix of this study are the longer documents, while many of the shorter ones are quoted in the text or footnotes and others are simply cited. In addition to the abundance of documentation and the fact that

[1] When Charles was crowned king of the Romans in Aix-la-Chapelle on 23 October 1520, he was given papal permission to use the title "emperor." This was reported by Baldassare Castiglione to Cardinal Bibiena in a letter dated 2 November 1520: ". . . il Papa, havendo approbata la elettion loro nella persona di Carlo Quinto, comandava, che da quel punto innanzi dovesse prender nome d'Imperatore." See *Lettere di Principi*, ed. Girolamo Ruscelli, Venice, 1564–1577, I, fol. 70v. This was done in Charles' case because, unlike his predecesors, he was crowned king of the Romans *after* the death of the previous

emperor, Maximilian I. Not long after, on 5 December 1520, Francisco de los Cobos, Charles' secretary, announced that the monarch was thenceforth to be addressed as "Sacra, Cesárea, Católica, Real Majestad"; see Hayward Keniston, *Francisco de los Cobos, Secretary of the Emperor Charles V*, Pittsburgh, 1958, p. 57.

[2] The catalogue of the documents in the Alhambra archive, compiled by archivist María Angustias Moreno Olmedo, has been published in sections since 1977 in the *Cuadernos de la Alhambra*.

the palace has survived relatively unaltered, there are three groundplans that came to light in this century. Because they were simply published without relating them to the palace itself or to documentary evidence, that still remains to be done.

My study of the palace and this presentation were conditioned by the unusual number of documents. Their coverage of the history of the palace is uneven, in that no year is complete and for some years nothing has survived, but the densely documented periods allow us—actually require us—to follow the execution of some parts of the palace in great detail. Abundant documentation does not necessarily make the historian's task easier since one document may contradict another, revealing that the story is not as simple as it seemed when the first document was found. There is no way of ignoring complications of this sort; one can only try to make them clear. Because of the detailed knowledge provided by the documents, however, we are able to study the building in the context of its specific circumstances rather than that of an historical abstraction of a stylistic, aesthetic, or ethnic nature.

The first four chapters of the book deal with the history of the design, construction, abandonment, and modern conservation of the palace. Special attention will be given to the periods of Pedro and Luis Machuca, and Juan de Minjares, because most of the construction took place in the years in which they guided the works. The chronology of the construction will enable us to identify the parts executed by Pedro Machuca and those probably faithful to his intentions. In the fifth chapter, precedents and analogies for those autograph parts will be sought with the aim of identifying, in the sixth chapter, the center in which Pedro Machuca was trained as an architect and formed his personal style. Finally, in the last chapter, the iconographic program of the palace and its place in the Spanish and Italian architectural traditions will be discussed.

THE PALACE OF
CHARLES V
IN GRANADA

I

THE DESIGN

DRAMATIS PERSONAE

CHARLES V'S DECISION to build a modern residence on the Alhambra requires no explanation to visitors who have enjoyed the extraordinary beauty of the site, and most will readily believe Sandoval's claim that Charles liked Granada best of all the Spanish cities he had seen.[1] Having arrived in June 1526 with his bride, Isabel of Portugal, after enduring a spring heat wave in the low-lying city of Seville,[2] the emperor and his court were pleased by the cooler temperatures, ample water supply, and verdant countryside of Granada. Above all, they were charmed by the exotic Nazaride palaces on the Alhambra, already widely known in Europe for the fabled richness of their interiors.[3] Their floors were then of white marble, the dado of glazed tile in small-scale geometric patterns, and the rest of the wall surfaces were enriched with minutely worked plaster decoration that was polychromed and gilded. Overhead there were wooden ceilings (*alfarjes*) composed of small pieces of a variety of woods arranged in interlace patterns and enlivened by gilding and insets of ivory and mother-of-pearl. A few of the preserved halls, such as that of the Two Sisters, are covered with cusped and faceted plaster vaults that seem to float weightlessly over the sumptuously decorated walls. Little wonder that Charles and his court viewed them with curiosity and delight.

Charles, however, was not accustomed to living in Moorish fashion as were his grandparents, the Catholic Monarchs, and his unfortunate mother, Joanna, who had retired in 1509 to the Franciscan monastery of Santa Clara, which was the old Mudéjar palace of Alfonso XI at Tordesillas near Valladolid.[4] No palace was built by Charles' predecessors on the Spanish throne because they often added royal quarters to a favorite monastery or they made piecemeal alterations in a Moorish residence or castle to adapt it to their needs, usually employing Mudéjar artisans to repair or decorate the interiors. These royal residences must have seemed curiously alien and somewhat inconven-

[1] Prudencio de Sandoval, "Historia de la vida y hechos del emperador Carlos V" (1618, bk. 14, chap. 17), *Biblioteca de autores españoles*, Madrid, 1856, LXXXI, p. 172: "Aposentóse en el Alhambra, y como mirase con curiosidad los edificios antiguos, obras moriscas, y los ingenios de las aguas, y la fuerza del sitio, y la grandeza del pueblo, si bien de todas las ciudades de su reino mostró tener gran contento, de ésta en particular recibió mucho gusto."

[2] Andrea Navagero, "Viaje por España," *Viajes de extranjeros por España y Portugal*, Madrid, 1952, I, p. 851. Francisco Bermúdez de Pedraza (*Historia eclesiástica, principios y progresos de Granada*, Granada, 1638, fol. 213) implied that Charles had not intended to come to Granada but that while he was in Seville, representatives of Granada asked him to honor their city with a visit. Charles' steward (*mayordomo*) came to Granada on 20 April to prepare for the reception of 5 June.

[3] In 1492 Peter Martyr of Anghiera wrote the Archbishop of Milan that the Alhambra palace was unique: "unica in orbe terrarum crede"; see *Opus Epistolarum*, Alcalá de Henares, 1530 (facsimile edition, Graz, 1966), fol. xxiii, no. XCI (p. 343). Shortly after, in 1494, the German visitor, Hieronymus Münzer, also stressed its extraordinary beauty: "Simile credo in tota Europa non esse. Omnia adeo magnificae, adeo superbe, adeo exquisite erant facta de vario genere, ut paradisum credres"; see Ludwig Pfandl, "Itinerarium Hispanicum Hieronymi Monetarii 1494-1495," *Revue Hispanique*, XLVIII (1920), p. 47. Navagero, a humanist and classical scholar of distinction, with a special interest in the arts, praised the city and the palace in both his diary and his letters, especially in a letter to Giovanni Battista Ramusio on 30 May 1527 (*Viajes*, I, pp. 886-892).

[4] For the inclination of Spanish kings to live *al morisco*, see Vincente Lampérez y Romea, "Los palacios de los reyes de España en la Edad Media," *Arte español*, III (1914), pp. 213-235.

ient to the young king who had been reared in relatively modern residences at the court of Burgundy in Flanders. Charles' Portuguese bride was apparently so dissatisfied with her rooms in the *Cuarto Dorado*, west of the Court of Myrtles, that she moved with her household to the second cloister of the convent of San Jerónimo in the city.[5] Nor was the elegant empress the only one displeased by the accommodations on the Alhambra. Housed in the halls of the Nazaride palaces and in the towers and various subsidiary buildings within the fortress as well as in private houses in the city, most members of the court complained bitterly about the inadequacy of their quarters.[6] The charm of exotic decoration was not sufficient compensation for ambassadors of the imperial court who were accustomed to being housed in European fashion. Charles, having been admonished by his mother and his grandparents to preserve the Nazaride palaces on the Alhambra as the prize trophy of the victory at Granada,[7] had no alternative but to build a modern residence for future visits to the city.

The decision to construct a new palace has led some scholars to suggest that Charles meant to make Granada the main center of his Spanish realm and even of his empire,[8] but the Alhambra was only the first of several royal residences renovated by the emperor. To be sure, his decision to be interred with his family in the new Granadine cathedral was made about the same time, but in doing this he was simply complying with the express wish of the Catholic Monarchs that their immediate descendants should be buried in the Royal Chapel founded by Isabella in 1504 alongside the future cathedral.[9] Rejecting the chapel as better suited to a merchant than to monarchs of his grandparents' achievements, Charles chose instead the sanctuary of the new cathedral and it seems this new function led Diego Siloe to conceive the extraordinary domed rotunda that serves as its *capilla mayor*.[10] While Charles favored the city in this way and also gave it the *Capitanía General* and the *Chancillería* or Royal Tribunal of Andalusia, along with a university and seminary, he could not have thought of Granada as the center of his empire. The predominantly Moorish city was too far away from his Flemish and Germanic realms and even from the old centers of power in Castile and Aragon. In 1527 Charles' idea of his role as king and emperor designate was still that of an itinerant monarch who continually traveled from one realm to another to avoid the suspicion of favoritism.

The grand scale and unusual design of the palace

[5] An inscription on the large plan of the palace of Charles V in the Royal Palace in Madrid (pl. 17-E) indicates that the Cuarto Dorado served as Isabel's quarters in 1526. Renovated by the Catholic Monarchs in 1492, these rooms were probably considered the best available in the Nazaride palaces; see Jesús Bermúdez Pareja, "Obras del Cuarto Dorada," *Cuadernos de la Alhambra*, I (1965), pp. 101-105. Bermúdez de Pedraza (*Historia eclesiástica,* fol. 213) stated that the empress stayed in the second cloister of the convent of San Jerónimo, but he does not say when she moved from the Alhambra to the city. It is likely that it occurred well before the announcement of her pregnancy on 15 September, reported by Sandoval ("Historia," p. 174). In a letter to Ramusio on 1 May 1527, Navagero (*Viajes*, I, 890) said the two cloisters of San Jerónimo (completed before 1520) were the most beautiful he had ever seen, and he especially admired the orange trees and other plants in the center of these courtyards. Of course, the Hieronymite nuns were accustomed to playing host to royal visitors because traveling Spanish kings usually stayed in the convents of that order; see Fernando Chueca Goitia, *Casas Reales en monasterios y conventos españoles*, Madrid, 1966, pp. 14-18.

[6] Even Jan Dantyszek (Juan Dantisco), the ambassador of King Sigismund I of Poland, who was well disposed toward the emperor, complained about the inadequacy and the high cost of his quarters; see "Embajador polaco en la corte de Carlos V," *Viajes de extranjeros en España y Portugal*, Madrid, 1952, I, p. 812, and Antonio Paz y Melia, "El embajador polaco Juan

Dantisco en la Corte de Carlos V," *Boletín de la Real Academia Española*, XI–XII (1924–1925), p. 63.

[7] Queen Joanna of Castile on 13 September 1515 ordered the repair of the "tan suntuoso y eçelente edifiçio," as the Catholic Monarchs had required, so that "queda para syenpre perpetua memoria," AGS, CMI, Leg. 1278. Münzer reported in 1494 that Morisco craftsmen were restoring the palace in conformance with its style ("Itinerarium," pp. 47-48). That Charles V and later rulers continued this policy is recorded in a résumé of 21 November 1612, which states that he ordered that in repairs of the old palace, "sienpre se tenga mucho ciudado imitando de la obra mosaica de moçarabes"; see AA, Leg. 104, 5, 6. On 12 October 1516, before he left Flanders, young Charles ordered that reparation on the Alhambra should be continued; see Ramón Carande Thobar, *Carlos V y sus banqueros*, Madrid, 1943, I, pp. 127-128.

[8] Antonio Gallego y Burín, "Unas obras conocidas y un maestro desconocido: el escultor Antonio de Leval," *Cuadernos de Arte*, VII–IX (1942–1944), p. 55. This idea may have been derived from Henry Swinburne's *Travels through Spain in the years 1775 and 1776*, London, 1779, pp. 267-268: ". . . and it is thought that he intended to fix his chief abode here."

[9] Navagero, *Viajes*, I, p. 857.

[10] Earl E. Rosenthal, *The Cathedral of Granada, A Study in the Spanish Renaissance*, Granada, 1961, p. 14, n. 51, and doc. 130.

planned for the Alhambra suggest that it was to have been an important and favored royal residence (pls. 1 and 2). The circular Doric peristyle within the block-design plan, which even today strikes many as unique, would have been more exotic than the Nazaride courtyards to most of Charles' Spanish subjects, and it is unlikely that more than a few ambassadors at his court in the late 1520s had even heard of a plan of that sort. Its extraordinary disposition has led to the assumption that someone other than the painter-architect, Pedro Machuca, was responsible for the design. Scholars have speculated that the idea was suggested by Charles V, or even his wife, or the governor of the Alhambra, Luis Hurtado de Mendoza, or perhaps an Italian ambassador at the imperial court. Because of these speculations and also some unsuspected conflicts during the extended period of the design of the palace, we must consider the attitudes and experiences, with respect to architecture, of the people who are presumed to have played a role in the planning of the new residence.

It has been claimed that Charles himself was responsible for the plan,[11] even though the geometric disposition is inevitably characterized as "Italian" and Charles, previous to his visit to Granada in 1526, had had little opportunity to become familiar with the new architectural style of the Italian Renaissance. He did not go to Italy until the summer of 1529 and then his extended visit was limited to the northern provinces from Genoa and Savona to Parma, Bologna, and Mantua, on his way to his German States. Before that trip, his travels were restricted to areas still faithful to the Gothic style in architecture—Flanders, the Rhineland, and England. After 1517 in Spain he may have seen a few works in the new Plateresque style, then often described as *a lo romano*, but these limited experiences would not necessarily have predisposed Charles to favor, let alone to conceive, so "Italian" a plan. Nor was he responsible for the

appointment of Italian-trained Diego Siloe as architect of the cathedral of Granada. Siloe was chosen in 1528 by Archbishop Pedro Ramírez de Álava to redesign the cathedral in the Renaissance style. Charles first learned of this change when canons of the independent Royal Chapel expressed concern that the "Roman" style of the cathedral would be prejudicial to their chapel, which was in *el modo moderno*, meaning the Gothic style.[12] Charles then ordered the canons of the cathedral to abandon the Renaissance style, but they sent Siloe to court, where he successfully defended his design. For the cathedral, therefore, Charles did not choose but, rather, was persuaded to accept the Renaissance style.

Charles' formative years were spent in Flanders where he and his four sisters were reared under the guidance of their intelligent and cultivated aunt, Margaret of Austria, who was regent of the Lowlands for her father, Emperor Maximilian I. We know that Margaret was a woman of refined taste who supported the arts and also had a good library. In 1517 she undertook the renovation of her palace in Malines to provide a suitable residence for her young charges and her court of about four hundred attendants.[13] But that late Gothic structure (as Charles knew it) is not likely to have stimulated an interest in Italian Renaissance or ancient Roman architecture. After he was declared of age by Emperor Maximilian in January 1515, Charles took up residence in the old ducal palace in Brussels. There he must have watched the completion of the famous Cour des Bailles, executed from 1513 to 1518 but now lost without any graphic record of its architectural form. It was described as having "eighteen marble columns" around a square basin that served as a Roman-style bath, but there is little reason to believe that the work departed from the late Gothic forms that persisted in Flanders until almost the middle of the sixteenth century.[14]

Charles' future wife, Isabel, may have been ex-

[11] Fernando Jiménez-Placer, *Historia del arte español*, Barcelona, 1955, p. 501.

[12] Rosenthal, *Cathedral of Granada*, doc. 36. Juan Antonio García Granados has quite properly pointed out that the canons of the Royal Chapel were probably worried that the new Renaissance cathedral would not buttress the chapel as effectively as the originally proposed Gothic cathedral, but it should be noted that all references to the concerns of the canons of the Royal Chapel and the emperor are expressed in terms of style.

[13] Elsa Winker, *Margarete von Osterreich Grande Dame der Ren-*

aissance, Munich, 1966, p. 180; Hauc J. B. Coninckx, *Cinq siècles d'architecture civile a Malines du XIIIᵉ au XVIIIᵉ siècle*, Malines, 1938, p. 33. For her interest in the visual arts, see *Bourg-en-Bresse, Exposition . . . en homage à Marguerite d'Autriche, fondatrice de Brou 1480–1530, 1 June – 15 June 1958*, Bourge-en-Bresse, 1958.

[14] Paul Saintenoy, "Les arts et les artistes a la cour de Bruxelles," *Academie Royale de Belgique. Memoires*, ser. 2, II (1932), p. 114, pl. xv. One might properly claim that the Renaissance style was first employed in architecture in the stylar facades of

posed to Renaissance ideas in Portugal because her father, King Manuel I, is known to have admired the new Italian style; but there is no evidence that she had a special interest in architecture or that she had any influence on the design of the new palace on the Alhambra, as has been suggested.[15] Apparently she was well informed in music and literature but less concerned with the visual arts.[16]

There is little basis for supposing that Charles himself took an active role in the design of the palace. Although he was reared by one of the great art patrons of the day, Margaret of Austria, Charles displayed less interest in the arts than most Renaissance princes.[17] As king of Spain from 1517, he was often petitioned to fund the construction and furnishing of cathedrals, like those of Segovia and Granada, and other religious buildings, but he left the choice of the architect or artist and the design to local officials.[18] Charles' interest in the arts increased after 1530 under the tutelage of two vassal princes, Federico Gonzaga of Mantua and Alfonso d'Este of Ferrara, and their recent convert to the new Renaissance style, Francisco de los Cobos, Charles' most trusted secretary. They fostered Charles' patronage of Titian and gradually he came to appreciate the Venetian artist's work and to re-

ward him handsomely, but with one exception, all of his commissions were family portraits, and they often had to be made from portraits previously painted by lesser artists.[19] It must be admitted that there are few known instances of Charles' taking an active role in the planning of a work of art. In 1546 he reviewed and approved Vermeyen's preliminary sketches for the tapestries depicting the campaign against Tunis in 1535, and in 1551 he gave Titian the iconographic program for the *Trinity*, which was to serve as the altarpiece in his chapel at Yuste.[20] He displayed great interest in the planning of his retirement residence and the gardens there, but he evinced a practical rather than aesthetic attitude toward architecture (as Martín González has observed).[21] It was the study of these last years that led William Stirling-Maxwell in 1852 to conclude that Charles was a "discerning lover of art," and that judgment has been repeated by English authors.[22] Still, convenience had precedence over matters of design at Yuste, and the portraits, tapestries, and other works of art he took with him were chosen more for sentimental than aesthetic reasons. This seems to have been the judgment of Charles' contemporaries because Lodovico Dolce in 1557, the year before the emper-

several houses in Malines, notably that of the De Lepelaer house of 1519 and the Salmon of 1530, but Robert Wellens (*Jacques DuBroeucq*, Brussels, 1962, pp. 101-110) judged DuBroeucq's projects of 1553 for a polygonal château for Charles V in Brussels to be the first truly Renaissance architecture in the Lowlands.

[15] George Loukomski, "The Palace of Charles V at Granada," *The Burlington Magazine*, LXXXIV (1944), p. 120.

[16] Francisco Javier Vales Failde, *La Emperatriz Isabel*, Madrid, 1917, pp. 142-143. A lost terracotta bust of Isabel was made in Seville by Pietro Torrigiani shortly after her wedding there in 1526, but there is no evidence that she herself chose the Italian sculptor. The commission to Torrigiani was mentioned in 1548 by Francisco de Hollanda, *Da pintura antigua*, III, *Do tirar polo natural*, Porto, 1918, fol. 180.

[17] Manuel Gómez-Moreno y Martínez went so far as to say that Charles displayed "indifference . . . to everything connected with art"; see his *Renaissanace Sculpture in Spain*, Florence, 1931, p. 66.

[18] José Luis Rodríguez Escorial ("Carlos I y la catedral de Segovia," *Cuadernos Hispanoamericanos*, no. 108, 1958, pp. 423-424) published Charles' instructions to the three main officials of the city (the bishop, the mayor, and the head councilman) to select a site and clear it and then to appoint an architect to make the project. I have identified (*The Cathedral of Granada*, pp. 13-14) the archbishop, Fray Pedro Ramírez de Álava, as the one who dismissed the Gothic architect, Enríque de Egas, and appointed Diego Siloe, a master of the new "Roman" style.

[19] Harold E. Wethey, *Titian. II. The Portraits*, London, 1971, p. 3, rejected Vasari's claim that Ippolito dei Medici was the one who arranged for Titian to make the first portrait "in full armor" of 1530. Keniston, *Francisco de los Cobos*, pp. 153-154; Giuseppi Campori, "Tiziano e gli Estensi," *Nuova Antologia*, XXVII (1874), pp. 601-604; Annie Cloulas, "Charles-Quint et le Titien. Les primiers portraits de'apparat," *L'information d'historie de l'art*, IX (1964), pp. 213-221, notes that in Barcelona in 1533 Charles conferred upon Titian the titles of Knight of the Golden Spur and Count Palatine, with the rank of nobility granted to his descendants.

[20] For the Tunis tapestries see, Paulina Junquera, "Las batallas navales en los tapices," *Reales Sitios*, v, no. 17, 1948, p. 42. The correspondence relative to the *Trinity* and Charles' testament have led most scholars (Crow and Cavalcaselle in 1877, Charles Holmes in 1927, Herbert von Einem in 1960, Craig S. Harbison in 1967, and Harold Wethey in 1969) to conclude that the theme and most of the identifiable personages in the painting were dictated by Charles himself, perhaps by way of an agent such as the ambassador, Francisco Vargas.

[21] Juan José Martín González, "El palacio de Carlos V en Yuste," *Archivo español de arte*, XXIII (1950), p. 31.

[22] William Stirling-Maxwell, *The Cloister Life of Emperor Charles V*, 4th ed., London, 1891, pp. 168, 366. The most recent English writer to designate Charles an "aesthete" is Hugh Trevor-Roper (*Princes and Artists. Patronage and ideology at four Habsburg courts 1517-1633*, New York, 1976, p. 14).

or's death, felt it necessary to comment on his limited patronage of the arts and to explain that, like Alexander the Great, the emperor was so preoccupied with tasks of government and war that there was little time to think about "this art [painting] that he loved and valued so much. . . ."[23] Because there is little evidence for Charles' interest in the arts previous to the 1530s, there is little reason to expect an active involvement in the design of the new residence on the Alhambra in 1526–1527.

The official to whom Charles entrusted that project was Luis Hurtado de Mendoza, governor of the Alhambra and the *Capitán General* of the armed forces of Andalusia. His father, Iñigo López de Mendoza, had been appointed governor in 1492 and that post remained in the family (with one break) for almost two hundred and fifty years.[24] On the Alhambra, Luis Hurtado was the sole authority, totally independent of the Council of Twenty-four who governed the city of Granada. He was also a member of the wealthiest and most powerful family in Spain, though the Tendilla branch in Andalusia was increasingly disengaged from the politics of the main Infantado line centered in Guadalajara. Iñigo López (in contrast to the Mendozas in Castile) had been a staunch supporter of Ferdinand the Catholic, rather than Philip the Fair of Burgundy, after the death of Isabella in 1504, and Luis Hurtado in 1516 was among the first nobles to recognize young Charles as the king

designate of Spain.[25] Luis Hurtado's brother, Antonio, was one of the Spanish nobles sent in February 1516 to the Burgundian court in Flanders to inform young Charles of the death of his grandfather, Ferdinand the Catholic, and Antonio stayed with Charles until he came to Spain in September 1517. The Mendozas of the Alhambra again stood with Charles during the most serious challenge to his authority in Spain, the revolt of a number of Castilian and Andalusian communes in the summer of 1520, shortly after Charles had left the peninsula for his coronation as the king of the Romans at Aix-la-Chapelle. Luis Hurtado took military action against the communes of Baeza and Huesca, and in Granada, he supported the young king against the Council of Twenty-four. He placed Gonzalo Fernández de Cordoba, the *Gran Capitán*, under surveillance, and he even held his own cousin, Rodrigo Díaz de Vivar y Mendoza, the marquis of Zenete, under arrest to forestall an uprising in Andalusia.[26] Little wonder that Charles trusted Luis Hurtado implicitly in political and military matters. Also, Luis Hurtado was among those who had recommended Isabel of Portugal as his bride—a choice Charles never regretted.[27] At the time of his visit in 1526 he used "relative" (*pariente*), a term that Charles did not use as freely as had previous monarchs; but by 1530, he addressed Luis Hurtado even more intimately as "cousin" (*primo*).[28] Though more a matter of trust than personal affection, previous relations with the Mendozas predisposed the

[23] Lodovico Dolce, *Dialogo della Pittura*, Venice, 1735, p. 132: ". . . e per i travagli quasi continui, che gli apportano le cose della guerra, non lascia de volger molte il pensiero a quest'arte, le quale ama e apprezza tanto. . . ." Frederico Baboaro (Badoer), the Venetian ambassador to the imperial court 1548–1557, complained that ". . . los gastos que hizo [Charles] para adornar sus palacios para las libreas de su corte y para sus fiestas no estuvieron en relación con la supreme dignidad de un emperador . . . ; see Louis Prosper Gachard, *Carlos V y Felipe II* (Colección Cisneros 100), Madrid, 1944, pp. 11-31.

[24] María Angustias Moreno Olmedo, "Un documento del Archivo de la Alhambra, pieza basica sobre los Mendozas de la Alhambra, *Cuadernos de la Alhambra*, IV (1969), esp. pp. 94-98; Gaspar Ibáñez de Segovia, marquis of Mondéjar, *Historia de la Casa de Mondéjar*, written in 1613 (Biblioteca Nacional, Madrid, Ms. 3315). Ibáñez's chapter on the third marquis of Mondéjar (1566–1571) was published in *L'Espagne au XVIᶜ et au XVIIᶜ siècle*, ed. A. Morel Fatio, Heilbronn, 1878, pp. 66-95. After consulting Ms. 3315 in 1963–1964, I used on several occasions the transcription of Professor José Cepeda Adán of the University of Granada. See also Gabriel Rodríguez de Ardila y Esquivias, "Historia de los Condes de Tendilla," ed. R. Foulché-

Delbosc, *Revue Hispanique*, XXXI (1914), pp. 63-131, of which pp. 89-93 are devoted to Luis Hurtado de Mendoza. An eighteenth-century manuscript in the Archivo Histórico Nacional in Madrid was published by Diego Gutiérrez Coronel, *Historia genealógica de la Casa Mendoza*, 2 vols., Madrid, 1946. The Mendoza governors are usually referred to as the "Conde de Tendilla," but clarity requires that we use the name of each because that title was sometimes ceded to the first son while the governor retained the title of marquis of Mondéjar.

[25] Luis Hurtado's support in 1516 was recognized by Charles in a letter of 1518 recorded by Ibáñez de Segovia (*Historia*, fol. 248v). The best account of the gradual alienation of the Mendozas on the Alhambra from the main line in Castile is found in Helen Nader, *The Mendoza Family in the Spanish Renaissance 1350–1550*, New Brunswick, New Jersey, 1979, pp. 126-127.

[26] José Cepeda Adán, "Andalusia en 1508. Un aspecto de la correspondencia del Virrey Tendilla," *Hispania*, LXXXV (1962), pp. 3-45; Nader, *The Mendoza Family*, p. 177.

[27] Charles recalled this recommendation in a letter to Luis Hurtado on 11 November 1525, cited by Ibáñez de Segovia (*Historia*, fol. 294).

[28] Ibid., fol. 298.

emperor to follow Luis Hurtado's recommendations in most matters. Even the design of the new residence on the Alhambra was placed in his hands, according to Gaspar Ibáñez de Segovia, the seventeenth-century historian of the Mendoza family, who based this claim on the last of several letters relative to the palace in the family archives.[29] The claim was repeated by M. Lafuente Alcántara in 1845 and by Elías Tormo in 1917, who called Luis Hurtado "the creator of the palace of Charles V," and in 1941 that role was inferred by Manuel Gómez-Moreno y Martínez.[30]

Of the intellectual interests and aesthetic attitudes of Luis Hurtado de Mendoza we know virtually nothing. It is often said that he was raised at court in the service of the Catholic Monarchs and that his teacher was Peter Martyr of Anghiera, the learned Milanese chronicler of the exploration of the New World; but Helen Nader concluded that there is no evidence for this assumption and that all of Luis Hurtado's training was received on the Alhambra.[31] His studies from the age of eleven were under the tutelage of Hernán Nuñez de Guzmán, who probably came to Granada in 1496 and by 1498 was employed by Iñigo López de Mendoza as a teacher to his children.[32] Luis Hurtado was described in the contemporary Chronicle of Francesillo de Zúñiga as "learned in Vergil and Boethius," but most of the account was devoted to his

personality rather than his learning.[33] Described as stiff and haughty in manner and uncompromising and difficult in personal relationships, he seems to have been a model of aristocratic restraint. These personal traits account in part for his administrative and military accomplishments, which were recounted in considerable detail by Ibáñez de Segovia; nothing, however, was said of his interest in the arts.

If we restrict the education of Luis Hurtado to the Alhambra, we must attribute his training in the supervision of architectural projects to his father, Iñigo López, who (according to Ibáñez de Segovia) initiated or intervened in a long list of works.[34] Shortly before 1508, Iñigo López commissioned the Florentine sculptor Domenico di Alessandro Fancelli to do a monumental marble sepulcher for his brother, Diego Hurtado de Mendoza, the archbishop of Seville. In the dedicatory inscription on that tomb, Iñigo López was identified as the captain of the forces of Granada and the first prefect of the acropolis of Illiberis (*Generalis granatensis regni, capitaneus ac illibertanorum arcium primus praefectis*).[35] The reference to the Alhambra as an acropolis and its identification with Illiberis (a nearby Roman town then thought to have been located on the Alhambra), together with his assumption of the Latin title *praefectus*, reveal Iñigo López's great interest in Spain's Roman past.

[29] Ibid., fols. 293v-294v. Ibáñez de Segovia incorrectly assumed that Charles' letter of 30 November 1527 (see doc. 1) was the emperor's last word on the matter.

[30] Manuel Lafuente y Alcántara, *Historia de Granada*, Granada, 1845, p. 263; Elías Tormo, "El brote del Renacimiento," *Boletín de la Sociedad Española de Excursiones*, XXV (1917), p. 62; Manuel Gómez-Moreno y Martínez, *Las águilas del renacimiento española*, Madrid, 1941, pp. 122-123.

[31] Professor Nader informed me in a letter of 4 May 1972 that Luis Hurtado's presence at court in 1506 was due to his having been elected *procurador de corte* by the city council of Granada and that it should not be taken as an indication that he was trained at court, as Ibáñez inferred (*Historia*, fol. 279). Letters from his father, Iñigo López, written during that year, offer advice that suggests Luis was unfamiliar with the court and even that the 1506 visit was his first. Perhaps that is why Iñigo López sent his mayordomo, Andrés de Dueñas, to accompany his son in 1506. By that time, Luis was already married, and the year before, Iñigo López had started resigning some posts in his favor, though he was only sixteen.

[32] Ibáñez de Segovia (*Historia*, fol. 279) stated that Hernán Nuñéz was Luis' first master, but he was not employed until 1498 when Luis was eleven; so, if Peter Martyr was ever his teacher, it would have to have been in the several years previous

to 1498. For recent accounts of Nuñéz, see Helen Nader, "The Greek Commander Hernán Nuñéz Toledo, Spanish Humanist and Civic Leader," *Renaissance Quarterly*, XXXI (1978), p. 470, and María Dolores de Asís, *Hernán Nuñéz en la historia de los estudios clásicos*, Madrid, 1977, pp. 26-27.

[33] "Crónica de don Francesillo de Zúñiga," *Biblioteca de autores españoles*, XXXVI, Madrid, 1871, pp. 15-16, describes him as ". . . Buen caballero, doto en Virgilio y Boecio; era melancólico . . . Era esforzado y sufrido, que bien parescía y respondía a su padre, de quien lo había heredero . . . Fué este marqués devoto y liberal; parescía caña fístola siempre; riyó pocas veces, regañó infinitas; tuvo quatro hermanos, los dos siete palmos más alto quo él . . ." This description was probably written in Granada in 1526 during the visit of Charles V because the chronicle reports events from 1504 to 1527, when he lost favor at court.

[34] Ibáñez de Segovia, *Historia*, fols. 242-243.

[35] Juan Agustín Ceán Bermúdez (*Diccionario histórico de los más ilustres profesores de las Bellas Artes en España*, Madrid, 1800, II, pp. 127) cited the document referring to the installation of the sepulcher on 18 september 1510. See also José Cepeda Adán, "El Conde de Tendilla, primer Alcayde de la Alhambra," *Cuadernos de la Alhambra*, VI (1970), p. 27.

A family with this image of the Andalusian fortress would quite naturally be inclined to propose the "Roman" style for the new residence ordered by the king of Spain and the Holy Roman Emperor designate.

Admiration for Latin models was already evident in the literary works of several Mendozas at the beginning of the fifteenth century, and toward 1490 the Renaissance style in architecture was introduced to Castile by the Gran Cardenal Pedro González de Mendoza.[36] Earlier, the cardinal's elder brother, Iñigo López de Mendoza, the first count of Tendilla, had encountered the new architectural style in Italy during the 1450s and 1460s when he served as ambassador to the papacy and to Florence and Mantua as well, and his teen-age son, of the same name, accompanied him. The latter, Iñigo López, the second count of Tendilla, in 1485–1486 headed a diplomatic mission to negotiate a treaty between the papacy and the kingdom of Naples, and most of that time he resided in neutral Florence, the fountainhead of the new style. During those years, at the request of his uncle, the Gran Cardenal, Iñigo López initiated the renovation of the Roman basilica of Santa Croce in Gerusalemme,[37] but little more than decoration remains from that work. He also requested papal permission to found the convent of San Antonio in Mondéjar near Guadalajara and by 1498 he ordered its construction by Lorenzo Vázquez, the architect who had worked for the Gran Cardenal. Iñigo López

soon became involved in the conquest of Granada and then the security of unstable Andalusia, so he was not able to see the work in Mondéjar until 1509—and then he was disappointed. He judged it to be well constructed and "nice" or "pretty" (*bonito*), but so small that it seemed more like "a model (as they say in Italy) for a larger work."[38] Evidently he found it lacking in the grand scale of Renaissance and Roman buildings he had seen in Italy. Still, the now ruinous church of that convent has the distinction of being the first in western Europe outside Italy in which pilasters and other features of the Renaissance style were employed.

Iñigo López's expertise in architectural matters is also indicated by Ferdinand's request that he look into and report on the problems of design and construction that caused friction between the canons of the cathedral and those of the Royal Chapel.[39] Luis Hurtado was certainly aware of his father's intervention in these royal projects and evidently he shared these and other architectural responsibilities, particularly during the period of illness that led Iñigo López to renounce the governorship of the Alhambra in favor of Luis in 1512, three years before his death. Several letters written by Iñigo López in 1514 and 1515 reveal further aspects of his interest in architecture and also that he sent his sons, Luis Hurtado and Antonio, to supervise the construction of towers and other fortifications between Granada and the Alpujarras, and further south at Orjiba.[40] It is clear from the letters that Iñigo

[36] Nader, *The Mendoza Family*, pp. 56-75; Manuel Gómez-Moreno y Martínez, "Hacia Lorenzo Vázquez," *Archivo español de arte y arquelogía*, I (1925), pp. 1-40; F. de B. San Román, "Las obras y los arquitectos de cardenal Mendoza," *Archivo español de arte y arquelogía*, VII (1931), pp. 153-161.

[37] Raimondo Besizzi, *La storia della basilica di S. Croce in Gerusalemme*, Rome, 1750, pp. 101-102.

[38] Gómez-Moreno, "Hacia Lorenzo Vázquez," p. 24: ". . . es bonito y bien labrado y hordenado, pero tan poquita cosa que no paresce syno que se hizo para modelo (como se dizen en Italia) de otra mayor." Later, on 14 May 1515, Luis Hurtado, writing to the Comendador Mayor of Castile referred to the faulty execution of the convent (a letter in the Archivo Histórico Nacional, Sección Osuna, transcribed by Helen Nader): "Muy magnífico señor. Porque vea vuestra merced que tengo espías en su labor, le enbío esta carta de Christóbal de Adonza, el qu'el es buen onbre y creo que guarda para toda verdad en lo que entendiere, pero también mire vuestra merced la primera labor en que entendió recia fué en el monasterio de Mondéjar y aquel regía y hordenaba en todo Lorenzo Vázquez, y después qu'el murió ovo algunos yerros que yo no he podido enmendar, que todo esto quiere decir que Christóbal ha menester otro que

sepa más. Suplico a v.m. que guarde esto y que no sepa Christóbal."

[39] For his part in the Royal Chapel and the cathedral, see Earl E. Rosenthal, "El primer contrato de la Capilla Real," *Cuadernos de Arte*, XI (1972), pp. 10-13, and idem., *The Cathedral of Granada*, p. 10, n. 29. Also included in Ibáñez's list of works visited by Iñigo López (*Historia*, fol. 242) are two lost churches, Santa Cruz in Seville and Nuestra Señora de Fuera in Guadalajara.

[40] Professor Nader kindly gave me copies of her transcriptions of about a dozen of Iñigo López's letters, now in the Archivo Histórico Nacional, Sección Osuna. In a letter written to the Gran Capitán, Gonzalo Fernández de Cordoba, on 6 May 1514, Iñigo López requested the return to Granada of his son Antonio, who had gone to look at a tower under construction between Ferreyra and Poqueira. On 18 May 1514, in a letter to King Ferdinand, Iñigo López noted that "Don Luys queda aquí en su cargo y de aquí. yrá cada día a ver una torre que se hazen en el camino de Guadix . . ." On 1 July 1514, in another letter to the Gran Capitán, Iñigo López mentioned that he had sent Luis to investigate the delay in the building of a tower near Orjiba. Iñigo López's expenditures on large-scale

López considered Luis more knowledgeable in these matters than Antonio, so presumably he had been entrusted with such tasks earlier. Luis Hurtado's experience in supervising the construction and repair of fortifications in Andalusia for more than a decade before the planning of the new palace on the Alhambra explains the confidence with which he undertook that project, but there is nothing in these experiences to suggest that he would have known the essentially theoretical plan for a square palace with a circular courtyard proposed to the emperor early in 1527.[41]

Because of the distinctly Italian character of that plan, several scholars have assumed that some of the ambassadors at the imperial court in 1526 proposed the project or recommended an Italian designer. Carl Justi in 1891 and, more recently, Loukomski, Gallego y Burín, Gallego Morell, and others have noted that some of the best and most progressive men of Renaissance Europe were in Granada in December 1526 when the emperor decided to build his palace on the Alhambra.[42] They cite Baldassare Castiglione, who published his *Il Cortigiano* the following year, Peter Martyr of Anghiera, the humanist and learned chronicler of the exploration of the Indies, Antonio de Guevara, the preacher and adviser to the emperor, Andrea Navagero, the learned Venetian ambassador, and the brothers Juan and Alfonso de Valdés, the latter being the emperor's secretary for Latin letters. In the same vein, Justi noted that Castiglione, the papal nuncio in Spain (1524–1529), was a close

friend of Raphael and also that he knew contemporary architecture very well, having studied and measured ancient ruins.[43] It was, of course, to him that Federico Gonzaga, Isabella d'Este, and Francesco Maria della Rovere looked for information about the disposition of Giuliano de'Medici's new villa on the Monte Mario (later known as the Villa Madama), which was designed by Raphael,[44] and in 1525 Federico asked him to obtain the services of Michelangelo and Giulio Romano for works in Mantua, most notably the renovation and decoration of the Villa Marmirolo and the construction of the Palazzo del Te.[45] There is no doubt that Castiglione could have suggested a circular courtyard within a square plan, since it was a type already found in the treatises of Francesco di Giorgio Martini and the sketches of the Sangallo, and it may have been presented among the early proposals for the Villa Madama designed between 1516 and 1519;[46] but it must be recognized that Castiglione was away from Rome until 1519 by which time the project for the villa was composed of several forecourts leading to an unporticoed circular courtyard (pl. 110). That seriate disposition is the plan he would have described to members of the imperial court in Granada in 1526.

Castiglione has to be excluded as a participant in the design of the palace because by the summer of 1526 he was alienated from the emperor. To be sure, he had been warmly received as the papal nuncio to Spain in March 1525, but tension arose over the arrest and execution of the eighty-year-

building projects were also noted by Helen Nader in a recent article, "Noble Income in Sixteenth-Century Castile: The Case of the Marquises of Mondéjar, 1480-1580," *Economic History Review*, 2d ser., xxx (1977), p. 415.

[41] There is no evidence that he ever saw the Renaissance courtyard installed in 1511 in the castle at La Calahorra by his cousin, Rodrigo Díaz de Vivar y de Mendoza, the marquis of Zenete, though Luis Hurtado might have stopped to see it on one of his trips to inspect the fortifications at Orjiba; see Hanno-Walter Kruft, "Un cortile rinascimentale italiano nella Sierra Nevada: La Calahorra," *Antichità viva*, VIII, no. 2 (1969), pp. 35-51.

[42] Carl Justi, "Anfänge der Renaissance in Granada," *Jahrbuch der königlich preussischen Kunstsammlungen*, XII (1891), pp. 186-187. Antonio Gallego Morell, "La corte de Carlos V en la Alhambra en 1526," *Miscelánea de estudios dedicado al profesor Antonio Marín Ocete*, Granada, 1974, I, pp. 267-294.

[43] We know that Castiglione, accompanied by Pietro Bembo and Andrea Navagero, visited "old and new Tivoli" in April 1516; see Vincenzo Golzio, *Raffaello nei documenti, nelle testimonianze dei contemporanei e nella letteratura del suo secolo*, Vatican

City, 1936, p. 42.

[44] Castiglione sent Raphael's description of that villa to Federigo Gonzaga in a letter of 16 June 1519; see Philip Foster, "Raphael on the Villa Madama: the text of a lost letter," *Römischen Jahrbuch für Kunstgeschichte*, XI (1967-1968), pp. 307-312.

[45] Egon Verheyen, *The Palazzo del Te in Mantua, Images of Love and Politics*, Baltimore and London, 1977, p. 46. For a letter from Felice da Sora to the duke of Urbino on 16 January 1525 telling of Castiglione's delivery of Michelangelo's project, see Luigi Dami, *The Italian Garden*, New York, n.d., p. 40, n. 23.

[46] David Coffin ("The plans of the Villa Madama," *Art Bulletin*, XLIX [1967], pp. 111-122) followed Geymüller's 1884 suggestion that a square plan with a round courtyard (Uffizi A1054) may have been an early project for the villa (because the central symmetry of that plan was altered in a way that would have accommodated it to the slope of the hill and the entry on the left; see pl. 105 below); and see Christoph L. Frommel, Stefano Ray, and Manfredi Tafuri, *Raffaello architetti*, Milan, 1984, pp. 331-332.

old bishop of Zamora, Antonio de Acuña, at the end of that year. In a harsh letter of March 1526, Pope Clement VII excluded the emperor from attending Mass and denounced him for his ambitions in Italy, where the pope held him responsible for the tumult.[47] The emperor responded sharply with a list of the pope's actions that had aggravated the situation, and he made the text of his reply available in several languages to the members of the imperial court. According to Jan Dantyszek, the ambassador of the king of Poland, the emperor's relations with some of the Italians had deteriorated to the point that the Venetian and Florentine ambassadors were expelled early in August.[48] He added that Charles V regarded most of the ambassadors at his court, and especially the Italians, as representatives of enemies, and Navagero claimed that Charles usually ignored members of the court. Only Dantyszek and the ambassador of the duke of Ferrara, Cesare Ferramosca, still enjoyed the favor of the emperor and (according to Dantyszek) they had little to do with the others (. . . *con ellos rara vez tratamos*). One cannot, thus, so readily imagine the emperor, Castiglione, and the other Italian ambassadors conversing amiably about the disposition of the new residence or even about famous villas such as that of Pliny the younger, which most humanists then believed had a circular court-

yard. Nor is it likely that the emperor would have asked any of them to arrange for an Italian architect to make a project for the new palace. He had his own ambassadors and agents all over Italy and they could have made such arrangements,[49] but Charles was not yet among those who thought that a noble palace had to be built in the classical style. Never, not even later, did he call upon an Italian architect as a designer or even as a consultant for one of his architectural works.

The other person to whom the unusual design has been attributed is the Italian-trained painter, Pedro Machuca. Ceán-Bermúdez in 1800 reported that Luis Machuca stated in 1567 that he and his father together had spent forty years in the works of the Alhambra (doc. 122), thus dating Pedro Machuca's first year to 1527.[50] This evidence was sufficient for scholars to put aside the legendary attribution of the design to Alonso Berruguete, a claim first made by Juan de Butrón in 1626 and then by Palomino and others into the nineteenth century.[51] Further support for the attribution to Machuca is found in two sixteenth-century sources: the commentary on Vitruvius by Lázaro de Velasco in 1563 and a poem by Vicente Espinel in the 1590s.[52] Still, some scholars have been uneasy about Machuca's role. Gómez-Moreno y González in 1885 questioned the painter's responsibility for the su-

[47] For the reports of Andrea Navagero and Baldassare Castiglione, see Emmanuele A. Cicogna, *Della vita e delle opere di Andrea Navagero*, Venice, 1855, pp. 188-189; Keniston, *Francisco de los Cobos*, pp. 91-94.

[48] A portion of the twenty-nine volumes of Dantyszek's official correspondence dating from 1506 to 1527 (once in the Stanislaw Gorski Collection in Cracow) was published in translation in the first volume of *Viajes estranjeros de España y Portugal*, Granada, 1952, I, pp. 810-811.

[49] Luis Hurtado's brother, Diego Hurtado de Mendoza, was in Italy from 1523 to 1527 (and in Rome at least twice during that period), but the brothers had strained relations from 1515 to 1531 as the result of an inheritance dispute (Ibáñez de Segovia, *Historia*, fol. 264). Another brother, Francisco, left for Italy in October 1526 and was there during the period in which Charles V directed the governor to build a modern residence on the Alhambra; see Erika Spivakovsky, *Son of the Alhambra, Don Diego Hurtado de Mendoza 1504-1575*, Austin and London, 1970, pp. 33-34.

[50] Ceán Bermúdez, *Diccionario*, III, pp. 58-59; Eugenio Llaguno y Amírola, *Noticias de los arquitectos y arquitectura de España, desde su restauración acrecentadas con notas, adiciones y documentos por D. Juan Agustín Ceán-Bermúdez*, Madrid, 1829, I, p. 222.

[51] Juan de Butrón, *Discursos apologéticos en que se defiende la ingenuidad de la arte de la pintura . . .*, Madrid, 1626, no. 15, fol. 121; A. Palomino de Castro y Velasco, *El museo pictórico y*

escala óptica [1715-1725], Madrid, 1947, p. 774. Richard Ford (*Granada*, Granada, 1955, p. 201) was told in 1830 that only the sculpture was the work of Berruguete. Recent studies of Berruguete have shown that he was in Valladolid from May 1526 (that is two months before the imperial court reached Granada in June) until the end of 1530; see José Maria de Azcárate, *Alonso Berruguete, Cuatro Ensayos*, Valladolid, 1963, p. 94. No modern scholars have accepted the attribution of the palace to Diego Siloe by Juan de Arfe y Villafañe (*Varia Conmensuración para la escultura y arquitectura* [1585], Madrid, 1773, p. 222).

[52] Lázaro de Velasco's introduction to his translation to Vitruvius (Biblioteca Provincial, Cáceres) was published in part by F. J. Sánchez Cantón (*Fuentes literarias para la historia del arte español*, Madrid, 1923-1941, I, p. 207): "En este tiempo [c. 1520] vino Machuca de Italia, pintor celebrado, discípulo de Michael Angel, el qual pintó maravillosas obras en el reyno de Granada y las ciudades de Jaén, Toledo, y convento de Uclés, y arquitecto que eligió la casa real del Alhambra que se labra al romano, la qual prosigue Luis Horozco, su hijo bien entendido, que estuvo en Italia." Ibid., v, p. 366, for Espinel's poem describing the damage on the Alhambra following the explosion of a powder mill and incidentally identifying the designer of the palace: "Más que mucho si el trueno incomparable / parte asoló de las del gran monarca / del gran Machuca fábrica admirable?"

pervision of construction and noted that his salary was well under that paid to Siloe for the cathedral of Granada, and Carl Justi in 1891 doubted that a painter could have conceived this extraordinary plan.[53] Gómez-Moreno y Martínez in 1941 observed that Machuca "had no title other than that of painter" and that he was a designer (*traçista*) "who did not personally supervise construction and had never intervened in works of stone masonry outside Alhambra."[54] The lack of evidence for any previous architectural training or experience was sufficient reason for caution in the attribution to him of the design and, even more, the supervision of the construction of the palace. Fortunately, a report on the state of the palace by Juan de Maeda, probably made in the spring of 1576, includes a reference to Machuca *el Viejo* as the designer of the palace (doc. 129). Mentioned in the context of his judgment that some of the interior walls were not thick enough to bear vaults, Maeda attributed "the measurements of the rooms and the walls" (and thus the plan) to Machuca. Because architect Juan de Maeda was often called to the Alhambra to appraise work on the palace from 1552 to 1576, he was well informed on the intentions of the Machucas, and we shall often refer to his report in the course of this study.[55]

A consideration of Machuca's training in the arts should be prefaced by a few comments about his social status. As he was a squire, or *escudero*, to Luis Hurtado de Mendoza, he must have been (as Gómez-Moreno suggested) an *hidalgo*, literally "the son of somebody [important]";[56] however, the *hidalgo* families were gentry, not nobility, and in the sixteenth century they were quite numerous and often impoverished.[57] Pedro Machuca may have been the grandson of a man with the same Christian name who in 1471 was an *escudero y procurador* in the service of Luis Hurtado's grandfather, Iñigo López de Mendoza, the first count of Tendilla. The reference to that probable forebear in Ibáñez's "Historia de la Casa de Mondéjar" tells us that in 1471 in Zaragoza an attorney for the count of Tendilla, named Pedro Machuca, collected some long overdue taxes on a farm owned by the count near the town of Ronces,[58] and it suggests that the Machuca family was in the service of the Mendoza for several generations. This longstanding association with the Mendozas would help to explain Pedro's settling in Granada on his return from Italy in 1519, as well as references to him as an *escudero*. Though the function of an *escudero* in the sixteenth century varied, that of Pedro on the Alhambra was clarified by a request in August 1550 by his widow,

[53] Manuel Gómez-Moreno y González, "Palacio de Carlos V," *Revista de España*, XVIII (1885), pp. 196-197; Justi, "Anfänge der Renaissance," p. 187.

[54] Gómez-Moreno y Martínez, *Las águilas*, p. 120: "Machuca no tenía más título profesional que el de pintor de imaginería. En obras de cantería fuera de la Alhambra nunca intervino; persí como tracista o arquitecto, aunque esta categoría casi no sonaba entonces, y ello explica lo módico de su salario, cien ducados annuales, como maestro mayor de las obras de la Alhambra, puesto que no acudía trabajando personalmente en ellas como Siloe, a diario, sino dando trazas e instrucciones." This view was repeated by Fernando Chueca Goitia (*Arquitectura del siglo XVI*, Ars Hispaniae XI, Madrid, 1953, p. 212).

[55] Juan de Maeda was *aparejador* of the cathedral of Granada under Siloe and, after the latter's death in 1563, Maeda was chief architect until his death on 26 June 1576. The first reference to Maeda on the Alhambra is a payment of 5 November 1552 for his appraisal of the swags (*colgantes*) carved for the doors of the west facade by Orea; see AGS, CMI, Leg. 1120 (doc. 63). By 1576, he had known the works on the Alhambra for almost a quarter-century.

[56] Gómez-Moreno y Martínez (*Las águilas*, p. 121) cited no documentary basis for the claim. Samuel Gili Gaya (*Tesoro lexicográfico 1492–1726*, Madrid, 1947, p. 950) noted that Covarrubias in 1611 defined *escudero* as "el hidalgo que lleva el escudo al cavallero en tanto que no pelea con él, y el que lleva la lança, que suele ser joven, le llaman page de lança. En la paz, los escuderos sirven a los señores de acompañar delante sus personas, asistir en la antecámara o sala: otros se están en sus casas, e llevan acostamiento de los señores, acudiendo a sus obligaciones a tiempos ciertos."

[57] The gentry and nobles of Spain were composed of several classes in the sixteenth-century—*grandes, títulos, caballeros,* and *hidalgos*—with the numbers increasing for each of the successive classes in this list. For his estimate that there were more than 108,000 *hidalgo* families in Spain at this time, see Antonio Domínguez Ortiz, *Las clases privilegiadas en la España del antiguo régimen*, Madrid, 1973, pp. 26-27, 50-59.

[58] Ibáñez de Sevogia, *Historia*, fol. 148: ". . . en Zaragoza a 2 del més de Octubre . . . 1485, Luis de la Cavallería . . . vendió al . . . Don Eniego López de Mendoza, señor de Tendilla . . . un huerto con una casa dentro del situada en Castallo término de la dita ciudad; de la manera que Domingo Abad Labrador, vecino del lugar de Ronces . . . estando en Zaragoza del mes de Octubre del año de 1471, otorgó como procurador del dicho lugar carta de pago a Pedro Machuca, escudero y procurador assimismo del Conde de los Pechos, que devía percibir su señor de los quatro años antecedents, ect." This notice was pointed out to me by Helen Nader. Estela Piñera Keim found several references to a "Diego de Machuca" (whose widow was involved in a law suit with the convent of San Miguel de los Ángeles in Toledo in 1488) in an eighteenth-century inventory of documents once in the convent but now dispersed.

Isabel Machuca Horozco, for compensation for the loss of a horse that her husband had used for the last six of his thirty years of service in the cavalry of the Alhambra, known as the *jinete*.[59] Evidently, he had joined the cavalry in 1520, the year he first came to Granada. Yet it is unlikely that Machuca was an active member of the famous light cavalry that fought in Moorish fashion with lances and leather shields, or that he was part of the select group of a hundred men who fought under Luis Hurtado de Mendoza at Tunis in 1535 and at Gibraltar in 1540. Machuca may have been a member of the reserve force stationed on the Alhambra, but even this limited service would indicate equestrian skills generally confined to the upper classes. Above all, his membership in the *jinete* from 1520 provides evidence of a longstanding relationship between Pedro Machuca and Luis Hurtado de Mendoza, and it would seem to have been quite close, since Pedro named his first son Luis and his daughter Luisa, presumably in honor of Luis Hurtado.[60]

Machuca's age at the time of his return from Italy and the length of time he spent there are unknown. According to Lázaro de Velasco, writing around 1563, his father, Jacobo Florentín, and Pedro Machuca came to Granada together,[61] apparently late in 1519 or early in 1520. That date is indicated by Isabel Machuca's statement that her husband had been assigned to the cavalry of the Alhambra for thirty years before his death in 1550. Further confirmation is provided by the first record of his artistic activity in Spain, a contract signed together with Jacobo on 8 February 1521 for several paintings to complete the retable of the Holy

Cross in the Royal Chapel in Granada.[62] Evidently Machuca was still in Italy in 1517, because his painting of the *Virgin of Souls in Purgatory (Madonna del Suffragio)* is signed and dated PETRUS MACHUCA, HISPANUS. TOLETANUS. FACIEBAT A.D. MCCCC.XVII., and it came to light in Spoleto shortly before it was acquired by the Prado in 1935 (pl. 3).[63] Beyond the fact that the painting was found in Italy, the stress on his Toledan and Spanish origin in the inscription suggests it was painted outside his homeland, while the subject—the Madonna giving succor in the form of milk from her breast to the souls in Limbo—was a peculiarly Italian image and not favored in Spain at the time.[64] These indicators, together with the style of painting, have convinced most scholars that it was executed in Italy. Also, the size of this panel (1.67 x 1.35 m.) suggests that in 1517 he was no longer a pupil but a master undertaking independent commissions.

Clues to Machuca's training in Italy must be found in the half-dozen paintings in oil on panel that make up the core of his pictorial oeuvre because the remainder of the works attributed to him are of such poor quality that they were likely executed by assistants or even followers. The most dependable is the *Madonna del Suffragio* which is signed and dated 1517, but its surface may have lost nuances of modeling and descriptive detail as well as the final glazes (pl. 3). It may have had the elegant finish and subtle chiaroscuro of the undocumented *Holy Family* in the cathedral of Jaén, for which Machuca is known to have done several paintings in 1520 and 1546 (pl. 4).[65] Another universally accepted painting is the *Descent from the*

[59] Gómez-Moreno y Martínez (*Las águilas*, p. 122, n. 1) published two of the documents transcribed and cited by his father in 1885 ("El palacio de Carlos V," p. 196, n. 1), though he could not locate them in the archive in 1940. They were found in 1956 by María Angustias Moreno Olmedo, archivist of the Alhambra, in Leg. 111, 3, together with several other documents pertinent to the petition that must date from the period between 18 August 1550 (doc. 49) and 1 December 1551. On 22 October 1550, two officials confirmed that Pedro Machuca was an *escudero* in the cavalry of the Capitanía and that he had been assigned a horse. According to Münzer in 1494 (Pfandl, "Itinerarium," p. 48) and Ibáñez (*Historia*, fols. 215v and 217), the early Mendoza governors had a light cavalry of five hundred men; however it is probable that at times only one hundred were stationed on the Alhambra.

[60] Gómez-Moreno y Martínez (*Las águilas*, p. 121, n. 2) cited baptismal records in the archive of Santa María de la Alhambra;

but, according to the parish priest, that archive was transferred to San Cecilio and subsequently lost in a fire.

[61] See this chap., n. 81.

[62] Gómez-Moreno y Martínez, Manuel, "En la Capilla Real de Granada," *Sobre el Renacimiento en Castilla*, Madrid, n.d., p. 119, doc. xxiv.

[63] *Museo del Prado. Catálogo de las pinturas*, Madrid, 1963, p. 380.

[64] According to Lázaro de Velasco, Pedro Machuca later painted an image of Nuestra Señora del Socorro for the high altar of the Dominican monastery in Granada, but since it is lost, we do not know if he followed the iconography of the 1517 painting now in the Prado. For Velasco, see Sánchez Cantón, *Fuentes*, I, pp. 207-208.

[65] Gómez-Moreno y Martínez, *Las águilas*, pp. 113-114, 119 and doc. xxiv.

Cross in the Prado, which is known to have come from Budapest to Paris sometime before 1870.[66] Its Plateresque frame has an inscription that identifies the donor as Doña Inés de Castilla, wife of the *regidor* of Montalvo, and gives the date of completion as 1547, though that date is barely legible. If 1547 is also the date of the painting—and that is by no means certain—we must conclude that Pedro Machuca's manner of painting changed little in the quarter century after his return from Italy. Closely related are the several panels Machuca made for the predella of the retable of the Holy Cross in the Royal Chapel in Granada.[67] Though a great deal of modeling and detail has been lost in darkened shadow areas, the *Arrest of Christ* and the *Agony in the Garden* would seem to be worthy of his hand. Another painting generally accepted as his is the long panel representing the *Descent of the Holy Ghost* in the Ponce Museum in Puerto Rico (pl. 5).[68] While much more animated and better composed spatially than the Royal Chapel paintings and the *Descent from the Cross* in the Prado, the figures in the Ponce painting are not drawn as well and the surface lacks the final glazes. Several documented works, such as that at Viznar, are lost. In the case of the retable in the chapel of San Pedro de Osma in the cathedral of Jaén, Pedro Machuca's role must have been limited to the design, with the painting done by his son, Luis, as Gómez-Moreno suggested.[69] The rest of the works attributed to him in recent years are poorly painted. At best, they may have been designed by him and executed by assistants or imitators.

Among those who have attempted to identify the artistic milieu in Italy in which Pedro Machuca was trained, Manuel Gómez-Moreno y Martínez, Chandler Post, and Andreina Griseri have stressed his dependence on Florentine Mannerists and north Italian painters, most notably Correggio.[70] However, Roberto Longhi observed that the Emilian artist had not developed his mature style before Machuca left Italy, and he suggested that any similarities in style are probably the result of their common experience in Rome around 1517.[71] For Longhi, Machuca's style (in his most dependable works) was more closely related to that of the Raphael School, especially at the time of the fresco decoration of the *Logge* of the Vatican palace in 1517–1519. In 1969 he claimed for Pedro the *Moses receiving the Tablets of the Law*, while Nicole Dacos in 1977 assigned him the *Isaac blessing Jacob*.[72] Though neither attribution was supported by a detailed account of the features and traits considered characteristic of Machuca, there are sufficient similarities in the squat figural proportions, the broad facial types, the spirited movement, and the handling of light and shade to grant at least plausibility to those attributions. One might, however, question the assumption that Machuca was trained as a fresco painter, since there is no record of his having worked in that medium in Spain. There, all the paintings attributed to him were executed in oil on panel. Admittedly, there were few opportunities to work in fresco in Spain, but murals in that technique were commissioned on the Alhambra in 1539 and Machuca was not asked to do

[66] *Museo del Prado. Catálogo*, p. 380. A preparatory drawing for this painting is found in the Louvre and another drawing of the same subject in Valencia is also attributed to Pedro Machuca; see Diego Angulo and Alfonso E. Perez Sánchez, *A Corpus of Spanish Drawings 1400–1600*, London, 1975, cat. nos. 202, 203.

[67] Gómez-Moreno y Martínez, *Las águilas*, p. 114, doc. XXIV, figs. 286-288.

[68] *Museo de Arte de Ponce. Fundación Luis A. Ferré, Catalogue I. Paintings of the European and American Schools*, by Julius Held, Ponce, Puerto Rico, 1965, pp. 105-106.

[69] Gómez-Moreno y Martínez, *Las águilas*, p. 119, doc. XXIV, figs, 295-296.

[70] Ibid., pp. 113-120; Chandler R. Post, *A History of Spanish Painting*, X, *The Early Renaissance in Andalusia*, Cambridge, Mass., 1950, pp. 259-273, with additions in vol. XII, part 2, pp. 740-745; Diego Angulo Iñiguez, *Pintura del Renacimiento* (Ars Hispaniae XII), Madrid, 1954, p. 226. Andreina Griseri, "Perino, Machuca, Campaña," *Paragone*, VIII, no. 87 (1957), pp. 13-21; idem., "Nove schede di manierismo ibérico," *Paragone*,

x, no. 113 (1959), pp. 33-34; Idem., "Berruguete e Machuca dopo il viaggio italiano," *Paragone*, XV, no. 10 (1964), pp. 3-19. Matias Díaz Padrón, "Un a tabla inédita de Pedro Machuca en el monasterio de Coria," *Archivo español de arte*, LIV (1981), pp. 441-448.

[71] Roberto Longhi, "Comprimarj spagnoli della maniera italiana," *Paragone*, IV, no. 43 (1953), pp. 3-15; idem., "Ancora sul Machuca," *Paragone*, XX, no. 231 (1969), pp. 34-39.

[72] Nicole Dacos, *Le Logge di Raffaello*, Rome, 1977, pp. 112-114, cat. no. v.3, p. 72 and pl. XXIIIb. Dacos also speculated that Pedro Machuca might be "Pietro spagnolo" who helped Pellegrino da Modena and Baccio Bandinelli in the decoration of one of eighteen carts used in a festival sponsored by Leo X in Rome in 1515; but, there were several other Spanish artists named Pietro at work in central Italy at the same time; see Herbert Janitschek, "Über einige bisher unbekannte Künstler, die unter Leo X, in Rom arbeiten," *Repertorium für Kunstwissenschaft*, II (1979), pp. 416-417. The fifth on the list of triumphal carts reads: "Quinto. Obedientia. el carro delle femme col jugo et cavallo. Pietro spagnolo."

them. They were the murals in the Tocador de la Reina depicting Charles V's successful campaign against the Turks in Tunis in 1535.[73] Furthermore, they were commissioned by Machuca's patron, Luis Hurtado de Mendoza, who had led the Spanish cavalry in that campaign. It is true that the two painters brought from Italy in 1539—Julio Aquiles and Alejandro Mayner as they are recorded in Spain—were associated with the Raphael School, but they had already been contacted by Francisco de los Cobos in the mid-1530s to decorate his palaces in Valladolid and Úbeda,[74] so Machuca may have had nothing to do with their selection. He did, however, approve the final payment to them after they completed their work in 1546.[75] In any case, Machuca's paintings in oil link him to the Raphael School, notably to Giulio Romano, Perino del Vaga, and Gianfrancesco Penni.[76]

Architectural backgrounds, so frequent in the paintings of the Raphael School are surprisingly rare in Machuca's panels. A unique example is the churchlike interior of the *Descent of the Holy Ghost* (pl. 5), but its architectural elements do not reflect any parts of the palace on the Alhambra. The plain surfaces, sharp edges, and light weight volumetrics of the slim pillars in this painting are at odds not only with Machuca's architectural repertory but also with his sense of proportion and mass. In my study of the Ponce painting in 1971, it seemed to me that the pigment of the architectural portions overlay that of the figures in front of them, but René Taylor, Director Emeritus of the museum in Ponce, has since written that, when seen under strong tungsten and ultraviolet light, the craquelure is continuous from the areas of the figures into the

architectural elements. Because of this and also because of the preparatory lines delineating the architectural forms under the pigment, he concluded that the architecture was painted at the same time as the figures. This leaves us with the problem that figures reasonably given to Machuca are combined with architectural elements that are at odds with his one extant architectural work. Of course, we do not know when or where the Ponce panel was painted or how many painters were involved. Even if one were to assume that the architectural setting was designed by Pedro Machuca, it provides no help in identifying the Italian centers in which he prepared for the design of the palace on the Alhambra.

No help is gained from the only other known architectural work by Machuca: the catafalque for Mary of Portugal designed in 1549 for the Royal Chapel in Granada. Machuca's rapid sketch for that temporary funerary monument is preserved in the archives of the Alhambra (pl. 6). We can attribute the sketch to Pedro on the basis of the payment of twelve ducats to him for the project and a detailed contemporary description.[77] Further support for the attribution is provided on the back of the drawing by Pedro's signature in receipt of a payment on 13 March 1549 for some unidentified work.[78] From this drawing and the contemporary description, it is clear that the catafalque was 6.57 meters square and 6.84 meters high. Four Doric columns rested on a plinth and supported an entablature and a truncated cover that was studded with candleholders and surmounted by a huge cross at the top. Devoid of all decoration, the columns were silver-plated, while their capitals and bases

[73] Manuel Gómez-Moreno y González, "Los pintores Julio y Alejandro y sus obras en la Casa Real de la Alhambra," *Boletín de la Sociedad Española de Excursiones*, XXVII (1919), pp. 20-33.

[74] Keniston, *Francisco de los Cobos*, pp. 188-189.

[75] Gómez-Moreno y Martínez, *Las águilas*, p. 238, doc. XXXIV.

[76] Most convincing is the comparison of Machuca's *Holy Family* in Jaén (pl. 4) and that of Raphael's *Holy Family of Francis I*, painted in 1518 and now in the Louvre (Sidney Freedberg, *Painting of the High Renaissance in Rome*, Cambridge, Mass., 1961, pl. 436); see also Giulio Romano's closely related paintings of the *Madonna della Perla* and the *Madonna della Rosa*, both dated about 1519 and now in the Prado Museum in Madrid, and Gianfrancesco Penni's *Madonna del Divino Amore* in Naples (pls. 448, 450, and 452). The Christ Child in the Jaén painting, however, has more affinities with those depicted by Alonso Berruguete than those by Raphael.

[77] The drawing is in the archive of the Alhambra, Leg. 225.

3. The undated description, once in the Sección Casa Real in the Archivo General de Simancas, was published as doc. XXX in Gómez-Moreno y Martínez, *Las águilas*. In his discussion (pp. 234 and 235, n. 2) he stated that Pedro Machuca had signed a receipt for twelve ducats "porque entendió en la traça del túmulo," apparently quoting from a document that was in (old) Leg. 84. Earlier, in 1539, Machuca had designed the catafalque for Empress Isabel (ibid., doc. XXIX); see Antonio Bonet Correa, "Túmulos del emperador Carlos V," *Archivo español de Arte*, XXXIII (1960), pp. 55-66.

[78] The receipt on the back of the drawing was not transcribed by Gómez-Moreno; it reads: "Dygo yo Pedro Machuca, que recibí de Jorge Hernández Abrnje [?] ciento y setenta y ocho ducados con seis maravedís y porque es asy oy está firmado de mi nombre fecha por 13 dyas de marzo de 1549 años. Pedro Machuca." In addition, there are some seemingly unrelated calculations on the back.

were gilded as were the royal arms mounted at the midpoint of the columns.[79] Above the tumba, on which the royal symbols were usually placed, two angels in flight held the arms of Mary of Portugal. The stepped and truncated hood of the catafalque is reminiscent of undated graphic reconstructions of the Mausoleum of Halicarnassus by Antonio da Sangallo the Younger on the basis of Pliny's description of the ancient monument.[80] In its severe simplicity and boldness of scale the catafalque of Mary of Portugal may represent the idea of the classical style that Pedro Machuca brought back from Italy in 1520 because even as late as 1549 the sobriety of that project had no analogy in Spain.

The most promising clue to Pedro Machuca's contacts in Italy is Lázaro de Velasco's statement around 1563 that Pedro returned to Spain at the same time as Lázaro's father, Jacopo Torni l'Indaco, who was known as Jacobo Florentín in Andalusia.[81] Vasari identified him as a Florentine painter who had been an apprentice in the workshop of Domenico Ghirlandaio at the time Michelangelo was there, that is to say in 1488, and who in the 1490s worked in Rome with Pinturicchio.[82] Evidently Jacopo remained a close friend of Michelangelo, who greatly enjoyed his company though at times was irritated by his practical jokes and lack of a sense of responsibility. Jacopo was among the Florentines Michelangelo first called to help him on the Sistine ceiling in 1508. After stating that

Jacopo spent "many years in Rome" and died there at age seventy-eight, Vasari attributed the scarcity of late works to laziness. Obviously, Vasari did not know about Jacopo's trip to Spain, where he was involved in several major pictorial, sculptural, and architectural projects until his death in January 1526. Lázaro de Velasco, Jacopo's son by a Spanish woman, Juana de Velasco, took his mother's surname, but he knew that he had been given the Christian name of his paternal grandfather, Lazzaro [di Pietro Torni], and he identified his father's brother as "Francisco el Indaco." Jacopo, born in 1476, did have a much younger brother named Francesco who was born in 1492. Vasari noted that he too was called *l'Indaco* and that he was of the same temperament as Jacopo.[83] Since Francesco Torni was not a prominent artist in Rome in the 1560s and certainly not an international figure, it seems unlikely that Lázaro would have mentioned him in the introduction to his commentary on Vitruvius unless Francesco had executed some works (presumably architectural) known to his Spanish readers. In view of this, it would seem reasonable to identify Lázaro's uncle, Francesco l'Indaco, with Francisco Florentín, who began the tower of the cathedral of Murcia in 1519 (pl. 8) and shortly after carved the choir stalls and the marble parapets of the stair to the high altar of the Royal Chapel in Granada.[84] Francesco, after quickly obtaining several commissions for architecture and sculpture in

[79] Leon Battista Alberti noted that the ancients sometimes plated columns with silver and made the capitals and bases of gilt brass; see *De re aedificatoria* (Trattati di architettura I), ed. R. Bonelli and P. Portoghesi, Milan, 1966, II, pp. 521-523 (bk. VI, chap. 13); henceforth identified as Alberti, *Trattati*.

[80] Gustavo Giovannoni, *Antonio da Sangallo il Giovane*, Rome, 1959, I, p. 11; II, fig. 7, cited Uffizi A894 (among a total of eight drawings of the monument in the same collection).

[81] Sánchez Cantón, *Fuentes*, I, pp. 207-208: "En el año de mill y quinientos y veinte vino a España mi padre, que sea en gloria maestro Jacopo, Florentín de nación, excellentíssimo pintor y primer escultor, hombre alto, enxuto cenceño, rubio y blanco, que casó con Juana de Velasco, mi madre, que ordenó la torre de Murcia y prosiguió la capilla del gran Capitán que avía empezado [blank] modernista daquí en esta ciudad de Granada, y que pintó algunas cosas como es la imagen que está de nuestra Señora del Socorro en el altar mayor del monasterio de los frailes dominicos y el retablo de la cruz, que dizen de la capilla real, la cena y los apóstoles y la salutación de piedra de sobre la puerta de la Sacristía de la dicha capilla y algunos retablos de la iglesia de San Francisco y en la iglesia mayor de Sevilla la imagen de nuestra Señora de la Antigua, pintura escellente y muy afamada de todos los officiales, y murió en un lugar de Murcia que se dize Villena."

[82] Giorgio Vasari, *Le Vite de' più eccellenti pittori, scultori e architettori nelle radazioni del 1550 e 1568*, ed. by R. Bettarini and P. Barocchi, Florence, 1971, III, pp. 629-630.

[83] Ibid., pp. 60-631. Perhaps *l'Indaco*—indigo, the deep blue dye—inferred temperamental qualities at the time.

[84] The identification of Francisco Florentín with Francesco Torni l'Indaco was expressly denied by Gómez-Moreno y Martínez in 1925 and by most scholars since; see his "En la Capilla Real," pp. 68 and 77. Gómez-Moreno must have been misled by what seems to have been a misstatement by Manuel González Simancas, who published the documents for Francisco's work in Murcia; see "La catedral de Murcia," *Revista de archivos, bibliotecas, y museos*, XXV (1911), pp. 520-521. González Simancas said, "Muerto Francisco Florentín, . . . occupó el puesto de aquel su hermano Jacobo;" but none of his documents indicate that Francisco had died. The final payment to Francisco reads: "yten, do en descargo que pague a maestre Francisco Florentín de finito de su salario de ocho meses e ocho días, diez y siete mill maravedís." This payment was made to *him*, not his heirs, and several additional payments for the doors of the archive and for eleven pieces of marble from the Sierra de Filabres were made to him at the same time. To be sure, there is no indication of his reason for giving up the post in Murcia before the completion of the contracted year, but clearly, the

Andalusia, must have written to his elder brother, Jacopo, to tell him of his good fortune. The news could have sparked Jacopo's interest and that of expatriate Machuca, inducing them to come to Granada the following year. Pedro must also have known Francesco, who was approximately his age, as part of the Jacopo's coterie in Rome during the second decade of the sixteenth century. Through them, he could have met major artists and heard about contemporary works and projects in that leading center of the High Renaissance style. Even after Francesco returned to Italy in 1522, he is likely to have kept his brother and Machuca informed about important art events in Rome, at least until the sack of 1527. So Machuca's association with the Torni brothers of Florence and Rome provides the best indication of the artistic ambience he knew in Italy; however, an appraisal of their influence on the young Spaniard must await our identification of the parts of the palace that can be attributed to Pedro Machuca.

Beyond his friendship with Jacopo and Francesco Torni, there are few clues to Machuca's professional associations and architectural training in either Italy or Spain before he was commissioned to do the palace on the Alhambra. No earlier buildings can be attributed to him, and even the frames of his first retables executed in collaboration with Jacopo, and from 1524 to 1543 with Esteban Sánchez, were designed not by Machuca but by his collaborator.[85] Not even later, for the retable for the chapel of San Pedro de Osuna in the cathedral of Jaén, is it likely that Pedro was responsible for the design. The contract of 1546 stipulates that the frame of the retable was to follow the design (*conforme a la muestra*) previously

approved by the prior and the dean, who noted that the subjects (*historias*) to be represented in the retable were written on the project.[86] No feature of that atectonic frame—least of all the foliate decoration between the roundels—suggests Machuca was the author of the design. Neither the architectural elements nor the sense of scale or composition of this or any of the retables with which he was associated present analogies to the architectural repertory used in the palace. Nor was Machuca asked to continue the church of San Jerónimo in Granada after the death of his friend Jacopo in 1526. It would seem that Machuca's capacity for architectural design was not yet recognized, even by his co-workers. That makes still more surprising the choice of Machuca as architect of the palace of Charles V.

The appointment of a painter to supervise architectural works was not then as common in Spain as it was in Italy,[87] but it was not without precedent. Neither Francesco nor Jacopo Torni seems to have had training other than that of painter and sculptor when they took charge of the construction of the tower of the cathedral of Murcia in 1519 and 1522, respectively. Diego Siloe had no technical training other than that of sculptor before he was entrusted in 1519 with the construction of the famous "golden staircase" in the left transept of the cathedral of Burgos and, in 1527, the tower of the village church in Santa María del Campo in the province of Burgos. The training and examinations required for the status of master mason at that time are not clear.[88] Most masons gained practical experience in family workshops, joined professional confraternities, and became *maestro de cantería* by general consent on evidence of dem-

cathedral was settling accounts with Francisco Florentín himself in 1522. I suspect González Simancas confused the final payment to Francisco with the one made to Jacobo's heirs on 27 January 1526 (". . . que mandaron dar a sus herederos. . . ."). In any case, Francisco Florentín (Francesco Torni) returned to Italy where (according to Vasari) he worked in the late 1520s in Montepulciano and, shortly after, in Arezzo.

[85] Gómez-Moreno y Martínez, *Las águilas*, pp. 113-120, and idem., "En la Capilla Real," p. 19, doc. XXIV, for the important retable of the Holy Cross for the Royal Chapel in 1521. It is wholly in the style of Jacopo Torni. Representative of Sánchez is the retable of Santa María la Mayor in Úbeda.

[86] Gómez-Moreno y Martínez, *Las águilas*, pp. 119, 225, doc. XXIV, fig. 295.

[87] Until the mid-sixteenth century, most Italian Renaissance architects were first trained as painters or sculptors and had no

practical experience as masons, because *disegno* was already considered the basis for all three arts. Antonio da Sangallo the Younger may be the first to have trained almost solely in the building crafts, and Vasari and Cellini expressed the belief that he would have been a better architect if he had had training in the representation of the human figure as a painter and sculptor. See Catherine Wilkinson, "The new professionalism in the Renaissance," *The Architect*, ed. Spiro Kostof, New York, 1977, pp. 134-136.

[88] For a valuable discussion of what is known about the training and examination required for the status of *maestro de cantería* in Spain see John D. Hoag, *Rodrigo Gil de Hontañón*, an unpublished doctoral dissertation, Yale University, 1957, especially pp. 105-114. Fernando Marías, "El problema de arquitecto en la España del siglo XVI," *Boletín de la Real Academia de Bellas Artes de San Fernando*, XLVIII (1979), esp. pp. 195-205.

onstrated ability. On the Alhambra, where the governor was the unchallenged authority in all matters, any guild regulations that may have pertained to the city of Granada would not have restricted the choice of a painter as *maestro mayor*.[89] Even so, scholars have wondered why Machuca was given so important a task as the design and then the supervision of the construction of the palace of Emperor Charles V on the Alhambra when there is no evidence for his interest or experience in architecture previous to 1527.

The answer may be provided by a precious notice transcribed long ago by Eduardo Molina Fajardo and María Angustias Moreno Olmedo, but never published and now mislaid. Both archivists recall a record of a payment to Pedro Machuca for decorations designed for Charles V's entry into Granada early in June 1526, and Jesús Bermúdez Pareja also remembers having seen a copy of the transcription in the house of Antonio Gallego y Burín. Apparently, the payment revealed little more than the fact that Machuca was commissioned by the merchants of the city to make several tableaux and triumphal arches.[90] Unhappily, only a few references to them were made by the several ambassadors who left accounts of the arrival of the imperial court in Granada. Andrea Navagero, the Venetian ambassador, mentioned two triumphal arches, one at the entry to the city and the other near the cathedral (still in the old mosque), but he did not identify the designer. He described them as "very ugly and clumsy" (*assai bruti et gofy*), but he was often disdainful of things of this sort seen in Spain.[91] The more sympathetic Polish ambassador, Jan Dantyszek, whom we have quoted before, simply says that there was "a grand reception" (*un grandioso recibimento*).[92] Ibáñez de Segovia,

writing in 1613 and drawing on Mendoza correspondence now apparently lost, said that Charles "was received with demonstrations not inferior" to those afforded him in Seville.[93] Fortunately, detailed descriptions of the seven triumphal arches set up for the reception in Seville are preserved. Each was characterized by an elaborate iconographic program centered around one of the virtues required for the successful rule of Charles' vast empire.[94] There is reason to assume that the "Twenty-four" of Granada and the governor on the Alhambra would have attempted to equal the reception in Seville; furthermore, if Pedro Machuca was chosen by the merchants of the city to make some of the decorations, it is likely that Luis Hurtado would also have called upon him to design similar festive works along the road to the Alhambra. Its ruinous entry gate, known as the Puerta Real (pl. 17-O), was demolished the following year, and most of the southwest corner of the upper precincts of the Alhambra (then a quarter of dilapidated houses) would have required a good deal of cosmetic treatment to make festive the emperor's path to the Christian entry to the old Nazaride palaces in the southwest corner of the Court of Lions (pl. 17-J). In any case, Machuca's triumphal decorations were probably designed in the "Roman Style," and later, when Charles ordered the building of the new residence, the governor may have asked Machuca to make some projects because that style was most appropriate for a regal or imperial palace.

To the *dramatis personae* we must add two previously unsuspected participants in the design phase of the palace—the Castilian mason, Luis de Vega, and his patron, Francisco de los Cobos, the trusted secretary of the emperor. Although Vega's visit to

[89] Professor Concepción Félez Lubelza of the University of Granada, who has studied the history of the construction of the Royal Hospital in Granada, told me she found little evidence of guild strength in the city of Granada. Chueca (*Arquitectura del siglo XVI*, p. 14) expressed the belief that local guilds (constituted as religious confraternities) continued to assert their authority well through the sixteenth century, but he noted that someone employed in royal works might be free of their jurisdiction.

[90] Helen Nader also heard (from Eduardo Molina Fajardo) of the payment to Pedro Machuca for his design of "the elaborate arches and tableaux that the city of Granada constructed for the emperor's entrance in to the city"; see *The Mendoza Family*, p. 198.

[91] Cicogna, *Della vita*, p. 340, for letter of 8 June 1526 in

which Navagero described Charles' entry into Granada by way of a city gate [evidently the Puerta de Elvira] in the guise of a triumphal arch. Charles was met there by a hundred cavalrymen who escorted him to a second triumphal arch in front of the cathedral. Because the authorities of the city of Granada first invited the emperor to visit their city early in March 1526, the preparations committee had very little time to plan entry decorations; see Gallego Morell, "La corte de Carlos V en la Alhambra," pp. 269 and 273.

[92] Dantyszek, *Viajes estrangeros*, I, p. 805.

[93] Ibáñez de Segovia, *Historia*, fol. 294.

[94] Sandoval, "Historia" (bk. 14, chap. 9), LXXXI, pp. 162-165; Diego Ortiz de Zúñiga, *Anales eclesiásticos y seculares de la muy leal ciudad de Sevilla*, Madrid, 1677, pp. 483-488.

the Alhambra has been known since Gómez-Moreno y Martínez published the governor's letter of 27 February 1528 to the emperor (doc. 2), no one seems to have recognized the importance of the event, presumably because the young mason was taken to be nothing more than a messenger.[95] The governor reported that he had shown Vega the plans and that he had explained his understanding of them and had "demonstrated the site and disposition where the new building is to be made." Clearly, there were some disagreements over various aspects of the design and location of the new residence, and, as we shall see, Vega's visit was a pivotal event in the history of the palace. In 1527, however, Vega was not yet in royal service. He was then supervising the construction of two palaces for Francisco de los Cobos, so it is likely that Vega was recommended for the mission to the Alhambra by Cobos, whose recent experience in the planning of several large palaces made him a logical consultant.

Our interest in Luis de Vega necessarily centers on the 1520s and early 1530s, but we know very little about that period in contrast to his well-documented activities at midcentury.[96] All that remains of the Cobos palace in Valladolid (the present Capitanía General, still called the Palacio Real) is its handsome courtyard (pl. 12), which seems to have been realized in 1525–1535.[97] Only a few capitals and gargoyles have survived from Vega's renovation of the Cobos palace in Úbeda in 1531–1532.[98] More remains of the palace in Medina del

Campo, begun around 1527 for Cobos' old friend, Dr. Beltrán, though that palace is identified with a later owner, the wealthy merchant Rodrigo Dueñas.[99] Cobos and Beltrán had been assigned to Charles' entourage in Flanders, having gone there after the death of Ferdinand the Catholic in February 1516 to serve the young king designate.[100] On their return to Spain with Charles in 1517, they rose rapidly at court, and their large palaces were probably intended to provide evidence of their higher status. As *parvenu* members of the court, they are more likely to have chosen an architect accepted by the aristocrats they wanted to impress. That Luis de Vega in 1525 was already well established is suggested by the fact that he had a workshop of masons and artisans who worked for him in both Valladolid and Medina del Campo.[101]

The emperor was well aware of the several palaces that Vega was building for Cobos because he stayed in the one in Úbeda on his way from Granada to Castile in December 1526 and he probably heard at that time of plans to renovate and enlarge it.[102] On his arrival in Valladolid on 28 January, he must have admired the new Cobos residence, which was being roofed by Luis de Vega at that very time.[103] As a result, the emperor is likely to have asked Cobos' opinion of the Alhambra projects when he received them during the spring of 1527. Late that year, on 30 November, "by order of His Majesty," Cobos wrote a letter to the governor that listed the emendations of the initial project required by the emperor (doc. 1). He stressed

[95] Manuel Gómez-Moreno y Martínez, *Diego Siloe*, Granada, 1963, pp. 79-81.

[96] Luis de Vega seems to have worked in Alcalá de Henares around 1520, when Pedro Gumiel, Pedro de Villarroel, and Juan Gil de Hontañón were active there; see José J. Rivera Blanca, *El Palacio Real de Valladolid*, Valladolid, 1981, pp. 32, 145-146.

[97] Ibid., esp. pp. 29-33, 141-145. Jesús Urrea Fernández ("El Palacio Real de Valladolid," *Boletín del Seminario de Estudios de Arte y Arqueología*, XL-XLI [1975], pp. 241-258) provides an up-to-date chronology of work on the palace from 1522 to 1601; see also Juan José Martín González, *Monumentos civiles de la ciudad de Valladolid* (Catálogo monumental de la provincia de Valladolid, XIII), Valladolid, 1976, pp. 178ff. The history of the building is very complicated because the Álvaro de la Luna residence was on the approximate site of the Cobos palace, but it seems that the latter was begun in 1522 and (after an interruption in the work) was entrusted to Luis de Vega around 1525. After it was sold to the duke of Lerma in 1600, drastic changes were made.

[98] Keniston, *Francisco de los Cobos*, pp. 151-152. There is also

a rough sketch of about 1531 for a new wing on the east side of the Cobos residence (pl. 13) that will be discussed later.

[99] Esteban García Chico, "El Palacio de los Dueñas de Medina del Campo," *Boletín del Seminario de Estudios de Arte y Arqueología* [Universidad de Valladolid], XVI (1949-1950), pp. 87-110; idem., *Medina del Campo* (Catálogo monumental de la provincia de Valladolid, III), Valladolid, 1961, pp. 33-39, pl. XIV. The building now houses the Instituto de la Segunda Enseñanza.

[100] Keniston, *Francisco de los Cobos*, pp. 30 and 94.

[101] Rivera Blanca (*El Palacio Real de Valladolid*, p. 32) stressed the prestige that Luis de Vega already enjoyed in the 1520s.

[102] Keniston, *Francisco de los Cobos*, pp. 96, 150-151.

[103] Luis de Vega on 26 October 1526 (or 1527?) informed Cobos that he himself was pleased with the completed facade of the palace in Valladolid and he noted that the tiling of its roof was underway. The letter in Simancas (AGS, Estado 14, fol. 44) was cited by Keniston (ibid., p. 96) and published by Urrea Fernández ("El Palacio Real," p. 245, n. 17), who noted that the letter bore no more than the month and day but that it was found in a bundle of material from 1526.

the need to join administrative offices and service structures to the residence, a convenience that may have been first suggested to the emperor by his efficient secretary. We should also note that Cobos' conversion to the Italian Renaissance style seems not to have occurred until he visited Mantua in 1530, following the coronation of the emperor in Bologna.[104] But in 1527, when Machuca's first projects were judged, Cobos had not yet seen Italy and there is no evidence of interest then in the Italian Renaissance style.

One more thing should be said about Cobos. He knew Granada, having been appointed in 1511 to the City Council known as the "Twenty-four,"[105] though after his transfer to young Charles' ducal court in Flanders in 1516 he seems not to have returned to the Andalusian city until the visit of the imperial court in 1526. He certainly would have had firsthand knowledge of the arrogant ways of the Mendozas on the Alhambra and could have told Charles V of the difficulties the Twenty-four of the city had with that family through the years; there may have been a personal antipathy between Cobos and Luis Hurtado de Mendoza as well.[106] Of greater importance is Cobos' attitude in architectural matters and that can best be learned from the work of Luis de Vega, his young architect, who was selected by the emperor for the mission to the Alhambra.

The best preserved of Vega's early palaces is the Dueñas palace, which was conscientiously restored in the 1950s, but only the main portal, vestibule, courtyard, and main staircase assuredly reflect the original state of the palace. The portal, framed in granite and surmounted by arms carved in limestone, is set against a brick wall (pl. 9). In its severity and boldness it is typically Castilian. The portal opens into the right end of the vestibule, while the door to the courtyard is located in the opposite corner and, as a result, the porticoed courtyard is well to the left of the center axis of the block of the palace. Also, the courtyard is raised four steps above the level of the vestibule and it is not quite square, in that it is four arches wide and five deep. While the ground floor arches are semicircular, those of the gallery are somewhat lowered (pl. 10). Fanciful and grotesque elements are found in the varied capitals, and the heads of Spanish kings were carved within the roundels in the spandrels of both stories. The stubby pedestals were originally joined by a low parapet that enclosed the center, but unfortunately that was removed during the recent restoration. Door and window openings in the courtyard and throughout the palace were placed for convenience rather than the demands of geometry or axial symmetry. The entry from the vestibule to the courtyard is slightly wider than the corridor into which it opens, and on the west side, a doorway (preceded by a small staircase with a carved parapet) was not aligned with the intercolumniation of the arcade. On the east side of the courtyard the newel post of the main staircase is in line with the fifth column, but the first flight is wider than the intercolumniation in front of it. Indifference to alignments of this sort is also found in the unpublished plan made by Luis de Vega in 1531–1532 for the rear wing of the Cobos palace in Úbeda (pl. 13).[107] Openings were placed without an attempt at symmetry, and it is clear that the window on the right was simply moved over far enough to open onto the orchard rather than the courtyard. Like the palace in Medina del Campo, the plan betrays no proportional schemes for the relation of the lengths and widths of the rooms. Though one happens to have a 4 to 5 ratio, being 12 by 15 Castilian feet, the others are 13 by 15, 22 by 25, and 22 by 50 feet. In the case of the Palacio Real in Valladolid only the por-

[104] It was in 1530 that he commissioned Italians to make a stone fountain for his courtyard in Úbeda (Keniston, *Francisco de los Cobos*, pp. 150-151), and he also contracted with two minor Bolognese painters to decorate his palace in Valladolid, but he seems to have changed his mind because the work was never realized; see Esteban García Chico, *Documentos para el estudio del arte de Castilla*, III, i *Pintores*, Valladolid, 1946, pp. 9-11. In 1533 he commissioned the two Raphaelesque painters known in Spain as Julio de Aquiles and Alejandro Mayner to decorate the interior of his renovated palace in Úbeda; see Keniston, *Francisco de los Cobos*, pp. 188-189.

[105] Ibid., pp. 16 and 151.

[106] Luis Hurtado must have considered Cobos ungrateful for the lucrative appointment as auditor of the *Contaduría* of Granada that his father, Iñigo López, had obtained for Cobos as part of the effort to gain the favor and cooperation of Charles' secretary at court. Already in 1514, Iñigo López had expressed the opinion that Cobos placed too high a price on his cooperation; see Nader, *The Mendoza Family*, p. 176, n. 50.

[107] AGS, Sección de Mapas, Planos, y Dibujos, xxxviii, 83 (formerly Estado 25, fols, 234, 236, as cited by Keniston, *Francisco de los Cobos*, p. 151, n. 33). The plan has been separated from the letter. Presumably the house enlarged in 1531 was the one begun by his father about 1506.

ticoes remain (pl. 12), because alterations of the walls of the corridors of the courtyard and the surrounding rooms have obscured the original disposition. It seems, however, that neither axial symmetry and alignment nor the concordance of openings and intercolumniations were characteristic of Vega's design practices. Convenience and privacy were dominant factors, in keeping with the Hispano-Moresque tradition. His was a practical rather than theoretical approach to architectural planning.

The materials, techniques, and architectural repertory employed by Luis de Vega are as deeply rooted in the Castilian tradition as are his planning practices. The grey granite and red brick present a familiar contrast, and the use of a single slab of granite to form the lintels of both the main doorway and the opening from the vestibule to the courtyard of the palace in Medina del Campo was standard Castilian practice, and so were the closely placed wooden beams with painted panels that form the ceiling of the vestibule, and the transverse beams with the intervals closed by narrow plaster-covered barrel vaults (bovedillas) over the corridors of the courtyard. To the same tradition belong the distended and almost flattened arches that cut diagonally across the corners of the corridors on both levels and support the wooden ceilings. The raised courtyard, four steps above the level of the vestibule, and the disalignment of the street entry with the vestibule and the opening from it to the courtyard are also characteristic of the Spanish house. Lowered or carpanel arches in the gallery had long been favored in Castile, especially for the top story of a courtyard, perhaps because they form a more continuous undulation that accords more readily than do semicircular arches with the terminal horizontal of the cornice. We should note that a major change in the courtyard was made in 1581 when Aparicio de la Vega was paid for replacing the top cornice (quitar todo el coronamiento de arriba de todo el dicho patio y abaxarlo);[108] thus, those terminal moldings cannot be taken as evidence of Luis de Vega's architectural repertory. Another traditional feature of the courtyard of the palace in Medina del Campo is the large newel or "cloister staircase" (claustrale), which is composed of three flights of steps in an open well that was originally covered by a truncated artesonado whose form is reflected in the modern plaster vault. While the leaf-covered balusters of the railing are distinctly Italian features, it is important to note that they were carved from a single slab of marble in the manner of a perforated parapet. In those early palaces, Vega displayed little evidence of inventiveness in either form or technique, but he obviously had a solid training in the building crafts of early sixteenth-century Castile.

Committed as he was to the Castilian tradition, Luis de Vega seems to have been flexible in matters of style and responsive to his patrons' wishes. In 1527, he was clearly amenable to the inclusion of sculptural decoration in the new Plateresque style: witness the richly varied fantasies of the capitals and wall brackets in the courtyards of the palaces in Medina del Campo and Valladolid (pls. 10 and 12) and the remaining fragments of the Cobos house in Úbeda. Stylistic differences in the ornament of the several palaces indicate that different sculptors were involved and also that each was free to invent his own ornament on a capital or bracket, but this was normal practice in the sixteenth century. Of course, Vega may have tolerated rather than fostered this ornament to satisfy his patrons. It is also evident that he was well aware of contrasting contemporary styles because he provided models of both "Castilian" and "Roman" moldings to let Dr. Beltrán's wife, Doña Ana de Mella, choose which she wanted for the main rooms above the vestibule of the palace in Medina del Campo.[109] Vega's flexibility in matters of style and taste seems to have been an important factor in his continuing success.

Though the only evidence of Luis de Vega's intervention in the works of the Alhambra is the governor's letter in February 1528 (doc. 2), it is possible that he was consulted during succeeding years on later stages of the construction of Machuca's palace. Around 1537, Charles V appointed Vega and Alonso de Covarrubias codirectors of the royal works in Castile. Later, in 1543, when the areas of responsibility were divided between the two, Covarrubias was given the royal palace, or alcázar, in Toledo and Vega was assigned the more important royal works in Madrid and its

[108] García Chico, "Palacio de los Dueñas," pp. 101-102, doc. 8.

[109] García Chico ("Palacio de los Dueñas," pp. 96-97, doc. 4) refers to "una moldura romana ó castellana."

environs.[110] Since Vega retained his royal appointment until his death in 1562, he could have been consulted on later projects for parts of the palace on the Alhambra. Apparently his idea of architectural form changed little in the next quarter-century, though he did reject the Plateresque ornament that had played an important role in his palaces in the 1520s. That change seems to have occurred during his renovation of the courtyards and the main or south facade of the royal palace in Madrid from the late 1530s until his death in 1562, but none of that work remains.[111] Its main facade is recorded in a sketch of about 1562 by Anton van den Wyngaerde and its groundplan was drawn by Juan Gómez de Mora shortly before 1626 (pls. 14 and 15).[112] Another royal residence, the hunting lodge near Madrid known as El Pardo, was designed anew by Luis de Vega in 1543–1547 and completed by 1558 (pl. 11),[113] but all that has survived a disastrous fire and several enlargements are the courtyard and the main portal with the two towers (minus the steeples) on that facade. Like his earlier works, the palace in Madrid and El Pardo show little concern for symmetry and axial alignments or concordances of an arithmetic or geometric nature. In Madrid, Vega retained courtyards of unequal size, and towers of different widths flanking the main entry. Even in El Pardo, where he laid the foundations, the porticoes and openings were distributed according to convenience without any attempt to enhance the inherent geometricity of the square plan with a centrally located courtyard and axial entry. In both buildings the *portada* is of stone against a brick wall, recalling that of Medina del Campo. The later works can be described as "severe" but not "classical" in style.

Because of the invariability of his architectural repertory and structural techniques, Vega's later works provide an indication of the kind of advice that he and his patron, Francisco de los Cobos, gave the emperor in 1528.

THREE LETTERS AND THREE GROUNDPLANS

Evidence for the initial project and successive changes during the design phase of the palace can be gained from three undated groundplans and three letters written from 1527 to 1529. All of the letters and the plans have been published previously, but little more than the obvious has been extracted from them, and no serious attempt has been made to relate them or to put them in chronological order. The larger of the two plans in the Royal Palace in Madrid was found in 1912 by Elías Tormo and published in 1922 by Vicente Lampérez; the smaller one was made known by Manuel Gómez-Moreno in 1941.[114] Both plans are drawn in pen and bistre over stylus guidelines, and in both, the measurements of most parts are figured. The larger plan of the entire Alhambra (pl. 17), which I shall refer to as the "large Royal Palace plan," has suffered losses around the edges and the paper has parted along the folds. Irregular in shape, its maximum dimensions are 0.62 by 1.32 meters, in contrast to the smaller plan of the palace alone, which measures 0.62 by 0.79 meters (pl. 18). While the larger plan has inscriptions identifying various parts of the old and new palaces and also an indication of its scale (below the south facade), the smaller plan has neither. The third plan in the Archivo

[110] Juan José Martín González, "Nuevos datos sobre la construcción del alcázar de Toledo," *Revista de archivos, bibliotecas, y museos*, LXVIII (1960), pp. 271-273; Chueca, *La arquitectura del siglo XVI*, p. 165.

[111] F. Iñiguez Almech, *Casas Reales y jardines de Felipe II*, Madrid 1952, pp. 62ff.; Juan José Martín González, "El alcázar de Madrid en el siglo XVI (nuevos datos)," *Archivo español de arte*, XXXV (1962), pp. 1-19.

[112] For the Wyngaerde drawing (Vienna, National-Bibliothek, Handschriften, Cod. Min. 41, fol. 78), see Egbert Haverkamp-Begemann, "The Spanish views of Anton van den Wyngaerde," *Master Drawings*, VII [1969], pp. 380, 391, pl. 4, who notes that Wyngaerde was called to Spain from England late in 1561. Iñiguez Almech (*Casas Reales*, p. 69) observed that the drawing must have been made well before 1566, when the stables enclosing the *caballeriza* in front of the main facade were

completed, and he discussed Gómez de Mora's plans on pp. 65-73.

[113] Juan José Martín González, "El Palacio de 'El Pardo' en el siglo XVI," *Boletín del Seminario de Estudios de Arte y Arqueología*, XXXVI (1970), pp. 4-41; Ramón Andrada Pfeiffer, "El palacio de El Pardo como obra de arquitectura," *Sitios Reales*, XIII, no. 49 (1976), pp. 29-39.

[114] Elías Tormo and Francisco de Paula Valladar announced the finding of the plans in 1912 in *L'Epoca* of Madrid, *Arte español*, and *L'Alhambra*. Lampérez (*Arquitectura civil*, I, p. 493) noted that "las compró recientemente S. M. el Rey Alfonso XIII." Both plans were published in 1941 by Gómez-Moreno y Martínez (*Las águilas*, figs. 297 and 298) but the plates are so small and so poor that many details and the inscriptions cannot be seen. Better plates were published by Antonio Gallego y Burín (*La Alhambra*, Granada, 1963, pls. 2, 3, and 4).

Histórico Nacional in Madrid was also drawn in bistre over stylus guidelines (pl. 19), but it differs from the other two in most other respects. Found by Francisco Iñiguez Almech around 1940, it was included without comment in Gómez-Moreno's 1963 monograph on Diego Siloe.[115] The plan is smaller than the others, being approximately 44 by 56 centimeters. Rather crudely drawn, it is not figured and has no inscriptions or indications of scale.

The first task is to determine the chronological relations of the letters and the plans.

According to Ibáñez de Segovia, several projects were initially sent to the emperor by the governor.[116] Presumably they were sent in the spring of 1527 when the court was in Valladolid, because later that year in Burgos, in the letter of 30 November to the governor (doc. 1), the emperor acknowledged that he has "kept [the plans] until now"—implying an extended period—with the intention of making "resolution and determination" of what should be done. Little wonder that Charles V had not found time to deal with the plans during that troubled year. In February he prepared for meetings with each of the major estates of Castile—the clergy, the knights of the military orders, and the representatives (procuradores) of the most important cities of the realm.[117] Soon after, he was preoccupied with the problem of raising money to placate the unpaid imperial army that ravaged the Italian countryside on its way south to Rome, which it sacked in May. The repercussions of that catastrophe required feverish diplomatic activity on the part of his ambassadors. The sack of Rome alienated most of Catholic Europe and further delayed his final coronation as the Holy Roman Emperor by the pope. Meanwhile, at the court in Valladolid, the Castilian nobles were in a rebellious mood. In the midst of all this, on May 21, Prince Philip was born and the happy event had to be properly celebrated. Even with these preoccupations it would seem that the emperor had had some correspondence with the governor about the palace previous to the letter of 30 November. Though it is the first of three known to us today, it was the *last* of several letters relative to the palace known to Ibáñez de

Segovia in 1613. An earlier exchange of letters explains the brevity of the emperor's references to the problems cited in the November letter. Apparently one of the projects sent to him initially was satisfactory in most respects but required some emendations; and because the emperor saw little chance that he himself would find time to resolve these problems, he decided to list his primary concerns and to entrust the solutions to the governor. Here are the pertinent portions of the letter of 30 November 1527 (doc. 1):

> . . . las traças que me enbiaste de lo que se ha de acreçentar y hedificar de nuevo en la casa real de la Alhambra, las he detenido hasta agora, esperando enbiaros resoluçión y determinaçión de lo que se ha de hazer, y al cabo, he acordado remitíroslo a vos para que lo hagáys como mejor os pareçiere. Solo os quiero dezir que la sala delantera sea grande y que en ella aya capilla para dezir missa, y que lo demás de los aposentos que se han de hazer se junten con la casa. Vos lo ordenad y hazed todo, como mejor os pareçiere, que con remitíroslo, pienso que se açierta, en lo mejor (added in another hand: digo que sy ser pudiere sea la capilla de manera que de arriba y de abaxo y por ambas partes se pueda oyr misa). . . . Ved si llevará camino, y pareçiendo os que puede hazer escrividme el despacho que ha menester para ello, para que conforme a la orden que alla dieredes se haga.

Charles and his advisers were obviously uncertain about the location and size of several important palatine functions. Of special concern was the audience hall, which Charles said should be sufficiently large and located in the front wing (la sala delantera), presumably over the main vestibule. The other was "a chapel for the saying and hearing of Mass" and, he added, "if it is possible [it would be desirable] to have a chapel in which one could hear Mass on both upper and lower levels and from both sides." Charles clearly wanted a "royal chapel," that is, one with two levels that would permit him and his empress to hear Mass from separate balconies, presumably on the level of their private

[115] See this chap., n. 95.

[116] Ibañez de Segovia, *Historia*, fol. 294r-294v; ". . . [el emperador] mandó hazer diferentes diseños según se reconoce de varias cartas escritas al marqués sobre la forma en que se havía

de executar, hasta que dexó al arbitrio del marqués la elección de qual se havía de executar. . . ."

[117] Keniston, *Francisco de los Cobos*, p. 97.

apartments, while other members of their households could attend on the lower level.

The third requirement listed in the letter of 30 November, that "the rest of the quarters that have to be made should be joined to the [new] residence," suggests that the first plan sent to him early in 1527 was for an isolated residence, without the forecourts delineated in the two plans in the Royal Palace in Madrid (pls. 17 and 18), and also that these plans were made sometime after the letter of 30 November 1527. It also appears that the governor misunderstood his assignment because he and his architect designed an isolated private residence for the imperial couple and their households, with the intention of providing for the needs of the court elsewhere in the Alhambra or below in the city. The emperor, perhaps belatedly, thought in terms of an official imperial residence with all the administrative offices and services and the halls needed for formal receptions and entertainment integrated into the plan of the residence itself. The disparity in their conceptions makes it clear that there had been little discussion of the plan and certainly no precise proposals while the emperor was on the Alhambra. The decision to build the palace may have come as late as three days before the emperor's departure because the financial agreement with the Moriscoes was not signed until 7 December and only then was Charles assured of a local source of funds for the building of the palace.[118] Evidently Charles left no more than sketchy, last-minute instructions to build a suitable modern residence alongside the old palace.

So eager was the emperor to start construction on the new residence in the autumn of 1527 that he stated in his letter that he was ready to assign the sizable sum of 18,000 ducats for the first year and a total of 90,000 over a period of eight years, in accordance with a previous discussion (*como está platicado*); and he even added that he was willing to release the money in less time if construction progressed more rapidly (doc. 1). So, clearly, the financing of the new residence was no problem and the assignment of funds awaited nothing more than a revised project incorporating the new requirements. The emperor urged the governor to get the work underway as soon as possible (*Ved si llevará camino*), and to facilitate matters he entrusted him with decisions on the particular form these functional emendations were to take (*para que lo hagáys como mejor os pareçiere*). He seems to have been confident that Luis Hurtado would follow his wishes and provide a large audience hall, a two-story royal chapel in the front wing, and a means of joining the service quarters to the residence. On the basis of the letter of 30 November, Ibáñez de Segovia in 1613 and most later scholars concluded that from that time the formal disposition of the plan was left in the hands of the governor, Luis Hurtado de Mendoza.[119]

Unfortunately, the governor's answer is lost but it seems that, instead of finding architectural solutions for the new requirements, the governor tried to dissuade the emperor from altering the original free-standing project. This can be deduced from the dispatch of Luis de Vega to Granada with firm instructions on the emendations. We know of this visit from Luis Hurtado de Mendoza's follow-up report to Charles V on 27 February 1528 (doc. 2):

S[acra] C[atholica] C[esarea] M[ajestad] . . . Recebí la carta de Vuestra Magestad, con Luys de Vega, sobre lo que toca a la casa que en esta Alhambra manda hedeficar, y hele mostrado las traças y platycado con él lo que dellas entiendo, y héchole mostrar el sitio y disposiçión donde se ha de hazer el edifiçio. Todo lo lleva muy bien visto y entendido, para que si Vuestra Magestad fuere servido, le pueda dar razón dello, y acá me

[118] The following seem to be the main events in the emperor's dealings with the Moriscoes. They sought his protection against ill treatment and requested the removal of restrictions on practicing their customs. Charles appointed a commission headed by the inquisitor-general to study the matter and to report their recommendations to him. On the basis of their report, Charles, on 7 December 1526, forbade the use of the Arabic language, the wearing of Moorish dress, the carrying of a sword or dagger, and the maintenance of public baths. The Moriscoes, evidently aware of Charles' imminent departure from Granada, offered to pay 80,000 ducats (in addition to their ordinary trib-

ute) if he would suspend the order. On 10 December, Charles accepted the offer, treating the payment as a tax or license for special privileges. See Henry Charles Lea, *The Moriscoes of Spain: Their Conversion and Expulsion*, New York, 1968, pp. 216-218.

[119] Gómez-Moreno y Martínez (*Las águilas*, p. 122) said the realization of the palace was entrusted to Luis Hurtado. Chueca (*La arquitectura del siglo XVI*, p. 112) expressed the belief that Machuca was given a free hand: "Pedro Machuca, gozando una libertad absoluta, pudo seguir fielmente la línea clásica sin las cortapisas de un medio nacional muy complejo, por suerte o por desgracia."

ha dicho lo que a él le pareçe, asý çerca de la capilla grande que Vuestra Magestad manda que se haga en el quarto delantero, como en todas las otras cosas que tocan al dicho hedifiçio, y antes que se comience haré hazer un modelo de madera, para que mejor se vea la graçia y proporçión que ha de tener, y se entienda y conozca lo que agora por la traça no se parece tan caro. . . .

From this letter we learn that the governor showed the plans to Luis de Vega and "demonstrated the site and disposition where the new building is to be made and he [Vega] understood it all very well." It is the reference to the "site and disposition" of the new residence that suggests that the governor had cited some difficulties in adding the service structures to the original free-standing project within the available area on the Alhambra. The governor assured the emperor that Vega "had also told him what seemed best in respect to the large chapel (*la capilla grande*) which your Majesty orders made in the front wing of the palace." He did not say that he would follow Vega's advice, and since the chapel was not placed in the front or west wing, we must assume that the governor opposed that location. Luis Hurtado was not a man given to compromise. In characterizing him, Ibáñez said he was an arrogant aristocrat who spoke his mind before the kings and emperors. His failure to follow instructions in the letter of 30 November had evidently surprised and irritated Charles V. Incidentally, although Machuca is nowhere mentioned in this correspondence and the governor stated that he himself talked with Luis de Vega about the resolution of the plan, it is probable that Machuca was very much involved in the attempt to save the original project because, as we shall see, the architect persisted in that effort for almost two decades. The governor recognized, in a somewhat condescending way, that it might not have been possible to appreciate the quality of the first project from the groundplan alone. But he assured the emperor that "one would better see the grace and proportions (*graçia y proporçión*) that it was to have . . ." when the wooden model was made, and he said that could be done as soon as the groundplan was approved. Previous to the Castilian architect's visit, Luis Hurtado and Machuca may have introduced a few of the emperor's emendations. The chapel may have been raised to two stories, possibly within the original area assigned to it, because the emperor insisted only on its enlargement in February 1528; but, it is not likely that they attempted to add the required services to the square plan. There wasn't sufficient time between the emperor's letter of 30 November and Vega's visit the following February to resolve all the architectural problems posed by such extensive additions. December and January seem to have been devoted primarily to preparing the case for the retention of the original free-standing project. As a result of the governor's reluctance to accept the emendations, at first indicated in a casual and friendly way, the emperor became adamant, and it seems he turned increasingly for advice to consultants in Castile—a change in the relationship of the emperor and the governor that was to have a profound effect on the history of the palace.

The essential difference in attitude is evident in the governor's praise of the "grace and proportion" of the initial project and the emperor's concern for the location, size, and convenience of several service areas. They differed fundamentally in their approach to architectural design. Luis Hurtado and Machuca evidently thought that the first step was to determine the abstract geometrical and proportional aspects of the groundplan and then, at a later stage, to designate certain halls and areas for particular functions. Apparently a theoretical proposal of this sort was first sent to the emperor, without indicating the location of the chapel, the audience hall, or any of the administrative offices or other services of interest to him. Unaccustomed to this peculiarly Italian Renaissance procedure, Charles must have looked in bewilderment at the square plan with rooms of various sizes distributed around a circular courtyard. The governor, for his part, was surely disappointed by the emperor's failure to appreciate the central symmetry and geometricity of the project. From the governor's point of view, planning began with a properly proportioned groundplan, whereas the emperor started with practical and functional concerns. So, in addition to the disparity between the governor's project for a private villa and the emperor's conception of an official palace, the two differed on the initial step in the process of architectural design. In fact, their attitudes represent a classic confrontation of *dispositio* and *utilitas*.

Only part of the alterations required by the emperor in the first project were mentioned in the two extant letters of autumn 1527 and winter of 1528 (docs. 1 and 2), but we can readily separate them into two groups: the external changes that were brought about by the addition of the service buildings to the original block, and the internal changes that were a consequence of the enlargement of the chapel.

The need to enlarge the chapel, first mentioned in the emperor's letter of 30 November 1527, was again discussed during Luis de Vega's visit in February 1528. Charles stated that he wanted a chapel composed of two stories, presumably to enable him and his wife to hear Mass from tribunes on the level of their separate main-floor apartments, while members of their households and a select group of courtiers congregated on the ground floor.[120] Machuca may have simply added another story to the original one-story chapel in a slightly revised plan that we have postulated was sent to the emperor in January or early February 1528. In any case, there was no further reference to the need for tribunes, although Vega in February informed the governor that the chapel had to be still larger, presumably in ground area. Luis Hurtado assured Charles V that "here, he [Luis de Vega] told me what to him seems likewise [that is, appropriate] relative to the large chapel that Your Majesty has ordered to be made in the front wing [of the palace]." As we noted, the chapel is not located in the front in any of the extant plans or in the present palace, so the governor seems to have successfully resisted that change. He probably convinced the emperor that the forward placement of a two-story chapel of that size would have made impossible the symmetrical disposition of the windows of the west facade and also would have inconvenienced the approach to the main audience hall and its anterooms. Whatever his arguments, the plan was spared that change, but the enlargement of the chapel in the rear corner brought with it other alterations

that must have been equally repugnant to the governor and his architect.

Since the size and location of the chapel in the three extant plans are the same, they must all postdate its final enlargement; but, still, there are some noteworthy differences in the several plans. In the rather crude Archive plan (pl. 19), the two corners of the courtyard on the west side are open in contrast to the complete enclosure of the corridor by a continuous wall in both plans in the Royal Palace and also in the present palace (cf. pls. 17 and 18); so, the plan in the Archivo Histórico Nacional would seem to represent an earlier stage of the courtyard. Presumably the open triangles between the circular corridor and the west wing were also found on the east side of the original plan before the octagonal chapel was expanded into the northeast corner and the staircase added in the southeast. The irregular shapes of the rooms adjacent to the chapel reveal a desire to use the extra space created by the new wall of the corridor, and the hall in the southeast corner was enlarged by setting back its inner walls to take advantage of a few feet made available by the curving wall behind the proposed staircase. These displacements of the walls, like the expansion of the chapel, reflect a mentality at odds with the one that designed the unaltered west wing. Presumably the first project was a centrally symmetrical, square plan enclosing a circular courtyard, with the rooms distributed in the balanced way still seen in the west wing of the Archive plan. The square (or possibly octagonal) hall in the northwest corner was probably designated by the governor as the location of the chapel in answer to the emperor's query in November 1527. Since that square hall had a diagonal span of no more than 30 Castilian feet or 8.36 meters, one can readily understand the emperor's insistence on its enlargement. His chapel service required a staff of about forty-five, including twelve chaplains and seventeen singers,[121] so an area that size was clearly inadequate.

[120] Tribunes, or balconies, were usually provided for the royal family in the chapels of royal residences in Spain and in the churches of monasteries they frequented. Notable examples of the latter are San Juan de los Reyes in Toledo, San Benito in Valladolid, and San Jerónimo in Madrid. Of the royal residences, the only contemporary example for which we have good evidence is the *alcázar* in Madrid, which had a chapel between the king's and the queen's courtyards that had three balconies; one for the royal family, one for the choir, and

another for the women of the royal household; see Iñiguez Almech, *Casas Reales*, p. 78, pls. 14 and 15. The tribunes of the chapel were constructed in 1540; see Luis Cevera Vera, "Carlos V mejora el Alcázar madrileno en 1540," *Revista de la Biblioteca, Archivo, y Museo del Ayuntamiento de Madrid*, no. 5, 1979, p. 76.

[121] From the time when his household was first organized in 1515 by Guillaume de Croy, Lord of Chièvres, Charles' household included an unusually large chapel service; see Luis P.

Although little is known about the size or form of the chapels of the royal residences in Spain during the 1520s (because they were altered during several renovations beginning in the late 1530s), the corner hall in the plan chosen by Charles in 1527 was smaller than private chapels that several Spanish nobles built in major churches. In Burgos, the city from which the emperor wrote the 1527 letter, he must have seen the somewhat irregular octagonal chapel of the Constable of Castile at the rear of the cathedral. Almost twice as large as the one proposed for the emperor, it has a span of 20 meters at its narrowest point. Another chapel of which he may have heard was that begun (according to the inscription) in 1507 by the Vélez family at the back of the cathedral of Murcia. Also octagonal with a span of 13.50 meters, it is about 5 meters wider than that of the corner hall originally designated as the chapel for the new palace on the Alhambra. The governor's proposal of so small a chapel underlines the private character of the residence as he first conceived it. He and his architect seem to have thought of a villa-like residence for the imperial couple alone, with the religious needs of their households and the court served by the nearby *mesquita* dedicated to Santa María (pl. 17-M) and the church of the monastery of San Francisco located a little further to the east on the Alhambra. Although we have no documentary evidence for the process by which the original corner chapel was enlarged to the size indicated in the Archive plan, it is likely that the first step was the opening of the main floor to form a

chapel of two stories. This must have been done in January 1528 in response to the emperor's criticism in November. At that time or, more likely, later, Machuca enlarged the floor area of the chapel, perhaps first expanding it into the one adjacent wing without disturbing the open corner of the courtyard (fig. 1). By this means he could have gained a span of 10.86 meters—an increase of only 2.50 meters (39 as against 30 Castilian feet). To attain the *capilla grande* ordered by the emperor in February 1528, the open corner had to be usurped and the octagonal chapel expanded to 13.95 meters or 50 Castilian feet. The Archive plan records this final step.

That the Archive plan precedes the one of the entire Alhambra is suggested by previously unnoticed internal evidence. Under the continuous hatching of the west wall of the corridor, one can detect free-standing pillars, which reveal that the courtyard in the large plan had open corners comparable to those in the Archive plan (cf. pls. 17 and 19). Setting aside for the moment the puzzling disparity in the number of supports (twenty-four in the Archive plan and thirty-two in the large Royal Palace plan), it is evident that the decision to close the circular corridor with a wall postdates the Archive plan. Also, the chapel in the latter has alternating rectangular and semicircular niches found in the Archive plan, but not in the small Royal Palace plan (pl. 18) nor in the chapel as it was finally constructed (pl. 2). The irregularly shaped rooms on either side of the chapel in the large Royal Palace plan are similar to their counterparts in the Archive

Gachard, *Retraite et Morte de Charles-Quint*, Brussels, 1855, II, pp. 71-80; and Carande, *Carlos V y sus banqueros*, I, pp. 164-165.

FIGURE 1. Successive stages of the enlargement of the chapel

plan, whereas the inner wall of those rooms in the small Royal Palace plan follows the curve of the corridor. On the basis of the chapel and the rooms alongside it, the three plans appear to have this chronological order: the Archive, the large, and then the small Royal Palace plan.

Thirty-two isolated pillars were first delineated in the large Royal Palace plan on the outer rim of the corridor, before the intervals between them were hatched to unite them into a continuous wall and the original pillars were replaced by pilasters or responds (pl. 17). Aligned with the columns of the colonnade, these pilasters divide the wall into four kinds of bays. There are large and small doorways, semicircular niches, and a few bays that seem to have no openings at all. The first three bays mentioned were carried over into the small Royal Palace plan where the niche was placed between the large and small openings to form a rhythmic continuity that was broken only by the group of three large openings for the staircases in the southeast and northwest corners and by the three doors to the west vestibule. Hence, it would seem that the large Royal Palace plan represents a typological change from that of the Archive plan. It is, in fact, a palimpsest of an earlier open-corner disposition that was transformed into an enclosed courtyard, which was then refined and developed rhythmically in the small Royal Palace plan.

Another change that resulted from the enlargement of the chapel suggests the same chronological order of the three plans. The staircase inserted into the southeast corner was first indicated by no more than four lines and two posts in the Archive plan and then it was more completely delineated in the large Royal Palace plan, with the supporting posts reduced slightly in size and the inner curve of the staircase transformed into a semicircle. This made possible the arrangement of the steps in a more continuous curve that eliminated the section of sharply tapered winders required in the previous plan (cf. pls. 17 and 19). That idea finally reached fruition in the continuous sweep of the southeast staircase in the small Royal Palace plan (pl. 18). Unfortunately, it was never built, and that corner remained open until this century when the present staircase to the museum was constructed in the

mid-1950s. In the opposite, or northwest corner, no staircase was indicated in the Archive plan, but one appears in both the large and small Royal Palace plans. In the latter, the semicircular niche is missing and this brings it closer to the present staircase, which was begun, after many delays, in 1634. Again, the differences suggest that the Archive plan was followed by the large and then the small Royal Palace plans.

Before attempting to date the rather crude drawing in the Archivo Histórico Nacional, we should cite several ways in which it differs from the other two. We have already noted that all three plans were drawn with a stylus and then reinforced with bistre pen lines, and also that the Archive plan is much smaller than the other two. In addition, the paper of the Archive plan is of lesser quality and of a different kind. While the two plans in the Royal Palace have watermarks in which the letters *M I* are enclosed in a circle surmounted by a cross, that of the Archive plan (though damaged) is a hammer on an anvil (fig. 2-c). Because Briquet's compilation of European watermarks does not include those of Spain, our best reference is Pascual de Gayangos's unpublished collection of about 1,500 watermark tracings made from papers used for Spanish books and manuscripts. Compiled in the nineteenth century, it is now in the library of The Hispanic Society of America under the title *Collection of Watermarks Traced from Spanish Manuscripts and Printed Books 1328-1795*. To this collection, Miss Clara Luisa Penney added photographs of watermarks from manuscripts and incunabula in the Society's library. Theodore S. Beardsley, the Society's director, compared the watermarks of the three plans with those of the collection and informed me that he found only one example of an anvil (without a hammer or an enclosing circle) on paper used for a book published in Seville in 1491, though that provides no assurance that the paper itself was made in Spain. Because the hammer and anvil is typical of Florentine papers dated 1514–1529.[122] it is likely that the Archive plan was drawn on paper made in Florence.

The watermarks of the Royal Palace plans have the letters *M I* enclosed within a circle, but the large Royal Palace plan is distinguished by a hor-

[122] C. M. Briquet, *Les filigranes. Dictionnaire historique des marques du papier des leur apparation vers 1282 jusqu'en 1600* (facsimile of 1907 edition), Amsterdam, 1968, I, p. 347, no. 5963, dated 1514–1529.

FIGURE 2. Watermarks: a) the large Royal Palace plan, b) the small Royal Palace plan, c) the Archive plan

izontal crescent in the upper part of the circle and a regular Latin cross at the very top (fig. 2, a and b). Among Gayangos' tracings there are a few watermarks of this general disposition on papers used in Toledo and Seville, but they lack the letters, which are often symbols of the paper-maker. Several of the type with the letter *M* accompanied by the number *2* are found on paper used in Venice in 1512.[123] Others with the letters *M J* were made in Genoa for more than two centuries, with examples dated from 1496 to 1633. The closest in form is a watermark dated in Genoa in 1526,[124] the year Charles visited Granada and decided to build a new residence on the Alhambra. The similarity of the watermark of the small Royal Palace plan makes it likely that it, too, was drawn on Genoese paper, though it differs in that its irregular "cross" ends in something like a pitchfork and it lacks a crescent. Though the reference of the letters has not been deciphered,[125] the watermarks of the paper of the two Royal Palace plans are close to those of Genoa in the 1520s, while that of the Archive plan is analogous to motives used on Florentine paper about the same time.

Matters of technique also set apart the Archive plan. Its lines are rather thick and many parts have

the appearance of being freely drawn, while the lines of the other two are finer and those defining the main walls appear to have been guided by a ruler. The washes are also darker in the Archive plan, and it lacks the distinctive hatching of the other two plans. The difference in the hatching, less finely done in the large than in the small plan, would seem to be explained by the fact that the latter was intended to be a finished presentation drawing, while the former was an exploratory plan in which Machuca attempted to resolve the problems posed by the enlargement of the chapel. Missing in the Archive plan are the carefully made numbers that indicate measurements in the two Royal Palace plans. Taking into account the different functions of the latter two, it would seem that they were drawn by the same person while the Archive plan was done by another hand.

There is a difference not only of technique but also of design principles between the two Royal Palace plans and that in the Archive. The draftsman of the latter was evidently unconcerned about either central or axial symmetry since he proposed to close the northeast corner of the courtyard with the enlarged chapel and to insert an open staircase in the southeast corner, while leaving the other

[123] Pascual de Gayangos, *Collection of Watermarks*, fols. 202-203, in The Hispanic Society of America.

[124] Briquet, *Les filigranes*, I, p. 310, no. 5264.

[125] Harold Bayley (*A new light on the Renaissance displayed in contemporary emblems*, 2d ed., New York, 1967, pp. 27 and 104) noted that *M* usually refers to the Virgin Mary, while *I C* and *I S* stand for *Jesus Christus* and *Jesus Salvator*. In the case of the two Royal Palace plans, *M I* could refer to Mary and Jesus.

two completely open. He took no care to align the doorways from the rooms on either side of the chapel with the axes of the portico, and he seems not to have foreseen the awkwardness of the angled piers jutting out from the corridor wall on either side of the doorways at the cardinal points of the courtyard. In contrast, the draftsman of the large Royal Palace plan, while starting with this general disposition, struggled to eliminate the gaffes and to recover a sense of central symmetry by continuing the wall around the entire corridor and introducing a rhythmic sequence of three distinct bays. In view of these differences in attitude, it is likely that the Archive plan was drawn by Luis de Vega to demonstrate to the governor that the octagonal chapel could be expanded into the open corner of the courtyard. The plan reflects the indifference to symmetry, balance, and axial alignments that we find in Vega's works in the late 1520s and early 1530s. Also, the rather crudely drawn sketch by Vega for the enlargement of the Cobos palace in Úbeda in 1531 is somewhat similar to the Archive plan (cf. pls. 13 and 19). In both, the lines are rather heavy and seem to have been drawn without the aid of a straight edge. Unfortunately, there are few other points of comparison, since the window screens, the Roman numerals, and the inscriptions included in the drawing for the Cobos palace are not found in the Archive plan. The plan does, however, reveal a concern for the practical and the convenient, that is to say for *uti-litas*, that we have found to be characteristic of Vega.

Certainly Luis de Vega is a more likely candidate for the authorship of the Archive plan than Diego Siloe, to whom Gómez-Moreno seems to have attributed it. No explanation was given for its inclusion among the illustrations in his 1963 monograph on Siloe, but Francisco Iñiguez Almech, who discovered the plan some twenty years before it was published, expressed the belief that the Granadine scholar attributed the plan to Siloe because of the courtyard piers, composed of half-columns engaged to rectangular pillars.[126] To be sure, Siloe was among the first in Spain to use the pier to support an arcade, notably in the courtyard of the Colegio de los Irlandeses in Salamanca, probably designed 1527-1529. A closer comparison of Siloe's piers and those indicated in the Archive plan reveals significant differences, however. Siloe's slim pillars, with fluted Corinthian half-columns, are light in appearance and tall in proportion—the ratio of the width to the height of the arcade is approximately 1 to 2. The piers of the unscaled Archive plan seem to have been about twice as wide, with the proportions of the opening of the arches being approximately 3.00 to 3.90 meters (fig. 3). Their proportions would have been closer to the massive piers used in 1517 by Antonio de Sangallo the Younger in the courtyard of the Farnese palace. Furthermore, when the enlargement of the chapel was discussed by the governor and Luis de Vega

[126] Conversation with Francisco Iñiguez Almech in 1964. See Gómez-Moreno y Martínez, *Las águilas*, pp. 63-64. Perhaps he was influenced in this attribution by the legend of Siloe's authorship of the palace reported by Juan de Arfe. See above, this chap., n. 51.

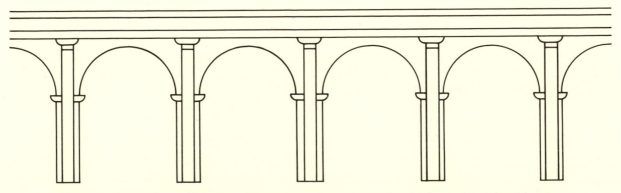

FIGURE 3. Approximate elevation of the courtyard arcade on piers in the Archive plan (pl. 19)

in February 1528, Siloe had not yet come to Granada. He first appeared there briefly in March of that year, at which time he agreed to make a yearly visit to the works of San Jerónimo, but he only moved to Granada after he was appointed to supervise the construction of the cathedral in May. Even then, there is no evidence that he was ever consulted on architectural matters relative to the palace on the Alhambra. It must, however, be admitted that Vega did not use that massive pier in any of his own courtyards. The closest approximation is provided by the rather delicate marble piers designed much later for the gallery of the Patio de las Doncellas in the *alcázar* in Seville and executed by his nephew, Gaspar de Vega in 1551. Perhaps the pier was included in one of the several alternative projects first submitted to the emperor by Machuca, and the draftsmen of the Archive plan simply transferred that sturdy support system to the circular courtyard, but the plausibility of that explanation depends on a full account of the disputes that troubled the design of the palace. That question aside, it would seem that the bulk of the evidence suports an attribution of the Archive plan to a Castilian adviser, most likely Luis de Vega at the time of his visit to Granada in 1528.

Before considering the addition to the forecourts and the service quarters, we should note that the original free-standing block proposed in 1527 was probably about the same size as the present palace, that is, about 63 meters square. While that was no mean size for a noble residence anywhere in Europe at the time, the irregular complexes of the royal *alcázares* in Seville, Segovia, Toledo, and Madrid were larger in area and so were some Hispano-Moresque residences such as the so-called Casa de Pilatos in Seville.[127] Of course, these complexes, like the ducal palaces in Mantua, Urbino, and Milan and the Doges' palace in Venice, were the result of a gradual accretion over several generations. More valid comparisons are found in the late fifteenth-century palace of the Infantado in Guadalajara, which measures about 50 meters across the front and about 65 meters deep, and the contem-

porary palace of the counts of Miranda at Peñaranda de Duero (Burgos), begun about 1530, which has a facade of about 60 meters and a depth of 46 meters. A few years later, about 1537, the count of Monterrey began a gigantic palace in Salamanca, which was to have had at least two courtyards covering an area about twice that of the original square plan proposed for Charles V's palace in 1527. In Italy during the same years, the largest palace under construction was that of the Farnese in Rome, which was begun in 1517 and was enlarged before 1530 to the present rectangle of about 56 by 74 meters, approximately the same area as Machuca's first project for the Alhambra. The megalomaniacal Pope Julius II in 1508 planned the huge Tribunal Palace, which was to have had a 98-meter facade along the Via Giulia in Rome, but only a few sections of its rusticated base were raised.[128] The Medici in 1513 asked the Sangallo to design a gigantic palace with an 80-meter facade on the Piazza Navona in Rome, but that ambitious project was not even begun. When compared to the largest palaces of the day, Machuca's 63-meter-square residence would seem to have been more than adequate to house the imperial couple, especially since it was to have been supplemented by the fourteen major halls of the old Nazaride palaces and the many large towers and other subsidiary structures of the Alhambra. But Charles and his advisers insisted on extensive additions that expanded the palatine area to three times that of the original block.

The additions were needed to provide for the exceptionally large households of Emperor Charles V and his fastidious wife, and the elaborate etiquette of their ceremonial lives. Charles was, of course, the heir to the most refined and ceremonial court traditions in Europe—those of Burgundy and Aragon—and his paternal line had held the imperial title for more than half a century. The household in which he was reared, that of his formidable aunt, Margaret of Austria, numbered four hundred persons, even though her court in Malines was simply that of a regent governing in the name of her father, Emperor Maximilian I.[129] When Charles

[127] Among the *alcázares*, that at Seville is about 95m. square, Segovia about 105 x 45 m., Toledo 84 x 75 m., and Madrid 103 x 84m. (at least in the early seventeenth century), while the Casa de Pilatos in Sevilla was about 110 x 80 m. and that of the Condes de Benavente in Valladolid, 96 x 75 m.

[128] The palace is known by several names: Palazzo dei Tri-

bunali, Palazzo di Giustizia, and Palazzo di San Biagio. The date 1508 for its design depends on the laying out of the Via Giulia in 1507. The plan (Uffizi A136) is believed to have been drawn for Bramante by Antonio di Pellegrino; see Arnoldo Bruschi, *Bramante architetto*, Bari, 1969, pp. 593-608, fig. 387.

[129] Winker, *Margarete von Osterreich*, p. 180.

came of age in 1515, the Lord of Chièvres drew up new orders to govern the etiquette of his own household as the duke of Burgundy. More elaborate than any known to that date, the orders were extended with each new title, so that by the time he received the imperial crown in 1530, Charles' personal household numbered 500 to 600 persons.[130] During the following years, he gradually relinquished some aspects of Burgundian pomp in favor of Castilian restraint, but his Hispanization did not result in a reduction in the size of his household because in the last years of his reign, shortly before he retired to Yuste, he had 762 personal attendants. If Charles' Burgundian ways raised some eyebrows in Castile on his arrival in 1517, the lavish expenditures after 1526 of his Portuguese bride, Isabel, actually brought forth protests from some courtiers.[131]

Suitable accommodations also had to be provided for the many representatives and ambassadors to the royal and imperial courts. While 1,000 to 1,500 people traveled with the itinerant court of the Catholic Monarchs, the emperor's entourage by the late 1520s is believed to have reached 4,000.[132] Few cities in Europe at the time could have provided properly for so many people of high station. Even so, Andrea Navagero, the Venetian ambassador, said that Charles' court had the poorest accommodations he had ever seen, and the friendly Polish ambassador, Jan Dantyszek, complained about the inadequacy of the quarters assigned to his servants and the stable facilities available in Granada; but they complained even more loudly in Valladolid in January 1527, when many of them had to be housed as far away as Tudela and Simancas, and they were no happier later that

year in Burgos.[133] These complaints obviously affected Charles' judgment of the proposed projects for the Alhambra. Well aware of the dissatisfaction of the court during its stay in Granada, the governor evidently thought that having provided a sizable and handsome residence for the imperial couple alongside the Nazaride palaces, he could renovate some of the other buildings within the fortress for the use of members of the court. The walled enclosure measures more than 820 by 220 meters at its widest part. In the old palace some fourteen major halls together with their subsidiary rooms were available, and more than twenty large towers located at intervals along the fortification walls could have been used. On the east end of the Alhambra, the Franciscan monastery could have provided additional temporary quarters, and its church, together with the nearby *mezquita* dedicated to Santa María, could have served the religious needs of members of the court. In the ample area immediately outside the walls of the citadel, other structures for housing or services could have been built. Within 150 meters of the proposed site of the new residence, there were two stables used by the Moors and both could have been enlarged.[134] Taking into account the available buildings and facilities on the Alhambra and also the convents and palaces down in the city, Luis Hurtado had good reason to think he could provide better accommodations than most cities in Spain. Of course, he himself felt perfectly at ease in the still largely Moorish city because he was respected and trusted by the Morisco leaders of Granada, but it is not likely that Charles or most members of his court felt safe among the exotic inhabitants. That concern probably played a part in Charles'

[130] Luis Gachard thought that the early household numbered about 400, without counting the large staff of singers and chapel attendants, and Karl Brandi estimated the number at between 500 and 600 in 1530 when Charles traveled to Bologna to be crowned Holy Roman Emperor, but by 1555 the household numbered 762; see Carande, *Carlos V y sus banqueros*, II, pp. 115-167.

[131] María del Carmen Mazarío Coleto (*Isabel de Portugal, Emperatriz y Reina de España*, Madrid, 1951, pp. 79-85) cites ledgers for her household preserved in the Archivo General de Simancas. Caranda (*Carlos V y sus banqueros*, II, pp. 158 and 169) states that the budget for her household was originally set at 48,670 ducats in 1526, whereas at Tordesillas, Joanna of Castile, who was still queen of Spain, had only 24,000 ducats.

[132] Lampérez, *Arquitectura civil*, I, p. 580, for the court of the

Catholic Monarchs. As far as I know, the only writer to estimate the number of people traveling with the imperial court was Gertrud von Schwarzenfeld (*Charles V. Father of Europe*, London, 1957), but I suspect most scholars would grant that the entourage easily reached 4,000.

[133] Dantyszek, *Viajes*, I, p. 312: "Nunca vi corte tan mal ordenado." For court dissatisfaction in Valladolid and Burgos, see Sandoval, "Historia," p. 233.

[134] A Moorish stable for about sixty horses is preserved on the far western end of the Alhambra, near the Torre de la Vela, while another was located to the east, below the Torre de los Picos, near the Puerta del Arrabal; see Manuel Gómez-Moreno y Martínez, "Granada en el siglo XIII," *Cuadernos de la Alhambra*, II (1965), pp. 16-17; and Antonio Gallego y Burín, *La Alhambra*, Granada, 1963, pp. 104 and 189.

decision to provide adequate permanent facilities for members of the imperial court within the fortress on the Alhambra.

Fortunately, some of the services Charles V wanted to add to the original block are identified by inscriptions on the large Royal Palace plan (pl. 17) because in the emperor's letter of 30 November 1527 they were simply described as "quarters" (*aposentos*) and in the governor's report on Vega's visit late in February of the following year, as "all the other things." One inscription in the west forecourt identifies it as "the square in front of the new palace" (*la plaça delante la casa nueba*), while another beneath it describes the function of both forecourts: "the quarters that surround these two forecourts, along the street that goes up toward the church, are for the guard, the stables, and the offices of the palace" (*los aposentos que están alderredor destas dos plaças en la calle que sube hazia la iglesia son para la guardia y para la cavalleriza y para los oficios de casa*). One can assume that the palace guard and the stables and their dependencies (quarters for grooms, blacksmith shop, storerooms, etc.) were to be located on the ground floor, while administrative offices and perhaps lodgings for officials and members of the court could be located in an attic stage above them. Both forecourts were as large as available space allowed. That on the west was figured as 150 by 252 Castilian feet, or 42 by 70 meters, while the smaller one on the south—not terminated on its east end—was to be 80 by 120 Castilian feet, or 22 by 33 meters. In both cases the stables were to be screened from view by a monumental arcade with an arch span of about 3.60 meters and piers 0.84 meters wide. The area allotted to the stables is not subdivided into individual stalls, so it is not easy to determine how many horses were to be accommodated around the two forecourts; but assuming an area of about 7 to 9 square meters for each and a total enclosed

area of about 582 square meters, 60 to 80 horses could have been stabled around the two forecourts. If the enclosure had been extended to the east (which would have required the razing of the old mosque dedicated to Santa María and the cutting down of the hill on which it stood), the number might have been increased by ten or twenty. Since the cavalrymen assigned to the Alhambra during the first fifty years numbered between 100 and 500,[135] the stables Machuca planned for the palace were not even sufficient to provide the supportive services for the force normally quartered there. Presumably, during the visits of the emperor and his court, the horses of the imperial guard and the most privileged courtiers and ambassadors could have been stabled around the two forecourts, and those of the cavalry would have been moved elsewhere for that period; but, normally, the forecourts and the stables could have been used by the cavalry stationed on the Alhambra under the leadership of Luis Hurtado de Mendoza, the Capitán General of the armed forces of Andalusia.

In view of this, the governor's resistance to the addition of the forecourts requires an explanation. One reason was certainly his desire to preserve the geometricity of the isolated block of the original project so that its "grace and proportions" could be fully appreciated; but he and, especially, his architect may have acquired the new sense of decorum relative to the location of palatine stables that developed in Italy during the latter half of the fifteenth century. Alberti in the 1450s noted that the stables should be placed so as not to offend the household, and Filarete in the 1460s insisted that they should be located at the back of the garden behind the palace;[136] over the turn of the century that attitude seems to have won general acceptance because stables were kept well away from the main entries of major Italian palaces.[137] In contrast, stables in Spain were apparently placed wherever suf-

[135] The inscription added to the Puerta de Justicia in 1599 informs us that Iñigo López de Mendoza in 1492 had 500 cavalrymen and a thousand soldiers (*peones*); ibid., pp. 29-30.

[136] Alberti, *Trattati*, I, pp. 427-429 (bk. v, chap. 17); Antonio Averlino, detto il Filarete, *Trattato di architettura* (Trattati di architettura II), ed. Anna Maria Finoli and Liliana Grassi, Milan, 1972, I, p. 224, pl. 32c (bk. VIII, fol. 58), and p. 326, pl. 62 (bk. IX, fol. 84v), henceforth cited as *Trattati*.

[137] Francesco di Giorgio Martini's stables for 300 horses designed for the ducal palace in Urbino in the 1480s was on a lower level on the side opposite the main entrance to the palace;

see his *Trattati di architettura, ingeneria e arte militare* (Trattati di architettura III), ed. Corrado Maltese, Milan, 1967, II, pp. 339-340 (Cod. S.IV.4, fol. 62, Biblioteca Comunale, Siena). The stables of the Cancelleria in Rome, begun around 1485, are believed to have been constructed along the north side of the garden behind the palace, and in other Roman palaces at the turn of the century, stables were sometimes located in nearby buildings, but usually out of sight; Christoph L. Frommel, *Der römische Palastbau der Hochrenaissance*, Tübingen, 1973, I, pp. 86-87, 168-172. Raphael's 1517 stables for Agostino Chigi's villa (later the Farnesina) were built along the garden and those

ficient space was available. Since most of the royal residences in Spain were renovated after 1537, it is often difficult to determine where the stables were located in the 1520s. At Segovia, we know that they were in the massive walls of the castle fortifications, while in the *alcázar* of Toledo, the medieval stables in the sub-basement were retained when that castle was rebuilt as a palace in the 1540s. In 1547 Vega placed the stables, lodgings, and offices of El Pardo forward of the main entry, and around the same time a similar location was chosen when new stables for about two hundred horses were designed for the forecourt of the main entry of the royal palace in Madrid.[138] We know that the front of the stables in Madrid was faced with granite (*piedra berroqueña*) and that there was armory on the upper floor, but, unfortunately, those sixteenth-century stables were lost during the rebuilding of the palace in the eighteenth century. Of course, the designer of the stables of El Pardo and the royal palace in Madrid was Luis de Vega, so it is quite possible that twenty years earlier he had recommended that the stables surround the forecourts of the new royal palace on the Alhambra.

Beyond serving the cavalry unit assigned to the Alhambra and the imperial court on its occasional visits, the west forecourt was planned to accommodate ceremonial receptions and celebrations and to serve as a tilt yard for equestrian tournaments and as an arena for other courtly spectacles. The surrounding arcades would have given protective cover for many spectators and an attic or balustraded terrace would have provided even better vantage points, while the imperial couple and special guests viewed events from the windows of the large audience hall over the main vestibule of the palace. Of course, during these early years, Charles was more often a participant than a spectator in the tournaments. At the age of seventeen in Valladolid, during his first trip to Spain in 1517, he

impressed members of the court with his skill in equestrian combat.[139] In 1526, while he was in Granada, he participated in a tournament held on 29 August, the Feast Day of St. John the Baptist, to celebrate the anniversary of the capitulation of the city to the Catholic Monarchs; and the following year, as part of the festivities celebrating the birth of Prince Philip in May 1527, Charles took part in a bullfight (*corrida*), killing a bull with his own hand.[140] Again, in 1530 in Mantua, he displayed his skill and prowess in a four-hour equestrian game with other courtiers.[141] Among the more popular of these games in Spain was one called *Las Cañas*, a legacy of the Moors.[142] Four horsemen, armed with javelin-like lances, entered in pairs from opposite sides of the arena and, from there, they rushed at one another with fixed lances to unseat their opponents. It was considered the most demanding of all equestrian games and the injuries were often serious. In Valladolid in 1527, so many were wounded early in the day that, at the request of the empress, the games were interrupted.[143] In view of Charles' special interest in equestrian sports, one can understand the great size and opposed entries planned for the west forecourt. The gates on the west and north sides have no other evident function (pls. 17 and 18). Only the one on the south end served as an entry, though the gate on the north side is aligned with the door to a "hall of festivals" (*quarto para fiestas*), which was to have been about 10 by 32 meters (pl. 17-C). This hall could have served for banquets and dances and perhaps the presentation of plays. If windows were planned on its north wall, the hall would have offered a magnificent view of the Moorish quarter known as the Albaicín and also of the majestic Sierra Nevada. The ground under that proposed hall slopes steeply toward the north, so a kitchen could have been planned beneath it. The large kitchen identified by the inscription *cozina*, to the east of the new palace (pl. 17-K), would have been

planned for Giuliano de'Medici's villa on the Monte Mario, known as the Villa Madama, were planned for the right side on a lower level on the slope down to the Tiber (pl. 110-C).

[138] Martín González, "En el alcázar de Madrid," p. 13, and "El Palacio de 'El Pardo,' " pp. 5-48, esp. p. 23; also V. Gerard, "L'alcázar de Madrid et son quartier au 16ᵉ siecle," *Coloquio*, no. 39, 1978, pp. 36-45.

[139] Laurent Vital, "Relation du premier voyage de Charles V en Espagne 1517 a 1518," *Collection de voyages des souverains de*

Pays-Bas, ed. Gachard and Piot, Brussels, 1881, III, p. 391.

[140] Pedro Mexía, "Historia de Carlos V," *Bulletin Hispanique*, VIII (1916), p. 426; Navagero, *Viajes*, I, pp. 319-320; Royall Tyler, *The Emperor Charles the Fifth*, London, 1956, p. 59.

[141] Stefano Davari, "Descrizione del Palazzo del Te di Mantua di Giacomo Strada," *Arte*, II (1899), pp. 248ff. and 329ff.

[142] Pedro de Aguilar (*Tractado de la cavallería de la gineta*, Seville, 1572, chap. 15) described the ceremonial sport.

[143] Navagero, *Viajes*, I, p. 322.

too far away to serve the festival hall. While its elevation is a matter of speculation, Machuca's west forecourt would seem to have provided modern facilities for ceremonial and festive functions unequaled in grandeur by any palace in Europe at the time.

The south forecourt, surrounded by stables surmounted by offices and living quarters, was considerably smaller than the west forecourt, being only about 22 by 33 meters (80 by 120 Castilian feet). Its lesser importance was further indicated by a single-door entry to the palace and a smaller vestibule, though a monumental staircase was planned for the southeast corner of the palace. These distinctions suggest that the south forecourt and its entry were intended to serve the household of the empress, while the larger west forecourt with its three-door entry and the main staircase (probably initially alongside the vestibule and then moved to the northwest corner of the courtyard) pertained to the household of the emperor. Separate households and entries were customary for royal and even noble couples in Spain and elsewhere. In Madrid, the main vestibule of the royal residence opens into two courtyards, identified in Gómez de Mora's 1626 plan as that of the king on the left and the queen on the right (pl. 15), and there is reason to assume that this arrangement was already in effect in the sixteenth century.[144] Toward midcentury, when the old *alcázar* at Toledo was renovated, the two households were relegated to opposite sides of the single courtyard, with the imperial staircase at the rear parting midway for direct access to either the king's or the queen's half of the palace.[145] Within the square residence planned by Machuca for the Alhambra, the emperor's apartments were probably located in the southwest corner, just south of the main audience hall in the center of the west wing. The best indicator of that location is the "secret" spiral staircase in the southwest corner (pl. 17), a telltale feature frequently found alongside the private chambers in a princely residence during the Renaissance. The emperor's household must have occupied the west and north wings, and the octagonal chapel located between his household and that of the empress presumably enabled each royal person to attend Mass in a private tribune on either side. Separated by the chapel in the northeast corner, the two households must have been joined by adjacent bedchambers near the secret staircase in the southwest corner.[146] The empress was probably to have had a bedchamber and an anteroom just west of the loggia or "window" over the south entry, with that loggia providing a delightful place for Isabel and her ladies to enjoy the air and the sun, and also the view of the fertile plain that, until the recent expansion of the city, extended south to the distant mountains. The rest of her household would have occupied the remainder of the southeast angle down to the octagonal chapel in the northeast corner, with her reception rooms located near the monumental staircase planned for the southeast corner. This division of the square residence was later used in the block-design retreat near Madrid called El Pardo, which was begun about 1547. Its chapel was located in the northeast corner; the queen's household occupied the northwest angle and the king's, the opposite (pl. 11). In Charles' palace on the Alhambra, each of the households had an independent forecourt, vestibule, and main staircase, but they shared the octagonal chapel in the northeast corner and the secret spiral staircase alongside adjoining bedrooms in the southwest corner.

The disturbing intrusion of the residential block into the area once occupied by the hall at the southern end of the Court of Myrtles must be understood in relation to the difficulty of accommodating the expanded plan within the confines of the Alhambra. For that problem the governor and the emperor had very different solutions, and their disagreement caused a delay of four years in the

[144] Iñiguez Almech, *Casas Reales*, pp. 79-80, fig. 14. It is, however, clear that in the early seventeenth century there were council rooms and even shops in the ground floors of both courtyards, so they were not reserved for the two households alone.

[145] Wilkinson, "The Escorial and the Invention of the Imperial Staircase," pp. 72-73. Covarrubias made the first model for the staircase in 1553 but the design was disputed and gradually enlarged until the final project of 1559.

[146] A similar arrangement seems to have pertained in the northwest corner of the *alcázar* of Toledo (the lower right corner of the courtyard in pl. 16). In an anonymous plan of the main floor dated 1581-1585, the staircase is found between the royal bedchambers that are numbered 5 and 8; see Iñiguez Almech, *Casas Reales*, p. 105, fig. 37. Alberti had expressly noted that the household of the wife of a prince ought to be entirely separated from that of the prince himself, with the exception of the bedchambers, which ought to be contiguous; see *Trattati*, I, p. 343 (bk. V, chap. 2).

initiation of construction. Charles V evidently had the impression that a good deal of space was available south of the old palace. He probably recalled that after passing through the Puerta Real, which was located until 1527 just south of the Puerta del Vino (pl. 17-O), he followed a road known as the *calle real* that continued in an easterly direction toward the monastery of San Francisco, that is to say to the south of the present palace. Along that path Charles would have recalled seeing to his right the massive southern wall of the upper fortress and, to his left, in an area that extended to the walls of the old palace, a quarter of small Morisco houses. These houses were hastily built shortly after the Christian occupation of the Alhambra to provide shelter for the families of about a hundred and fifty of the soldiers and workers who had the task of defending the stronghold within a city that had about 200,000 inhabitants.[147] During the following quarter century, as the Christians felt more secure and moved down into the city itself, the houses on the Alhambra were abandoned, and by 1526 they had fallen into disrepair.[148] This unsightly quarter of dilapidated Morisco houses is what Charles would have seen as he preceded from the Puerta Real toward the ruinous little mosque consecrated as the church of Santa María (pl. 17-M). There, he would have turned left, leaving the former Madrasa (which housed the church's three chaplains) and the royal cemetery to his right as he approached the entry to the Nazaride palace in the southwest corner of the Court of Lions (pl. 17-J). Farther to the east, was the handsome house of the Mendoza, which Münzer in 1494 described as "noble and proud";[149] but, immediately south of the Nazaride palaces, Charles is not likely to

have recalled any structure that was worthy of preservation. Hence, when he left instructions to build a modern residence alongside the old palace, he probably had in mind an available area extending approximately 200 meters in the eastwest direction and about 80 meters north to south.

Within that ample space south of the old palaces, the emperor had a preferred location in mind, though it would seem from later events that he had not made that clear to the governor when he directed him to make plans for a new residence. The location he wanted is revealed in a letter written by the archbishop of Granada to the empress and simply dated 23 November (doc. 4). The prelate referred to her recent request for "his consent in the taking of the church of the Alhambra for the royal palace that was ordered made there." After expressing the wish that it were in his power to do so, he explained that only the pope could return the area to profane use. He did, however, point out that the old mosque had been consecrated as the first collegiate church in Granada after the conquest and that many of the early settlers of the city were buried there. Clearly, he did not approve the proposed demolition, because he reminded Isabel that early Christian emperors, such as Constantine and Theodosius, never took a church for the site of a residence but, to the contrary, gave their palaces for the use of the Church. This letter serves at this point to provide evidence that Charles V wanted to locate his residence south of the Court of Lions, which he had frequently enjoyed while dining in the Hall of the Two Sisters on its north side; apparently he wanted to have direct access to this extraordinary courtyard from his private apartments in the new residence. Perhaps Charles

[147] Jesús Bermúdez Paraja, "Exploraciones arqueológicas en la Alhambra," *Miscelánea de estudios árabes y hebraicos*, Granada, 1963, II, p. 49.

[148] The foundations of poorly constructed Morisco houses of this type have been found wherever excavations were made in the area of the palace of Charles V. In the center of the round courtyard, Mariano Contreras uncovered the walls that formed the courtyard of a small house; see Manuel Gómez-Moreno y González, *Guía de Granada*, Granada, 1892, pp. 24, 55-60. Leopoldo Torres Balbás in 1926 found similar foundations under the room to the north of the west vestibule; see *Cuadernos de la Alhambra*, III (1967), p. 143. In 1964, I found the narrow staircase of another house four meters from the southwest corner of the palace where I had hoped to find the foundations of the outer pier of the arch initiated on that corner (pls. 17-N and 31). In 1646, those Morisco houses still occupied the area

of the west forecourt (pl. 17-B); see Francisco Henríquez de Jorquera, *Anales de Granada*, ed. A. Marín Ocete, Granada, 1934, I, p. 55. These humble houses for the soldiers apparently replaced the finer houses of the Nazaride aristocracy because Guillebert de Lannoy in 1411 referred to noble residences around the old palace; see "Voyages ambassades," *Collection des chroniques et trouvères belges*, ed. C. Potvin, Louvain, 1878, p. 18. The foundations of such a house, discovered by Torres Balbás in 1922, can be seen south of the present palace; see his "Plantas de casas árabes en la Alhambra," *Al-Andalús*, II (1934), p. 382.

[149] Pfandl, "Itinerarium," p. 46: ". . . tandem ad pallacium nobile et superbum domini castellani applicavimos, cuius nomen dominus Inicun Lopes de domo Mendosse ex Castella et comes Tentilie et Castellanus Granate." In 1646, Henríquez de Jorquera (*Anales*, I, p. 57) still found the palace "una casa muy buena y de gran primor."

imagined the residence directly south of that court, well to the east of the present location. That location would have left a large area to the west for the forecourt and its dependencies.

Luis Hurtado de Mendoza, who had spent all of his life on the Alhambra, had a more intimate knowledge of the interrelations of its various parts, and, above all, their historical and emotional significance for the Christians of the city. Because of this, it is not likely that he ever contemplated the demolition of the little mosque to make way for the new palace. The revered, if ruinous, *mezquita* was one of the inviolable structures, in his view. Another was the large water storage tank (pl. 17-B) built by his father in 1494 alongside a road that went south from the square forward of the Patio de Machuca to the Puerta Real on the higher southern side of the Alhambra (pl. 17-O). Because water had to be conducted from the Sierra across a gully, the tank was essential for the survival of the fortress under circumstances of siege. Thirty-four meters long, six wide, and eight deep, it was shown with pride by the first governor, Iñigo López de Mendoza, to the German traveler, Hieronymus Münzer, who was duly impressed.[150] In 1527, it was still the primary storage tank on the Alhambra. Consequently, Luis Hurtado assumed the following limits for the area of the new residence: the storage tank on the west, the old mosque on the east, the massive fortification walls on the south, and, of course, the Nazaride palaces on the north. That somewhat rectangular area occupied by small Morisco houses measured less than a hundred meters east and west and about eighty meters north and south; but it had the advantage of being a more nearly level area than the terrain directly south of the Court of Lions. Another factor in the governor's choice may have been his awareness of the former function of the Court of Myrtles as the center of the official palace, the Palacio de Comares. In this part of the palace were located the royal apartments, the reception rooms, and the Hall of the Ambassadors, or the throne room, in the Tower of Comares. The Court of Lions, on the other hand, was a delightful villa-like adjunct, which Bermúdez Pareja has described as a sumptuous *carmen*, added to the early fourteenth-cen-

tury palace during the third quarter of that century.[151] The governor may well have thought it proper for Charles' new residence to be located alongside the former official palace so that its facilities could be used. While it is not possible to determine precisely the location that the governor had in mind for the free-standing project, he evidently proposed the level area southwest of the Court of Myrtles (pl. 1).

Though the governor had not yet given up his effort to save the original project when he reported to the emperor on the February visit of Luis de Vega, the expanded plan and the difficulties involved in its placement had already been discussed. The governor wrote in his letter of 27 February 1528, "I showed the plans to him [Vega] and discussed with him my understanding of them and I showed him the site and disposition where the building has to be made" (doc. 1). Unless the governor misread Vega's response or the visitor's objections were not expressed until he returned to Castile, it would seem that the governor thought his arguments for the placement of the enlarged plan southwest of the Court of Myrtles had been accepted by the Castilian mason. Already in the Archive plan (pl. 19), here attributed to Luis de Vega, the governor's placement pertained, because there are no indications of windows east of the north staircase where the new palace was to be set against the wall of the south portico of the Court of Myrtles. Though Vega seems to have agreed to this placement in February 1528, the emperor did not; and the governor, after losing his struggle to save the original free-standing project, turned his efforts to convincing the emperor that the expanded project had to be restricted to the area southwest of the Court of Myrtles, between the church and the water storage tank.

The delineation of the governor's placement seems to have been the primary function of the large Royal Palace plan (pl. 17). Some of its inscriptions identify the inviolable structures, while others locate various parts of the Alhambra that the emperor was likely to have recalled. The inscription in the Hall of the Two Sisters on the north side of the Court of Lions (pl. 17-I) identified the "room where your Majesty used to eat" (*cuadra donde comía*

[150] Pfandl, "Itinerarium," p. 47.

[151] Jesús Bermúdez Pareja, "Identificación del Palacio de Comares y del Palacio de Los Leones en la Alhambra de Gra-

nada," *Actas del XXIII Congreso Internacional de Historia del Arte. España entre el Mediterráneo y el Atlántico. Granada, 1973,* Granada, 1976, II, pp. 55-56.

su Magestad). Another, placed alongside a room in the southwest corner of the Court of Lions, indicated the "quarters of the Court of Nassau" (*aposento de Conde Nasao*), referring to Count Henry of Nassau-Dillenberg who was Charles' First Chamberlain (*camarero mayor*) and who previously, in 1521, had commanded the imperial army in Italy.[152] The rooms west of the Tower of Comares (pl. 17-E) were identified as the "quarters where the empress stayed" (*aposento donde posaba la emperatriz*), and further to the west (pl. 17-D) we find the "courtyard of the Mexuar where Queen Germain [de Foix] stayed" (*Patio del Mexuar donde posaba la reyna Germana*). She was, of course, the last wife of Charles' grandfather, Ferdinand the Catholic. None of these inscriptions pertains directly to problems of planning or replacement, but they refer to parts of the old palace that the emperor would have remembered. Evidently they were intended to help him visualize the proposed relation of the new residence to the old. Most significant, of course, is the inscription placed near the disputed old mosque (pl. 17-M), "Here is the church" (*aquí está la iglesia*). To the west, the huge water storage tank was labeled *aljibe* (pl. 17-B). The identification of these inviolable structures suggests that the large Royal Palace plan was part of the governor's effort to convince the emperor that the *mezquita* and the *aljibe* had to be preserved and that the expanded plan for the new palace had to be built in the area between them.

From the way in which the governor and his architect used every square meter of that restricted area, there is reason to suspect that Charles had wanted even larger forecourts and service buildings than the enlarged project of 1528 provided. To gain only a few meters, the block of the palace was backed into the area of the hall on the south end of the Court of Myrtles. Clearly this "insolent intrusion" of the new into the old was an act of desperation, but since Luis Hurtado retained the inner wall and portico of that hall, the integrity of the Nazaride court was preserved. A basic factor in the planning of the forecourts seems to have been the emperor's decision to accept the original square plan with the circular courtyard as the core of the new complex. Perhaps he did so to placate the governor who persisted in his defense of the

first project, but certainly the expanded plan would have been spared some incongruities if Machuca had been permitted to redesign the whole complex anew as a multicourt palace. Given the circumstances and the emperor's insistence on attaining the maximum size possible for the forecourts and other parts of the project, necessity and compromise seem to have played a larger role than design principles in the location of the expanded plan and the disposition of its forecourts.

Several technical peculiarities of the large Royal Palace plan support the assumption that it was the first presentation of the governor's counterproposal for the location of the enlarged project and that it was made shortly after Vega's visit in February 1528. In this plan, the walls of the old palace and its fortifications were given an ink wash, with some of the thicker walls of the western fortification (known as the *alcazaba*) receiving a slightly darker wash, probably at a later time (pl. 17-A). In contrast, the walls of the square block of the new palace were shaded by means of hatching, and those of the two added forecourts and the kitchen extension on the east were left clear. The distinction of the block of the new residence from both the Nazaride structure and the proposed forecourts suggests that each had a different status at the time the plan was made, but the significance of these different treatments is not immediately evident. A singular departure from the wash technique within the walls of the old palace provides a clue. In the rooms between the Patio del Mexuar and the Cuarto Dorado (pl. 17, D and E), the west wall was hatched, while the more massive east wall (1.20 meter, in contrast to 0.75 meter of the west) was given a wash. The east wall is known from modern investigations to be an Islamic construction, while the west wall was built in the Christian period,[153] and in the plan the four rooms along the hatched wall are all identified as "new" (*nuebo*). From this information, one could conclude that the hatched walls represent Christian projects, while the ink wash identifies walls of Islamic construction. That explanation, however, would seem to be denied by the contradictory evidence of the walls of the so-called new quarters built for Charles north of the Garden of Daraxa, here labeled *jardín* (pl. 17-H). The six rooms of this suite were constructed be-

152 Tyler, *The Emperor Charles V*, p. 238.
153 I owe this information to Jesús Bermúdez Pareja; see his

"Obras del Cuarto Dorado," pp. 101-102.

tween 1528 and 1533 to serve as interim quarters for the imperial couple, should they return to the Alhambra before the new palace was finished, but the walls of these rooms were given the ink wash used for the Nazaride palace. Evidently the project for these rooms had been determined by the governor and Luis de Vega during the latter's visit to the Alhambra in February 1528 because the emperor approved a five-year budget for their construction in April (doc. 3) and work was begun shortly thereafter. The disposition of the required service quarters and the forecourts, however, had not been determined during that visit. Thus, it would seem that a wash was given to extant walls and those already under construction, while hatching was reserved for approved projects not yet begun, and new proposals were left clear. At odds with this explanation is the use of washes for parts of the massive bastion west of the water storage tank that were never constructed; however, these washes are much darker and more crudely applied, and in some cases, they surpass the delineated width of the walls (pl. 17-A). As there is no trace of lighter washes under these crude, dark washes, it is likely that they were added at a later time when more massive walls were considered. One wall of that bastion forward of the *aljibe* is defined by lines alone, without wash or hatching, suggesting that all of the fortification walls in question may have been unshaded in 1528, and thus, proposals.[154] This explanation would leave intact the theory that the ink wash was used for extant walls and those under construction, while hatching indicated approved projects not yet begun or even budgeted, and the walls left clear represent wholly new proposals. That significance of the various treatments of the walls would have been true only after 22 April 1528, when the budget for the "new quarters" was approved and the governor had finally given up in his effort to save the free-standing project, and this would suggest that the large Royal Palace plan

was drawn in late spring or early summer of that year.

The proposal of 1528 is, of course, at odds with the date 1542 often given to that plan. The latter seems to depend, ultimately, on Gómez-Moreno y González's undocumented claim in 1885 that "plans of the new palace drawn on paper of Milan" were sent to the emperor in 1542 and, more recently, Gómez-Moreno y Martínez's identification of the plan of the entire Alhambra as the one sent to the emperor in 1542.[155] Because no explanation was offered for making so extensive a plan at that late date, George Kubler questioned the validity of that claim while Fernando Chueca assigned the plan to 1530, without expressly rejecting Gómez-Moreno's claim.[156] The document that Gómez-Moreno y González must have seen is found in the account ledger for 6 March 1542 (doc. 36). It is a payment of 119 maravedis for "a box of sheets of Milan in order to carry the project of the palace to the emperor" (*una caxa de oxa de Mylan para llebar la traça al emperador de la casa*). Probably as the result of his hurried reading while ordering the disheveled documents of the archives in the mid-1880s, Gómez-Moreno mistook "sheets of Milan" for "Milanese paper." If he looked at the watermarks of the paper on which the large Royal Palace plan was made, he might have thought that the letters *MI* supported his interpretation of the phrase *hojas de Mylan* (fig. 2-b). As we noted, the watermark is peculiarly Genoese and the order of the two letters was interchangeable. Since Gómez-Moreno did not mention the watermark, it is more likely that he was misled by the word *hojas*. In the sixteenth century, *hojas de Mylan* was the equivalent of *hojas de lata* or "sheet tin."[157] That this was the meaning of the term is evident from other references in the 1540s to *ojas de Milan para moldes*, that is, sheet tin for the making of patterns or molds.[158] Later, in 1612, when plans of the old and the new palace were sent to Tomás Angulo, the

[154] No traces of foundations of the sort indicated under the heavy shading were found in that area during the excavations of the 1950s, according to Jesús Bermúdez Pareja; see his "Excavaciones en la Plaza de las Aljibes de la Alhambra," *Al-Andalús*, XX (1955), pp. 436-452.

[155] Gómez-Moreno y González, "Palacio de Carlos V," p. 195. Gómez-Moreno y Martínez, *Las águilas*, p. 124. (Though he mistakenly referred in his text to 298 rather than 297, it is clear that the large Royal Palace plan is the one to which he assigned the date 1542.)

[156] George Kubler and Martín Soria (*Art and Architecture in Spain and Portugal and their American Dominions 1500-1800* (The Pelican History of Art 17), Harmondsworth, 1959, p. 11, n. 35) noted that the groundplan of the east vestibule did not follow the present form of that hall. Chueca (*Arquitectura del siglo XVI*, p. 218) referred to them as "trazas originales."

[157] *Diccionario enciclopédico de la lengua castellana*, París, n.d., II, p. 48. *Gran diccionario de la lengua castellana*, Barcelona, n.d., III, p. 328.

[158] Among the citations of *ojas de Milán* in the early 1540s in

secretary of the Junta de Obras y Bosques, reference was made to "two large boxes of sheet tin made to carry the said plans."[159] Thus, the payment of 1542, on which Gómez-Moreno seems to have based his claim, simply refers to a *traça*—which could be a groundplan or an elevation—that was sent to Madrid in a protective roll or box of sheet tin, and so there is no documentary basis for dating the large Royal Palace plan in 1542.

Several discrepancies between the large Royal Palace plan and the palace itself also indicate a preconstruction date. George Kubler pointed out that the configuration of the east vestibule in the groundplan differs from that of the hall as constructed; but, as we shall see, the bearing walls of the east vestibule were not raised until the third quarter of the sixteenth century, so its form provides no basis for denying 1542 as the date for the large plan. There are, however, other portions known to have been constructed previous to 1542 that differ from this plan. The present chapel, founded in 1537, has only rectilinear niches, while the large Royal Palace plan has alternating rectangular and semicircular recesses (cf. pls. 2 and 17). The south facade, which was well advanced in 1537, has seven bays on either side of the central portal, whereas the plan shows only six. In the case of the west facade, which was under construction before 1540, there are now six bays on each side of the marble *portada*, whereas the groundplan has only five. Furthermore, the extra pedestals of the south *portada* (those with the reliefs of modern trophies to complement the ancient spoils on the main pedestals: pls. 44 and 45) were completed by Niccolò da Corte in 1539, but they, too, are missing in the plan. We have already noted that the large Royal Palace plan is a palimpsest of the early project with an open-corner courtyard and Machuca's revision enclosing the corridor with a wall. The general looseness and tentativeness of the drawing in this plan also indicates that it was a

project rather than a record of a building already founded and partly raised on at least three sides. In addition to these indications that we are dealing with a preconstruction plan, one difference between the present palace and the large plan would seem to be conclusive: the north-south axis of the present palace is located about three meters to the east of its position in the plan. Apparently the north-south axis was shifted to align the north staircase with the small room on the southwest corner of the Court of Myrtles (cf. pls. 2 and 17). Because this important alignment between the new and the old palaces is not recorded in the large Royal Palace plan, it must predate the laying of the foundations and (as we argued on the basis of other data) postdate the letter of 27 February 1528.

The small plan follows the large plan in many respects but it more closely approaches the form in which the palace was constructed. This is true in the case of the rectangular niches in the octagonal chapel, the semicircular ends of the "oval" vestibule, and the rhythmic disposition of the bays of the wall of the courtyard (pls. 17 and 18). The small plan also has the proper six bays on either side of the west entry and seven on either side of the south, and the half-columns of the aedicular frame of the east portal are indicated here for the first time. There are also closer affinities in respect to some of the measurements, such as the width of the west vestibule (50 Castilian feet rather than the 48 of the large Royal Palace plan) and the rooms on either side of it (13 rather than 14 Castilian feet).[160] In most respects, the small plan is more carefully drawn and more precise in details and closer to the present palace, but it differs from the palace as constructed in a good deal more than the single rather than the double doors on the side walls of the west vestibule noted by Gómez-Moreno. The most striking differences are found in the courtyard. The width of the corridor in the small plan is 13 Castilian feet, the same as that in

the archives of the Alhambra are the following: 15 December 1540 (Leg. 2, 2b), 6 March, 7, 11, and 12 July 1542 (Leg. 2, 2c), and 3 and 30 July 1544 (Leg. 3, 5). References to the purchase of paper during the same period usually follow this form: "media mano de papel de marca mayor para traças," recorded on 9 October 1542 (Leg. 2, 2c).

[159] AA, Leg. 153, 1, Nóminas, on 3 November 1612: "A Marcos de Quebara, veynte y quatro reales, que a de aber por dos cajas grandes de hoja de lata que hiço para en que se llevaron las dichas traças, ocho cientos y diez y seys maravedís." Two

weeks later, on 17 November 1612, a payment was made to the courier who delivered two "traças" to Madrid; see AA, Leg. 153, 1.

[160] The shifting of the walls to enlarge the main vestibule is evident from the fact that transverse walls run into facade windows in the Archive and the two Royal Palace plans (pls. 17, 18, and 19). One such wall was removed by Torres Balbás in October 1929 to clear a west-facade window; see Leopoldo Torres Balbás, "Diario do obras en la Alhambra 1927-1929," *Cuadernos de la Alhambra*, IV (1968), p. 126.

the large Royal Palace plan, while the corridor of the present palace is 17 Castilian feet (4.73 meters as against 3.62 meters). Equally surprising is the indication of square pillars (inevitably supporting an arcade) rather than the colonnade later constructed and already indicated in the large Royal Palace plan. Apart from the support system of the courtyard, the small Royal Palace plan seems to be a careful delineation of the architectural forms of the large plan, with the several differences in most cases bringing the small plan closer to the palace itself. Because a "clean" version of this sort is not likely to have been made before the location was approved, the date of the small plan would seem to depend on the decision to locate the multicourt complex where the governor had suggested, northwest of the Court of Myrtles.

The emperor's continued insistence on building the new palace alongside the Court of Lions is evident from a letter apparently written by the empress to the archbishop of Granada. In it she must have requested permission to raze the *mezquita* dedicated to Santa María. We have the archbishop's response dated 23 November (doc. 4). Gómez-Moreno y Martínez added "1528," but that year is at odds with internal evidence. The archbishop addressed Isabel as "regent," a responsibility that she assumed for the first time during the spring and summer of 1528, when Charles went to Monzon in Aragon and then down the coast to Valencia. He returned to Madrid, however, on 4 August of that year,[161] so Isabel was not regent in November of 1528. The second period of her regency occurred the following year in late July when Charles sailed from Barcelona to Genoa on his way to Bologna for his coronation. Thus, the earliest year in which the archbishop could have addressed Isabel as regent in the month of November was 1529.[162] Of course, Charles did not return from that trip until April 1533, but there is another reference that restricts the letter's date to 1529. This

is the archbishop's request that Diego Siloe be permitted to return from court to continue his work on the cathedral of Granada. We know that the emperor, in December 1528, expressed concern about the contrast of the "Roman" style of the new cathedral with the traditional Gothic form of the Royal Chapel and that, on 23 January 1529, the chapter of the cathedral decided to send Siloe to court to explain and defend his project.[163] It is possible that Siloe's trip was delayed or that he returned to Madrid later that year, because we know that he was in Granada in August when he signed a payment for the wooden model of the cathedral.[164] In any case, 1529 was the first year in which Isabel was regent in the month of November and that was the year in which Siloe was sent to court, so the most likely date of the archbishop's letter in which he refused to approve the razing of the little church on the Alhambra is 23 November 1529, and at that time the archbishop was Gaspar de Ávalos.

The emperor must not have approved the governor's recommended placement of the new multicourt palace southwest of the Court of Myrtles before his departure for Italy in July of that year; and it is not likely that the archbishop's attempt to shame him by comparisons with more pious early Christian emperors dissuaded him from his obsession to building his new residence alongside the Court of Lions. But, as the archbishop informed Isabel, only the pope could deconsecrate the church of Santa María and, in 1529, the pope was Clement VII, who two years earlier had been imprisoned in the Castel San Angelo by the imperial troops that sacked Rome and set fire to his villa on the Monte Mario. Perhaps the emperor brought up the matter in one of several meetings with the pope shortly after his coronation in Bologna in January 1530; but, if he did at that time or later, he failed to gain the pope's approval. The first hint of the emperor's acceptance of the place-

[161] Ramón Menéndez Pidal, *Historia de España*, Madrid, 1966, XVIII, p. 393. Charles named Isabel regent on 20 April 1528; see AGS, Catalogue v, p. 363, no. 2594.

[162] The authorization was signed 8 March 1529; see AGS, Catalogue v, p. 365, no. 2606, and also *Corpus Documental de Carlos V*, ed. M. Fernández Álvarez, Salamanca, 1973, I, pp. 143-147.

[163] Charles' letter of 23 December 1528 to the archbishop (AGS, PR, Leg. 25, fol. 61) was published by Gómez-Moreno y Martínez (*Siloe*, p. 81). After noting that he had been advised

that the Royal Chapel would suffer as a result of the contrast in style, Charles stated: "Yo os encargo e mando que no deys lugar a que se haga edificio de que pueda subçeder el dicho perjuizio. . . ." To avoid the conflict of styles, the cathedral was also to be built in the "modern" style (*al modo moderno*)— that is, in the Gothic style. For the action of the canons of the cathedral, see Rosenthal, *Cathedral of Granada*, pp. 17-18 and doc. 36.

[164] Ibid., doc. 40.

ment suggested by the governor is the royal order in December 1531 for the demolition of the residence of Santa María's three chaplains, with the assurance that a new one would be built for them near the church.[165] But that work was not carried out until 1541 when construction reached the southeast corner of Charles' palace. From these circumstances and observations, it would seem reasonable to conclude that the carefully drawn small Royal Palace plan (pl. 18) was not made until late in 1531, when Charles finally accepted Luis Hurtado's location of the expanded plan of the new palace.

The wooden model for a major architectural work was usually made after the approval of the final plan and shortly before beginning construction, and that procedure was outlined by Luis Hurtado himself in his letter of 27 February 1528 (doc. 2). Yet Gómez-Moreno y González in 1885 stated flatly that the model was not made until 1539.[166] Because of his familiarity with documents in the palace archives, most scholars have felt compelled to accept that date, even though no specific source was cited. Some have been troubled by the delay of twelve years between the beginning of construction (1527, according to the Gómez-Moreno) and the making of the model. One would have to postulate a major change in the design of the palace in 1539 to accept such a delay. Still, Gómez-Moreno y González probably had a documentary basis for that date. He must have seen several payments of 1539 for the carving of the colonnade of the courtyard in the wooden model (docs. 21-24). On 7 and 15 March of that year a payment was made for "what carver Ruberto made for the model" and also for a half-day's work on the model by a carpenter named Pierre; in May (the pay ledger for April is missing), Ruberto was again paid "for 20

columns made for the model," and Pierre and another carpenter named Juan Garros were paid for five days of work. No further payments were found, though more than half of the monthly ledgers for the period 1538 to 1540 are preserved. If the entire model had been made at that time, one would expect other notices of payments to carvers and carpenters.

About the model itself we know very little. It was studied by Juan de Maeda in 1576 when he was asked to appraise projects for the completion of the palace, and we know that a few years later, in 1589, the model was kept in the so-called *Patio de Machuca* (pl. 17-D).[167] Apparently it survived until the mid-eighteenth century because a former *alcaide* of the Tower of Comares, Don Antonio Ximénez Montalvo, told Padre Juan Velázquez de Echevarría in 1764 that he had once seen a model of Charles V's palace in one of the halls of the Alhambra. He described it as "a model of the two main facades, executed in wood, about a meter (*cinco quartas*) long on each side, and correspondingly [meaning proportionately] high," and he added that it was "an enchantment because of the excellence and delicacy of its workmanship" (*un embelso por su primor, y delicadeza*).[168] In the mid-1760s, when the Academy of San Fernando in Madrid ordered a search for all surviving plans or models of the palace of Charles V, it could no longer be found.[169] From these scattered references to the lost wooden model, it would seem that it was about a meter long and included the two main facades, the south and the west (perhaps only half of each) and a segment of the lower and upper colonnades of the round courtyard (at least 10 of the 32 columns on each level). Evidently it was a table-sized model like that of the Strozzi palace in Florence, which was made about 1489 and is still preserved in the

[165] AA, Leg. 208, 39. The copy of a letter from Isabel to the governor, Luis Hurtado de Mendoza, dated 1 December 1531, in Medina del Campo begins: "Por la que su Magestad mandó del ecellentísimo Señor Capitán Gral de la Costa d'este regno, que en órden a las casas de los Benefiziados de dicha yglesia que eran cerca de ella, y se las pretendían tomar e yncorporar en la Casa Real que se labrava, en casso de havérseles de tomar les proveyese en razón de ellas de manera que no reciviesen agravio, e se les diese todo el contentamiento que hubiese lugar. . . ."

[166] Gómez-Moreno y González, "Palacio de Carlos V," p. 195, n. 2.

[167] AA, Leg. 21, 4, 2, records a payment on 8 April 1589 for

". . . yesso para adereçar en el patio que dizen de Machuca, el aposento a donde está el modelo d'esta obra real. . . ."

[168] Padre Juan Velázquez de Echevarría, *Pasoes de Granada y sus contornos*, Madrid, 1764, I, p. 28. In 1829, Llaguno (*Noticias*, I, p. 220) claimed that the model had survived until almost his time (*no ha muchos años existía el modelo*), but it seems that it had disappeared about seventy-five years earlier.

[169] On 13 September 1766, Luis Bucareli, the governor of the Alhambra, informed the marquis of Grimaldi that he had searched the archives of the Alhambra carefully and found no drawings, plans, or models of the palaces on the Alhambra; see Academia de San Fernando, Madrid, Armario 1°, Leg. 37.

palace itself.[170] Of course, models were often made for major churches in both Spain and Italy, but only in exceptional cases were they made, even in Italy, for secular buildings.[171]

With this review of what is known of the lost wooden model, we can return to the carving of the colonnade for the model in 1539. The explanation for that anomaly is provided by an incidental comment in Juan de Maeda's report on the state of the palace early in 1576 (doc. 129). In discussing a current proposal to cover the gallery with a vault, Maeda warned that it would be difficult because a change had been made in the "substance and design" of the support system of the porticoes on both levels, from sturdy piers to a colonnade, and he specifically says that change was made in the wooden model (*esto causa aver movido la sustancia y traza del modelo, porque era primero con sus colunas aconpañadas por los lados derechos y movimientos sobre que se çerraban los arcos redondos. Devioles de pareçer que esto enbaraçaba, haziéndose en lo baxo y alto, y así se hizo de colunas redondas . . .*). That change must have occurred in 1539 when the several carvers were paid for the making of columns for the wooden model. Presumably the model was made shortly after the emperor approved the final project, and the portico of its courtyard was an arcade on massive piers, in contrast to the square pillars indicated in the small Royal Palace plan. Therefore, that groundplan represents, at best, the penultimate stage of the design (pl. 18). Having dated the small Royal Palace plan in the summer or early autumn of 1531, the plan with the massive piers that superceded it can be placed in the winter of 1531–1532, and the wooden model probably was made late in 1532. Of course, Charles was still abroad, so the model awaited his return to Barcelona in April 1533. He must have approved it there because funds for the construction of the palace were allotted the following month (doc. 5).

The foregoing account of the design phase of the palace lacks a beginning because we do not have the project chosen by the emperor from among the several sent him early in 1527 and then emended

to provide services he considered necessary. But the reconstruction of the 1527 plan is made difficult by the fact that the first extant plan, the one in the Archivo Histórico, was drawn by someone other than Pedro Machuca, probably the Castilian intruder, Luis de Vega, in February 1528. In that plan (pl. 19), Vega seems to have introduced the emendation required by the emperor: sturdier supports for the courtyard's portico, distinctive main, secondary, and tertiary entries, the enlarged chapel in the northwest corner, and the newel staircase in the southeast. Before these changes were introduced, the residence would seem to have been a free-standing block with four axial vestibules of equal size and a courtyard with a circular portico attached to the enclosing wings only at the cardinal points (fig. 4) This odd disposition of the courtyard has no typological precedent and the isolated portico and open corners make no sense from a structural or functional point of view. Figure 4 would certainly be quickly dismissed as an unlikely state

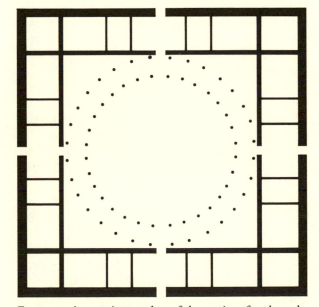

FIGURE 4. Approximate plan of the project for the palace of Charles V previous to February 1528

[170] The wooden model of the Strozzi palace is preserved in the museum in the basement of the palace; see Alessandro Parronchi, "Il modello del palazzo Strozzi," *Rinascimento*, ser. 2, IX (1969), pp. 95-116.

[171] In 1488, Giuliano da Sangallo made a wooden model of the huge palace he designed for the King of Naples, but it

disappeared without a trace, as did the one Giulio Romano made in 1523 for an addition to the Gonzaga villa at Marmirolo near Mantua. For the Italian use of models, see James S. Ackerman, "Architectural practice in the Italian Renaissance," *Journal of the Society of Architectural Historians*, XIII (1954), p. 8.

of the design if it were not for a similar disposition of the courtyard in the bird's-eye view of the palace depicted by Ambrosio de Vico in 1596 (pl. 22). Even though, by that time, the two-story palace was nearly completed, Vico depicted an isolated one-story residence with a single circular portico. Because these changes go beyond Vico's customary simplification of the forms of monuments in his perspective plan, the coincidence of his image of the palace and our figure 4 invites speculation that he depicted an early state of the design previous to the emendations of February 1528. Of course, the awkwardness of Vico's one-story portico would have been increased by raising it to two stories—an elevation indicated by the staircase in the Archive plan. The isolated gallery and the open corners have no evident use. The corners might have been filled with tall cypresses or other trees and plants, but Pedro Machuca (as we shall come to know him) is not likely to have designed a courtyard that required cosmetic treatment to that sort. While the Vico image and figure 4 may represent a Castilian modification, or mutilation, of Machuca's original project, the disposition of the courtyard portico is implausible from a structural and functional as well as typological point of view and hence it can not be accepted as the project Charles V chose in 1527.

Because we can not reconstitute the original project of 1527, we should consider a mysterious villa-like plan identified in several Italian sketchbooks as a residence in Spain (*questo in Spagnia*). It is found in a collection of sketches attributed to Aristotile and Giovanni Battista da Sangallo and dated to the 1530s or possibly 1540s (pl. 20).[172] It was copied around 1582 by Oreste Vannocci Birringucci in another sketchbook that was described as a collection of the most noble modern and an-

cient buildings.[173] The "villa in Spain" is a square plan with four axial vestibules and symmetrically disposed rooms and it has a courtyard with a rectangular portico that encloses a circular colonnade. the latter borders an uncovered circular path, whose inner side is marked by a parapet and, at the cardinal points, by pairs of columns. These features identify it typologically with Francesco di Giorgio's speculative designs for princely villas with garden courtyards (cf. pls. 20 and 21).[174] Although we might speculate that a plan like this preceded the design represented by our figure 4 and Vico's depiction of the palace (pl. 22), we would have to assume that the rectangular portico had been removed and the colonnaded path transformed into a circular portico, but changes so drastic were not required by the emendations known to have been ordered by the emperor. If there is no place for the "villa in Spain" in the sequence of changes made in the design phase of the palace of Charles V, it may record one of the several projects first proposed by Machuca in 1527. To be sure, neither Aristotile da Sangallo nor Birringucci identified the plan as one for Emperor Charles V, and it must be admitted that the "villa in Spain" is about one third smaller than the palace of Charles V, which is 63 meters square. Even so, Machuca is the only architect likely to have known Francesco di Giorgio's model plans for centrally symmetrical villas previous to 1550 and I know of no patron other than Luis Hurtado de Mendoza (for Charles V) who would have proposed a princely villa of this sort. Perhaps the failure of the Italians to identify Charles as the patron of the "villa in Spain" and its apparent difference in size can be explained by this scenario. Charles, or one of his advisers, may have asked one of the Italian ambassadors for his opinion on the puzzling projects sent by Machuca

[172] Henry Pluchart, *Musée Wicar, Notice des dessins, cartons, pastels, miniatures et grisailles exposés*, Lille, 1889, no. 370. Heinrich von Geymüller ("Documents inédits sur les manuscrits et les oeuvres d'architecture de la famille des Sangallo, etc.," *Mémoires de la Société nationale des Antiquaires de France*, XLV [1885], pp. 222-231, 243-246) gives a general account of the sketchbook. It is now in the collection of Lille's Musée des Beaux-Arts, Fonds Wicar, and bears the number 730. That the writing on this plan is Aristotile's was confirmed by Professor Gianni Baldini of the University of Florence, who plans to write a monograph on that architect. I greatly benefited from my correspondence with Professor Baldini on this plan.

[173] The sketchbook, titled "Architettura, fortificazioni e macchine," is in the Biblioteca Comunale in Siena (Ms. S. IV. 1,

fol. 13v) and has been identified as that of Oreste Vannocci Biringucci on the basis of the handwriting. He probably undertook this collection of sketches of noble monuments shortly before he went to Mantua in 1583, but he died two years later at the age of 27. See Ludwig Heydenreich, "Über Oreste Vannocci Biringucci," *Mitteilungen des Kunsthistorischen Instituts in Florenz*, III (1929-1930), pp. 434-444, though he does not discuss the sketch for the palace "in Spain." In 1964, George Kubler sent me a photograph of the Biringucci sketch and asked if I had any idea of what it could have been, but at that time neither of us seriously considered the prospect that it might reflect the design phase of the palace of Charles V.

[174] Francesco di Giorgio, *Trattati*, II, pp. 352-353, pl. 208 (Magliabechiano, II, I, 141, fol. 24v).

in 1527.[175] That ambassador may have sent a description or a quick sketch (not a scale drawing) of one project to his sovereign and, in time, the plan may have lost its identification with the emperor and come to the attention of the Sangallo as a "building in Spain." At best, if assumptions of this sort are made, we can postulate that the mysterious villa in the Sangallo and Birringucci sketchbooks was one of the several projects first proposed for the palace of Charles V on the Alhambra.

Although we have not been able to reconstitute the project first chosen by Charles in 1527, it is safe to say that it was a centrally symmetrical, square plan having vestibules of equal size on the four sides and a symmetrical distribution of rooms between the vestibules and the square or octagonal halls at the corners. Since Charles decided to retain one of those villa projects as the residential core of the expanded official palace, the design was never wholly released from the villa tradition.

[175] Rulers all over Europe were interested in what their counterparts were building, renovating, or decorating, and so the letters of ambassadors occasionally include references to architectural projects or works under construction at the court to which they were assigned.

II

CONSTRUCTION UNDER PEDRO MACHUCA, 1528-1550

THE "NEW QUARTERS," 1528-1533

THE FIRST project approved for construction on the Alhambra was not the new palace itself, but the suite of six small rooms on the northern rim of the old palace, then referred to as the *quartos nuevos*. They are all labeled *nuebo* in the large Royal Palace plan (pl. 17-H). These rooms were built on the outer edge of the descending garden directly north of the Hall of the Two Sisters but still inside the outer walls of the Tower of Abul Hachach, later known as the Tocador de la Reina, or the Peinador. Charles, when he dined in the Hall of the Two Sisters, had enjoyed that terraced garden and, beyond it, the magnificent panorama of the Albaicín and the Sacramonte, with the Sierra Nevada in the distance. When enclosed on the northwest side by the new rooms and on the east (after 1539) by a corridor, the area became a courtyard, called in more recent times the Garden of Daraxa. Other than the marvelous view—now seen from the Tocador in the new quarters—nothing of any

value was lost as a result of the construction of these rooms. The sloping terrain required the building of a substructure to bring the floor level of the new rooms up to that of the Tower of Comares and the Court of Lions, of which Charles was so fond. The corridor connecting the new quarters and the Courtyard of the Myrtles (or of Comares) is identified as "the corridor ordered by His Majesty" (*corredor que mandó hazer su Magestat*). South of the room that probably was to have served as Charles' office were the palatine baths, which are identified as *los baños*. After October 1537, new doors were opened in the north wall of the baths to make them accessible from the new quarters,[1] and other changes were made in the interior that permitted bathing by immersion in the Burgundian (and Roman) fashion instead of the Moorish practice of pouring water over the standing bather.[2] Perhaps because the baths here became part of the royal suite, they were preserved, while those in the city of Granada were destroyed in 1566.[3] The disposition of the new quarters must have been

[1] For the destruction of the building described as the *quarto cabe de los baños*, see AA Leg. 2, 2a, Nóminas, payments of 17 to 27 October 1537. Since this building had to be on the north side of the baths (the only free side), its demolition made possible the opening of the two new doors on that wall. The Morisco tiles bearing the letters *P.V.* (for Charles' motto *Plus Ultra*) date from that renovation. Later, in 1584, Juan del Campo was paid for 110 pieces of colored glass to cover the openings in the vaults of the baths; other replacements date from 1612 and the 1930s, but the baths still retain the general disposition of the 1537 renovation. The Catholic Monarchs did not approve of public baths, but they preserved those in several Arabic palaces used as royal residences, notably at Tordesillas (where

Joanna of Castile retired), the *alcázar* at Seville, and the castle at Olite; see Lampérez, "Los palacios de los Reyes de España," p. 216.

[2] Emilio García Gómez and Jesús Bermúdez Pareja, *La Alhambra: la Casa Real* (Forma y Color 10), Granada, 1966, p. 4. Marble slabs were used to close a recess and, thus, to form a basin for bathing. The baths built for young Charles in the palace in Brussels in January 1517 had eighteen columns that framed a square basin into which one descended to bathe in Roman fashion; see Saintenoy, "Les arts . . . a la cour de Bruxelles," p. 83.

[3] Lafuente y Alcántara, *Historia de Granada*, p. 184.

one of the problems resolved by the governor and Luis de Vega during the latter's visit in February 1528 because by April 22 the emperor approved a five-year budget for the construction of the "six new rooms," and according to a report on that work, they were nearly completed by May 1533.[4] Though the period of work on these rooms is well documented, there is no reference to the designer (most assume it was Pedro Machuca), to the carpenter who did the handsome ceilings (Gómez-Moreno y González in 1892 suggested Juan de Plasencia), or to the carvers of the two fireplaces. Because it was the first work carried out during Machuca's tenure as chief architect and because, previous to his death, construction on the new palace was not sufficiently advanced to permit the design of its interiors, this suite is of special interest.

The four rooms that run along the north side of the Garden of Daraxa are entered by way of two larger rooms with coffered ceilings located between that garden and the small Courtyard of the Cypresses (pl. 17, left of the letter H). The one to the north was probably a guard room or an anteroom, since it served as the entry to the suite from the corridor that connected it to the Palacio del Comares, the old official palace. The larger room to the south of the anteroom has a stone fireplace and a coffered wooden ceiling with an inscription identifying Charles as king and emperor, and was probably Charles' office. It was connected with the first room of the east wing by way of an angled corner passage seen in the large Royal Palace plan and not removed until 1928.[5] Probably intended as Charles' bedchamber, that room has a handsome ceiling composed of octagonal coffers and also a fireplace with the personal devices of the emperor and empress (pl. 25). The next room in the east wing, which also has a coffered ceiling carved with the personal devices of the imperial couple, was probably planned as Isabel's bedchamber because it is connected by a bridge to the old tower that served as a *mirador* and came to be known as the *Tocador de la Reina*. The two small rooms to the east are called *de las frutas* because fruit predominates in the decoration of the painted wooden ceilings. Apparently, they were sitting rooms for Isabel and her ladies. Along the south side of these four rooms there was, until modern times, a glazed gallery that served as a connecting corridor and also as a place to enjoy the sun in the winter months. Not indicated in the large Royal Palace plan (here assigned to the spring or summer of 1528), it must have been added later. Charles probably remembered well the chill he experienced before leaving Granada in early December 1526 and, therefore, he wanted small rooms with a southern exposure.[6] By way of another gallery along the north that connected the *tocador* with the anteroom, Isabel had a second entrance to her bedchamber and sitting rooms. This improvised entry and the small rooms are not likely to have satisfied the fastidious empress. Her intended bedchamber and that of the emperor are no more than 5 by 5.50 meters and the two sitting rooms are only about half that size. The largest of the suite is the irregularly shaped "office," which is about 6 by 8.60 meters, while the anteroom is slightly smaller. Byne and Stapley assumed the walls of the main rooms had been covered with plaster decoration (*yeserías*),[7] but I know of no documentary basis for this assumption. Other scholars have suggested that all the rooms were painted in the Pompeian style, similar to those executed from 1537 to 1539 by Juilio de Aquila and Alejandro in the *tocador*.[8]

The new quarters have suffered a number of changes. In 1590 they must have been damaged by smoke from the fires started by the explosion of

[4] For the emperor's letter of 22 April 1528, see doc. 3. Francisco de Biedma, the paymaster from at least 1518 to about 1547, accounted for expenditures on the new quarters from April 1528 through 1532; see AGS, CM1, Leg. 1278. Previously, it was assumed the construction of the suite dated from 1527 to 1537; see Leopoldo Torres Balbás, "Paseos por la Alhambra: La Torre del Peinador o de la estufa," *Archivo español de arte y arqueología*, VII (1931), p. 200, n. 12.

[5] Torres Balbás, "Diario de obras en la Alhambra: 1927–1929," pp. 115-121.

[6] The rooms planned for Charles V at Brussels in 1553 were also small, the two largest being about 7.60 m. square; see Saintenoy, "Les arts . . . a la cour de Bruxelles," p. 115. The rooms in the house built in 1554 for his retirement at Yuste were no larger, probably so that they could be kept warm. We know that Charles required the installation of a fireplace in every room; see William Stirling-Maxwell, *The Cloister Life of Emperor Charles V*, 4th ed., London, 1891, p. 155.

[7] Arthur Byne and Mildred Stapley, *Spanish Architecture of the Sixteenth Century*, New York-London, 1917, p. 312.

[8] Gallego y Burín, *Granada*, p. 139. They were not paid for that work until March 1546 when Pedro Machuca recommended payment; see Gómez-Moreno y Martínez, *Las águilas*, p. 238, doc. XXXIV.

gunpowder stored on the north slope of the Al-
hambra,[9] and though the coffered ceilings sur-
vived, they probably lost the gilding and paint that
usually enriched Renaissance ceilings of this kind.
We know that the rooms were restored and a new
doorway from the anteroom to the bedchamber
provided for the visit in 1624 of Philip IV, the first
monarch to use this suite.[10] A century later, in
1729, the rooms were whitewashed for the short
stay of Philip V.[11] After that, they probably suf-
fered the same neglect as the rest of the old palace,
though the rooms were still sufficiently intact in
1829 to serve as the living quarters of Washington
Irving, the American writer whose *Tales of the
Alhambra* did so much to awaken concern for the
conservation of the Nazaride palaces. Still, carved
door panels from these rooms—known to us only
by way of poor plates published by Gómez-
Moreno[12]—are said to have been carried off to Italy
at the beginning of this century before restoration
of these rooms was undertaken by Leopoldo Torres
Balbás in November 1928. His brief notes reveal
that the foundations were reinforced, the roofs re-
paired, and the present floor of bricks and tiles
(*olambrillas*) laid at that time.[13] A few years later
he must have removed the glazed gallery along the
south side of the bedchambers and the sitting
rooms.[14] With the exception of these changes, this
modest suite of rooms still follows the original plan
of 1528.

That Pedro Machuca was the designer of these
rooms has generally been assumed, but there is
reason to doubt that he was responsible for their
disposition or even much of their decoration. As
we have noted, not only the site but also the gen-
eral layout of these rooms seems to have been de-
cided during the visit of Luis de Vega in February
1527 because the budget for their construction was
approved so shortly after. Vega may have deliv-
ered specific instructions from Charles V as to the

kinds of rooms needed, together with his prefer-
ence for a location near the Court of Lions. Cer-
tainly the disposition of these rooms evinces prac-
tical rather than aesthetic concerns in that doors
and windows are placed in accord with conven-
ience and the alignments of the walls are sometimes
skewed. The shapes and proportions of the rooms
fill the space available rather than conform to ideal
ratios or proportions. Several of the rooms fall
short of a square plan, and as we shall see, this
presented problems for the designer of the coffered
ceilings. Granted that difficulties were posed by
the site, it was still possible to realize a regular and
geometrically coherent design, but the planner of
these rooms valued *utilitas* over *dispositio*. Because
this attitude is uncharacteristic of Pedro Machuca
and quite typical of Luis de Vega, it is probable
that the new quarters were planned by the Castilian
mason during his visit in February 1528.

The four ceilings of reddish pine wood and the
two stone fireplaces that have survived are too
different in style to be assigned to a single designer.
The Italianate character of the ceilings with square
coffers in the anteroom and the office has fre-
quently been noted (pls. 26 and 27), as well as the
typically Hispano-Moresque interlace pattern of
the ceiling over the room that was probably in-
tended as the bedchamber of the empress.[15] Be-
tween these two extremes is the oddly muddled
design of the ceiling with octagonal coffers in
Charles' bedchamber.

In the anteroom (pl. 27), a Doric entablature
supports a ceiling of deeply recessed, square coffers
that now lack the usual rosette ornament. Because
the room was just short of being square in plan (7
by 7.65 meters), the designer of the ceiling used
five square coffers in each direction and added a
strip ornamented with a running fret on both the
east and west sides to make up the difference. Even
with these adjustments, the frieze on the east side

[9] The estimate of damage from the explosion was made by
Juan de la Vega on 18 February 1590 (AA, Leg. 21, 4, 3).

[10] Gallego y Burín (*La Alhambra*, p. 108) cited Leg. 61 (the
1880s not the 1850s numeration) in the archive of the Alhambra.

[11] Torres Balbás, "La Torre del Peinador de la Reina o de la
estufa," p. 200.

[12] Gómez-Moreno y Martínez, *Las águilas*, p. 135, fig. 330.
These panels may have been carved by the Siloesque sculptor
Juan de Arteaga (who had worked with Siloe in the ornamen-
tation of the cathedral of Granada) because he was paid during
October and November 1537 for "the carving of the doors of

the rooms" (*la talla de las puertas de las cuadras*). Another carver,
Luys de Aguilar, was paid for similar work in March 1538. See
AA, Nóminas, Leg. 2, 2a for the months cited.

[13] Torres Balbás, "Diario de obras . . . 1927–1929," pp. 115–
116, 120.

[14] Ibid., p. 116, listed repairs on the roof of "la galería del
saliente del Patio de Daraja" in November 1928, but Jesús
Bermúdez Pareja informed me that the gallery was removed
by Torres Balbás. The outline of the door to the gallery can
still be seen on the exterior wall of the office.

[15] Gómez-Moreno y Martínez, *Las águilas*, fig. 323.

had to be made to lean forward part of the way to accommodate the rectangular frame of the ceiling to the slightly splayed alignment of the wall. The same person is not likely to have built so irregular a room and then attempted to accommodate it to the square format of a coffered ceiling. The Doric entablature, quite new to Spain in 1530, is "correct"; and the dentil and egg-and-dart courses and the guilloche decoration on the main beams are also found on the lower part of the west *portada* of the new palace, which was designed by Pedro Machuca, probably in 1549 (pl. 68). Though the coffers of the ceiling of the anteroom are more deeply recessed (pl. 27) and the whole is less ornamental than contemporary Italian examples, the general design pertains to that tradition. The moldings and decorative motives are particularly reminiscent of those used in the ceilings of the Sangallo and Baldassare Peruzzi.[16] Strikingly similar to the ceiling of the anteroom is one later included in Serlio's fourth book, published in 1537, as noted by Gómez-Moreno (pl. 29).[17] Of course, coffered ceilings were not new to Spain since the Islamic equivalent, the *artesonado*, had been continued by Mudéjar carpenters.[18] The analogy to Roman coffered ceilings described by Vitruvius was duly noted by Felipe Guevara about 1560 in his commentary on painting,[19] but no Mudéjar *artesonado* served as the model for the ceiling of the anteroom. Its decorative motives and bold scale reflect Italian Renaissance precedents.

The adjacent room, probably the emperor's office, is slightly larger and more oblong in shape. Its ceiling is characterized by deeply recessed coffers framed by coupled beams that intersect to form oblong and square recesses (pl. 26), a disposition later illustrated in Serlio's fourth book.[20] Charles' motto, in its French form *Plus Oultre*, is repeated

on the underside of the beams, while the initials of the imperial couple, *K* and *Y*, are used on either side of the oblong and square panels. Within the large coffers, three small brackets were placed on each side of the central panel, which is now devoid of decoration. On the frieze of the entablature that supports the ceiling is an inscription in leafy letters that reads grandly: IMPERATOR CAESAR KAROLUS V HISPANIARUM REX SEMPER AUGUSTUS PIUS FOELIX INVICTISSIMUS ("Emperor Caesar Charles V, King of Spain, ever august, pious, blessed, and most invincible"). The cornice includes decorative elements such as the dentil, egg-and-dart and bead-and-spindle courses, and also brackets of the kind later used by Machuca on the sandstone facade and the marble *portadas* of the new palace. Because the ceilings of the anteroom and the office follow types unprecedented in Spain but popular in Italy during the first third of the century and because many of the decorative motives are found in parts of the palace later designed by Pedro Machuca, it is reasonable to attribute the two ceilings to him.

The ceilings of the rooms in the east wing of the "new quarters" (the rooms later assigned to Washington Irving) are of different character. The first, the presumed bedchamber of the emperor,[21] has a ceiling with octagonal coffers, but it is less in accord with the Italian tradition. In an Italian ceiling, the beams that form the octagonal coffers and the intermediate diamond-shaped panels remain inviolate because the ornament is subordinated to the architectural elements, whereas in the ceiling of Charles' bedchamber, the diamond-shaped panels were expanded to form a decorative area carved with tendril motives that spread over the entire interval between the octagonal coffers, obscuring the outlines of the beams that frame them.[22]

[16] The closest analogy is provided by the somewhat richer ceiling designed by Antonio da Sangallo the Younger for Santa Maria della Quercia in Viterbo, which was contracted in 1518 and executed before 1525, with gilding and painting added in 1536; see H. van Dam van Isselt, "I soffitti della Sala del Consistoro e della Sala Regia in Vaticano," *Rendiconti. Atti della Pontificia Accademia Romana di Archeologia*, XXVII (1954–1955), pp. 101–102, fig. 1; also Giovannoni, *Antonio da Sangallo il Giovane*, fig. 32. The same type was used by Peruzzi for the ceiling of his famous Sala delle Prospettive in the Villa Farnesina in Rome, completed by 1519.

[17] Sebastiano Serlio, *Tutte l'opere d'architettura et prospectiva*, Venice, 1619, bk. IV, fol, 193v. A structural peculiarity in the joining of the beams of the anteroom is also found in Serlio's

bk. I, fol. 15v. Though the latter was published in 1545, the technique reflects earlier practice.

[18] Fifteenth- and early sixteenth-century examples of *artesonados* composed of square coffers are found in B. Martínez Caveró, "Carpintería Mudéjar toledana," *Cuadernos de la Alhambra*, XII (1965), p. 225, esp. pls. IVb (cloister Laureles, Toledo), XIb (Cárdenas Palace in Ocaña), and XLIII, a and b (the Sala Capitular, convent of Santo Domingo el Antiguo and the crossing of the Hospital de Santa Cruz, both in Toledo).

[19] Felipe de Guevara, *Comentarios de la pintura* (c. 1560), Madrid, 1788, p. 84.

[20] Serlio, *Tutte l'opere*, bk. IV, fol. 194.

[21] Gómez-Moreno y Martínez, *Las águilas*, fig. 324.

[22] The Italian type, from which this ceiling departs, is rep-

The interlace design on the ceiling of the fourth room, probably intended as Isabel's bedchamber, belongs to the Mudéjar, not the Renaissance, tradition, and the ceilings of the two lesser rooms to the east are not of architectural interest because they are composed of shallow coffers in which various forms of fruit were painted while the motto *Plus Oultre* was repeated on the wall frieze.

Of the six rooms, then, only two ceilings can reasonably be attributed to Machuca: those of the anteroom and the office (pls. 26 and 27). A third, that of Charles' bedchamber, may be based on his design, but if so, it was altered by both the carpenter and the carver of the ornament. After supervising the ceilings of the first two rooms, Machuca seems to have left the rest to others. Perhaps he became involved late in 1531 and 1532 with the final plan and model for the new palace and then with the preparation of its site.

The carpenters and carvers who made these ceilings are not known since few documents from this early period have been found. Most scholars have accepted Gómez-Moreno's 1892 attribution of all the ceilings to Juan de Plasencia on the basis of the similarity of his coffered ceiling over the southeast staircase of the Royal Hospital in Granada to that of the anteroom (cf. pls. 27 and 30).[23] Certainly these two ceilings have the same basic disposition and similar moldings and decorative courses, including the guilloche on the underside of the beams, though in the hospital ceiling rosettes rather than knobs were used at the crossing points. Perhaps large rosettes like those in the recessed coffers of the ceiling in the hospital were once found in the now barren panels of the ceiling on the Alhambra. Noteworthy are the traces of gilding still visible on the rosettes and the ornamental courses of the ceiling over the hospital staircase. Clearly, there is

a close affinity between the two ceilings, even though the ceiling in the hospital was not made until 1559—almost thirty years later.[24] More important than the time interval is the fact that Plasencia's ceilings prior to the one over the stairwell, such as those he made in the early 1550s for the crossing tower of the cruciform hospital and its Cuarto Real, were *artesonados* of the Mudéjar type.[25] One would have to postulate a thirty-year hiatus from the Renaissance style to attribute to Palencia both the 1530–1533 ceiling of the anteroom on the Alhambra and that of the stairwell of the hospital of 1559. Furthermore, his name appears only once in the pay ledgers of the Alhambra and that was in 1547 as a bondsman (*confiador*) of Baltasar Suárez, who was sued for his failure to provide the stone contracted for the palace.[26] So there is little basis for continuing the old attribution of the ceiling of the anteroom or any of the others in the new quarters to Juan de Plasencia. His design for the hospital ceiling of 1559 was probably based on Serlio's model, which was by then available in Villalpando's 1552 translation,[27] while Machuca's design of about 1530 was based on central Italian ceilings seen by him prior to 1520. With the exclusion of Plasencia as designer and carpenter, we must assume that the *obrero mayor*, Gonzalo de Lorca, executed Machuca's designs for the ceilings of the office and the anteroom.

Machuca's responsibility for the fireplaces must also be restricted. Neither fireplace can be dated, but they were probably made before 1533, the terminal date of the budget for the construction of the two rooms in which they appear. The fireplace of white sandstone in the emperor's bedchamber is the finer and the more interesting. Its mantelpiece is ornamented with courses of the dentil and egg-and-dart motives favored by Machuca (pl. 25).

resented by the ceiling designed by Antonio da Sangallo the Younger for the ducal palace in Castro; see Giovannoni, *Antonio da Sangallo*, figs. 33 (Uffizi A1623) and 101. But a comparable confusion of the type occurred around 1500 in a coffered ceiling in the Colegio de Santa Cruz in Valladolid; see Gómez-Moreno y Martínez, "Hacia Lorenzo Vázquez," fig. 11.

[23] Gómez-Moreno y González, *Guía de Granada*, p. 89; Byne and Stapley, *Spanish Architecture of the Sixteenth Century*; Gómez-Moreno y Martínez, *Las águilas*; and Gallego y Burín, *La Alhambra*.

[24] The ceiling was appraised by Diego Siloe in 1559, though payment was delayed until 24 September 1562; see Concepción Félez Lubelza, *El Hospital Real de Granada*, Granada, 1979, p.

130, nn. 27, and 28. Transcriptions of the documents (not included in the publication) are found in Félez's dissertation, University of Granada, 1973. Though Gómez-Moreno y Martínez stated that Juan de Plasencia was already involved in the works of the hospital in 1521, the first notice of his activity is 1544. Unfortunately documents were not included in the subsequent publication of the study in 1979.

[25] Ibid., pp. 130 and 175.

[26] AA, Leg. 188, 38, fol. 16.

[27] Sebastián Serlio, *Tercero y quatro libro de architectura*, trans. F. de Villalpando (facsimile edition, Toledo, 1552), Valencia, 1977, bk. IV, fol. lxiii verso.

Brackets faced with acanthus leaves support the mantel and raise it well above the opening of the fireplace, which is framed by three graduated fascias with no transitional moldings between them. This form appears in the frames of Machuca's doors and windows and the architraves of most of the entablatures in the new palace. In the center, above the mantel, a large double-headed imperial eagle holds a globe of the earth on which the continent of Africa occupies the lower center (pl. 24), with Europe indicated above it, India to its right, and Brazil to the far left. On either side of the imperial eagle holding the globe are the Columns of Hercules, the distinctive elements of the emperor's famous device. A huge swirling banderole (with its top loop unfortunately broken away) bears his motto *Plus Oultre*. It is disposed in perfectly symmetrical fashion to intertwine the columnar device in the center and the windlass on each side. The windlass was apparently Isabel's device at this time, though I can find no other instance of her use of the nautical motive. Odd though it may seem for a woman, it probably refers to the maritime achievements of her native Portugal. That assumption is strengthened by the central placement of Africa on the globe, as that disposition represents a peculiarly Portuguese vision of the world. It most effectively displays the two major Portuguese sea routes—the exclusive one granted by the pope around the tip of Africa to India and the other across the Atlantic to Brazil. Elsewhere I have interpreted the interlacing of these two devices to be a celebration of the unification of the two great empires of the time, with the inference that imperial power would expand still further beyond (*plus oultre*) the Columns of Hercules.[28] On the Alhambra, in the citadel of the *Capitán General* in charge of the defense of Andalusia against Turkish incursions, the continent of Africa represented Islam, and thus the imperial device would also have been read as a vow to carry the Christian banner south of the Columns of Hercules across the Straits of Gibraltar into Africa. While this is not the usual interpretation of Charles' device, at least since the mid-sixteenth century, it appears to be its earliest meaning.[29]

The other fireplace on the south wall of the office has decoration of no programmatic significance.[30] The winged head of a cherub is centered over the axis of two symmetrically placed cornucopia-like scrolls from which Siloesque monsters emerge. If carved in the early 1530s, this fireplace (together with the door panels that are said to have pertained to these rooms) offers evidence of the early entry of Siloesque sculptors into the works of the Alhambra. The warm-colored stone of this carving also differs from that of the fireplace in Charles' bedchamber, which was executed in the fine-textured, pure-white sandstone of Santa Pudia that Machuca later used for the exterior facing of the new palace. The moldings of the frame of the Siloesque fireplace in the office present no analogies to those later used by Machuca, while the architectural elements of the one in the bedchamber are characteristic of his repertory and were executed with the care on which he seems to have insisted. Thus, we can claim for Machuca the fireplace in Charles' bedchamber and reject the one in his office, just as we accepted the ceilings of the office and the anteroom and not those of the other rooms in the suite. That seems to be all that clearly reflects Machuca's artistry in the *quartos nuevos*.

THE NEW PALACE: BUDGET AND WORK FORCE

Fate has been kind in its choice of the one surviving document relative to the palace between the last of the three letters, written in November 1529, and the first of the pay ledgers, dated March 1537. It is a royal *çédula* of 23 May 1534 in which Charles refers to his having granted, the previous spring, a six-year budget for the construction of the new palace (doc. 5). From the 80,000 ducats paid yearly by the Moriscoes of Granada for the right to continue certain of their customs, the emperor assigned 8,333⅓ ducats to the construction of the new palace. This annual sum was independent of the regular income allotted for the repair of the

[28] Earl E. Rosenthal, "*Plus Oultre*: the *idea imperial* of Charles V on the Alhambra," *Hortum Imaginum. Essays in Western Art*, ed. R. Enggass and M. Stokstad, Lawrence, Kansas, 1974, pp. 85-94.

[29] Earl E. Rosenthal, "The Invention of the Columnar Device

of Emperor Charles V at the Court of Burgundy in Flanders in 1516," *Journal of the Warburg and Courtauld Institutes*, XXXI (1973), pp. 198-230.

[30] Gómez-Moreno y Martínez, *Las águilas*, fig. 329.

old palace and its fortifications that had been pro-
vided in 1515 by Queen Joanna of Castile from the
fines of the Appellate Court of Corrections (*los
correjimientos penas de cámara*) in Granada, Loja, and
Alhambra. That income was received regularly until
1571, when one of the officials of the Chancillería
of Granada began to usurp the funds.[31] Some writ-
ers have confused this income with that for the
new palace, and Prudencio de Sandoval in 1618
misled others by his claim that before leaving the
Alhambra in December 1526, the emperor as-
signed 18,000 ducats a year for its construction.[32]
He must have been referring to the sum mentioned
in the letter of 30 November 1527 (doc. 1) in which
the emperor indicated that a satisfactory plan would
be funded immediately with an initial assignment
of 18,000 ducats and whatever was needed after
that to keep the work going at a fast pace. While
the *cedula* of 1534 indicates an income during the
first six years of 8,333⅓ ducats,[33] it must have been
raised to 10,000 in 1538 or shortly thereafter, since
documents of the 1570s refer to that income from
the farda paid by the Moriscoes from the beginning
of the work. And Manuel Gómez-Moreno y Gon-
zález in 1885 claimed an initial income of 10,000
ducats on the basis of documents once in the ar-
chives of the cathedral of Granada, but not found
during my research in 1948 to 1953 or by Padre
Manuel Casares in his cataloguing of the archives
in the early 1960s.[34] Fortunately, the Moriscoes

paid the annual tribute for the next thirty-five years,
until the Rebellion of 1568; and so work on the
Alhambra continued undisturbed by the financial
difficulties that plagued Charles V and his son Philip
II.[35] While the income remained constant, its pur-
chasing power was diminished by the inflationary
tendencies of the Spanish economy in the sixteenth
century. Prices rose steadily during the second
quarter of the century, but the increases were rel-
atively moderate. After 1550, however, the infla-
tionary pressures intensified at an ever-quickening
pace, with the result that by 1600 prices had quad-
rupled over those of 1500.[36] Thus, during Pedro
Machuca's supervision of the works from 1533 to
1550, the purchasing power of his ample annual
budget for the new palace declined only slightly,
and no funds had to be diverted to the old palace
because its income continued uninterrupted.

In this context, we should recall Gómez-Mo-
reno's concern for the meager salary of 100 ducats
paid to Machuca and his suspicion that it indicated
a limited role in the supervision of the construc-
tion.[37] It is true that Machuca received only half
Diego Siloe's salary of 200 ducats as architect of
the cathedral in the same city, and a decade later
in 1537, Luis de Vega and Alonso de Covarrubias
each contracted for a half year's supervision of the
royal works in Castile for the sum of 67 ducats,
plus 4 reales a day.[38] Assuming 150 working days
in a half year, the supplement amounted to about

[31] See above, chap. 1, n. 7. The history of this income was
summarized on 30 October 1612 by Gaspar de León (then *veedor*
and *contador* of the works) in a report to Tomás de Angulo, the
secretary of the Junta de Obras y Bosques (AA, Leg. 47, 1),
and in a second account dated 21 November 1612 (Leg. 104,
5, 6) and a rough draft dated 22 April 1613 (Leg. 47, 2). Ap-
parently it was customary in the sixteenth century to assign
income from a specific source to a given architectural work;
see Peter Burke, *Tradition and Innovation in Renaissance Italy. A
Sociological Approach*, London, 1974, p. 101.

[32] Sandoval, "Historia," (bk. 14, chap. 18), p. 174: ". . . de
los ochenta mil ducados que los moriscos dieron, libró diez y
ocho mil para que le comenzasen a una casa en el Alhambra,
y así fue que se comenzó la obra costosamente."

[33] The annual income for the rebuilding of the *alcázar* in
Toledo was also 8,000 ducats in 1537; see Francisco Martín
Arrué and Eugenio de Olavarría, *Historia del alcázar de Toledo*,
Madrid, 1889, p. 84.

[34] Gómez-Moreno y González, "El palacio de Carlos V," pp.
9-10, n. 1; Manuel Casares Hervás, *Archivo Catedral, Inventario
General* (Publicaciones Archivo Diocesano II) Granada, 1965.
The two *Libros de cédulas reales* in the archive of the Curia in
Granada were also checked, but no documents relative to the

budget were found.

[35] José Cepeda Adán, "El palacio de Carlos V, símbolo de
una frustación," *Cuadernos de la Alhambra*, II (1966), pp. 53-58.
Richard Ford (*Granada*, Granada, 1955, p. 200), in the 1830s,
also characterized the palace as "great in conception and im-
potent in conclusion" and, thus, symbolic of both Charles V
and Spain.

[36] Jaime Vincenz-Vives, *Manual de historia económica de Es-
paña*, Barcelona, 1959, p. 346.

[37] Gómez-Moreno y González, "El palacio de Carlos V," pp.
196 and 197, n. 1.

[38] In addition to his cathedral salary and a house, Siloe got
300 ducats for supervising the construction of the church of
San Jerónimo in Granada, and he undertook independent sculp-
tural works for which he was well paid. For the salaries of
Vega and Covarrubias, see Llaguno, *Noticias*, II, p. 167. The
four reales a day were added "para ayuda de su mantenimento
durante dichos seis meses [when they were in residence in the
royal works]." For payment to Covarrubias in 1532 of 20,000
maravedís or 53 ducats as *maestro mayor* of the cathedral of
Toledo, see Verardo García Rey, "El famoso arquitecto Alonso
de Covarrubias," *Arquitectura*, IX, 1929, p. 172.

54 ducats and the total sum received was about 120 ducats for a half year. In addition, Covarrubias got 53 ducats as visiting architect of the cathedral of Toledo. Supplementary income of this sort from lesser works and occasional consultations make difficult a comparison of architects' incomes. There are no indications that Pedro Machuca supervised architectural projects beyond the confines of the Alhambra, but he executed paintings for retables all his life. Already in 1520, shortly after his return from Italy, he received 50 ducats for a painting of Nuestra Señora de la Consolación in the cathedral of Jaén,[39] and by the 1540s he was earning a good deal more. For the retables of the church at Viznar and that of San Nicolás in Granada, he received 200 and 280 ducats, respectively.[40] Occasionally, he was consulted on architectural projects elsewhere, but those instances tend to be late in his career.[41] As we noted, he also designed catafalques for Empress Isabel in 1539 and for Philip's first wife, Mary of Portugal, in 1549. Throughout his tenure on the Alhambra, Machuca and his family lived in the tower and adjacent rooms on the north side of the area known as the *Patio del Mexuar* or *de Machuca* (pl. 17-D).[42] With his residence provided and a salary of 100 ducats as chief architect together with what he received for his paintings, Pedro Machuca was probably satisfied with the post of *maestro mayor* on the Alhambra.

The administrative organization of the architectural works on the Alhambra was composed of five major officials: the paymaster (*pagador*), overseer of accounts (*veedor*), chief architect (*maestro mayor*), superintendent (*obrero mayor*), and assistant (*aparejador*). The paymaster, Francisco de Biedma, served from at least 1518 to 1547, while Baltasar de León y Biedma was replaced by Juan de Me-

drano as overseer in 1528.[43] Occasionally the paymaster signed payments for the overseer, and this casual attitude towards administrative responsibility often makes it difficult to determine who held a particular post at a given time. Juan de la Vega, who was still *maestro mayor* in 1524, must have been considered incapable of presenting suitable projects for the emperor's new residence because he was replaced by Pedro Machuca, probably in December 1526.[44] There is no record of the appointment of Gonzalo de Lorca as *obrero mayor* or Juan de Marquina as *aparejador*. The first was evidently the more important official because he was always listed immediately after the *maestro mayor*, he received eight ducats a year more than the *aparejador*, and, when work rules were written in 1546 (doc. 41), he had the longest list of duties. Unfortunately, we know nothing about Gonzalo de Lorca's training or his earlier activities. He must have been considered more capable and experienced than the third official, Juan de Marquina, who had worked with leading architects on royal commissions and, by the late 1520s, had received independent commissions in Granada.

Marquina's surname suggests that he was of Basque origin and acquired an early training as a stonecutter in his mountainous homeland, but the first record of his activity was as stoneworker (*pedrero*) in the works of the Royal Hospital in Santiago de Compostela directed by Enrique de Egas. He carved keystones (*claraboyas*) designed by Egas for the vaults of the hospital chapel and, shortly after, he began to execute the portal of its refectory, but that work had to be given to another in August of 1510 when Marquina accompanied Egas to Granada.[45] There he probably worked with Egas in the Royal Chapel and the Royal Hospital, though

[39] Gómez-Moreno y Martínez, *Las águilas*, p. 114.

[40] Ibid., docs. XXIII, pp. 224-225, and XXXIII, p. 237.

[41] Llaguno (*Noticias*, I, p. 222, n. 1) quoted a payment to Pedro in 1545 for the ten days he spent in coming from Granada to give his opinion on the plans for the Hospital de la Sangre in Seville (for which Luis de Vega and others had submitted plans), and he referred to another payment in 1548 in the archives of the cathedral of Toledo for Machuca's appraisal of Alonso Berruguete's sculpture of the *Transfiguration* mounted above the foot of the choir. For his appraisal of the choir stalls on 27 September 1548, see José Martí y Monsó, *Estudios histórico-artísticos relativos principalmente a Valladolid*, Madrid, 1898-1901, p. 460.

[42] I know of no references to the location of his residence during his lifetime, but documents from the 1580s (8 April and

15 July 1589, AA, Leg. 21, 4, 2) through the mid-seventeenth century associate the Mexuar with Pedro Machuca.

[43] Francisco de Biedma signed as *pagador* in a document of 11 August 1518 (AGA, CR, Leg. 25, fols. 33-34) and seems to have given up the post between 1547 and his death in 1551 (AA [old], Leg. 119, 49). His salary was 25,000 maravedís (almost 67 ducats). For Medrano's succession as overseer, see AGS, CMI, Leg. 1278, account of January 1530.

[44] There is a record of a payment to Juan de la Vega in 1524 (AGS, CMI, Leg. 1278).

[45] Gómez-Moreno y Martínez, "En la Capilla Real," pp. 79-80. Pablo Pérez Costanti, *Diccionario de artistas que florecieron en Galicia durante los siglos XVI y XVII*, Santiago de Compostela, 1930, pp. 357-358, for pertinent early documents.

no reference to him has been found in the records of either building until 1530. Then, he was identified as a master mason (*maestro de cantería*) in the Royal Hospital, with a house near its main entry.[46] This information suggests that Marquina, after working in the hospital with Egas until 1516, continued as assistant to Juan García de Prades (or Praves) until 1524, and then was given charge of the work. In 1521, however, he signed a contract to construct within one year the columnar church of Moratalla in the northwest corner of the province of Murcia, following the designs of Francisco Florentín (Francesco Torni, L'Indaco); but the distinctly local character of the structural techniques employed would lead one to believe that his role was limited to a few brief visits to the site.[47] The attribution of the design of this church to Francisco Florentín led Gómez-Moreno to suggest that Marquina may have worked with the Italian earlier on the foundations for the tower of the cathedral of Murcia (pl. 8), even though there are no reminiscences of the Florentine's architectural or decorative repertory in Marquina's later works. His most independent and securely documented works in Granada, the 1530 portals of the new university (now the Curia) and the church of San Andrés, reveal a greater dependence on the idiom of Juan García de Prades. His personal variation of that architect's repertory is also found, I believe, in several portals in the Royal Hospital's unfinished front right courtyard and also the rear one on the left. Common to these portals are stocky proportions, decorative motives that are bold in scale, and the use of stop-fluting, egg-and-dart, and dentil courses. On the basis of these observations, it would seem that Juan de Marquina spent most of the period from 1510 to 1534 in Granada working

on royal projects, and that his experience in stone-masonry construction led to his appointment as assistant to Pedro Machuca and Gonzalo de Lorca on the Alhambra.

Marquina probably joined the work force on the Alhambra in 1533 or 1534, when his portals for San Matías and San Cecilio were nearing completion, as Gómez-Moreno y Martínez assumed;[48] but the first evidence of his presence on the Alhambra is the payment of his salary for the first third of 1538 (doc. 18). Machuca was, indeed, fortunate to have a second assistant who had twenty-five years experience in brick and stone-masonry construction and yet no strong artistic ideology of his own to interfere with the execution of another's designs. That he was able to execute the projects of architects as varied in style as Enrique de Egas, Francisco Florentín, Juan García de Prades and, finally, Pedro Machuca testifies to his flexibility.[49] Perhaps Machuca was favorably inclined to Marquina because he had executed a work designed by Francisco Florentín, and Machuca may also have liked the bold sense of scale of Marquina's portals of 1530–1534. Marquina continued in the works of the palace after the death of Gonzalo de Lorca in 1546, and he even survived Pedro Machuca by three years.[50] One can only assume that Gonzalo de Lorca, as the second man in the works on the Alhambra, had qualifications at least equal to those of Marquina and that Pedro Machuca had two experienced and skilled craftsmen to aid him in the construction of the new palace.

The stability of the administrative staff and the work force on the Alhambra, from the officials to the stonemasons and carvers, is matched by the continuity of the Mendozas as governors of the Alhambra. Luis Hurtado in 1543 passed on the post

[46] Gómez-Moreno y Martínez ("En La Capilla Real," p. 80, n. 1) cited the document in the file of notary Francisco Muñoz (fol. 844) in the Archivo de Protocolos in Granada; see Félez Lubelza, *El Hospital Real en Granada*, p. 139.

[47] Concepción Félez Lubelza, "Francesco Florentino: nuevas observaciones sobre la presencia italiana en Granada," *Actas del XXIII Congreso Internacional de Historia del Arte: España entre el Mediterráneo y el Atlántico, Granada, 1973*, Granada, 1977, II, p. 278.

[48] Gómez-Moreno y Martínez, "En La Capilla Real," pp. 78-80; José Camón Aznar, *La arquitectura plateresca*, Madrid, 1945, figs. 108, and 111, for the portals of San Matías and San Cecilio in Granada.

[49] Félez Lubelza (*El Hospital Real de Granada*, p. 140) de-

scribed Marquina as "yielding" (*ductil*). His 1539 design for the church of Montejícar indicates that he responded to Machuca's severe architectural style. Gómez-Moreno y Martínez ("En La Capilla Real," p. 80, n. 3) cited specifications for the church in the "Archivo de Diezmos," but that designation seems to mean nothing to present-day Granadine archivists.

[50] Gonzalo de Lorca apparently died in the summer of 1546, because he was paid for only the first third of that year (AA, Leg. 3, 5, Nóminas, 30 April 1546). Though documents for 1552–1553 are missing on the Alhambra, reports for these years are preserved at Simancas. Among them is a document signed by Marquina on 8 September 1552 to confirm the delivery of stone and a payment for limestone, which he witnessed on 4 February 1553 (AGS, CMI, Leg. 1278).

to his son, Iñigo López, and this continued (with one break in the descent) until 1734, when the Mendozas lost the governorship by order of the Bourbon king because they had supported the rival Austrian succession.[51] Family continuity was even characteristic of the notaries of the Alhambra. Francisco de Ribera held the post of *escribano* from at least 1537, the year of the first extant documents, until he was succeeded in 1546 by his son, Luis, and then by his grandson. The functions of the paymaster and the overseer remained in the hands of the De León and Biedma families well into the seventeenth century. To these dynasties, we can add that of the Machucas, in that Pedro was succeeded in 1550 by his son, Luis, and in 1572 by his son-in-law, Juan de Orea. The constancy of the staff and work force, together with the secure funding of the palace, provided the Machucas with circumstances that favored the rapid completion of the new residence on the Alhambra.

An unusual degree of informality characterized the administration of the Alhambra, particularly in respect to hiring and working procedures. Officials seem to have signed reports for one another from time to time, most notably in the cases of the paymaster and the overseer. Of course, they worked on the Alhambra in the service of the governor, where the governor's authority was absolute; therefore, the usual legal formalities and precautions were not considered necessary, and even normal building trade rules may have been ignored. Apparently, the governor had not bothered to write Work Rules, or *ordenanzas*, that list the privileges and responsibilities of each official, though that was usually done for architectural works of this magnitude and importance. In any case, no rules previous to those of 1546 are mentioned in the inventories of 1567 and 1580. Some general directives had probably been given in 1492 when the first governor, Iñigo López de Mendoza, assumed command of the Alhambra, and as a result of daily experience, the relative responsibilities of the several officials were gradually determined by

practice. When the new palace was begun in 1533, a new *maestro mayor* was appointed and the work force was enlarged, but it seems that no major changes were made in the rules or in the records of the works. Under these easy-going circumstances, it is not surprising that irregularities occurred. Some were discussed in May 1545 at the first meeting of a new royal commission, the Junta de Obras y Bosques, which was established to watch over all royal works and properties.[52] At that meeting, the members expressed concern about irregularities in the hiring and firing of craftsmen in the work force of the Alhambra and also about the failure to determine their qualifications for the work assigned to them. Because the very personal rule of Luis Hurtado de Mendoza on the Alhambra ended in 1543,[53] Prince Philip (who was regent in 1545) probably thought it was a good time to bring the lax practices of that citadel into accord with the rest of the royal works.

The new royal commission requested a copy of the written Work Rules that governed the construction of the new palace, but apparently none was found, because the rules finally sent on 31 July 1546 by the new governor, Iñigo López, were drawn up by him at that time.[54] The new rules were not approved by the Junta de Obras y Bosques until 1549, but the delay should not be taken as an indication of reluctance on their part because dilatoriness of this sort became the hallmark of the increasingly powerful commission. It is likely that practices outlined in the Work Rules of 1546 were similar to those that had governed the work on the palace from 1533, though a few sections are clearly aimed at avoiding the irregularities discussed at the meeting in May 1545. In addition to the stern admonition that no changes in the plans shall be made by the architect without the consent of the governor, it is stated that no work for the palace shall be contracted independently (*a destajo*) without his approval. Also, there is a stipulation that no mason or craftsman is to be accepted for work until the *maestro mayor* is satisfied that he has

[51] Moreno Olmedo, "Un documento . . . sobre los Mendozas," pp. 89-98.

[52] Martín Arrué, *Historia del alcázar de Toledo*, p. 78. Although the Junta de Obras y Bosques continued to function until the mid-nineteenth century, when it was abolished by Charles III, it has received little scholarly attention.

[53] Moreno Olmedo, "Un documento . . . sobre los Mendozas," p. 94; Ibáñez de Segovia, *Historia*, fols. 308-309. When

Luis Hurtado was sent to Navarre in 1543 to take charge of the armed forces deployed against France, he resigned the governorship of the Alhambra in favor of his son, Iñigo López.

[54] Doc. 41, AGS, CSR, Leg. 265, fol. 13 (a second copy in CM1, Leg. 1120). The Work Rules of 1546 were published by the duke of San Pedro de Galatino; see "Instrucciones para las obras en la Alhambra (1546–1549)," *Archivo español de arte y arqueología*, XI (1935), pp. 209-216.

"the ability needed and the sufficiency required" for the work to which he will be assigned, and that the *obrero mayor* is to be responsible for avoiding the irregularities of the past. Further indication of those indiscretions is provided by insistence on the good character of all members of the work force and the stipulation that they work full time, that is, sunup to sundown.

Of special interest in the Work Rules of 1546 is the definition of the duties and responsibilities of the *maestro mayor*. He was "to design and order (*traçar y hordenar*) all that was constructed on the Alhambra in conformance with the project (*traça*) that the count of Tendilla . . . had approved," and he was also to give the carvers of architectural ornament (*intalladores*) and the stonecutters "the drawings and designs (*dibuxos y deseños*) . . . with their precise proportions and sizes in conformance with the art of architecture" (doc. 41). In view of the vocabulary employed, notably the reference to the *arte del arquitectura*, the Italianate word *deseños*, and the Vitruvian *hordenar*,[55] it is surprising that Machuca was not given the title *arquitecto* in place of *maestro mayor*. The latter was the title of the post established in 1492 and, presumably, it was simply continued. The title *arquitecto*, while not unknown in Spain, was not often used until the second half

of the sixteenth century.[56] Pedro Machuca from the beginning had displayed the independence and willfulness of an Italian Renaissance "architect" rather than the more deferential attitude characteristic of master masons in Spain. Because of this, it was necessary to insist that final designs for specific parts of the palace be given to the governor so that he could "add and eliminate or amend" what he thought necessary before they were given to the stonemasons and carvers. While defining Machuca's role as that of designer, the Work Rules state that he had to make out the specifications for the works and that he was to visit the site every day and point out faulty work to the *obrero mayor*. Incidentally, "perfection" in the cutting of the stone was required and the exceptionally fine workmanship under Pedro and his son, Luis, testify to their fulfillment of that requirement. He also had to be present, together with the *obrero*, whenever contracts were made with stonecutters or those who delivered stone or made iron tools. He was by no means detached from the execution of the work. While Machuca's lack of training in structural and technical matters probably led to the appointment of two assistants with broad practical experience, the Work Rules of 1546 gave full responsibility for proper construction to the *maestro mayor*.[57] He was

[55] Diego de Sagredo (*Medidas del Romano necessarias a los oficiales que quieren seguir las formaciones de las basas, colunas, capiteles y otras pieças de los edifiçios antiguos*, Cali, 1967, p. 17, facsimile edition of Toledo 1526, fol. Aviiᵛ) also described architects as *ordenadores de edificios* and used the verb *ordenar* throughout his little book, probably following Vitruvius (I, 2, 10, and III, 1, 9). Iñigo López de Mendoza, the second count of Tendilla, in a letter of 14 May 1515 (quoted above, chap. I, n. 38) stated that Lorenzo Vázquez "ordered" (*hordenaba*) the work on the convent at Mondéjar. In 1577 Lázaro de Velasco said the function of the architect "es ordenar principales edifiçios por arte labrados"; see Rosenthal, *The Cathedral of Granada*, p. 192, doc. 145. Quite different terms were used in describing the duties of the "maestro mayor" of the royal works in Castile in 1537. He was required "mirar . . . , trazar y hacer las obras que conviniesen en los dichos alcázares, redactaban las condiciones a que habían de ajustarse las obras, daban los dibujos, trazas y a veces modelos de las mismas, y señalaban el precio a que habían de salir a concurso"; see Chueca, *Arquitectura del siglo XVI*, p. 165.

[56] The Spanish seem to have been slow to adopt the title "architect," which had been revived in Italy during the fourteenth century and was commonly used there in the latter half of the fifteenth century. Originally a Greek word, accepted by the Romans during the second century B.C., it was occasionally used during the Middle Ages, notably by Isidore of Seville (*Etymologiarum*, bk. xx). For a general history of the term, see

Nicholas Pevsner, "The term 'architect' in the Middle Ages," *Speculum*, XVII (1942), pp. 549-562; Margherita Morreale, "Apuntes para la historia del término 'arquitecto'," *Hispanic Review*, XXVII (1959), pp. 123-136; and Marías, "El problema del arquitecto en la España del siglo XVI," pp. 175-216. Some scholars have cited Juan Bautista de Toledo in 1561 as the first to enjoy the title "architect" in Spain, but Francisco de Villalpando had already claimed that designation for himself on the title page of his Spanish translation of Serlio's third and fourth books on architecture in 1552. Even earlier, in 1541, Diego Siloe was called *arquitecto* in the records of the chapter of the cathedral of Segovia (Hoag, *Hontañon*, p. 105, n. 4). In 1526 Diego de Sagredo (*Medidas del Romano*, p. 17) used the term. Unnoticed by the scholars cited above is the sepulchral inscription in Roman letters in the chapel of the University of Alcalá de Henares that identified Pedro Gumiel as PETRUS GOMELIS COMPLUTENSIS ACADEMIAE ARCHITECTUS; see Vincente Lampérez y Romea, *Historia de la arquitectura cristiana española en la Edad Media*, 2d ed., Madrid and Barcelona, 1929-1930, I, p. 32. Though the date of that inscription is admittedly uncertain, I am inclined to think it was placed during the decade following Gumiel's death in 1516 because a later generation was not likely to have considered him worthy of the title "architect."

[57] The role of *aparajador* in Spain varied in accord with responsibilities that the *maestro mayor* chose to delegate to him. For example, Pedro de la Cotera, the *aparejador* of Rodrigo Gil

the one who had to draw up the specifications for cutting stone, let contracts, determine the qualifications and skill of craftsmen, and supervise masonry construction. It is not likely that these responsibilities would have been listed if Machuca were not capable of fulfilling them—at least by 1546.

A change in the administrative records of the Alhambra may have been introduced in 1537 to bring them into accord with the practices of other royal works because there are no pay ledgers previous to March 1537. We could assume, as some do, that the records of the early years were lost, destroyed, or sold for paper pulp; but we would have to account for their loss before 1775 when Lorenzo de Prado made his inventory of the documents in the archive of the Alhambra because he listed none previous to 1537.[58] A few brief reports of the salaries paid to major officials of the Alhambra from 1492 to 1500 and for January 1530 were found,[59] and I suspect they are all or most of the scant records of expenditures that were kept during the early years. The change on the Alhambra may have been brought about by the total reorganization of the administration of the royal works of Castile in 1535–1537.[60] In any case, the daily accounts of expenditures (nóminas) are preserved from March 1537, and though there are erratic losses in most years, we are able to follow in considerable detail the troubled history of the construction of Charles V's palace.

THE FOUNDATIONS, 1533–1540

The construction of the new palace must have started by May 1533, when funds from a new five-year budget became available.[61] Though the pay ledgers previous to 1537 are missing, the work accomplished during the first four years of construction can be deduced from the state of the building in the late 1530s. Unfortunately and inexplicably, the ledgers for about half the months in most years are lost, not only during Machuca's tenure but throughout the history of the palace. In 1537, for example, the pay ledgers for March and then June through November are preserved, while in 1538 those from February through September have survived. From the losses in these two years one might at first suspect that work was suspended during the winter months, but that is not the explanation because the pattern of loss varies from year to year.

In the ledgers the salaried officials (Machuca, Gonzalo de Lorca, and Marquina) were mentioned only three times a year, when each was paid a third of his salary. Most clues as to the work underway at any time are gained from payments to masons and other craftsmen, such as carpenters and tool makers, who received daily wages or piece-work prices for specific tasks. In the late 1530s the number of stonecutters or quarriers (canteros) varied from day to day, but twenty was about average, and most of them were at work in the limestone quarries at Alfacar, about five kilometers west of Granada, on the northern slope of the Sierra Nevada. Many were cutting the blocks needed for the foundations and bearing walls of the new palace, while on the Alhambra stonemasons (asentadores) worked with as many as fifteen to thirty laborers (peones) in the digging of trenches and the laying of foundations. Most of the references provide no clue as to the part of the palace on which work was underway, but there are two payments in the spring of 1538 that refer to the founding of the south side of the chamber under the octagonal chapel in the northeast corner of the palace. One cartload delivered by Domingo de Orende on 19 May 1538 was identified as "wedge-shaped stones for the spiral staircase of the chapel" (20½ varas de dobelas del caracol de la capilla).[62] This obviously refers to one of the spiral staircases on either side of the entry to the chapel from the round courtyard (pls. 17

de Hontañón at Alcalá de Henares in 1541, was required to keep the accounts and also to pay wages and bills for materials, because Hontañón visited the works only occasionally. Cotera also drew full-scale patterns on wooden tablets for moldings, cornices, and other architectural details. Similar tasks, as well as the inspection of the stone on delivery, were duties assigned to the aparejador of the cathedral of Segovia in 1576. As John Hoag observed (Hontañón, pp. 115-116), most aparejadores remained in that status all their lives, rarely rising to maestro mayor.

[58] José Vasco y Vasco, Memoria sobre la Alhambra [1875], Gra-

nada, 1890, p. 26.

[59] AGS, CMI, Leg. 140 (for salaries 1492-1500) and Leg. 1278 (for 1530).

[60] Chueca, Arquitectura del siglo XVI, p. 165.

[61] At the earlist, construction started in 1533, not in 1527, as most scholars have assumed. Gómez-Moreno y Martínez (Las águilas, p. 132) even claimed that "las obras de este palacio ya iban avanzadas en 1531," and that assumption explains many of his conclusions.

[62] AA, Leg. 2, 2a, Nóminas.

and 18), specifically the descent from the floor of the chapel to the chamber beneath. Payments to the laborers excavating the trenches for those foundations (*los moços que hecharon tierra . . . de las çanxas de la capilla*) are found on 9 March and again in June and early July 1538 (doc. 16).

By 1538 the elevation of the south facade was well advanced because payments were made for sculpture on the lower story of its marble frontispiece. The Lombard sculptor Niccolò da Corte was paid in November 1537 for the marble relief of a Victory over the pediment of that portal, and by the following February it was put in place (docs. 10 and 13). From this information we can assume that most of the south facade had been raised and at least the lower story faced with sandstone by 1538 since sculptural decoration of this sort would not be set in place until the construction, including the facing of adjacent walls, had been completed. Though the carving of the ornament on window frames and the cornice continued into the 1540s, the south facade was clearly the most advanced in 1537, and thus it is therefore reasonable to assume that its foundations had been laid first. There are no specific references to the foundations of the west wall, but most of the lower story of that facade was completed by December 1542, when work on the three doorways of a sandstone entry was halted by order of the emperor (doc. 37). The foundations of the west wall must have been laid about the same time or shortly after those of the east, which by 1537 had reached the chapel in the northeast corner, while the foundations of the north wall were probably completed by the end of December 1540, the last date on which references to work on the çanxas were found.[63]

Machuca seems to have been eager to found the entire block of the residence, including the chapel,[64] and to raise the south wing, with the apparent intent of restricting changes in plan and elevation by a successor. The intensity of his work schedule

is evident from the completion of three-fourths of the foundations for the exterior walls and most of the elevation of the south wing, with much of its sandstone facing, within the short period of four years, 1533 to 1537. In view of what was accomplished previous to 1537, one must assume that most of the area of the palace had already been cleared of the dilapidated Morisco houses before 1533 when Charles V, on his return from Italy, approved the project and provided the funds for construction. Perhaps preparation of the site began shortly after December 1531 when Isabel first ordered the demolition of the house of the three clerics of the church of Santa María located somewhat northwest of the converted mosque. At that time, the governor and his architect probably selected the quarries and prepared the roads that would be used for the delivery of stone. In spite of the informality that characterized administrative procedures and records on the Alhambra previous to 1537, the work force must have been very well organized and unusually efficient to have accomplished so much in the first four years.

Further information about the foundations is provided by the razing of a structure identified as the *Quarto de las Helias*. Raphael Contreras, the conservator of the Alhambra, reported in 1885 that he had seen a contract of 1524 with Juan de la Vega for the demolition of a part of the Nazaride palace adjacent to its entry (pl. 17-J) that had been damaged by fire;[65] but Gómez-Moreno y González in 1892 decided that Contreras was mistaken because Juan de la Vega was the name of the *aparejador* of Juan de Minjares during the last decade of the sixteenth century.[66] Fortunately, documents supporting Contreras were found in the pay ledgers of 1537–1538. During October and November 1537 (December and January are missing) and February 1538, over fifteen to thirty day-laborers were listed for the razing of the Quarto de las Helias.[67] The length of time and the number of workmen in-

[63] AA, Leg. 2, 2b, Nóminas, 13 to 31 December 1540, lists from seven to eleven "peones en una canxa."

[64] This may have been common practice when the entire site was clear. The 1506 contract for the Royal Chapel and the cathedral of Granada stipulated that Enrique de Egas was to lay the foundations for both immediately, though the chapel was to be realized first; see Rosenthal, "El Primer contrato de la Capilla Real," p. 24. This practice was also followed later in the much larger Escorial.

[65] Rafael Contreras y Muñoz, *La Alhambra, el Alcázar y la*

gran Mezquita de Occidente, 3d ed., Madrid, 1885, p. 222: "Por otro lado sabemos que un tal Juan de la Vega, el año 1524, contrató el derribo de la parte quemada del palacio, junto a la entrada, encendio atribuído a los soldados"; he added that this information was found in "una escritura que firma un tal Rojas y por consiguiente antes de la fecha que se principió el palacio del emperador."

[66] Gómez-Moreno y González, *Guía de Granada*, pp. 58–59.

[67] AA, Leg. 2, 2a, Nóminas, 9 to 27 November 1537 and 2 to 16 February 1538.

volved suggest that the structure was of considerable size. A clue to the form of the hall is provided by a payment on 27 October for seven pine logs to shore its corridor (*De VII pinos apuntalar el corredor de las helias, a 1500 cada uno, monta 10,550 maravedís*) and another on 16 November for pavement stones for that corridor (*losas para el corredor de las helias*).[68] Clearly, the lost hall had an adjacent corridor that had to be stabilized by shoring while the hall itself was being demolished. Precautions of this type would certainly have been necessary in the case of the two-story portico on the south end of the Court of Myrtles because it was dependent on the inner wall of the narrow hall behind it (pl. 17-G). Most scholars have assumed that this hall was similar in design to the *Sala de la Barca* on the opposite end of that courtyard, though somewhat narrower. In the 1950s, fragments of architectural and decorative elements similar to those of the north hall were uncovered west of the large *aljibe* in an area known to have been used in the sixteenth century for the disposal of debris, and at the time they were found it was assumed that they came from the lost south hall of the Court of Myrtles.[69] In addition to the correspondence of the "corridor" alongside this hall and that of the *Quarto de las Helias*, there is a temporal relation in that the latter was razed when work on the foundations had reached the octagonal chapel in the northwest corner of the palace, and there is a physical relation in that the chapel occupies part of the area of the lost hall at the south end of the Court of Myrtles. Furthermore, we now know that in the 1520s, previous to the appointment of Pedro Machuca, the *maestro mayor* of the Alhambra was a man named Juan de la Vega.[70] Thus, there is no reason to doubt that Contreras found a contract of 1524 for the demolition of the lower end of the Court of Myrtles or that its south hall had been damaged by a fire caused by careless soldiers. Presumably, that contract was not fulfilled and the hall remained standing until the area was needed and a work crew of sufficient size was available in 1537. Though the meaning of *las helias* remains uncertain,[71] it would

seem that the hall razed in 1537 was the one on the south end of the Court of Myrtles.

Returning to the foundations of the new palace, our attention naturally centers on the extraordinary vaulted chamber beneath the octagonal chapel. The stone delivered for it is readily distinguished from the simple blocks used for the rest of the foundations. As we noted, payments for the digging of the "trenches of the chapel" in March 1538 (doc. 37) were accompanied by the delivery of wedge-shaped stones (*dobelas*) for the small spiral staircases that connect the lower chamber with the chapel above (pl. 18). Although *la capilla* was used in the documents for both the lower and upper level, the term *chapel* will be reserved here for the latter. During the summer of 1538, references to payments for cartloads of limestone from Alfacar "for the foundations" are occasionally interspersed with payments for stones identified as "outer corners" (*esquinas*), "inner corners" (*rincones*), "wedge-shaped pieces" (*dobelas*), "square pieces" (*quadradas*), and in one case, on 15 July 1538, pieces of this sort are specifically identified as for "the vault of the chapel," meaning the lower chamber (doc. 19). This lowered vault, which required an unusual number of distinctively shaped stones, is one of the most magnificent examples of stone cutting in Spain. Only 4.75 meters high, the octagonal chamber has a span of 13.50 meters (fig. 5), and on each of the eight sides (coinciding with the niches of the octagonal chapel above) there is a triangular severy that frames a rectangular doorway. Behind each door there is a wider, barrel-vaulted recess that is about 2.50 meters deep, and the recess directly under the chapel entry in the southwest corner is four times as deep. By late summer 1538, the massive walls (approximately 3.50 meters thick) must have been completed because several carpenters were occupied in the construction of centering (*çimbras*) for this complex vault (doc. 20) and references to this work continue into the following spring. By the summer of 1542 the vault must have been completed because during the autumn and winter of that year its surface was smoothed by

[68] AA, Leg. 2, 2a, Nóminas.

[69] Bermúdez Pareja, "Excavaciones en la Plaza de los Aljibes de la Alhambra," pp. 450-451.

[70] See this chap., n. 44.

[71] Earl E. Rosenthal, "The Lost Quarto de las Helias in the Arabic Palace on the Alhambra," *Homenaje a Antonio Marín*

Ocete, Barcelona, 1974, II, pp. 941-943. "Las helias" may refer to Moorish princesses or to two women (sisters, or a mother and daughter) or to a dangerous dance (a sword dance?) known to have been performed on the Alhambra for the imperial court in 1526.

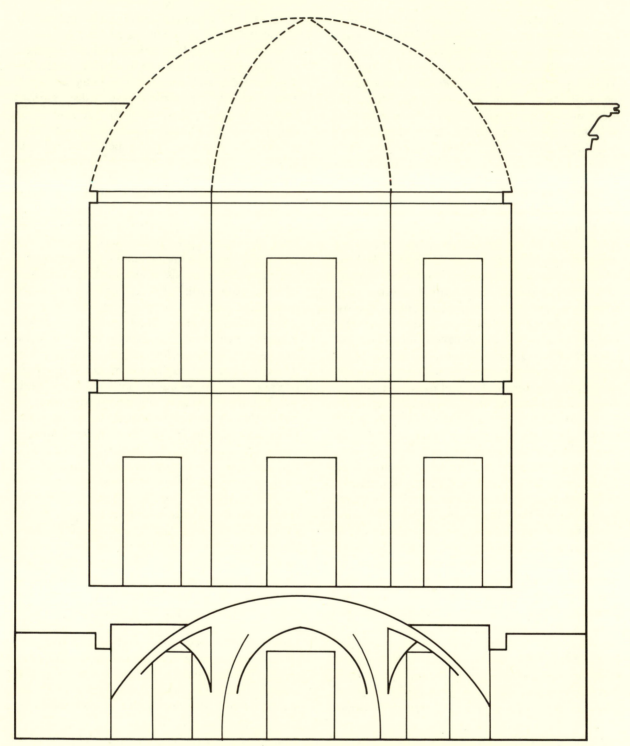

FIGURE 5. Section of the octagonal chapel and its lower chamber as planned by the Machucas

chipping (*picando*).[72] The complex plan and lowered curve of the vault required an unusual variety in the shapes of component stones and, thus, great skill in stereotomy. We have no evidence that Pedro Machuca in the mid-1530s was capable of so complex a design in stone masonry, and no comparable construction is found in any of the works with which Juan de Marquina was associated, so we can only assume that the mysterious *obrero mayor*, Gonzalo de Lorca, was the experienced mason who drew up the specifications.[73]

The function of this lower chamber remains a mystery. Although it was referred to in the documents as "the chapel," the lower chamber has no features that would indicate it was to be used for either cult or funerary purposes. The rectangular doorways leading into its broader, barrel-vaulted tunnels could not serve as recesses for altars or even sepulchers, and there was no proper entry into the chamber that would make it suitable for a chapel. Before the construction in 1930 of the broad staircase that descends to the lower chamber from the east vestibule, there were only two small spiral staircases (*caracoles*) embedded in the massive masonry to provide access to the lower chamber from the new palace; and these staircases are very steep and poorly lighted and barely wide enough for a man to pass, brushing the walls most of the way. Since they are about one third the diameter of the "secret staircase" delineated in the courtyard's southwest corner, these small *caracoles* must have been intended for service personnel only. Furthermore, all three extant sixteenth-century plans of the palace show that the present connection of the lower chamber with the south portico of the Court of Myrtles was intended from the beginning. The barrel-vaulted recess in the northwest corner of the chapel opens into an irregularly shaped room that is connected by a doorway to the portico of the Nazaride courtyard, and it is also connected by a passage under the north staircase to a long barrel-vaulted hall that extends to the west facade. The relationship of the lower chamber to these basement rooms along the north wall and to the

old palace was stressed a century later, in the 1630s, when these rooms were decorated as a group, apparently to serve for banqueting and entertaining.[74]

The circular courtyard was the last part of the residence to be founded. Two brief records of payments in the ledger for February 1540 provide our only evidence for the initiation of that work (docs. 27 and 28). The first, on the eighteenth of the month, is a payment "for 14 ounces of iron wire for the measurement of the rotunda of the palace" (*de 14 onças de hilo de yerro para las medidas del redondo de la casa*), and the second, one of many payments for gravel in February and April, was made to Hernán Sánchez on 28 February for almost 32 metric tons of gravel for the circular foundations of the courtyard (*2780 arrobas de piedra de guixarro para las çanxas de los redondos de la casa*). Only occasionally did the notary Francisco de Ribera identify the destination of the materials for which payments were made; but, from this one instance and the payment for wire to measure the diameter of the courtyard (doc. 27), we are assured that Pedro Machuca did not lay the foundations of the circular corridor until after February 1540. We have already noted that less than a year earlier, in May 1539, a carver named Ruberto was paid "for 20 columns made for the model," and that Juan de Maeda in 1576 (doc. 129) stated that these columns replaced an arcade on piers (*colonas aconpañadas por los lados con los pies derechos y movimientos sobre que se çerraban los arcos redondos*). He added that the piers were considered awkward or inconvenient (*pareçe que esto enbaraçaba*) and that their replacement with columns "changed the substance and design of the model." Apparently, in 1539 Machuca revived the idea of a colonnade found in his large Royal Palace plan. Then, on 18 December 1542 a carpenter was paid for constructing a wooden cart of sufficient size to transport "the large columns" (*las colunas grandes*) from an unnamed quarry to the Alhambra (doc. 38). Since no other work requiring large columns was underway at the time, it is reasonable to assume that they were model columns for the double portico of the courtyard. Also, the delivery

[72] AA, Leg. 2, 2c, 4 November 1542: "25 peones con los asentadores picando en la bóveda, 850 [maravedís]." Comparable entries were made from 21 October to 11 December, when the number of "peones" was reduced to 21 for the rest of the month.

[73] Bermúdez Pareja has suggested that the designer was a

mason schooled in the Mudéjar tradition, because of the framing of the rectangular doorways (leading to vaulted recesses) with pointed arches.

[74] AA, Leg. 41, 2, Nóminas, 7 March 1637 to 29 November 1642; see part 1, nn. 676–685. See Velestá's plan of 1793 (pl. 97, here), rooms lettered D, E and G.

of those columns in December 1542 provides reasonable assurance that the two rings of gravel had been completed by that time.

The two brief notices of the laying of the foundations of the courtyard leave several questions unanswered and they have important implications for the design of the palace. First, we do not know if those foundations were used by Luis Machuca in 1561 when he raised the Doric colonnade, but it is likely that they were, because no payments were found at that time for gravel or for labor on new foundations. The limestone blocks ordered in August of 1561 (doc. 197) were probably placed on the gravel rings and directly under the Doric columns. If Pedro's foundations were used by Luis, it was the former who increased the width of the corridor by four Castilian feet (1.10 meters) over that of the three extant plans of 1528–1531 (cf. pls. 2, 17, 18, and 19). Earlier, we concluded that the carving of the columns for the wooden model in 1539 represented an unauthorized return to the rejected colonnade, and the widening of the corridor may have been part of that revival of the original project of 1527. The corridor may have been narrowed in 1528 for the same reason the columns were replaced by piers in the plan of 1531 and the model of 1532—that is, to assure the stability of the annular vault of stone masonry.

The greater proportional integrity of the wider corridor over the narrower one in the three extant sixteenth-century plans would seem to support the proposal that Pedro in 1539–1540 returned to the dimensions of the 1527 plan. With the wider corridor, all parts of the plan conform to a geometric scheme in which circles and squares are alternately circumscribed (fig. 6). The heavier lines represent the wings, the corridor wall, and the colonnade of the present palace—and, perhaps, the plan of 1527— while the dotted line indicates the position of the colonnade in the three extant sixteenth-century plans. Because the present width of the corridor coincides wih the geometric configuration and the diminished width disrupts it, there is further reason to suspect that Pedro Machuca first proposed that geometric scheme in 1527, suffered its disfigurement in 1528, and revived it in 1539. The dependence of the first plan of 1527 on that configuration would make understandable Luis Hurtado's praise for its "grace and proportion." Also pertinent is the conformance of the "villa in Spain" to

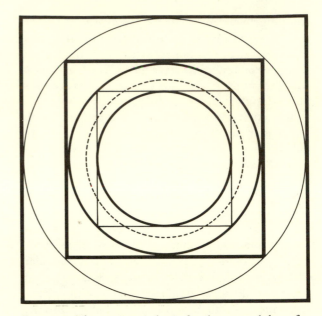

FIGURE 6. The geometric basis for the groundplan of the palace of Charles V

the same scheme (pl. 20), and this coincidence provides support for our surmise that this rapid sketch reflects one of the other projects proposed by Machuca early in 1527.

THE SOUTH FACADE, 1533–1548

The first bearing walls of the palace raised by Machuca were those of the south wing and its facade was the first faced in sandstone (pl. 31). Many payments for limestone from Alfacar and sandstone from Santa Pudia were recorded during these years, but the pieces were simply described in general terms, such as "blocks," "bonders," and "voussoirs" (*sillería, rabudos, dobelas*), "jambs" and "lintels" (*pies derechos* and *tranqueros*), or "large" and "small." Payments were also made to three or four stonecarvers for ornament, but no specific architectural details were mentioned. A few years later, from December 1541 to September 1544, two of the stonecarvers, Martín Cano and Ruberto (who formerly worked with Siloe on the ornament of the cathedral), were credited with carving corbels (*mínsulas*).[75] In 1546, in the first unambiguous references, Ruberto, Cano, and several other carv-

[75] AA, Leg. 2, 2c, Nóminas (doc. 34). While Cano and Ruberto were assigned the carving of other ornament (*talla*) during

ers were recorded as occupied with "the work of the windows" (*talla de las ventanas*).[76] Since pay ledgers have survived for only six months of the previous three years and for no more than that number during the following three years, the beginning and progress of work on the windows are poorly documented; but by 1546, the south facade had been raised (with the exception of its central window) and carvers were at work on its ornament. The "corbels" carved from 1541 to 1544 were probably those of the final cornice of the south facade because they would have been set in place before the carving *in situ* of the double-voluted brackets of the window crowns and their ornament was undertaken. The top cornice is made up of about ninety pieces, each composed of a corbel, with a rosette on the overhang and a lion's head on the cymatium (pl. 39). Already in 1537, work on the south facade must have reached the upper story because payments were made in June for timber to be inserted in the put-log holes left in the bearing walls to support the scaffolding (*maderos de álamo para machinales*).[77] By January 1542, the south facade was sufficiently finished to affix to each rusticated pilaster one of the handsome bronze tie rings held in the jaws of lions or the beaks of eagles (pls. 32, 33, and doc. 35). From these references to the south facade, it would seem that its foundations were laid in 1533 and that its wall reached the upper story by 1537, that the top cornice was completed during the early 1540s and the windows were carved from the mid-1540s. While most of the south facade (with the exception of the window over its portal) was completed well before Pedro Machuca's death in 1550, there are reasons to suspect that not all of its parts reflect his ideas.

Our inquiry must start with a careful description of the south facade. It rests on a stylobate in the form of a limestone benchtable (pls. 31 and 44) that is 50 centimeters high and 35 deep, and beneath it there is a slab that serves as a damp proof course and projects another 13 centimeters. Forward of that slab, a limestone rain trough of about 45 centimeters was uncovered along the north end of the west facade.[78] The slab and trough augmented the benchtable in both height and extension and, if preserved, would have counterbalanced the massive cornice, which now makes the building appear to be top heavy. The lower story of the south facade rises 6.85 meters from the benchtable to the limestone string course that divides it from the upper story and is faced with rusticated sandstone blocks of various shapes in a complex, symmetrical pattern centered on the keystones of the rectangular and round windows in each bay (pl. 37). Thirteen pairs of distinctly shaped stones, together with the keystones over the two windows, comprise each bay, while the flanking pilasters are composed of alternating wide and square pieces that interlock with the pattern of the bays. In the lower courses, the smaller pieces of the pilasters are approximately 55 centimeters square and the larger, 85 by 55 centimeters, providing the near viewer with a ready measure of the grand scale of the building. The stone was worked with a chisel to give it a rusticated texture, but today patterns on the several fronts range from highly regular (the "chain-mail" type found on parts of the west facade) to finer, more granular textures (pls. 37 and 38). The latter predominate on Machuca's south facade in early photographs and it would seem to be the original treatment, although virtually all of the blocks in the lower courses have been replaced in this century. Limestone was used for the Tuscan capitals of the rusticated sandstone pilasters and for the string course separating the two stories. The string course has the form of a contracted entablature because it is composed of two fascias (reminiscent of an architrave) and a cyma reversa molding, a large fillet, and a strongly projected cymatium (comparable to a cornice). The facade is dominated by its central bay, which is 9 meters wide in contrast to the 3.3 meters of the seven bays

this period, their main work was identified as corbels (*ménsulas*) through the following months: December 1541, January and March 1542, and September 1544 (the pay ledger for 1543 is missing). The corbels may be those under the surround of each bay or those supporting the window crowns, but it is more likely that they are the corbels of the final cornice.

[76] AA, Leg. 3, 5 (doc. 40). Nóminas are preserved for the months of April through August and then November and December 1546.

[77] AA, Leg. 2, 2a, Nóminas, 8 and 22 June 1537.

[78] I owe this information to Jesús Bermúdez Pareja. Perhaps this rain trough led Francisco de Paula Valladar to assume that Machuca had used a massive pre-Christian wall as the foundations for the south facade, because it is clear that no fortification walls crossed this part of the Alhambra.

on either side. The lat... framed by single pilasters, have a regular ... that is terminated at the ends of the facade ... pilasters and in... Corinthian ... marble facing a... ... frame the porta...

In the upper story (pls. 31 and 39), the same bay system is marked by Ionic pilasters, with a small niche (0.60 by 1.80 meters) between the paired pilasters at both ends of the facade and, in the center, Corinthian half-columns framing the marble-faced window. The pilasters rest on tall pedestals that bear emblems carved in half-round relief. One is Charles V's personal device, the Columns of Hercules, intertwined with a banderole reading *Plus Oultre* and placed on either side of a globe (pl. 34). The other is the emblem of the Burgundian Order of the Golden Fleece, of which Charles became master in 1516 (pl. 36). It is dominated by the decussate cross of Saint Andrew, the patron of the Order, and at the cross-point is the steel and sparking flint stone, both of which are symbols that express the flaming fervor of the Order's commitment.[79] In the unusual "Ionic" order (pl. 39), the volutes of the capitals appear to be formed by a leatherlike band that runs across the top and is tightly rolled on either side. Between these rolls and above the necking are moldings with egg-and-dart and bead-and-spindle ornament. The shaft of each pilaster is 4.35 meters tall, the capital measures 50 centimeters, and the base molding, 51 centimeters, while the pedestal (together with the plain courses beneath it) rises 2 meters. The shaft is tapered from 58 centimeters at the bottom to 50 at the top, and its salience is also diminished from 12 to 8 centimeters. The front taper is reflected in the fielded panel of the pilaster and is readily measured against the plumb line of the surround that frames each bay. The surround is bound to the pilasters by common base moldings. The sharp arris of the fielded panel of the pilasters is set off against the moldings on the opposite side of the recessed channel, just as the edges of the fielded panels framing the bull's eye attic windows contrast with the cyma reversa and two fillets that border the bold surround of the bay itself. This interplay of the arris of the fielded panels and the molded channels that articulate them provides a common treatment that relates order and wall. The interdependence of the two is further stressed by the way in which the leather-roll volutes of the Ionic capitals are riveted into the corners of the surrounds and, within each bay, by the deviation of both the fielded panel and its channel around the central corbel.

The main-floor windows, measuring 1.37 by 3.05 meters, are framed by wide and narrow fascias with a quarter-round molding between them and a cyma reversa at the outer edge. Large, leaf-faced, double-voluted brackets, placed alongside the upper part of the window casing, are joined by a rigid swag of fruit and flowers that rests on the top of the casing, and the brackets support window crowns in the form of triangular pediments and lintels (pls. 39 and 41). Again, fillets and the cyma reversa comprise the articulating moldings of the window crowns. On the lintels there are three small vases set on a platform and flanked by winged geniuses that emerge from leaves and hold baskets of fruit on their heads, while large pomegranates rest on the lower edges of the triangular pediment. The tympanum of the latter encloses the cross of Saint Andrew and an elaborately but symmetrically disposed banderole with no trace of an inscription.

We should also recognize that the main facades were to have had various accessories. About the bronze tie rings we know only that some were affixed to an unidentified facade in January 1542. The payment (doc. 35) simply refers to a quantity of "lead to affix some of the rings on the new royal palace" (*plomo para asentar unas argollas en la casa real nueva*). Presumably, those completed and set in place in 1542 were no more than the sixteen needed for the south facade because it was the only front sufficiently advanced at that time. The rings, about forty centimeters in diameter, are held in the beak of an eagle or the jaws of a lion. The lion ring is composed of two Ionic columns bent to form a circle and intertwined with a banderole that bears the motto *Plus Oultre* (pl. 32). On the other ring, held by the eagle, there is a shouting head with hair and beard in the form of leaves (pl. 33). Though Henríquez de Jorquera mistakenly described the tie rings as held by lions and serpents

[79] Victor Tourneur, "Les origines de l'ordre de la Toison d'Or et la symbolique des insignes de celui-ci," *Bulletin de la* *Académie royale des Sciences Belgique, Classe des Lettres*, 5ᵉ série, XLIII (1956), pp. 300-323.

(*sierpes*), his reference assures us that in 1646 there were only two kinds.[80] Unfortunately, he did not indicate how the two were disposed on the facade, but Richard Twiss in 1776 noted that "between the windows are fourteen lions' mouths and eagles' beaks *alternately*, of bronze and of very fine workmanship, each holding a large bronze ring," and he added that "twenty-five of these are on the other sides of the edifice."[81] So he infers that all were still in place and that the two types were alternated along the facades. Yet, a generation later, only lions' heads were depicted in the 1793 elevation of the west facade (pl. 102). Over the turn of the century, the tie rings were stolen one by one until in 1814 only eighteen were left; fortunately, by 1852 the remainder were removed for safekeeping.[82] In 1922, Torres Balbas rediscovered them, and after having them renovated, he placed the two eagles' heads on the paired pilasters and nine lions' heads on the single pilasters of the south facade,[83] and that disposition was retained when about two dozen replicas were made in 1967 to replace those that had been lost.[84]

Another accessory, now lost, was the torch standard in the form of a human arm that was, until the late eighteenth century, mounted on each of the three exposed corners of the palace.[85] Not one has survived, but the remains of the iron clamps that secured one of them to the wall were until recently visible on the southeast corner (pl. 40). In a palace of this category, which has forecourts for ceremonial entries, equestrian games, and other festivities, it is likely that metal torch standards of a less fanciful kind were affixed all along the main facades. One possible location is the incised rectangle that interrupts the window casings on either side of the pedestals (pl. 43). Its flatness, in contrast to the layered and modeled forms around it, makes this area look unfinished, but that would have been corrected if holes for torch standards and flagstaffs, as well as the wrought iron railings of the windows, had been inserted within this area. Iron window railings were indicated by the draftsman of the elevation made for the Academy of San Fernando in 1793 (pl. 102), when the palace was to be finished to serve as a military school; and that idea was revived in 1966 when the conservator installed wooden railings modeled on the wrought iron railings of the Chancillería in Granada.[86] This was almost certainly Pedro Machuca's intention, as the iron railings would have been less disruptive of the horizontal line of the pedestals of the Ionic pilasters than balustrades would have been. The iron railings would almost certainly have had counterparts in the grilles on the ground floor and mezzanine windows, and the rich ornament concentrated on the crowns of the main-story windows was complemented by bronze tie rings and torch standards. Though the material and form of some of these metal accessories are unknown, they must be kept in mind when judging the architectural form of the south facade.

The fairly well documented marble *portada* warrants special attention because it can tell us a great deal about the history of the south facade. We owe the documentation to the sculptural ornament of the *portada* (pl. 44) because a sculptor of figures and reliefs—in contrast to carvers of architectural ornament—usually signed a contract that identified the work to be done. He often received two payments "on account" while work was in progress and then a final payment after the sculpture was

[80] Henríquez de Jorquera, *Anales de Granada*, I, p. 55.

[81] Richard Twiss, *Travels in Portugal and Spain in 1772 and 1773*, London, 1775, pp. 240-241.

[82] By 1852, the surviving tie rings had been mounted on doors in the Tower of Comares; see Leopoldo Torres Balbás, "El Museo Arqueológico de la Alhambra," *Al-Andalús*, IX, (1944), p. 239.

[83] Fifteen surviving tie rings were returned to the south facade of the palace in June 1924; Leopoldo Torres Balbás, "Diario de obras en la Alhambra: 1924," *Cuadernos de la Alhambra*, II (1966), p. 95.

[84] Francisco Prieto Moreno, "Obras recientes en la Alhambra y Generalife: Resumen del año 1967," *Cuadernos de la Alhambra*, IV (1968), p. 130.

[85] Velázquez de Echevarría, *Paseos*, I, p. 28: "En las tres esquinas, o vivo de estos ángulos exteriores, van situados en

correspondiente alto y separados a distancia oportunados brazos de bronce de algo mas de tamaño natural, y con cañones en sus manos, como para sostener hacheros de luz." A footnote added to the 1814 edition informs us that "una mano ambiciosa y rapaz" had stolen them. This must have occurred sometime before the making of the 1767 elevation, because no torch standards were delineated there (pl. 60).

[86] For the royal order of 14 May 1793 for the completion of the palace as a military school, see Vasco y Vasco, *Memoria sobre al Alhambra. Año 1875*, p. 16. The projects are preserved in the library of the Academia de San Fernando in Madrid and they have the signature 67 BA/18. For the wooden window railings of 1966, see Francisco Prieto Moreno, "Obras recientes en la Alhambra y Generalife Resumen del año 1966," *Cuadernos de la Alhambra*, III (1967), p. 155.

appraised by two or three outside sculptors. In these documents, the figure or relief was usually identified by subject, and since no other work in grey marble was recorded in the 1530s, references to sculpture in this material are readily recognized as pertaining to the lower story of the south *portada*. Already in June 1537, materials were delivered for the centering of the doorway of the south portal (*çimbra para el trasdós* [extrados] *de la puerta de la casa nueva*), and in July, a carpenter was paid for constructing centering described as *un pontefis grande* (docs. 6 and 7).[87] Two months later, in September 1537 (doc. 8), a payment was made for three pieces of limestone for the relieving arch that distributes the weight of the bearing wall over the rectangular opening of the south doorway (*3 pieças grandes de tova para el arco de la puerta*). The belated construction of this protective relieving arch in limestone suggests that the rectangular door of the marble *portada* differed in size or shape from the original door framed in sandstone. In September and November 1537 (docs. 9 and 10), the triangular pediment for the door (*un frontisfriçio de la portada*) and one of the Victories that reclines on it were delivered to the Alhambra (docs. 7 and 9). Both pieces must have been set in place before February 1538 when Bautista began carving the inscription on the frieze of the main entablature because the latter *rests on* the panel of the Victory (doc. 13). From June 1537, payments were made for tools and materials (notably clamps, braces, and asphalt) needed to affix the marble facing of the *portada* to the limestone bearing wall;[88] so it would appear that most pieces were put in place as they arrived, with the entablature terminating the first story set in place by February 1538.

The designer of the lower story of the marble *portada* was surely Pedro Machuca, because its component parts are wholly consistent with his architectural repertory. Its engaged columns have the peculiar leather-roll version of the Ionic capitals used on the upper story of the south facade (cf. pls. 38, 44, and 55). The stop-fluted shafts of the

paired half-columns reappeared in his design for the lower story of the west *portada*, though the order of the latter is Doric; and the simple architrave, composed of three graduated fascias without transitional moldings, was used consistently throughout the palace. Sharply defined and stepped arrises, with no quarter-round moldings to soften their edges, are typical of his casings, string courses, and architraves. The plain band, or surround, that frames the pedimented portal is also found in the bays of the upper story, on the back wall of the Pilar de Carlos V, and also in the west frontispiece. The egg-and-dart, bead-and-spindle, and the dentil courses on the pediment and the capitals are part of his restricted decorative repertory. The marked taper of the pilasters supporting the pediment over the door follows the same principle as that in the upper story of the palace (pl. 46). Although the broad pedestals (for the paired half-columns) were indicated in the small Royal Palace plan of 1531 (pl. 18), they are missing in the large plan of 1528 where the south entry has paired sandstone pilasters (pl. 107). Hence, the marble *portada* was not Machuca's first idea, but one he accepted in the penultimate project. Even so, the grey marble frame strikes many scholars as an alien and incongruous feature within the stylar facade. George Kubler has noted that both the south and west *portadas* "intrude upon the cadenced Italian fronts," and he took the disruption of the regular rhythm of the facade bays to be an example of the "principle of discontinuity," which is often accepted as a "constant" in Spanish architectural design.[89] Thus, some scholars would say that, by intruding a Spanish *portada* into an Italian facade, Pedro Machuca affirmed his Hispanic roots.

Before considering this explanation, we should recognize that the passage of time has greatly diminished the disruptive effect of the marble *portada* within the sandstone facade. The present deep golden color of the sandstone is due, in part, to the oxidation of the iron content in the stone after prolonged exposure to weather,[90] and in part, to

[87] AA, Leg. 2, 2a, Nóminas, 19 July 1537.

[88] Ibid., 7 June and 19 to 21 July 1537.

[89] Kubler-Soria, *Art and Architecture of Spain and Portugal*, p. 11.

[90] Sandstone (*arenisca*) is composed of grains of quartz bound together by lime or calcium carbonate. When cut from the quarry, it is bland and easily trimmed (and, thus, designated *piedra franca* or free stone in the documents), but it hardens with

exposure to air. Centuries of exposure to dampness and extreme changes of temperature (particularly in Granada) result in chemical changes by which the lime becomes soluble in water and the stone crumbles. In the sandstone of Santa Pudia (near Santa Fé in the jurisdiction of the Alhendín), there is a significant iron content and that has led to the extreme coloration of the stone.

the iron content of the soil of Granada, the dust of which has gilded much of the grey marble. Originally, the sandstone from the quarries of Santa Pudia was *white*. As late as 1764 Velázquez de Echevarría could still describe the palace as *de piedra blanca*, though he may have ignored the beginning of the yellowing process because he knew the natural whiteness of the local sandstone.[91] All through the sixteenth century, contracts required that the stone had to be very white (*muy blanca* and *blanca sin ningún deffecto*) and without any reddish discolorations (*bermejas*), and in the 1590s some deliveries of sandstone were rejected because of such discolorations.[92] The natural whiteness of the sandstone of Santa Pudia could still be seen twenty years ago in the protected interior of the west vestibule. If one were able to restore the original whiteness of the sandstone facades and to eliminate the gilding of the bluish-grey marble, the disruptive effect of the dark *portadas* would be considerably greater than it is today. To the difference in color, we should add that of texture. Originally, there was a greater contrast between the polished marble and the mat sandstone, chipped in the lower story to suggest the granular texture of rustication. We should recognize, therefore, that the *portada* not only interrupted the cadence of the stylar facade but also the original chromatic unity of the south wall.

There are other incongruities of a more architectural nature. The odd Ionic capitals of the *portada* confront the severe Tuscan capitals of the rusticated pilasters, but Machuca clearly tried to align the Ionic capitals with the Tuscan and to confine the grey marble entablature to the width of the limestone string course, allowing only the lowest band of its three-fascia architrave to drop below that line. The near coincidence of the full entablature of the *portada* and the contracted string course can be seen in angle views of the south facade (pl. 44), though the elevations made for the Academy of San Fernando in 1767 (pl. 35) and 1793 incorrectly represent the architrave of the *portada* lowered to the level of the Tuscan capitals of the rusticated pilasters. The stop-fluted shafts of the half-columns, set off against the smooth slabs of marble

behind them, rest on pedestals that rise above the level of the limestone benchtable. The slightly smaller, recessed pedestals on which the lions now rest cut across both the benchtable and the courses of rusticated masonry with surprising indifference to these important horizontal lines. Even more puzzling is the way in which the marble *portada* was literally intruded into the sandstone pilasters on either side. The large and small bossed stones that form the pilasters were bisected, resulting in the unsightly undulating line of the sandstone blocks against the straight edge of the smooth grey marble. Neither the membering nor the masonry courses of the sandstone wall appear to have been designed to accommodate the marble *portada*, with the result that it seems to violate rather than climax the stylar facade.

Equally telling is the fact that not one of the three extant groundplans indicates precisely the present disposition of the south *portada*. The best indication, as usual, is given by the small Royal Palace plan (pl. 18), which is probably the penultimate project of 1531. There, the broad pedestals for paired half-columns overlap the rusticated pilaster framing the adjacent bay, though there is no indication of a contrast in material. More importantly, we do not find the secondary pedestals on which the lions now rest (pl. 45). The earlier Archive plan, in contrast, clearly indicates by the break in the tone of the wall that there was to have been a *portada* of a material other than that of the wall (pl. 19), but it, too, differs from the present palace in that it does not show the half-pilasters of rusticated sandstone on either side. The solution in the Archive plan would have been even more awkward than the present facade because it would have left the inner edge of the bay on either side of the portal unframed and it would have disrupted the interplay of the wide and narrow blocks of the pilaster with the pattern of the masonry framing the ground floor windows. Again, by his insistence on a *portada* of a different material, the draftsman of the Archive plan (probably Luis de Vega) displayed insensitivity to the basic principle underlaying the cadenced and closed rhythm of Machuca's stylar facade and the interlocking of the

[91] Velázquez de Echevarría, *Paseos*, I, p. 18. A few years later, the stone was described as "yellow" by Richard Twiss (*Travels through Portugal and Spain*, p. 240).

[92] The first preserved contracts for sandstone are those of 26

September 1561 (AA, Leg. 5, 50), 25 February and 4 March 1590 (Leg. 6, 28), 19 August 1594 (Leg. 210, 1, 7), and 31 December 1598 (Leg. 210, 1, 21). Presumably the earliest lost contracts included the same requirement.

component blocks of the pilasters with the masonry of the wall.

In the large Royal Palace plan (pl. 107), the south doorway is framed by paired pilasters of the same material as the rest of the wall and set at the same interval as the pairs on the ends of the facade. It would seem that Machuca first proposed a facade *entirely of white sandstone*, with single pilasters sectioning the bays and pairs framing the wider central bay and terminating the rhythm at the ends of the wall. A closer look reveals that alternate solutions were delineated on either side of the south door. On the right side, the pair of pilasters occupy the same plane as the rest of the facade, while on the left, the pilaster of the adjacent bay is overlapped by the advanced pair that frame the portal. We cannot now tell which project was executed, because the present marble *portada* covers all but half of the outermost of the paired sandstone pilasters. Also unknown is the shape of the doorway of that first sandstone facade delineated in the large Royal Palace plan. There is an indication of a small upright on either side of the doorway in both the large and small Royal Palace plans, but it could be the casing of an archway or a rectangular door, or pilasters supporting a pediment. A clue to the shape of the door is provided by the belated construction of a relieving arch over the south doorway in September 1537. That would not have been necessary if the original opening had been rectangular be-

cause it would already have had a relieving arch within the limestone wall, so the first opening must have been arched. The arch would have distinguished the central doorway from the large rectangular windows of the ground floor and it would have complemented the triumphal archway that was to join the south forecourt to that of the main facade on the west. The haunch pieces of that unfinished arch are seen on the west side of the south facade (left side of pl. 31). Except for the mezzanine and attic roundels, the semicircular motive was lacking in the facade, even though the south forecourt was to have been enclosed by an arcade of about thirty arches. For these formal and structural reasons, the speculative reconstruction of the elevation of the first, all-sandstone south facade includes an archway framed by paired pilasters of rusticated white sandstone (fig. 7). It would seem this entry was realized and then its outermost pilasters were bisected for the insertion of the grey marble *portada*.

Machuca's role in the sculptural ornament of the south *portada* needs to be examined. Since 1885 we have known that most of it was executed by the Lombard sculptor, Niccolò da Coret,[93] but in 1908 Carl Justi expressed the belief that the Italian worked from Machuca's designs, and Gómez-Moreno y Martínez and others have agreed.[94] The presumed dependence on Machuca was supported by the belief among Italian scholars that Corte, in his earlier

[93] Gómez-Moreno y González, "Palacio de Carlos V," p. 212, n. 2.

[94] Justi, "Anfänge der Renaissance in Granada," p. 188: "Machuca hatte dies alles skizziert, aber er war kein Bildhauer." Gómez-Moreno y Martínez, *Las águilas*, p. 133: "Parece seguro

que también diese Machuca diseños para las estilobatas del palacio." Kubler-Soria (*The Art and Architecture of Spain and Portugal*, p. 127, n. 6) also attributed the designs for the sculpture reliefs of both *portadas* to Machuca.

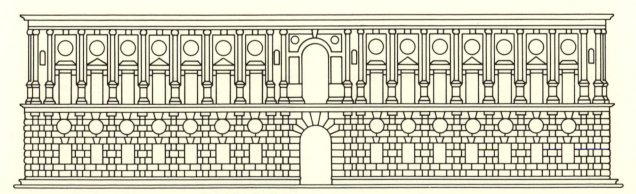

FIGURE 7. Reconstruction of the south facade of 1533–1536

collaboration in Genoa with Gian Giacomo and Guglielmo della Porta, was restricted to carving architectural ornament, while his colleagues did the figural sculpture;[95] however, there are significant stylistic analogies between his documented sculpture on the Alhambra and some figures in his collaborative works in Genoa.[96] Similar physical types, as well as certain peculiar limitations in anatomical knowledge and the handling of drapery folds, provide convincing evidence that Corte was responsible for the design as well as the execution of figural sculpture in both Genoa and Granada. In the immediate context of the south facade, however, we are primarily concerned with how Corte came to be involved in the sculpture of its portal and the part he played in its design and execution as well as the effect of his sculpture on the appearance of Machuca's *portada*.

The first notice of Niccolò da Corte's activity on the Alhambra is a payment on 15 November 1537 for "a figure that he made in the stone of the Sierra Elvira for the portada . . . which is the figure entitled 'Fame' " (*una figura que yzo para la portada . . . que es la figura intitulada la Fama*, doc. 10). Since no other work in grey marble was being executed at that time on the Alhambra and because allegorical figures were still sufficiently new in Spain to excuse the designation of a *Victory* as *Fame*,[97] no one has doubted that the payment refers to one of the two reclining figures along the top edge of the pediment of the south portal (pl. 55). The Victory must have been his first work on the Alhambra (as Justi assumed), because Corte was still in

Genoa in the summer of 1537.[98] Though we do not know why or when he came to Granada, it is likely that he delivered and installed a balustrade and a fountain of marble that Admiral Álvaro de Bazán had ordered from Gian Giacomo della Porta and Giovanni Pietro Passalo in April of 1536, because in August of that year Guglielmo and Niccolò were at work on that commission in Genoa,[99] and it was customary for a young member of a workshop to accompany a shipment of monumental sculpture to a distant patron to supervise the assemblage of the work in its place. Corte's delivery of the fountain would certainly have been known to Iñigo López de Mendoza, then acting governor of the Alhambra, and Mendoza would probably have been curious enough to see the Lombard's work. He might then have enticed Corte to remain in Granada to complete the sculpture of the south portal. However it happened, Corte entered the work after the first Victory had been carved because the two figures were put in place shortly after he was paid in mid-November 1537. This is evident from a payment to Bautista [de Artiaga] in February 1538 for carving "the letters of the *portada*," that is the inscription P[LVS] V[LTRA] IMP[ERATOR] CAES[AR] KAR [OLVS] V. P[LVS] V[LTRA] on the frieze of the entablature (pl. 55 and doc. 13). These letters were certainly carved on the frieze after the entablature was affixed to the wall, since the entablature rests on the Victory panels and also on the vertical bands behind the Ionic half-columns (which, in turn, *overlap* the Victory panels). Thus, it is evident that

[95] That view was fostered by S. Varni in "Delle opere di Gian Giacomo e Guglielmo della Porta e Nicola da Corte," *Atti della Società Ligure di storia Patria*, IV (1866), pp. 35-78; Raffaele Soprani in *Le vite de' pittori, scoltori et architetti genovesi e de'forastieri che in Genova operavano*, Genoa, 1674, p. 277; and Renato Roli in "Le sculture di Guglielmo della Porta nella Cattedrale di Genova," *Arte Antica e Moderna*, XXXIII, nos. 34-36 (1966), pp. 212-213.

[96] Earl E. Rosenthal, "The Lombard Sculptor Niccolò da Corte in Granada from 1537-1552," *Art Quarterly*, XXIX (1966), pp. 209-244.

[97] The personifications of Victory and Fame are sufficiently close in imagery and allegorical associations to have been confused in 1537. The palm leaf and even the laurel branch held by the Victories are attributes also given to Glory and Renown, personifications closely related to Fame, but the primary attribute of the latter in the sixteenth century was the trumpet; see Guy de Tervarent, *Attributs et symboles dans l'art profane 1450–1600*, Geneva, 1958, cols, 401, 125, 157, 293-294; and Vincenzo

Cartari, *Le imagine con la sposition de i Dei de gli antichi*, Venice, 1556, fol. 78v-80v. In 1551, Juan de Orea gave a trumpet to the figure of Fame in the relief commemorating the Peace of Mühlberg on the west facade (pl. 61).

[98] Alizeri, *Notizie dei professori del disegno in Liguria*, V, p. 203, n. 1.

[99] Ibid., p. 228, n. 1. The commission for the balustrade and fountain might have been arranged by one of the Genoese merchants or bankers living in Granada; see J. Heers, "Le royaume de Granada et la politique marchande de Gênes en occident," *Moyen Age*, XVII (1957), pp. 91-188. It has been suggested that Niccolò and Guglielmo dissolved their common workshop sometime after 10 April 1537, though they formed another partnership on 30 April 1538, at which time Niccolò apparently planned to return from Granada to Genoa; see Hanno-Walter Kruft and Anthony Roth, "The Della Porta workshop in Genoa," *Annali della Scuola Normale Superiore di Pisa* (Classe de Lettere e Filosofia, ser. 3), III (1973), p. 909.

both Victories were set in place along with the other architectural membering shortly after Corte submitted his figure for appraisal in mid-November 1537. If we recognize that Corte had to work at an unusual pace to complete one life-size figure in marble in the two and a half months after his arrival in Granada, we must conclude that the other Victory was made previously by another sculptor.

Stylistic differences alone support that conclusion. The Victory and its attendant genius on the right are well placed within the spandrel, filling it with an ample margin all around; while on the left, the wing of the Victory touches the central corbel, and the foot of the genius and part of his wing had to be cut off in order to make the panel fit the area (pl. 55). Perhaps the left panel was carved before the present architectural disposition was determined, or the sculptor may have failed to take into account the vertical band behind the Ionic columns. Whatever the explanation, the error was discovered in time to correct the right panel. That properly measured and composed panel is more likely to be the second of the two and, therefore, the one by Corte. It also displays a peculiarly Italian sensitivity to the subordination of the figural sculpture to the plane of the wall (pl. 46). The broad planes of the figures—the wings, the chest and arms, the face, the torso and the legs of the Victory, the entire body of the genius, and even the laurel wreath—are accorded to a plane parallel to the wall. Because of this, and also because of its carefully gauged intervals and crisply defined detail, the right panel is more successful as architectural decoration than the one on the left. In the latter, emphasis on the roundness of the body of the Victory, as well as its easy turn and the convexity of the wings give the figure the illusion of a three-dimensional existence independent of the surface of the wall. Furthermore, the coloristic treatment of the wings, the hair, and portions of the drapery contributes to the impression of an enveloping atmosphere and, thus, of deeper space. The difference between the two attitudes is even evident in the rich irregularity of the deeply undercut laurel branch on the left in contrast to the incised plane of the palm leaf on the right. The languor of the body of the left Victory and the gentle inclination of her head, together with the appearance of soft flesh, convey lifelike qualities

not found in the hard surfaces and brittle detail of the austere matron on the right. The sculptor of the latter was not as capable as that of the former in the anatomical definition of the body, though the admittedly inept formation of the abdomen and the handling of the drapery over that area in the left panel may be the work of an assistant. The few analogous parts in the two figures indicate nothing more than the dependence of the second sculptor on the general disposition of the first; but the stylistic differences are too great to assume a single designer with the disparities attributable to execution by different hands. The differences assure us that the two Victories were carved by sculptors of different schools. The relief on the right, in its orderly planes, the just balance of the figures and the interstices between them, is characteristically Italian, while the one on the left, in its relative freedom from the plane of the wall and its emotional warmth, appears to be the work of a Spanish sculptor.

The Spaniard who carved the left Victory was clearly an early follower of Diego Siloe, who dominated the architectural and sculptural activity of the city. Distinctly Siloesque are the heaviness of the limbs and the languor of the body as well as the facial type (pl. 46). A number of sculptors by the mid-1530s had gained their training under Siloe's supervision, most notably in the execution of the figural sculpture on the portals of the convent of San Jerónimo and the cathedral. The contemporary figures of Faith and Justice over the cathedral's Puerta del Perdón show a number of similarities to the left Victory: the heavy limbs with bossed shoulders, the broad faces with low foreheads and large features (pl. 7), and the arrangement of the veil over the back of the head. While the execution of the Alhambra Victory falls short of Siloe's bravura and artistry and the figure lacks his graceful movement, lively contours, and swelling volumes, it reflects his figural type and the ease with which his figures move free of the plane of the wall. I assume yet another, not trained with Siloe, carved the genius. Its elongated proportions and delicate surface qualities and the feeble handling of the wings cannot be attributed to the more capable sculptor of the Victory itself. Also inferior is the half figure of *Abundance* in the tympanum (pl. 46). Though the several hands dis-

tinguished here cannot be identified at this time,[100] the differences in individual manner and skill indicate that several sculptors had worked on the portal before the Italian appeared, and that the one responsible for the left Victory was a follower of Siloe in Granada.

The Victory and genius on the right side, which we have characterized as "Italian" in the adjustment of the figures to the plane of the spandrel, are comparable to several works attributed to Niccolò da Corte in Genoa. One is the dedicatory inscription placed in 1528 over the portal of the palace of Andrea Doria on the Piazza San Matteo.[101] The two little geniuses holding that inscription are readily recognized as the *fratelli* of the little genius attending the right Victory (cf. pls. 51 and 55). The massive square head, the bloated jowls, the dimpled chin, the sharply cut eyes and lips, and the curled and somewhat matted locks are found in both. The fat rings around the neck, ankles, and waist and an unnatural flatness of the arm that crosses the body in both the Doria and the Alhambra figures, together with the windblown drapery, present convincing evidence that Niccolò da Corte did both works and that by 1528 he had become an identifiable artistic personality. He also repeated certain facial types, most notably that of the small sphinx above the Doria inscription, which reappears in the Victory. The ridged hair parted in the center over a low forehead, the broad nose with flaring nostrils, the full bow-shaped lips and the strongly marked wrinkles around the neck are found in both faces. Also comparable is the treatment of the feathers of the wings, alternately wide and narrow with a wavy edge and a marked upward turn of the outer ends. Because of these similarities, the documented Victory on the Alhambra portal must be the one on the right.

The success of Niccolò's first work on the Alhambra, which was appraised at the high price of 120 ducats (doc. 10), apparently emboldened him to suggest other sculptural enrichments for the lower story of the south *portada*. Even though all the marble facing must have been in place before February 1538 when the inscription was cut into the frieze of the lower entablature, Corte got the governor's approval for making low reliefs for the pedestals. We know that Corte spent ten days in February 1538 at the Sierra Elvira quarries selecting the vein of marble from which the panels for these reliefs were to be cut (doc. 14). Only panels of a fine and consistent grain, without flaws or discolorations of any kind, could be used for the subtle art of *schiacciato* relief. When the four pieces of marble arrived on 15 March (doc. 17), they were described as "bases and sub-bases" (*basas y subasas*), apparently referring to the pedestals and the side extensions that now support the recumbent lions. As we noted earlier, those side extensions do not appear in the small Royal Palace plan of about 1531 (pl. 18), and as we shall see, the lions were carved by Antonio de Leval a generation later (doc. 114), probably for the west entry, and placed on these pedestals sometime before 1767 (pl. 35). So the original function of the added outer "pedestals" remains a mystery, and I know of no precedents or analogies for them. Because they are not indicated in the groundplans and have no architectural function, it is likely that they were introduced by Niccolò da Corte, and since ancient trophies are depicted on the secondary pedestals and modern on the primary, that programmatic function probably led to the additions.

Various iconographic aspects of the reliefs also indicate that the idea and the design were Corte's rather than Machuca's. The use of the trophy motive on pedestals was rare in Spain[102] and they were not generally popular in Italy, but they were favored by Lombard sculptors working in Genoa, especially for the pedestals of palace portals. Tro-

[100] No careful study has been made of the sculpture of Diego Siloe and his large school, so we cannot confirm or deny Simón de Argote's claim that Pierres Morell and Juan de Vera did some of the sculpture for the south portal; see his *Nuevos paseos históricos artísticos, económicos-políticos por Granada y sus contornos*, Granada, 1807, II, 2, p. 60. Antonio Gallego y Burín believed that two carvers of window ornament in the 1540s, Ruberto and Martyn Cano, worked on the lower story of the south portal, but he may have mistaken payments for "la talla de las puertas de las cuadras." (AA, Leg. 2, 2a, Nóminas, for July

1537) as a reference to the south portal. Those carvings were probably panels for the doors of new quarters built for Charles V in 1528-1532. One sculptor who is known to have worked with Siloe, Juan de Arteaga, was also paid for work on the "puertas de las quadras" in 1537 (Leg. 2, 2a, Nóminas for October and November 1537).

[101] Earl E. Rosenthal, "Niccolò da Corte and the Portal of the Palace of Andrea Doria in Genoa," *Festschrift Ulrich Middeldorf*, Berlin, 1968, pp. 358-363.

[102] The only contemporary instances of the theme on ped-

phaic reliefs were used on the early sixteenth-century portal of the palace of Andrea Doria in the Piazza San Matteo, to which Niccolò added the dedicatory inscription in 1528, and also for the portals of the Villa Doria in Fassola around 1529, the Lanfranco Cicala palace, and the Salvago palace on the Piazza San Bernardo which he contracted to do with Gian Giacomo della Porta in 1532 (pl. 47).[103] The Ligurian city also provides a precedent for another unusual feature of the reliefs—the contrast of ancient Roman arms and armor on the outer pedestals with their modern counterparts on those that support the paired Ionic columns (pl. 45). This contrast (on jambs rather than pedestals) is found on the portal of the Grillo-Cattaneo palace, undertaken in 1504.[104]

The armor in the trophaic reliefs on the Alhambra is readily identified as Italian and predominantly Milanese of the first quarter of the sixteenth century.[105] The fluted breast plates on the outer corners follow the Milanese version of the so-called Maximilian style of about 1510 to 1520. Typical of that mode are the bulbous shape, the large scale of the regularly spaced fluting and the straight, wide, plain panel at the top. Next to it is a smooth-surfaced breast plate with the globose form typical of Italian work of about 1510. The tusset, or thigh piece, above these breast plates is also of an Italian type favored since the late fifteenth century, and closest to some made about 1500 to 1510. Near the top, there is a plumed *armet à rondelle*, named for the disk projecting at the back of the neck. Though this type of helmet appeared as early as

1450, the deep curve at the back of the neck indicates a Milanese model of the first third of the sixteenth century. Under the muzzle of that cannon are the hilts of the two kinds of swords used by the Moorish cavalry and, in the 1530s, still prized possessions of Spanish nobles. Below them and behind the crossbow are the familiar leather shields (*adargas*) of the cavalry, identified by their twin-arch silhouette.[106] A note of irony is introduced by the appearance on one of the shields of the familiar Moorish epigram "Only God is Victorious" (*No vence sino Dios*). The bold spherical shape of the fluted breast plate in the inner corner of the modern relief is characteristically Italian, but the curved baseline of the panel at the top of the breast plate and the fine fluting (now barely visible) are German traits. It is significant that neither the Italian nor the German version of the Maximilian style found in these reliefs was favored by Spaniards,[107] and neither is found in armor of a known Spanish provenance nor represented in contemporary Spanish painting or sculpture. Thus, both the trophaic motive and the kind of armor represented in these reliefs strongly favor an attribution of the design to Corte rather than to Machuca.

Perhaps the most compelling reason for accepting Niccolò da Corte as the designer is a technical one. The *schiacciato* relief was rarely attempted in Spain,[108] and well into the sixteenth century it remained an essentially Italian art. Furthermore, so intimate is the relationship between design and execution in the case of a successful illusionistic relief

estals in Spain are the simple vignettes of arms and armor on the doorways on the south end of the east facade of the Casas Consistoriales in Seville. This portion of the building, which bears the dates 1537, 1538 and 1539 inscribed on several pilasters, differs markedly in style from the first construction, begun about 1527, which centered on the vestibule and staircase in the center of the east facade. The pilasters with trophaic decoration on the portal of the palace of Antonio de Mendoza in Guadalajara were executed before 1526.

[103] For this and related examples, see Hanno-Walter Kruft, *Portali genovesi del Rinascimento*, Florence, 1971, pls. 50, 68, and 69; idem., "The Della Porta workshop in Genoa," p. 926, pls. CIII, and CV.

[104] Alizeri, *Notizie*, v, pp. 42-43, n. 1.

[105] Dr. Helmut Nickel, curator in the Department of Arms and Armor of the Metropolitan Museum of Art in New York, confirmed the essentially Milanese character of most of this armor. For the citation of specific comparisons and bibliographical references, see Rosenthal, "The Lombard Sculptor Niccolò da Corte," pp. 216-217, nn. 35-43.

[106] J. Ferrandis Torres, "Espadas granadinas de la jineta," *Archivo español de arte*, XVI (1943), p. 145.

[107] Milanese armor of the fluted type is not included in accounts of Spanish armor worn during this period; see Guy Francis Laking, "Armor termed 'Spanish'," *A Record of European Armour and Arms*, London, 1920, III, pp. 302-329; and A. F. Calvert, *Spanish Arms and Armour, being a Historical and Descriptive Account of the Royal Armoury of Madrid*, London, 1907. Claude Blair, Deputy Keeper of the Department of Metalwork of the Victoria and Albert Museum, also believes that Milanese armor of the fluted type was rarely worn in Spain.

[108] The low reliefs used in 1524 by Felipe Vigarny on the predella of the retable of the Virgen del Pilar in the cathedral of Toledo were described as exceptional by Beatrice G. Proske, *Castilian Sculpture, Gothic to Renaissance*, New York, 1951, p. 285, and J. M. de Azcárate, *La escultura del siglo XVI*, fig. 29, pp. 42-45. While lower in relief than any carved by Domenico Fancelli, Diego Siloe, or Vazco de la Zarza, those of Vigarny fall far short of the skillful handling of the trophaic reliefs of the south portal.

that Corte could not have executed another's design so successfully. The designer must fully understand the requirements and the limitations of the idiom. Of course, he must have a fine-grain marble of consistent color and texture and, for that reason, sculptors of low reliefs from the time of Donatello often went to the quarries to select the proper material, as we know Corte did in this case. To attain the illusion of relief and depth, a sculptor depends on the effect of overlapping contours (some sharp and apparently near, others vague and seemingly farther back), and on slight changes in the bevel of surfaces within these outlines to attain subtle variations in values (pl. 45). Unfortunately, during the last twenty years, discoloration and abrasion have reduced the effectiveness of the spatial illusion of the reliefs. While some scholars describe reliefs of this sort as "pictorial," the technical means employed are distinctly sculptural, since the effect is dependent on the relative salience or inclination of planes to one another. To be sure, no true *schiacciato* reliefs are found among the Genoese works on which Corte is known to have collaborated, but there are several half-reliefs that suggest he was capable of work as subtle as that of the south portal. Foremost among them are small trophy reliefs on the portal of the Genoese palace of Agostino Salvago on the Piazza San Bernardo (pl. 47), which he contracted to do with Gian Giacomo della Porta in 1532.[109] Though limited to only a few pieces of ancient armor, the forms compare favorably to those of the secondary pedestals of the south portal. For all these reasons—historical, technical, and iconographic—we can confidently attribute the design as well as the execution of the trophaic reliefs to Niccolò da Corte.

Within the context of the portal itself, the subtlety of the relief and its delicate detail are so at odds with the bold scale and robust forms of the architectural members of the south portal that one would be inclined to doubt that the same man would have conceived both. The illusionism of the reliefs dissolves the frontal planes of the pedestals, depriving them of the appearance of solid, cubic mass. Machuca is not likely to have deliberately demeaned their support function in this way or to have identified them, by way of their ornament,

with the secondary "pedestals" on which the recumbent lions were later placed. The function of the latter is not architectural but, rather, iconographic, in that they provide the means of contrasting ancient armor with that of the sixteenth century.

The absolute mirror reversal of the ancient and modern trophy reliefs is also found in the much simpler trophaic reliefs on the pedestals of the Salvago palace in Genoa by the Della Porta and Corte (pl. 47). This reversal is rare, however, and these sculptors, like most Italians, usually maintained a general balance of configurations within a symmetrical composition rather than strict symmetry. The wildmen with lions, who probably held the arms of Agostino Salvago between them, are representative of the near symmetry of heraldic figures in contemporary Italian portals. Also, as we shall see, Corte did not maintain strict symmetry in the sculptural decoration for the Fountain of Charles V (pl. 48) or for the upper story of the south portal (pl. 55), in both of which he seems to have been given a free hand. Machuca, on the other hand, applied the principle of mirror reversal as early as 1530–1533 in the design of the imperial device over the fireplace in the bedchamber of Charles V in the new quarters (pl. 27), and again in 1549, in the reliefs on the pedestals of the west *portada* (pl. 62). Apart from the strict symmetry, probably required by Machuca, the design and even the idea of using low reliefs on the pedestals are attributable to Niccolò da Corte.

From at least 1537, a loggia-like window was planned over the south door. It was consistently called "the window" (*la ventana*) during a quarter century of dispute and indecision over its construction. The first preserved reference was made in a payment of 23 November 1537 to blacksmith Francisco Dávila for the delivery of four stonecutter's hammers to an unnamed quarry and for the sharpening of tools to be used for the "cutting of the columns of the window and other pieces" (*sacando las columnas de la ventana y otras piecas*); later that month, on the 28th (doc. 12), there was a payment for "a very large cart for [carrying] the columns" (*un carretón grande para las columnas*).[110] This reference to columns makes it likely that the

[109] Alizeri, *Notizie*, v, p. 155, n. 1; Kruft, "The Della Porta Workshop in Genoa," p. 941.

[110] Doc. 11 and AA, Leg. 2, 2a, Nóminas, 23 ad 28 Novem-

ber 1537: "A Lavaría, cantero, porque aguzó las herramientas XII días en la cantera, que estuvieron X oficiales sacando las columnas de la ventana y otras pieças, cada día, son dos reales,

south window was a three-light opening, perhaps like the present Serliana form (pl. 44), though we have no clear indication of its design. Materials for it must have been on hand by 14 October 1539 (doc. 25) when payments were made to "6 laborers with a stone mason [who are] closing the portal so that it does not collapse" (*6 peones con un cantero cerrado* [sic] *la portada para que no se estruge*). Evidently the rectangular doorway was filled with masonry so that the lintel would not collapse under the pressure of work above it. Then on 22 December 1539, two months after the south doorway was closed, Gonzalo de Lorca reached an agreement with quarrier Pedro Muñoz on the disputed price for a large quantity of marble for the window of the *portada* (doc. 26), and this agreement makes it clear that the material delivered for the window in 1537 was *piedra negra de la Sierra d'Elvira*. Since the price was the large sum of 199,034 maravedís or 533 ducats (ten times the price of the pediment of the south portal, doc. 9), the quantity of marble could have been enough to face most of the window. It would seem that the specifications for the south window were drawn up by Pedro Machuca late in 1537 or early in 1538, when the lower story was nearing completion; and by December 1539, the south doorway was closed with masonry, and the marble for the window was on hand. No further references were found until 1548, when the window was redesigned.

From these circumstances and observations, we can infer the following sequence of events in the history of the south facade. Machuca first proposed an all-sandstone frame for its portal, with membering like the alternatives indicated in the large Royal Palace plan of 1528 (pl. 107), but he was required to replace it with a marble frame and pedestals broad enough to support coupled half-columns. That project is recorded in the small Royal Palace plan, probably made in 1531 (pl. 18). Then, between 1533 and 1536, he constructed the rejected all-sandstone entry, and early in 1536, he was required to insert a marble *portada*. He probably intended nothing more than Victories in the spandrels and the figure of Abundance in the tympanum of the pediment over the door; but, early in 1538,

Corte induced the governor to face the main pedestals with reliefs of modern trophies and to add secondary pedestals for contrasting reliefs of ancient trophies. By 1539, the trophy reliefs must have been finished, the grey marble for the window above the south portal was delivered, and the doorway itself was filled with masonry in preparation for work on the window. Even so, nothing more was done. A gaping hole was left over the south portal, while the rest of the facade was completed and most of its metal accessories added. Fortunately, some clues to the reason for the delay are found in the better documented history of the disputed west entry.

THE FIRST WEST FACADE, 1540–1542

The lower story of the present marble *portada* on the west facade has usually been dated 1541 (pl. 62), following Manuel Gómez-Moreno y Martínez.[111] Apparently he or his father saw some of the many payments for the delivery of various parts of the west entry during that year, but neither noticed that some of the parts mentioned in these scattered and fragmentary references are not found in the present marble *portada*. What is more important, the pieces delivered in 1541–1542 were cut not from the grey marble of the Sierra Elvira but from the *white sandstone* of the quarries of Santa Pudia. So these payments document an unsuspected first west entry in white sandstone.

The foundations and limestone bearing walls of the west front must have been begun by 1538 because several payments from June through December 1541 identify the material as sandstone facing for that facade (docs. 29-31). The first references to the three-door entry are payments in mid-June 1541 to Martín Cano for carving "some scallop shells for the main entry" (*unas veneras para la portada prinçipal*), and similar payments recorded in 1542 identify them as "shells for the doors" (*veneras de las puertas*).[112] The plural form, "doors," as well as the designation "principal," assures us that the shells were carved for the three-door west entry. Also, among the payments to Domingo de Orende

816 maravedís." There is also a reference on 14 November to "4 maços de yerro . . . para la canteora [?] que se traen para la ventana," and Sonia Csaczar has suggested that the garbled word "canteora" may be "cantonero," which is an angle iron.

[111] Gómez-Moreno y Martínez, *Las águilas*, p. 132; and Gallego y Burín, "Antonio de Leval," p. 59.

[112] AA, Leg. 2, 2c, Nóminas, 14 June to 31 August and 4 October to 29 November 1541, and 1 to 22 March 1542.

for a large order of sandstone from Santa Pudia, there is a reference on 30 June 1541 to "18 pieces for the doorways of the royal palace" (*18 pieças para las portadas de la casa real*, doc. 30). Orende's deliveries continue into 1542, with the stone occasionally identified as "30 pieces for the doorways from the quarries of Santa Pudia" and, at times, as "large and small lintels" (*tranqueros*), "jambs" (*pies derechos*), panels for the intrados of the splayed doorways (*capialzados*), and wedge-shaped stones (*bolsores*).[113] Niches (*nichiles*) were also listed, so it is likely that the "scallop shells" (*veneras*) carved by Cano were shell-faced half-domes for the tops of these sandstone niches.[114] They were not made for the west vestibule, which—contrary to some speculations—was first faced in sandstone in the 1560s, with the remainder done in the 1590s. The niches must have been made for some part of the west facade. We should also note that payments were made from March into July 1542 for at least thirty "large capitals" and seventeen "small capitals," and also for nine pieces of an architrave, all in sandstone.[115] They must have been ordered for the upper story since the Tuscan capitals and the string course of the ground floor are of limestone; but, only twenty-two Ionic capitals were needed for the pilasters of the entire upper story, so the quantity delivered of both sizes is difficult to explain. Perhaps capitals were on order for other facades or, more likely, the term *capiteles* was used for parts of capitals. In any case, it would seem that the three center bays of the upper story included some edicular frames for windows or niches in which the small capitals were used. Though it would seem that some of the facing for the upper story was delivered in 1542, work was apparently still restricted to the lower story because references were made to centering for the construction of the doorways in January 1542.[116] Deliveries of sandstone were recorded through October 1542, but work on the west doors ended in December of that year with the surprising notice of a payment for "tiles to cover the new entry" (*texas para cubrir la*

portada nueva, docs. 29-31, 37). Presumably the tile was used to protect the top course of the unfinished wall above the three sandstone doorways of 1541–1542.

Visual evidence that the present grey marble *portada* was clearly intruded into the sandstone wall confirms the existence of an earlier all-sandstone entry. The undulating edges of the huge severed stones cut across not only the grey marble frame but also the figural reliefs on the outer sides of the outermost pedestals (pls. 59 and 62). It is unlikely that Machuca would have deliberately revealed his massive stones to be sham masonry, and since he was capable of designing the complex and elegant pattern of the rusticated facing, he surely could have conceived a more satisfactory accommodation of the marble *portada* to the sandstone wall. Similar observations with respect to the south entry led to the conclusion that the sandstone facade delineated in the large Royal Palace plan had been constructed first. Now for the west facade, we have documentary evidence for an all-sandstone entry in 1541–1542.

A general idea of the first west entry can be gained by correlating the architectural parts mentioned in the payments and the disposition of the three-bay entry indicated in the large Royal Palace plan, which seems to represent Machuca's proposal of 1528 (pl. 107). References to "doorways" assures us that the sandstone facade under construction—like the one delineated in the plan—had a three-door entry. Because of the reference to lintels, it would seem that at least two of the three doors had rectangular openings. The form of the center door is a matter of speculation, but it was probably similar in shape to the monumental gateways on the three other sides of the west forecourt because (in the large Royal Palace plan) the center door of the facade and the gateways have the same width and are framed by comparable paired pilasters. That format and the function of the gateways would lead one to expect a triumphal-arch elevation, but within the Renaissance idiom, either a

[113] Ibid., 30 June through 13 December 1541, with a reference to "30 pieças para las portadas" on 11 October 1541 and to "capialzadas" on 10 October, 14 November, and 13 December 1541. Comparable payments were recorded during the months of January, March, April, and June 1542.

[114] AA, Leg. 2, 2c, Nóminas, 11 October and 13 December 1541.

[115] Ibid., 17 March, 10 June, 8 and 21 July 1542. Payments

were made to Domingo de Orende for sandstone capitals (or parts of capitals), described as "capiteles mayores" or "grandes," and "capiteles menores" or "chicos."

[116] Though payments for scaffolding were frequently recorded through the years, there is only one instance in which the wood was identified as "para çimbras a las puertas"; see AA, Leg. 2, 2c, Nóminas, 27 January 1542.

semicircular arch or a "flat arch" could have been used. In the case of the south portal, we reasoned that the belated construction of a limestone relieving arch over the rectangular doorway of the marble frontispiece indicates that it was preceded by an arched opening in sandstone. Pedro Machuca clearly intended to use an archway for the passage connecting the two forecourts on the west end of the south facade because the springing of that arch can still be seen (pl. 31). If it were the only large arched opening in the west forecourt, it would have had undue prominence, and for that reason, I am inclined to believe the gateways on the three sides of the west forecourt were arched openings and, thus, that the three-door entry on the west facade was composed of an archway flanked by smaller rectangular doors (fig. 8). Because there was no place in the lower story for the shell-faced half-domes, they must have been intended for the upper story; and, because Martín Cano worked on them for six months, the *veneras de las puertas* must have been made for very large niches. They could only have been located on either side of the central window in the bays above the side doors. Although the documents of 1541–1542 tell us nothing about the form of the window, the greater breadth of the central bay assures us that it was a distinctive opening, perhaps a three-light Serliana window. Obviously, our reconstruction of the lower story of the first, all-sandstone west facade is more dependable than the bays above it, but the drawing serves to give the general configuration of that facade.

[117] Ibáñez de Segovia, *Historia*, fol. 305v, and Ignacio López de Ayala, *Historia de Gilbraltar*, Madrid, 1782, pp. 228-238.

Unexplained by the payments recorded in the account ledgers are the circumstances that led Machuca to initiate the construction of the all-sandstone facade in 1541 and the emperor to suspend work in December 1542. There was no evident impediment to the completion of the west entry, which was begun in 1541. The stone was on hand, including pieces for the upper story, and there was no change in major officials or the work force and no shortage of money. A more likely explanation may be found in the continuing dispute over that entry noted earlier in the discussion of the three extant groundplans. Machuca's erection of an all-sandstone entry in 1541 would appear to have been a clear act of defiance. Perhaps he thought that the emperor in 1539-1540 was so preoccupied with personal sorrow and grave political matters that he would not pay attention to a change in the far-off palace on the Alhambra. It was, of course, in May 1539 that Charles' beloved wife died in childbirth and, disconsolate, he withdrew to a monastery. His retreat of several months was interrupted by reports of a tax revolt in Ghent, and preparations were made for an extended trip to the Lowlands. Charles left Spain in November 1539 and did not return until December 1541. During the same period, Luis Hurtado de Mendoza was often absent from the Alhambra, either to inspect the coastal fortifications or to direct the military forces that protected Gibraltar and the southern coast from the threat of the Turkish fleet.[117] With both the governor and the emperor absent or distracted by more serious matters, Pedro Machuca

Young Iñigo López de Mendoza, the fourth count of Tendilla, was the acting governor of the Alhambra during most of the

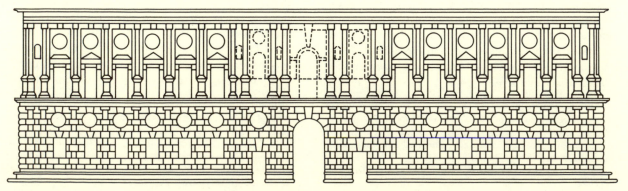

FIGURE 8. Reconstruction of the west facade of 1540–1542

apparently took the opportunity to revive his original idea for the west facade, trusting that, once constructed, it would be accepted, either because its demolition would be too costly or (more in character) because its superiority to the approved marble *portada* would be evident. When Charles returned to Spain in December 1541, he must have heard rumors of Machuca's departures from the approved project and asked for a report on the work. The *traça* sent to court in March 1542, the one wrapped in a roll of sheet tin (doc. 36), was probably an elevation of the west entry, rather than a groundplan as Gómez-Moreno supposed.[118] Taking into account the pace at which matters of this sort were dealt with by Charles and his advisers at court, a nine-month delay until his response in December 1542 would not be unusual. Even so, it was simply an order to stop construction on the sandstone entry and to protect the part already constructed with tile until a final decision on the unauthorized construction could be made.

That Machuca willfully abandoned the approved *portada* and returned to his own earlier proposal for a sandstone entry is also inferred by several restrictions written into the new Work Rules drawn up by Iñigo López de Mendoza in 1546 at the insistence of the court. The new rules include the explicit statement that the *maestro mayor* must show the working drawings of any new part of the palace to the governor and must get his approval before beginning work on it (doc. 41). In another clause, the architect is required to design and order all parts of the palace in conformance with "the project left by the marquis, my lord," referring to Luis Hurtado, under whom the palace was begun. As we noted, written rules were requested by the newly formed Junta de Obras y Bosques, a commission responsible for the supervision of royal works and property. It first met in 1545 during Charles' absence, while Prince Philip at eighteen was regent. Even at that early age Philip displayed great interest in the construction of the royal residences in Madrid and Toledo,[119] and he may have been instrumental in the formation of the Junta to ensure a closer supervision of royal works. While never as interested in the residences in Seville or Granada as in those in Castile, the new commission took up various complaints about irregularities in the works on the Alhambra at its first meeting in May 1545. They must have heard about the six-year delay in the construction of the south window, and then the suspension of work on the west entry and (still to be discussed) the round courtyard. Confronted with Machuca's deliberate departures from the approved project, they were naturally curious to see the rules under which he had worked. The governor, in belatedly writing those rules in July 1546, included the restrictive clauses just mentioned to preclude a repetition of such violations. The Junta may have consulted Luis de Vega, who was then in charge of the royal residence in Madrid and still a favorite of the young prince. Either Vega or Francisco de los Cobos (left behind by Charles for the first time to advise Philip)[120] could have told the prince and members of the Junta that the sandstone entries proposed by Machuca had been expressly rejected by the emperor in 1528. They certainly would have recalled the delay in the construction of the palace caused by the resistance of the former governor and his architect to the wishes of the emperor. Even given this background, the members of the Junta were not able to come to a quick decision against Machuca. They may have waited for a response from the emperor, who was in his German states contending with Protestant princelings. By summer of 1548, certainly before October, a decision was made on the south window and, shortly after, on the use of marble for the frame of the west entry. Thus, the disruptive *portada* was likely the result of a conflict between the design principles of the Italian-trained architect and those of the emperor's Castilian advisers.

period 1535 to 1543, though his father, Luis Hurtado, retained the title marquis de Mondéjar. First, Luis Hurtado left for the Tunis campaign in 1535 and returned with a serious lance wound that required a long period of recovery and then, after the Turkish attack on Gibraltar in the spring of 1540, he was preoccupied with the defense of Andalusia. The royal order appointing Iñigo López as acting governor, dated 22 May 1535, is found in AA, Leg. 2, 1.

[118] See chap. 1, n. 159.

[119] Martín Arrué (*Historia del alcázare de Toledo*, p. 78) stressed the enthusiasm with which Philip assumed responsibility for the royal works in 1543 when Charles V left Spain for extended travel through his other realms. Llaguno (*Noticias*, II, p. 5) noted that Prince Philip later instructed Luis de Vega to keep him informed on the progress of work on the royal residence in Madrid during his own trip abroad in 1548.

[120] Keniston (*Francisco de los Cobos*, p. 257) noted that it was the first time Cobos did not accompany the emperor, and also that, of the three major advisers (Cardinal Tavera, the duke of Alba, and Cobos), Cobos was the most influential.

Because of Machuca's commitment to the monochromatic unity of the all-sandstone facade, he (with the governor's agreement) may have begun construction with the secondary facade on the south rather than the main facade (which was usually raised first) in order to postpone a final decision on the west entry. The narrow forecourt of the south entry restricted the entrant's view of that facade to, at most, the central portal and two bays on either side of it (pl. 35); so Machuca may have reasoned that a marble *portada* on the south would be less disturbing than one on the completely exposed west front. If, however, he succeeded in demonstrating the majestic effect of the sandstone facade, he might win approval for his monolithic project for the more important west facade.

UNCONTESTED CONSTRUCTION, 1542–1548

The prolonged suspension of work on the three controversial projects—the south window, the west entry and the round courtyard—broke the rapid pace of construction maintained from 1533 to 1542. Had that pace been sustained, Pedro Machuca could easily have raised the two main fronts and most of the courtyard before his death, but the work force had to be shifted to the undisputed and less important east and north wings and to the octagonal chapel. During these years, he also undertook the construction of the wall-fountain located at the foot of the Portal of Justice (pl. 17-Q), just below the upper precincts of the fortress; and he seems to have sought more commissions for paintings in the city of Granada and elsewhere because he undertook a half-dozen retables in the mid-1540s.[121] We should recognize that an account of his work on the Alhambra during this period is inconvenienced by the loss of most of the ledgers of the period 1543 to 1550. From these last seven years of his life, the records of only thirteen months have survived, most of them in 1546. The gaps in the

documents make it difficult to determine exactly what was accomplished, but it is evident that the work force was not idle.

The east wing seems to have been the first focal point for work after covering the suspended west entry with protective tile in December 1542. This can be deduced from several unusual activities of the work force around this time. Already in October 1541 and continuing through October 1542, an average of twenty-two laborers were occupied with excavating and then paving a "street alongside the royal palace"(*calle cabo la casa real*).[122] The only side of the palace that would have required that many workers for that length of time in 1541 was the east side. There the foundations of the palace ran along the foot of the hill where the *mezquita* (the church of Santa María) and the *madrasa* (the residence for its three chaplains) were located (pls. 1 and 17-M). Coincidentally, during the winter of 1541–1542, payments were made to carpenters and plasterers for the construction of a new house for the church's chaplains (*abades* or *beneficiados*), "because their house was taken for [the site of] the royal palace."[123] The demolition of that house, ordered by Empress Isabel as regent in December 1531, must have been delayed until late in 1541 when that hill had to be cut away to clear and pave a work strip along the east wall of the palace. Meanwhile, deliveries of limestone blocks and sandstone facing seem to have continued unabated, and from three to six stonecutters, together with their helpers, were paid during all of the months for which we have pay ledgers in the 1540s. Carpenters were occasionally assigned to the construction of scaffolds or cranes for the lifting of stone, but in none of these payments is there a reference to the facade on which they were working. In one instance, on 1 September 1544, a crane was dismantled (probably along the suspended west facade) and another constructed during the following year, presumably along the east wall.[124] While we have this circumstantial evidence, there was no explicit reference to any identifiable part of the east

[121] Gómez-Moreno y Martínez, *Las águilas*, pp. 116-119, p. 225, doc. XXIV. If the date 1547 on the frame of the *Descent from the Cross* in the Prado is also the date of the painting itself, it is another work of this late period.

[122] AA, Leg. 2, 2c, Nóminas, 19 October through 31 December 1541, and 2 January through 12 October 1542.

[123] Ibid., 7 November through 24 December 1541, 2 January through 30 March 1542 (doc. 33).

[124] AA, Leg. 3, 5, Nóminas, 1 and 2 September 1544, for the reference to the dismantling of the crane (*doblando la grúa*). For the construction of the new crane in 1545, see Gómez-Moreno y Martínez, *Las águilas*, p. 231, doc. XXVII, a document copied by his father from old Leg. 228 in the 1880s but not yet found in the new review of the documents by María Angustias Moreno Olmedo.

facade previous to 1576 when the work remaining on that wing was listed by Juan de Maeda (doc. 128). His list includes the transverse walls of the room alongside the chapel on the upper floor and the last four windows over the portal, together with the remainder of the attic level of the facade and its cornice. From this we can conclude that both stories of the south end of the east facade and the entire lower story, including the portal, had been completed before the work force was gradually reduced during the 1570s, following the loss of the yearly tribute paid by the Moriscoes until 1568.

Separation of the work done on the east under Pedro previous to 1550 from that later executed by Luis is hampered by the latter's faithfulness to the designs of the former. The membering and facing of the south facade was simply repeated on the east; however, one small but significant departure assures us that the entire upper story was realized after Pedro Machuca's death in 1550. That departure is found in the corbel. On the east facade, the corbel centered in each bay directly under the architrave of the cornice of the palace interrupts the surround and its cyma reversa molding, whereas on Pedro's south facade, both the surround and its molding were made to pass under the corbel, thus accommodating it to the paneling of the wall (cf. pls. 39 and 43). The absence of this refinement on the east indicates that Pedro's work from 1542 to 1550 was limited to the lower story of the east facade, and that Luis completed all but the last four windows of the main floor during his twenty-two years as architect.

The octagonal chapel on the north end of the east wall was also raised during the 1540s (pl. 1), and the work was amply documented by specifications and contracts for limestone from Alfacar and Monachil and by payments for its delivery. As we noted, the lower chamber that forms the foundations of the chapel had been completed by the autumn of 1542, when workmen smoothed the surface of its vault. The next notices, in the summer of 1543, are specifications for limestone. One

was dated 18 August (with the contract signed on 29 August) and another, though undated, seems to pertain to the same period.[125] Among the great number of nondescript blocks delivered during the next three years, there were payments for 200 interior and 200 exterior corner pieces (*esquinas y angles de los dos ochavos asy de la parte de dentro como de fuera*). Because the massive walls of the chapel are composed of gravel framed by inner and outer walls of limestone, the *esquinas* and the *angles* must be their inner and outer corners. The wedge-shaped voussoirs (*claves*) that close the chapel's flat-arched windows and the springers (*salmeres*) on which they rest were not delivered until 1552 (doc. 64), that is, two years after Pedro Machuca's death. Work on the chapel apparently continued under his son, Luis, who seems to have used the stone ordered in 1543–1545.

With work on the palace restricted to its northeast angle in the mid-1540s, the new governor, Iñigo López de Mendoza, decided to employ Machuca in the design of the architectural frame of a monumental wall-fountain at the top of the steep road leading up from the Cuesta de Gomérez to the Portal of Justice (pl. 17-Q) and then into the upper precinct of the Alhambra. Known since the eighteenth century as the *Pilar de Carlos V* (pl. 48), it is composed of a marble basin of over eleven meters, set against a white sandstone wall that rises almost seven meters into the side of the steep hill leading up to that portal. Because of the dampness that seeps through the wall, much of the marble sculpture had to be replaced in 1624. One would expect that the more fragile sandstone would have also deteriorated by then and have been replaced, but the first recorded restoration is that of the 1960s.[126]

Machuca's specifications for the fountain and its marble basin are preserved, and we also have a record of the contract with Niccolò da Corte in October 1545; on November 5, a contract was signed with quarrier Juan de Nabardayn for the delivery of the marble needed for the panels and moldings of the parapet and the six pieces that were

[125] Full transcriptions of these specifications are found in Gómez-Moreno y Martínez, *Las águilas*, pp. 226-228, doc. XXV. The first undated contract is now in Leg. 5, 52, and the second, dated 18 August 1543, in Leg. 3, 4.

[126] Alonso de Mena noted that the mythological roundels were in very bad condition "because they were of sandstone"; see Rosenthal, "The Lombard sculptor Niccolò da Corte," p.

218, n. 51, for the list of repairs in 1624. Photographs of the early part of this century show the deteriorated condition of the sandstone wall previous to the partial renovation of the 1960s, in which weathered sandstone was taken from the old post office (*Casa de Correos*), formerly located along the Calle de los Reyes Católicos at the head of the Gran Via de Colón.

to form the lunette at the back of the fountain.[127] The only reference to sculpture in the contract is the statement that Machuca was to provide the design for the imperial arms in the lunette (*para el medio redondo, donde an de venir las armas ymperiales, devastados por su contramolde*). There was no mention in Machuca's specification of the two winged geniuses hugging dolphins on either side of the lunette nor the two pouring water from vases on the lower level (pls. 48 and 49), and none of the pieces Nabardayn agreed to provide in November 1545 can be identified with those figures. Marble for the winged geniuses was not delivered until a year later, on 22 December 1546 (doc. 44), and then by another stonecutter, Miguel de Velustegy, in a delivery that included ten other pieces from the quarries of the Sierra Elvira (*dyez pyeças de la Serra d'Elvyra para el pylar para las armas y nyños*). A few days before, on 17 December, the first quarrier to contract the marble, Nabardayn, was paid fifty ducats for "all the stone for the fountain from the [quarries of the] Sierra Elvira and Santa Pudia that was ordered from him" (*de toda la pyedra del pylar de la Syerra d'Elvira y de Santa Pudya que fue rematada en él, cynquenta ducados*).[128] Because the sum paid was eight ducats less than the fifty-eight stated in his contract and because the piece for the lunette with the imperial arms listed in that contract was delivered by the second stonecutter, Velustegy, it is reasonable to assume that Machuca's lunette was replaced by another designed by Corte and that its parts were ordered along with the marble for the added figures of the geniuses.

Corte's alteration of the lunette with the imperial arms is also indicated by stylistic evidence. The voussoirs that compose the present archivolt are all of equal size, whereas, according to Machuca's specifications of 1545, his keystone was to have been larger in size and to have projected 28 centimeters more than the other voussoirs. Also the great discrepancy between the width of the present archivolt and that of its paneled supports (carved with imperial emblems) suggests that the lunette was reduced in size to provide a place for the two small figures with dolphins. Furthermore, the strongly modeled archivolt is at odds with Machuca's linear and sharply edged forms. Also, while the emblems of the city (the pomegranates or *granadas*) in the center of the lower level and the arms of the Mendoza family on the ends are enclosed in architectural frames,[129] the three heads of bearded men with bundles of wheat, flowers, and grapevines in their hair were carved on unframed panels. Most incongruous of all, within the context of Machuca's architectural repertory, are the awkward scrolls on either side of the central unit. It would seem that Corte not only added sculpture to the fountain but that he also made changes in the architectural design to accommodate his sculpture. Machuca, with so many of his projects suspended, may have been at a disadvantage in any disagreement with the Italian sculptor, then favored by the governor and given high appraisals for his sculpture by Diego Siloe. There is no evidence of a prolonged dispute: laborers were assigned to the preparation of the foundations for the fountain from April to August 1546, and even before they had completed that task, stonemasons (*asentadores*), with from ten to forty assistants, were at work on the construction of its sandstone wall.[130]

[127] The two contracts were published by Gómez-Moreno y Martínez (*Las águilas*, pp. 232-233, doc. XXVIII, then in Leg. 228 and now in Leg. 3, 8). The pertinent item reads: "yten a de aver seis pieças de la Syerra Elvira para el medio redondo donde an de venir las armas ymperiales devastadas por su contramolde que tenga de lecho pie y medio y de grueso un pie ortogado, y a de aver una pieça con este mismo contramolde que tenga de grueso dos pies y medio por la fruente y pie y medio de lecho para le clave del dicho medio redondo."

[128] AA, Leg. 3, 5, Nóminas, 17 December 1546.

[129] María Angustias Moreno Olmedo (*Heráldica y geneología granadinas*, Granada, 1976, p. 75, pl. XXXVII, 1) identified the arms of the fountain as those of Iñigo López de Mendoza, the second count of Tendilla and first marquis of Mondéjar, who died in 1514. In the upper and lower segments of their decussate shield, there is a diagonal band (red, edged with gold, on a green ground), while *Ave Maria* and *Gratia plena* in gold letters on a red ground are found in the side segments. Both recall the victory over Islam at Salado in 1340 in which the Mendozas played a key role. The points of the star that guided the Magi to the Christ Child project from behind the shield. The star and the motto *Buena Guia* (on the banderole) were granted by Innocent VIII to Iñigo López de Mendoza, the first marquis of Mondéjar, in gratitude for his successful negotiation of the peace with the pope, King Ferdinand of Naples, and other powers of Italy. The device was first used by Iñigo López in his entry into Rome on 13 September 1486; see Ibáñez de Segovia, *Historia*, fol. 93.

[130] AA, Leg. 3, 5, Nóminas, 28 April to 3 May 1546, for references to the excavation of the trenches, and 26 May through 19 August for construction of the foundations (docs. 39 and 42). Mena in 1624 referred to the "fountain of the horns" (*de las cornetas*), and we know that "two horns of iron" (*dos cornetas de hierro*) somewhere on the fountain were mended and gilded in 1589; see AA, Leg. 21, 4, 2, Nóminas, 11 March 1589.

So it would seem that Machuca made the basic architectural design, limiting sculptural ornament to the imperial arms, but Niccolò da Corte redesigned the latter and extended the sculptural program of the fountain as he had that in the lower part of the south portal.

We can determine the sculpture of the fountain that best represents the artistry of Corte by excluding the parts that Alonso de Mena listed as restored or replaced in 1624 in preparation for the visit of King Philip IV.[131] The parts completely replaced were the three heads of the bearded men, the two large pomegranates, and the arms of the Mendoza family at the outer ends of the lower parapet behind the basin; on the next level, the emblem of the Order of the Golden Fleece to the right of the inscription, the tops of the columns and the head of the eagle in Charles' device on the left (pl. 48). Of the four geniuses, the heads of two and the arm of one had to be redone. In the lunette, Alonso de Mena had to replace one quarter of the imperial arms and a few feathers of the double-headed eagle. Finally, he noted that the four roundels in sandstone with mythological subjects (*fábulas*) had disintegrated to the point that they had to be made anew. So these elements must be put aside in an evaluation of Niccolò da Corte's art. Mena also stated that all of the sculpture in "hard stone," meaning marble, "was *shaped-up* with the chisel and polished with pumices" (*se retundió en boca de çinçel y se bruñó con bruñidores*). While the pieces not replaced were resurfaced or at least polished, the sculptural form seems to have been left more or less intact. Thus, still representative of Corte's hand are the lunette with the imperial arms (in which Mena replaced only one quarter), the magnificent eagle (minus a few feathers), most of Charles' columnar device, and (with the exception of two heads, and the arm of one) the four geniuses. Of these last, the best preserved genius is the one with the dolphin to the left of the lunette. He is readily compared to the vigorous little figure in the right spandrel of the south portal and also to those alongside the inscription over the portal of the palace of Andrea Doria on the Piazza San Matteo in Genoa (cf. pls. 46, 49, and 51). All have similarly shaped heads and features, puffy jowls, and slightly dyspeptic expressions. None of the

other heads seems to be Corte's, so it is likely that the head of a third *putto* had to be replaced after Mena's time. The new head of the little fellow with the dolphin, to the right of the lunette, was displaced so that he turns and looks back over his shoulder, and this results in a marked spiral rhythm that is not found in Niccolò da Corte's figures. It is more likely that the original head faced toward the front, because the shoulders and the chest were not prepared for so abrupt a turn. The other two geniuses on the lower level have suffered greatly since Mena's restoration, but their bodies still evince the physical traits and the angular rhythms characteristic of the Lombard sculptor (pl. 51). Also in the handling of the wings of the imperial eagle, there are reminiscences of the Victory in the right spandrel of the south portal (cf. pls. 49, 51, and 53). The alternation of narrow and wide feathers (less rigidly maintained in the eagle than in the Victory) and the rippled edges of the feathers reveal the two wings to be by the same hand. The double-eagle and the undulating banderole inscribed with the motto PLUS OULTRE are beautifully disposed to fill the lunette and to form a plastic climax along the central axis. Its successful adjustment to the lunette recalls the skill with which the Victory was accorded to the area of the spandrel. Carved with delicacy and precision, the lunette reveals that Corte had gained a greater technical command of the marble of the Sierra Elvira, a material still new to him when he undertook the Victory and the trophy reliefs on the lower part of the south portal. With the exception of the broken beaks of the double-headed eagle and the badly repaired imperial crown, this relief represents one of the high points of his art. Its quality and style confirm our attribution of the design of the lunette to Corte.

Even the panel with Charles' titles presents analogies to the one above the portal of the palace of Andrea Doria (cf. pls. 49 and 51). The frames surrounding both inscriptions are composed of a large fillet, a cyma reversa molding, and a small fillet, while the leafy scrolls on either side are made up of similar elements. A simplified version of the scroll was later used as a crest atop the tablets held by the seated figures above the window over the south portal (pl. 50). The lively curve of these small scrolls contrasts with the awkward line and

[131] Rosenthal, "The Lombard Sculptor Niccolò da Corte," pp. 218-220, n. 51. The cherub's head at the top of the lunette was not mentioned by Mena, and its pristine condition suggests

it is a more recent replacement. According to Ceán Bermúdez (*Diccionario*, III, p. 59), two Victories were mounted over the lunette in 1800.

the gross ornament of the overly large scrolls on either side of the central unit. In their present form they cannot be attributed to Corte and they are wholly at odds with Machuca's repertory, so we must assume that they are either replacements or additions of the seventeenth century. Beneath the scrolls, a crinkled banderole bears the letters *PLUS O* on the left and *ULTRA* on the right (an ambiguous presentation of both the original French form and the later Latin translation of Charles V's motto).[132] Corte can also be attributed the design of the letters because they are shaped in essentially the same way as those of the inscription on the Doria Palace in Genoa (cf. pls. 49 and 51). Particularly notable are the *R* with the long trailing curve, the *E* with an unusually long center bar, the *S* with the equal curves in the upper and the lower portions, the *M* with the first two strokes closer together than the other two. The letters were also spaced according to the same simple scheme. In both, the sculptor allotted the same interval along the baseline between adjacent letters, unmindful of the resulting closeness of combinations such as *IM* or *NI* in contrast to the openness of others such as *KA* or *RA*. The results of this faulty system are seen in the disruptive spacing of *LIBER ATORI* on the Genoese portal and *IMPER ATORI* of the Alhambra fountain. The repetition of the motives and techniques used on the Doria portal in 1528 assures us that Corte was responsible for the plaque announcing Charles' titles.

Corte had also agreed to execute the oblong basin according to Machuca's specifications, but the present form has a width of 1.70 meters and that is a good deal more than the specified range of 3 or 4 Castilian feet (0.83 to 1.20 meters). Beyond that difference in measurement, the bold, bulbous shape of the basin points to a seventeenth-century rather than a sixteenth-century designer (pl. 48). Furthermore, Machuca's specifications call for a lion or, more probably, a lion's head at some point; it is cited in a muddled passage (*más que a de ser laborado todo este pilar según está señalado en la traza donde está el león con que se dará la moldura para ello*).[133] However that passage is interpreted, the disparity of the measurements of the present basin and its distinctly Baroque shape, together with the lack

of a lion, indicate that the basin no longer follows Machuca's original design.

Corte's round reliefs representing mythical subjects on the back wall of the fountain were in such poor condition by 1624 that they had to be replaced by Alonso de Mena. Today, three hundred and fifty years later, Mena's reliefs have deteriorated to the point that it is difficult to speculate on how closely he followed Corte's original compositions and figural types. The fragile forms and lively movement of the present reliefs have no counterparts in Corte's sculpture, so it is possible that Mena retained the original iconography while redesigning the compositions. There is, however, no reference to his renovation of the membering of the back wall, but it is difficult to believe that it survived unaltered until it was restored in the 1960s.

As the work on the wall-fountain was drawing to a close and the east front and the massive walls of the octagonal chapel were reaching the second story, decisions were made on the disputed south window and the west entry. The design and preparation for the execution of these two major projects seem to have occupied Pedro Machuca during the last two years of his life.

THE SOUTH WINDOW, 1548–1555

The dark gaping hole over the marble frontispiece framing the south portal must have looked like an open wound on the otherwise completed white sandstone facade. We noted earlier that the loggia, usually called *la ventana*, was intended from at least November 1537 when reference was made to work on "the columns for window" (docs. 11 and 12). Two years later, in October 1539 (doc. 25), the south door was filled with masonry, and on December 22 of that year, the price for the grey marble delivered for the window was settled, after a dispute of unknown duration (doc. 26). No further references were found until nine years later when Niccolò da Corte signed a contract on 26 October 1548 to execute the window according to a new project by Pedro Machuca (doc. 45). The sculptor was to supervise its construction by a stone mason

[132] Earl E. Rosenthal, "*Plus Ultra, Non Plus Ultra*, and the Columnar Device of Emperor Charles V," *Journal of the War-* *burg and Courtauld Institutes*, XXXIV (1971), pp. 217–219.

[133] Gómez-Moreno y Martínez, *Las águilas*, p. 232, doc. XXVIII.

and laborers of the work force assigned to that task. A minimum price of 1,100 ducats was agreed upon, with a possible maximum of 1,400, depending on the appraisal of the finished work by Diego Siloe and Pedro Machuca. Incidentally, the specifications refer to encasements of wood with glass panes (*encasetes para puertas e vedrieras*), indicating that it was to be a glazed casement window. Of special interest is Machuca's stipulation that the pedestals of its paired Corinthian columns had to coincide in height with those of the sandstone pilasters and also that its entablature (*recuadrada de molduras*) was to follow that of the rest of the facade. Care was to be taken in the selection of marble for the window to assure that "there would be no difference" with that of the lower story, presumably in color. Another clause required Corte to follow Machuca's project, even in details such as "the moldings, designs, and carvings" (*moldes, debuxos y entalles*). Evidently, Machuca wanted to make certain his design would not suffer the alterations and elaborations that Corte had introduced into the lower story of the south portal and the fountain.

The portal's sculptural ornament was not delineated in Machuca's project, but the contract reads: "on these above-mentioned pedestals have to go four stories (*historias*) in half relief which his Lordship will order" (*en estas susodichas estilóbatas an de yr quatro ystorias de medio relieve de lo que su señoría mandare*). Since the governor, Iñigo López de Mendoza, had not yet chosen the subjects, nothing more than the size of the panels was stated by Machuca. The same seems to have been true for the figures above the arch of the window. Machuca's specifications read: "above this said arch [of the window] have to go two Victories of a size that is appropriate [for the area and] of half-relief, with two vases at their feet" (*encima d'este dicho arco an de yr dos vitorias de la grandeza que convinyere, de medio relieve, con dos vasos a los pies*). So, there is no documentary basis for the general assumption, first expressed by Carl Justi, that Pedro Machuca made designs for the reliefs and the figures of the upper story of the south portal. In view of our earlier judgment that Corte's trophy reliefs were too delicately carved for the pedestals of the robust half-columns of the lower story, it is significant that Machuca stipulated that the carving on the

pedestals of the window were to be in "half-relief" (*medio relieve*). Had Machuca lived to see the window completed, I suspect he would have found the rougher texture of its reliefs better scaled to his architectural membering than the delicate reliefs of the lower story, but he is not likely to have approved the size of the figures over the window. Described in the specifications simply as "of an appropriate size," these figures extend beyond the confines of the architectural frame of the spandrels in that their wings and writing tablets cut across the enclosing surround. With this exception, Corte seems to have followed Machuca's project because the pieces listed in the sculptor's later contract with the stonecutters on 23 August 1549 coincide with those in the architect's specifications (doc. 48).

No materials for a marble balustrade or parapet were mentioned, so it is likely that nothing more than a wrought-iron railing was intended for the casement window. If ever installed, the railing was gone by 1767 when José de Hermosilla made his drawings of the south facade (pl. 34). A generation later, however, Domingo Velestá, in his engravings for the Academy of San Fernando in 1793, proposed iron railings in all the main-story windows (pl. 102). The present marble parapet and the plate-glass enclosure of the south window were designed in December 1965 to serve the needs of the provincial museum installed in the upper story of the south wing (pl. 44), but Machuca in 1548 intended casement windows that could be closed during cold or inclement weather and, probably, a protective iron railing.

About the progress of Corte's work we know very little because the pay ledgers for 1550 and 1551 are missing. Already on the first of November 1548, shortly after signing the initial contract, Corte wrote to his friend Pietro Ponserto in Genoa to request an assistant to help him with the sculpture of the *finestra*.[134] The following February, Ponserto informed Corte that young Niccolò de'Longhi, the son-in-law of Gian Giacomo della Porta, had agreed to go to Granada as his assistant, but there is no record of Longhi's arrival nor any reference to his participation in the work on the window. By February 1549, when Corte heard of that arrangement, he knew that he was going to have difficulty in contracting the delivery of the marble facing because the governor was evidently

[134] Alizeri, *Notizie*, v, p. 234, n. 1.

not willing to pay a sum commensurate with the difficulties involved. In fact, there was a ten-month delay in the signing of the contract with the stone carters. Because of the ten-month delay, Corte probably advised Longhi to postpone his voyage to Spain, and in the interim, the young sculptor may have become involved in other work in Genoa.[135] We know that some of the large pieces of stone were not yet on hand in June 1551, when the two carters asked to be released from the task of delivering what remained of their contract. In their petition (doc. 52), they recalled how much difficulty the architect and the overseer had encountered in making arrangements for the costly delivery of the "two pieces for the two figures" (*dos piedras para dos figuras*), presumably those mounted over the window.[136] Because the two stone carters refer to Pedro Machuca's involvement in these negotiations, it is evident that these pieces were delivered only shortly before his death in July 1550.[137] At the same time, in early June 1551, the stone carters requested payment for 125 pieces of marble already delivered for the window, and in early December a second delivery included some architectural elements (docs. 52 and 57). By that time, Niccolò da Corte seems to have been seriously ill because in July 1551 he gave up his house on the Alhambra and moved down to the city, probably to the house of a Genoese merchant, Girolamo Spinola, who in January 1552 reported the sculptor's death to the governor.[138] The executor of Corte's will, in rejecting a claim against his estate (doc. 58), apparently by the governor of the

Alhambra, stated that the sculptor had done all that was asked of him;[139] however, it is clear that the window was not yet assembled, though it seems most of the pieces were on hand. Corte's guarantor (*confiador*), Juan del Campo, then took responsibility for completion of the window, finally terminating the work in June 1555 (docs. 80 and 81). At that time, he received the final payment, which brought the total to only 1,290 ducats—well under the maximum of 1,400 ducats stated in the contract. Known to us primarily as a designer of glass windows, and so identified in the contract of 1548, Juan del Campo is not likely to have finished any of the sculpture as some have assumed.[140] His responsibility was characterized in October 1553 as "the manufacture of the window of dark marble."[141] Apparently dissatisfied with the first appraisal, Juan del Campo in May 1555 protested that he had to pay "the craftsmen who made it" (*los oficiales que la labraron*).[142] As the guarantor, he was responsible for the completion of the work but not necessarily the execution of the sculpture. From this information, we can conclude that the Neptune reliefs were executed before the large figures over the window. Even so, the four pedestal reliefs were not begun before autumn 1549, as the contract with the stone carters was not signed until August of that year, and the large pieces for the two winged figures were not delivered until a half-year later. As a result, Corte could not have completed both figures and all the reliefs before he became ill in July 1551. Before looking to stylistic evidence for the works attributable to him, we

[135] Kruft ("The Della Porta Workshop in Genoa," p. 912, n. 6), unaware of this delay in acquiring the marble, assumed that Niccolò de'Longhi kept his promise; but, if Longhi had worked with Corte, he is likely to have been mentioned in the arrangements to complete the window after the latter's illness and death in 1552. Though Alizeri (*Notizie*, v, p. 235) assumed that the window was finished by sculptors called from Genoa, he did not name them.

[136] The size of the pieces given in the 1549 contract (doc. 46) was 4 by 7.5 Castilian feet or 1.39 by 2.19 meters.

[137] The stone carter's request for payment on 4 June 1551, see AA, Leg. 5, 16c.

[138] Corte left his house on the Alhambra (which had two stories and a little tower) before 1 August 1551, when it was leased for rent. The document (AA, Leg. 208, 17) was kindly shown to me by María Angustias Moreno Olmedo. We know he made out his will on 17 August 1551, with some additions on 29 December of that year. For his testament and the report of his death by Spinola, see "Il testamento dello scultore Niccolò da Corte," *Bollettino storico della Svizzera italiana*, XXX

(1908), p. 53.

[139] AA, Leg. 3, 11, fol. 9 (undated but certainly 1552): ". . . el dicho Nicolao de Corte hizo en su vida todo lo quel era obligado y mucha obra más."

[140] Antonio Gallego y Burín, "Documentos relativos al entallador y vidriero Juan del Campo," *Cuadernos de arte*, 1 (1936–1937), pp. 354ff. José María de Azcárate, *La escultura y la rejería españolas del siglo XVI* (Summa Artis XVIII), Madrid, 1961, p. 253.

[141] AGS, CM1, Leg. 1120, a payment on account of 4 October 1553, "para en quenta de la manifatura della ventana de mármol negro que haze en la puerta açesorias (sic) de la dicha casa real, que encomença a labra mase Nycola de Corte que falleció. . . ." (doc. 69).

[142] AA, Leg. 5, 32, fol. 3, for a reclamation of 19 to 24 May 1555 against the appraisal of Diego Siloe and Luis Machuca on 18 May 1555 (docs. 78 and 79). Campo was still considered responsible in 1568, when some moldings on the pedestals had to be repaired (doc. 125).

should identify the pair of figures over the south window.

The two winged figures were described in the contract as "Victories . . . with two vases at their feet," but their actions connote a more specific significance. The handsome woman seated on the right has one foot on a cubic block and writes on a tablet braced against her raised knee (pl. 53). The strong rhythm of her arm and the way the drapery swirls about her body indicate that she writes with great enthusiasm and even excitement, but her face is serene and her gaze fixed on high, suggesting that she records deeds of an elevated and even transcendental nature. Surely she is a personification of History recording the triumphs and great deeds of Emperor Charles V. Ancient Roman and Renaissance representations of History usually depict her as a standing Victory, with one foot placed on a helmet to brace an oval shield against her raised knee.[143] Even so, Corte's seated figure is not without precedents. Nicoletto Rosex da Modena's early sixteenth-century engraving of a seated Victory in profile, writing on a curvilinear shield braced against her knee, is identified by the inscription as *Fama Volat* (pl. 52).[144] She is seated on a cuirass and her raised foot rests on a helmet, following the ancient Roman image. In contrast, the raised foot of Corte's figure of History over the south window is placed on a cube, a symbol of Truth according to the late sixteenth-century explanations of Luca Contile and Cesare Ripa.[145] Since Giulio Romano in 1530 also depicted a seated History writing on an oval shield in a lunette of the Sala degli Stucchi in the Palazzo del Te in Mantua,[146] it would seem to be a type employed by artists working in northern Italy during the first half of the sixteenth century.

The winged figure seated on the left side of the Alhambra window has the physical traits of a youth rather than a woman (pl. 50). He does not write but simply displays a tablet, presumably one on which History wrote the first part of the inscription she is about to conclude on the right. Unfortunately and surprisingly, no letters were inscribed on the tablets, but it is likely inscriptions were intended. Sometimes the shield held by personifications of Victory bear nothing more than the word VIHTORIA, as in the drawing after an antique model in the Codex Escurialensis attributed to the School of Ghirlandaio and known to have been in Spain by 1509.[147] At times, the inscriptions were more extensive, like the one on a triumphal arch erected for Charles' entry into Burgos in February 1520. There Fame held an inscription predicting that young Charles would surpass the military exploits of his illustrious forebears, the Catholic Monarchs: PLUS ULTRA QUE LOS PASADOS / CARLOS AVEIS DE PASAR . . .[148] Six years later, on an arch erected for his entry into Seville, Fame wrote "For Perpetual memory on earth and in Heaven" (PARA PERPETUA MEMORIA EN LA TIERRA Y EN LA GLORIA).[149] The shield held by Giulio Romano's seated figure of History in Mantua mentioned earlier had the letters CAROL[O]. Eneas Vico commemorated the 1547 victory at Mühlberg in an engraving depicting Valor as a woman in full armor viewing the battle, and writing: "Magnanimity is the propagator of the most illustrious deeds" (MAGNANIMITAS PRAECLARISSIMARUM RERUM PROPAGATRIX), while a genius holds the inscription, "Responsibility augments wealth and power" (DIVITIAS ET IMPERIUM AUGET SOLICITUDO).[150] The south window exhibits no evident reference to that important victory at Mühlberg but, rather, it celebrates imperial maritime power, perhaps referring back to the 1535

[143] L. D. Ettlinger, "The pictorial source of Ripa's 'Historia'," *Journal of the Warburg and Courtauld Institutes*, XII (1950), pp. 322-323.

[144] A. H. Hind, *Early Italian Engraving*, London, 1938-1948, V, p. 117; and VI, pl. 646, fig. 17.

[145] Cesare Ripa, *Iconologia, overo descrittione di diverse imagini cavato dall'antichità e di propria inventione*, Rome, 1603, p. 235: "[History] tiene posati il piede sopra il quadrato, perche l'Historia deve star sempre salda, ne lassarsi corrompere, o suggiarcere de la alcuna banda con la bugia per interesse, che perciò si veste di bianco." See also Ettlinger, "Ripa's 'Historia'," p. 323. The cube was said to have been symbolic of "virtù ferma e ben fondata" by Luca Contile (*Ragionamento sopra le proprietà*

delle imprese con le particolari degli accademici affidati et con le interpretationi e croniche, Pavia, 1574, pp. 71-72).

[146] Frederick Hartt, *Giulio Romano*, New Haven, 1958, pp. 148-149, figs. 307 and 320.

[147] Egger, *Codex Escurialensis*, pp. 94-95, fol. 31. Hanno-Walter Kruft, "Concerning the date of the Codex Escurialensis," *Burlington Magazine*, CXII (1970), pp. 44-45.

[148] J. Alenda y Mira, *Relaciones de solemnidades y fiestas públicas de España*, Madrid, 1953, p. 18.

[149] Ortiz de Zúñiga, *Anales eclesiásticos*, p. 487.

[150] Adam Bartsch, *Le peinture graveur. XV. Les graveurs de L'Ecole de Marc-Antoine Raimondi*, Leipzig, 1867, p. 339, no. 255.

victory at Tunis. Since the youth on the left side is an assistant or companion of History who makes known the worthy deeds she has recorded, his role seems to be similar to that of Fame on the triumphal arches in Burgos and Seville in the 1520s, and also the figure with a tablet sketched about 1524 by Michelangelo for the Medici tombs and described by the sculptor as "Fame [who] holds the epitaphs in position."[151] With these precedents in mind, I think it is reasonable to suggest that the companion of History on the Alhambra portal is Fame.

Still problematical, however, is the significance of the ewers or water jars in the form of the late Roman oinochoe at the feet of both figures. Apparently the ewers were important iconographically because they were specifically mentioned as *vasos a los pies* in Machuca's specifications. Some scholars have suggested that the ewers refer to the sea and are thus related to the Neptune iconography of the pedestals, but vases representative of rivers or the sea are usually overturned so that water appears to pour from them. A comparable upright ewer is found in Andrea Riccio's Terrestrial Fame in a bronze relief, now in the Louvre but formerly on the Della Torre tomb in San Fermo in Verona, that was executed about 1516–1521. Riccio's winged Victory, blowing a trumpet and holding a laurel wreath, stands on a globe, with the winged skeletal figure of Time and his fallen scythe at the right and Pegasus on the left, probably representing "illustrious fame" (*la chiara fama*), the meaning that Cesare Ripa gave to the wondrous winged horse.[152] To the right of the globe, together with a book and a small cornucopia, is a ewer, with branches of the unwithering laurel leaves emerging from its neck and spout. The ewer bears the inscription VIRTUTIS, so it would seem that the ewer in Riccio's relief represents the virtues that assure eternal fame. A somewhat similar reference is found in the inscription on a ewer in Giorgio Vasari's portrait of Lorenzo de'Medici, executed about 1534.[153] It reads "the vase of all virtues" (VIRTUTUM OMNIUM VAS) and a second inscription on the pedestal explains that it

contains "the virtues that subjugate vices" (VITIA VIRTUTI SUBIACENT). A third inscription under his arm on the left explains that by passing on to his descendants the virtues of the Medici family, Lorenzo had lighted the way to their ascendency in Florence. Renaissance humanists tended to identify virtue as man's highest achievement and to hold that the glory it attains enables man to transcend death. That would seem to be the meaning of the ewers in both Riccio's and Vasari's works and it would be well suited to the vases alongside Corte's winged figures.

The two winged figures are intimately related iconographically, but they differ in quality. The superb personification of History on the right is exceptionally well composed and beautifully modeled (pl. 53). Most admirable is the sculptor's control of the successive planes by which the figure gradually emerges from the surface of the wall and attains its plastic climax in the three-quarter round relief of the head and the writing arm. The continuous volume of the body under the swirls of the *draperie mouillé* is fully realized. Rhythmic vitality is given to the figure by the flow of the undulating lines from the arm into the shoulder, encircled by the billowing sleeve, and on into the contour of the wing. By contrast, the youth, here identified as Fame, is rather uncertain and awkward in form and movement (pl. 50). The flat, undifferentiated planes of his back and shoulder, like most other parts of the figure, are almost devoid of interior modeling. The sculptor was not able to achieve the richly bossed form of History, and he failed to use the oculus to enhance the relief of his figure. Also missing is the linear vitality of the contours, the crisp definitions of the folds, and variety in the disposition of the drapery of History. Clear evidence that a lesser sculptor carved the figure of Fame is found in the short horizontal ridges of the folds of the garment, in the erratic line of the hem, which obscures the shape of the lower legs, and in the meaningless folds over the shoulder. The wavy ridges of his hair contrast with the softer and more varied disposition of History's hair. Equally awkward are the size and salience of

[151] Luitpold Dussler, *Die Zeichnungen des Michelangelo. Kritischer Katalog*, Berlin, 1959, p. 97, no. 153r, pl. 61 (a drawing in the British Museum, London).

[152] Ripa, *Iconologia*, col. 143.

[153] Vasari's portrait (Galleria degli Uffizi, Florence, no. 1578)

was interpreted by Ute Davitt Asmus (*Corpus Quasi Vas. Beiträge zur Ikonographie der italianischen Renaissance*, Berlin, 1977, pp. 48-59) who identifies the several inscriptions with the Ciceronian metaphor characterizing the human body as a vase or vessel of the spirit.

the end feathers of the wing that projects beyond the tablet held by Fame, as well as the bulbous shape and inelegant contours of the ewer at his feet. Because Fame betrays no evidence of the corrective hand of the Lombard sculptor, I suspect it was one of the works executed by an assistant after Niccolò's death. Whether his assistant was Niccolò de'Longhi (who agreed to come to Granada but was not needed for almost a year) or another unknown Italian or a local Spaniard is of interest only for the purpose of completing the story of the south window since the modest talents employed here are not likely to have made an impression on the Granada school of sculpture.

That the personification of History is the work of Niccolò da Corte is assured not only by the quality of its conception and execution but also by its similarity in figural type to Fortitude in the relief on the Altar of the Apostles (formerly a tomb) in the cathedral of Genoa, which Corte did in collaboration with Gian Giacomo and Guglielmo della Porta from 1533 to 1537 (pls. 53 and 57). Analogies are found in the general proportions of the figures and in the fleshy, dimpled arms, the cylindrical form of the neck, the full, rounded cheeks, and the mass of hair over the low forehead. The swirls of the drapery over the abdomen and the wind-blown sleeve of the two figures are also similar in treatment, but the clinging "wet drapery" of the Virtue in Genoa was avoided in the History on the Alhambra, perhaps in deference to a different sense of decorum in Spain. The similarity of the two figures serves to identify both the Fortitude and the History as Niccolò's because he was the only sculptor who worked on both the Genoese altar and the south portal of Charles V's palace on the Alhambra. In the intervening thirteen years he had gained greater skill in the definition of the body beneath the drapery and in the rhythmic coherency of the figure, but apparently he continued to admire the same physical type, which is seen again in the small figure of Amphitrite in Neptune's sea chariot on the right pedestal of the south window (pl. 54). The facial type found in all three figures is characterized by a square jaw, full cheeks, and a low forehead under a full head of wavy hair. In both, the mouth is small and full and the nose is rather flat. Again, as in the figure of History, the cylindrical neck, the rounded belly, and the general proportions of Amphitrite present striking similarities to the Virtue in Genoa, thus assuring us that all three were executed by Niccolò da Corte.

Before continuing our search for Corte's hand in the four reliefs on the pedestals, we should note that the subjects, *Neptune Calming the Tempest* and *The Marriage of Neptune and Amphitrite* (pls. 54 and 56), may have been new to Spain though references to Neptune were frequently used in programs for Charles V's triumphal entries in Italy.[154] While we must assume that Corte had seen representations of these subjects in maritime Genoa, where the story was a favorite, he did not follow the conventional Italian compositions in the reliefs for the south portal. In his representation of Neptune and his consort, he depicted Amphitrite as if she were being carried off in a manner reminiscent of the Rape of Europa, instead of seated alongside her husband in a chariot pulled by sea horses, as she is usually portrayed in antiquity and the Renaissance.[155] Also unusual is Neptune's placement of his hand on Amphitrite's breast, a motive ultimately derived from the Nereid sarcophagus in the Vatican and, by the sixteenth century, a gesture often employed in marriage portraits in northern Italy. The composition of the relief of *Neptune Calming the Tempest* also departs from the three standard ancient images, in which Neptune is standing or striding.[156] Corte must have drawn primarily on literary sources, particularly the accounts of Homer and Vergil, who stressed the vigor and vehemence of Neptune's action. Lacking exemplars of the standard imagery for the two Nep-

[154] References to Neptune were found in the decoration for Charles' entries into Bologna in 1529, Rome and Genoa in 1536, and Tournai in 1548; see, *Les Fêtes de la Renaissance: II. Fêtes et Cérémonies au temps de Charles Quint*, ed. J. Jacquot, Paris, 1960, pp. 420, 255, 458.

[155] The best known ancient examples are the relief from the Altar of Domitius, second century B.C., no. 115 in the Glyptothek in Munich, and the mosaic from Pompeii, no. 10007 in the Museo Nazionale in Naples.

[156] The three types were identified by A. Rumpf in *Die An-*

tiken Sarkophagreliefs, V. Die Meerwesen auf den Antiken Sarkophagreliefs, Berlin, 1939: no. 116, a relief in the Giardino della Pigna in the Vatican (pl. 40, figs. 67-69); no. 117, the Medici-Della Valle Nereid sarcophagus, once in the Villa Medici in Rome (pl. 40, figs. 70-72); and no. 118, a sarcophagus in the Ancona Museum (pl. 38). This restricted group of examples was noted by Phyllis P. Bober in discussing Renaissance drawings after the Vatican sarcophagus; see "An Antique Sea-Theosos in the Renaissance," *Essays in Memory of Karl Lehmann*, New York, 1964, pp. 43-48.

tune episodes, Corte seems to have improvised his compositions, with the result that the imagery for these subjects that he introduced into Spain was of an eccentric sort.

Although marred by anatomical deficiencies and some iconographical uncertainties, the Neptune reliefs are not only well composed but also extremely successful as architectural decoration (pl. 55). Again, as in the Victory in the spandrel of the first story, the larger planes of the main figures parallel the surface of the pedestal to accord the sculpture with the architectural plane. It is important to note that the outermost pedestals were enlarged by the addition of pieces about 17 centimeters wide. These additions on the outer ends are seen in plates 54 and 56, and it is evident that a less skillful hand did the waves of the sea and the clouds of the sky in those pieces. Originally, Neptune and Amphitrite on the right and Neptune with his trident on the left were placed off center with respect to the outer edge of the relief. This placement resulted in a more dynamic composition that filled the whole panel. With the added pieces, the figural groups are shifted to the center, leaving a meaningless expanse of sea and sky behind them. A belated request in 1568 by Juan del Campo for compensation for quarrying several pieces of marble for the top moldings of the pedestals was approved by Luis Machuca, who stated that he had required Campo to cut the new moldings because those provided by Niccolò da Corte were too small and in error (*de estar herradas y ser pequeñas*).[157] Presumably those top moldings were congruent with Corte's original reliefs, which were also too small. The augmented pedestals of the Corinthian columns are just a fraction over the width of six and a half Castilian feet listed for the "panels of the pedestal" (*planos de la estilòbata*) in the specifications of 1549 (doc. 48), so it would seem that the additions required by Luis Machuca restored the width intended by his father. While it is difficult to explain the error, this document together with the physical evidence of an addition by another hand, permit us to recognize that Corte's original compositions were characterized by a dynamic imbalance with the movement of the figures directed

toward the central axis of the portal. Because the figurative elements are larger and the range of the relief greater and the texture more open, the Neptune reliefs are better scaled than the earlier *schiacciato* reliefs to the architectural elements they enrich.

While equally effective as decoration, the four main reliefs differ in quality. In the *Marriage of Neptune and Amphitrite* the relief is more skillfully graded from the low level of the farthermost sea horse to the sculptural climax in the figure of the consort (pl. 54). A plastic concentration comparable to the *Marriage* panel was probably planned for the relief of *Neptune Calming the Tempest*, but it was lost in the execution of the work, which was apparently by an assistant (pl. 56). Although Corte was admittedly no master of anatomy and was especially weak in the rendition of the muscular male body in action, the Neptune in the previous panel is superior to its counterpart in the *Tempest*. In the latter, a less skillful hand is evident in the ragged fins and the scraggly hoofs of the horses and the less certain delineation of the open mouths. Even the tight corkscrew locks of the manes and the rigid waves of the sea were carved by a less expert hand. That hand seems to have executed most of the panel of the old triton (pl. 55) alongside the *Tempest* and also the strip added to the outer edge of the *Marriage* panel. The awkward sea monster on the right may also be by the same hand, but the rhythmic vitality of the youthful triton (perhaps Delphinius, Neptune's messenger) suggests that it was executed by Corte himself. Thus, of the reliefs on the pedestals of the second story, the two panels on the right and the winged History immediately above them can be taken to represent the art of Niccolò da Corte shortly before he became ill in the summer of 1551. These works show that he continued to develop as a sculptor in the stimulating atmosphere of Granada.[158]

While a good deal of attention has been given here to Niccolò da Corte's contributions to the south window, the ultimate purpose is the identification of features that can be attributed to Pedro Machuca. Though he was inclined to restrict sculp-

[157] AA, Leg. 46, 6 (doc. 125) and Leg. 54, 29, dated by no more than the year 1568.

[158] Kruft ("The Della Porta Workshop," p. 911) has reasoned that Corte must have returned to Genoa in June 1543, because

on the seventh of that month he gave a notary power of attorney and he was not referred to as "absent"; see Varni, "Delle opere di Gian Giacomo e Guglielmo della Porta e Nicola de Corte," pp. 75ff.

tural ornament, the south window designed in 1548 had to equal the richness of the lower story, to which Corte had added pedestal reliefs. It was understood from the beginning that there were to be two Victories above it and reliefs on its pedestals, with Machuca requiring that the sculpture was to be in half-relief (*medio relieve*). If Machuca tried to impose his principle of mirror symmetry (as he apparently did earlier in the trophaic reliefs and later on the pedestals of the west frontispiece), he was not successful. Although the contract proscribed changes in the architectural design, there is reason to suspect several minor departures. Pedro Machuca is not likely to have approved the way in which the tablets and wings of both History and Fame overlap the surround and the oculus (pls. 50 and 53), but the specifications had simply stated that the figures were to be "of an appropriate size." Among the architectural elements, the only one without analogy in Pedro's repertory is the continuous molding over the three-light Serliana window. To be sure, the bead-and-spindle and the egg-and-dart courses on that molding were frequently used by him, but the relative widths of the three fascias, together with the multiplication of the moldings edging them, are not typical of Pedro Machuca's designs. Apart from this molding, the basic disposition of the Serliana window seems to follow his intentions, because the key feature, the columns, have the total height of nine Castilian feet (2.51 meters) found in the 1549 contract for the marble for the window. With these qualifications noted, we can accept the south window as representative of the architectural form of Pedro Machuca.

THE PROJECT FOR
THE FRONTISPIECE OF
THE WEST FACADE

Pedro Machuca's last project for the palace was the design of the marble frontispiece for the west facade—an unwanted task that he had successfully delayed for twenty years. As we noted, a frontispiece or, more likely, a two story *portada* was first indicated in the crude Archive plan (pl. 19), probably drawn by Luis de Vega in February 1528. That feature was revived in Machuca's small Royal Palace plan, here assigned to the autumn of 1531 (pl. 18), and presumably the *portada* was included in the wooden model, probably made in 1532. But in 1540, Machuca ignored the approved project when he began to construct a white sandstone entry (fig. 8) comparable to the one recorded in his large Royal Palace plan, probably drawn in the spring of 1528 (pl. 107). After work on that sandstone entry was abruptly stopped, it was covered with protective tile in December 1542 (doc. 37), and no further references to it were found until 1550. In December of that year, several stonecutters who had agreed to quarry marble for the west frontispiece were accused of cutting pieces for private commissions from the "King's Quarry," and the following month, Domingo de Paguaga and Martín de Alquiza were docked two months wages for stealing (doc. 50). Among the unauthorized pieces they cut were two large basins (*dos pilas grandes*), several panels for a sepulcher in the cathedral, and four or five large pieces for other unnamed projects. That the two stonecutters had contracted for the marble for the frontispiece early in the summer of 1550 is evident from the testimony of a prosecution witness who stated that the pair had been sent to the marble quarry seven months earlier by Pedro Machuca. This assures us that the contract was signed before July 1550 when Pedro died.[159] Taking into account the usual delays in getting the Junta's approval of a project and also the difficulties experienced in the 1550s in finding carters to transport marble from the Sierra Elvira, the date of the design can safely be moved back to 1549 or even the autumn of 1548, following the contract for the south window. Gómez-Moreno in 1885 and most scholars since then have assumed that the marble *portada* was designed by Pedro Machuca, but these references to the investigation of errant stonecutters in December 1550 provide the first documentary evidence that the architectural design was made and the marble ordered before

[159] Gómez-Moreno y González ("El Palacio de Carlos V," p. 196, n. 1) and Gómez-Moreno y Martínez (*Las águilas*, pp. 121–122) stated, without citing a document, that Pedro died on 4 July 1550. We know that on 18 August 1550 (doc. 49), Pedro's widow claimed compensation for the loss of the horse assigned to him from the cavalry unit on the Alhambra and on 11 December 1550 (doc. 50) reference was made by the accused stonecutters to Pedro's instructions "seven months earlier," that is, in May.

Pedro's death. To this we can add Juan de Maeda's observation in 1576 that Pedro and Luis did very well "in composing and adorning" (*en componer y adornar*) the west frontispiece (doc. 128). Presumably he knew the design was made by Pedro and the work executed by Luis.

Further support for dating the lower part of the present *portada* to the winter of 1548–1549 is provided by its iconographic program. The identification of the battle represented on the outermost pedestals is the key to the program (pls. 62, 64, and 66),[160] because the rest of the iconographic references are of a generic kind. The companion reliefs on the innermost pedestals are dominated by twin personifications of Peace, each holding an olive branch in one hand and, in the other, columns that are placed on either side of the globe of the earth. At both ends of the symmetrical compositions, geniuses put the torch to heaps of war trophies and, above, figures of Fame vigorously blow trumpets, presumably in celebration of the successful end of a battle (pl. 61). These large reliefs, measuring 85 by 198 centimeters, face the entire die of the pedestals. The guttae of the triglyphs of the Doric frieze were carved on the upper edge of the relief panels, with the result that the guttae drop into the sky area of the battle and the allegory of Peace. The rest of the sculptural ornament includes Victories over the center doorway, boys holding garlands over the side doors, and, above them, roundels depicting four charging cavalrymen.

The battle on the outermost pedestals was identified by the Gómez-Moreno as the Battle of Pavia in 1525,[161] and most scholars have followed them. They assumed that the sculptural program was planned along with the palace in 1527, two years after the battle was won, and that the original design was faithfully executed by father and son. We now know that the design of the palace was not approved until 1533 and the working project for

the marble frontispiece framing the west entry was not made until 1548–1549. Equally important is the fact that on regaining his freedom, Francis I retracted most of the agreements he had made as Charles' captive in Madrid, and so the Battle of Pavia was soon recognized to be a hollow victory, not worthy of celebration a generation later as a battle that had secured peace. Also, it seems unlikely that a battle of 1527 in which Charles did not take part would have been chosen for representation on the main entrance of a major residence in 1549, since in the interim he himself had led his troops in a number of more successful campaigns. The depiction of Charles V's personal device, the Columns of Hercules, on the trumpeter's banner on the far right of the left battle relief (though not in the reverse copy on the right) assures us that Charles was a participant in the campaign represented on the west entry (pl. 66).[162] Already in 1768, Padre Velázquez de Echevarría had observed that the most of the conquered soldiers in the reliefs were Germans.[163] He must have recognized the slashed trousers as a type worn by German foot soldiers (*Landsknecht*), but since that outfit was worn throughout the sixteenth century, it is of little help in determining the specific battle represented.

The laminated body armor worn by the equestrian figure and by the standing man on the left seen from the back provides the best clue (pl. 66). Riveted lames on tussets (thigh pieces) and on the shoulder cops were introduced at the end of the fifteenth century in trotting armor, but both forms, notably the breast plates of a type called *anime*, belong to the late 1530s and after.[164] This very new type was given a prominent place among the trophies in the Peace panel and also in the narrow reliefs (dominated by the field cannon) on the sides of these pedestals. We know that a suit of this kind was made for Charles V in 1539 by the Negroli brothers in Milan (now no. A 139 in the Royal Armory in Madrid), and Laking described it as a

[160] The records of payments and appraisals simply refer to the reliefs as "batallas" and so did Bermúdez de Pedraza (*Antigüedades y excelencias*, p. 16) in 1608; in the mid-seventeenth century Henríquez de Jorquera (*Anales de Granada*, I, p. 55) said of the reliefs, ". . . se miran todas las batallas y victorias de Carlos quinto. . . ."

[161] Gómez-Moreno y González, "El palacio de Carlos V," pp. 216–217, and Gómez-Moreno y Martínez, *Las águilas*, p. 131.

[162] The columnar device, taken by young Charles V in 1516

when he became the Master of the Order of the Golden Fleece in Flanders, was used all his life. Other emblems or devices included in the relief are the Medusa head on a shield on the far right of the left battle relief, and a standing female figure (probably Minerva) with a lance or staff on an oval shield located under the rearing horse mounted by a figure seen from the back in both reliefs. I know of no Lutheran prince who used these emblems.

[163] Velázquez de Echevarría, *Paseos*, I, p. 25.

[164] G. C. Stone, *A Glossary of the Construction, Decoration and*

very advanced example of laminated body armor because it provided the flexibility of seven lames beneath the gorget of the breast plate.[165] The one represented in our relief (rather crudely, it must be admitted) has ten lames. More to the point is the contemporary notice that Charles wore a new suit of laminated armor (*armaduras de fangas anchas*), made by Desiderius Colman of Augsburg, on the occasion of the Battle of Mühlberg on 24 April 1547.[166] This was, of course, the armor portrayed in Titian's famous equestrian portrait of "Charles at Mühlberg," painted in 1548 and now in the Prado.[167] Unlike Titian, the sculptor of the left panel did not have the emperor's armor nor the trappings of his horse at hand to lend authenticity to the portrayal, but he made it clear that the main equestrian figure in the battle wore the latest laminated armor. Loukomski, in 1944, assumed that the main figure represented Charles (though he did not identify the battle).[168] Certainly that figure presents the emperor's bodily proportions and his gravity of bearing; and the prognathism of his jaw (at least the shape of his beard) is suggestive of the emperor's profile. Of course, in Titian's portrait Charles carries a spear (or *hasta*) as a symbol of authority, while our figure wields a mace, which was a weapon that had come to function symbolically as a commander's baton.[169] The side reliefs of the other pedestals also offer an important clue. The prominent place given to mobile field cannon is probably a reference to the most prized booty of the battle of the Danube, which preceded that at Mühlberg—fifteen pieces of artillery captured in the field (pl. 58).[170]

The extraordinary importance of the Battle of Mühlberg in April 1547 made it an event worthy of commemoration on a frontispiece ordered by the emperor in the winter of 1548–1549; and the victory did, indeed, warrant the accompanying celebration of the *Triumph of Peace* on the innermost reliefs. The emperor, by means of superb generalship and diplomacy, defeated the Schmalkaldic league of Lutheran princes, who had led his Germanic states in rebellion. Luis de Ávila, who recorded the progress of that campaign, noted with pride that Charlemagne had required thirty years to defeat the Saxons, whereas Charles V had done it in less than three months.[171] Many historians consider it his greatest victory because it saved both the Holy Roman Empire and the Catholic Faith in Germany. In the months following the battle, a five-year treaty was signed with the Turks and ratified by the Diet of Augsburg, and in June 1548, the ordinance known as the Augsburg *Interim* was declared to hold open the possibility of reconciliation between the German reformers and the Church.[172] The new state of peace in 1548 (not the quickly repudiated treaty of 1525) made contemporaries feel that, like the geniuses on either end of the relief, they could indeed put to the torch the weapons Christians had used against one another, and peace would reign over the entire globe. That aspiration was represented by the twin figures of Peace who hold the Columns of Hercules at the poles of the earth, clearly delineated in the relief on the left (pls. 61 and 63). This subtle but important detail was missed by the sculptor of the reverse copy on the right. He also failed to portray Charles in laminated armor (transferring it to another horseman!), and he eliminated the columnar device on the trumpeter's banner. On the basis of the left relief (pl. 66), however, the battle can be confidently identified as that of Mühlberg in 1547, which was Charles' last military campaign, and the peace celebrated was the period of relative calm that followed it.

Though this identification of the battle depicted on the frontispiece assures us it was designed after

Use of Arms and Armor, New York, 1934, pp. 10, 143-145.

[165] Guy Francis Laking, *A Record of European Armour and Arms*, London, 1920, III, p. 307, fig. 1064.

[166] Eberhart Lutze, "Armaduras alemanas," *Archivo español de arte*, VII (1944), p. 301.

[167] Harold E. Wethey, *Titian, II, The Portraits*, London, 1971, p. 87. Repainting after damage in 1548 and 1734 may explain the lack of clarity in some features of the armor, notably the laminated tussets (or thigh pieces).

[168] Loukomski, "The Palace of Charles V," p. 123. The main equestrian figure was identified by Gómez-Moreno y Martínez (*Las águilas*, p. 164), as the marquis of Civita de San Angel, who (according to Sandoval) fought his way with an iron mace

to Francis I and captured him. The Granadine scholar explained that the French king was not depicted "out of respect for his person."

[169] Erwin Panofsky, *Problems in Titian, mostly Iconographic*, New York, 1969, p. 85.

[170] Luis de Ávila y Zúñiga, "Comentario de la Guerra de Alemania hecho por Carlos V," *Biblioteca de autores españoles*, XXI, Madrid, 1858, p. 413; María Luisa Serra Belabre, "De la victoria de Mühlberg a la paz de Augsburgo," *Revista de archivos, bibliotecas y museos*, LXIV (1958), pp. 527-534

[171] Ibid., p. 449.

[172] Tyler, *The Emperor Charles the Fifth*, pp. 103, 341.

1547, there was still time for Pedro Machuca to make designs for the sculptural ornament, as several scholars have claimed.[173] Of course, our expectations are now tempered by the realization that he had designed nothing more than the architectural membering of the two stories of the south portal and, with the exception of the imperial arms, had had no part in the design of the sculpture of the Fountain of Charles V. In both cases, the figural sculpture was left to Niccolò da Corte. Even so, there are special circumstances at the inception of work on the west frontispiece that might suggest that Pedro had a role in the composition of the pedestal reliefs.

That the first of these reliefs was executed by his young son-in-law, Juan de Orea, and could have been begun before Machuca's death is evident from the appraisal by Siloe and Corte on 8 September 1551 of a relief by Antonio de Leval that was described as representing "certain victories and spoils of arms" and as following the same composition (*de un mismo dibuxo*) as another completed earlier by Juan de Orea (doc. 53). The reliefs in question are those representing the *Triumph of Peace*, and we are aided in distinguishing one from the other by the notice that Leval was awarded ten ducats more than Orea had received earlier because the appraisers valued the greater care he had taken in the execution of certain details and in the polishing of the surfaces (*algunas diligençias que hizo en el empomedar y bruñir y dar lustre a la dicha pieça*). Orea evidently blamed Siloe for this affront because shortly after, on 20 September, in his written objection to the governor's appointment of Siloe as one of the appraisers for his second relief, he condemned Siloe as "odious and suspect" (doc. 55). That second relief was, of course, Orea's battle scene (doc. 56), with Leval's reverse copy submitted for appraisal a year and a half later, during the week of 22 to 29 April 1553 (doc. 66). Again Leval was awarded more for his panel than had been granted to Orea because of its greater "perfection" (usually meaning "completeness" and "finish") and the addition of some figures and other ornaments (*la labor y perfición della y lo que en ella ay añadido de más figuras e de otros ornatos*). Surely Leval's is the overworked relief on the right (pl. 64) and Orea's is the simpler, bolder one on the

left (pl. 66). Leval's "improvements" are surprisingly petty and insignificant, while the important laminated armor and the physical proportions and facial peculiarities of the main equestrian figure (apparently Charles V) were ignored, as was the banner bearing the Columns of Hercules. Earlier, in the relief of the *Triumph of Peace*, he had missed other significant details. In the globe between the figures of Peace, he failed to indicate the continents of Europe and Africa and the tip of Brazil, as well as the lines of longitude and latitude that remind us Charles had removed the Columns of Hercules from the Straits of Gibralter and placed them at the poles, the true ends of the earth (pl. 63). It is surprising that these omissions were not noted by the appraisers and it is especially disappointing that a sculptor of the caliber of Siloe would have prized so highly mere diligence in the rendering of insignificant detail. As we noted, Orea and Leval were said to have worked "from the same design" (*de un mismo dibujo*), which could mean (as Gómez-Moreno assumed) from a common design; however, in view of Orea's completion of both of his reliefs earlier—in the case of the battle relief, a year and a half earlier—it is more likely that with that phrase the appraisers recognized that Leval had reversed and elaborated Orea's compositions. One might assume from the year and a half interval between the completion of the two battle reliefs that each panel required about that length of time to carve. Even if we were to halve that time in the case of the first pair of reliefs representing the *Triumph of Peace*, we would have to assume that Leval began his reverse copy around January 1551, and Orea, his original, around May 1550, two months before Machuca's death. That means the panels for these reliefs had to be delivered before the signing of the first known contract for the architectural parts in June 1550 (doc. 50), but it is quite possible that other quarriers, previous to the erring Paguaga and Alquiza, had started to deliver and then failed to complete an earlier contract, or that the special pieces for the reliefs had been selected and cut independently. In any case, it is probable that Orea began his first relief while his father-in-law still lived.

Also favoring a designer's role for Machuca is the fact that young Orea's previous assignment had

[173] Gómez-Moreno y Martínez (*Las águilas*, p. 133) stated the reliefs "fueron esculpidas por Juan de Orea sobre diseños ajenos, que serían también de Machuca, si no de su hijo Luis."

been limited to the carving of window ornament. He was first recorded in the ledger for April 1546, when he was paid for carving some of the rigid swags between the brackets of the main-story windows (*unos festones para las ventanas*), probably still on the south facade.[174] Of course, for those he simply followed the design used earlier by Martín Cano and Ruberto. Around this time, probably in 1548, Juan de Orea married Machuca's daughter, María,[175] and quite naturally the architect saw to it that his young son-in-law rose from *entallador* to *escultor*. In view of this relationship and of Orea's youth, Pedro Machuca could have provided the designs and arranged to have Orea carve them. We know that Machuca favored half-reliefs rather than the low or *schiacciato* type Corte had used on the lower story of the south portal, and also that the architect insisted on the mirror reversal of architectural ornament whenever possible. While the *Triumph of Peace*, is symmetrical in itself, the battle scene had to be reversed, even to the point of putting swords and daggers into the left hands of combatants.

Other than the mirror reversal and the half-relief of these panels, there is little stylistic evidence to support an attribution to Pedro Machuca. The only specific feature ever cited in his favor is the figural group on the far left of Orea's battle piece in which a soldier, after having subdued an enemy, is attacked from behind (pl. 66). Though the main figure is clothed rather than nude, the motive is clearly reminiscent of a famous group in the *Battle of Ostia* in the Stanza dell'Incendio in the Vatican, which Raphael painted with the help of Giulio Romano in 1515.[176] Gómez-Moreno y González, to whom we owe the observation, reasoned that in 1527— his presumed date for the design of the frontispiece and its reliefs—no one on the Alhambra except Italian-trained Pedro Machuca was likely to have

known that motive. However, that reasoning does not pertain to a design that we now know was made twenty years later in the winter of 1548– 1549. By that time Raphael's motive must have been widely diffused in Europe by way of drawings and reflections in the works of others. Also widely known by 1548 was the motive of the soldier mounted on a rearing horse, used here for the figure identified as Charles V. It appears a few years later in Orea's sculpture of St. James subjugating the Moors (*Santiago matamoros*) in the niche above the side portal of the church dedicated to that saint in Almería.[177] Not only the bulky proportions and scant anatomical articulation but also the pose of the rider, and even the harness of the horse, in the battle relief were repeated in Almería. Of the female personifications of Peace in Orea's other relief, one must admit that they are somewhat reminiscent of the short-waisted, well-rounded, broad-faced female figures used by Pedro Machuca and most dependably seen in his paintings of the *Madonna del Suffragio*, dated 1517, and the *Descent from the Cross*, now given the date 1547 found on its frame. However, these personifications are closer still to Orea's 1558–1561 reliefs of the Virgin of the *Annunciation* and the sibyl carved above the seat of the archbishop in the handsome walnut choir stalls of the cathedral of Almería (cf. pls. 61 and 65).[178] Unfortunately, no composition involving as many figures and as much depth as *The Battle of Mühlberg* is found in the paintings attributed to Machuca or the later sculptural reliefs of Orea, but the sculptor's complete command of the illusory devices of half-round to low relief is amply demonstrated in the figures he carved for the choir stalls in Almería. Evidently Orea had studied Niccolò da Corte's technique in the trophaic reliefs on the south portal and the roundels in sandstone on the wall of the Fountain of Charles

[174] AA, Leg. 3, 5, Nóminas, for April through August 1546 (with November and December missing). Antonio Gallego y Burín (*Granada. Guía artística e histórica de la ciudad*, Madrid, 1961, p. 191) said that Orea had been working as a carver (*entallador*) since 1542, but he is not listed among the *entalladores* in the eight months of account ledgers preserved for that year, nor for the three extant months of 1544.

[175] Gómez-Moreno y Martínez, *Las águilas*, p. 121, n. 4.

[176] Sidney Freeberg, *Painting of the High Renaissance in Rome and Florence*, Cambridge, Mass., 1961, I, p. 294; II, fig. 375.

[177] The portal of the church of Santiago in Almería was probably done in 1552, when Orea himself said he built the tower

of that church; see Rosenthal, *The Cathedral of Granada*, p. 204, doc. 163. Bartolomé Carpente Rabanello, in "Breves apuntes para la historia eclesiástica de Almería," *Revista de la Sociedad de Estudios Almerienses* (Estudios eclesiásticos de Almería), IX (1918), p. 101, dated Orea's work in Santiago to 1553 without citing documents.

[178] The beginning of work on the choir stalls of the cathedral of Almería in 1558 is evident from several references in the Actas Capitulares (book II, fols. 69v, 76v, 95v, 207) to the purchase of large quantitites of walnut wood (*nogal*) for that purpose. The first payment to Juan de Orea for work on the stalls was made on 17 June 1558 (fol. 76v).

V. In his execution of the battle scene, he demonstrated great skill in controlling successive layers of the relief to sustain a convincing illusion of recession.[179] No comparable skill in the creation of a spatial illusion was demonstrated by Machuca, even in his most ambitious painting, the *Descent from the Cross*.

On the basis of style, figural types, and technique, it would seem reasonable to attribute the design of the two pedestal reliefs to Orea, restricting Machuca's role in the frontispiece to its architectural membering. The bold scale of the relief and the principle of mirror reversal were almost certainly required by Pedro Machuca, though a few years later, in 1555, Orea followed that principle in the two youths holding the cardinal's arms over the pediment of the north transept portal of the cathedral of Almería (pl. 89).[180] The identification of Juan de Orea as the designer of the pedestal reliefs not only provides us with the earliest examples of his skill as a composer, but it also completes the exclusion of Pedro Machuca from the design of the figural ornament of the *portadas* of the palace.

ORNAMENT OF THE MAIN FACADES

Responsibility for the design of other facade ornament must be considered before listing the parts of the palace attributable to Pedro Machuca. The problematic features are the bronze tie rings on the rusticated pilasters of the lower story, the alternating window crowns, and the emblematic reliefs on the pedestals of the Ionic pilasters of the main story. Because extant documents provide no clues

to the designer of these features, we must look to circumstantial, technical, and stylistic evidence and also take into account our conclusions on the relative roles of the architect and the sculptors who worked on the two marble *portadas* and the wall-fountain. Of the sculptural ornament considered thus far, we have been able to attribute to Pedro Machuca only two pieces of heraldry: the imperial arms combined with the personal devices of Charles V and Isabel of Portugal over the fireplace in the emperor's bedchamber in the quarters built in 1529–1533 (pl. 25), and the imperial arms for the lunette of the wall-fountain of 1545, though it was completely redesigned by Corte.

In Spain, facade fixtures were usually made of wrought iron, not of bronze,[181] and they were seldom fashioned in the form of figures. It was in Tuscany, particularly Florence and Siena, during the latter half of the fifteenth century that fixtures were first made of bronze in figural forms.[182] During the sixteenth century, the practice spread to other parts of Italy—with the most notable examples preserved in Lombardy, Emilia, and Vèneto—but bronze figural forms were still not used on facades in Spain. For that reason, Gómez-Moreno assumed the bronze rings of the palace of Charles V were made in Florence.[183] That is, however, unlikely for technical reasons. The tie rings of 1542 were solid cast, a wasteful technique rarely used in Italy after 1490.[184] It is more likely that they were made in some local foundry accustomed to casting church bells, though we cannot assume (as Gallego y Burín did) that the rings of 1542 were cast by Juan Vélez, who twenty-seven years later made the bells for the Torre de las Velas.[185] In Italy, craftsmen of this sort were often used by Renais-

[179] A decade later, about 1563, Lázaro de Valasco would praise him as "el ábil Juan de Urea, maestro mayor en el obispado de Almería, gran debuxador, escultor y ordenador"; see Sánchez Cantón, *Fuentes*, I, p. 208. The effectiveness of the illusion of these reliefs has been diminished by exposure to the weather and, in recent years, some parts have been polished by the hands of thousands of tourists.

[180] The unpublished contract of 11 February 1555 for white marble from Macael for the two youths holding the arms of Archbishop Diego Fernández de Villalán over the pediment of the north portal of the cathedral was found by Lolita Ibarra in the registry (*protocolos*) of notary Diego López de Badajoz (fol. 84) in the Archivo de la Delegación de la Hacienda in Almería.

[181] Proske (*Castilian Sculpture*, p. 6) noted that bronze was seldom used for sculpture in Spain, and no examples were mentioned by Azcárate in *La escultura del siglo XVI*.

[182] Attilio Schiaparelli, *La casa fiorentina e i suoi arredi nei secoli XIV e XV*, Florence, 1908, p. 54, n. 1. Paul Schubring (*Die Plastik Sienas im Quattrocento*, Berlin, 1907, pp. 216-217) stressed the leadership of Siena in the design of figural tie rings, torch standards, and lamps in bronze, with Florence, Bologna, Milan, and Venice following closely.

[183] Gómez-Moreno y González ("El Palacio de Carlos V," p. 210) described them as "a la manera florentina," and Gómez-Moreno y Martínez (*Las águilas*, p. 230) inexplicably compared them to those of the Medici palace in Florence, though the remaining fixtures and those indicated in late fifteenth-century depictions of the Medici palace are clearly of wrought iron and have no figural motives.

[184] Anthony Radcliffe, *European Bronze Statuettes*, London, 1966, p. 16.

[185] Gallego y Burín, *La Alhambra*, p. 43, n. 58. Even in Italy,

sance sculptors for the casting of bronze fixtures, and also statuary, when no local workshops had appropriate facilities.

More important than the founder was the sculptor who made the model and later chased the rough casts to sharpen the outlines of the ornamental detail. Because of the intimate relation between the design and its realization in the chasing process, it is likely that the designer participated in the chasing or closely supervised assistants. This would exclude Pedro Machuca, who is not known to have done sculpture in any medium, let alone in the highly specialized technique of bronze casting. Niccolò da Corte, however, as an Italian, may have claimed the ability to work in bronze, though I know of no examples of works in that medium by him or his collaborators in Genoa.[186] Also favoring an attribution to Corte, is the fact that extended work on the tie rings for the south facade would account for his remaining on the Alhambra after completing the trophy reliefs for the south portal, probably early in 1540, and also for his withdrawal in July of that year from the new partnership he had formed with the Della Porta in April 1538,[187] when his work on the south portal was drawing to a close. Between his involvement with the trophy reliefs of 1538–1540 and his contract for the Fountain of Charles V in 1545, there are no references to his activities on the Alhambra, though he seems to have remained in Granada, with only one brief return trip to Genoa in 1543. Because Niccolò had been successful earlier in elaborating the sculptural program of the south portal, he may have suggested the figural tie rings in bronze around the time that his work on the trophy panels was nearing completion. If he continued to make the rings needed for the west and east facades after

finishing those for the south front in January 1542, he would have been busy for most of the five or six years for which we have no record of his activities; and if he also did the torch standards in the form of a human arm of natural size, which Velázquez de Echevarría saw on the corners of the facade in the 1760s, he would have been fully occupied during those years.[188]

The window crowns on the main story of the palace would normally be an integral part of the architect's design. Certainly, the leaf-faced, double-voluted brackets supporting the crowns compare favorably to those used earlier on the fireplace in the bedchamber of Charles V in the new quarters (cf. pls. 25 and 41). While the cylindrical fruit swag has no counterpart in Machuca's work, there is no reason to suspect that this feature was designed by the earliest carvers, Martín Cano and Ruberto, since they were simply *entalladores*, who usually executed the designs of others. The Cross of Saint Andrew and the fire steel in the tympanum of the triangular pediment are also reminiscent of the imperial emblems on the fireplace just cited. In both instances, the banderole is disposed symmetrically and it interlaces the several heraldic elements. The huge pomegranates, emblems of the city, are bold and vigorous forms, but the leaves on either side of the spherical fruit conform to a severe rectangular outline that disciplines its exuberant form. While it would seem that ornament of the triangular window crowns can confidently be attributed to Pedro Machuca, the small and rather petty ornament of the lintel crown is less characteristic. The winged geniuses emerging from leaves and the shell flanked by intertwined dolphins are admittedly somewhat Siloesque, but quite similar figures are found over the facade windows of the

bronze sculptors often used foundries that normally made bells and utilitarian objects; see Charles Seymour, *Sculpture in Italy: 1400–1500* (The Pelican History of Art 26), Harmondsworth, 1966, p. 17.

[186] Alizeri (*Notizie*, v, p. 311) referred to a Della Porta commission to do a bronze work for Andrea Doria, but it was realized later by Bandinelli. Of course, Niccolò did some work in terracotta from which models for cast bronzes were often made; see Kruft, "The Della Porta Workshop in Genoa," pp. 910, 941, for a *Lamentation* group of 1528 and the model for the Salvago portal in terracotta.

[187] Ibid., p. 909. Kruft noted that Niccolò was represented *in absentia* in the formation of a new partnership with Gian Giacomo della Porta and five other sculptors on 30 April 1538

in Genoa, so presumably he intended to return there after completing the trophaic reliefs; but on 5 July 1540, Niccolò's brother informed the group that the sculptor would not return for some time and he recommended that Niccolò's share of the work be given to others in the partnership. Presumably Niccolò had obtained a new commission in Granada.

[188] Because of the generic nature of the motives employed in the tie rings, stylistic suport for the attribution to Niccolò da Corte is limited. One might claim an affinity between the lion's head on one of the returns of the pedestals of the south window and, even more, the lions accompanying the wildmen of the portal of the Salvago palace on the Piazza San Bernardo in Genoa (pl. 47).

Granadine Colegio de Niñas Nobles, designed about 1532 by Juan de Marquina, Machuca's *aparejador* (cf. pls. 42 and 43). Therefore, it is likely that Marquina introduced some changes into the lintel crown. Even though no analogy for the grouping of the three vases has been found in the designs of Marquina or Machuca, the symmetry of the water ewers (with their handles turned inward on either side of a double-handled vase) follows the principle of mirror symmetry favored by Pedro Machuca throughout his lifetime.

The undocumented emblematic reliefs on the pedestals of the Ionic pilasters of the main story may have been introduced at the order of the emperor as late as 1540. Both reliefs would seem to reflect the design principles of Pedro Machuca in the strict mirror symmetry (with the single-headed imperial eagle over the globe in the columnar device being an unavoidable departure from that principle) and in the use of half-relief, without a hint of the aerial perspective so characteristic of Corte. If the Lombard had designed them, one would expect greater subtlety and refinement in the articulation of successive relief planes than is found in the two emblems on the pedestals. In summary, then, the main-story pedestal reliefs and the ornament of the triangular pediments can be credited to Pedro Machuca, while the ornament of the lintel crown is Marquinesque and the bronze tie rings are most reasonably assigned to Niccolò da Corte.

THE STATE OF THE PALACE IN 1550

During the last three years of Machuca's life there is little evidence of his activities beyond the design of the south window and the west frontispiece and the ordering of materials for the latter. Presumably work continued on the east facade and, perhaps, the sandstone parts of the west, but we lack the account ledgers for his last three years. Except for the retable of St. Peter in the cathedral of Jaén in 1546 and the catafalque for Mary of Portugal in 1549 (pl. 6), there are no notices of outside commissions. It is possible that he was often not well during his last years. Gómez-Moreno y Martínez

stated that Pedro was ill in 1548 but that he recovered.[189] Unfortunately, he did not cite his source and I have found no documents to support his claim. Part of those last years may have been devoted to the design of the edicular portal on the east facade and the triumphal entry gate to the Alhambra, known in modern times as the Puerta de las Granadas, but the separation of the late work of Pedro from the first of Luis must await our review of the latter's tenure as *maestro mayor*. We know that Pedro died before mid-August, and from the reference to his signing a contract "about seven months before" the 11 December inquiry into the misappropriated marble from the king's quarry, it is evident he was still alive in May, so there is no reason to doubt the Gómez-Moreno's undocumented claim that Pedro died on 4 July 1550.

In the seventeen years of his tenure as chief architect Pedro Machuca had completed almost half the square residence—somewhat less than most scholars have assumed. The silhouette of the palace in 1550, presented graphically in figure 9, reveals in its irregularity the troubled history of construction under its first architect. While the sandstone facade of the south wing was finished in all other respects, above the marble frame of its portal it still lacked the central window—not contracted for execution by Corte until 1548. The first story of the west front seems to have been raised, but its three-door entry was covered with protective tile in 1542 when further construction was prohibited. On both the east and the west the sandstone facing is not likely to have advanced beyond the first story, while the relatively independent construction of the massive walls of the octagonal chapel rose to the midpoint of the second-story window jambs. It is difficult to say how much was achieved in the north wing, but we can assume the raising of the transverse walls of the basement rooms that extend from the vaulted chamber under the octagonal chapel toward the west facade, and Machuca seems to have constructed a north staircase down to the Court of Myrtles.[190] The transverse walls buttressing the facades of the other three wings must have kept up with those fronts, rising through both stories on the south and only one story on the east and west. So carefully were the blocks cut

[189] Gómez-Moreno y Martínez, *Las águilas*, p. 121.

[190] Because the only recorded work on that north staircase in the 1590s is the sandstone facing of the stairwell, it is likely

that the steps of the staircase had been completed earlier; but, in 1729, the first staircase was replaced with the one recorded in the 1767 and 1793 sections of the palace (pls. 78 and 101).

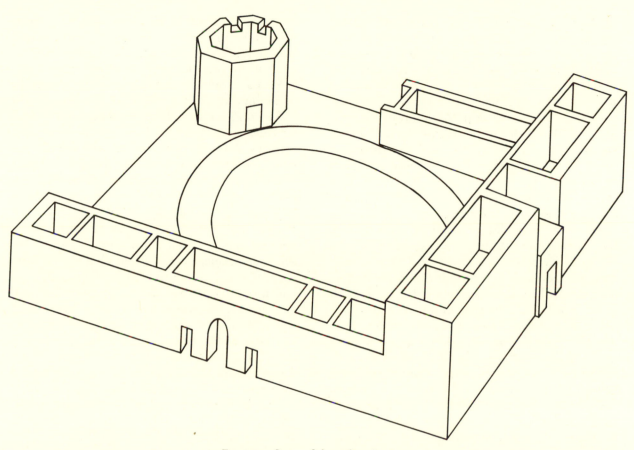

FIGURE 9. State of the palace in 1550

and set that a few of the bearing walls constructed under Pedro Machuca successfully withstood four hundred years of exposure before the building was finally covered by a roof in the twentieth century. In the courtyard, two rings of gravel for the foundations of the colonnade and the wall of the corridor provided an indication of its circular form. As no references were made to the foundations of the forecourts and no trace of them has been discovered in modern times, it seems that Pedro Machuca concentrated most of his work force on the square block of the residence itself. If he had not lost five years in dispute and indecision during the initial design phase and at least as many in the change of the south entry and the suspension of work on both the courtyard and the west entry, he would probably have finished the two main facades and the round courtyard before his death in the summer of 1550.

Pedro Machuca and his *obrero mayor*, Gonzalo de Lorca, had organized the work force for max-

imum efficiency, and they maintained a fast pace of construction that would be difficult to match in contemporary works. No delay was caused by the difficulties that usually plague architectural enterprises of this scale. The work force was exceptionally capable and stable, and the income for the construction of the new palace was sufficient and unusually dependable. Machuca's problems arose, in part, from the vagueness of the emperor's initial order to build a modern residence alongside the Nazaride palaces—which the governor and his architect conceived as a private villa for the imperial households alone—and, in part, from the conflict of Machuca's Italian Renaissance ideas and values with the traditional architectural practices and attitudes of the Castilian advisers of the emperor. The novel idea of an isolated square villa with a circular courtyard so pleased the pair on the Alhambra that they saw the emperor's emendations and additions as mutilations. In their persistent efforts to save the geometricity of its form, they

strained the patience of their patron and caused him to depend increasingly on the advice of Castilian court architects, who had little sympathy for most of Machuca's ideas. The governor and his architect must have found the emperor and his advisers insensitive, while the group at court must have been convinced that Machuca was wholly impractical and not to be trusted. First Machuca presented a novel groundplan with the unfamiliar and seemingly unstable circular colonnade, and then he insisted on the regular cadence of a stylar facade entirely of white sandstone, inexplicably rejecting an ennobling *portada* of marble.

Machuca's new ideas required a greater capacity for salesmanship than he possessed. Most disturbing must have been his notion that the architect was the arbiter of the final form of the palace. Apparently, he was not accustomed to the Spanish practice of "design by committee," nor the practical concerns for convenience as a primary determinant of the disposition. He seems to have believed that he was responsible for the formal integrity of the building, and this new attitude evidently bewildered and then irritated Charles. The friction and distrust generated during the design phase made adversaries of the group at court and the pair on the Alhambra, and Machuca intensified the conflict when he successively revived rejected projects for the south entry, the courtyard, and finally the west entry. Within the annals of Renaissance architects, there are few parallels to Machuca's persistent opposition to patron-approved projects and his surreptitious reinstatement of his own.

Another major source of friction was the presence of the Lombard sculptor, Niccolò da Corte, who arrived just four years after the foundations were laid. Increasingly influential, especially after Iñigo López de Mendoza substituted for his father as governor in 1543, Corte successfully intruded his ideas into both stories of the south *portada* and the Fountain of Charles V, not only extending the sculptural programs but actually changing some aspects of the architectural design. Countermanded on so many parts of the palace by court

advisers, Machuca in the mid-1540s was apparently unable to oppose the Italian sculptor's changes. He himself seems to have had a preference for heraldic motives and an inclination to keep sculpture to a minimum and subject to the constraint of absolute symmetry.

As a result of our review of the history of construction under Pedro Machuca, we can firmly deny several widely held assumptions: the governor was not given a free hand in the design and execution of the palace; construction was not started in 1527, but in 1533; and the original project was not faithfully executed during the next fifty years by Pedro and his son. Also, incongruities and solicisms in the plan and elevation did not result from an inability to assimilate classical forms but, rather, from the conflicting architectural ideas of the governor's Italian-trained architect and the emperor's Castilian advisers, not yet converts to the new Italian style. Machuca's original concentric project was first violated by the enlargement of the octagonal chapel and then by the addition of forecourts and dependencies. These changes were accommodated by a series of compromises, followed by partial returns to Machuca's original intentions, and finally settled by court-ordered reinstatements of the approved projects. In view of this history, it is a wonder there are not more incongruities.[191] We can also dispel the assumption that Pedro Machuca provided compositions for the figural ornament of the two *portadas* and the wall-fountain. His role must be restricted to the design of the plan and architectural membering of the elevations of the palace, and probably the heraldic ornament of the main-story pedestals and the triangular window crowns. But before we can complete the list of the parts of the palace that most dependably represent the architectural ideas of Pedro Machuca, we will have to take into account the several alterations introduced by his son, Luis, and later architects, as well as the damage suffered during several centuries of neglect and, finally, the restorations of this century.

[191] Only Byne and Stapley (*Spanish Architecture*, pp. 302-303) sensed that the palace was "a much checkered enterprise, in which so many, often unsympathetic, hands intervened"; and Lampérez (*Arquitectura civil*, I, p. 496) found the plan "inharmonious" (*inarmónica*); but most who have commented on the palace seem to have assumed that the formal conflicts resulted from Machuca's incomplete knowledge of the new Italian idiom or a Spaniard's congenital inability to comprehend classical forms.

III

CONSTRUCTION UNDER LUIS MACHUCA, 1550-1571

ADMINISTRATIVE AND ECONOMIC CONDITIONS

LUIS MACHUCA succeeded his father as chief architect, according to the testimony of two contemporaries, Lázaro de Velasco and Juan de Maeda, and the review of Luis' salary from 1550 to 1568 included in Philip II's letter granting him a second increase.[1] From that letter we learn that, when Pedro became chief architect in 1527, he extracted the promise that his son, at the proper age, would enter the works as a mason apprentice (*cantero aprendiz*) and would eventually succeed him as chief architect.[2] Since Luis did become chief architect, he must have undergone the apprenticeship with Gonzalo de Lorca and Juan de Marquina who held the posts of *obrero mayor* and *aparejador* throughout his father's tenure. At the same time, he must have learned not only architectural design but also painting from Pedro. He may have worked with his father and Esteban Sánchez in 1543 on a retable for the church of San Matías in Granada, but unfor-

tunately, it was removed in 1750 and then lost.[3] Gómez-Moreno has suggested that Luis worked with Pedro in 1546 on the retable of the chapter house dedicated to San Pedro de Osma in the cathedral of Jaén.[4] Its execution by Luis would explain the uncharacteristic painting of distinctly Machuca-like figures, but I know of no documentary basis for this or any other collaborative works. Later, in December 1556, Luis was paid by the governor of the Alhambra for making copies of a portrait of the Catholic Monarchs and another of their children for the Royal Chapel in Granada.[5] A few years later, in 1558, he was called upon by the governor to "gild and paint" the wooden statue of Our Lady on the Portal of Justice, generally attributed to Ruberto Alemán and dated about 1500.[6] Since none of Luis' paintings has been identified, we have no way of knowing how closely he followed his father's manner. We can assume that Luis was not trained in sculpture because Pedro did not practice the art and seems to have arranged for Juan de Orea, his son-in-law, to obtain several important commissions early in 1550, most no-

[1] For Velasco's reference, see above chap. 1, n. 55, and for Maeda's, doc. 128. A letter of 2 September 1567, in which Philip II noted Luis Machuca's request for a raise, was published by Llaguno (*Noticias*, I, pp. 222-223) without indication of its location. In another letter of 22 February 1568 (doc. 124), Philip approves the raise.

[2] Since Pedro made these arrangements for his son's apprenticeship in 1527, Luis was probably born before his sister Luisa, whose baptism was recorded on 30 March 1528 in the first book of baptisms in the church of Santa María de la Alhambra. Cited by Gómez-Moreno y Martínez (*Las águilas*, p. 121, n. 2), the baptismal records can no longer be found.

[3] Gallego y Burín, *Granada*, p. 268.

[4] Gómez-Moreno y Martínez, *Las águilas*, p. 112, doc. XXIV.

[5] The governor on 5 December 1556 paid 13,600 maravedís (a little over 36 ducats) for the group portraits, described as being "en dos tablas, las quales sacó de otras" (AGS, CM1, Leg. 1023). The individual portraits now in the Royal Chapel in Granada are usually taken to be seventeenth-century copies of lost royal portraits.

[6] AA, Leg. 6, 22. For the statue itself, see Gallego y Burín, *Granada*, p. 99. The payment was found by María Augustias Moreno Olmedo.

tably the pedestal reliefs of the west frontispiece. According to Lázaro de Velasco in his commentary on Vitruvius, Luis was well informed (*bien entendido*) in architectural matters and had visited Italy (*que estuvo en Italia*).[7] The trip must have taken place in the several years before he succeeded his father in 1550 because there is no indication that he left the works for an extended period after that date.[8] Evidently, Pedro still thought study in Italy was an essential experience in the formation of his son as an artist; but, in the late forties, Luis saw a somewhat different kind of art and architecture in Italy than Pedro had previous to 1520, and for that reason one would expect some differences in form and style between father and son. Beyond these few notices, our knowledge of Luis Machuca as an architect depends on the parts of the palace he constructed during his twenty-one years as chief architect.

The circumstances of Luis' appointment as *maestro mayor* were essentially the same as those of his father. He was also paid a salary of 100 ducats a year, though by 1550, as a result of inflation, it was worth about twenty percent less than in 1527, and only in 1563 was it raised to 150 ducats (doc. 124). Fortunately, he inherited a number of properties and, in marrying Doña María de Herrera, he seems to have improved his financial circumstances.[9] Even so, he continued to live in the tower on the north side of the courtyard that is still designated by the family name (pl. 17-D). Like his father, he chose an experienced master mason, Bartolomé Ruiz, to serve as his *aparejador* when Marquina died or retired sometime after February 1553 and before January 1554.[10] The Work Rules drawn up by Iñigo López de Mendoza in 1546 and approved by the Junta de Obras y Bosques in 1549 were still in effect in 1550. Some of the restrictive

clauses introduced to restrain his willful father seem not to have been necessary for Luis, since he was apparently more flexible and accommodating in matters of design and ornament. In any case, during his tenure there is no evidence of conflict or interruptions in the progress of work on the palace. The yearly payment of 10,000 ducats (allotted since the late 1530s) continued, though it purchased less in the inflated economy of the third quarter of the sixteenth century,[11] and that sum was received annually until the uprising of the Moriscoes in 1568. Fortunately, the income established by Joanna of Castile for the repair of the Nazaride palaces, that is to say the fines from the appellate courts of Granada, Loja, and Alhama, was also received regularly.

Many of Luis' working circumstances remained essentially the same as those of his father, but there were a few changes. Between 1547 and 1550, the daily ledgers were replaced by weekly accounting, perhaps as the result of the appointment of Ciprian de León to succeed Francisco de Biedma as paymaster sometime during that undocumented three-year span. Another major official, the overseer (*veedor*) Baltasar de León, was replaced in 1550–1551 by Sebastián de Peñalosa, who was then succeeded in 1552 by Juan Arias Mansilla. Beyond the Alhambra, an even more important change occurred. Charles V's interest in work on his residences declined rapidly during the early 1550s, and Prince Philip assumed increased responsibility for royal architectural projects. In February 1556, when Philip became king of Spain, the Alhambra was regarded as just another distant and costly royal residence. Already in March of 1551 it had been inspected during a routine visit to six royal residences by Padre Bartolomé de Bustamante Herrera,[12] a Jesuit engineer and architect with a marked

[7] See chap. 1, n. 52.

[8] In 1557, he was consulted on the vault of the Royal Chapel in Seville (see this chap., n. 17) and he made a fourteen-day trip to Cádiz to show Juan Bautista de Toledo the plan of the Alhambra's fortifications (AGS, CMI, Leg. 1120, payment for expenses on 23 August 1557); in the royal cédula of 22 February 1568 (doc. 124), Philip II noted that Luis had seldom been absent from the Alhambra in the past eighteen years.

[9] Gómez-Moreno y Martínez (*Las águilas*, p. 139) said that, at the time he succeeded his father, Luis was already "rich, in possession of houses, inheritances, and [independent] income" (*Le vemos ya rico, en posesión de casas, heredades y censos*); but he did not cite the evidence for these claims.

[10] See chap. 2, n. 50, for the last references to Marquina. By

13 January 1554 (Nóminas, Leg. 1278), sandstone for the facade windows was received by Bartolomé Ruiz. The post of *obrero mayor* must have been abolished, because it was never mentioned again.

[11] Until about 1545 inflation had little effect on building materials, but from 1553 to 1568 their prices increased more rapidly than other commodities; see Earl J. Hamilton, *American Treasure and the Price of Revolution in Spain 1501–1650*, Cambridge, Mass., 1934, pp. 234-235, and chart 14.

[12] Philip's letter advising the governor of the projected visit was dated 26 March 1551 in Cigales (doc. 51), and the release of 150 ducats to Bustamante de Herrera was signed in the same town on 31 March. Both documents are found in the Archivo General del Palacio Real, Madrid, Sección Cédulas Reales, vol.

inclination to sobriety in architectural design.[13] His report on the state of the works has not been found, but it is likely that his comments on the Alhambra were favorable because the following year, sometime before August 1552, Prince Philip appointed Luis Machuca *maestro mayor* of the Alhambra. Since Philip was inclined to subordinate the architects of distant royal residences to his court architect, Luis Machuca in August 1557 was required to bring "the plan of the fortifications of the Alhambra" to "Juan Bautista [de Toledo], the engineer of His Majesty."[14] This practice was continued by Juan Bautista's successor, Juan de Herrera, who would rule the royal works with a firm hand. The young king never visited the Alhambra since he had little inclination to travel beyond the environs of Madrid. He focused his architectural interest on the completion of the royal residences, there and in Toledo, and the hunting lodge known as El Pardo; after 1559, he was totally absorbed in the design and construction of the Escorial. Philip's letter of October 1567 expressing concern about the slow pace of the work in several distant royal residences, including the one at Lisbon, was simply another routine letter ordering the rapid completion of the approved projects.[15]

Most of Luis' twenty-one years as chief architect were devoted to the realization of two of his father's long-disputed projects: the one-story marble frontispiece for the west entry and the round courtyard. He also continued the massive walls of the octagonal chapel after the four-year interruption that was due to the failure of stonecutter Godios

to complete his 1543 contract for limestone. A new contract must have been signed because large quantities of limestone were delivered between November 1552 and October 1554.[16] Since the kinds of blocks delivered are identified by the same terms as those previously ordered by Pedro in 1543 (*ochavos de rincones, esquinas, escondes,* and *bolsores*), it would seem that Luis simply continued to raise the walls according to his father's project. In October 1554 (doc. 76), seventy pieces of the top course of the chapel (*los sobrados de la capilla*) were delivered; so Luis seems to have raised the wall of the chapel to the original springpoint of the vault, which was six courses below the present level (cf. fig. 5 on p. 60 and pl. 1). No features of the interior were ever mentioned and there is no indication of the way in which the Machucas intended to articulate the walls of the chapel. That Luis did not construct the chapel's vault is no indication of indecision as to its form or of doubt as to his ability to complete it successfully; he was considered sufficiently expert to be called to Seville in 1557 to give his opinion on the project for the vault of the slightly larger Royal Chapel at the back of the cathedral there.[17] Presumably construction on the chapel vault was postponed because not enough of the transverse walls had been constructed to support a truss roof over the entire palace, including the dome of the chapel. Even in 1580 bearing walls still had to be raised before the common roof could be built, and for that reason, it is unlikely that wood was ordered for the roof in 1554 as Gómez-Moreno y Gónzalez claimed in

I, 1545–1555, fols. 100-101. The letter of 25 April 1551 authorizing Bustamante's visit to Seville was published by Llaguno (*Noticias*, II, p. 214), but he incorrectly assumed (p. 54) that Bustamante's trip to Seville preceded his visit to Granada.

[13] Alfonso Rodríguez Gutiérrez de Ceballos, S.I., *Bartolomé de Bustamante y los orígines de la arquitectura jesuítica en España,* (Bibliotheca Instituti Historici S.I., vol. XXVII), Rome, 1967. To this well-documented and thorough account of Bustamante's work, we can add the minor but interesting fact that he first came to Granada in 1551 (not 1556) and that he had the opportunity to inspect Machuca's palace on the Alhambra as a visitor for the Crown. Bustamante had traveled in Italy in 1536, visiting Florence, Rome, Naples, Genoa, and other centers. In 1537, he undertook his first known architectural work, the parish church of Caravaña in the diocese of Toledo, and in 1541 he took charge of the Toledan hospital of San Juan Bautista (or Tavera), which has been called "the first classical building in Castile."

[14] AGS, CMi, Leg. 1120, payment of 23 August 1557: "En veynte e tres de agosto del dicho año [1557], libró a Luis Ma-

chuca, maestro mayor, diez excudos de oro, que los uvo de aver de catorze días que se ocupó en yr a la çiudad de Cádiz a comunicaron con Juan Bautista, yngenero de su magestad, la traza de la forticaçión [d]el Alhambra."

[15] AGS, CSR, Leg. 265, fol. 31, for Philip's letter to Iñigo López de Mendoza on 2 September 1567 (doc. 122) and the latter's letter to his son, Luis Hurtado, the acting governor of the Alhambra, on 15 October.

[16] AGS, CMi, Leg. 1120, for payments on 6 November (doc. 64), 3 and 30 December 1552, and monthly payments from 13 January through 2 December 1553, and 5 January (doc. 70) through 22 December 1554.

[17] Llaguno, *Noticias*, I, p. 223, cited no more than the year. The Royal Chapel at the rear of the cathedral of Seville was begun in 1541 on the basis of a project by Martín Gaínza and later revised by a series of consultants, and then given its present form by Hernán Ruiz the Younger after 1556; see Antonio de la Banda y Vargas, *El arquitecto andaluz Hernán Ruiz II*, Seville, 1974, pp. 118-120.

1885.[18] He must have seen a contract for the delivery of a hundred cartloads of wood in 1554–1555, presumably for general repairs, scaffolds, and centering.[19] But, in respect to the common roof, it is important to note that a near hemispherical vault over the massive walls of the octagonal chapel, as terminated by Luis in 1554, could have been enclosed under a low truss roof.

Luis also continued the sandstone facing of the east and west facades.[20] Juan de Maeda's work list of 1576 (doc. 128) reveals that Luis had completed most of the upper stories of both these fronts, leaving unfinished only the last four windows over the east entry and the two on either side of the *portada* on the west facade. That the main story of both these fronts was executed by Luis is confirmed by the failure to interlock the corbel and the surround at the top center of each bay as Pedro had done on the south facade (cf. pls. 39 and 43). Little more is known about work on the facades, the transverse walls, or the chapel, so our attention must turn to the amply documented west frontispiece and the round courtyard and, finally two undocumented works, the east portal and the Puerta de las Granadas.

THE MARBLE FRONTISPIECE AND THE WEST FACADE, 1550–1568

The contract for the marble of the one-story frontispiece was signed, as noted above, before the death of Pedro Machuca in the summer of 1550, but various difficulties delayed delivery of the architectural membering until May 1552 (docs. 60 and 62) even though the carving of the reliefs for the pedestals was begun about two years earlier. Not until late 1559 did Luis have enough finished pieces of marble facing to begin to assemble the frontispiece (pl. 68). As usual, the most ample doc-

umentation has to do with the sculptural ornament rather than the architectural membering, so we can establish the chronology of the frontispiece by way of the sculpture, most of which was done by Antonio de Leval who (shortly after Luis became chief architect) replaced Juan de Orea as the main sculptor.

Antonio de Leval is known as a sculptor only from his work on the Alhambra. In fact, until Simón de Argote came across some references to him among the documents in the archives of the Alhambra in 1807, scholars were unaware of his existence.[21] Published in 1942 by Antonio Gallego y Burín, these documents refer to him variously as Maese Antonio, Antonio Flamenco, Antonio de Leval, Antonio del Valle, and Antonio de Flandes.[22] Beyond his Flemish origins, the documents reveal nothing about his training or previous work. He probably was quite young in 1551 when he made the reverse image of Orea's *Triumph of Peace*, because Orea himself could have been no more than twenty-five. Gallego y Burín discovered that Leval had married the daughter of stonecutter Antonio de Ovalle, who worked with Siloe in the cathedral between 1547 and 1555 and occasionally was recorded in the works of the Alhambra. From 1551, when he made his reverse copy of Orea's *Triumph of Peace* (doc. 54), until February 1566, when he was paid for his last recorded sculpture, a pair of lions in grey marble, the career of Antonio Leval is unusually well documented. Presumably, after work on the west entry came to an end, he did what he had threatened to do earlier in 1561, "to go out in the world to seek a livelihood" (*yr por el mundo a buscar mi vida*).[23] Gallego y Burín, while publishing most of the documents relative to Leval's work in the Alhambra archives, made no attempt to describe his style or characterize his artistic personality, perhaps because he assumed that Leval simply executed the designs of Pedro Ma-

[18] Gómez-Moreno y González, "El Palacio de Carlos V," p. 197; repeated by Francisco de Paula Valladar y Serrano, *Guía de Granada*, Granada, 1906, p. 389.

[19] AA, Leg. 5, 28. The undated document was titled (probably by Gómez-Moreno) "Una oblig. para poner en este sitio 100 carros de madera para sus obras, años 1554–1556."

[20] AGS, CMI, Leg. 1023, payment of 31 October 1567 for "Quatro tranqueros que llebó de Santa Pudia para las ventanas," and 24 January 1568 for "tranqueros," "frisos," "cornixas," "sobasas," and "un pedestal." Similar pieces were delivered on 24 December 1568 and 14 March 1569.

[21] Simón de Argot, *Nuevos Paseos*, II, 2, pp. 50–54.

[22] Gallego y Burín, "Antonio de Leval," pp. 56–83. The documents then in Leg. 228 are now found in Leg. 5, 19, fols. 18–27. Only eight of the seventy-four documents published by Gallego are included in my appendix, and fourteen previously unpublished documents now found at Simancas have been added because the *final* payments for Leval's work (missing in the Alhambra archives) are preserved there.

[23] Leval's second petition for reappraisal, dated 14 April 1561, was published by Gallego y Burín, "Antonio de Leval," p. 75, doc. V, no. 13 (now in AA, Leg. 5, 19, fol. 26).

chuca. But after reversing Orea's two compositions for the reliefs of the left pedestals, Leval seems to have made the designs for the remaining sculpture.

Leval's pedestal reliefs compare unfavorably with the bolder, more robust forms of Juan de Orea's panels (cf. pls. 64 and 66). The Flemish sculptor's sensibility to painterly qualities is especially evident in his attention to the texture of hair, manes, plumes, and tassels in his version of the battle relief (doc. 67), and that tendency became more marked in his later work. Also, his figures became more slim and delicate, with their contours increasing in liveliness if not descriptive precision. In matters of composition, he was never strong. The extra figures added to his battle scene (for which he received sixteen ducats more than Orea) served to open the closed composition of his model. In Orea's relief, our attention is firmly guided by the disposition of the outermost figures toward the center of the relief, whereas that clear sense of direction is muddled by Leval's addition of a horse and a foot soldier with a banner on the right side of his relief. Though he cluttered the surface with these additions and with much insignificant detail, he failed (as we noted) to recognize the importance of several meaningful features in Orea's panel, such as the laminated armor worn by Charles at Mühlberg and the columnar device on the banner upheld by the horseman on the far right. Leval's relief also lacks the careful grading of successive levels of the relief of his model, and the foreshortened shape of the fallen drum on the far right and the shields are less securely defined, but the delicacy of his line and the lower level of his background relief contribute to the suggestion of deeper space.

In 1554–1555, following the battle scene, Leval seems to have designed and carved the reliefs dominated by mobile field cannon on the sides of the two inner pedestals fronted by the *Triumph of Peace*.[24] So marked are the pictorial qualities in these reliefs that one must assume graphic models, most notably for the puffs of cumulus clouds in the sky (pl. 58). The cannon are clearly based on those in Niccolò da Corte's modern trophy reliefs on the south portal, made fifteen years earlier, while the armor reflects examples found among the spoils in Orea's composition of the *Triumph of Peace*. Though Leval attempted to suggest a deep pictorial space, the illusion is disrupted by disparities in the relative sizes of the objects represented, especially the outsize cuirass forward of the cannon. It totally spoils the intended continuity of the side into the field of trophies on the front of the pedestal and that was clearly his intention because neither the front nor the side reliefs were framed by moldings or separated from one another in any way.

On the returns of the outer pedestals, made in 1556, he used equestrian and foot soldiers similar in size and dress to those in the battle scene (pl. 68), successfully avoiding gaffes of the sort that marred the continuity from the side to the front of the innermost pedestals (docs. 83 and 86). Of course, the reliefs on the inner sides of these pedestals (alongside the small doors) are better designed: the dominant equestrian figure rushes toward the front, while on the outer side, the same figure charges toward the massive stones of the rusticated wall (pl. 59). It is not likely that Pedro Machuca would have approved this confrontation of the small figure and the huge block of stone facing, and even less likely that he would have conceived the wraparound reliefs. Pedro Machuca's unusual use of the Doric frieze along the top of the pedestal suggests that by the use of that architectural ornament he had hoped to forestall other enrichments. When the figural reliefs on the front face of the pedestal were ordered they were allowed to spread the full width, following the Doric frieze. As we noted, that decision was made before Pedro's death, but the side reliefs must have been suggested later by Leval. This sequence of elaborations would explain the disparities between the front and sides of the wraparound reliefs, as well as the odd combination of the illusory reliefs and the Doric frieze.

The robust boys with garlands reclining on the pediments of the side portals were presumably Leval's next works (pl. 67) since the marble was delivered in April 1556 and the final payment was made in June 1557 (docs. 85 and 93). In document 93 they were described as "the four figures of boys (*muchachos*) which I made in white marble for the main portal." Because Gallego y Burín found

[24] Ibid., p. 66, doc. III, nos. 1-9. Gallego published the appraisals of the first pair of side panels recorded on 22 January and 3 February 1554 (doc. 71) and for the second pair on 9 to

11 April 1555 (now AA, Leg. 5, 19, fols. 8-10). The final payment for the latter pair on 13 April 1555 was again found at Simancas (doc. 77).

nothing more than an undated petition for payment, he assigned the boys to the 1560s,[25] but clearly they precede rather than follow the Victories over the central portal. More robust than most of his figures, they seem to be nothing more than boys with fruit swags, a familiar reference to abundance in Carolian programs.[26] The fruit swags hanging down on either side of the side doorways were Juan de Orea's last recorded works for the west entry in 1552 and 1553 (doc. 63). Made to appear to hang independently from the outer ends of the pediments (pl. 62), Orea's swags may have induced Leval in 1556 to give swags to the boys on top of the pediment. Contorted into symmetrical poses, the boys reveal the sculptor's uncertain grasp of anatomy, notably in the attempt to suggest a twist of the torso by placing the bloated abdomen at a marked angle (pl. 67). The facial type of the boys was repeated in the more delicately modeled profile busts of youths in the small roundels within the tympana of the side portals, completed by December 1557.[27] The brittle carving of the mass of the boys' hair and the fruit in the garlands lends a hardness to the surfaces that is at odds with the suavity of the carving of the later medallion busts and the Victories, but this may be due to the participation of assistants. Because of the way the boys turn toward the center, leaving an open arc between them that is concentric with the roundel above, they may have turned to look at some central motive, now lost, that had been mounted on the crest of the pediment, though there is no documentary or physical evidence for anything of the sort. Leval's undated petition noted that the boys were carved in *white* marble. All previous sculpture was made of the same grey marble as the architectural elements; so, while the figures of the boys are badly stained today, their execution in white marble represented the introduction of a contrasting material into the west frontispiece.

The Victories mounted over the triangular pediments of the central portal are slightly under life size and carved in the white marble of Filabres (pls. 62 and 71). Work on both figures was underway

before September 1558 when Leval received another payment on account, but they were not ready for final appraisal until March 1561 (docs. 96 and 105). For this purpose, Leval named Baltasar de Arce as his representative, and the overseer, Juan Arias Mansilla, named Toribio de Liebana; both were sculptors of the Siloe School. When informed on 13 March that they had set the price at only 100 ducats apiece, Leval objected, saying that the appraisers were not accustomed to seeing a work "so subtle and ethereal" (*tan sotil e i[n]material*) and, for that reason, did not know how to appraise it properly (doc. 105). His pride in these figures is understandable because they are superior to anything he had done for the *portada* and equal to the work of any sculptor then active in Granada. To settle the matter, the overseer asked the venerable Diego Siloe himself to make a definitive appraisal, but Siloe said he no longer wanted to come up to the Alhambra for that purpose, probably because of illness or advanced age.[28] So Juan de Maeda and Francisco Sánchez were asked to make a new appraisal and they raised the price for the two figures to approximately 227 ducats.[29] Incidentally, Leval's claim for a higher price on the basis of the subtle and ethereal qualities of his figures presents a rare instance in which truly aesthetic values are mentioned in an appraisal on the Alhambra. In the few cases in which reasons for the price are given (not only on the Alhambra but elsewhere during the Renaissance), they are usually of a technical or craftsmanly nature, more often involving diligence than artistry. The descriptive terms used by Leval— "subtle" and "ethereal"—provide a clue to his own aims in figural sculpture. Slim and elegant, the Victories bear no resemblance to the stocky personifications of Peace in his 1551 reverse copy of Orea's panel. Clearly he sought to attain highly finished surfaces with gentle changes in direction and subtle refinements in the rendition of detail. To enhance the suggestion of the softness of flesh, the ridges of the rumpled drapery were given a contrasting crispness. Because of these qualities one readily assumes a Hellenistic model. That associ-

[25] Ibid., pp. 61, 82, doc. VIII.

[26] Loukomski ("The Palace of Charles V in Granada," p. 123) described them as cupids with bunches of grapes and thus a reference to Bacchus, but abundance or liberality are more likley themes.

[27] The payment for the three tympanum reliefs on 22 De-

cember 1557 (not published by Gallego y Burín) is found in AGS, CM1, Leg. 1120; see doc. 94.

[28] Gallego y Burín, "Antonio de Leval," p. 75, doc. v, no. 12, 31 March 1561 (now in Leg. 5, 19).

[29] Ibid., p. 76, doc. v., no. 15, appraisal of 19 April 1561. For the final payment on 24 July 1561, see doc. 106.

ation lends special interest to an undated payment to Antonio de Leval for piecing together some broken statues said to be of ancient origin (*figuras antigoallas*).[30] Midway in Leval's work on the portal, these figures may have provided an impetus to a more delicate surface treatment of the Victories and the profile busts. Of course, the qualities that Leval prized so highly were largely lost when the slightly less than lifesize figures were raised to the top of the central pediment, seven meters above ground level. They could not have been made any larger because little space was left between the pediment and the main entablature. Even at this reduced size, they obscure the important line of the surround framing the central bay and cut across the lower edge of the architrave of the entablature. Machuca, who was inclined to limit sculpture or to subordinate it to the architectural membering, is not likely to have planned these undersize Victories over the large pediment of the central door. The upraised hands of both Victories are now lost, but presumably they held something. Gómez-Moreno said they held pomegranates, symbolic of the city, but I know of no basis for this claim. That symbol would be no more in keeping with the presumed reference to the victory at Pavia in 1527, which he proposed, than to that at Mühlberg in 1547, proposed here. Neither Granada as a city nor its famous cavalry was involved in either battle.

The huge medallions over the side portals were already underway in June 1562 when Leval requested a payment on account for this work (pl. 70), and they were completed by January 1563.[31] As usual, in the account ledgers, the subject of the mirror-image reliefs is identified in descriptive rather than thematic terms. They are variously described as "three equestrian figures and one soldier on foot" (*tres figuras a cavallo y un soldado a pie*), "knights" (*figuras caballeros*), and "cavalry" (*cavallería*). The lances and light armor suggest that the relief honored the famous Hundred Lancers of the Alhambra, though they had no part in the Battle of Mühlberg commemorated on the pedestals. But that disparity should cause no surprise because the program of the frontispiece had gradually lost specificity in favor of generic ornament. Of course, a reference to the Hundred Lancers of the Alhambra

would be appropriate over these doors because the west forecourt (if it was still intended) was to have served for the training of cavalrymen in equestrian competitions and also for exercising and stabling their horses. Of all the sculpture on the frontispiece, only these round reliefs were clearly intended by Pedro Machuca, though he may have had the imperial arms in mind. The relief on the right is obviously the second of the two because it has the extra swords and lances noted in the appraisal of January 1563 (doc. 113). The diagonals of the added weapons contribute to the sense of movement and vigor, and they also serve to direct our attention toward the central axis of the frontispiece. Though Leval attempted to establish the three equestrian figures in successive planes, he did not reduce the relief of the rear figures sufficiently to attain a convincing illusion of recession. More skillful is the rhythmic variation in the placement of the heads and forelegs of the rearing horses, which are reminiscent of Niccolò da Corte's sea horses on the pedestals of the south window. Vitality is also suggested by the lively contours and the coloristic details so characteristic of Leval, but the compositions are not masterful. The foot soldier looks like a space-filling afterthought, and the tree trunk that follows the curve of the frame forward of the rearing horses disrupts the spatial illusion. The barking dog, prancing along in the lower arc of the medallion, adds a trivial note to the heroic theme of equestrian battle. In scale, the figures in these reliefs are better suited to the architectural membering than any of the other sculptural ornament. They are about twice as large as the equestrian figures in the pedestal reliefs, but are too small for the size of the boys over the pediments of the side doors. These disparities in size disrupt the visual unity of the frontispiece and confirm our conclusion that the sculptural program was not planned as a whole.

The architectural parts of the west entry are not as well documented as the sculptural, but some scattered notices have been found. From May through July 1552, several of the "columns of the royal portal" were delivered, four more arrived in January 1553, and still others were ready for delivery in October 1554 (docs. 62, 65, and 73). In

[30] Ibid., p. 83, doc. CI (now Leg. 5, 19, fol. 43, bearing the date "9 April" and included with other payments of 1564).

[31] Docs. 108 and 113. The first payment on account on 14

October 1561 was not included in the Alhambra documents published by Gallego y Burín, but it is found in AGS, CMI, Leg. 1023; see doc. 116.

November of 1552, Juan de Orea completed the fruit swags that hang from the pediment of one of the side doors, and the following year, in September 1553, he was paid for those of the other door (doc. 63). Several exceptionally large pieces for the medallions over the side doors arrived in August 1555 (doc. 82). In July 1556, Cubillana and Morales were paid for carving three corbels, presumably those centered under the surround in each of the three bays of the frontispiece, and during most of that year, Cubillana was occupied with the carving of sections of its Doric entablature (docs. 84, 87, and 88). A few more pieces identified as parts of lintels and panels (*espejos*) were delivered from September 1559 to September 1560, and in the meantime, Luis had apparently begun to assemble the frontispiece because lead needed to affix the marble facing (*plomo para começar asentar la portada prinçipal*) was purchased in December 1559.[32] By March 1560, payments were made for equipment to lift the columns (*tres guindaletas de cañamo*), and by November, for the construction of scaffolds.[33] From this information, it is evident that the acquisition of the marble for the first story required almost a decade, during which time most of the sculpture was executed, and that the assemblage of the frontispiece was delayed until the 1560s.

Material for the facing of the second story of the west entry was delivered from the mid-1550s through the mid-1560s. Often it was identified as "for the *portada*" or "for the main portal" or "for the accompaniment of the main portal" but, occasionally, more explicitly "for the accompaniment of the window of the main portal."[34] The term *portada* obviously included the three bays over the doors. The clearest, though not the earliest, references are found in 1565 and 1567 (docs. 118, 119, and 121), when payments were made for parts of the architrave, frieze, and cornice—all identified as pieces "for the frame of the window of the main portal" (*para acompañamiento de la ventana de la puerta prinçipal*). Already in August 1556 (doc. 88), Sebastián Díaz delivered "ten pieces of the frieze for the frame of the main entry" (*10 pieças de los frisadis*

[sic] *para aconpañamiento de la portada prinçipal*). Since all these pieces were *white sandstone* from Santa Pudia, they were not intended for the lower story, where all the architectural parts are of grey marble from the Sierra Elvira. The same is true of a payment for white sandstone in January 1557, part of which was described as "three large pieces, each thirteen [Castilian] feet long, for [placement] between the columns of the portal" (*tres pieças grandes, de treze pies de largo cada una, para entre colunas de la portada*).[35] Presumably these 3.62-meter pieces of white sandstone were panels between the paired half-columns of the upper story. Three other payments in the winter of 1556–1557 for "pieces of shells" (*pieças de veneras*) help to complete the picture of the second story (doc. 91) because *veneras* in the records of the palace, whether for the facade or the courtyard, refer to shell-faced half-domes mounted over semicircular niches. Similar pieces had been delivered in 1541 for Pedro Machuca's all-sandstone entry, then under construction on the west front (docs. 29 and 31). From the amount of time spent on the carving of these pieces, we concluded that they must have been a good deal larger than the niches between the paired pilasters at the ends of the upper story and that they probably occupied the bays over the side portals. Apparently Machuca carried over that motive from the 1540 project to the project of 1549.

Some features, such as the half-columns and their pedestals, were of white marble from Macael, located about 30 kilometers southeast of Granada. In August 1554 (doc. 73), nine pieces of white marble were delivered for the main entry (*nueve pieças para la portada prinçipal, todo de mármol blanco de las dichas canteras de Macael*), and a few years later, in July 1558 (doc. 95), payments were made for two pieces of white marble from Macael for the returns of pedestals (*dos retornos de mármol blanco . . . para la puerta prinçipal*). There is also a reference to a white marble column, finely finished (*labrada a punta de pico*), on 12 October 1563 (doc. 115). Since Luis Machuca decided as early as 1556 to use columns of the conglomerate stone of Turro in

[32] Ibid., payments for marble of 9 September through 17 October 1559, and 30 January through December 1560 (docs. 97-98), with the payment for materials needed to affix the marble dated 23 December 1559 (doc. 99).

[33] AGS, CM1, Leg. 1023, payment on 17 March 1560 (doc. 100), and Leg. 1120, payment of 11 November 1560.

[34] See doc. 103, for sandstone lintels of the window of 16 July 1560. Juan de Maeda in 1576, when he estimated the cost of completing the second story of the west *portada* (doc. 128), also referred to parts that "accompany" (*que . . . va aconpañando*) the main portal or its window.

[35] AGS, CM1, Leg. 1120, *Nóminas*, 3 January 1557.

place of the white marble originally intended for the round courtyard and since no other parts of the new palace required white marble at the time, we can safely assign this column to the central window of the west entry. The arrival of this column five years after the pieces for the pedestals is in keeping with the pace at which parts of the facing for both stories were delivered from 1550 to 1556, and also with the delay often encountered in finding someone to undertake the delivery of large columns. There was, of course, no hurry because the assemblage of the grey marble facing of the lower story was not begun until December 1559.

The general disposition of the three central bays over the west entry in Pedro Machuca's project of 1549 can be reconstituted from the several payments for the delivery of architectural elements in sandstone and white marble "for the *portada*." A large window in the wider center bay had pedestals and columns of white marble from Macael, while its cornice and spandrels were of white sandstone. The bays on either side had large semicircular niches with shell-faced half-domes, wholly of white sandstone. Presumably, paired Ionic pilasters like those used at the ends of the facade (with or without small niches between them) framed the three bays. The large niches in the side bays are reminiscent of Machuca's 1540 project, though some changes must have been made, because the sandstone *veneras* delivered in 1542 were replaced by others of 1556. Clearly, neither Pedro nor Luis projected a two-story *portada* of grey marble on the west facade. Pedro planned and Luis executed a one-story grey marble frontispiece set against the all white sandstone facade.

A pair of mysterious sculptural works for the west entry are mentioned in the records. On 7 April 1563 (doc. 114), Leval was paid for two pieces of marble from the Sierra Elvira for "two lions for the main portal" (*dos leones para la portada prinçipal*), and this reference was repeated on 26 February

1564 and again on 16 February 1566, when they were described as "the lions of dark marble for the main portal of the main entry" (*los leones que labra de piedra prieta para la portada prinçipal de la puerta prinçipal*).[36] Because the documents Gallego y Burín found in 1942 did not mention their destination, he assumed that Leval, having finished the sculpture of the west entry, was asked to make the lions for the south portal (pl. 44). Although they were eventually placed there, they were made initially for "the center portal" of the west facade. Since their bases are 0.43 by 1.36 meters, the lions could not have been placed on the shallow benchtable under the pedestals of the center doorway, nor anywhere else within the one-story frontispiece. The most plausible placement is the ledge of the advanced entablature over the paired columns of the center bay, so that the grey marble lions would have been silhouetted against the white marble pedestals of the center window of the upper story. The 1.93-meter width of those ledges provides ample depth to accommodate the 1.36 by 0.43 meter bases of the recumbent lions. Also the notches, about 4 by 9 centimeters, that are cut into these bases could have served to clamp the lions securely in place atop the advances of the entablature, whereas in the lions' present placement on the secondary pedestals of the south portal, the notches serve no purpose. The lions might also have been intended for placement over the frame of the central window in a position comparable to the recumbent lions over the arcuated lintel of the loggia depicted around 1520 by Giulio Romano in a window embrasure of the Hall of Constantine in the Vatican (pl. 138); but, the advanced entablatures over the coupled columns framing the center doorway would seem to be the more likely location.

Of great interest for the history of the west facade is a drawing from the Burlington Collection that appeared on the London market in 1971 (pl. 74).[37] Executed in pen and brown ink, with light washes, it seems to be the central portion of a larger

[36] AGS, CMI, Leg. 1023.

[37] *Catalogue. Exhibition of Italian Old Master Drawings, November 16th – December 3rd, 1971*, Baskett and Day, London, 1971, no. 30. Priscilla E. Muller, curator of the Hispanic Society of America, called my attention to this Spanish drawing in the otherwise Italian exhibition. We know that it was acquired about 1720 by Richard Boyle, the third Earl of Burlington, and it seems to have remained in that collection until it was offered

for sale by Baskett and Day in London in the autumn of 1971. It was then purchased by another London dealer, Cyril Humphris, who kindly made it available to me for study; see Earl E. Rosenthal, "A sixteenth century drawing of the west facade of the palace of Charles V in Granada," *Miscelánea de estudios dedicados al Profesor Emilio Orozco Díaz*, Granada, 1979, pp. 137-147. In 1981 the drawing was purchased by the Department of Prints and Photographs of the Metropolitan Museum in New

drawing. The torn outer edges, particularly on the left side, reveal that the drawing had included at least the adjacent bays. The drawing seems to have parted along a center fold (and perhaps along other folds) between the third and fourth bays on either side of the *portada*. In any case, the two central pieces have been mounted on another paper and framed with double lines in red ink. It bears the inscription: *Escala de pies [castellanos]. Por do[nde] está traçada esta delantera*, which simply identifies the drawing as a scale elevation of the main facade in Castilian feet. The accuracy of its scale is confirmed by its close agreement with most measurements of the eighteenth-century elevation made for the Academy of San Fernando (cf. pls. 60, 74, and 102).

A comparison of the Burlington elevation (as I have named this drawing) and the two groundplans in the Royal Palace in Madrid provides no support for an attribution to Pedro Machuca. The materials, the manner of drawing, and the forms of the letters and numerals differ from those of the two groundplans that were almost certainly drawn by Pedro (cf. pls. 17, 18, and 74). Even the format of the scale indicator differs in that the smaller units are placed at its end rather than its beginning. Therefore, not only is there no technical basis for the attribution of the drawing to Pedro himself, but a post-Machuca date is assured by the indication that the three central bays of the main story were to be faced with the same material as the three-door entry—that is, with grey marble. We know that Pedro resolutely opposed marble facing on the west facade until about 1549, and only then did he design a one-story frontispiece in grey marble surmounted by an upper story of white sandstone. Luis began to execute that project in the 1560s, shortly before work was disrupted by the ·Rebellion of the Moriscoes at the end of 1568. It is also clear that no serious effort was made to resume work on the new palace until 1574, when the acting architect, Juan de Orea, went to Madrid to get instructions for the completion of the palace. Thus, the Burlington elevation is likely to have been drawn after 1574. We can also be quite certain that it was made previous to June 1580, when Juan

de Herrera rejected Orea's proposal for a three-light central window flanked by two huge niches and ordered their replacement by three windows equal in size to the rest of those in the main story (doc. 132, a and b). As shown below, that decision was never reversed, and so the Burlington elevation would seem to belong to the late 1570s.

Especially noteworthy in the report of 1580 is the information that large niches on either side of the central window appeared in the project submitted by Orea to Herrera because they are also seen in the Burlington elevation (pl. 74). The coincidence supports not only the association of that drawing with Orea in the late 1570s but also our reconstruction of Pedro Machuca's first all-sandstone facade of 1540-1542 (see fig. 8, p. 76 and his project for the three bays in sandstone above his marble frontispiece of 1549. We reasoned that the "veneras"—to which several carvers devoted a great deal of time in 1542 and again in 1556–1557—were the shell-faced half-domes of similar large semicircular niches flanking a central window over the three-door entry. Orea's inclusion of large niches in his designs of 1574 to 1580 assures us that he respected Pedro Machuca's original intention and, though the facing had to be changed from sandstone to marble, he retained the niches (without the Renaissance shells) that his father-in-law had used in the projects of 1540 and 1549.

Also reminiscent of Pedro Machuca's architectural repertory is Orea's use of the fielded panels with narrow channels and sharp arrises. Only in the late 1550s in the pilasters of the upper story of the west portal of the cathedral in Almería (pl. 69) did Orea begin to use the fielded panel. By the time he returned to Granada in 1572, it had become an obsessive motive, most notably as used on the second stage of the tower of the cathedral of Granada executed from 1577 to 1580 (pl. 73).[38] Thus, stylistic evidence confirms historical circumstances in suggesting that the project for the marble facing of the upper story in the Burlington elevation was designed by Orea in the late 1570s.

Further support is found in the drawing of the upper story of the *portada* in a technical difference that contrasts with the rest of the Burlington el-

York. It was purchased with funds from the A. Hyatt Mayor Purchase Fund, Marjorie Phelps Starr Bequest, and its accession number is 1981.1213.

[38] The only other contemporary Spanish architect who oc-

casionally used the linear version of the fielded panel was Hernán Ruiz II. For examples from the 1560s in Córdoba, Seville, and Cádiz, see Banda y Vargas, *El arquitecto andaluz Hernán Ruiz II*, pls. VIII, XII, XIII, and XVI.

evation. The corbels centered over the side doors of the *portada* and the pedimented main-floor windows were delineated in a naive perspective, as if they were all seen from the right while the corbels over the niches flanking the central window were represented frontally in orthogonal or vertical projection (pl. 74). Clearly, the more up-to-date draftsman of the three central bays of the second story of the *portada* had not drawn the rest of the facade. Fortunately, we have evidence that Orea was an early practitioner of vertical projection in Spain. This is clear from his criticism of one of his competitors for the post of chief architect of the cathedral of Granada in 1577: in commenting on Lázaro de Velasco's competition projects, Orea observed that the window frames were drawn in perspective and not orthographically or, as he said *en perfil*; and in another session, Orea pointed out that one of his own elevations had been misinterpreted by Velasco because the latter did not understand vertical or orthographic projection.[39] Had Orea made the entire Burlington elevation, he would not have used the angled corbels under the top cornice. Presumably they were copied by an assistant draftsman from an earlier drawing of the facade that simply served to provide a setting for Orea's project for the completion of the *portada* in the late 1570s.

The earlier drawing used as a model for the Burlington elevation seems to have differed from the facade as it was executed prior to 1568. Notable differences are seen in the lower story of the *portada*, for which the component parts were delivered during the 1550s and assembled in the 1560s. Neither the figural reliefs on the pedestals nor the figures reclining on the pediments of the three doors were depicted, while the pomegranates and vases on the main-story window crowns were delineated with care. Because we know that Pedro Machuca included no more than the architectural membering and heraldic ornament in his projects for the Fountain of Charles V in 1545 and the south window in 1548, it is reasonable to suggest that the

drawing used by Orea's assistant was Pedro's presentation drawing for his marble frontispiece in 1549.

Differences are even seen in the architectural membering of the frontispiece. The width of the Doric entablature in the Burlington elevation coincides with that of the string course separating the two stories of the sandstone facade, whereas in the present facade the entire architrave of the Doric entablature falls below the string course, disrupting that important horizontal division of the facade (cf. pls. 60, 74, and 100). In this feature the Burlington elevation is closer to Pedro's south facade, where there is a near coincidence of the limestone string course and the marble entablature of the *portada* in that only one fascia of the latter's architrave falls below the lower edge of the string course (pl. 44). On the upper level of the south *portada*, there is an exact coincidence of the entablature above the window and that of the palace itself. As we noted, Machuca's specifications expressly required the coincidence of the two entablatures (doc. 45). On the west facade, the disalignment of the membering of the marble frontispiece and the sandstone facade is also evident in the drop of the Doric capitals of the half-columns below the level of the Tuscan capitals of the rusticated pilasters, whereas in the Burlington elevation both are on the same level (pls. 74 and 100). Because most of the width added to the present marble entablature was allotted to the frieze, it could no longer accommodate as many square metopes as that of the Burlington entablature. The wider frieze of the present *portada* has only three metopes over the side bays and five over the center, in contrast to four and six, respectively, in the elevation. Inevitably, the patera and ox skulls are disposed in a different way. If O is understood to represent the configuration of the patera and V that of the skulls, the Doric frieze in the drawing is distinguished by its rhythmic disposition, O V V O in the side bays and O V V V V O in the center. The present *portada* (if the half-patera on the sides

[39] Rosenthal, *Cathedral of Granada*, p. 199, doc. 151 (for Orea's criticism of Velasco): "E luego se le entregó el quarto pliego de la invención del dicho licenciado Velasco, y aviéndolo visto y entendido, dixo que el perfil y montea está muy ensoseado de moldura, los güecos dél y las bueltas de los enxarxamentos están en perspectiva, siendo todo un perfil, que es gran defecto para un maestro. . . . Ytem, dixo que en el perfil

de la nave de en medio, a donde él finge ser el zimborio, no tiene talle de zimborio, no lo demuesta como él lo finge en la fachada, y tiene en los enxarxamentos el mesmo defecto que los otros perfiles"; and see p. 204, doc. 163, for his explanation of the consistency of scale in his elevation of the facade, which Velasco evidently misunderstood.

of the advanced entablatures are taken into account) employs the simple alternation of ox skull and patera that was customarily used during the Renaissance period. Earlier we noted Machuca's inclination to rhythmic variations in the *A c b c A c b c A* sequence of the three distinctive bays of the courtyard corridor and the use of paired pilasters to distinguish the end and center bays of the stylar facades in the large Royal Palace plan. Because of the rhythmic disposition of the metopes and the coincidence of the string course and the marble entablature, as well as the lack of figural ornament, the lower story of the marble *portada* in the Burlington elevation is more in accord with Pedro Machuca's design principles than with the frontispiece itself as executed by his son.

Another feature, this time in the sandstone portions of the facade, that points to the use of a drawing by Pedro Machuca as a model is the treatment of the corbel centered under the top entablature in each bay of the upper story. In the Burlington elevation, the corbel is interlocked with the fielded panel that frames the bull's eye window. The molding and channel of the fielded panel pass under the corbel as they do on the south facade realized by Pedro, whereas that refinement is missing in the east and west facades executed under Luis. Since this treatment of the corbel is peculiar to Pedro, it provides strong confirmation for the theory that his presentation drawing for the west frontispiece in 1549 was copied in the 1570s to provide the setting for Orea's project for the upper center of the main *portada*, but that conclusion is called into question by several surprising departures from the main-story fenestration already realized on the south facade by the mid-1540s.

The main-story windows of the present facades are taller than those of the Burlington elevation by about twenty-eight centimeters, approximately a Castilian foot. The difference is readily gauged by a comparison of the relative distance between the window lintels and the top moldings of the pedestals of the pilasters framing the bays and also by the smaller interval between the ornament on the window crowns and the bull's eye windows of the attic level (cf. pls. 74, 100, and 102). This is true even though the triangular pediments and the hooded lintel crowns in the Burlington elevation are taller proportionately than those executed. That difference is especially evident in the broad Vitru-

vian proportions of the present triangular pediments in contrast to the taller format in the elevation. So, the openings of the present main-story windows are taller and the crowns more squat in proportion than those delineated in the drawing. Also, the pomegranates of the present windows are located along the lower edge of the broadly proportioned pediments, while they are somewhat smaller and placed nearer the apex in the taller pediments of the Burlington elevation. The higher placement of the pomegranates produces a configuration that is closer to the silhouette of the three vases on the lintels, and that similarity suggests that the drawing records the original design of the triangular pediments in 1533 and that the change to the larger size and lower placement of the pomegranates occurred in the late 1530s and early 1540s when the window crowns were constructed and their ornament carved. Furthermore, the alternate crowns in the drawing are hooded and have a sloping cover instead of the little ledges on which the vases are placed in the present lintel crowns (cf. pls. 39 and 74). They also differ in that the hooded form has no ornament other than the three symmetrically disposed vases, whereas the lintel crowns of the facade itself have additional ornament, notably dolphins, scallop shells, and geniuses that emerge from leaves and support baskets of fruit. Thus, the odd lintel crown of the present facade could be understood as a reduction of the hooded form that was then elaborated with Plateresque ornament, probably by Pedro's *aparejador*, Juan de Marquina.

Another striking disparity is seen in the disposition of the alternating window crowns. In the Burlington elevation, they are symmetrically disposed, in that there is a triangular pediment on either side of the marble *portada*, whereas the present facade has a triangular pediment to the left and a lintel to the right (cf. pls. 60, 74, and 100). Responsibility for this bizarre disposition seems to rest with Luis since Pedro could not have done more than the rusticated ground floor before work was interrupted in 1542 and there is no indication of a renewal of work on the west facade until the 1550s. Though this extraordinary asymmetry had been introduced well before the Burlington elevation was drawn in the late 1570s, it was not recorded by the draftsman. Assuming the original Burlington drawing included the entire facade, the

alternation of window crowns must have begun at the outer ends with a lintel crown in order to terminate the six-window series with a triangular pediment on either side of the *portada*. That is the way Pedro had begun the series of alternating window crowns on either end of the south facade, but because there are seven crowns on either side of its smaller *portada*, the series not only begins but also ends with a lintel. Luis, on the south end of the east facade, also began the series with a lintel, and this effectively disengaged the east from the south facade and stressed the closed symmetry of each (pl. 40). The disposition of the Burlington elevation (which must have begun with a lintel crown) followed the same principle, whereas Luis' triangular pediment on the south end of the west facade represents a continuity of the alternation of crowns from the south to the west facade. Perhaps he deliberately sacrificed the closed symmetry of the west facade in order to terminate the series alongside the west *portada* with a lintel, as his father had done on the south facade, but that still does not explain the reversion to the lintel crown on the north end of the west facade.

A possible explanation for the asymmetry of the window crowns is found in the progress of work on the west front. Presumably Luis began the sandstone facing on the south end, and after facing the first four windows, he decided to postpone work on the two innermost windows until the marble frontispiece and the three sandstone bays above it were completed. He probably transferred stonecutters to the north end of the west facade, and after executing the four northernmost windows, he interrupted their work again because the marble frontispiece was still not quite finished. As we noted, Juan de Maeda's 1576 report makes it clear that only eight of the twelve windows of the west facade had been completed and that the four remaining were a pair located on either side of the *portada*. That location is confirmed by Anton van den Wyngaerde's sketch of 1567, which reveals that both ends of the west facade had been raised, leaving a huge gap—larger than the three central bays—in its center (pl. 69).[40] If Luis first directed the masons to begin with a triangular pediment on the south end, the masons assigned later to the other end might have inadvertently followed Pedro

Machuca's original project for the west facade, which almost certainly began with a lintel crown as does the Burlington elevation. The gaffe may not have been noticed immediately because the west half of the forecourt was still occupied by old Morisco houses and they would have obstructed a view of the facade as a whole. Then, when the asymmetry was noticed, the Junta may have decided it was too costly to correct.

Because the Burlington elevation is more in accord with Pedro Machuca's architectural repertory and design principles than with the present facade, it is quite possible that the drawing records the initial projects for both the sandstone facade of 1528 and the marble frontispiece of 1549. That combination in one drawing could have occurred in the following way. In 1549 an outdated 1528–1531 drawing of the sandstone facade was copied to provide a setting for Pedro's proposal for the marble frontispiece with an upper story in sandstone. Then, in the mid-1570s, when Orea needed a drawing of the facade to serve as a setting for his projects for the second story of the *portada* in grey marble, he simply directed an assistant to copy the presentation drawing of 1549, leaving the upper story of the *portada* blank for the insertion of one of his proposals. If the Burlington elevation is accepted as a record of Pedro Machuca's original project for the sandstone facade, it follows that he himself changed the height of the main-story windows and the shape of their pediments. Also, the absence of the petty ornament accompanying the three vases on the lintel crowns supports our attribution of those additions to Marquina, and the absence of the bronze tie rings makes even more likely our assumption that Niccolò da Corte not only designed but suggested that accessory. There is, however, no support in this drawing for our suspicion that the emblematic reliefs on the pedestals were carved into fielded panels comparable to those on the pilasters, because no panels are indicated on the die of the main-story pedestals. Nevertheless, because the Burlington elevation represents a preconstruction project, it is still possible that fielded panels were included on the pedestals in the final working drawing for this facade. As to the balustrade along the roofline, its form is more reminiscent of Herrera than of Machuca, so

[40] For Wyngaerde's drawing (Vienna, National-Bibliothek, Handschriften, Cod. Min. 41, fol. 55), see Haverkamp-Be-

gemann, "The Spanish views of Anton van den Wyngaerde," p. 390, pl. 6.

it was probably introduced by Orea in the 1570s under orders from Herrera. Also, we have noted that in several instances in which Machuca might have used a balustrade (for the main-story windows and the Serliana window over the south portal), he did not. If the Burlington elevation is accepted as a record of Pedro Machuca's project for the lower story of the west frontispiece, it also provides a measure of Luis' departures from his father's design. Finally, Orea's use of large niches on either side of the central window assures us that the mysterious *veneras* carved for Pedro Machuca's west entry in 1540 were shell-faced half-domes for comparably placed niches (fig. 8).

Apart from the palace, the Burlington elevation has an important place in the history of Spanish, and even European, architecture. If the sandstone portions were copied from a lost drawing of 1528–1532, the Burlington elevation records the earliest evidence for the use of orthogonal projection—or a close approximation—in Spain; and since that technique is thought to have been first used in Italy around 1520, this elevation (even with its wayward brackets) must be a copy of one of the earliest extant drawings of this type in Europe.[41] Because of its importance for the understanding of the roles of the several architects involved in the construction of the palace, we shall often consult the Burlington elevation.

THE ROUND COURTYARD, 1556–1568

Luis Machuca's ordering of model columns in 1553 is the first clear reference to the round courtyard

since his father laid the two rings of gravel for the foundations of the Doric colonnade and the wall of the corridor in February 1540 (docs. 27 and 28). About that abortive venture we know only that Pedro Machuca in 1539 altered the approved wooden model by replacing its arcade on piers with a Doric colonnade—the support system he first proposed in 1527. The twenty wooden columns carved and inserted in the model in 1539 probably formed about a third of the circular portico, which was composed of ten lower-level and ten upper-level columns. Thus, Luis had the circular foundations, the wooden model with about a third of the two-story portico, and full-scale model columns for both levels, which had been cut at an unnamed quarry and delivered in December 1542 (doc. 38). Even so, with all this to guide him, Luis was not as faithful to his father's project as most scholars have assumed.

For the columns, Luis in 1553–1555 still considered white marble from two quarries about a hundred kilometers from Granada, those of Filabres and Macael in the mountains north of Almería. In February 1553, Sebastián de Lizana delivered a white marble column from Macael and, in December, another from Filabres;[42] then in August 1554 he was paid for a second column from Macael (doc. 73), which was described as "finished with a fine chisel" (*labrada de picola*). Though it was delivered along with nine pieces of white marble for the central window of the west facade, this second column from Macael was evidently a full-scale model for the lower colonnade because only ten days later, on 20 August, Luis drew up specifications for thirty-one white marble columns (one

[41] In Spain, "elevations" seem to have retained the perspective component (like the famous drawing of the crossing of San Juan de los Reyes in Toledo of about 1477); but from that northern European type, Spaniards seem to have developed an elevation that approximated an orthogonal projection in drawings such as those by Juan Gil de Hontañon for the cathedral of Segovia in 1524; see Angulo and Pérez Sánchez, *Corpus of Spanish Drawings*, I, nos. 1 and 5, and Antonio Casaseca Casaseca, "Trazas para la catedral de Segovia," *Archivo español de arte*, LI (1978), pp. 29-51, figs. 3, 4, and 6. Some scholars have suggested that orthogonal projection was first introduced into Spain by Juan Bautista de Toledo and then diffused by architects who worked at the Escorial; see George Kubler, *Building the Escorial*, Princeton, 1982, p. 62, and figs. 26 and 32. Fernando Marías ("El problema del arquitecto en la España del siglo XVI," pp. 207-210) concluded that, while some Spanish architects must have started to use orthogonal projection around mid-century, it did not become general practice until the 1560s in the work of Juan de Herrera.

In Italy, Antonio da Sangallo's elevations for Saint Peter's in the 1520s are believed to be the first instances of true orthogonal projection; see Wolfgang Lotz, "The Rendering of the Interior in Architectural Drawings of the Renaissance," *Studies in Italian Architecture*, Cambridge, Mass., 1977, pp. 1-65. But the technique of orthogonal projection is already evident in Antonio da Sangallo's project for the portal of the Cancelleria in Rome (pl. 165), which Giovannoni dated 1517, and Hermann Vischer's drawings of Italian buildings during his trip to Rome in 1515, and Il Cronaca's in the 1490s, approximate that technique. Certainly, Pedro Machuca encountered proto-orthogonal drawings in Italy before 1520, and Machuca's drawings for the palace of Charles V were seen by court architects from 1527 to 1550. Pedro must have trained his son, Luis, and evidently his son-in-law, Juan de Orea, in a close approximation to orthogonal projection; so the architects of the Alhambra, rather than those of the Escorial, may have been the first to foster Italian orthogonal projection in Spain.

[42] AGS, CMI, Leg. 1120, 10 February and 3 December 1553.

short of the thirty-two needed), and he required that they, too, were to be *desbastadas y labradas a picola* (doc. 74). The height of the shafts was to be the same as that of the present Doric column, that is, 16 Castilian feet or 4.44 meters, and though the bases were somewhat taller and the capitals a little shorter, the total height was very nearly the same. So the Doric order planned in 1554 differed slightly from the final version in the design of the capitals and bases, but more importantly, it was still of white marble.

The function of the column from Filabres, delivered in December 1553, is known only because it was requested three-quarters of a century later by the city of Granada. In November 1625 (doc. 171), the city council noted the existence on the Alhambra of a single white marble column that had been delivered from the quarry at Filabres "over seventy years ago . . . for the upper corridor of the courtyard," and they asked that it be given to them to serve as the support for an image of the Virgin of the Immaculate Conception.[43] The column was relinquished for that purpose with Royal approval, and the monument was set up in the Campo del Hospital Real, where it remained until its removal in 1960 to the rose garden on the site of the old Plaza de Toros.[44] The governor noted that the shaft (now elaborately carved) had a height

of sixteen Castilian feet, and its base and capital brought the total to eighteen. Because the shaft of the column delivered for the gallery in December 1553 was sixteen feet, while the specifications that Luis later drew up in August 1554 called for a shaft of only twelve, it is evident that he made a major change in the elevation of the gallery. The new twelve-foot shafts, with capitals and bases measuring about three-quarters of a foot each, were shorter than originally planned, so Luis must have intended to place the columns on pedestals. In the earlier elevation of December 1553, the columns rose the full eighteen-foot height of the gallery, with their intercolumniations closed by a balustrade or, more likely, by an iron railing. Pedro Machuca's original design employing eighteen-foot columns would have had a lighter and more open elevation (fig. 10), while that of Luis in 1554 is likely to have had a column of about thirteen and a half feet (a twelve-foot shaft plus its base and capital) set on a four-foot pedestal. The effect of that elevation would have been similar to that of the modern model in the conservator's office in the palace of Charles V (pl. 75).

Thus far, we have accounted for two of the three columns ordered by Luis in 1553 and 1554. The remaining column is the first from Macael, delivered in February 1553. It must have been the model

[43] The city council probably became aware of this column as a result of a report by the officials of the Alhambra to Tomás de Angulo on 15 September 1620 in which they stated that they had "una coluna grande y otras quatro o cinco pequeñas de mármol inútiles para su edificio por haverse mudado el acuerdo primero de que fuese de mármol, i haverlos traído

después de jaspe ermoso . . ." (AA, Leg. 47, 6). The city's request to the governor is dated 25 November 1625 and the governor's letter (doc. 171) to the king bears the date 9 December 1625 (AGS, CSR, Leg. 332, fols. 692-693).

[44] Gallego y Burín, *Granada*, p. 444.

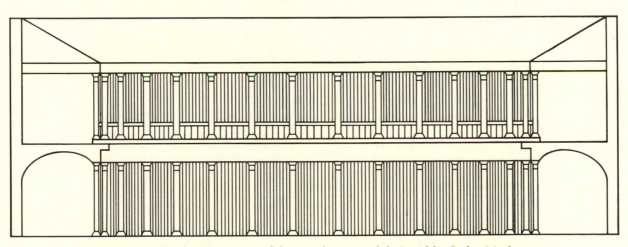

FIGURE 10. The double portico of the round courtyard designed by Pedro Machuca

for the Doric colonnade that accompanied the eighteen-foot Filabres column ordered for the gallery; but with the change in the design of the gallery in August 1554, there was probably a change in the lower colonnade as well. Hence, the model column delivered in February 1553 was abandoned and another was required. That was the one from Macael, delivered in August 1554.

Soon after, Luis decided not to use the white marble of Macael for the columns, but rather, the multicolored conglomerate stone from Turro near Loja. That decision must have been made early in 1556 because three *conglomerate* columns had already been delivered by an unknown contractor previous to 16 June 1556, when Pedro de Astaiço signed a contract to provide the twenty-nine remaining columns for the Doric colonnade (docs. 89, 90, and 92).[45] Though he agreed to deliver three columns a month, beginning the first of July, there is no record that any were received, and a third contract was signed with stonecutter Gabriel Ramírez in July 1557.[46] It called for a full complement of thirty-two columns, rather than the twenty-nine needed, but the notary must have made an error because Ramírez delivered no more than the twenty-nine cited in 1556. Ten shafts arrived by September 1557, but the remaining nineteen were delayed for more than two and a half years, with the last arriving in May 1560 (doc. 101). By August of that year, the pieces for all the capitals and bases were also on hand (docs. 102 and 104).

A few words should be said about conglomerate stone (pls. 80 and 81). Called *jaspe* in the documents and *pudinga* by modern geologists, it is composed of rounded pieces of slate, serpentine, quartz, quartzite, dolomite, and other minerals encased in limestone, so its colors vary from warm tans through roses to blue-greys.[47] Components that vary so much in color and density have very different factors of expansion and contraction in response to changes in temperature and moisture, and as a result, the conglomerate stone of Turro is an unstable material that readily disintegrates in

a climate with Granada's exceptional range of temperature from the heat of mid-day to the cold of night. Ample testimony to its fragility is provided by the columns on the north side of the courtyard, which (after four centuries of exposure to the sun) have suffered more losses and required more restoration than those along the shadowed southern half. Clearly, Luis Machuca did not choose conglomerate stone for its durability, nor for ease in carving the moldings and ornament of the Doric capitals and bases. The varying degrees of hardness and consistency must have posed great difficulties for the carvers since there was always the likelihood that one of the component stones would fall out of its limestone encasement. For that reason the blocks chosen for the capitals have smaller component stones than the pieces used for the shafts of the columns. Since it lacked the advantages of durability and technical convenience, conglomerate stone must have been chosen because the quarry at Turro was only one-fifth the distance of Macael. Columns from the latter quarry, which lies to the east of Granada, had to be transported over about a hundred kilometers of predominantly mountainous roads, while Turro lay about twenty kilometers to the west, with the more level terrain of the Genil river valley making transportation much easier. These more favorable circumstances reduced not only the costs and difficulties of delivery but also expenditures for the repair of roads and bridges over the longer and more mountainous route. We should expressly exclude the possibility that the conglomerate stone of Turro was chosen because Luis had already detected the natural gilding of the sandstone or that he foresaw its eventual accord with the warm tonality of the *jaspe* columns. As we noted, the sandstone facing of the palace was consistently described as "white" even well into the seventeenth century, when Henríquez de Jorquera boasted that the palace was *toda de fortísima piedra blanca de Santa Pudia*.[48] It is true that had white marble columns been used in the courtyard, they would today stand out against the deep

[45] A decade earlier, on 22 and 31 May, and 26 June 1546, three columns of the conglomerate stone of Turro were delivered to the Alhambra (AA, Leg. 3, 5), but it is not likely that they were ordered for the round courtyard because there is no record of work on it between 1542 and 1553.

[46] AA, Leg. 5, 41, fol. 4, 11 to 18 July 1557. The delivery of ten columns on 15 September is recorded in fol. 3.

[47] My knowledge of the nature of this conglomerate stone and the other stones and marbles used in the construction of the palace was gained in conversation with Professor Asunción Linares of the Department of Geology of the University of Granada.

[48] Henríquez de Jorquera, *Anales*, I, p. 55.

golden color of the wall of the corridor, while the conglomerate stone of Turro now blends nicely with it. That blending is an accident of time, not the result of foresight. In 1557, when Luis decided to use conglomerate stone for the columns, he knowingly, and perhaps reluctantly, relinquished the monochromatic unity of the courtyard. Though Luis may have departed little from the form of his father's Doric column, he is responsible for the introduction of the multicolored conglomerate columns into the white sandstone courtyard.

In the meantime, Luis had apparently drawn up specifications for the limestone blocks and the sandstone facing of the circular wall of the lower corridor because from December 1552 through November 1553, deliveries of both kinds of stone were identified as "for the corridor."[49] Constructed between 1552 and 1557, the wall of the lower corridor is composed of stone as carefully cut and set as any in the palace, thus assuring us that Luis continued the work with his father's high standards of craftsmanship. The corridor wall is scanned by tapered and fielded pilasters that mark bays of equal width but of three distinct types disposed in a rhythmic pattern (pl. 82). The type used at cardinal and intracardinal points (except for the three-door west entry and the main staircases) is a large arched opening, framed by a continuous molding without articulation at the springpoint of the arch. The smaller openings are broadly proportioned rectangular doorways with casings composed of fascia of successively diminishing widths. Above these doors are large round panels framed by a torus molding between two fillets. The third type of bay, which is placed between the other two, is a closed wall with a semicircular niche topped by a shell-faced half-dome and, above it, a shallow oblong panel with a frame similar to that of the roundel over the rectangular doors (pl. 80). In all three bays the moldings of the surround pass under the central corbel, following Pedro's handling of that motive on the main story of the south facade. This refinement and the corridor's general accord with the small Royal Palace plan of

1531 suggest that Luis was fairly faithful to Pedro's design.

The pilasters, however, represent a notable departure. While they still taper in width and salience,[50] their fielded panels are not edged with the sharp arrises that give a linear character to Pedro's pilasters. Luis rounded the edges of the raised panel, giving them a more modeled and sculptural form and the appearance of greater resiliency and vitality (cf. pls. 39 and 82). His pulvinated version of the fielded pilasters and his tendency to reduce the linearism of his father's forms, together with an inclination to polychromy, were probably his main departures from his father's architectural style. Also, Luis seems not to have inherited Pedro's fine sense of proportion and interval because both the oblong panel above the niches and the roundel above the rectangular doors are too large for the available area, with the result that the frames of the door and the roundel actually touch one another. We already noted that in the Burlington elevation (taken to be a record of Pedro's 1549 project for the west frontispiece) the roundels over the small doors were given ample space, whereas in the present *portada* executed by Luis, the frames of the roundels nearly touch the surround of the bay (cf. pls. 74 and 82).

The corridor was never completed, but the Machucas probably envisioned colorful frescoes in the annular vault and on the round and oblong wall panels, as well as near lifesize statues in marble or bronze (or simulated bronze) in the niches. Appropriate subjects, such as ancient Roman emperors or mythological heroes, were probably intended, but we have no actual specification of the decorative program the architect or the governor had in mind. Even so, one cannot properly judge the architectural design of the corridor without recognizing that the white sandstone wall was to have been enriched by colorful frescoes and statuary, and that this ornament would have heightened the rhythmic variety and continuity of the bays.

The most disturbing irregularities in the rhythmic distribution of the three types of bays were the

[49] AGS, CM1, Leg. 1120, payments on 3 December 1552, and 4 February through 30 November 1553. Presumably the deliveries continued during the following four years but the payments do not identify the sandstone as material for the corridor. Account ledgers for this period were not found in the archives of the Alhambra but, fortunately, some are preserved at Simancas. See doc. 107 for the delivery on 30 August 1561 of the limestone blocks under the columns.

[50] The width of the pilaster tapers from 56 centimeters at its base to about 50 at its top, while its salience is reduced from 8.5 centimeters at the bottom to 5 at the top.

result of compromises made by Pedro himself when he drew the large Royal Palace plan in the spring or summer of 1528 (pl. 107). Especially disruptive were the groups of three arches allotted to the main staircases in the southeast and northwest corners, the small door replacing the arch for the spiral staircase in the southwest corner, and the three-door entry on the west; however, the basic pattern can still be appreciated in the sixteen bays of the northeastern half of the courtyard, which maintain the original *A c b c A c b c A* rhythm. If, as I suspect, Juan de Maeda in 1576 reflected Pedro Machuca's original intentions in the suggestion that large spiral staircases be used in the southeast and southwest corners instead of the two-flight newel staircases, then that rhythm would have been broken only by the west entry. Maeda expressly stated that a spiral staircase would require only one door.[51] It is not clear whether Luis Machuca in the 1550s or Juan de Minjares in the 1590s replaced Pedro's group of three large arches alongside the staircase in the northwest corner with an arch flanked by rectangular doors, but they were changed again to arches in recent years.

Not to be attributed to the Machucas are the three distorted doorways leading from the corridor to the west vestibule (pl. 84). Though the date of their execution cannot be documented, the overly large moldings and the crude masonry of their frames suggest that they were constructed during the first third of the seventeenth century when standards of workmanship fell to their lowest point. Also alien to the Machuca repertory of architectural forms are the awkwardly splayed openings of these doorways. As drawn rather freely in the large Royal Palace plan and then more carefully in the small plan (pls. 17 and 18), each of the three

doors was aligned with the radius of its bay, but neither of the side doors was angled as sharply as the present openings. So we can deny Pedro's responsibility for these distorted doorways on the basis of his Royal Palace plans, and we can deny Luis' responsibility on the basis of the overly large moldings and poor workmanship. Excepting these departures by Luis or his successors, the wall of the corridor appears to follow Pedro's final intentions.[52]

Late in 1561, Luis made final preparations for the erection of the Doric colonnade, along with related segments of the annular vault. The last of the conglomerate columns, together with their capitals and bases, had arrived by August 1560 (doc. 104), and a year later, in August 1561, limestone blocks were delivered for placement beneath the colonnade (doc. 107). Apparently they were set on the innermost of the two rings of gravel laid by Pedro in 1540. Specifications for the component parts of the massive Doric entablature of the lower colonnade were announced and public bids were made in September 1561 and contracted for the following month with Martín de Velastigui.[53] The lower portion of the entablature—that is, the architrave and the frieze—is constructed in the form of a flat arch, composed of pyramidal stones (*salmeres*) placed directly over the columns and three voussoirs (*bolsores*) that span the intercolumniations, while the cornice above it is composed of four pieces (pl. 79). The order of 1561 would seem to have provided material for most of the Doric entablature, and while deliveries may have been made earlier, the first extant payments are dated September 1562 and they continue until January 1568, when deliveries were interrupted by the Rebellion of the Moriscoes.[54]

[51] Maeda stated "Sería yo de parezer que se mudase la intención del hazer de las dichas escaleras, haziéndolas redondas, porque según el sitio se podrían hazer grandes y mui descansadas y de mayor autoridad que se pretenden, dando la puerta de la escalera por en medio, y con las paredes d'ella quedarían aquellas partes, que agora son más flacas, las más fuertes del edificio." See doc. 129.

[52] Much of the facing of the lower part of the corridor wall had deteriorated by 1793, but it was not replaced until the late 1960s when fidelity to the original forms was the evident intention; see Francisco Prieto Moreno, "Obras recientes en la Alhambra y Generalife: Resumen del año 1968," *Cuadernos de la Alhambra*, v (1969), p. 126, "se continua la restauración de sillares de los paramentos, apilastrados y hornacinas del patio. . . ."

[53] The specifications, bids, and contract for the sandstone entablature, which were made between 26 September and 8 November 1561, are found in AA, Leg. 5, 50. Payments for delivery begin 24 September 1562 (doc. 109).

[54] AGS, CM1, Leg. 1120, payments on 7 April, 13, and 26 June, 3 July, 9 October, and 19 November 1563; and, in Leg. 1023, on 24 March, 8 June, and 25 November 1564; and AA, Leg. 230, 17, payments on 6 July, 27 November 1565 (doc. 118), 6 February and 6 April (doc. 119) 1566, 7 June 1567 and 17 January 1568. Though Martín de Velastigui, who cut the stone for the Doric entablature, provided stone for the west facade and the wall of the corridor, the payments on the dates listed are identified as pieces of the entablature.

Stones for the annular vault had also apparently been specified and ordered (pl. 80) because from September 1562 to July 1567 wedge-shaped pieces of porous limestone were delivered and identified as *dovelas* for that vault.[55] About fifteen distinct stonecutters' marks can be seen on the exposed surfaces of the stones for the annular vault, but I know of no basis for identifying any of them with Velastigui, Astiaço, or Falconete, to whom payments were made. Documentation for the 1560s is unusually sparse, but work on the annular vault seems to have kept pace with the delivery of stone because at least one segment of the Doric colonnade and the annular vault must have been completed by December 1565 when payments were made for polishing some of the Doric columns.[56] Evidently, all the colonnade and the annular vault had been constructed by 1569, when the work on the palace slowed down, because Juan de Maeda in 1576 did not mention the lower corridor or its vault on the list of work still to be done.

The raked form of the annular vault seems to be the result of a series of ad hoc solutions for the peculiar structural problems posed by a stone vault resting on a widely spaced colonnade on one side and a wall of no more than 56 centimeters on the other (pl. 78). The extraordinary variety in the shapes of the individual stones and the patterns of the masonry in successive segments of the vault indicate that the masons had no ready model and also that they never felt they had found the right solution. Also suggestive of improvisation is the use of Doric columns that are 25 centimeters taller than the responding pilasters that support the contracted entablature of the corridor wall. By this means, the annular vault was tilted back against the wall—as some modern architects contend—to relieve the continuous pressure of the vault on the discontinuous support system of the colonnade. The stability of that support system evidently concerned the Castilian advisers who in 1527 rejected

Pedro's colonnade (recorded in the large Royal Palace plan), and also his counterproposal for an arcade on three-foot square pillars (indicated in the small Royal Palace plan of 1531). Instead, the advisers required the use of the sturdier piers already used in the Archive plan of 1528 and in the final plan and the wooden model of 1532 (cf. pls. 17, 18, and 19). Castilian distrust of the novel colonnade suggests that from the beginning a masonry vault was required, and that concern for its outward thrust against the support system of the courtyard led the advisers to insist on a more massive pier. When Pedro Machuca changed the model in 1539, he revived the colonnade and, probably, the original width of the corridor (5.72 rather than 3.62 meters); and in 1540, he laid the two rings of gravel for the wall of the corridor and the Doric portico. Twenty years later, Luis ordered nothing more than limestone blocks to be placed directly under each of the columns (doc. 107), presumably on the gravel foundations laid by his father. In the elevation, the reduction of the gallery columns from eighteen to thirteen and a half feet and the addition of weighty pedestals were evidently intended to counter the outward thrust of the annular vault.

In view of the disruptive effect of the decision to construct the corridor vault of stone, there is reason to suspect that it, too, was intruded into Pedro's original design by the Castilian advisers. They were, of course, trained in an area of Spain that boasted one of the great stone masonry traditions of Europe and, as a result, they were not likely to have trusted the use of lightweight rubble for the annular vault as contemporary Italians might. Even if Pedro Machuca proposed the recently revived Roman technique of cast conglomerates or "concrete," which he might have known from the works of Sangallo and Bramante,[57] the Castilian advisers are likely to have considered it too untried and even inappropriate for so important a building. But of all possible structural techniques, stone ma-

[55] Payments were made from 24 September 1562 through 26 July 1567 (docs. 109, 112, 116, and 119), and a payment for wood for the centering of the corridor vault was made as late as February 1567 (doc. 120).

[56] AGS, CM1, Leg. 1023, 22 December 1565.

[57] Vasari (*Le vite*, ed. Milanesi, IV, p. 271) noted that Sangallo had experimented with that structural technique in the vault of a hall of his own house before using it at Poggio a Caiano. Paolo Sanpaolesi (*Brunelleschi*, Milan, 1962, p. 79) confirmed the use of cemented masonry in the barrel-vaulted hall and

porch of the villa at Poggio a Caiano, but he expressed the belief that Brunelleschi had rediscovered the Roman technique earlier. Howard Burns noted that Alberti (bk. VIII, chap. 11) claimed to have used coffered vaults of cast concrete; see "A Drawing by Leon Battista Alberti," *Architectural Design*, L (1979), p. 45. For Roman precedents, see Giuseppe Lugli, *La technica edilizia romana*, Rome, 1957, I, pp. 361-442, pls. XVII, 1, and XXXV, 3 and 4; and William MacDonald, "Some implications of later Roman constructions," *Journal of the Society of Architectural Historians*, XVII (1958), pp. 2-3.

sonry is not likely to have been proposed by Pedro himself. That was also Juan de Maeda's supposition in 1576 when he was consulted on the covering of the gallery (doc. 128). He noted that the Machucas had planned and constructed walls with a thickness of no more than two Castilian feet or 56 centimeters, and he judged that to be less than Machuca would have used if he had intended vaults of stone masonry. Furthermore, contemporary annular vaults of courtyards or garden loggias in Italy were entirely frescoed, concealing the material used in the construction. The use of a porous limestone and the scratching of stonecutters' marks on the exposed faces of the blocks, together with the varied patterns of experimental masonry, assure us that the Machucas intended frescoes and probably depended on illusionistic devices to make the lowered and tilted vault appear to be semicircular in form. All of these peculiarities lend support to the suspicion that the disputes and successive changes in the design of the two-story portico were the result of Castilian insistence on an annular vault of stone masonry.

Parts of the Ionic colonnade of the gallery began to arrive from the quarry at Turro in the summer of 1564, but the work force seems to have been occupied with the stylar wall of the upper corridor (pl. 83). That is clear from the inventory of material on hand shortly before Luis' death at the end of 1571 and from Juan de Maeda's report in the spring of 1576 (doc. 128-c). Among the parts needed to complete the gallery, Maeda listed only the entablature of its wall. In addition, the high quality of the cutting and setting of the sandstone and the carving of the moldings—a precision not characteristic of the post-Machuca era—provide further assurance that the gallery wall up to its entablature was completed before the death of Luis. In the inventory of material on hand in 1571 (doc. 127), Luis listed thirty-two columns, together with their bases and capitals, and also some pedestals (*estilobatas*) and their top moldings (*cornissas*), and the

same parts were repeated in Maeda's report.[58] The latter noted that only nine pedestals still had to be carved and polished and two still remained at the quarry, and that thirteen top moldings for the pedestals and the entire entablature of the gallery colonnade were needed. Maeda expressed some concern about the slimness of the columns, which were only one and a quarter Castilian feet in diameter, but he granted that they could be used if special precautions were taken in the construction of the gallery. Although pieces of conglomerate stone had been cut for the base course directly over the Doric entablature of sandstone,[59] Maeda recommended instead the dense and consistent grey marble of the Sierra Elvira because it would provide better protection for the sandstone cornice beneath it. Neither Luis Machuca nor Juan de Maeda mentioned stone for a parapet or balustrade, so Luis probably intended to use an iron railing between the pedestals of conglomerate stone.

Maeda's other main concern in 1576 was the current intention to cover the gallery with an annular vault similar to that of the lower corridor. If such a vault were used, he advised countering its outward thrust with the weight of a parapet (*antepechos*) set above the gallery colonnade; but he thought it would be wiser to give up that idea and, instead, to cover the gallery with a ceiling of wood (doc. 129). That apparently became the accepted solution because several times during the next century references were made to the wood needed to cover the gallery, but there is no hint as to the design of that ceiling. The regular file of equal putlog holes for beams in the limestone bearing wall above the sandstone facing of the gallery wall, first mentioned in the work orders of 1597 (pl. 83), were used in 1967 by the conservator of the Alhambra, Francisco Prieto Moreno, when he constructed the present coffered ceiling (pl. 76).[61] Five wedge-shaped coffers traverse the breadth of the corridor, and four span each bay. Because the beams that connect the columns and the wall pilasters are

[58] All the columns seem to have been delivered between 14 October 1564 and 26 September 1566 (docs. 116, 117, and 119) because in 1576, when the materials needed to resume work were listed by Juan de Maeda (doc. 128-c), only eleven pedestals were needed for the gallery from the quarry at Turro.

[59] 29 June 1569, AGS, CMi, Leg. 1023.

[60] Jesús Bermúdez Pareja informed me that many years ago Manuel Gómez-Moreno y Martínez had a section of the parapet of the gallery removed to see if the stone beneath it had been

prepared for a balustrade. When he found no such preparation, he was convinced that Pedro had intended a parapet; however, we now know that the band of marble he uncovered was not proposed until 1597 and not ordered until February 1599.

[61] Francisco Prieto Moreno ("Obras recientas en la Alhambra y Generalife: Resumen del año 1967," p. 130) reported the construction of the ceiling between 11 April and 20 June 1967. For the work orders of 1597, see AA, Leg. 47, 6.

not distinguished from those between them, the individual bays marked by the colonnade and the membering of the wall are obscured by the continuous rows of equal coffers and beams of the ceiling. Since Pedro Machuca was inclined to articulate architectural parts rhythmically, he is not likely to have designed a ceiling that did not respond to the bays defined by the wall pilasters and the colonnade. Even so, the present coffered ceiling is a handsome covering in the Renaissance style and it protects the long exposed stone of the corridor wall.

TWO PROBLEMATIC WORKS: PEDRO OR LUIS?

While most scholars have assumed that Luis was faithful to his father's intentions, our review of his execution of the west entry and the circular courtyard revealed that he introduced significant changes—usually for practical or structural reasons, but occasionally, the alterations suggest that his sense of form differed from his father's. What we have learned about the slight differences in sensibility and design principles between father and son can now be brought to bear on the question of the authorship of two problematic works that date from midcentury, the borderline between their tenures as chief architect. The first is the gabled edicular portal on the east facade and the second, the huge triumphal arch, now known as the Puerta de las Granadas, that serves as the main entry to the Alhambra.

No documentary reference to the execution of the east portal has been found,[62] but its edicular frame was already indicated in Pedro Machuca's small Royal Palace plan of 1531 (pl. 18). The interval between the centers of the half-columns in the plan is slightly less than the present portal—about 4.46 meters (16 Castilian feet) in contrast to 4.63 meters as executed—and the opening of the

door itself is a good deal narrower in the plan, about 1.75 meters in contrast to the present 2.40. So we can confidently attribute the general idea of the edicular frame in 1531 to Pedro, while recognizing that the present portal differs from his first intention in the width of its doorway and edicular frame.[63] In the absence of documents, a terminal date for the east portal may be inferred from the dedicatory inscription, IMP[ERATOR] CAES[ARE] KAROLO V, on the plaque mounted directly above the door frame, and also from the use of his motto PLUS OULTRE on the fluttering banderole arranged over a pomegranate at the base of the tympanum of the pediment (pl. 88) because references of this sort on a building usually pertain to the reigning monarch. Charles relinquished his title to Spain in January 1556, but his later abdication as emperor of the Holy Roman Empire was not recognized by the electors until April 1558, shortly before his death;[64] so, because of the reference to that title, the east portal might have been initiated as late as the winter of 1557-1558. For the earliest probable date, we must depend on the progress of the sandstone facing of the lower story of the east facade. That work was probably begun shortly after December 1542, when construction of the west entry was stopped. By 1548, the stonemasons facing the east facade could have reached its center, but then decisions were made on the more important south window and the west entry, and the work force was probably shifted back to the main facades. Thus, we are able to reduce the probable period of its execution to the decade of 1547 to 1557. But, since Luis succeeded Pedro in 1550, we must still depend on formal and stylistic evidence for the identification of the designer of the east portal.

The peculiarities of the Doric order of the portal do not serve to identify either Pedro or Luis as the designer because in the two other instances in which that order was used (the round courtyard and the west frontispiece), Luis executed Pedro's design,

[62] The date 1581 was given by Loukomski ("The Palace of Charles V in Granada," p. 120) without giving the basis for that claim. That date is unlikely because the east portal was not listed by Juan de Maeda among the parts of the palace still be be executed in 1576 (doc. 128-e), and as we shall see, very little work was done from 1572 to 1583.

[63] A drawing of the east portal was studied in 1964 in the library of the Academia de San Fernando in Madrid (no. 13M, 54 BA/60), but when I returned in 1972 it could not be located.

My notes indicate that it was filed with drawings published in the Academy's *Antigüedades árabes de España* in 1804, and I judged it to be a drawing of the late eighteenth or early nineteenth century. Drawn to scale in Castilian feet, its measurements coincide with those of the present portal in respect to the width of the aperture, the height of the columns, and the distance between their centers.

[64] F.A.M. Mignet, *Charles-Quint, son abdication, son séjour et sa mort au Monastère de Yuste*, Paris, 1854, p. 349.

apparently with some changes in the order. The rhythmic and symmetrical distribution of the ox skulls and patera on the frieze of the east portal (pl. 88), simulated graphically as V O V V O V, is a curious feature used by both father and sòn, but more readily associated with the former. That principle was followed in the bays of the Doric colonnade of the courtyard constructed by Luis, but in the execution of the frieze of the west frontispiece, he reverted to the customary alternation of the metopes, in contrast to the V O V V V V O V disposition indicated by the draftsman of the Burlington elevation, here taken to reflect Pedro's 1549 project (cf. pls. 62 and 74). Also favoring Pedro as the designer of the east portal is the convoluted banderole bearing Charles' motto within its tympanum. That late fifteenth-century motive was used to relate the imperial devices on the mantle of Pedro's fireplace in the emperor's bedchamber in the new quarters, and again in the triangular pediments of the main-story windows (cf. pls. 25, 41, and 90). Undulating ribbons of this sort were not often used in Spain, but they were favored in central Italy in the late fifteenth and very early sixteenth centuries. All of these factors favor Pedro as the designer.

One unusual feature—the forward inclination of the Doric frieze—would seem to be the most promising in assigning the east portal to Pedro (pl. 90). It is also found in the Doric frontispiece on the west facade (pl. 68), but not in the Ionic portal on the south front, so it would, at first, seem that the Machucas associated that feature with a Doric entablature. It may have been used in the original entablature of the Doric Fountain of Charles V because the simplified replacement has a slight forward inclination of the horizontal member that can be described as the frieze of an entablature deprived of its architrave (pl. 48).

A clue to the reason for tilting the frieze may be provided by the difference in the angle of the frieze of the west frontispiece and that of the east portal. The latter is inclined one-twelfth the height of its frieze, while the former is almost one-eighth

(pls. 68 and 90). Since the entablature on the west frontispiece is 7.50 meters above ground level and that of the east portal is about 5 meters, the greater degree of inclination on the west could have been intended to correct the increased foreshortening caused by the steeper angle of view. Of course, optical compensations of various kinds played an important role in Classical Greek architecture, but I know of no examples of a Doric frieze with a forward inclination, and adjustments of this sort seem to have had very little place in the design of Roman buildings. Probably for that reason there is little evident interest in optical compensations in the works or the theoretical treatises of the Renaissance period. Objective proportions seem to have been used by both Brunelleschi and Alberti. The latter insisted on the use of "true" measurements rather than adjustments for apparent proportions, and most Renaissance architects continued that attitude in practice.[65] Only in the books of Serlio does one find the recognition of the foreshortening of architectural members placed high above the eye level of the viewer and the recommendation that they be made taller so that they appear to have the proper proportion in relation to members closer to eye level.[66] The idea of compensations of this sort guided by the "judgment of the eye" is also found in Giorgio Vasari (1550), Daniele Barbaro (1556), Vignola (1562), and Giovanni Paolo Lomazzo (1585),[67] but none of them recommends tilting a member to make it perpendicular to the line of sight of the viewer in his most probable position.

Pedro Machuca, a decade before the first publication of Serlio, might have extrapolated this principle from the passage in which Vitruvius recommended the forward inclination of the entire entablature. The ancient theorist advised that "all members above the capitals of the columns, that is the architraves, friezes, coronae, tympana, gables, and acroteria, should be inclined to the front a twelfth part of their own height," and he goes on to explain that, if this is not done, they will appear to lean back, "but, when the members are

[65] Alberti, in *Trattati*, II, pp. 98-99 (bk. II, chap. 1), insisted that architects should use true, not illusory, measurements (*veris*, not *apparentibus*).

[66] Serlio, *Tutte le opere*, bk. IV, fol. 169, and bk. I, fol. 9.

[67] Pertinent passages from the works of theorists mentioned are conveniently gathered in Gerda Soergel, *Untersuchungen*

über den theoretischen Architekturentwurf von 1450–1550 in Italien, a published dissertation, University of Cologne, 1958, pp. 5-6, nn. 1-4. She noted that concerns for compensations of this sort are not characteristic of the Renaissance previous to the mid-sixteenth century.

inclined to the front, as described above, they will seem to the viewer to be plumb and perpendicular."[68] Perhaps this was one of the passages Renaissance architects found to be "obscure," because Alberti seems to have understood that only the cornice was to be inclined forward by one-twelfth its height and that was also the interpretation of Cesariano in 1521 and Serlio in 1537.[69] Among Renaissance theorists, only Diego de Sagredo in 1526 seems to have repeated the advice that all members of the entablature and even pediments should be inclined forward one-twelfth their height.[70] This is the formula that was followed in the Doric frieze of the east portal, while that of the west frontispiece was inclined forward somewhat more, about one-eighth its height. That compensatory device would seem to have been particularly useful in the case of the unusually narrow frieze of the entablature in the Burlington elevation. Constricted to the width of the string course of the sandstone facade, the entablature was reduced to less than the normal proportion, since it is a fifth rather than a quarter of the height of the column, and of the three parts of the entablature, the frieze was the most reduced. That reduction required the use of metopes that were broader than the usual square format. The frieze—if it had followed the plumb line—would have appeared even narrower in the foreshortened view. Confronted with this problem, Pedro Machuca may have decided to apply the Vitruvian formula, intensified to one-eighth, to compensate for the narrowness of that member. Following the current theory of visual angles, he tilted the frieze forward so that its surface assumed an angle approximately perpendicular to the centric ray of the near viewer at ground level, with the result that the full width of the constricted

Doric frieze would be seen. Luis, who executed the west frontispiece, probably retained the idea, because the frieze (even within his enlarged entablature) was still narrower than canonic proportions required.

Difficult to associate with either of the Machucas is the trapezoidal shape of the east door (pl. 88) because none of the other doors or windows in the palace nor those of the Burlington elevation are tapered. Furthermore, the proportions of the doorway do not follow those recommended by Vitruvius, Alberti, and Serlio for the Doric portal, in that the base width of 2.40 meters is too wide for a height of 4.25 meters.[71] The only feature of this portal that seems to follow the Vitruvian formula is its taper, which is approximately one-third the width of the door's casing, with the latter being one-fourteenth the height of the aperture. Incidentally, if Pedro Machuca's doorway—measuring 1.75 meters in the small Royal Palace plan—followed the Vitruvian scheme, it would have been only 3.84 meters high, with the result that the enclosing edicule would not have risen above the fascia of the lower half of the string course, as does the present frame. Equally odd within the Machuca repertory is the oblong plaque inserted between the door casing and the surround, which pertains to the edicular frame. No molding of the kind framing the plaque was used by either of the Machucas, and the brittle vegetal decoration that emerges from its notched ends has the appearance of ornament of the late rather than the mid-sixteenth century. Also alien are the awkwardly shaped and poorly spaced letters of the inscription IMP[ERATOR] CAES[ARE] KAROLO V, though the carver did repeat a few peculiarities of Bautista's letters on the south portal of 1537, no-

[68] Vitruvius, III, 5, 13: "Membra omnia, quae supra capitula columnarum sunt futura, id est epistylia, zophora, coronae, tympana, fastigia, acroteria, inclinanda sunt in frontis suae cuiusque altitudinis parte XII, ideo quod, cum steterimus contra frontes, ab oculo lineae duae si extensae fuerint et una tetigerit imam operis partem, altera summam, quae summam tetigerit, longior fiet. Ita quo longior visus linea in superiorem partem procedit, resupinatam facit eius speciem. Cum autem, uti supra scriptum est, in fronte inclinata fuerit, tunc in aspectu videbuntur esse ad perpendiculum et normam."

[69] Alberti, *Trattati*, II, p. 587 (bk. VII, chap. 9): ". . . observaruntque coronarum opus hoc ex parte XIIᵃ proclinatum ponere; id quidem, quod compertum haberent eas partes respuinatas videri, ubi ‖ ad rectos angulos porrigerentur." Cf. *Vitruvius de Architectura*, translated into Italian, with commentary and

illustrations by Césare di Lorenzo Cesariano (facsimile edition, Como, 1521), London, 1968, fol. lx. Serlio, *Tutte l'opere*, bk. I, fol. 9.

[70] Sagredo, *Medidas del Romano*, p. 72 (fol. Eiii): "El primero y principal es que los architraves, fressos, cornisas, frontispicios sean formados y assentados de tal manera que sus planos queden inclinados hazia delante y no caygan a plomo, ca si a plomo cayessen se mostrarían a los que de abaxo los mirassen ser acostados y derrocados hazia tras y causarían mucha fealdad e desgracia en el edificio puesto que en sus formaciones no la huviesse. . . ." This is followed by an explanation of the emission theory of sight held by the ancients.

[71] Vitruvius, IV, 6, 1-6; Alberti, VII, 8, and Serlio IV, fol. 143v and 144. They recommend the division of the doorway's height into twelve parts and the width into 5.5.

tably the long lower arm of the *E* and the very high center of the *M*. All these features suggest that the casing of the door was delayed because stone for the facing of the interior of the vestibule had to be brought in through that opening. As we shall see, the east vestibule was not faced until about 1600, and that date is congruent with the style of the plaque ornament. With the casing excluded, the High Renaissance character of the edicular frame is more evident. Its closest analogy is found in the side portals of the Sangallo project of 1516 for the facade of San Lorenzo in Florence (pl. 132). This affinity inevitably favors the attribution of the design to Pedro.

In sum, the factors favoring the attribution of the design of the east portal to Pedro Machuca are the following: its inclusion in the small Royal Palace plan of 1531, its High Renaissance format (except for the later trapezoidal door and the plaque above it), the heraldic ornament and convoluted banderole in the tympanum, and concern for rhythmic disposition and optical compensation.

The second problematic work is the three-door triumphal arch that provides access to the Alhambra from the Plaza de Santa Ana by way of the Cuesta de Gomérez. Known since the eighteenth century as the Puerta de las Granadas (pl. 91), it is a sixteenth-century replacement of an Islamic gate, called Bib Albaxar, which originally served as a secondary entry to the Alhambra. Under the Catholic Monarchs, it became the primary gate, probably because it was approached through a part of the city inhabited by Christians. The mid-sixteenth-century date usually assumed for the present triumphal arch depends primarily on the imperial arms of Charles V on its pediment, but Emilio Orozco Díaz has noted the stylistic affinities of the archway with works of the late sixteenth and even early seventeenth centuries.[72] Of course, the portal has suffered some changes through the years. The small side arches were closed, probably in the nineteenth century, and then reopened in this century; and the lower parts of the jambs of the central arch were cut away to accommodate the huge buses

that grind their way up the Cuesta de Gomérez to the Alhambra. The depth of the central arch, with recesses in the side walls to accommodate doors, follows an Islamic disposition that was probably used in the gate that preceded it. The greatest change in the appearance of the triumphal arch results from the rise of the ground level, probably as much as a meter. This can be deduced from the mere 2-meter height of the side openings and the overwhelming size of their gigantic voussoirs. Also, a meter added to the stubby pedestals under the rusticated half-columns framing the central arch would result in proportions better suited to the order and the opening. From Lafuente Alcantara's mid-nineteenth-century description, we know that the figures of Peace and Abundance—already badly deteriorated—reclined along the upper edge of the pediment and held the miter crown over the imperial arms and between the heads of the Habsburg eagle.[73] Today nothing can be seen of these figures except their hands, which are still attached to the crown, and the head of one of the figures, said to have been in the city's Museo Arqueológico, can no longer be found. Unfortunately, very little about the original form of the triumphal arch or the chronology of its construction can be learned from late sixteenth-century views of the Alhambra, such as those of Hoefnagel, Wyngaerde, and Vico. Vico depicts the Puerta de las Granadas as a *single* arch with vaselike finials (pl. 22, no. 57, in the lower left corner).

Only three documents relative to the Puerta were found and those deal with its coat of arms. The earliest is a payment of 26 March 1552 to Juan de Orea for carving, among other things, "a *tiara* for the Portal of the Gomérez" (*una tiara para la puerta de los Gomeles*),[74] but it is not clear if the object made was a crown or a coat of arms. On 7 May, Orea was paid the large sum of 10,000 maravedís for carving "a coat of arms that he made for the royal residence" (*un escudo de armas que hizo para la dicha casa real*), evidently following the appraised value set by Juan de Maeda and Esteban Sánchez. In the payment to the latter for his services on 26

[72] Emilio Orozoco Díaz, "La puerta del Antiguo Rastro de Granada," *Cuadernos de Arte*, II (1937), pp. 405-411.
[73] Lafuente Alcántara, *Historia de Granada*, pp. 362-363.
[74] See doc. 59. *Gomel* is defined as an individual pertaining to the Berber tribe of the *Gomera* in Marruecos in the *Diccionario*

de uso del español, so it is an accepted variation of *Gomérez*. We noted that *Gomeles* was used by Ambrosio de Vico in his 1596 perspective plan of Granada and *Calle de los Gomeles* was evidently still in use in the 1830s when Richard Ford wrote his account of the Alhambra (*Granada*, p. 196).

May, the work was identified as "the imperial arms" (*un escudo de armas imperiales*).[75] Because of the large price paid and the very fact that the carving was appraised, the *escudo* could not be one of the small emblematic reliefs on the pedestals of the main story of the facades; so it was probably the shield held by the Habsburg eagle on the pediment of the Puerta de las Granadas, and the *tiara*, clearly identified with it, must be the miter crown held over the imperial arms by the allegorical figures of Peace and Abundance.

The imperial arms on the gateway are readily identified as Orea's on the basis of their stylistic affinity with his documented sculpture for the cathedral of Almería in the mid-1550s. On the lower story of the north-transept portal, the arms of Bishop Diego Fernández de Villalán (contracted for in 1555)[76] are also carved on shields animated with vigorously curled strapwork; and the two youths on the top of the Almería pediment hold the cardinal's hat over Villalán's arms in the way the lost figures of Peace and Abundance were said to have held the imperial crown over Charles' arms on the pediment of the Puerta de las Granadas (cf. pls. 89 and 92). Strapwork of this kind was used by Orea for Villalán's arms over the cathedral's west portal and for the accompanying shields on the flanking buttresses, commissioned in 1556 (pl. 72);[77] and wedge-shaped platforms (comparable to those on which the huge pomegranates are set on the pediment of the gateway) were used to support the flaming spheres on the outer ends of the segmental pediment over the cathedral's west doorway. The single-headed eagle holding the arms of Philip II over the upper story of the Almería portal—though damaged and badly worn—compares favorably to the double-headed Habsburg eagle on the Alhambra in the shape of its head and the scale-like pattern of its neck feathers (cf. pls. 72 and 92). Because of these analogies to Orea's ornament in Almería, the imperial arms on the Puerta de las Granadas can, I believe, be attributed to him and identified with

the *tiara* and the *escudo de armas imperiales* for which he was paid in 1552.

This conclusion has significant implications for the date and, the attribution of the design of the gateway because the imperial arms crowned by Peace and Abundance would have required at least a year and a half or two to execute, especially since Orea was also doing reliefs for the west entry at the same time. Though architectural sculpture was usually not commissioned until a structure was well advanced,[78] we know that elderly Pedro Machuca attempted to establish his young son-in-law, Juan de Orea, as the sculptor of the Alhambra. We reasoned that Orea must have begun the first relief for the pedestals of the west frontispiece in the summer of 1550, well before the marble for its architectural frame had been delivered and a decade before it was assembled. It must have been Pedro who made arrangements for Orea to do the arms of the Puerta de las Granadas because the young sculptor later received little support from his brother-in-law, Luis. Less than two years after Luis became chief architect in 1550, Orea was reduced to carving window ornament, the work he had done in 1546, and by late 1552 he seems to have accepted architectural and sculptural commissions in Almería, finally transferring his household there in 1556. Thus, the assignment of the sculptural ornament of the Puerta de las Granadas to Orea was almost certainly arranged by his father-in-law, and it follows that the architectural design for the triumphal arch had been approved before Pedro Machuca's death in midsummer 1550.

Still, if found elsewhere, the Puerta de las Granadas would not be attributed to the architect of the palace of Charles V. Most scholars would be deterred by the gigantic scale of the structure and the powerful advance of the gabled edicule of the center arch from the plane of the sides of the triumphal arch and, especially, by the lack of refinements in the articulation of the parts (pls. 91 and 92). None of the moldings of the pediment are anal-

75 AGS, CMi, Leg. 1120, 26 March and 21 May 1552 (doc. 61). At the same time, Orea was paid for "three pomegranates" (*tres granadas*), which may be those mounted above the pediment of the main-story windows, because other payments were made for "two boys" (*dos niños*), which must be the boys with fruit baskets on the lintel crowns of the main-story windows, so he seems to have been doing work for both the west facade and the triumphal gateway on the Cuesta de Gomérez in spring

1552.
76 See chap. 2, n. 180.
77 See chap. 4, n. 8.
78 During the same years, the imperial arms for the Visagra gate in Toledo were carved before the architectural membering of the arch was ordered in 1559; see chap. 5, n. 136 for the documents.

ogous to those used in the pediments of the palace, and the haphazard cutting of the pieces that make up the entablature is wholly at odds with the precision that characterized workmanship on the palace under Pedro and Luis. Most alien to Pedro's architectural repertory is the rusticated facing of the triumphal arch. Its rounded forms contrast with the faceted or chamfered blocks and the distinctly linear emphasis of the rustication on the lower story of his palace. Furthermore, the uniformity of the blocks, in size and shape, differs from the patterned variety and complexity of the rustication of the palace. Especially odd is the continuity of the top course of the side section into the third voussoir of the central arch, dividing it into two pieces (pl. 92). Also, the capitals and bases of the Tuscan half-columns of the Puerta de las Granadas are not comparable to those on the ground floor of the palace, and there is nothing in the palace like the smooth band marking the springpoint of the center arch and extending across the entire arch. Finally, the inordinately small corbel under the massive pediment bears no resemblance to the leaf-faced corbels used by Pedro. So, while Orea's execution of the imperial arms for the pediment of this gateway by March 1552 would suggest that Pedro Machuca made a project and secured the ornament for his son-in-law before July 1550, the form and style of the present Puerta de las Granadas is at odds with Pedro's architectural repertory and design principles.

The discrepancies might be explained in the following way. With work suspended on the west entry, the south window, and the round courtyard, Pedro Machuca was required in the mid-1540s to design the wall-fountain and a replacement for the old Islamic gateway located further down along the same path of entry to the Alhambra. In view of the size of the gateway and the dilatory ways of the Junta de Obras y Bosques, to whom all projects now had to be submitted, the process of design and approval might easily have taken a year or two. Only then could Pedro have begun the demolition of the old gateway and the laying of the massive foundations that the new structure required. At the same time, he secured the carving of the arms for his son-in-law. Then,

in 1548, decisions were made on two major features of the palace on which work had been interrupted, the south window and the west entry. Once occupied with these more important parts of the palatine complex, he postponed work on the foundations of the new gateway. Then, when Luis became chief architect, he was fully occupied with completing the massive walls of the octagonal chapel, acquiring the architectural and sculptural parts of the west frontispiece, and resolving the very difficult problems of the colonnade and the annular vault of the round courtyard, in addition to continuing the sandstone facing of the upper story of the east and west fronts. For that reason, the Machucas may have completed no more than the foundations and possibly the masonry core of the Puerta de las Granadas before work fell off after 1568. This chronology postpones the rusticated facing and the massive pediment with its gigantic pomegranates until the 1590s, when the works were executed by Juan de la Vega under the absentee direction of Juan de Minjares. While admittedly speculative, the proposed sequence of events would account for the design of the arch by Pedro Machuca in 1545 to 1548, the execution of the imperial arms by Juan de Orea in 1550 to 1552, and the eventual alienation of the work from the architectural style of both Pedro and Luis.

THE STATE OF THE PALACE IN 1571

Construction on the palace was slowed down during the last three years of Luis Machuca's life by the Rebellion of the Moriscoes in 1568.[79] This event and the Mendoza recommendation of tolerance in dealing with the Moriscoes had long-range repercussions on the architectural works of the Alhambra, but only its immediate effect on Luis' last years will be mentioned here. The cause of the Rebellion was Philip II's refusal to allow the Moriscoes to use their own language and to retain some of their customs and their traditional dress in exchange for an annual tribute of 80,000 ducats, a sum paid regularly since Charles V agreed to that arrangement in December 1526. Philip's negation of that agreement pleased the archbishop of Granada, Pedro

[79] The most useful accounts of the Rebellion in relation to Granada are Pascual Boronat y Barrachina, *Los Moriscos españoles y su expulsión*, Valencia, 1911, I, x, pp. 246ff.; and Julio Caro Baroja, *Los Moriscos del Reino de Granada* (Ensayo de historia social), Madrid, 1957.

de Guerrero, who returned from the Council of Trent determined to force the Moriscoes of Andalusia to give up their alien customs. He quickly gained the support of the bishops of Almería, Gaudix, and Málaga, as well as the new president of the Audiencia in Granada, Pedro de Deza. Philip readily responded to their plea that he revoke the edict granting these privileges. On 1 January 1567, the king announced that the objectionable practices of the Moriscoes would be proscribed at the end of the year. He had been inclined to terminate the agreement immediately, but the Mendozas managed to delay the order for a year. After months of indecision, in September 1567, the Moriscoes elected a leader and withdrew to an old stronghold, the mountainous area of the Alpujarras. Tension grew in Andalusia because it was clear that the Moriscoes would resist this change. Toward the end of the allotted year, on Christmas Eve, they boldly attacked Granada, sacking several houses, but they were disheartened by the failure of residents of the Albaicín to join them. Even so, the Moriscoes demonstrated that they could strike in any direction from their mountain stronghold and, as a result, ordinary travel and the transport of materials in Andalusia had to be curtailed. Though several payments were made for sandstone from Santa Pudia in 1568 and early 1569, the governor finally decided to close that quarry and the one at Turro in March 1569.[80] Until then, work had continued with the material on hand, and it might have been sustained a little longer if the officials of the Alhambra had been able to meet the payroll.

Philip II assigned other sources of income to replace the 10,000 ducats formerly provided by the Moriscoes, but very little of the new income was ever received. Officials and workers became uneasy about their jobs, and many left the Alhambra as they found opportunities elsewhere. To avoid the decimation of the work force in this haphazard fashion, Luis suggested in 1571 that the staff be gradually reduced to six selected workers who would be responsible for essential maintenance, with the assurance that they would be retained.[81] He judged that a budget of about 400,000 maravedís (about 500 ducats) would be sufficient for the repair of the old Nazaride palaces and the protection of what had been constructed in the new. Unfortunately, that sensible plan was not adopted by the Junta de Obras y Bosques, and the work force gradually drifted away during the following several years. With the disruption of the steady income previously provided by the Moriscoes and the disbanding of the work force, the unusually stable conditions enjoyed by the officials of the Alhambra for half a century came to an end.

What Luis Machuca achieved in his twenty-one years as chief architect can be seen by comparing figure 9 (p. 97), which represents the state of the palace in 1550 when he succeeded his father, and figure 11, which reconstitutes the appearance of the palace at the time of his death, probably in September 1571 when work on the palace was stopped.[82] Of course, one important achievement of his period, the marble window over the south portal, was executed by Niccolò da Corte and

[80] Payments for sandstone from Santa Pudia for the facing of the facades are recorded in AGS, CMi, Leg. 1023, for 17 and 25 January, 20 August, and 24 December 1568, and 21 and 29 March (doc. 126) and 29 June 1569. Payments to those who brought back tools and other equipment from the quarries at Santa Pudia and Turro are recorded on 29 March 1569.

[81] AGS, CSR, Leg. 265, fol. 136, dated simply by the year, 1571 (doc. 127).

[82] The last recorded payment to Luis Machuca is dated 15 June 1571 and it was a belated payment for the first third of the year; see AGS, CMi, Leg. 1023. By 12 January 1572, Juan de Orea's application for the post of architect of the Alhambra had reached Juan de Herrera; see *Documentos para la historia del Monasterio de San Lorenzo el Real de El Escorial*, El Escorial, 1962, V, p. 73: "a 12 [January] mostré a Herrera un memorial de Juan de Urea que pretendía la mayoría de las obras del Alhambra de Granada. Su Magestad havía mostrado en San Lorenzo se le mostrase y luego se remitiese a quien tocase remitise a Gestelu." Reference to the termination of the works

on 3 September 1571 is found in a report of the paymaster, Ciprián de León, dated 1 February 1572, in which he also stated that no daily wages had been paid since 18 December 1570: . . . y quedan por pagar, por falta de dineros, las libranzas de jornales que se an hecho diez y ocho de dizienbre di quinientos y setenta años hasta tres de setienbre de setenta y uno, que pararon las dichas obras reales . . . ; see AGS, CMi, Leg. 1023. We should note that Manuel Gómez-Moreno y González ("Palacio de Carlos V," p. 198, n. 1) stated that he had found the baptismal records of Luis' eighth child in the church of Santa María del Alhambra on 22 January 1573 and that the record revealed that Luis had died before that date, so the Granadine scholar placed his death in 1572. As we noted, the baptismal records were lost in a fire in San Cecilio, so we can only assume that Gómez-Moreno was wrong in the year of the baptism or that Luis was so ill that he resigned his post before January 1572, making possible the application of his brother-in-law before the twelfth of that month.

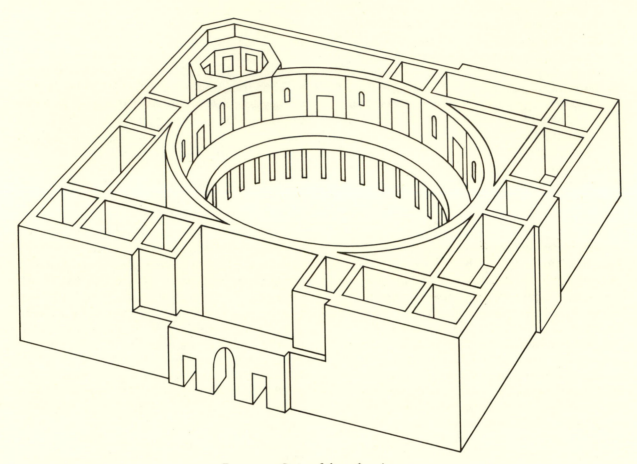

FIGURE 11. State of the palace in 1571

completed by his guarantor, Juan del Campo, but Luis Machuca made certain that it was faithful to his father's design of 1548. Luis himself supervised the assemblage of the one-story, grey marble frontispiece designed by Pedro about 1549 for the west facade, and he ordered the materials for the central window, framed in white marble and flanked by large sandstone niches, in the second story of the west entry. If we trust Wyngaerde's 1567 drawing of the palace (pl. 69), the central section of the west facade was not raised, though four bays on each end had been faced with sandstone before work slowed down in 1569. As we shall learn in discussing the documented work on the west vestibule in the 1590s, Luis must have begun the sandstone facing of its two long walls in the mid-1560s. In the east wing, he raised some of the transverse bearing walls and it seems (on the basis of later

evidence) that he began the curving walls of the oval vestibule.[83] He faced the first seven bays of the upper story of the east facade with sandstone, leaving unfinished the four northernmost windows over the portal. Luis either initiated or continued the construction of its gabled edicule, following his father's general design but stopping short of the execution of the casing of the door itself, perhaps because the oval vestibule still had to be faced. That vestibule remained uncovered, as did the octagonal chapel, though Luis closed the second-story windows of the latter and, after adding three courses above them, placed the terminal moldings of the chapel wall. In the north wing (as we shall deduce from the documented work of the

[83] This is evident from Minjares' Work Orders of 12 October 1596; AA, Leg. 52, 1 (doc. 157).

1590s), he probably constructed a north staircase leading down to the Court of Myrtles in the old palace, but he did not face its enclosing walls. In the round courtyard, he completed the wall of the lower corridor (replacing his father's fielded pilasters with his own pulvinated version) and raised the Doric colonnade along with the tilted annular vault. Though most parts of the gallery colonnade, with the exception of the entablature, had been delivered by the mid-1560s, Luis did not have time to construct it, but he did complete the sandstone wall of the gallery, short of its entablature. On this level, he also abandoned the tight leather-roll form of the volutes of Pedro's Ionic capitals in favor of a more open spiral and a slightly canted volute. Beyond the block of the palace, Luis seems to have done very little. There is no evidence that he laid any of the foundations for the two forecourts, and Juan de Maeda in 1576 did not mention them. In fact, Maeda described the palace as "a square building on the exterior" (un edifiçio quadrado por la parte de fuera). Even so, Luis did not remove the springers of the double arch intended to connect the two forecourts (pl. 31). He may also have constructed the massive core of the Puerta de las Granadas,

leaving the membering and the rusticated facing to be completed in the 1590s.

Luis differed less from Pedro in his architectural forms than one might expect of father and son, but the up-to-date architectural repertory that Pedro brought back from Italy in 1520 was continued and developed in Italian works during the next three decades, so Luis on his study trip in the late 1540s would not have had reason to think of his father's architecture as markedly old-fashioned. Luis, in accord with his generation, did depart from the linear, planar, and monochromatic aspects of his father's architectural designs, and Luis was not averse to the inclusion of figural ornament. Also, he had a tendency toward greater orthodoxy in that he corrected Pedro's odd Ionic capitals and his rhythmic disposition of the metopes in the Doric frieze of the west frontispiece. Apart from these differences, his changes were more often motivated by practical rather than aesthetic considerations. Finally, the regularity of the silhouette of the palace in 1571, in contrast to that of 1550 (cf. figs. 9 and 11), reflects the lack of disputes and, thus, the more orderly progress of the work during Luis' tenure.

IV

THE POST-MACHUCA PERIOD

YEARS OF ADVERSITY, 1572–1583

THE REBELLION of the Moriscoes resulted in the loss not only of income for the works on the Alhambra, but also of royal favor. The Mendozas recommended leniency before and even during the uprising, and although they could point to more than sixty years of the peaceful coexistence of Christians and Moriscoes in Andalusia in support of their policy, the king and his advisers more readily understood the hardline position of the bishops of southern Spain. Consequently, Philip became increasingly uneasy about leaving the defense of the Christians of Andalusia in the hands of Iñigo López de Mendoza, a Morisco sympathizer. After the preliminary attack on Granada on 26 December 1568, the revolt began in earnest on New Year's Day. Many atrocities were committed, but still the Mendozas recommended a moderate response. In April 1569, Philip II sent his half-brother, Don Juan of Austria, to take charge of the military forces. By October he had suppressed the Rebellion and initiated the removal of the Moriscoes from the coastal areas to inland cities, where they could not aid a Turkish invasion from the sea. Iñigo López de Mendoza was called to Madrid in September 1569 and then detained there for an extended period, though he continued to hold the title of governor of the Alhambra until 1580, when he was succeeded by his son, predictably named Luis Hurtado. Discredited by their conciliatory attitude toward the Moriscoes, the Mendozas no longer enjoyed the trust of the king. Even in regard to the construction of the royal residence, their role was diminished. According to the old Work Rules of 1546, the governor was to be consulted by the architect before any changes in the project could be made, but in the new rules of 10 June 1580 (doc. 132), approval of changes had to be obtained from "His Majesty or his ministers and *no other* person" (*a Su Magestad o a sus ministros y no a otra persona alguna*). The works of the Alhambra were from this time wholly under the purview of the Junta de Obras y Bosques and the architects of the court. The Mendozas, who had played so important a role in the design and construction of the palace, were restricted to making reports on the income received and the progress of the works.

The diminished status and influence of the Mendozas apparently encouraged an old foe, Pedro de Deza, to withhold the fines of the Appelate Court of the city, which had formerly been delivered regularly to the Alhambra. First assigned by Joanna of Castile in 1515 and affirmed by her successors, the fines (*penas de cámara*) from the courts of Granada, Loja, and Alhama had provided a steady annual income of about 2,200 ducats for the endless repairs of the old Islamic palace. By 1571, however, the amount passed on to the governor fell to around 1,000 ducats; and even though Philip II reaffirmed the order in the 1570s and again in 1580, 1589, and 1596, only sporadic payments were received.[1] As a result, needed repairs had to be postponed, and because repairs on the old palace were considered more urgent than the construction on the new, the loss of funds reduced work on the palace of Charles V. Meanwhile, Juan de Maeda estimated in 1576 that as much as 100,000 ducats would be needed to complete the new palace (doc. 128), and Philip II began to look for other sources

[1] A report of 14 November 1577 on the financial plight of the Alhambra is found in AA, Leg. 190, 3, and several other reports in Leg. 47, 2, are dated November 1612 and 4 February 1621.

of income; but from 1579 to 1613, only a small part of the revenues assigned to the Alhambra was received.[2] The drastic decline in income, together with spiraling inflation in the last years of the sixteenth century, meant that very little could be done on the still uncovered Renaissance building or the backlog of repairs in the fragile Nazaride palaces.

During these unfunded years, administration officials and workers gradually left the Alhambra, as Luis Machuca feared they would. Only paymaster Ciprian de León continued in office, but obviously he had little to do. Death also took its toll. Overseer Juan Arias de Mansilla died in 1570, but not until June 1579 was Gaspar Maldonado appointed to fill that post. He, in turn, was replaced after little more than a year by Hernando Verela, who served without salary as both overseer and paymaster. Three years later in 1583, Alonso Arias de Riquelme became overseer. This rapid change of officials presents a marked contrast to the stability of the first fifty years of construction. The *aparejador*, Bartolomé Ruiz, left to join the works at Aranjuez in 1571 or 1572,[3] and there is no further mention of anyone holding that post until 1584, when Juan de la Vega was appointed. After Luis Machuca's death or retirement late in 1571, his brother-in-law, Juan de Orea, applied for the position of chief architect. Named acting *maestro mayor*, Orea drew up a report on the state of the old and new palaces that was sent to Juan de Herrera late in 1572 and then forwarded to Secretary Gaztelu of the Junta de Obras y Bosques;[4] and in 1574 Orea was called to Madrid, where he spent "many days" explaining the need for repairs in the old palaces and the fortifications of the Alhambra (doc. 130). Still identified as acting *maestro mayor*

in 1576 by Juan de Maeda, Orea seems to have continued in that status until November 1579 when he received official approval, but he died the following year, in December 1580.[5]

Juan de Orea returned to the Alhambra in 1572 with a severe architectural style that differed from the Siloesque manner characteristic of his architecture in Almería in the early 1550s. Though he blamed Siloe in 1551 for the low appraisals of his reliefs for the pedestals of the west frontispiece, he seems at the time to have admired Siloe's architectural forms more than those of his father-in-law. In the following twenty years, while working independently as the chief architect of the cathedral of Almería and its diocese,[6] his architectural style underwent a change that brought his designs closer to those of Pedro Machuca. Evidence of this change is seen in the north portal of the cathedral of Almería, which bears the arms of Bishop Diego Fernández de Villalán on the lower story (pl. 89) and those of Emperor Charles V on the upper. Since the bishop died in July 1556 and the emperor was relieved of the imperial dignity in April 1558, those events provide terminal dates for the two stories.[7] For the lower, he followed Pedro Machuca in the mirror symmetry in the sculptural ornament, the surround, and pilasters with fielded panels, though the edges of the panels were enriched with small egg-and-dart and leaf courses. This ornament, along with the vegetal decoration on the frieze of the lower story, the Cherubim on both levels, and the Corinthian order of the upper, reveals a lingering admiration for the more sumptuous style of Diego Siloe. His next dated work was the cathedral's main or west entry, begun in 1556 (pl. 72).[8] The Doric columns are unusually slim in proportion, but there

[2] On 18 April 1579, the king directed the governor of the royal residence in Seville to send the Alhambra the 6,000 ducats formerly provided each year for the construction of the *alcázar* in Toledo; see AA, Leg. 47, 2. That order was repeated on 21 February 1580 and 3 February 1581, but no funds were received from Seville until 1583 and then only token payments were made. Finally, in December 1603, the new king, Philip III, ordered the sugar factories in Granada to provide 4,000 ducats; but again, repeated directives were ignored. In August 1608, the income of the nearby royal hunting preserve and forest known as the Soto di Roma was added, but little was received from that source.

[3] Chueca, *Arquitectura del siglo XVI*, p. 377.

[4] See chap. 3, n. 82.

[5] The appointment on 14 November 1579 was published in part (without noting the location of the document) by Ceán Bermúdez in his annotations to Llaguno's *Noticias*, I, p. 223;

see our doc. 131. Orea is now know to have died before 20 December 1580 when his professional and personal effects were auctioned on the Alhambra; see Juan Martínez Ruiz, "El taller de Juan de Orea," *Cuadernos de la Alhambra*, 1 (1965), pp. 59-73, for the list of items now found in Leg. 103, 32 and 39.

[6] Notice of his appointment as chief architect of the cathedral is found in the archive of the cathedral of Almería, Actas Capitulares, bk. III, fol. 49, on Tuesday, the last day of July 1556.

[7] See chap. 2, n. 180, for the 1555 contract for the figures holding Bishop Villalán's arms over the north portal. The death of Villalán on 7 July 1556 adds further assurance that the lower story was completed about that time. For the life of Diego Fernández de Villalán, see José Angel Tapia Garrido, *Los obispos de Almería*, Almería, 1968, p. 19.

[8] The date can be deduced from inscriptions on the shields on opposite sides of the portal that read AI ANˢ QUARTˢ 1556 and REGNÃTE PHILIPO. While the first part is unclear, the

is a new severity in the plain surround and the fielded panels on either side, even though the latter are edged by ornamented moldings. In the upper story, which seems to have been executed several years later, the forms are heavier than those of the lower. Most striking is the obsessive use of the fielded panel (with a less obtrusive molding) on the pedestals, pilasters, and spandrels. The vases and other sculptural ornaments were carved in high relief, resulting in a robust massiveness of forms that contrasts with the linearity of the frame of the lower story. That he contributed to the general trend of his generation toward an architecture *desornamentado* is confirmed by his design for the second story of the tower of the cathedral of Granada, evidently initiated between October 1577 and his death in December 1580 (pl. 73).[9] The fielded panel, with no moldings to soften its sharp edges, was used on pilasters, pedestals, spandrels, and other wall areas alongside the openings of that tower. It is significant that Orea had adopted Pedro's severe fielded panel rather than Luis' pulvinated version and had done so in Almería before his return to Granada.[10] In 1572 Orea was the best suited among contemporary architects to continue work on the palace of Charles V, but because of the court delays and Orea's other assignments on the Alhambra, he can be credited with nothing more than projects and decisions for the palace. Even so, those decisions conditioned future work on the palace.

Orea had to devote a great deal of his time to reports on the deteriorated state of other buildings and the fortifications on the Alhambra. His first report on the Islamic buildings was compiled late in 1572, and then in Madrid in 1574 he recounted the most urgent needs to the king's advisers.[11] A major concern was the old Nazaride mosque that had served as the church of Santa María since the conquest because it was near collapse. In August 1575, Juan de Orea was ordered to design a new church, but Juan de Herrera required changes in his project, and though the foundations were laid in 1581 to 1583, other architects made changes before construction was continued in 1618.[12] While little of Orea's project remains, his involvement in the initial design of the church of Santa María del Alhambra prevented him from giving full attention to the new palace.

Orea, uneasy about the delay in his permanent appointment as architect of the Alhambra, began to look for a post elsewhere. In the winter of 1576–1577, he informed Juan de Herrera that he had been offered the post of architect of the diocese of Murcia and asked how soon his Alhambra appointment would be made official. Herrera answered that he had been directed by the king to consult Gaztelu and that it was decided that no one would be put on salary because all available funds were needed to pay the craftsmen who made the necessary repairs on the fortifications and on the Islamic palace and its waterworks.[13] Even so, Orea stayed on, probably because shortly after that exchange he was invited, along with Francisco de Castillo and Lázaro de Velasco, to participate in the competition for the post of architect of the cathedral of Granada. A good deal of his time was spent from April through July 1577 in making a groundplan, an elevation, and a transverse section of the cathedral of Granada, and similar drawings for an "invention" of a comparable church. Then, he participated in prolonged discussions of the competition projects. After obtaining that post in October 1577, he must have devoted most of his time to the works of the cathedral, though he remained the frustrated unofficial architect of the Alhambra.

What Orea proposed for the completion of the

inscription evidently refers (as do several others in Almería) to Villalán's being the fourth post-conquest bishop of the city; and, thus, the combination of references to Philip (who began his reign in January 1556) and Villalán (who died in July 1556) dates the beginning of the lower part of the portal in the first half of 1556.

[9] For documents of the tower, see Rosenthal, *The Cathedral of Granada*, p. 38, docs. 154, 155, 163, and 166.

[10] The fielded panels on the 1572 portal of the convent of San Luis in Vélez Blanco make it likely that Orea was the designer, and the same motive on the pillars in the large cloister of Santo Domingo (then known as Santa Cruz el Real) in Granada also points to Orea. Although these works are undocu-

mented, we know Orea worked for both convents; see Gallego y Burín, *Granada*, pp. 244-251, and José Angel Tapia, *Vélez Blanco. La villa señorial de los Fajardo*, Madrid, 1959, pp. 258-259.

[11] For the governor's letter of 6 July 1576, see doc. 130, and Herrera's response is found in AGS, CSR, Leg. 265, fol. 76.

[12] The best account of the rebuilding of the church is still Manuel Gómez-Moreno y Martínez, "Juan de Herrera y Francisco de Mora en Santa María de la Alhambra," *Archivo español de arte*, XIV (1940–1941), pp. 6-7, pl. III.

[13] AGS, CCR, Leg. 265, fol. 135, for a copy of Herrera's letter.

new palace can be inferred from Juan de Maeda's reports, probably written in the spring of 1576. Maeda was first asked to estimate the cost of completing the new palace "in the manner proposed," presumably by Orea, and then to give his opinion on those proposals and to point out any flaws in the building already constructed (docs. 128 and 129). It is clear that Orea considered the covering of the palace to be of primary importance. In recommending that all walls be raised to the main cornice of the palace, he listed the need to complete the four windows and the transverse walls of the room above the east entry as well as the four remaining windows on the west facade and its three center bays. Also related to the roofing of the palace was the need to order the missing parts of the colonnade of the gallery, which included some pedestals and the entire entablature above it (though Maeda recommended the use of the denser grey marble rather than the conglomerate stone apparently proposed by Orea and, perhaps, by Luis Machuca). Maeda was especially concerned about the proposal to cover the gallery with a vault. He feared that the corridor wall, which has a thickness of only 56 centimeters, was not sufficient to support an annular vault on both levels of the double portico; but, if a vault was to be used, Maeda advised the addition of a third story to provide a stabilizing weight against the outward thrust of the vault.[14] Also related to the problem of that vault was Maeda's proposal of the replacement of the two-flight, open-well staircase planned for the northwest and southeast corners with monumental spiral staircases because the cylindrical wall enclosing them would buttress the corridor wall in the corners, where it would be the weakest. Of course, the spiral is the only kind of staircase that could be accommodated to both the triangular corner and the rhythmic disposition of the corridor bays.

While apparently sensitive to the intention of Machuca in the courtyard, Maeda approved the raising of the walls of the chapel, beyond the terminal moldings placed by Luis Machuca in 1554, to the level of the cornice of the palace. As we noted, the original height—three courses above the lintels of the windows—would have made possible the enclosure of a hemispherical dome within a low-pitched truss roof covering the palace (fig. 5, p. 60), and that was probably what the Machucas intended. Since no reference was found to work on the chapel between 1554 and 1574, it would seem that the decision to increase the height of its walls was made when Orea went to Madrid to discuss the completion of the palace with Philip's advisers in 1574. Whether they or Orea proposed the change cannot be determined from the information available.

About Orea's project for the completion of the upper center of the west facade, Maeda provided more information (doc. 128). He estimated its cost at 25,000 ducats "because it is of hard stone and marble like that which was built [in the lower story]" (*siendo de piedra dura y mármol como lo que está edificado*). While *piedra dura* and *mármol* are both used in the documents for the grey marble of the Sierra Elvira, the contrast of the two terms in Maeda's report suggests that the facing of the upper story was to be composed of two materials, probably the grey and white marbles used in the lower story. In his use of the two marbles for the three bays over the west doorways, Orea clearly departed from the project designed by Pedro in 1549 and initiated by Luis in the 1560s because its upper story was faced in white sandstone with some white marble to frame the central window. Having worked on the Alhambra in the 1540s, Orea was certainly aware of Pedro's prolonged resistance to the two-story *portada* proposed for the west facade; but, the decision to face the second story in grey marble was probably made by the Junta during Orea's visit to Madrid in 1574 because Maeda included cost estimates for the grey marble in the report made shortly before his death in the summer of 1576. Orea was evidently the first to design a project for facing the second story in grey marble. Several important features of the project Orea presented to Juan de Herrera in Badajoz in 1580 are revealed by the court architect's corrections. He ordered that the "three-light window" over the central door and the "niches" over the side doors in Orea's project be replaced by three large rectangular windows of the same size as the rest of the upper story (docs. 132, a and b). Those orders were later followed when the upper story was ex-

[14] Doc. 129. Concern for the annular vault led Maeda to suggest that the Junta consult Rodrigo Gil de Hontañón and Andrés de Vandelvira, but there is no evidence that either came to the Alhambra.

ecuted in the 1590s, but the project Orea submitted had a distinctive central window with three openings—one naturally thinks of a Serliana comparable to Machuca's south window—and large niches in the side bays. Presumably they were similar to the niches in the upper story of the *portada* in the Burlington elevation (pl. 74), which we identified as a drawing presenting a slightly earlier project by Orea for the marble facing of the upper story. In view of his respect for his father-in-law's intentions, it is unfortunate that he was subject to the supervision of Herrera. Had Orea been able to follow his own inclinations and had he been given the means to proceed with the construction of the palace, the west facade would not have suffered the alterations introduced by Herrera and, later, by Juan de Minjares.

Though no work was carried out in the palace before Orea's death in 1580, several important changes were made in Pedro Machuca's design. The one that would have disturbed him most was the decision to face the upper story of the west entry with grey marble, thus producing the traditional two-story *portada* apparently proposed by Luis de Vega a half-century earlier. Another was the raising of the massive walls of the chapel to the height of the common cornice of the palace, since this would mean that the chapel, if covered by a domical vault, could no longer be enclosed under the common low truss roof of the palace.

Only two of the directives in Herrera's work orders were realized. One was the replacement of the three-light window flanked by niches over the west entry with three equal rectangular windows of the same size as the rest on the upper story. This was necessary because these three windows and the ones on either side of them opened into the enlarged, five-window audience hall. The other was Herrera's order to simplify the sandstone ornament of the remaining main-story window crowns to reduce the cost of completing the palace, but that order was followed only in the four windows over the east portal. Herrera's work orders of 1580 had another far-reaching effect. They com-

pletely superceded those of the Machucas, so that there is rarely any later concern for the intentions of the original designer of the palace. Herrera's work orders, not Machuca's, came to be known in the seventeenth century as "the old orders" (*la horden antigua*).[15]

JUAN DE MINJARES, 1583–1599

After the death of Orea, more than three years passed before Juan de Minjares was named his successor in November 1583 (doc. 133). Though Minjares seems to have made a brief visit to the works in January 1584, he failed to take the oath of office, so the officials of the Alhambra withheld his salary. Finally, on 13 July 1588, the secretary of the Junta de Obras y Bosques informed them that Minjares had taken the oath, apparently in Madrid, and that he was to be paid.[16] Castilian born and trained, he seems to have begun his career as a mason in the works of the Hospital of San Juan Bautista in Toledo in 1549, where he served under Hernán González de Lara, the faithful follower of Alonso de Covarrubias, until 1555.[17] After a mysterious period of six years during which he must have worked elsewhere, he returned to the hospital in 1561 and, three years later, he was identified as the assistant (*aparejador de las obras*) to Gonzáles de Lara. In 1573 he became an assistant to Juan de Herrera at Aranjuez, but little work of that period has survived since that royal residence was virtually destroyed by several fires in the 1660s. In 1576 he was assigned to the Escorial as Herrera's *aparejador de la cantería*; in November 1583 he was sent to Seville to execute Herrera's Exchange and, while there, was consulted on the works of the cathedral.[18] Herrera may have suggested to the secretary of the Junta that his capable assistant could make occasional visits to the Alhambra from Seville and, thus, supervise the completion of the palace on the Alhambra. At any event, Minjares was appointed to both posts on the same day and granted a yearly salary of 400 ducats.

[15] See doc. 167 for Juan Gómez de Mora's reference in April 1623 and December 1625 to Herrera's 1580 Work Orders (doc. 132).

[16] AA, Leg. 104, 5, 1, for his visit on 30 January 1584 and Ybarra's letter on 13 July 1588 affirming that Minjares had taken the oath of office. We should note that the Architect's surname is usually spelled "Minjares" in the Alhambra documents and

only occasionally "Mijares."

[17] Catherine Wilkinson, "Juan de Mijares and the Reform of Spanish Architecture under Philip II," *Journal of the Society of Architectural Historians*, XXXII (1974), pp. 122–132. For his later career, see Chueca, *Arquitectura del siglo XVI*, pp. 377–378.

[18] AGPM, SCR, vol. 162, años 1582 a 1656, fol. 13r and 13v on 19 November 1583 (doc. 133).

The assignment of a part-time architect to the Alhambra was symbolic of the decline in its importance as a royal residence. The low regard of the court was further evident in the appointment of a mediocre mason, Juan de la Vega, as *aparejador* in May 1584, probably because he had eight years experience in the works of the Alhambra.[19] In a letter to Philip II in January 1584, the governor, Luis Hurtado, expressed gratitude for the assignment of so experienced an architect as Minjares to the Alhambra—though he apparently had had nothing to do with the choice—and he observed that the court architect will "continue the work more to your taste" and will execute "what your Majesty has ordered added [to the palace]."[20] The governor's detachment from the works and the architect's absence were inevitably detrimental. Presumably the governor was asked to suggest the other main officials because people with familiar names were appointed. Gaspar de León succeeded his father, Ciprian de León, as paymaster and Alonso Arias Riquelme became the overseer. Late in 1583, the Work Rules written in 1546 and approved in 1549 were sent to the king for additions and corrections. More than four years later, in May 1588, an amended set of rules was finally approved.[21] The new secretary of the Junta, Juan de Ibarra, was identified as the person who would supervise and order (*provean y manden*) what His Majesty wished done, and the chief architect was given authority, independent of the overseer, to name officials to the works, though the overseer was expected to report any departures from proper procedures.

Even though the secretary of the Junta and the chief architect were directing the works from a distance, construction was maintained at a fairly steady pace through the decade of the 1590s. Already in October 1584, a huge order for 400,000 limestone blocks of the standard size used for the transverse bearing walls was placed with Juan de las Landeras, but I found no evidence of deliveries until June 1591, and then the contractor was Juan de la Fuente.[22] The only major disruption of the works occurred in February 1590, when there was a catastrophic explosion of large quantities of gun powder stored in a powder magazine (*un molino de pólvora*) located alongside the nearby church of San Pedro (today San Miguel el Alto) on the northern slope of the Alhambra. The explosion threw burning debris over the Alhambra, setting fires that damaged the Hall of the Abencerrajes and some of the other rooms immediately next to the palace of Charles V.[23] Had the new palace been covered with a wooden roof at the time, it might have suffered a great deal more damage, but the major effect of the explosion was delay in work on the new palace while the limited staff repaired damage to the old. After this was done, Minjares and Vega sustained a work schedule reminiscent of the Machucas, and—probably because the chief architect and the secretary of the Junta were absent—there are fairly complete records and frequent reports on the progress of the work.

One of Minjares' main tasks was the facing of the upper story of the west *portada* with grey marble, presumably following Orea's project as corrected by Juan de Herrera in Badajoz in 1580 (pl. 100). The first notice of preparation for this work is a record of bids in July 1587 for "columns and other pieces" from the Sierra Elvira.[24] Of course,

[19] AA, Leg. 240, records a payment to Juan de la Vega on 12 March 1585 (doc. 134) and identifies him as the *aparejador* since 14 May 1584. Later, in 1612, when he died, he was said to have had thirty-six years in the works of the Alhambra, and that would identify his starting year as 1576, probably as a mason under Juan de Orea; see Leg. 104, 5, 6, on 21 November 1612.

[20] AGS, CSR, Leg. 13, fol. 84, a letter from Luis Hurtado de Mendoza to Philip II on 2 January 1584: ". . . y a sido muy açertado el mandar Vuestra Magestad y a ella a Juan de Minjares, porque con la experiencia grande que tiene, yr entendiendo mejor la voluntad de Vuestra Magestad, se proseguían aquellas obras más a su gusto, y lo que Vuestra Magestad a mandando que se añada en ellas, e visto y embiado a Alonso Vélez de Mendoça, mi teniente, un translado para que puntualmente se cumpla."

[21] AA, Leg. 206, 6, titled "Auto sobre lo que se a de observar en las obras reales" and dated 31 May 1588. There is a copy in AGS, CSR, Leg. 265, fol. 111.

[22] The specifications and the contract are found in AA, Leg. 240, and the payments, which begin on 1 June 1591, are preserved in Leg. 52, 1.

[23] Jesús Bermúdez Pareja and María Angustias Moreno Olmedo, "Documentos de una catástrofe en la Alhambra," *Cuadernos de la Alhambra*, II (1965), pp. 77-87, published Juan de la Vega's report on the damage to the Alhambra now found in Leg. 6, 27. The Spanish poet Vicente Espinel wrote a long poem about the event including the passage "más ¿qué mucho, si el trueno incomportable / parte asoló de la del gran Monarca, / del gran Machuca fábrica admirable?" The poem was quoted in part by Francisco de Paula Valladar, *El incendio de la Alhambra*, Granada, 1890, pp. 11-14.

[24] AA, Leg. 240, Nóminas, 11 July 1587: "A Campos, pregonero en Santa Fe y otros lugares comarcanos de Granada, el acarreto de las colunas y otras pieças, que se an de traer de la cantera de la Sierra Elvira, y rematar lo suso dicho catorze reales, quatro çientos y setenta y seys maravedís."

that quarry had been closed since 1569, following the Rebellion of the Moriscoes. By August 1587, three stonecutters were at work there, and during the following two years, payments are preserved for the delivery of virtually every piece of marble comprising the present facing of the upper story of the *portada*. Identified as material for the "main windows" or the "main *portada*," deliveries began on 8 August 1587 with two of the half-columns, and ended on 19 April 1589 with four pieces of serpentine (*piedras verdes*) from the quarries at Picacho de la Veleta in the Sierra Nevada—evidently the green bars set on the front face of the pedestals.[25] Other pieces of the same material delivered in September of that year were surely for the frames of the round reliefs of the Labors of Hercules.[26] Already during the summer of 1589, dealers in wood were paid for the cutting of timber needed to make "scaffolds for the main entry" or "for the main window" (*andamios de la puerta prinçipal* or *de la ventana prinçipal*);[27] and in September of that year, sturdy ropes and various parts of a crane were purchased for the lifting of "the columns and other pieces of the main facade" (*las columnas y otras pieças para la portada prinçipal*, doc. 137). By 6 October, the columns were set in place and, to celebrate the achievement, wine was passed out to all who had

participated.[28] Only the sculptural ornament and the final cornice were needed to complete the facade. Contracts for round white marble panels for the royal arms and the two Labors of Hercules had been signed with Damian Plan, apparently in September 1589,[29] and the three reliefs were carved before mid-June 1591 by the Sevillian sculptor Andrés de Ocampo because the clay models were then sent to Granada for the appraisal of the finished marble reliefs.[30] Though the officials of the Alhambra were told by the Granadine sculptor Pablo de Rojas that the reliefs were well finished (*bien acabados*), they found them less polished than the contract required and so the price was reduced from 430 to 410 ducats (doc. 140). Payments for the carving of the Ionic capitals and the cornice were recorded from autumn 1591 through autumn 1592, and in mid-June, Juan de Ibarra was informed that only about fifteen pieces of cornice had to be finished and set in place to complete the entire work.[31] Among the last things to be done in October 1592 were the securing of the huge serpentine bars to the fronts of the pedestals of the Ionic columns and—truly the final touch—the painting over of several flaws in the marble by Antonio de Aquila.[32]

While Minjares may have been charged with the

[25] All the documents for the grey marble of the Sierra Elvira are found in AA, Leg. 240, under nóminas or libranzas. The six columns were delivered between 14 August and 5 September 1587 (doc. 135), with their bases, capitals, pedestals, and cornices following between 12 September and 24 October of the same year. The payment for green serpentine stone is found in Leg. 21, 4, 2, for Saturday, 19 April 1589: "Bartolomé del Campo y Andrés Álvarez, de la trayda de quatro piedras verdes de la cantera de la Sierra Nevada, para los pedestales de la fachada prinçipal d'estas obras nuebas, a razón de quinze reales cada una, sesenta reales, dos mill y quarenta maravedís."

[26] AA, Leg. 21, 4, 2, on 2, 9 (doc. 137), and 16 September 1589.

[27] Weekly payments were recorded from 15 July through 19 August 1589 and again on 14 October and 11 November 1589, and 13 June 1590; see AA, Leg. 21, 4, 2.

[28] AA, Leg. 21, 4, 3, Nóminas, 6 October 1590: "a Francisco Martín, dos reales, para vino para la gente que subieron las colunas. . . ." Apparently celebrations of this sort were common when some difficult part of a building had been completed successfully. A comparable celebration was held when an important vault of the cloister of the old cathedral of Segovia was closed at the end of April 1475; see Arturo Hernández, "Juan Guas," *Boletín del Seminario de Estudios de Arte y Arqueología*, XIII (1946–1947), p. 89: "Esta dicha semana se acabó de cerrar la capilla que tiene en la clave la Verónica, di a los oficiales e peones medio real para vino e fruta."

[29] The pieces of marble surrounding the roundels were paid for on 2 September 1589 (AA, Leg. 21, 4, 2), but Plan must have withdrawn from the contract, because his guarantor was paid for pieces of the roundels on 16 February 1591 (AA, Leg. 52, 1).

[30] See doc. 139. Gallego y Burín, *Granada*, p. 193, stated that Ocampo's round reliefs "conforme a los modelos de barro que conservaba la Alhambra, quizá debidos a Machuca." He didn't say that he had seen them but apparently he knew that these models had survived until modern times. Emilio Orozco Díaz, the former director of the Museo de Bellas Artes, informed me that he had never seen these clay reliefs and that they do not appear in the annotated catalogue of the museum's collection made by Manuel Gómez-Moreno y Martínez in the first decade of this century.

[31] Payments were made to Cristóbal de Salazar and Juan Darta for carving Ionic capitals on 12 October, 16 and 29 November, 14, 20, and 24 December 1591, and 4 January 1592, and for carving units of the cornice (composed of "un florón y una cartela y una cabeça de león") on 31 August, 28 September, and 12 October 1591, and two or three times a month for the whole of 1592; see AA, Leg. 52, 1. Materials for lifting the pieces of cornice into place were purchased on 6 June 1592; see doc. 142.

[32] AA, Leg. 52, 1, Nóminas. On 12 and 19 October 1591, Gaspar López, a blacksmith, was paid for "grapas de yerro grandes para trabar las piedras verdes de la fachada prinçipal.

execution of the Orea project as corrected by Herrera in 1580, some new features seem to have been intruded by the Junta in its instructions in 1583 or by Minjares later.[33] The Ionic capitals follow the type used by Herrera in the Escorial and Seville, and the failure to advance the entablature over the coupled columns (a feature found in both Machuca's and Orea's designs) is also in accord with Herrera's works. The segmental pediment of the windows over the side doors is not characteristic of Herrera or Minjares, but Orea used that form in Almería (pl. 72). Not associated with either Orea or Herrera are the truncated bars of serpentine on the front faces of the pedestals. They are intolerably massive in comparison to the finely fluted Ionic columns and the general scale of the architectural membering and ornament of the *portada*, especially in the lower story. Minjares was capable of such a gaffe in scale. He is generally considered responsible for the gigantic obelisks over the corners of the Exchange in Seville and, as we shall see, for the overly large fielded panels of the present parapet of the gallery of the round courtyard (pls. 81 and 83). More readily associated with Minjares than with Herrera is the introduction of the vivid green color of the serpentine bars and the frames of the three roundels above the windows into the *portada*'s grey and white color scheme. Because Herrera abjured figural ornament, the Labors of Hercules are not likely to have been included in his project. Presumably they were suggested by Minjares. The only residue of Pedro Machuca's 1549 project seems to be the surround in each bay and the coupled half-columns on common pedestals.[34]

The huge round reliefs of the Royal Arms and the Labors of Hercules over the side doors by Andrés de Ocampo,[35] who was chosen for the task by Minjares, are mediocre works. Neither of the Labors is well composed nor skillfully executed (pl. 98), and Ocampo's assistants may have had a large part in their execution because his own work—all in wood it should be noted—is usually of somewhat better quality. Perhaps the stunted legs and enlarged head of Hercules were intended to compensate for the foreshortened view of these reliefs, which are located more than fourteen meters above eye level, but it is difficult to attribute such subtle compensations to Ocampo. Also, the curve of the back of Hercules subduing the Cretan Bull and the distribution of trees and animals in that panel are so adapted to the circular frame that the spatial implications of size differences are in great part negated. The mythical hero clubbing the Nemean Lion assumes a strong zigzag rhythm that contrasts with the roundel in an essentially two-dimensional way, but neither composition is successful spatially. In his first Labor, Hercules is usually represented confronting or straddling the Nemean Lion and strangling it with his powerful arms, but in Ocampo's relief he is seated on the docile animal, which he holds precariously by the lower jaw! Ocampo chose the moment when Hercules, having failed to pierce the Nemean Lion's impenetrable skin with arrows and a sword, attempts to beat him to death with his club. Of course, the club shattered and he had to strangle the lion, so that final act is usually represented in cycles of the Labors. The seventh Labor, the bringing back to Mycenae of the mad, fire-belching Cretan Bull that

. . ." A payment for painting over the flaws was made on 3 October 1592: "a Antonio de Aquilo, pintor, de dar çierta color al olio a unos gabarros de las piedras negras de la fachada prinçipal d'estas obras, çinquenta y cinco reales, mill y ocho çientos y sesenta maravedís."

[33] In the letter announcing the appointment of Minjares as chief architect of the Alhambra on 19 November 1583, the king stated that Minjares had ". . . cargo y cuydado de la continuación, reparo, y conserbación d'ellas, conforme a las traças que para ello están hechas o se hizieren de nuebo por nuestro mandado. . . ." See doc. 133.

[34] Byne and Stapley in 1917 assumed a drastic and lamentable change in Pedro Machuca's design for the upper story of the west *portada*, whereas Gallego y Burín in 1946 seems to have thought only the Ionic columns were changed and the side niches eliminated. Chueca in 1953 described the lower as Renaissance and the upper as Mannerist in style, while Camón

Aznar in 1961 thought the dissonance between the two stories was due to the intrusion of a "Tridentine severity" into Machuca's project. Now it is clear that Pedro Machuca never made a project for the marble facing of the upper story of the *portada*.

[35] Antonio Martín Macias, "Andrés de Ocampo, maestro escultor," *Archivo Hispalense*, LV (1972), pp. 9-51, is the most recent and complete account of Ocampo's work, but Macias mistakenly believed that the three round marble reliefs had been commissioned for the patio of the palace of Charles V and seems not to have known they were preserved on its facade. See also, José Hernández Díaz, *Imaginería hispalense de Bajo Renacimiento*, Seville, 1951, pp. 76-85. Acampo spent his earliest years in Jaén and Córdoba, coming to Seville about 1570 to study sculpture, probably with Juan de Oviedo (whose daughter he married); he became a master in 1575, so he was an experienced and prominent sculptor in Seville in 1591 when he received the Alhambra commission.

had ravaged the lands of King Minos, is closer to conventional Renaissance imagery for this less frequently represented Labor: Hercules kneels on the bull, holding it by the horns (parts of which have fallen away in recent times and are preserved), but the animal is surprisingly docile and the hero lacks conviction. Incidentally, the complete nudity of Hercules in both reliefs was most unusual in the early 1590s because Spain persisted in its enforcement of the Council of Trent's prohibition against "dishonest" figures well into the seventeenth century. Placed on either side of the royal arms, the two Labors seem to be generic references to the heroic (but very elderly) Philip II. The reference to Hercules (like those to the cavalrymen, the boys with garlands, and the Victories of the lower story) bears little relation to the original theme of the sculptural program of the marble frontispiece, which was the celebration of the victory at Mühlberg in 1547.

The four remaining windows on the upper story of the west facade were constructed while work continued on the marble *portada*. Already in February 1590, a few years after ordering the marble for the upper part of the *portada*, Minjares drew up specifications for the blocks needed for the limestone frames of the windows and their facing in sandstone. A total of seventeen pieces make up the window facing: three voussoirs (*claves*) form the flat arch of the window and seven pieces make up the jambs on each side. The topmost pieces are referred to as "springers" (*salmeres*).[36] The sides and lintels of the window casing (*pies derechos* and *capialçados*) are specifically identified in the payments. The sandstone—still to be "white without any defects"—was ordered from Esteban Pérez in February 1590. The first delivery was promised for the following month, but none was recorded until August; a consignment received in September had to be rejected because it was improperly cut and, by February 1591, a new contract was made with Juan Martínez.[37] Among the payments, there are several references to the crowns (*remates*) for two windows, "one that supports pomegranates . . . and the other, three jars with a shell" (*una que*

lleva las granadas por remate . . . y la otra tres jarros con una venera), both carved by Juan Darta, who was paid for them on 27 April 1591. Fortunately, in carving the last four windows, Darta did not simplify the ornament as Herrera had ordered. In May of 1591, Darta was at work on the corbels of the top cornice in sandstone (doc. 138), and that work continued into the summer of 1592, when he was joined by Cristóbal de Salazar. Significantly, none of the documents in 1590-1591 refers to the sandstone membering of the facade, so the pilasters may have been done under Luis Machuca, leaving only the top cornice and the frames of the four windows to be completed by Minjares. As we noted, the four were identified in the 1576 work list of Juan de Maeda as located "on either side of the *portada*," and that location would seem to be confirmed by Wyngaerde's 1567 sketch of the palace (pl. 69) because it reveals that both ends of the main story had been raised, leaving a huge gap in the center that appears to be wider than the unfinished upper story of the marble *portada*. If Minjares and Vega had failed to notice that the window crown on one end was a lintel while that on the other was a triangular pediment, they certainly realized what had been done when they undertook the frames of the two windows on either side of the *portada*. By the 1590s, however, the error could not be corrected because Minjares had orders to complete the palace quickly and at the lowest possible cost.

The next step in the completion of the west wing was the facing of its vestibule with white sandstone. Because the only documentary references to the vestibule found by Gómez-Moreno y González in 1885 were payments for work on its vault in 1592, he and most scholars have assumed that the wall membering was designed and executed by the Machucas and the vault closed by Minjares; but, the story is not that simple.

Early in the autumn of 1592, limestone for the vestibule's benchtables and sandstone for its facing were ordered, and by November (doc. 149), Martín Falconete delivered thirteen pieces of limestone for "the benchtables of the end walls of the ves-

[36] For the specifications of 25 February 1590, the contracts of 10 and 18 March, and the specifications of 4 March 1590, see AA, Leg. 6, 28.

[37] For 4 and 25 August, and 7 September 1590 (the latter recording the rejection of improperly cut stone), see AA, Leg.

21, 4, 3. The new contract of 23 February 1591 is found in Leg. 52, 1. The reliefs were raised into place shortly after 30 August 1591 when iron clamps for the purpose were purchased; see doc. 141.

tibule" (*poyos de los testeros del zaguán*). That delivery provided limestone for benchtables along both end walls, with enough left over to continue around to the side doors of the main entry. A payment for sandstone from Santa Pudia on 7 August 1593 again identified it as facing "for the end walls of the main entry" (*para los testeros del zaguán prinçipal*), and among more than a hundred pieces, there were four slabs for "four lintels of the portals" (*quatro dinteles de puertas*), which are the pair of doors on the end walls (pl. 102).[38] Late in August and again in November of that year, payments were made for seventy-two pieces for the jambs of the side doors of the main entry and the pilasters on that wall (*los pies derechos de las xanbas de las puertas colaterales con las pilastras que van con ellas*), and they were delivered on 29 January of the following year.[39] On the same day, payment was made for seven pieces of the splayed soffit of the main portal (*el capialçado de la puerta prinçipal*).

For the vault of the vestibule, 470 pieces of limestone were already ordered in October 1592. The blocks were to be "hard and closed" and not porous (*que sea piedra mui serrada y dura y que no tenga ningún génera de tierra ni caliches*), that is to say, not porous like the tufa used for the annular vault of the courtyard. This order was delivered by 24 December.[40] On 26 February 1594, wood was purchased for "the centering which has to be made in order to close the vault of the main entry" (*para çimbras que se an de hazer para cerrar la bóveda del çaguán prinçipal d'ellas*).[41] Apparently, this was the first third of the vault because in July the centering was dismantled and reconstructed, presumably under the center section. Of interest are payments made in June and August 1594 for the plastering of small holes in the limestone blocks of the vault, and three years later, the entire vestibule was coated with plaster and polished.[42]

From the relatively ample documentation for work on the vestibule in the 1590s it is clear that, in addition to the vault, Minjares executed the sandstone facing of the two end walls, together with their limestone benchtables and parts of the interior casings of the three entry portals. Because there are no references to work on the long walls and because the stone for the vault was ordered only a month after the sandstone for the end walls, it is likely that the facing of the long walls had been completed previous to 1570.

Before we can identify the author of that earlier work, we must note several twentieth-century renovations in the vestibule. In 1924, when Leopoldo Torres Balbás undertook its restoration, he found the floor framed all around by a raised limestone slab that extended from the base of the benchtable. On the assumption that the original flooring had been lost, probably during the Napoleonic war when French troops occupied the palace, Torres Balbás covered the entire floor, including the limestone slab, with marble from the Sierra Elvira.[43] The modern flooring makes the vestibule look more like a room than a *zaguán*, which in the sixteenth century was usually surfaced with cobblestones (*piedra del río*) for the entry of horses and carriages. The marble pavement also deprives the benchtable of its lowest member and, in that reduced form, it becomes too slight a form to serve as the stylobate for the trabeated wall membering. Not only the benchtable but also the steps to the round courtyard are missing in sixteenth-century groundplans of the palace. Presumably, the center passage to the courtyard once had a flight of five steep steps set within the depth of the wall like those still preserved in the two side passages, but they would have been damaged by French soldiers moving crates of ammunition into the round courtyard for storage during their oc-

[38] Payments on account are recorded on 26 September 1592 (doc. 146) and 23 January 1593, and a final payment on 7 August 1593 (doc. 151); see AA, Leg. 52, 1.

[39] Payments on account are recorded on 28 August and 6 November 1593, and 29 January 1594; see AA, Leg. 52, 1. The original contract of 24 August 1593 is found in Leg. 210, 1.

[40] See AA, Leg. 6, 36, for undated specifications (doc. 149), and Leg. 52, 1, for the contract with Alonso Martínez on 3 October 1592 and the payment of 24 December 1592. A second order of limestone for the vault, perhaps the second third of it, was made in the summer of 1593, with a payment on account recorded on 18 August and a payment for partial delivery on 16 October.

[41] AA, Leg. 52, 1.

[42] AA, Leg. 52, 1, for payments on 25 June and 5 August 1594 for plastering the vault of the west vestibule, and Leg. 47, 6, for work orders marked 1597 that call for ". . . una capa de cal sobre la bóveda del çaguán de la puerta prinçipal y se bruñirá muy bien. . . ."

[43] The project for the flooring of the vestibule and the entries was sent to Madrid on 13 July 1924, and the work was completed by 15 May 1925; see Leopoldo Torres Balbás, "Diario de obras en la Alhambra: 1924," p. 99, and "Diario: 1925," pp. 143-144. The flooring was extended into the opening of the central door.

cupation of the palace from 1810 to 1812. The present side steps and the lost center steps could have been built in the 1560s or 1590s, or even in the first years of the seventeenth century, but the present center flight, with its seven steps, ample treads, and low risers, was constructed in 1925.[44] To permit the expansion of the two lower steps, part of the benchtables had to be cut away. Originally, the benchtables extended to the frame of the arch, but Torres Balbás reduced them so that the paired pilasters of that wall would be centered on that segment of the benchtable, instead of being off center (pl. 93).[45] Apart from these changes, the restorations of this century were restricted to the cleaning of the smoke-stained vaults and the repair of damage to the stone facing.

The best clue to the designer of the long walls of the west vestibule is provided by the fielded panels of the Doric pilasters. Those panels are rounded or pulvinated rather than planar and sharp-edged, so they can be identified with Luis Machuca. However, although that form was continued by Minjares on the end walls, the pilasters are broader and the taper characteristic of the Machucas is eliminated. Also alien to the Machucas are the wide pilasters folded into the corners; presumably they were introduced by Minjares. Equally at odds with the Machuca repertory are the incised rectangles on the frieze of the entablature: they are incongruously shallow in relief and even delicate in contrast to the robust forms of the pulvinated pilasters and the fully modeled benchtable. Incised rectangles were also used on the frieze of the gallery wall—clearly done in the post-Machuca era since Maeda in 1576 said that the gallery wall had been raised only to the level of its architrave (doc. 129). Because incised rectangles are also found on the second story of the tower of the cathedral of Granada designed by Juan de Orea, it is reasonable to attribute both the gallery and the vestibule frieze to him (cf. pls. 73, 83, and 94). Hence, it would seem that Luis Machuca faced the long walls of the west vestibule up to the frieze, which was done by Orea, and then the end walls and the vault were designed and executed by Minjares. None of the membering of the vestibule reflects Pedro Machuca's intentions as no pilasters were delineated along

the walls of the west vestibule in his two Royal Palace plans (pls. 17, 18, and 107), in contrast to his indication of pilasters along the wall of the round courtyard, the facades, and the piers of the forecourt arcades.

Also pertinent to the authorship of the stylar treatment of the vestibule is the disalignment in Pedro Machuca's groundplans of the three facade doors and the three passages that lead to the round courtyard. In the small Royal Palace plan (pl. 18), the three passages to the courtyard are narrower than their counterparts in the entry, and they are aligned with the radii of the round courtyard. As executed by Luis, the side passages were enlarged and angled more sharply to bring their outer frames into alignment with the side doors of the main entry (cf. pls. 2 and 18). Alignments of this sort are a requirement of the stylar treatment of the wall and so is the steep inclination of the passages that reduced the size of their openings into the vestibule to approximately the height of the main entry doors. While Luis seems to have been responsible for the angles of the side passages and the steep inclination of all three, as well as the splayed openings of the three facade doors, he could not have designed the intrados of their openings. The large raised disk in the recessed panel over the splayed top of the side doors of the main entry, must be assigned to Minjares because the scale is more readily associated with him than with Luis Machuca, Juan de Herrera, or Juan de Orea (pl. 94). The best candidate for the workmanship in the crude moldings of the intrados of the three distorted passages from the vestibule to the round courtyard (pl. 84) is Juan de la Vega, perhaps after the death of Juan de Minjares in 1599.

The paired doors on the end walls represent a change in Pedro Machuca's project for the west vestibule since in both the Royal Palace plans he indicated a single, centered door. The change in the end wall may have been made because Herrera wished to introduce fireplaces, for which the Machucas seem to have left no instructions. In 1574 Orea was probably ordered by Herrera to construct a fireplace on the central axis of the south wall of the main audience hall, then only three windows wide and located directly above the ves-

[44] Ibid., p. 143. The risers of the side stairs are 23.5 centimeters high (the height recommended by Vitruvius, III, 4, 4), while the modern steps in the center have a riser of 19.5 cen-

timeters.

[45] Jesús Bermúdez Pareja kindly informed me of this change.

tibule. That fireplace required a solid mass in the center of the end wall of the vestibule, and as a result, Machuca's single door was replaced with doors on either side of the closed center. If Orea made a design for the membering of the end walls at that time, it was evidently altered by Minjares in the early 1590s because Orea is not likely to have used the broad pilasters or those folded in the corners, or the huge pulvinated panel that occupies the center of the end walls. Most of these features are also found in the facing of the north staircase that led to the Court of Myrtles (before the stair was covered to provide an entry to the Museo Arqueológico), and as we shall see, that north stairwell was executed under Minjares. Thus, the end walls of the west vestibule retain nothing that can be associated with the Machucas.

We do not know how Pedro Machuca intended to cover his astylar vestibule. The transverse and interior walls of the palace have a thickness of no more than 56 centimeters, as Juan de Maeda noted in 1576 when he expressed doubt that vaults had been intended over the corridor or any of the halls (doc. 129). The same opinion was offered by Melchor Ruiz Callejón around 1622 in a report on the south vestibule.[46] He believed that the architect who had constructed the slight bearing walls of the south vestibule had not intended more than transverse arches of stone with the intervening parts executed in lightweight brick, and the same reasoning could have been applied to the west vestibule because its walls have the same thickness. Of course, Pedro might have intended a coffered wooden ceiling of the type he designed for two of the halls of the new quarters around 1530 (pls. 26 and 27). Whatever the original intention, neither of the Machucas is likely to have proposed a banded elliptical vault because it is a peculiarly Herreresque form used at the Escorial (for the refectory and the narthex of the church) and frequently thereafter for the vaulting of large halls or passages. So, neither the vault nor the stylar wall of the west vestibule reflects the architectural ideas of Pedro Machuca.

By the summer of 1594, when the west facade was completed and its vestibule well advanced, Minjares ordered sandstone for the frames of the four windows over the east portal (pl. 86), and delivery of that material was completed within the next three years.[47] Among the pieces specifically identified in the contract and payments were "the capitals for the four pilasters" (*los chapiteles de las quatro pilastras*). Thus, it seems that the membering of the wall, as well as the frames of the round attic and the rectangular main-floor windows, was ordered at this time. Already in the summer of 1595, the carving of the emblems for these pedestals was assigned to Diego de Aranda (perhaps the son of Siloe's pupil of the same name), and from late autumn and through the winter until 25 May of the following year, Juan de Vera and Pierres Morell carved the ornament of the window crowns (docs. 155 and 156). In October 1596, the work list included the raising of the wall between the last window and the octagonal chapel in order to place the top cornice over the four completed windows on the east facade (doc. 157).

The next task Minjares assigned to Vega was the east vestibule, which measures about 5.57 by 7.50 meters (pl. 95). According to Maeda in 1576, the east vestibule was still to be built (*está por hacer*), while Herrera's work orders of 1580 list the need "to close the vestibule" (*Cerrar el portillo*), which might be interpreted as simply the vaulting of the entry (docs. 128-e and 132-l); but Minjares, in his work orders of 12 October 1596 (doc. 157), referred to the curved form (*la arca y forma*) of the vestibule, which he said was explained to Vega, and he also noted the need for limestone to raise the walls to the top cornice, and for sandstone to face the vestibule (*piedra de las canteras de Santa Pudia para acabar de cerrar el dicho portillo*). So, it appears that the Machucas had begun but had not completed the limestone walls of the east vestibule. The format followed by Vega, however, was that of the small Royal Palace plan (pl. 18), where the vestibule is composed of a rectangle between two half-circles, permitting the use of a barrel vault

[46] In his report (doc. 166), Ruiz Callejón identified the vestibule as *el çaguán principal*, but he clearly meant the one on the south because he describes the vault as "under construction" (whereas the vault of the west vestibule had been closed in 1594) and he refers to the death of Philip III, which occurred in March 1621.

[47] AA, Leg. 210, 1, 7, for the specifications dated 19 August

1594, and Leg. 52, 1, for several payments on account to stonecutter Blas Enríquez on 20 August 1594 (doc. 154), 24 March, 19 August (doc. 155), and 23 December 1595. A final reckoning of the sandstone delivered for the east facade on 9 August 1597 is found in Leg. 210, 1, 15. References to scaffolds were first noted on 7 October 1519 and to equipment for cranes to lift stone, on 16 December 1595.

flanked by half-domes. Incidentally, we should note that this geometric basis for the plan of the east vestibule was not recognized by José de Hermosilla in 1767 or by Domingo Velastá in 1793 when they made their groundplans of the palace (pl. 97). For the membering of the wall, Minjares seems to have directed Vega to follow the Machucas' architectural repertory: the tapered Doric pilaster with the pulvinated version of the fielded panel, the surround, the semicircular niches with shell-faced half-domes and recessed panels above them, door casings composed of three graduated fascias, a shallow roundel above it, and the leaf-faced corbel. In the cornice, Vega repeated the frieze used in the gallery of the courtyard and in the west vestibule, though the rhythmic disposition of the rectangles is somewhat muddled in contrast to the earlier Orea examples. Most disturbing is the interruption of the architrave and frieze of the entablature by the rectangular frame inserted behind the arched opening from the courtyard. On the opposite end, the inner lintel of the exterior door was kept under the entablature, even though the straight edge of the door cuts across the curve of the entablature of the wall. What could have been an elegant hall is disturbed by the intrusion of these two incongruous doorways as well as the modern vault set too far back of the cornice. Had the vault been initiated closer to the edge of the cornice, the east vestibule could have attained the fusion of the wall and the vault as a continuous shell enclosing a unified space and, thus, approximated that characteristic of the true oval hall. We know only that a model for the vault was made in May 1621 (doc. 163), but since Velázquez de Echevarría described the east vestibule in 1764 as still open to the sky,[48] it is clear that no vault was constructed until this century.

The nearby octagonal chapel in the northeast corner of the palace had been raised to its original cornice by Luis Machuca in 1554, but Juan de Maeda in 1576 stated that the chapel, because of its great size and purpose (*su grandeza y capacidad y intento*

que el edifiçio lleba), should be raised to the level of the cornice of the palace itself (doc. 127). He implied that the diameter and spatial volume of the octagonal chapel demanded greater height than the Machucas had given it. The idea of raising the walls of the chapel was evidently accepted by Herrera, who planned to cover the palace and its taller chapel with a steeply pitched roof with dormers on two levels. In September 1596, Minjares drew up specifications for the limestone needed for raising the massive walls, and by May of 1598, an order was placed for gravel to fill the interval between the outer and inner shells of limestone.[49] The final payment for the sandstone cornice around the exterior of the chapel was made in December 1598 and the last delivery of the limestone blocks for its interior wall was recorded in April 1599,[50] so work on the chapel seems to have proceeded at the rapid pace generally maintained by Minjares, despite his absence. The courses added by Minjares are readily distinguished as the top six because they are slightly taller than the rest and have a thicker and distinctive mortar. Unfortunately, there is no indication of the kind of vault intended in the 1590s, and the chapel remained uncovered until 1970, when the officials of the Alhambra wisely decided not to second-guess the architects of the sixteenth century and, instead, covered the octagonal structure with iron beams.[51]

Work was also underway in the north wing. Sandstone for the facing of the wall and limestone for the vault of the staircase leading down to the Islamic palace were ordered by Minjares in October 1596. The stair itself must have been constructed before that date, because there is no reference to limestone for either the steps or the transverse walls that frame it. During the following year, there were eighteen deliveries of pieces of door jambs and lintels, and also of the entablature, identified in March 1597 as "for the vestibule of the well of the staircase that connects the new royal palace with the old" (*para el portillo de la caxa de la escalera para comunicarse la cassa real nueba*

[48] Velázquez de Echevarría, *Paseos*, I, p. 22.

[49] The specifications for limestone were written on 21 September 1596; see AA, Leg. 210, 1, 23. For a reckoning of the limestone delivered from 13 July 1596 through 21 June 1597, see AA, Leg. 210, 1, 12; and for the payment for gravel on 30 May 1598, Leg. 210, 1, 19.

[50] The final reckoning with Blas Enríquez for the sandstone

cornice over the octagonal chapel is recorded on 31 December 1598. See AA, Leg. 210, 1, 21, and the last payment for limestone for the walls of the chapel, on 9 April 1599, Leg. 210, 1.

[51] Francisco Prieto Moreno, "Obras recientes en la Alhambra y Generalife: Resumen del año 1970," *Cuadernos de la Alhambra*, VII (1971), p. 82.

con la vieja).[52] The limestone voussoirs delivered over the same period were described in one payment in August as for "the vault [*arco*] and staircase that descends from the new royal palace to the royal courtyard of Comares," but that first staircase was replaced for the visit of Philip V in 1729. Not simply repaired, it was totally rebuilt to provide a more suitable staircase (*se formó y hizo de nuebo una escalera . . . con más decencia*).[53] In the 1930s the eighteenth-century staircase was covered by the corridor that now leads to the Museo Arqueológico, but the 1729 staircase can be seen in the 1767 engraving of the north-south section of the courtyard by José de Hermosilla for the Academy of San Fernando and also in the section and groundplan of 1793 (pls. 78, 97, and 101). Composed of three flight of seven steps each, its first flight began immediately inside the archway from the corridor of the courtyard, and the section shows that its lowered vault had partly fallen by 1767 and that the wall membering by Minjares has survived to our day. Here, as in the east vestibule, Minjares employed the architectural repertory of the Machucas; however, there are several simplifications typical of his period, notably the elimination of the taper of the Doric pilasters and the surround. Wholly alien is the overly wide folded pilaster in the corners and the disruptive rectangular frame set inside the archway to the corridor of the courtyard.

Of the first staircase we know only that it was constructed previous to October 1596 and that it differed from the one of 1729. It may have been constructed in the 1560s by Luis Machuca because there was no cost estimate for it in the work list of Juan de Maeda in 1576. What Pedro Machuca had in mind for the north vestibule is not clear since no steps were delineated in his plans; but, his moving the block of the palace three meters east of its position in the large Royal Palace plan resulted in the alignment of the north vestibule with the room in the southwest corner of the Court of Myrtles (cf. pls. 2 and 17), and for that reason, it is quite certain that he intended a staircase there.

Evidently it was to have had an ample landing at the top because there are small doors opening into the rooms on either side of the north vestibule in the large Royal Palace plan of 1528. That top landing and perhaps another at the bottom would have required a single flight of steps with risers of at least 23 centimeters (like those used for the side passages from the west vestibule to the round courtyard). Since the small doorways on either side of the top landing were not included in the small Royal Palace plan of 1531 (pl. 18), it is likely that by then he contemplated a change in the design of the north staircase. At present the narrow door at the foot of the staircase is off center, whereas in both of Machuca's plans, and also those made in 1767 and 1793, the door is centered. Presumably Pedro Machuca intended it as a private staircase connecting the new and the old palace.

In the courtyard, Luis Machuca had completed the sandstone membering of the gallery wall, short of its entablature, and had ordered most of the parts of its Ionic colonnade. Twenty-one of the thirty-two columns, together with their capitals, bases, and pedestals, had been delivered before the quarries at Turro were closed in May 1569, but not even the pedestals were set in place. Maeda in 1576 recognized the presence of twenty-one columns on the Alhambra and two still at the quarry and, thus, the need to cut nine more (doc. 128-c). For the entablature, however, he suggested the use of the grey marble from the Sierra Elvira, rather than the porous stone from Turro, and he recommended the placement of a protective band of that marble over the sandstone cornice of the lower colonnade. Those changes were apparently approved by Herrera because they were carried out by Minjares. Preparation for work on the gallery began in the autumn of 1587, when several carpenters were assigned the task of covering the annular vault of the lower corridor with a wooden floor (doc. 136), but there are no references to further work until June 1592, when Minjares wrote to Juan de Ibarra, the secretary of the Junta de Obras y Bosques, for permission to reopen the

[52] For the payment to Juan de Hontoya on 16 November 1596 for the delivery of part of the sandstone facing ordered on 12 October 1596 "para la escalera y arcos que a de baxar de la cassa real nueba al quarto de Comeres," see AA, Leg. 210, 1. Other payments for the jambs, lintels, frieze, and other parts

were made two or three times a month from 8 March to 2 August 1597. These documents were found by José Manuel Oliver y Hurtado in the early 1870s in old (Catalogue A) Leg. 87; see *Granada y sus monumentos árabes*, Málaga, 1875, p. 524.
[53] AA, Leg. 206, 3, fol. 2, undated.

quarries at Turro so that stone for the gallery could be cut.[54] At the same time, he expressed reluctance to begin so costly a venture when there were no more than 1,500 ducats in the coffers of the Alhambra because the 6,000 ducats due them from the *alcázares* of Seville had not been received the previous year. Ibarra must have reassured him that the funds would be forthcoming, and not long after, on 1 August 1592, a payment was made for a "cord to level the round courtyard" (*cordel* [para] *nibelar el patio redondo d'estas obras*, doc. 143). Early in October various tools for the cutting of stone were taken to Turro, and two pedestals that had been cut before the quarries were closed in May 1569 were brought to the Alhambra (docs. 145 and 148), but then an unusually cold winter seems to have required a temporary postponement of stone cutting there.

These preparations, together with new work orders for the stonecutters in April 1593, indicate a need for more stone from Turro than one would have expected—especially since the missing entablature was to be made of grey marble from the Sierra Elvira—but, the reason for additional stone is revealed by the contract with Blas Enríquez on 30 March.[55] He was to deliver various parts of a parapet—*antepechos, basas, témpanos*, and *antepechos altos*—and they were to take the place of the railing apparently planned between the pedestals of the columns already delivered. The more massive parapet was intended to provide a continuous downward pressure against the outward thrust of the annular vault below. Even without this documentary evidence, the difference between the huge pulvinated panels of the present parapet and the less salient, beveled fielded panels of the pedestals would be sufficient to tell us they pertain to different generations (pl. 81). The overly large and aggressive panels of the parapet are reminiscent of the huge serpentine bars that Minjares seems to have added to the pedestals of the upper story of the west *portada*. He sought grandeur in sheer size, with no

sense of scale to restrain him from allowing one part to dwarf the others. The components of the parapet were delivered by Enríquez from June to October 1593; a second order was granted to Luis González in May 1594, and deliveries were made through June.[56] In the contract for the latter, the function of these panels is made clear by the phrase "the panels that serve as balusters [or balustrade]" (*los témpanos que sirven de balaustres*). During August 1594, new specifications were made and patterns of wood (*moldes*) were provided for the architrave and frieze of the entablature of the gallery (doc. 153), and contracts for grey marble were signed on August 15 with Blas Mateo and Alonso Hontoya.[57] Apparently this order was not delivered on schedule because other contracts had to be made in January 1595 and even then the last of the stone was delayed until Janaury 1598.[58] The final element ordered was "the band (*hilada*) above the cornice of the Doric order (*la prinçipal ordenança*)," and it was contracted with Damian Plan in February 1599.[59] As explained in the work orders of 1597, the band was included in the project (*conforme a la planta*) to protect the sandstone cornice from moisture (*para la defensa de las injurias de los tiempos de la cornisa blanco del patio*); but, none of the Ionic colonnade could be raised until that base course was in place, and deliveries did not begin until March 1599.[60]

The covering planned for the corridor of the gallery is also indicated in the work orders of 1597. It required the cutting of a horizontal groove about seven centimeters high and seven deep in the wall of the chapel on the courtyard side in order to insert a string course of wood (*solera de madera*), and also the cutting of put-log holes just above the sandstone facing of the corridor wall for the insertion of wooden dowels (*nudillos*) to which the string course could be nailed (pl. 83). Above them, other holes in line with the radii of the courtyard passing through the columns were to be opened for the insertion of small beams (*viguetas*) to support the

[54] AA, Leg. 47, 6.

[55] AA, Leg. 210, 1.

[56] Payments to Blas Enríquez on 12 (doc. 150), 19, and 26 June 1593, and those to Luis González on 7 and 28 May, and 10 June 1594, are recorded in AA, Leg. 210, 1.

[57] The specifications dated 6 August (doc. 153) and the contract of 15 August 1594 are found in AA, Leg. 6, 39; and payments to the carpenters who made the molds for the component pieces of the entablature are recorded on 2 July and 13

August 1594 in Leg. 52, 1.

[58] Payments for deliveries from 27 August 1594 to 17 January 1598 and the final reckoning are found in AA, Leg. 210, 1, 18.

[59] The specifications and contract dated 8 and 18 February 1599 are found in AA, Leg. 210, 1, 22.

[60] For the orders of 1597, see AA, Leg. 47, 6. Deliveries are recorded from 3 March 1599 to 14 November 1600 in AA, Leg. 210, 1.

lean-to roof over the wooden ceiling. The cutting of the holes for the ceiling and roof makes it clear that neither Luis Machuca nor Juan de Orea prepared for such a covering and this leaves open the prospect that they had contemplated an annular vault. Herrera's work orders of 1580 simply refer to the construction of the ceiling (*tejado*) over the corridor "as seen in the elevation," without any indication of its design. A third-level corridor, set back from the lean-to roof covering the gallery ceiling, was intended to serve the attic rooms in the steeply pitched roof designed by Herrera. Whether or not Herrera's project is reflected in the truss-roof construction delineated in Domingo Velestá's section of the palace engraved in 1793 (pl. 101) is difficult to say, but it is fortunate that form was not followed in the roofing of the palace in the 1950s.[61] With all the materials for the completion of the gallery on hand or contracted for, Minjares died in April 1599,[62] and full responsibility was passed on to the less capable Juan de la Vega.

We gain an insight into the character of Minjares and his manner of working during his last few years from the newly appointed overseer, Pedro Arias de Riquelme, who in 1596 succeeded his relative, Alonso Arias de Riquelme. The new overseer was understandably dissatisfied with the quality of work done under Juan de Minjares and offended by the man himself. Pedro Arias reported to Juan de Ibarra, the secretary of the Junta, that the architect came to Granada only in the summer to avoid the heat of Seville, and while on the Alhambra, he tended to rise at nine (whereas the work force reported at dawn), and when he finally reached the accounting office, he would put his feet up on the desk and tell stories.[63] He paid no attention to either the governor or the overseer and did not consult them in the hiring or firing of workers (which was his prerogative), and when he ambled to the site to see what the masons were doing, he often countermanded the orders of the *aparejador*, Juan de la Vega. Minjares was obviously very sure of his position and did not feel the need to ingratiate himself with any of the officials of the Alhambra or members of the work force. Despite the new overseer's unfavorable report to the sec-

retary of the Junta in 1597, Minjares maintained his post for the remaining two years of his life.

With all of his shortcomings, Minjares accomplished a great deal between 1583 and 1599. The marble facing of the upper story of the west *portada* followed a project by Orea with important modifications by Herrera and a few intrusions by Minjares himself. The four remaining frames of the upper-story windows on the west facade and the four last bays on the east were faced with sandstone, following the original design but with a reduction in the window ornament of the latter. In accord with a recommendation by Maeda that had been approved by Herrera, the walls of the chapel were raised six courses to the present height. Minjares completed the sandstone facing of the west vestibule (evidently begun by Luis Machuca on the long walls) and covered the hall with a lowered elliptical vault of the type introduced by Herrera. He also faced both the east entry and the north staircase to the Nazaride palace. In preparation for raising the Ionic colonnade of the gallery of the round courtyard, he ordered the missing nine columns from Turro and also conglomerate stone for the massive parapet; and he opened the put-log holes for the beams of a wooden ceiling and a lean-to roof that was to cover the gallery. The design of the Puerta de las Granadas was probably made by Pedro Machuca in 1545–1547 and the massive core of the triumphal arch was probably constructed by Luis Machuca, but the rusticated facing seems to belong to the post-Machuca period. The outsize scale of the rusticated blocks, the limited variety in shape and pattern of their disposition, and the less precise workmanship point to the period of Juan de Minjares and Juan de la Vega.

THE LAST YEARS OF CONSTRUCTION, 1599–1637

Philip III, who became king in 1598, was even less interested in the palace on the Alhambra than his father had been. Perhaps his indifference led several reluctant contributors to the building fund of the

[61] Francisco Prieto Moreno, "Obras recientes en la Alhambra y Generalife: Resumen del año 1967," p. 130.

[62] Minjares' death date was given as 16 April 1599 in a petition from the officials of the Alhambra to the king on 21 November

1612, now found in AA, Leg. 104, 5, 6.

[63] Arias de Riquelme's letter of 25 August 1597 is preserved in AA, Leg. 47, 6.

Alhambra to withhold the money they had been ordered to forward. In any case, the income of the Alhambra in 1599 dropped to a third of what it had been in 1598, and funds were so low in 1600 that there was a work stoppage of "several days."[64] For the next decade, the annual income was erratic, ranging from 934,000 *maravedís* in 1602 to a mere 3,060 the following year. If translated into ducats, the income of the best of these years was no more than 252 in contrast to the pre-Rebellion budget of 10,000 ducats. Work was further hindered by the Junta's failure to appoint a new chief architect. Juan de la Vega, who had supervised the work for more than fifteen years between the summer visits of Minjares, continued to carry out the duties of *maestro mayor*, but without full title or salary. The elderly Luis Hurtado de Mendoza, the fourth marquis of Mondéjar and the fifth count of Tendilla, who had been governor since 1580, urged Juan de Ibarra, the secretary of the Junta, to reinstate the work force on the Alhambra in November 1600, but apparently Ibarra did not respond; in January 1603, the governor informed the secretary of the deterioration of parts of the old palace, but again nothing came of these efforts.[65] The following year, in 1604, Luis Hurtado died, and since Luis' only son had died before him, the direct descent of the Mendozas as governors of the Alhambra came to an end. Philip III then appointed the husband of Luis Hurtado's sister, Catalina de Mendoza—Cristóbal Gómez de Sandoval y Rojas, duke of Uceda y Cea, the brother of the king's favorite, the duke of Lerma—and he served as governor of the Alhambra until 1646.[66]

There is little evidence of work on the palace from 1600 to 1610, but the weekly accounts for 1611 list ten stonecutters at work in the quarries at Alfacar, and in February references were made to the repair of the carts used for transporting limestone from that quarry. Fairly regular deliveries

were recorded from January through June, but there is no indication of where the stone was to be used. In spring, specifications were drawn up for sandstone blocks from Santa Pudia, including pieces for "the top cornice of the new royal palace," presumably for the west end of the north facade, and the order was put up for bids on 30 June 1611 (doc. 158). A contract was signed on 4 August with Blas Enríquez, who had long served the works, and later on 11 December with Pedro Velasco.[67] The first sandstone cut by Enríquez was rejected as "too yellow," and so in mid-October 1611 Juan de la Vega selected another part of the quarry where the stone was still white.[68] The number of quarriers on the payroll dropped from eight to six early in 1612, and by April, none was listed; the final payment for stone in June 1613 reveals that all the sandstone ordered had been delivered.[69]

Already in May of 1612, the work force on the new palace had been reduced to Juan de la Vega, the acting architect, one mason (*asentador*), Juan de Landeras, and four assistants, while the repairs of the old palaces were to be carried out by a bricklayer, a carpenter, and eight laborers.[70] Apparently Juan de Ibarra, the secretary of the Junta, had requested plans of both the old and new palaces sometime before his death in early October 1612 because the overseer, Gaspar de León, explained to the king and the impatient new secretary, Tomás de Angulo, that when the plans ordered by the absent governor were completed, others would be made for the secretary.[71] Those plans must have been made shortly before 3 November 1612 because a mason who assisted Vega in measuring the two palaces was paid on that date, and by 17 November two plans had been delivered to Madrid.[72] That was one of Vega's last tasks before his death in mid-November, which terminated thirty-six years of service on the Alhambra.[73]

Pedro de Velasco was named chief architect by

[64] A record of annual expenditures for the Alhambra from 1596 to 1620 is preserved in AA, Leg. 52, 1.

[65] AA, Leg. 5, 16, xii, 23, and Leg. 47, 1.

[66] Moreno Olmedo, "Un documento . . . sobre los Mendozas de Granada," pp. 93-94.

[67] See AA, Leg. 153, 1, for the Nóminas of 1611, and Leg. 210, 1, 30 and 32, for the specifications, contract, and payments for the sandstone for the cornice from 20 April 1611 through 13 July 1613.

[68] AA, Leg. 153, 1.

[69] The payment to Pedro Gil, dated 22 June 1613, is found in AA, Leg. 210, 1, 30.

[70] The payment of Juan de Landeras on 19 May 1612 and the description of the work force of the new palace are found in AA, Leg. 153, 1, while that of the Islamic palace is recorded in a report of 20 November 1612, now in Leg. 47, 2.

[71] AGPM, SCR, vol. 11, 1608–1620, fol. 273, records the king's appointment of Tomás de Angulo as secretary of the Junta de Obras y Bosques, following the death of Ibarra. See AA, Leg. 47, 1, for Gaspar de León's letter to the king on 30 October 1612.

[72] AA, Leg. 153, 1.

[73] The death of Vegas was given as 17 November 1612 in the letter from the officials of the Alhambra to the Junta de

the new secretary, Tomás de Angulo, within a month of Vega's death.[74] Velasco was a local mason who had agreed in December 1611 to deliver sandstone from the quarries of Santa Pudia, so presumably he was recommended by the officials of the Alhambra as someone familiar with the works. From the rough draft for a lost letter written by the officials of the Alhambra to the secretary on 22 April 1613, it is evident that they gave priority to the construction of the gallery of the round courtyard because the material was already on hand, and following that, they recommended the roofing of the entire palace.[75] Apparently, this sequence of work was accepted by the secretary. Velasco first assigned his limited staff, that is Landeras and the four masons, to the task of raising the colonnade of the gallery. The parapet (composed of the pedestals ordered by Luis Machuca and the intervening panels ordered by Juan de Minjares) was constructed by 20 September 1614, when the masons set "the keystone of the parapet"—presumably the last piece—and on that day they celebrated the event with a picnic lunch (merienda) for the workers (doc. 159). Equipment for a crane to lift the columns of the gallery was purchased from October 1616 through August 1618, and in January and February 1617, lead plates were delivered for placement beneath the columns (plomo . . . para las planchas que se ban poniendo debajo de las colunas del corredor de la casa real nueba).[76] The Ionic colonnade seems to have been erected between December 1615 and May 1619, when there are references to iron clamps and adhesives to set the pieces of the entablature (cornisas) of the gallery. Beginning in October 1617,

payments made for "the tie rods (tirantes) that they are putting in the corridors."[77] This was, of course, done to stabilize the entablature of the colonnade by securing it to the corridor wall. Before his death in 1619 (doc. 160), Velasco completed the Ionic colonnade and designed the ceiling of the gallery because wood was delivered for the ceiling in 1622.[78]

Already in 1613, Velasco had made specifications for the use of limestone for the vault of the south vestibule, but the first references to wood "for the centering of the vault of the vestibule of the new Royal Palace" are not found until February 1619.[79] Sandstone was ordered for parts of the entablature and the lunettes on each end, and deliveries of this stone are recorded in late August and again in January of the following year, 1620.[80] In August 1620, Darta was paid for "eight consoles which he had made and carved for the 'pilasters' of the vaulted vestibule of the second portal of the new royal palace that opens to the south" (por ocho cartelas que hiço y labró para las pilastras para la bóveda del çaguán de la segunda puerta de la casa real nueva que sale al mediodía).[81] The word pilastras here must refer to the advances of the entablature (pl. 96) since (in contrast to the others) the south vestibule has an astylar wall. The vault was not yet completed when Velasco died in December 1619, but it was continued by his assistant, Juan de Landeras.

Prospects for the rapid completion of the palace were very good at the end of 1619. The income assigned was received more regularly than before and the new secretary of the Junta de Obras y Bosques, Tomás de Angulo, consulted officials of the Alhambra on all major matters and, even more

Obras y Bosques on 21 November 1612 and is recorded in AA, Leg. 104, 5, 6.

[74] AA, Leg. 104, 5, 7, for the appointment of Velasco on 13 December 1612.

[75] AA, Leg. 47, 2.

[76] References to the purchase of equipment such as "una marometa y quatro sogas y una madeja de cordel . . . para el tiro" begin on 22 October 1616 and continue through August 1618, and payments for sheets of lead for placement beneath the columns were made on 14 January and 18 February 1617. Iron for the making of clamps was purchased on 24 December 1615, 4 March 1616, 28 January, 2 and 16 June, and 7 September 1618, 16 March, 13 April, and 18 May, 1619. See AA, Leg. 153, 1.

[77] The iron tie rods for the gallery colonnade (los tirantes que se ban poniendo en los corredores de la casa real nueba) were mentioned on 21 and 27 October, and 4 and 11 November 1617, also in Leg. 153, 1.

[78] The report of 28 July 1622 states that Velasco ordered the wood on 9 June 1617; see AA, Leg. 44, 3.

[79] The specification of September and the contract of 15 November 1613 are found in AA, Leg. 201, 1, 33. Payments for the wood centering were made on 7 February, 9 March, and 23 November 1619, and on 9 March and 12 September 1620, with the last payment including the most explicit indication of the use of wood (. . . las çinbras que se haçen para la casa real nueba que mira al mediodía . . .); see Leg. 153, 1. The only reference to the raising of stones for the construction of the vault is a payment on 24 October 1620 for a part needed for a winch (un tequelo que hiço para el torno con que suben la piedra para la bóbeda del çaguán de la casa real nueba), but it is clear that the work had been underway for some time.

[80] AA, Leg. 210, 1, fols. 1-14, 20.

[81] AA, Leg. 153, 1, payment to Juan Pérez Darta on 14 August 1620.

important, usually made decisions quickly. All these favorable circumstances were negated by the appointment of a controversial architect from Valladolid to succeed Pedro de Velasco as chief architect. The intensity of the ensuing conflict and the number of participants precludes the relating of the full story. It seems the difficulty arose, in part, from the recommendation by the Alhambra officials of five mediocre Granadine masons as candidates for Velasco's post (doc. 161). Angulo, apparently uncertain of their qualifications, required that all candidates come to Madrid at the end of March to be examined.[82] When they got there, the Granadine group found that a mason from Valladolid, Francisco de Potes, had also entered the competition and that their examiner was none other than Juan Gómez de Mora, the former assistant of Herrera, who since 1611 was the leading architect of the court of Philip III. Gómez de Mora found all of the Granadine masons deficient in mathematics, while the outsider, Francisco de Potes, won his approval. Potes had given a good account of all matters related to geometry and arithmetic and to stone masonry, and what is more, he had had a good deal of practical experience in the construction of buildings in Valladolid. Unfortunately, the buildings were not cited, and moderen scholarship has discovered only that Potes was the architect of the Order of Alcántara and inspector of several bridges at Medellín, Mérida, Badajoz, and León.[83] Whatever his background, he seems to have been better qualified on the basis of both practical experience and theoretical knowledge than the candidates proposed by the officials of the Alhambra. The Junta took Gómez de Mora's advice and six weeks later, on 17 May 1620, the king named Francisco de Potes "assistant, acting as chief architect" of the Alhambra.[84]

The officials and workers of the Alhambra and the five Granadine masons who were rejected were angered by the decision. They regarded Potes as an interloper, and as they became more familiar with the man himself, their animosity grew and their opposition to him hardened. He was temperamentally incapable of handling so delicate a situation with tact. Often abrasive and high-handed, he was disrespectful of the other major officials, ignoring or usurping their well-established privileges within the management of the works. He quickly came into open conflict with the paymaster and the overseer, who in less than a year had to request a reaffirmation of the directives and Work Rules of 1579 and 1588,[85] and emendations and clarifications had to be made in April 1622 and again in December 1626.[86] The major officials noted that in the past they had always worked harmoniously with the chief architect, but with the arrival of Potes there was continual conflict. Of him they said in their report of May 1621, "[there] is really a lack of judgment and, because of his bad disposition, behavior, and pride (realmente es falta de juicio y por su mala condición, término y sovervia), he does not have the respect for his coworkers that he ought to have" (doc. 163, fol. 2v). He was accused of mistreating laborers "by word and deed," and the bricklayers said he did not know what he was talking about in respect to their craft. After stonemason Juan de Landeras and a carpenter, Francisco González, made statements against some of his projects in May 1621, he dismissed them summarily, though each had thirty years of service in the works of the Alhambra. The Junta in April 1622, while affirming the chief architect's right to fire workers, stated that the overseer had to approve all craftsmen added to the work force, and they admonished Potes not to wrong longtime employees.[87] Apparently, he had to take Landeras back into the works because in November of that year the mason was acting aparejador during the absence of Potes.[88] The recounting of this bick-

[82] AA, Leg. 104, 5, 14.

[83] Llaguno, Noticias, III, 183; Gómez-Moreno y González, "El Palacio de Carlos V," p. 19.

[84] AA, Leg. 104, 5, 15.

[85] AGS, CSR, Leg. 265, fol. 78, for the clarification of orders on 17 June 1579, and AA, Leg. 206, 6, for orders of 31 May 1588.

[86] AA, Leg. 104, 5, 14. Potes had failed to witness payments to workers on Saturday and to consult with the other officials on what was to be done the following week. In addition, he neglected to put up the work for bids on several occasions, in violation of the Work Rules.

[87] The firing of González and Landeras was reported on 20 May 1621 (doc. 163, fol. 2v), and the reprimand to Potes and the reinstatement of the two workers are found in a letter from the secretary of the Junta dated 26 April 1622, now in AA, Leg. 104, 5, nos. 19, 20, 21, and 25.

[88] Other charges against Potes included his frequent absences from the Alhambra without permission and the hiring of his son, Roque, in violation of the Work Rules; see AA, Leg. 104, 5, 21.

ering—and more that followed—serves to show the personality of Potes and the personal basis for continual friction and persistent opposition to his projects.

There were many controversies. Shortly after his arrival on the Alhambra, Potes noted that most of the transverse walls of the palace had been raised to the level of the common cornice and that his first task would be the covering of the entire palace.[89] Though this had been Herrera's priority in 1580, the Granadine masons insisted that, before the common roof was built, the vaults of the octagonal chapel and the south and east vestibules should be constructed, and the main audience hall covered. Their view prevailed, and at a meeting of the officials on 24 September 1621, it was decided that the vault of the octagonal chapel and four other vaults had to be closed before the transverse walls were raised and the top cornice set all around the palace in preparation for the construction of the common roof (doc. 164). They calculated these works would require about twenty years. While there was general agreement on the work schedule, Potes and the Granadine faction disputed the form of the roof and its cladding (doc. 170). Potes insisted on lead plates because the material was readily available in nearby Linares and was the most effective covering. The Granadine group indicated a preference for glazed tiles (*tejas vidriades*), though they granted that slate, which had been recommended by Herrera in 1580, would be satisfactory. It seems that both Potes and the Granadine masons departed from Herrera's paper model for the roof, which followed those of the royal residence at Aranjuez and the Escorial. Evidently, there was no resolution of the matter because five years later, in 1625, Bartolomé Fernández de Lechuga, the new *aparejador*, submitted six drawings of his variation on the Herreresque roof (a plan, an elevation, and four sections), together with a model (doc. 172). This new project, along with those of Potes and Herrera, was studied by Juan Gómez de Mora in Madrid, and in December 1625 he proposed adding an attic story (in place of dormers) over the gallery of the round courtyard (doc. 171). While we cannot gain a clear idea of the individual projects under consideration in 1625,

the compromise form recommended by Gómez de Mora in 1625 was that of a steeply pitched roof—probably not as tall as that of the Escorial—with dormers on the facade side and an attic over the gallery of the courtyard. The roof was to be covered by lead cladding and screened from the near viewer by an Herreresque balustrade along the top cornice of the facades and the courtyard; and this general solution seems to be reflected in the 1793 project for the completion of the palace as a military academy (pl. 101).

Changes proposed by Francisco de Potes in the stone vault begun by Pedro de Velasco over the south vestibule provided the basis for the most bitter conflict. The king appointed a judge of the Chancillery of Granada, Luys Gudiel, and a councilman of Guadix, Alonso de Loaysa, to investigate two complaints: that the vault of the south vestibule as revised by Potes was in error (*iba herrada*), and that Potes was not competent to complete the palace. Most of what we know of the dispute is found in their report to the king on 30 November 1621 (doc. 165). Gudiel and Loaysa reported that they summoned not only the Granadine masons who had criticized the change in the vault but also several outside experts. The investigators found that the main objection was Potes' departure from the Herreresque form of the vault that Velasco had begun to construct, but they noted that even the most ardent critics did not claim to have found any fault "in the cutting or setting of the stones or the stability and permanence of the construction" (*en quanto a la labor y asiento de la piedra y a la seguridad y perpetuidad del edifiçio*). They concluded there was no structural necessity to dismantle what had been done by Potes in the vault of the south vestibule.

Gudiel and Loaysa then turned to the second question they had been asked to investigate, the general competence (*sufiçiençia*) of Potes to construct the vault of the huge octagonal chapel and the small east entry and to roof the entire palace. Probably at the suggestion of the Granadine masons, the investigators decided to require Potes to make models for these two vaults within a set period and without help from others. He was assigned a room in the new palace—perhaps the one

[89] The proposal was first made in May 1620 and specifications were drawn up for the initial order of wood for the roof on 4 October 1620 (AA, Leg. 206, 3). These steps were recalled in

the report of a meeting of the officials on 16 July 1620 and again on 1 August 1621, when Potes answered his critics (Leg. 205, 3, 3, fol. 15).

he had readied in October 1620 in the mezzanine near the east door[90]—with a guard in attendance to assure that he was unaided. When the models were finished, after an unspecified time, the investigators invited opinions from his Granadine detractors and four other masons named by Potes himself. All agreed that the models were not good and lacked the finish and inventiveness required for such a work (*que no estaban buenos ni con la pulicia y curiosidad que convenía a semejante obra*). The word *pulicia* was later replaced by *perfección*, so it is clear that "finish" in the sense of "completeness" is its meaning, and *curiosidad* could also have been closer to "skillfulness" than to "inventiveness," because a lack of manual dexterity was clearly the primary meaning of the criticism. Potes, it was reported, admitted that his models had neither *perfección ni curiosidad*, but he excused himself for not having the "handiness [or manual dexterity] of others of a more craftsmanly [nature]" (*de manos como le harían otros más moços*), and like his Renaissance predecessors, he claimed a more important skill for an architect, the ability to design.

In their introduction to the report on Potes' competence, Gudiel and Loaysa observed that the palace of Charles V was not surpassed even by the most grandiose and sumptuous of the royal residences in Spain and that it exceeded all others "in difficulty and artifice" (*dificultad y artifiçio*)—words that recall Mannerist theorists of the sixteenth century. A building of this importance, they reasoned, should not be entrusted to a man whose credibility and competence were doubted by so many but, rather, should be given to one who had general approval. Upon hearing of this recommendation at the end of November 1621, the Granadine faction must have been certain that they would soon be rid of Francisco de Potes. To their amazement, he was not dismissed. He even dared to request a change in title from *aparejador* to *maestro mayor*.[91]

We gain a better idea of the vault Potes proposed from a report by Melchor Ruiz Callejón in 1522 (doc. 166). He noted that "the centering [of the south vault] rests on the armature that the previous architect [Velasco] had completed with a different intent, namely, that only the main arches were to be of stone masonry while the surfaces in between were to be lighter materials" (*cuya çimbra cargan sobre el releje y estribo qu'el maestro antiguo dejó hecho con diferente yntento, de que sólo los arcos mayores fuesen de cantería y las lunetas de los entremedios a lo lijero*), and it was further intended that those surfaces were to be made of brick. This vault placed less weight on the walls of the vestibule, which (at 56 centimeters) were not given the thickness (*fortaleça*) necessary to support a vault completely of stone. So, it would seem that Velasco had intended transverse arches of limestone with panels between them of brick, while Potes insisted on making the vault totally of limestone.

Despite the unfavorable reports late in 1621 and early in 1622, Potes got a raise in April 1622.[92] His project also survived intact, though its construction was apparently delayed until June 1623, when specifications for stone were made (doc. 168), and a payment was made for a cord to guide "the cable with which they raise [the stone of] the vault of the vestibule they are making" (*cordel de traylla para atar la maroma grande con que se sube la bóveda que se ba haciendo en el çaguán*).[93] Wood for centering was delivered in January, and limestone for the vault, in March 1624,[94] but the officials of the Alhambra again charged that the vault was faulty. Finally, Pedro de Hoff Huerta, the secretary of the Junta, responded in July that their charges had never been demonstrated, and since the Junta had several times concluded that Potes was adequate to his post, further accusations of this sort were forbidden.[95] But when several stones of the vault fell the following year, the jubilant officials of the Alhambra

[90] Payments were made for the plastering of the walls and the tiling of the floor of a new drafting room (*aposento que se a hecho en la casa real nueba para a donde traçe el maestro mayor*) and, on 10 October, for the lock and key of its door; see AA, Leg. 153, 1. The pertinent passage in the Gudiel-Loaysa report of 30 November 1621 (doc. 165) is: "nos pareçio ordenarle que hiziese los modelos de las dichas bóbedas dentro del termino que la fué señaldo y porque no se pudiese aiudar de nadie. . . ."

[91] Ambrosio Vico, in his letter of 22 February 1622, declared that Potes "es tan inútil y tan ignorante que es berguença decillo será bueno dalle un maestro maior, que el título que tiene es de aparejador . . ."; see AGS, CSR, Leg. 330, fol. 257.

[92] AA, Leg. 104, 5, 23.

[93] AA, Leg. 44, 4, Nóminas, payment on 17 June, 1 and 29 July, and 16 December 1623. On 25 November 1623, there is a reference to materials for the mortar "para apretar las piedras que se ban asentando en la bóbeda que se ba çerando en el çaguán de la casa real nueba."

[94] AA, Leg. 44, 4, Nóminas, payment on 13 January 1624, for wood, and on 2 and 16 March 1624 for wedge-shaped stones (*dovelas*).

[95] The overseer and the paymaster made the charge of incompetence in a letter of 23 January 1624, which was cited by the secretary in his delayed response of 9 July 1624 (AA, Leg.

felt they had the required "demonstration," so they withheld payment of the next third of Potes' salary and awaited his dismissal.[96] Castilian masons sent by the Junta to investigate the matter reported on 27 September 1625 that the failure was due to having set the stone of that portion of the vault during the cold of winter rather than to faulty design or poor stonecutting and setting. Inevitably someone observed that few local masons would have been so foolish as to set stones in the cold of a Granada winter, and the officials of the Alhambra must have pointed out that the Work Rules of 1588 required a halt to stone setting in December, January, and February.[97] In November 1625 the Junta ordered that the model of the controversial vault be sent to Madrid, and again, their consultants apparently found no fault because in March 1626 Potes was paid the portion of his salary that had been withheld.[98]

Because of these conflicts, Potes accomplished little during a quarter century at the works of the Alhambra. Potes was frustrated in his effort to cover and complete several of the main halls of the west wing in preparation for roofing the palace. Though Velasco's specifications for a truss roof (armadura) over the main audience hall were approved as early as July 1619, there is no record of a contract for the wood until September 1621. Four years later, references to that order make it clear that nothing had been delivered.[99] While it is evident that some of the Granadine faction had proposed a coffered wooden ceiling for the audience

hall, the officials decided on a vault by August 1621.[100] It seems that the protective rafters above the vault were to have been inserted in the wall of the main hall at a height of about 30 Castilian feet (8.36 meters), which was about 1.95 meters above the room's wall cornice, and in between them Potes planned to construct a lowered elliptical vault of plastered brick. It would have had very nearly the same appearance as the present vault of that hall, constructed by Prieto Moreno in 1955 that replaced the coffered ceiling installed by Torres Balbás in 1929 over the entire southern end of the west wing.[101] Photographs from about 1920 show that the transverse walls forming the original rooms of the west wing had collapsed and many of the stone blocks had been carried away (pl. 1), so the original size of the main hall and the adjacent rooms was no longer evident. The main hall, originally the same size as Machuca's vestibule beneath it, was extended by order of Herrera to include two more facade windows in 1580, so the main hall in the 1620s was to have had five windows like the present one and probably a lowered elliptical vault. Potes must have completed the vault because it was one of five that Oliva in 1645 was charged with preserving against deterioration. Potes also introduced flues for fireplaces, which were approved by Herrera in 1580 and then confirmed by Potes in 1621 (doc. 164). One of the flues was on the south wall of the main hall, where the handsome fireplace with the relief of Leda and the swan was located until recently.[102] Potes also made spec-

104, 5, 73), which includes the phrase ". . . se a acordado que se les reprehenda de hablar de nuevo en esto."

[96] AA, Leg. 104, 5, 29, records a review of the event and its aftermath from early autumn 1625 through 10 March 1626.

[97] The Work Rules of 31 May 1588 (copy of 16 March 1751) are found in AGS, CSR, Leg. 303; another copy is in AA, Leg. 183, 2, 5.

[98] AA, Leg. 104, 4, 29, for 10 March 1626.

[99] Velasco's specifications for a truss roof are dated 4 July 1619 and the contract for the wood with Ruiz Ibáñez, 24 September 1621. Five years later, on 13 October 1625, the officials of the Alhambra notified Ruiz that they still expected him to honor his contract. These documents, together with opinions on the design of the common roof from Diego and Benito Vilches and Bartolomé Fernández Lechuga on 9 and 14 September 1625 (doc. 170), are found in AA, Leg. 206, 3.

[100] The Work Orders of 10 August 1621 (AA, Leg. 206, 3, fol. 23) include this description of the vault of the main audience hall: "Y en quanto si a de ser bóbeda o guarneçida de madera los enmaderamientos de los quartos reales de la dicha casa real, le pareçe que se hagan de bóveda debaxo del suelo tosco del dicho enmaderamiento, la cual bóbeda sea de yeso y ladrillo

tabicada, que tenga seis pies de buelta y un pie de cornissa y que darán beynte y tres pies de alto de pie derecho, porque tiene de alto hasta el dicho enmaderamiento treynta pies, y en las dichas bóbedas echarán sus faxas y guarniciones en la forma que está en el quarto real, que está dorado de su magestad en el alcáçar de la villa de Madrid." The Junta de Obras y Bosques was still undecided on 22 April 1623 when Potes again submitted a statement proposing a vault over the main hall. Marginal notations on that proposal make it clear that the proposal was approved by Giovanni Battista Crescenzi, the Italian designer who was a consultant on royal works from 1617 until his death in 1635. For the document see Llaguno, Noticias, III, pp. 372-375.

[101] Photographs by Torres Molina of the coffered ceiling constructed by Torres Balbás are found in the Oficina Técnica of the Alhambra, and Prieto Moreno's project for the vault of 1955 is recorded in several drawings (nos. 787 and 791) in the same office. Torres Balbás noted on 29 January 1929 that he was raising the wall of the hall over the west vestibule "para cerrar el salón"; see "Diario de obras en la Alhambra: 1927-1929," p. 126.

[102] The fireplace was removed in 1926 from the Mexuar in

ifications in January 1622 for the laying of parquet floors (*enmaderar los suelos de madera quadrados*), but there is no evidence this work was ever done.[103]

When young Philip IV made an eight-day visit to the Alhambra in April 1624,[104] he had to be housed in the suite of rooms in the old palace built for Charles V in 1528–1533 because none of the halls of the "new palace"—under construction for ninety years—were yet covered. Preparation for the king's visit diverted both funds and workers to temporary works of a cosmetic nature. Since there was little more than a month's notice of the royal visit, the work force was increased from six to eighty-six laborers by early March, and it remained at that high level beyond the royal visit from 3 to 11 April.[105] Already on 29 February a plasterer was paid for a week's work in the refurbishing of the walls (*enlucir las paredes*) of the suite of rooms in the old palace built for Charles V. We know that the Hall of Ambassadors in the Tower of Comares and the Court of Lions were also touched up with paint and gilding because on 9 May, when the officials got around to having the work appraised, the painter refused to accept the price.[106] On 22 May, a lamp was placed in the north staircase that led down from the round courtyard into the southwest corner of the Court of Myrtles.[107]

In the new palace, work centered on the main facade, and in March, wooden doors were installed in the three portals of the west *portada*. The areas in front of it and the south entry were surfaced with cobblestones, and the same treatment was given to the steep hill leading up to the Portal of Justice. As we noted earlier, a sizable expenditure was made on the renovation of the Fountain of Charles V, located just below that portal in the ascent of the Alhambra (pl. 48). Clearly, the primary concern in 1624 was the renovation of the road to the upper Alhambra, together with the two main facades of the palace, the areas in front of them, and the north staircase to the Nazaride palace. Within the new palace itself, the only recorded work is the construction of a wooden staircase to the upper corridor.[108] But we know that the king and his party did not use the uncovered main audience hall as a vantage point for viewing the bull fights held in the area in front of the west facade on 8 April because Henríquez de Jorquera reported that they were seated "at the portals" of the facade.[109]

After the royal visit, serious attention was given to the several staircases, but the only one that is clearly identifiable in the documentary references was the "secret" spiral staircase originally planned to serve the private chambers of the emperor and empress in the southwest corner (doc. 169 and pl. 17).[110] These staircases were not realized by Potes because every project he proposed was immediately opposed by the other officials of the Alhambra or the disgruntled Granadine masons.

In view of the failure to realize these important projects, it is surprising to find much of the work force, after Potes' death in July 1637, involved in the decoration of the three vaulted rooms in the basement of the north wing. Most of this work

the Nazaride palace and installed in the main-floor hall in the center of the south facade. Although no documents of earlier references to this fireplace have been found, its style suggests it was made in Genoa in the third quarter of the sixteenth century. See Leopoldo Torres Balbás, "Diario de obras en la Alhambra: 1925–1926," *Cuadernos de la Alhambra*, III (1967), p. 152, and also his "Notas de la Alhambra, Historia de una chimenea," *La Esfera*, XV (1928), no. 752.

[103] AA, Leg. 206, 3, 3, for reports on 16 July and 24 September 1621.

[104] Philip IV was only nineteen at the time of his visit to Andalusia from 8 February to 18 April 1624. Later he was less inclined to travel beyond the environs of Madrid. He resided in the *alcázar* in Madrid and the nearby Buen Retiro, which he favored over more distant royal retreats such as the Casa del Campo, El Pardo, La Zarzuela, El Escorial, and Aranjuez; see Jonathan Brown and J. H. Elliott, *A Palace for a King. The Buen Retiro and the Court of Philip IV*, New Haven and London, 1980.

[105] AA, Leg. 44, 4, Nóminas, from 29 February through 11 May 1624.

[106] Ibid., 9 May 1624.

[107] Ibid., payment on 22 May 1624.

[108] Payments were made on 9 and 16 March, and 2 April 1624 to Agustín Durasno for "la escalera que está haciendo para subir a los corredores de la casa real nueba y puerta del Caril para la venida de su magestad . . ."; see AA, Leg. 44, 4.

[109] Henríquez de Jorquera, *Anales de Granada*, III, p. 660: "Subieron a el Alhambra por la tarde, corrieron delante de las puertas de Palacio, donde estubo su magestad y su alteça [the governor] con los grandes."

[110] The second staircase must have been the main one in the northwest corner of the courtyard. Specifications for thirty-six treads of grey marble were drawn up by Potes on 28 December 1620, but the foundations for the staircase were not contracted until 5 May 1629 and the delivery of that stone was spread over the next four years; see AA, Leg. 210, I, 49 and 50. Even then, the officials were still uncertain about the design of the staircase because on 13 April 1635 they discussed its "modo y forma" (Leg. 152, 1).

was done after Granadine Bartolomé Lechuga was appointed to replace Potes,[111] and probably for that reason, the entire decorative program was carried out without a hint of conflict.

The rooms decorated from 1637 to 1639 include the octagonal chamber under the chapel, the irregular room west of it, and (beyond the base of the north staircase to the Court of Myrtles) a long hall that extends to the west facade.[112] The suite is designated D, E, and G in the 1793 groundplan made for the Academy of San Fernando (pl. 97), and the individual halls are identified by way of the descriptive terms used in the account ledgers. One is "the hall with the long vault (bóveda larga) that opens on the square of the water tank (aljibe)." Another is identified as "the octagonal hall (ochavada)" or "the round hall (redonda)" or "the vaulted hall beneath the chapel (la bóveda vaxo de la capilla)," with the added notice that it opens on the Court of Myrtles. Clearly, this is the subterranean chamber with the magnificent vault of 1538 that we earlier attributed to Pedro Machuca's obrero mayor, Gonzalo de Lorca (fig. 5, p. 60). All three of these rooms were given a common treatment in that the floors were covered with the familiar combination of bricks and small square glazed tiles and the lower part of the walls was faced with a tile dado, but some special features were added to the hall of the "long vault." There were eight sideboards of conglomerate stone (bufetes de jaspe),[113] so presumably it was intended for banquets. The walls above them had large paintings on pine panels (seys tablas largas de pino . . . para los bastidores que se están haciendo para las pinturas de la bóveda larga).[114] The vaults of all three rooms were painted in June 1639, but after that there is no further notice of this work. The intense pace of the work suggests that the suite was decorated for a projected return visit of Philip IV that was never realized. Presumably, most of this decoration was already lost in 1729 when the hall under the octagonal chapel was fitted out as a kitchen in preparation for a visit of Philip V.[115]

The "long hall" was provided with a small edicular portal along its north side (pl. 85).[116] An awkward scroll between the casing and the entablature bears the crudely cut inscription, IMP[ERATOR] CAES[AR] KAROLO V. This reference to the emperor rather than to the current king, Philip IV, reveals that eighty years after his death the palace was still identified as that of Charles V. Indeed, it is likely that the building was continued out of respect for its founder rather than the personal interest of the several kings of Spain who followed him. Though some scholars have thoughtlessly assigned the design of this portal to Pedro Machuca, its stubby columns, pulvinated frieze, and squat proportions cannot be attributed to either of the Machucas, and there was, of course, no need for an exterior portal at this location before these rooms were selected in 1636 to form a suite related to Court of Myrtles. As it turned out, the decoration of this suite of basement rooms in 1537–1539 was the last major work on the palace of Charles V.

Francisco de Potes, harassed by his enemies to the end, was able to complete only two of the disputed projects before his death in 1637, the vault of the south vestibule and that for the main audience hall. His projects for covering several nearby rooms, the east vestibule, and the more important octagonal chapel were not executed. The only legacy of his 1620 design for the main staircase was the use of treads made of marble from the Sierra

[111] Diego de Oliva was appointed acting maestro mayor on 6 July 1637 (AA, Leg. 104, 5, 37, 6), but Lechuga was appointed maestro mayor on 13 December 1537 (Leg. 104, 5, 50) and, eight years later, on 13 June 1645, Oliva became the chief architect (AGPM, SCR, vol. 14, fols. 100-101).

[112] The first evidence of work on this suite of rooms are the bids and contract on 10 February 1635 for stone for "las portadas que se han hecho y ban haciendo para la entrada de Comares y bóveda vaxo de la capilla que se a de ser (sic) en la casa real nueba"; see AA, Leg. 206, 6, fol. 2. The next notice is a contract on 29 July 1636 (Leg. 206, 3) with Fernando Piçarro for brick and tiles (azulejos) to be used for the floor (solería) of the "vault of the new royal residence" (bóveda de la casa real nueba); and later, when his widow claimed payment for the work (Leg. 41, 2, on 5 December 1637), it was identified as

"the floor of the octagonal vault and the hall that is alongside it" (la solada de la bóveda ochabada y sala que está junto a ella). Payments for the work as it progressed are found in Leg. 41, 2.

[113] Payments to the carpenters who constructed the sideboards were made on 19 June and 2 October 1638; see AA, Leg. 41, 2.

[114] Ibid., 15 June 1639, payment for the panels.

[115] AA, Leg. 206, 3, report on preparations for the visit of Philip V in 1729.

[116] AA, Leg. 41, 2, Nóminas, 5 September, 7 and 28 October, and 5 December 1637, for the steps of the portal; 14 November for the excavation of the area in front of the portal; 13 and 19 December, for the columns and pedestals of its edicular frame.

Elvira. After Bartolomé Lechuga completed the decoration of the three rooms in the north wing, only minor repairs are recorded in the weekly pay ledgers during the seven years of his tenure. There must have been a brief moment of hope that work would be resumed because in April 1644 the paymaster-overseer, Ginés de Gadea y Anasco, summarized the work orders for the palace.[117] The summary was given royal approval in May 1645, shortly after the death of Lechuga in January. His successor, Diego de Oliva, however, was charged with nothing more than the preservation of the five vaults of the palace:[118] those of the subterranean chamber beneath the octagonal chapel, the corridor of the round courtyard, the south and west vestibules, and the main audience hall. The oldest vault, the superb lowered one of the subterranean chamber constructed under Pedro Machuca in the early 1540s, had suffered greatly because it had been unprotected for a century. Only in March 1637, after that chamber had been decorated as part of the three-room basement suite, did Potes provide proper drain pipes to remove the water that collected on the floor of the open chapel above; even so, in December 1645 Oliva had to undertake a major repair of the vault "because it was falling down" (*por estar se cayendo*).[119] Also repaired were the protective tile roofs over the south vestibule and the main audience hall described by Oliva as the *quarto imperial en la quadra donde está la chimenea*.[120] Its brick floor (which was to have been covered with wood eventually) required about a week's work in January 1646. Also in need of attention was the tile roof over the annular vault of the lower corridor of the courtyard. Repairs were carried out in 1643 and 1644, and again in 1647, when rain pipes were inserted by Oliva, and new metal tie rods were added to stabilize the Ionic colonnade of the gallery in August 1648.[121] Through his tenure, Oliva made repairs on the fortifications of the Alhambra and its hydraulic systems, but even that essential work ta-

pered off during the 1650s. Like Lechuga before him, Oliva, who died in 1659, constructed nothing new. They devoted the scant available funds to the preservation of the old palaces, so the two decades of their combined tenure mark the end of the construction of the "new" palace.

Severe economic difficulties, combined with mediocre masons and royal disinterest, further diminished the prospects of completing the palace. The decade of the 1630s was one of inflation and financial trouble throughout Europe, but for Spain it was the beginning of a depression that lasted well into the 1650s. Spain's economy had been on a downward trend since the mid-sixteenth century, with only a slight upward turn in the first quarter of the seventeenth before the disastrous midcentury plunge. Kubler noted that a contemporary architect, Fray Lorenzo de San Nicolás, lamented the effect of the depressed conditions of the 1630s on architecture in Spain: there was no money for building new structures and not even enough to maintain those already built.[122] The palace of Charles V was one of the victims of this unhappy period.

For all practical purposes, the construction of the palace of Charles V ended in 1637, one hundred and ten years after Pedro Machuca and Luis Hurtado de Mendoza presented the first project to the emperor. The state of the palace in 1637 was very nearly the same as that of the palace in 1920 (pl. 1), except that in 1637 the transverse walls of the main story were still in place. Comparison of the air view of 1920 with the state of the palace in 1572 (fig. 11) reveals how little had been accomplished in the interim of sixty-six years. Most of the post-Machuca construction was realized by Juan de Minjares in the 1590s. Potes, after much opposition, closed the vault over the south vestibule and that over the main audience hall on the west facade. Velasco then raised the Ionic colonnade of the gallery and some transverse walls. In 1637 the structure was finally ready for the construction of a

[117] AA, Leg. 152, 1, report of 29 April 1644.

[118] The appointment of Oliva on 13 June 1645 was made retroactive to January when Oliva first replaced Lechuga; see AGPM, SCR, vol. XIV, fols. 100-101.

[119] AA, Leg. 41, 2, report of 16 December 1645.

[120] Ibid., 6 and 13 February 1644.

[121] These repairs are recorded in AA, Leg. 41, 2, in the scanty weekly account books of the 1640s.

[122] Laurenzo de San Nicolás, *Arte y uso de arquitectura*, Madrid, 1663, 1, chap. lxxix, pp. 258-259. Jaime Carrera Pujal, *Historia de la economía española*, Barcelona, 1943-1947, 1, pp. 548-623, identified the mid-seventeenth century as the nadir of Spain's economy, and though conditions improved slightly in the two decades between 1660 and 1680, no further income was allotted for the continuation of the palace of Charles V.

common roof, but the palace remained uncovered for three hundred years.

ABANDONMENT AND DETERIORATION, 1648–1923

The successors of Diego de Oliva were undistinguished architects who had so little to do that they were willing to accept the salary of 250 ducats, set in the 1630s, until the end of the century, when it was reduced to 100 ducats—the salary first paid in 1527 to Pedro Machuca.[123] After 1788, the architect of the Alhambra was paid only when asked to perform a specific task.[124] Weekly account ledgers were maintained until 1663, but repairs listed for the new palace were rare indeed. Thus, it is no exaggeration to say that the uncovered palace of Charles V was abandoned to the weather from the mid-seventeenth to the beginning of the twentieth century.

The new palace survived as well as it did only because it was a locked enclosure for the storage of material and equipment, while the old Islamic palaces remained accessible and subject to misuse. The round courtyard had long served for the storage of stone and marble, as well as tools and equipment for the works, and stonecutters and carvers did the final work on individual pieces there. The storage function seems to have continued even when the remaining material was nothing more than unused or rejected pieces of stone. We know that two hundred iron grilles were removed from the circular courtyard in 1795, but the ambiguity of the reference makes it impossible to tell if they were intended for use in the new palace or elsewhere on the Alhambra, and there is no way of knowing how long they might have been stored there.[125] Timber for the repair of the Torres Bermejas was also kept in the courtyard in 1785, when it was referred to as the "warehouse of the courtyard" (*almazén del patio*); so it is likely that materials for the maintenance of the entire Alhambra were stored

in this secure enclosure. Meanwhile, in 1664, the Islamic palace was declared an extra-juridical asylum for debtors, and later it housed invalid soldiers, prisoners, and convicts. Even in the early nineteenth century, Richard Ford could still refer to it as a "den of thieves."[126] Frequented for several centuries by people of this sort, it is little wonder that the Islamic palaces suffered, while the Renaissance palace was preserved because it remained off-limits. When, in 1718, the dispossessed Mendoza governor destroyed the house south of the Partal, where his family had resided since the conquest, the new governor appointed by the Bourbon king moved into the rooms adjacent to the Sala del Mexuar and over the Cuarto Dorado and the Sala de la Barca (pl. 17-D).[127] That residence must have had restricted entrance to at least the official portion of the old palace. In April 1729 Philip V made known his intention to visit Granada and that announcement initiated a year of general repairs on the Alhambra, previous to his arrival in the spring of 1730. Among the recorded work was the whitewashing and glazing of the suite of rooms built for Charles V alongside the Garden of Daraxa and the refurbishing of the Royal Chapel in the Mexuar, but the only parts of the new palace that were affected were the north staircase and the group of rooms in the basement of the north wing that open on to the Court of Myrtles.[128]

During the second half of the eighteenth century officials of the Academy of San Fernando in Madrid beecame interested in the palaces on the Alhambra and there was a growing awareness of their exceptional character and artistic merit, but little was done to protect them from vandalism or deterioration. New interest was awakened in December 1750 when the governor of the Alhambra, Francisco José de las Infantadas, wrote a letter to the Academy advising them that, if repairs were not made promptly, the Tower of Comares and the porticoes of the Court of Myrtles would fall into ruin (*si prontamente no se atendía a su reparo*

[123] The reduction occurred on 16 December 1700, when Antonio Velásquez Vázquez replaced F. González Zurita as both *maestro mayor* and *aparejador* of the Alhambra; see AA, Leg. 104, 5, 43.
[124] A royal order of 10 April 1788 stated that Maestro Tomás López would be paid eight reales a day when called upon to work; see AA, Leg. 104, 5, 70.
[125] The removal took place on 12 March 1785; see AA, Leg. 28.

[126] Ford, *Granada*, p. 192.
[127] José Díaz Martín de Cabrera, *Curiosidades históricas. Los Hidalgos de la Alhambra*, Granada, n.d., p. 77.
[128] For Philip IV's visit, see María Cruz Ramos Torres, "Álbum de la Alhambra. Preparativos en la Alhambra ante le venida de Felipe V," *Cuadernos de la Alhambra*, VIII (1972), pp. 91-98. See also AA, Leg. 206, 3, for the report on the repairs made for his visit.

amenazaba ruyna).[129] Of course, some self-interest was involved because the governor was housed in quarters adjacent to the tower and courtyard mentioned in his letter. Evidently the Academy decided that it could do no more than make graphic records of the two palaces and their decoration before they were lost.[130] The first indication of this response was a discussion in 1752 about commissioning an artist to make drawings of the deteriorating portraits of the Moorish kings on the oblong wooden dome over the central alcove of a hall in the east end of the Court of Lions, known as the Sala de los Reyes. Not until four years later, on 15 November 1756, was a member of the Academy, named Ximénez, commissioned to make copies of these portraits, and also groundplans, sections, and elevations of the palaces on the Alhambra; but, he seems not even to have gone to Granada. Another four years passed before the Academy, in September 1760, asked the new governor of the Alhambra, Luis Bucareli, to find a Granadine painter capable of the task. On 15 September, he recommended Diego Sánchez Sarabia, whom he described as a *profesor de pintura y arquitectura, muy instruído en la antigüedad,* and the Academy approved the commission. Sánchez began with an oil copy on canvas of the portraits of the Moorish kings in the Sala de los Reyes, and that copy was sent to Madrid on 1 December. He spent the next six months copying inscriptions in the Islamic palace, and in June 1761, he was instructed to make a plan of the whole palatine complex, then separate plans, elevations, and sections of the old and new palaces, and, finally, additional drawings of the capitals, friezes, arches, and ornament in the Islamic palaces. When the drawings of the last were nearing completion, Sánchez Sarabia informed the Academy that he thought he would be ready to begin those of the Renaissance palace in April 1762,

and he added that he had heard that some "original plans and projects of the palace of Charles V" were preserved in the archive.[131] By the time the Academy requested those plans on 28 August 1766, the governor was unable to find them, though he said all bundles in the archives were searched.[132] The Academy's interest may have been motivated in part by dissatisfaction with Sánchez Sarabia's drawings. Already on 12 September 1762, when the drawings of the Islamic palaces were first submitted, there was some reluctance to accept them, but they were finally approved by the Academy of San Fernando and the artist was asked to do the drawings of the palace of Charles V. These were finished by 4 November 1763, when they were shown to the king, but they were not well received at court.

José de Hermosilla, another member of the Academy, was named on 15 January 1764 to make new drawings, though the commission was not given until 26 August 1766. Hermosilla took with him to Granada two assistants, Juan Pedro Arnal and Juan de Villanueva (later to become an important architect), and they worked there from September until April, making drawings of both palaces and correcting those of Sánchez Sarabia.[133] On 20 April 1767, Hermosilla submitted a statement of expenses, and by 8 November, the payment was approved with an expression of gratitude on the part of the Academy. On the basis of the first of Hermosilla's drawings, the Academy decided on 26 August to make engravings and to publish them (pls. 35, 60, and 78). That was done in 1786 and again in 1804 under the title *Antigüedades árabes de España.* Meanwhile, several English draftsmen in 1775 made somewhat less accurate drawings from which engravings were cut and published in 1779 in Henry Swinburne's *Travels through Spain.* This publication and the Academy

[129] AA, Leg. 104, 5, 55.

[130] The story of the Academy's effort from 1752 to 1770 to record what remained of the palaces of the Alhambra is related in the minutes of the Juntas Particulares, Libro 1, 1756-1770, in the library of the Academia de San Fernando in Madrid. The dates of events discussed in the text will serve to locate the pertinent portion of the minutes of the meetings. The whole matter was reviewed by the Academy in 1786 at the instigation of Gaspar Melchor de Jovellanos; see his "Informe que dio, siendo individuo de la Academia de San Fernando, sobre arreglas de la publicación de los monumentos de Granada y Córdoba, grabados por orden superior [1786]," *Obras de Gaspar Melchor de Jovellanos* (Biblioteca de autores españoles 46), Ma-

drid, 1858, pp. 364-368.

[131] The notice of the original plans and projects for the palace of Charles V was reported to the Academy on 12 September 1762, and at the same meeting they examined Sánchez Sarabia's drawings of the Islamic palace; see Academia de San Fernando, Leg. 37, Armario 1°, no. 3.

[132] His report, dated 28 August 1766, is found in the Academia de San Fernando, Madrid, Leg. 37, Armario 1°, no. 2, Representaziones de la Academia y resoluziones del Rey. Events of the 1760s mentioned in the accompanying text can be found by date in the "representaciones."

[133] Fernando Chueca Goitía, *Juan de Villanueva,* Madrid, 1949, p. 104, n. 3.

drawings, together with the *Paseos de Granada* of Velázquez de Echevarría in 1764, are indicative of the growing interest in the palaces on the Alhambra. Although these publications did not lead to the repair or even the protection of the palaces, Spaniards and other Europeans were at least made aware of what they were about to lose through neglect.

While concern was centered primarily on the Islamic palaces, some defenders of the Alhambra also recognized the importance of the Renaissance building. José de Hermosilla, in a letter written shortly after his arrival in Granada in September 1766, claimed that the architecture of the palace of Charles V "is not as good as the ancient [works] of the Greeks and Romans [but] it is the equal of any other of the time of the restoration [of antiquity] and, thus, it can stand alongside the ["best" is crossed out] modern buildings in Rome, and it even surpasses them in simplicity and exactitude."[134] Hermosilla relates that some of his contemporaries thought it had been designed by Alonso Berruguete and that, after his departure from Granada, construction was continued by "a certain N. Machuca, a celebrated painter and architect [and] (according to Antonio Palomino) a disciple of Raphael of Urbino or a follower of his school."[135] Swinburne also had high praise for the Renaissance palace: "In this work is discovered a most transcendent genius, grandeur of style, elegance, and chastity of design," though he, too, thought the designer was "Alphonese Berruguete."[136] His praise and the engravings published in London made not only the Islamic but also the Renaissance palace known to a wider European and American public; and the new interest aided concerned Spaniards in their efforts to gain royal support for the repair and preservation of the two palaces on the Alhambra.

King Charles IV was willing to complete the Renaissance palace but he wanted it to serve a useful function. The only known suggestion came from the architect of the Alhambra, Tomás López, who in 1792 made preliminary drawings showing how the building could be completed to serve as a military school. The king liked the idea and, in May 1793, ordered engineer Domingo Velestá and architect José Martín Aldegüelas to collaborate on working plans and to make cost estimates; these were completed the following November (pls. 97, 101, and 102).[137] The only alteration they suggested in the facades was the addition of gables or *remates* over the south and west *portadas* for the display of arms and emblems that were to be held by allegorical figures. In the courtyard, however, major additions were planned to provide a circular dormitory for eighty beds immediately above the gallery and still another within a steeply pitched roof. The mezzanine floor was to provide the remainder of the dormitory space to bring the number of beds to two hundred. Clearly Velestá and Martín Aldegüelas derived the pitched roof from the project of the 1620s, which was itself a variation on that of Juan de Herrera in 1580. These additions to the courtyard would have altered the dominant horizontality of the double colonnade and further compromised its Renaissance character. Many other changes were planned for the interior of the palace, but the king was soon distracted by the French Revolution and its aftermath, so the project for the military school was put aside. Two generations later, in 1840, Queen María Cristina de Borbón seems to have revived the 1793 project as the basis for a school for "noble Americans" (*Colegio de Nobles Americanos*) because it, too, was to house 200 students.[138] Fortunately, neither project was realized.

The engravings made from the drawings of 1767 and the projects of 1793, and their accompanying reports, suggest that the palace of Charles V was

[134] Academia de San Fernando, Madrid, Leg. 37, Armario 1°, no. 3, a letter written in September 1766: ". . . aunque su arquitectura no es tan buena como la antigua de Griegos y Romanos, es de tanto mérito como qualquiera del tiempo de su restauración, y assí puede mu bien estar al lado de los edificios modernos de Roma y aun los excede en simplicidad y exactitud."

[135] Ibid.: "Acerca del autor de las obras o edificios referidos, algunos dicen que el insigne Berruguete dió el proyecto para el palacio del emperador y lo empezó a construir, que por su ausencia continúe un N. Machuca, célebre pintor y arquitecto (como dice Don Antonio Palomino) discípulo de Rafael de Urbino ó que sequía su escuela: que por muerte ó ausencia de este prosiguió y dejó en el estado actual este palacio Diego de Siloe: quien tambien dio el proyecto para la yglesia catedral."

[136] Swinburne, *Travels through Spain*, p. 176. For authors identifying Berruguete as the designer of the palace (beginning with Juan de Butrón in 1626), see above, chap. 1, n. 51.

[137] Vasco y Vasco, *Memoria sobre la Alhambra. Año 1875*, p. 16. The projects are preserved in the library of the Academia de San Fernando with the signature 67 BA/18.

[138] Gómez-Moreno y González, "El palacio de Carlos V," p. 209.

still in fairly good condition in the late eighteenth century, shortly before it was occupied by French troops. Of course, Hermosilla's drawings of 1767 and the engravings following them seem not to have been intended as accurate records of the state of the two palaces at the time, but, rather, as an indication of the way they would appear after some refurbishing. The list of repairs and changes needed to make the Renaissance palace usable as a military school in 1793 included the replacement of some of the badly corroded sandstone facing on the lower parts of the south and west facades and on the wall of the corridor of the courtyard, and the replacement of some of the base moldings of the Doric columns (presumably along the north side of the courtyard, which is exposed to the sun). Some minor repairs to the annular vault of the corridor were recorded in 1784–1786, but three years later the protective wooden roof over the gallery was judged to be in near collapse and so had to be removed.[139] The walls and vaults of the south and west vestibules were said to be in good condition, but no stairs were delineated in the groundplan (except the north staircase, of course), so it is likely that there were only dirt ramps like the one indicated in the south vestibule in the 1767 and 1793 sections of the palace (pls. 78 and 101).

French troops did not enter Granada until January 1810, though they had been in Andalusia since 1808.[140] Quite naturally they occupied the fortified heights of the Alhambra, where they quartered 1,500 soldiers, mainly in the monastery of San Francisco, and they stored ammunition in the warehouse of the Alhambra—the round courtyard of the palace of Charles V. Guards occupied the vestibules of the palace and, inevitably, during winter they built fires to keep warm. That was minor damage in contrast to their use of all available wood, from door frames to protective roofs, to sustain their fires. Most of those wood fittings were not of great historical interest but their removal left some parts of the building exposed to the weather. The blackened vaults of the vestibules were cleaned in 1929.[141] Damage to the Islamic

palaces was evidently more severe because the curious decoration invited the removal of souvenir fragments. Worst of all, shortly before they left in mid-August 1812, the French unnecessarily destroyed eight of the fortified towers as well as the water works of the Alhambra,[142] but the Renaissance palace itself suffered relatively little damage. Of course, when Spanish residents of the Alhambra returned, they discovered the lethal arsenal of gunpowder, shells, and granades left by the French in the round courtyard of the palace of Charles V. Some observed that these explosives were not stored with the precaution required by Spanish regulations for such depots and also that the palace was not guarded at night, but no concerted effort to remedy the situation was made until April 1822, when the residents petitioned the governor, Antonio del Prado.[143] The following month he informed the Royal Patrimony of the danger,[144] and presumably the explosives were removed soon after.

Interest in the Alhambra, particularly the old palaces, grew with the rise of romanticism in western Europe. Valued as a unique legacy of Islam on European soil, this exotic residence came to occupy a special place in the hearts of romantics, and they urged the Spanish government to preserve it from further damage. Foreign tourists—mostly English, French, and German—praised the extraordinary charms of the Islamic palaces, but they rarely said anything about the intrusive Renaissance structure. Following Henry Swinburne's illustrated account of his travels in Spain in 1779, the most influential non-Spanish publication was Alexander de Laborde's *Voyage pittoresque et historique de l'Espagne* of 1806–1820. These publications and that of the Academy of San Fernando in 1804 made the several courtyards and major halls of the Islamic palace familiar to well-educated Europeans, but it was an American author, Washington Irving, who made the old ruins come alive in the imagination of the Western world. Visiting the Alhambra in 1828–1829, he came to love not only the Granada of the Moorish past, but also the city of his own day because it had the kind of

[139] A payment was made on 4 April 1786 for the repair of the vault (AA, Leg. 206, 3), and the removal of the gallery roof in 1789 was reported by Gómez-Moreno y González ("El Palacio de Carlos V," p. 209).

[140] Charles Oman, *A History of the Peninsular War*, Oxford, 1902–1930, III, p. 150; IV, p. 478; and V, p. 544. A total of three

or four thousand French soldiers were stationed in Granada by 1811 and their number rose to 45,000 by late 1812.

[141] I owe this information to Jesús Bermúdez Pareja.

[142] Oman, *A History of the Peninsular War*, V, p. 545.

[143] AA, Leg. 67, 2, petition of 8 May 1622.

[144] Ibid., letter of 20 May 1822.

ambience that excited the romantic imagination. Even before the publication of his *Tales of the Alhambra*, he is credited by some with inducing King Ferdinand VII in 1830 to allot 50,000 reales for the most urgent repairs of the Islamic palaces.[145]

Another visitor who came to Granada a few years later, 1830–1833, was an Englishman, Richard Ford, but his interests were of a more historical and factual nature.[146] Less emotional, but partisan still, he contrasted the fabulous wealth of the Moorish Alhambra with its impoverished state under Spanish Catholics. As he viewed the history of the citadel, the moors adorned it and the Spaniards disfigured it—and the palace of Charles V was part of the disfigurement. He found inexplicable the perverse pride some Spaniards displayed in the Renaissance palace. For him, it was great in conception and impotent in conclusion and, thus, emblematic of the reign of Charles V and of Spain itself.[147] Of course, he made some assumptions that we now know to be false. He believed that the Islamic palace had had a magnificent facade and that "large portions" of the old residence had been destroyed to make way for the massive Renaissance building. As proof of Spanish insensitivity to the marvelous Islamic palace, he noted that the rooms alongside the Mexuar assigned to him (until recently the residence of the governor of the Alhambra) had been stripped of every vestige of Moorish ornament. He also related that while he was there in the 1830s, the roofless Renaissance palace was offered to the duke of Wellington in the hope that English gold would complete it, and he took evident satisfaction in reporting that nothing came of that proposal.[148] Incidentally, another foreigner, the duke of Montpensier considered buying the palace of Charles V around midcentury but he finally decided to establish his residence in Seville.[149] Little is learned about the state of the Renaissance palace from Ford's comments because his several references to it are incidental to laments on the fate of the Islamic palaces.

In response to continued pressure from Spaniards and foreigners at court, Queen Regent María Cristina de Borbón ordered the covering of the palace in 1840, and three years later a project for the roof was submitted by Mariano Contreras, but nothing more is known of that proposal.[150] During the following quarter-century, the Alhambra continued to pertain to the Patrimony of the Crown, but the only known repairs on the two palaces were of a cosmetic nature, in preparation for the brief visit of Queen Isabel II in October 1862, and it seems the deterioration continued after the revolution of 1868, though the Alhambra was declared a national monument in 1870.[151] In June of that year, the painter Mariano Fortuny y Marsal came to the Alhambra to do sketches, including several of the south facade and especially its Serliana window, but he transformed the window into a ground-level loggia that served as the background for a chivalresque scene, and for that reason, his drawings have little to tell us of the state of the palace in 1870.[152] Shortly after, in 1873, the Academy of San Fernando acquired the projects made in 1793 in order to complete the palace to serve as a school,[153] and in August 1875 the new government named José María Vasco y Vasco delegate to the Alhambra as a first step in the formation of a new administration for the citadel;[154] but evidently, no funds were made available for the conservation of the Alhambra. In June 1889, a decision was made to install an archeological and a provincial museum in the palaces on the Alhambra; however, the competition for projects for the former was not announced until 12 May 1902, and then nothing seems to have come of it.[155] In 1910 and again in 1919, serious consideration was given to completing the Renaissance palace, at least sufficiently to house a major Hispano-Arabic exhi-

[145] Francisco de Paula Valladar y Serrano, *La Alhambra: su historia, su conservación y su estado en la actualidad*, Granada, 1907, p. 11.

[146] A short biography of Ford serves as an introduction to the 1955 publication of his account of the visit to the Alhambra; see Ford, *Granada*, pp. 3-9.

[147] Ibid., p. 200. See also above, chap. 2, n. 35.

[148] Ford, *Granada*, p. 201.

[149] Byne and Stapley, *Spanish Architecture*, p. 298.

[150] Valladar, *Guía*, p. 385.

[151] Francisco Prieto Moreno, "La Conservación de la Alhambra," *Revista nacional de arquitectura*, I, no. 3 (1941), p. 49.

[152] Antonio Moreno Garredo, "El Palacio de Carlos V a través de varios dibujos de Mariano Fortuny," *Cuadernos de la Alhambra*, VIII (1972), pp. 59-63.

[153] Valladar, *La Alhambra*, p. 4.

[154] The previously cited inaugural lecture delivered by José M. Vasco y Vasco in 1875 was printed in 1890 under the title "Memoria sobre la Alhambra."

[155] Luis Seco de Lucena, *La Alhambra. Novísimo estudio de historia y arte*, Granada, 1920, pp. 251-255.

bition. Perhaps as a result of that consideration, the inspector of the Alhambra, Ricardo Velázquez Bosco, in 1920 prepared a detailed report on the state of the buildings on the Alhambra and a list of the essential repairs and structural reinforcements, including a project for the covering of the Renaissance palace.[156] That 1920 compilation served as the point of departure for the program of conservation initiated in 1923.

CONSERVATION AND RESTORATION

The appointment of Leopoldo Torres Balbás as architect-director of the Alhambra in 1923 marks the beginning of a sustained program of conservation of the fortress and its palaces. As a student of Islamic art and architecture, his primary concern was quite properly the preservation of the Moorish palaces and fortifications, but he occasionally made small repairs in the Renaissance palace. Fortunately, he kept a diary of his conservation activities from 1923 to 1936 and it was published in the *Cuadernos de la Alhambra* during the late 1960s.[157] While one can see something of a program in the sequence of work on the Islamic palaces, the projects undertaken in the Renaissance palace are surprisingly unrelated and cosmetic in nature, even though the very structure of the palace was threatened with collapse. The aerial view of the Alhambra taken by Torres Molina in 1920 reveals the lamentable state of the palace of Charles V (pl. 1). The seventeenth-century vault of the audience hall and most of the transverse walls of the upper story had fallen and much of their debris had disappeared. It was said by Elías Tormo that some Spaniards were willing to raze the Renaissance ruin to clear the approaches to the Islamic palace,[158] but fortunately the palace of Charles V was spared. Still, no serious effort was made to protect and consolidate the Renaissance structure.

In April 1923, Torres Balbás removed the scaffolding sustaining the north hall that housed the staircase leading down to the Court of Myrtles, presumably to prepare for the repair of its vault and the construction of the floor leading to the small Museo Arqueológico that was installed in 1927 in the northwest wing of the palace.[159] In January 1924, the fifteen remaining bronze tie rings were repaired by Guevara in Madrid and, upon their return in June of that year, they were attached to the south facade. Projects for the pavement of the west vestibule and the wooden leaves for the side doors were sent to Madrid in July 1924, but that work was not completed until the spring of 1926. A brick closure that filled in the south entry to the palace of Charles V was torn down in October 1925; and in the winter of 1927–1928, a fireplace, composed of pieces from the Sala de Ninfas and the altar retable in the Mexuar, was installed by Torres Balbás in the uncovered hall above the south vestibule.

The first structural renovations on the Renaissance palace are recorded in January 1929 when the vaults beneath and above the north staircase were repaired. Rubbish was removed in June 1929 from the lower hall of the palace alongside the chapel (*habitación baja del palacio de Carlos V junto a la capilla*) and earth was removed from two halls in the west wing north of its vestibule (*dos habitaciones del piso bajo en la fachada principal al norte del vestíbulo*). In November and December 1929, Torres Balbás mentioned the painting of "new ceilings" and the plastering of the walls of four halls on the upper story and one on the lower level of the palace of Charles V (presumably the north wing), though no earlier reference to the construction of those ceilings was found. In January 1930, he noted that he raised the south wall of the main hall above the west vestibule and that he left an opening for the flue of the fireplace and cut put-log holes for the beams that would cover that hall. In the same year, he closed the door that had been opened in 1639

[156] The projects signed by Ricardo Velázquez Bosco are preserved in the library of the Alhambra, with signature 615-1.

[157] The small notebook of about three hundred pages was given by the son of Torres Balbás to the Patrimony of the Alhambra and its contents were published in five parts under the title "Diario de obras en la Alhambra" in the *Cuadernos de la Alhambra*, volumes I (1965) to V (1969). To avoid additional footnotes, the month and year of repairs will be given in the text so that references can be found by date: *Cuadernos* I, for 1923; II, 1924; III, 1925–1926; IV, 1927–1929; and V, 1930–1936.

[158] Elías Tormo, "Carta sobre el patrimonio artístico nacional, al Exmo, Cardenal Arzobispo de Granada, 30 October 1929," published in *La Época* of Madrid on 4 November 1929: ". . . Yo sé que en Granada han cegado muchos a las bellezas del Renacimiento el hábito de no querer ver otras que las de la Alhambra y lo árabe granadino, millares y millares de personas que serían capaces de derribar el palacio de Carlos V . . . que es otro portento, por tenerle como pegote."

[159] Leopoldo Torres Balbás, "El Museo Arqueológico de la Alhambra," *Al-Andalús*, IX (1944), pp. 236-241.

on the west facade from the hall described as the *bóveda larga* in the basement of the north wing (pls. 60 and 100). Throughout his account of 1930, he referred to the laying of marble pavements in the halls of the main floor and, in the first months of 1931, the polishing of them. From the summer of 1930 to the winter of 1931, drain pipes were installed to discharge rainwater clear of the palace walls, and unnamed parts of the structure were reinforced with concrete. In 1934, balconies were installed in the windows of the main hall and its floors were surfaced with serpentine stone, and during the summer of 1935, floors were laid in other halls. No further references to repairs or construction in the Renaissance palace were made previous to the Civil War of 1936–1939.

The city of Granada was not occupied during the Civil War and so the Alhambra suffered no damage. Once the war was over, the Patronato de la Alhambra lost no time in outlining plans for the conservation and repair of the buildings in its charge. As architect and conservator the Patronato appointed the energetic and resourceful Francisco Prieto Moreno. They entrusted the directorship of the Museo de la Alhambra to Jesús Bermúdez Pareja, who has an intimate knowledge of the site and a deep affection for the Alhambra because he has lived there since childhood. By 1941, the plans included the completion of the Renaissance palace as a museum.[160] First proposed in the royal decree of 1889, that function was reaffirmed by the Dirección General de Bellas Artes in 1941, when they called for the installation of two museums in the palace of Charles V. According to the new plan, the Museo del Arte Árabe was to have occupied the southwest corner on the ground floor, and the Museo de Bellas Artes, the main floor above it. That proposal naturally included a project for the covering of the entire palace with a low truss roof of the sort used during the early sixteenth century for major palaces in Spain, but work was not initiated until the early 1950s, when the income of the Alhambra was increased by the swelling numbers of tourists visiting the citadel. By then, the area allotted to the Museo de Bellas Artes had been expanded to include the north, east, and south wings on the main floor, and the southeast corner of the

ground floor was reserved for its offices. As the roof over each wing was completed from 1951 to 1956, the halls of the top story were finished: elliptical vaults were constructed, the windows were glazed, the walls were plastered, and the floors were faced and the doors framed with dark marble. Fortunately, no attempt was made to second-guess the kinds of interiors Pedro Machuca had intended on the main floor in the 1530s; but one cannot help but wish that the extraordinary staircase in the southeast corner, composed wholly of winders in the small Royal Palace plan, had been realized. Most of this work in the palace of Charles V was completed by 1958, when the Museo de Bellas Artes and the expanded Museo Arqueológico were opened to the public.[161] In the west wing, the audience hall on the main floor was covered with an elliptical vault and furnished for official receptions, and the archive of documents, together with a small library and study room, were given space on the attic level in the southwest corner. Naturally, the halls adjacent to the west entry had to be used for the sales of tickets, books, and postcards. While no attempt was made on the interior to simulate sixteenth-century halls, great care was taken on the facades and in the round courtyard to preserve the Renaissance character of the building.

During the 1960s, the Patronato decided to cover the gallery of the courtyard, replace the deteriorated facing, and provide the missing accessories. Unfortunately, the only work records of this decade on the Alhambra that have been published are those of 1967–1970, but many of those pertain to the palace of Charles V.[162] Wooden balconies, modeled on those of wrought iron on the sixteenth-century Chancillería in Granada, were designed for the main-floor windows in July 1966 and executed shortly after. In June 1967, reproductions were made of the fifteen bronze tie rings that had survived and been refurbished in 1924 under Torres Balbás, though the modern reproductions are hollow, whereas the original tie rings were solid cast. Eagles were placed on the paired pilasters at the ends of the facade, while lions were affixed to the single pilasters (as I suspect Pedro Machuca intended). With the addition of the missing tie rings, we can better appreciate the effect of

[160] Orozco Díaz, *Guía*, pp. 14-15.

[161] Gallego y Burín, *Granada*, p. 204.

[162] The conservation efforts of the three post-war years were reported by Francisco Prieto Moreno, "Obras recientes en la

Alhambra y Generalife," *Cuadernos de la Alhammbra*, IV (1968) through VII (1971), with work of the previous year published in each.

this important accessory on the three major facades. In 1967 and 1968, corroded stone facing on the facades was replaced, beginning with the west and continuing around to the east. I understand that much of the new facing came from the old Casa de Correos, which was razed to make possible the new Plaza de Isabel la Católica. Of course, this well-weathered stone was closer to the golden color of the old facing of the palace then newly quarried stone. In chiseling the front faces of these new blocks, the stone workers tended to follow the more regular patterns used during the time of Luis Machuca rather than the more granular texture first employed under Pedro. In November 1967, the coffered wooden ceiling of the gallery of the round courtyard was begun (pl. 76). As we noted earlier, it is likely that the Machucas intended a wooden ceiling, but I suspect they would have articulated the bay system of the wall in the ceiling, perhaps by means of broader or distinctive beams between the Ionic columns and the pilasters along the wall.

The one part of the palace still uncovered in 1970 was the octagonal chapel. After Minjares raised its walls six courses above the original terminal moldings placed by Luis Machuca in 1554, a domical vault could no longer be accommodated under a low truss roof. For that reason, the Patronato decided to place steel girders across the top of the chapel, putting aside any pretension of approximating the original vaulting. Several renovations were also made in the round courtyard. The archway in the intracardinal bay of the southwest corner was reinstated using sandstone from Úbeda that was painted to look like the gilded stone of Santa Pudia. The bases of the columns, especially those along the northern half of the colonnade, were repaired or replaced. Finally, from January to March 1970, the offices of the director of the Museo de Bellas Artes were installed on the ground floor in the southeast corner of the palace.

This brief account of the conservation of the palace of Charles V is sufficient to indicate that it is now in excellent condition, with the prospect of surviving for many more centuries; but the main interest of the present study is retrospective. We are concerned with the identification of recent work on the palace that must be excluded from the parts attributable to the first architect, Pedro Machuca.

From our review of a little over a half-century of the programmatic conservation of the buildings on the Alhambra, it is clear that most of the lower half of the rusticated facing on the main facades has been replaced. Also, all the ceilings and vaults of the palace are modern, with the exception of the annular vault of the corridor of the round courtyard (by Luis Machuca), the west and north vestibules (by Juan de Minjares), and the south vestibule (by Francisco Potes). Of special importance is the realization that none of the late sixteenth- or early seventeenth-century vaults reflect the intentions of Pedro Machuca. It is also evident that virtually all the transverse walls on the main floor of the palace and, of course, all the frames of the interior doors, the revetments of the walls of the rooms, and the floor pavements are modern, and all the wooden window frames and their glazing, as well as the wooden window railings, are of this century. Replacements for the corridor wall membering in the round courtyard, and for the bases of the columns of the colonnade, have been faithful to the originals. These modern completions or replacements and alterations, along with the parts of the palace demonstrably executed by Luis Machuca, Juan de Minjares, or Francisco Potes, effectively isolate the parts that are attributable to Pedro Machuca. The autograph parts of the palace, together with those by Luis that we have judged to be faithful to his father's intentions, will serve as the basis for our study of Pedro Machuca's architectural style and for the identification of the artistic ambience in which he was formed and on which he drew for the design of the palace of Charles V.

V

PRECEDENTS AND ANALOGIES

To UNDERSTAND the genesis of the extraordinary palace of Charles V, we must identify the artistic *milieu* in which Pedro Machuca acquired his architectural repertory and design principles. That ambience has been variously characterized as Raphaelesque, Bramantesque, Peruzzian, provincial Giulio Romano, Tuscan-Roman, or Mannerist, with the last gaining favor in recent years, but specific comparisons are seldom cited in support of any of these characterizations. More often than not, scholars have taken what can be called the "buck-shot" approach and have named virtually every Renaissance or Roman building even vaguely analogous to the palace.[1] Inevitably, some of these "precedents" must be on target, but this indiscriminate approach conveys a false idea of eclecticism and infers a lack of artistic integrity and individuality.

The present study is based on the premise that the Italian Renaissance style was not diffused in the configuration of a particular school nor in the guise of a personal synthesis but, rather, in its component elements—its architectural types, orders, ornamental motives, and principles of design. Unfortunately, few studies have been made of these components of the Renaissance style in Italy or Spain, so in some cases it will be necessary to undertake brief studies of pertinent architectural forms to provide the necessary context. We cannot assume that Pedro Machuca was aware of the latest stage of the development of every Renaissance form he encountered in the 1520s, because as an alien convert to the new architectural style, Machuca encountered all at once the whole gamut of variations conceived by three inventive generations of Italian architects. His idea of the new style depended on the particular centers and works he knew and the formal preferences he developed by way of earlier architectural experiences in his homeland. So our point of departure for the characterization of Machuca's architectural style is not an abstract definition of the essence of the Renaissance

[1] Manual Gómez-Moreno y González in 1885 and most scholars since then have mentioned Bramante or the courtyard he planned for his Tempietto, and Carl Justi in 1891 and Otto Schubert in 1908 added the unporticoed round courtyard of Raphael's Villa Madama outside Rome. Torres Balbás in 1936 cited ancient Roman forums, the fourteenth-century circular castles at Bellver and Pau, Peruzzi's plan for an unidentified convent (Uffizi A350), and the fortified villa of the Farnese at Caprarola. Gómez-Moreno y Martínez in 1941 observed that the round courtyard of the Villa Madama is "exactly the same size" as that of the palace of Charles V. G. Valli in 1944 used a photomontage to set Bramante's Tempietto in the middle of the courtyard of the palace of Charles V. Chueca Goitía in 1953 mentioned the small unfinished house of Andrea Mantegna in Mantua, which combines the circle and the square. Pevsner in 1960 cited Raphael's Villa Madama and Giulio Romano's Palazzo del Te, but he added, "somewhat provincially interpreted." Andreina Griseri in 1957 encountered unspecified reminiscences of Vitruvius, Francesco di Giorgio, Cesariano, Cola dall'Amatrice, Giuliano da Sangallo, Peruzzi, Bramante, and Raphael, "con precisi ricordi di Villa Madama." Kubler in 1959 cited Torres Balbás' list of precedents for the round courtyard and Bramante's Caprini palace for the stylar facade. Anthony Blunt in 1963 also stressed eclecticism with a barrage of reminiscences, and his interpretation was accepted by Mario Rosci in 1967, but the latter scholar noted the evident relationship of Machuca's plan to a much later one in Serlio's sixth book (Munich, fol. 27) and found it difficult to explain. Damian Bayon in 1967 repeated the full list of Italian architects and monuments and stressed the essentially Italian and classical character of Machuca's palace. John Shearman, in the same year in a study on the Villa Madama, noted that an early project with a porticoed round courtyard (Uffizi A1054) appeared to be "causally connected" with the palace of Charles V. Wolfgang Lotz in 1974 and Roberto Pane in 1980 placed the palace first among reflections of the new "Bramante synthesis" outside Italy.

style or the synthesis characteristic of any Italian school or individual architect, but, rather, the specific repertory of architectural forms he used in the palace and the design principles and personal sensibilities that guided him. It will be convenient to consider the groundplan first, then the elevation of the sandstone facades and the *portadas*, and, finally, the round courtyard.

THE GROUNDPLANS

The project chosen by the emperor in 1527 is lost and the first extant plan, the Archive plan (pl. 19), was probably drawn by Luis de Vega, not Pedro Machuca. Because that plan includes emendations known to have been required by the emperor in February 1528, we attempted to reconstitute the previous plan by eliminating the emendations. The resulting plan (fig. 4) has a courtyard with a two-story circular portico attached to the wings of the palace at its cardinal points, thus leaving the four corners open. I know of no typological precedent for the isolated double portico, but the other aspects of the reconstituted plan—its square format, the equal-size vestibules on the four axes, and the symmetrical disposition of the rooms on either side of them—recall Francesco di Giorgio's model plans for princely villas (cf. pl. 21 and fig. 4).[2] Some of his plans have circular porticoes but the corners are usually closed by a corridor wall. For that reason, it is likely that Vega made changes in the portico of the courtyard, as well as the emendations required by the emperor, and that the original plan of 1527 may have been an isolated square villa on the pattern of the "case di signori o vero prencipi" designed by Francesco di Giorgio.

Confronted with the mutilated state of the design represented by the Archive plan, Pedro Machuca recovered the integrity of the courtyard by enclosing its corridor with a wall, and with this change, he joined the circular portico to the wings of the block-design palace. The resulting plan is one for which there are several precedents in the treatises of Francesco di Giorgio dated from 1476 to 1492, and also variations and elaborations in the projects of Bramante, Peruzzi, and the Sangallo (pls. 104, 105, 106, and 108).[3] A very small sketch of a block-design palace by Leonardo da Vinci (sometimes cited as a precedent for Machuca's project) has an octagonal, not a round courtyard.[4] Of course, the polygonal courtyard is closely related to the round in its ornamentality and centricity, but the faceted form of its elevation differs markedly from the continuous sweep of a round portico. Among early sixteenth-century variations of Francesco di Giorgio's round-courtyard plans, the closest analogy to Machuca's revised project of 1528 is a sketch attributed to Antonio da Sangallo the Younger and associated with the earliest phase of the design of the villa begun by Raphael for the Medici on the Monte Mario overlooking Rome and known since the late sixteenth century as the Villa Madama (pl. 105).[5] Characterized by a porticoed round courtyard within a square block, it has four very different sides that would seem to be the result of the adjustment of the ideal, centrally symmetrical plan to the peculiarities of the slope of the Monte Mario—the three-lane entry on the left, the full-length loggia on the lower side (overlooking the Tiber River), a porticoed garden loggia on the right, and the suppressed front on the upper side (where an amphitheater was to have been cut into the rising hill). It also has a unique

[2] The Francesco di Giorgio plan and that of the palace of Charles V appear on the same page of Mario Rosci's *Il trattato di architettura di Sebastiano Serlio*, Milan 1967, p. 73, figs. 172-173, but that is quite accidental because (being unaware of the plan for the villa "in Spain") Rosci did not recognize that it might be related to Machuca's first proposals of 1527.

[3] Francesco di Giorgio, *Trattati*, I, pls. 31 (a house), 33 (a castle), 122 (a cloister), 153 (Roman ruin), 164 (a sanctuary); and II, pl. 199 (a princely palace). For the Sangallo in the Uffizi: Giuliano, A1799; Antonio the Elder and Younger together, A7890, 7891, and 7905; Antonio the Younger, A1054 and 775; and Francesco, A7907; and Baldassare Peruzzi, A350 and 456.

[4] Leopoldo Torres Balbás, "Los patios circulares en la arquitectura española," *XIVᵉ Congrès international d'histoire de l'art. 1936. Actes du Congrès*, Berne, 1936, pp. 114-115. The sketch

is found among several other drawings on fol. 315r-b of the Codex Atlanticus, 78v-b, Biblioteca Ambrosiana, Milan. The best reproduction is found in Carlo Pedretti, *Leonardo architetto*, Rome, 1978, p. 251, figs. 369 and 370, where it is identified as a sketch for the palace the Medici considered building in 1515 on the Via Larga in Florence opposite the palace by Michelozzo begun by Cosimo in 1444.

[5] Heinrich von Geymüller (*Raffaello studiato come architetto*, Milan, 1884, p. 61, fig. 37) was probably the first to associate Uffizi A1054 with the Villa Madama. Among more recent scholars who concur (with varying degrees of qualification) are Gómez-Moreno y Martínez in 1941, Gustav Giovannoni in 1959, David Coffin and John Shearman in 1967, and Giusseppe Marchini and Christoff Frommel in 1969, Renato Lefèvre in 1973, and Christoph Frommel in 1983.

feature of the Villa Madama, the round turret-like "dyeta" from which (according to Baldassare Castiglione) one could enjoy views of Rome and the surrounding landscape.[6] The recently rediscovered Castiglione letter to the duke of Urbino in 1522 (in which he repeated Raphael's 1519 description of the final plan of the Villa Madama) has reassured us that the groundplan with an unporticoed round courtyard (Uffizi A314, pl. 110) was the final project of 1519,[7] but many scholars still consider the porticoed round courtyard plan (Uffizi A1054, pl. 105) to be an early proposal for the villa, around 1516.[8] Surprisingly, it is not this early proposal but the final plan of the Villa Madama that is usually cited by scholars as a precedent for the palace of Charles V. While the courtyard of that final plan is circular, it is *unporticoed* and it was to have been enclosed by a wall scanned by colossal half-columns with huge rectangular niches in each bay (cf. pls. 110 and 172). Although the 31-meter diameter of the Villa Madama's round courtyard coincides with that of the 30.30 meter *clearing* of the present palace of Charles V, the full diameter of the latter is 42 meters.[9] In any case, it is clear that no known stage of Raphael's villa served as a model for the lost first project of 1527 or the second phase represented by the Archive plan. Machuca's earliest plans seem to have been closer to Francesco di Giorgio's princely villas than to the Villa Madama.

The initial stimulus for plans with round courtyards in Italy seems to have been Pliny the Younger's description of his Laurentian villa, which (because of an error in the manuscripts known to the Renaissance) was described as having an atrium or a courtyard in the shape of an *O*. Later in the seventeenth century, newly found manuscripts revealed that Pliny had described that courtyard as having the shape of a *D*,[10] but, in the meantime the unknown copyist's error inspired Renaissance designs for a variety of circular courtyards. The type was not mentioned by Vitruvius, so Francesco di Giorgio looked to the circular casino or retreat in Hadrian's villa at Tivoli, which was the only ancient example known to have survived into the Renaissance.[11] Presumably the Sienese theorist thought it was a sanctuary because he identified a plan for a round temple enclosed by a circular portico as an "edifitio in Tiboli vecchio" (cf. pls. 103 and 104).[12] In place of the forty columns of Hadrian's retreat, Francesco di Giorgio used sixteen in the portico of his sanctuary and multiples of eight are found in most of his other round courtyards.[13] This change represents a Renaissance transformation of the type because his followers also tended to use porticoes of eight, sixteen, twenty-four, or thirty-two columns in round courtyards. These numbers made possible a clearer articulation of the geometricity of the circle, in that the the designer could stress its cardinal and intracardinal axes. Later architects such as Bramante, Raphael, Sangallo, Machuca, and Peruzzi clearly extracted that principle from his speculative projects. The closest contemporary analogy to Machuca's 1528 design is an undated project for an unidentified convent that has two courtyards of equal size, one round and the other polygonal in shape (pl. 106).[14] Reminiscent of the seriate plans for multicourt palaces by Francesco di Giorgio, the convent has un-

[6] Coffin, "The plans of the Villa Madama," p. 120. For Castiglione's letter, see above, chap. 1, n. 44.

[7] Foster, "Raphael on the Villa Madama," pp. 307ff.

[8] John Shearman has expressed the suspicion that A1054 is "causally connected with the palace of Charles V"; see "Raphael . . . 'fa il Bramante,' " *Studies in Renaissance and Baroque Art presented to Anthony Blunt*, London, 1967, p. 17, n. 34. But the lost first plan of 1527 had a free-standing circular corridor, so it is only the second stage of Machuca's design in spring 1528 (when the corridor was enclosed with a wall) that can be compared to Uffizi A1054.

[9] The dimensions were provided by the former architect-conservator of the palace, Francisco Prieto Moreno.

[10] Coffin, "The plans for the Villa Madama," pp. 118-119. The same author, in *The Villa in the Life of Renaissance Rome*, Princeton, 1978, p. 248, noted that the copy of the letter once owned by Leo X (printed in 1506 and 1508 and now in the Laurentian Library in Florence) has a blank space rather than

the letters *O* or *D*, so the scribe must have been uncertain of the reading of the manuscript he copied.

[11] Villas with polygonal courtyards were occasionally depicted in Pompeian murals but I do not know of any that are circular in plan; see L. Curtius, *Die Wandmalerei Pompeiis*, Leipzig, 1929, p. 338, fig. 210.

[12] Francesco di Giorgio, *Trattati*, I, pl. 164 (Saluzziano 148, fol. 88). See Earl E. Rosenthal, "The antecedents of Bramante's Tempietto," *Journal of the Society of Architectural Historians*, XXIII (1964), pp. 70-72.

[13] Francesco di Giorgio did use 40 columns for the round cloister of a convent and the courtyards of a castle and a palace; see *Trattati*, I, pls. 12, 33, and 122; and II, pl. 199.

[14] A modern copy of that drawing (Uffizi A350) was published by Rudolf Redtenbacher, *Mitteilungen aus der Sammlung architektonischer Handzeichnungen in der Gallerie der Uffizien zu Florenz*, Karlsruhe, 1875, part I, p. 13, pls. 9 and 10. Paolo Portoghesi ("La lingua universale," *Controspazio*, Nov.-Dec.,

CHAPTER FIVE

derstandably been attributed by some to Peruzzi. Like Machuca's 1528 project, the round courtyard of the convent plan has thirty-two columns,[15] and the portals are located on the cardinal and intra-cardinal axes, with niches in most of the bays between them. A similar stress on the cardinal axes and on rhythmic variation in the bays is found in Peruzzi's project for the Orsini palace on the site of the Baths of Agrippa, which is usually dated about 1530 (pl. 109). Machuca is clearly more directly dependent on the Renaissance elaboration of the circular courtyard than on its ancient anteype, the circular casino in Hadrian's villa at Tivoli; but it is significant (as Gómez-Moreno and others have noted) that the courtyard of the palace of Charles V and the famous casino have the same diameter—42 meters.

Another factor in the formulation of the Renaissance version of the square plan with a circular courtyard was a geometric diagram that conveniently determined the proportions of its component parts. As we noted earlier, the wider corridor, for which Pedro Machuca laid the foundations in 1540, reinstated the geometric scheme (based on the successive circumscription of circles and squares) that probably characterized the original plan of 1527 (fig. 6, p. 62). That geometric scheme also governed the design of the villa "in Spain," though Sangallo's sketch was loosely drawn (pl. 20), and the scheme may have been used as early as the 1470s by Francesco di Giorgio (it clearly was his basis in 1482 for the design of a Greek Cross church and the centralized east end of a basilican church).[16] Bramante may have learned that configuration from Nordic architects working in the cathedral of Milan, as has

been suggested,[17] but he first used it in a project derived from the speculative designs of Francesco di Giorgio. That was, of course, the Tempietto and its enclosing courtyard, which was designed in 1502 and is known to us by way of the plan published by Serlio (pl. 108).[18] The same diagram was used by Bramante in the design of his first and second projects for Saint Peter's in 1506–1507 and it was also the basis for Peruzzi's variation of the latter plan.[19] Of special interest is its use for the loosely sketched plan associated with an early phase of the Villa Madama (pl. 105). In 1545 Serlio described this geometric construction in book I, and earlier, in 1540, he superimposed it on Raphael's plans for Saint Peter's in book III and demonstrated its use for the planning of a Greek Cross church in book V.[20] While known examples are not numerous, it is clear that this scheme was used by Tuscan architects during the years Machuca was in Italy.

The early fourteenth-century castle at Bellver at Palma de Mallorca is sometimes mentioned as a precedent for the palace of Charles V, but, other than sentiment, there is little to support this supposition.[21] The delicate Gothic tracery of Bellver's porticoes contrasts strongly with Machuca's severe Doric colonnade, and the plan of the castle—based on three concentric circles with the transverse walls of its halls aligned on the radii (pls. 107 and 23)—differs markedly from that of the palace. Thus, there is no reason to entertain the prospect that the circular castle figured in the conceptual process of the palace of Charles V on the Alhambra.

The open corners of the first round courtyard in the 1527 plan were used for staircases as well as for the enlarged octagonal chapel. Initially, the main

1970, pp. 16-17) seems to have been the first to publish the Peruzzi drawing itself. Though he suggested that it was a plan for the convent of San Domenico in Siena, the church is totally at odds with Peruzzi's preserved plans for it; see Gino Chierici, "Baldassare Peruzzi e la chiesa di S. Domenico a Siena," *Rassegna d'arte senese*, XVI (1923), pp. 70-75.

[15] Peruzzi's pupil, Serlio, also used thirty-two columns in several princely palaces with round courtyards in his sixth book; see Sebastiano Serlio, *Il sesto libro delle habitationi di tutti li gradi degli homini* (facsimile edition, Cod. Icon. 189, Bayerische Staatsbibliothek, Munich), Milan, 1966, fols. 26 and 27. Another pupil, Pietro Cataneo, included a palace with a round courtyard and a portico of thirty-two columns in his *I quattro primi libri di architettura*, Venice, 1554, bk. IV, fol. 54.

[16] Francesco di Giorgio, *Trattati*, I, pp. 136-137, pls. 60 (Saluzziano 148, fol. 32), 235 and 236 (Magliabechiano, fol. 42r and 42v).

[17] Soergel (*Untersuchungen über den theoretischen Architekturentwurf von 1450-1550 in Italian*, pp. 107-112) stressed Bramante's use of this geometric construction without noting that Francesco di Giorgio preceded him.

[18] The most complete scholarly and graphic account of the Tempietto is found in Bruschi, *Bramante architetto*, pp. 464-527.

[19] Otto H. Förster, *Bramante*, Vienna and Munich, 1956, fig. 96. Soergel, *Untersuchungen*, pp. 108-111.

[20] Serlio, *Tutte le opere*, bk. I, fol. 3v; bk. III, fols. 65r and 67, and bk. V, fol. 213v. This geometric scheme is the only one that appears on the title page of his book I on geometry, published in Paris in 1545; see illustration in Rosci, *Il trattato di architettura di Sebastiano Serlio*, p. 6.

[21] Torres Balbás, "Los patios circulares," p. 115; Gómez-Moreno y Martínez, *Las águilas*, p. 127. Only Lozoya in 1949 and Camón Aznar in 1945 expressly denied its role as a model.

staircases must have been located in halls alongside the vestibules, but by February 1528 (the date here assigned to the Archive plan) a two-flight newel staircase had been intruded into the southeast corner of the round courtyard, and in the spring of that year a second was added in the northwest corner of the large Royal Palace plan (cf. pls. 17 and 19). Neither Pedro nor Luis ordered materials for the main staircases,[22] and this suggests that they opposed the newel form because (as Maeda later noted)[23] a monumental spiral staircase would have served to buttress the cylindrical wall of the corridor and its annular vault and would have been accessible from a single archway on the intracardinal axes. Further support for the prospect that Pedro intended monumental spiral staircases is provided by the insertion of that type staircase in the triangular corners of several round courtyards in the treatises of Francesco di Giorgio[24] and also in the 1519 project for the Villa Madama (pl. 110-B).

Machuca's counterproposal to a newel staircase in the southeast corner was a continuous flight composed wholly of winders (pl. 18). It is not likely that anything of the sort had ever been proposed in Spain and there were few analogies in Italy at the time. Italians preferred the dog-leg staircase, composed of two parallel flights with a double-turn landing, but around 1500 they occasionally added a short introductory flight of steps from the corridor to a first landing.[25] The earliest known examples of staircases fitted into the corners of round, polygonal, or oblong courtyards are found in some of Francesco di Giorgio's model

plans in the 1470s,[26] and in projects by his compatriot, Baldassare Peruzzi, who was the most venturesome designer of staircases during the first third of the sixteenth century. As Wolfgang Lotz and Paolo Portoghesi have noted,[27] Peruzzi had a predilection for difficult formal problems and an inclination toward eccentric solutions. Of special interest to us is the staircase he arranged within a broad U-shaped area between the round and rectangular courtyards of his plan of about 1530 for the Orsini palace on the site of the Baths of Agrippa (pl. 109).[28] Still, whereas Machuca's staircase in the southeast corner of the small Royal Palace plan is composed wholly of winders, Peruzzi's has them only at the two turns.

The octagonal chapel is another distinctive feature of the palace. It was probably an octagon confined to the square formed by the intersection of the two wings in the northeast corner of the 1527 plan since Charles did not require a change in shape, only its enlargement. Corner halls in model plans for square villas by theorists from Francesco di Giorgio to Serlio were usually octagonal or round.[29] Their functions are seldom identified, but there are a few plans by Antonio da Sangallo the Elder and Sebastiano Serlio in which an octagonal corner hall was designed as a chapel,[30] so in function, as well as shape and location, Machuca's octagonal chapel in the 1527 project reflects the Tuscan tradition.

The most notable feature of Machuca's chapel in the two earliest plans is the alternation of semicircular and rectangular recesses on its eight sides. Found in an architectural type invented by the Romans in the first century A.D., that feature was

[22] A temporary staircase of wood had to be constructed in the northwest corner for the visit of Felipe IV in 1624; see chap. 4, n. 108.

[23] For the pertinent passage of that report, see above, chap. 3, n. 51 (doc. 129).

[24] Francesco di Giorgio, Trattati, I, pls. 30, 31, and 134 (Saluzziano 148, fols. 17, 18, and 73v). Circles in the corners of Leonardo's octagonal courtyard were taken to be spiral staircases by Pedretti (Leonardo architetto, p. 251, figs. 369 and 370).

[25] Lauren Sloth, The Staircase in Italian Architecture, Master's thesis, Institute of Fine Arts of New York University, 1962, p. 7, n. 21. Frommel (Der römische Palastbau, I, pp. 60-65) recognized that winders were used only in restricted spaces that did not permit landings; see J. P. Richter, The Literary Works of Leonardo, London, 1939, II, p. 22.

[26] Francesco di Giorgio, Trattati, I, pls. 172, and (less close) 136 and 138 (Saluzziano 148, fols. 92v, 74v, and 90v), now dated in the mid-1470s. See also Bramantino (Bartolomeo Suardi), Le rovine di Roma al principio del sècolo XVI. Studi del Bramantino

(Bartolomeo Suardi), ed. G. Mongeri, Milan, 1880, pls. 15 and 27.

[27] Ludwig H. Heydenreich and Wolfgang Lotz, Architecture in Italy 1400-1600 (The Pelican History of Art 16), Harmondsworth, 1974, p. 192; and Paolo Portoghesi, Rome of the Renaissance, trans. P. Saunders, London, 1972, p. 38.

[28] Peruzzi's plan (Uffizi A456) was published by Alfonso Bartoli, I monumenti antichi di Roma nei disegni degli Uffizi di Firenze, Florence, 1914-1922, II, p. 56, pl. CLXXV, fig. 310. For a discussion of the ornamental staircase as a Mannerist feature, see John Shearman, Mannerism (Style and Civilization), Baltimore, 1967, pp. 113-121.

[29] Francesco di Giorgio, Trattati, I, pl. 177; and II, pls. 200, 201, 207, and 208. Serlio, Tutte l'opere (bk. VII), fols. 57, 211, 213, and 231, and Il sesto libro, fols. 24 and 34. Cataneo, I quattro primi libri, fol. 49v.

[30] Antonio da Sangallo the Elder, Uffizi A7891, and Serlio, Il sesto libro, fols. 24 and 34.

used throughout the empire for nymphaeums, caldariums, and mausoleums. Several of the type, probably nymphaeums, are preserved on the lower and upper levels of the Domus Augustana on the Palatine, with the one on the lower level being a one-story structure and the one on the upper having a two-story elevation.[31] Machuca's first chapel in 1527 may have been similar to the one-story nymphaeum on the lower level, but when he was required to raise it to two stories to provide tribunes opening from the apartments of the emperor and empress, he may have recalled the two-story type on the upper level (cf. fig. 5 on p. 60, and pls. 107 and 112). Machuca might also have known this architectural type by way of mid-fifth-century baptistries, built first in Lombardy and then in the rest of Italy and Provence;[32] but, it is more likely that he saw Renaissance versions in the sketchbooks and projects of architects and theorists such as Francesco di Giorgio Martini, Giuliano da Sangallo, Fra Giocondo, Bramantino, and Antonio da Sangallo the Younger.[33] Machuca's chapel is closer to the plans of the theorists than to Roman antetypes in that the width of the recesses in Renaissance plans was usually reduced to about half the sides of the octagon, whereas the recesses of ancient Roman and Early Christian examples are usually wider, about three-quarters the width of the sides. But the elevation of the chapel, as completed by the Machucas, did not coincide with either the broad proportions of octagonal halls in Tuscany or the tall proportions of Lombardy. Because the chapel's second story was six courses lower than its present height, the two stories had an unusual three-to-two proportion, but its elevation was determined by the need for tribunes on the level of the main floor of the palace and also by a domical vault that had to be covered by the common roof of the palace.[34]

The kind of membering planned for the interior of the chapel is unknown, but Machuca may have intended a treatment similar to that of the huge octagonal chapel proposed by Giuliano da Sangallo in 1488 for the palace of Ferdinand I, the king of Naples (pls. 113 and 114), or the comparable chapel designed about 1491 by his brother Antonio for the Medici on the Via Laura in Florence.[35] Since the interiors of most of the Sangallo chapels are rotundas articulated by free-standing columns, it is likely that they were modeled on the Mausoleum of Diocletian at Split, which is also round on the interior and octagonal on the exterior (cf. pls. 107, 111, and 113).[36] When Machuca relinquished alternating recesses in favor of rectangular in the small Royal Palace plan of 1531 (pl. 18), he could have had in mind the early fifth-century rotundas with shallow rectangular recesses attached to the left transept of Saint Peter's in Rome; but, more characteristic of the late imperial period and of Renaissance versions of the type is the rhythmic alternation of semicircular and rectangular recesses.

[31] Luigi Crema, *Manuale di storia dell'architettura antica*, Milan, 1962, pp. 250-262. Alternating rectangular and semicircular niches are also found in the octagonal Mausoleum of Saint Helen begun by Constantine.

[32] Richard Krautheimer, *Early Christian and Byzantine Architecture* (The Pelican History of Art 24), Harmondsworth, 1965, pp. 132-133, and A. Khatchatrian, *Les baptisteres paleochrétiens*, Paris, 1962, p. 49, figs. 327-331.

[33] Though Italian Renaissance architects favored round halls with alternating recesses, they occasionally designed octagonal versions of the type. See Francesco di Giorgio, *Trattati*, I, pl. 137, and Uffizi A329; Giuliano da Sangallo, *Il libro di Giuliano da Sangallo* (facsimile edition of Cod. Vat. Barb. Lat. 4424), 2 vols., Leipzig, 1910, fol. 75, and *Il taccuino senese di Giuliano da Sangallo*, ed. R. Falb, Siena, 1902, fol. 8; Bramantino, *Le rovine di Roma*, fol. 33; Fra Giocondo, Uffizi A1527v, in Bartoli, *I monumenti antichi di Roma*, I, pl. XXVIII, fig. 55; and Antonio da Sangallo the Younger, Uffizi A962 (a project for a temple on the Isola Bisentina in the Lago di Bolsena), in Giovannoni, *Antonio da Sangallo*, pp. 223-235, fig. 13.

[34] A segmented dome comparable to one sketched by Giovanni Battista da Sangallo (Uffizi A1177) was probably intended; see Bartoli, *I monumenti antichi di Roma*, IV, pl. CCCI,

fig. 492.

[35] For the palace of the king of Naples, see Giuliano da Sangallo, *Il libro*, fol. 41v, and H. Biermann, "Das Palastmodel Giuliano da Sangallo für Ferdinand I, König von Neapel," *Wiener Jahrbuch für Kunstgeschichte*, XXIII (1970), pp. 154-195. The octagonal chapel proposed for the king of Naples would have had an interior span of almost 18 m., whereas the diameter of the enlarged chapel of the palace of Charles V was only 13.95 m. For the Medici palace on the Via Laura (Uffizi A282), see G. Miarelli Mariani, "Il disegno per il complesso Mediceo dei via Laura a Firenze," *Palladio*, XXII (1972), pp. 127-162, and Caroline Elam, "Lorenzo de'Medici and the urban development of Renaissance Florence," *Art History*, I (1978), pp. 46-49. A comparable octagonal chapel was designed by Antonio da Sangallo the Younger for the Sapienza in Perugia in the early 1520s; see Giovannoni, *Antonio da Sangallo*, pp. 300-320, fig. 358.

[36] F. Bulic, *Kaiser Diokletians Palast in Split*, Zagreb, 1929, pl. XII. Diocletian's mausoleum also has a lower chamber and a diameter of about 13.5 m., while Charles' is 13.95 m., but the former has a height of 22 m., while the latter was to have had only 17.5 m.

We should also recognize the possible role of Spanish precedents, because they are sometimes mentioned as an explanation for Machuca's choice of the octagonal form for his chapel. Certainly polygonal and faceted architectural forms were favored by architects of the Islamic, Mudéjar, and Gothic styles in Spain,[37] and familiarity with those forms may have predisposed Machuca to adopt the octagonal plan at a time when most contemporary Italian theorists preferred the round to the polygonal. Particularly important for explaining Machuca's predisposition is a funerary chapel used from the mid-fourteenth century by leading noble families, especially in Castile. Though these chapels are often irregular in groundplan, their spectacular star vaults are usually disposed within an octagon. Among the earliest and grandest is the one begun before 1364 by Gil de Albornoz at the rear of the cathedral of Toledo and, just north of it, there is another started by Cardinal Álvaro de Luna in 1432. The two most famous turn-of-the-century examples are the chapel of the Condestable, constructed from 1482 to 1498 at the east end of the cathedral of Burgos, and that of the Vélez, begun in 1507 in the cathedral of Murcia.[38] None of these Spanish chapels, however, has alternating semicircular and rectangular recesses, and there is no hint of a reference to ancient precedents, even in the ornament.

The tribunes required for the imperial couple were readily accommodated in the expanded two-story version of the octagonal hall. It was the custom of Spanish royalty and nobility to hear Mass from tribunes in their palatine chapels while their households congregated on the ground floor. The practice was evidently imported from France into Aragón, Navarre, and Catalonia in the thirteenth or fourteenth centuries and adopted in Castile by the fifteenth century.[39] Ultimately, the two-story chapel with a royal gallery goes back to Byzantine antecedents; important early Western examples are the octagonal chapels attached to San Lorenzo in Milan and San Vitale in Ravenna, and Charlemagne's palatine chapel at Aix-la-Chapelle.[40] The tribunes for royalty, nobility, and princely prelates in Europe appear in many forms in the later Middle Ages. Sometimes they are simply small recesses with balconies reached by narrow staircases in the rear walls of chapels, such as those of the Condestable in Burgos and the Vélez in Murcia. In the royal church of San Juan de los Reyes in Toledo, begun by the Catholic Monarchs in 1477, they are relatively small balconies mounted over the crossing piers opposite the high altar. In the royal residence in Madrid, the chapel (under construction in 1540) had tribunes on three levels, with the lowest used by the royal family, the second by the chapel choir, and the uppermost by the women of the royal households.[41] Charles V arranged to view Mass through a window from his bedchamber in the monastery of San Jerónimo el Real in Madrid, and also at Yuste, where he retired, and the practice was followed by Philip II at the Escorial and Aranjuez.[42] But, in 1528, there were no Spanish or Italian precedents for symmetrically disposed tribunes in a central-form chapel, and so Machuca seems to have turned to an ancient Roman type represented by the two-story nymphaeum on the upper level of the Domus Augustana on the Palatine (pl. 112).

The east vestibule is often described as oval or elliptical, but neither of these forms is found in the three sixteenth-century plans of the palace. In the two earliest, the Archive and the large Royal Palace plans, that vestibule has a long tapered shape determined by two arcs swung from centers still evident on the outer edge of the opposite wall; whereas in the small Royal Palace plan, probably the penultimate plan of late 1531, the vestibule was formed by the addition of semicircles on either side of a

[37] Chueca, *Invariantes Castizos*, pp. 72-73.

[38] Leopoldo Torres Balbás, *Arquitectura gótica* (Ars Hispaniae VII), Madrid, 1952, pp. 292-301. Teófilo López Mata, *La catedral de Burgos*, Burgos, 1966, pp. 229-232.

[39] François Benoît (*L'architecture de l'Occident médiéval du romain au roman*, Paris, 1933, pp. 227-228) cites the chapel of the twelfth-century episcopal palace in Laon as the first known example. For royal tribunes in Spain, see Lampérez, "Los palacios de los reyes de España," *Arte español*, III, p. 215, and IV, p. 285; and Juan Iturralde y Suit, *Memoria sobre las ruinas del Palacio Real de Olite*, Pamplona, 1870, pp. 9-15.

[40] W. Eugene Kleinbauer, "Charlemagne's Palace Chapel at Aachen and its Copies," *Gesta*, IV (1965), pp. 2-11.

[41] Iñiguez Almech, *Casas Reales*, p. 78, figs. 14 and 15.

[42] Chueca, *Casas Reales*, pp. 67, 78 and 199. Openings from private chambers into a chapel date from at least the 1480s in Italy, though they were probably used earlier. Such a facility was found in the Palazzo dei Cavalieri del Santo Sepolcro in Rome where it was probably introduced by Cardinal Domenico della Rovere shortly after 1478. About the same time, Francesco di Giorgio recommended that convenience; see *Trattati*, II, p. 352 (Magliabechiano, II, I, 141, fol. 24), for his reference to "una capella dove per le camere appresso si possa udire e vedere messa senza esser visto."

rectangle (cf. fig. 12 and pls. 18, 19, and 107). That plan for the vestibule was begun by Luis Machuca before 1568 and completed by Juan de Minjares after 1596. An oval plan was quite new, since Baldassare Peruzzi is believed to have introduced that form in designs for the side chapels of Saint Peter's from 1506 to 1520,[43] and Machuca's vestibule might well be the first example outside Italy, as George Kubler suggested.[44] Still, the procedures used to form the oval in the plans for the Alhambra palace do not follow the geometrical constructions used by Peruzzi and later illustrated by his pupil, Sebastiano Serlio in 1545 (pl. 28).[45]

The odd two-arc construction used by Machuca in the large Royal Palace plan was unusual (pl. 107 and fig. 12) but not without precedent. Giuliano da Sangallo employed that method of construction in his plan of the Colosseum.[46] Its form is somewhat broader than the east vestibule but the principle is essentially the same. The method was also used for the somewhat narrower Flavian amphitheater by the Ghirlandesque draftsman of the Escorial Codex, usually dated in the 1490s and now known to have reached Spain before 1509.[47] The two-arc method could also have been derived from structures like the Loconicum, or sauna, alongside the octagonal hall designated D in the baths of the forum in Ostia, where Giuliano repaired fortifications in 1483, and like the nymphaeum (next to the triclinium) in the Domus Flavia on the Palatine in Rome.[48] Whatever the immediate source of his method, Machuca formed his earliest oval for the east vestibule according to a construction used by

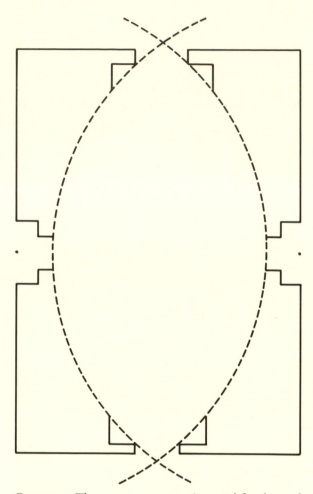

FIGURE 12. The two-arc construction used for the oval vestibule

[43] Wolfgang Lotz, "Die ovalen Kirchenräume des Cinquecento," *Römisches Jahrbuch für Kunstgeschichte,* VII (1955), pp. 7-99.

[44] Kubler-Soria, *Art and Architecture of Spain,* p. 11, n. 35. We should note that the groundplan made for Kubler (his fig. 6) does not follow Machuca's "oval" in either the large or the small Royal Palace plans but, rather, the Peruzzian construction. The latter was not used by Jerónimo Quijano who designed the "oval" anteroom of the Junteros Chapel in the cathedral of Murcia; see Cristina Gutiérrez-Cortínes Coral, "Jerónimo Quijano, un artista del Renacimiento español," *Goya,* no. 139, 1977, pp. 5-6. The oblong dome designed by Diego Siloe in 1528 for the central vault of the cruciform nave of the cathedral of Granada may be reflected in the several vaults in Andrés de Vandelvira's treatise compiled in 1575-1591; see Geneviève Barbé-Coquelin de Lisle, *Tratado de arquitectura de Alonso de Vandelvira,* Albacete, 1977, II, fols. 71v and 78v.

[45] Peruzzi's methods are recorded in several drawings in the Uffizi collection (A553, 554, 469, 577, 599, and 4137), and they were clearly demonstrated by Serlio, *Tutte l'opere,* bk. I, fols.

13v and 14. We should note that Francesco di Giorgio had already used a freely drawn (rather than geometrically constructed) oval form; see L. Châtalet-Lang, "La 'forma ovale' si come costumarono il antichi romani sailles et cours ovales en France au 16e siècle," *Architectura,* VI, 1976, pp. 128-147.

[46] Giuliano da Sangallo, *Il taccuino,* fol. 7, and *Il libro,* fol. 12v.

[47] Egger, ed., *Codex Escurialensis,* fol. 70v; Kruft, "Codex Escurialensis," pp. 44-45. In 1545 Serlio (*Tutte l'opere,* bk. I, fol. 4) illustrated this geometric construction for the formation of a lowered arch and "many other things" and identified it as "terza acuto."

[48] Edwin D. Thatcher, "The open rooms of the Terme del Foro at Ostia," *Memoirs of the American Academy in Rome,* XXIV (1956), pp. 199-202, pl. I, 2. Thatcher corrected the mistaken 1932 reconstruction by Johnson, who evidently assumed Roman architects had employed the tangent-circle construction later recommended by Serlio. For the nymphaeum on the Palatine, see William L. MacDonald, *The Architecture of the Roman Empire,* New Haven, 1965, fig. 50.

several Tuscans between 1480 and 1520 and ultimately derived from the ruins of imperial Roman buildings.

In the small Royal Palace plan, probably made late in 1531, the long tapered form of the early vestibule was replaced by one based on the addition of semicircles to either side of a rectangle (pl. 18). The new disposition may have been chosen to facilitate the vaulting of the hall, which could be accomplished by a combination of half-domes and a barrel vault,[49] whereas the first plan would have posed stereometric problems never before faced by the skilled stonemasons of Spain. Whether Machuca or the Castilian advisers of the emperor suggested this solution is difficult to say because it is found in both the ancient Rome and the Hispano-Moresque traditions. The Nazaride palaces themselves provided several examples of the combination of barrel vaults and half-domes of wood, notably over the mid-fourteenth-century Sala de la Barca (the 17-meter hall between the Tower of Comares and the Court of Myrtles) and the three small alcoves alongside the Hall of the Kings on the east end of the Court of Lions.[50] These ceilings may be Islamic versions in wood of Roman vaults over halls with semicircular ends in the Baths of Trajan, Caracalla, and Diocletian, though in the latter there is often a distinct break (a difference in width or a screen of columns) between the barrel-vaulted center and the half-domed ends. Several early sixteenth-century drawings by the Sangallo, Peruzzi, and others record halls of this type in the baths of Rome.[51] Neither these Roman halls nor the first form of the east vestibule can properly be described as oval in the Italian Renaissance sense.

The shape of the west vestibule, approximately one-third wider than it is deep, can also tell us something about Machuca's architectural inclinations. The broad format was probably carried over from the initial project in 1527, which must have been a centrally symmetrical villa with four equal vestibules like those found in Francesco di Giorgio's treatises and in Sangallo's sketch of the villa "in Spain" (pls. 20 and 21). Even after it was enlarged as the main entry, the west vestibule, at 7.50 by 15.15 meters, was only about half as large as that of the royal residence in Madrid.[52] Admittedly the latter served both the king's and the queen's households (pl. 15), while the west vestibule in Machuca's palace was apparently the entry to only the household of Charles V and the official halls of the palace. A wide vestibule, like the west entry, was identified by Vitruvius as Roman, while the narrow passage (favored during the Italian Renaissance) was associated with the Greeks, and Alberti and Francesco di Giorgio recommended the use of the Roman type.[53] In Fra Giocondo's 1511 and 1513 editions of Vitruvius on architecture, the wide vestibule appears in the groundplan of a typical Roman house.[54]

Precedents in the works of Italian theorists have been stressed because the broad shape of the west vestibule and its identification as a *zaguán* in the large Royal Palace plan may lead some to assume that it represents an intrusion of an Hispano-Moresque feature into an ideal Italian plan. To be sure, the wide *zaguán* persisted in Hispano-Moresque houses such as the Casa de las Conchas in Salamanca and early Renaissance palaces such as those of the Medinaceli in Cogolludo and the Dueñas

[49] The earliest extant examples of half-domes on either side of a barrel vault date from the middle of the sixteenth century: the vestibule of the cloister of the cathedral of Cuenca of 1545–1550, the altar room of the sacristy of Seville, and the 1554 vault of the chapel of San Juan Bautista in San Nicolás in Córdoba.

[50] Leopoldo Torres Balbás, *Arte Almohade. Arte Nazarí. Arte Mudéjar* (Ars Hispaniae IV), Madrid, 1949, p. 103 and fig. 87 (for the Sala de la Barca), and p. 120 (for the alcoves).

[51] Thomas Ashby, "Sixteenth century drawings of Roman buildings attributed to Andreas Coner," *Papers of the British School in Rome*, II (1904), pl. 10 (fol. 6). Drawings by Antonio da Sangallo the Elder (Uffizi A2134 and 2162) and Baldassare Peruzzi (Uffizi A622 and 476) are found in Bartoli, *I monumenti antichi di Roma* II, pl. XCVIII, fig. 178, pl. CLXII, fig. 307, and pl. CLXXX, fig. 315.

[52] The *zaguán* of the royal residence in Madrid (as recorded in the plan by Gómez de Mora in 1626) was about 10 by 30

m., while the vestibule of the residence in Toledo, renovated since 1537, measures 7.78 by 15.87 m.—approximately the size of the west vestibule of the palace of Charles V; see Iñiguez Almech, *Casas Reales*, figs. 14 and 35.

[53] Alberti, VI, 7, 1; Vitruvius VI, 3, 8. The ambiguity of Vitruvius' account of the *vestibulum* and *atrium* is evident in the varied interpretations of Renaissance theorists. Francesco di Giorgio, *Trattati*, II, p. 345 (Magliabechiano, II, I, 141, fol. 17v).

[54] Fra Giocondo, ed., *M. Vitruvius per Jocundum Solitor Castigatior factus*, Venice, 1511, VI, fols. 63 to 64v. Sienese born Pietro Cataneo in 1554 was one of the few to follow Francesco di Giorgio and Fra Giocondo in the use of broadly proportioned vestibules (round, octagonal, or oblong); see *I quattro primi libri*, bk. IV, fols. 48v to 51. Serlio usually used the narrow passage as an entry, but the broader vestibule was indicated in his plan for a royal palace (*Il sesto libro*, fol. 67) and in several villas (*Tutte l'opere*, bk. VII, fols. 9 and 25).

in Medina del Campo. If a vestibule of this sort had not been proposed by Machuca, the emperor's Castilian advisers would probably have insisted on it; but, since the wide vestibule was probably a feature of the ideal villa plan first proposed in 1527, it represents a coincidence of the Hispano-Moresque tradition and the ancient Roman form as it was understood by contemporary Italian theorists.

A couple of features of the west vestibule reinforce the suspicion that Machuca identifed the Roman atrium with the Spanish *zaguán*. It has a limestone benchtable, which was a standard feature of the *zaguán*, serving as a seat for people waiting to be admitted to the palace and also as a ledge for dismounting from horseback. In Italy, however, the interior benchtable was apparently rare since it is found only in wider vestibules, such as those of the ducal palace in Urbino, and the Cancelleria and the Farnese palace in Rome. Also typical of the Spanish *zaguán* is a flat wooden ceiling or *artesonado*. It is found in the vestibules of the palaces of the Medinaceli in Cogolludo and the Dueñas in Medina del Campo and in the royal residences in Madrid and Toledo,[55] and Machuca may have intended to use a comparable wooden ceiling over the west vestibule, since its walls were judged in the 1570s to be too slight to support a stone masonry vault. Furthermore, a flat ceiling would have allowed sufficient interval above the archway from the round courtyard for an entablature or frieze, without resorting to the ugly slope of the present arch. Though we have no documentary or physical evidence for Pedro Machuca's intentions in the west vestibule beyond his groundplans, it is quite possible that he believed that the ancient Roman atrium and the Spanish *zaguán* shared these features: the broad format, the benchtable, and the coffered wooden ceiling.

We are not likely to find an architectural model for the overall design of the multicourt complex recorded in the two Royal Palace plans because it was the result of a series of compromises made in expanding the palace as much as possible within the limitations set by the several inviolable structures. Unfortunately, Machuca was not given an opportunity to design a new project for a multi-

court palace, nor could he freely apply his principles of design to the courtyards added to the free-standing villa,[56] but the kinds of compromises he made reveal some of the principles he espoused.

The arcade of the smaller south forecourt, where Machuca seems to have encountered the fewest obstacles, was not closed on the east end in the early groundplans because the fate of the old mosque consecrated as Santa María de la Alhambra was still undecided. Presumably, when permission to demolish it was obtained, the stables and arcades were to be continued around the east side of the palace, even though that required leveling a good deal of the high ground on which the old mosque was located. The south forecourt itself was to have had the width of the five center bays of the facade. This is evident in both the large and the small Royal Palace plans, but differences between the two are instructive (cf. pls. 17 and 18). In the first, of 1528, Machuca considered a six-arch arcade on the sides with six slightly narrower arches on the south end, apparently to give the impression of a square courtyard. Then, in the second plan, of 1531, he used only five arches on the south end, but they were equal in width to the six on the sides, and he made up the slight difference by means of distinctive corner pillars pierced by small openings. These pillars, together with the uneven number of arches, served to stress the longitudinal axis of the south forecourt and to direct our attention to the portal and the large window above it. Of course, the arcades also masked the angled entry as well as the stables, with the result that anyone viewing it from the south portal or loggia would have had the impression of absolute symmetry.

Arcades on piers also screen the stables of the west forecourt, but there are large gateways centered on each of the three arcaded sides. The south and north gates are centered on the short sides, but (because the forecourt was extended 8.36 meters beyond the south end of the facade of the palace) the gate on the west side could not be centered and still coincide with the axis of the central portal of the palace. The extension was apparently motivated by a desire to use all available space, and it also made possible the connection of the

[55] For a description of the lost vestibule of the *alcázar* of Madrid in the sixteenth century, see Martín González, "El alcázar de Madrid," p. 3.

[56] Because of his evident knowledge of the speculative designs of Francesco di Giorgio, it is possible that Machuca would

have employed a variation of the seriate form of the multicourt princely palace proposed by the Sienese theorist and later reflected in plans of the Sangallo and Serlio; see Francesco di Giorgio, *Trattati*, II, pl. 199 (Magliabechiano, II, 1, 141, fol. 20).

main and the secondary forecourts by an arch barely initiated on the southwest corner of the palace (pl. 31). Because of the extension, the gate on the west side of the main forecourt was inevitably off center or out of line with the palace's main portal, which was to have had the same width and probably the same coupled pilasters that frame the gateways. In the large Royal Palace plan, Machuca apparently tried to minimize the disalignment of the west gate and the palace's center door, but that solution was put aside in the small Royal Palace plan, where the gate was located in the center of the west arcade even though it resulted in a 4.45-meter displacement from the axis of the main portal. Of the two solutions, the smaller displacement of the gate in the large Royal Palace plan would seem to be more in keeping with Pedro Machuca's design principles. Respect for the inherent geometricity of the initial block of the palace is evident in the four axial entrances and the rhythmic disposition of the bays of the circular corridor that stressed the cardinal and intracardinal axes, and also in Machuca's insistence on axial symmetry in the south forecourt. Surely, since he held to a symmetrical disposition in the lesser south forecourt, he would have wanted at least the semblance of axial symmetry in the main court, where the most solemn of court rituals were to be enacted. Also, we have consistently found that the large Royal Palace plan is the best record of Machuca's ideas, while the small plan includes several compromises—the arcade on pillars rather than a colonnade in the round courtyard, marble *portadas* instead of the all-sandstone facades, the simplified shape of the oval vestibule, and the octagonal chapel with only rectangular recesses. To these departures from Machuca's idea we can, I believe, add the marked disalignment of the west gate with the central portal of the facade in the small Royal Palace plan. That discrepancy would seem to reflect the indifference of the emperor's advisers to axial symmetry rather than the conscious application of the principle of the broken or discontinuous axis. Furthermore, when that principle was employed in Spain it was usually for purposes of defense or privacy,[57] and neither was gained in this instance.

The location of the stables around the main forecourts of the palace is not likely to have pleased Machuca because the Renaissance sense of decorum relegated the stables of a princely residence to the back of the garden, or off to the side or in the basement of the residence itself. In Spain, there seems to have been no fixed location for stables during the fifteenth and sixteenth centuries, but we know that Luis de Vega in 1547 made designs for stables and offices in front of the main entrance of El Pardo, the royal hunting lodge near Madrid, and in 1556 he constructed the stables of the royal residence in Madrid along the west side of its main forecourt. Because of this, we reasoned that Luis de Vega, who visited the works of the Alhambra in February 1528, may have suggested the same location for these services in the expanded palace of Charles V. When required to surround the forecourts with stables (apparently surmounted by offices and guest rooms), Machuca screened them from view by means of an arcade on piers, probably faced with rusticated sandstone like the lower story of the palace. That device had been used earlier by Raphael for the stables of the Villa Madama, which were located on the Tiber side, below the villa, on the slope of the Monte Mario; even though they coincided with the basement level of the villa, the stables would have been visible from the main-story windows that overlook the Tiber and so were screened by the arcade. We know the stables of the Villa Madama only from two groundplans, because the stables were never constructed or even founded. The design of the villa was probably close to the Uffizi groundplan numbered A314 (cf. pls. 17, 18, and 110-C), which is believed to have been made the spring of 1519, well before Pedro Machuca left Italy. The Spaniard's project is reminiscent of Raphael's not only in the use of an arcade on piers to screen the stables but also in the large gate framed by paired pilasters that is centered along the arcade. The similarities are sufficiently close to claim Raphael's project as Machuca's model.

THE FACADES

The elevation of Machuca's first project may have been no more than a ground floor with an attic level, somewhat like Ambrosio de Vico's depiction

[57] Lampérez (*La arquitectura civil*, II, p. 367) noted that the zigzag path of entry was characteristic of private residences but in civic palaces the doorway into the courtyard was sometimes aligned with the entry from the street.

of the palace (pl. 22). If that was the case, the first project followed Francesco di Giorgio's suggestion that, when sufficient space was available, a villa should be confined to one story because it was "more convenient,"[58] presumably because it provided easier access to the outside. Alberti had also recommended a one-story villa because the "bothersome staircases" required by multistoried residences could be avoided.[59] These recommendations were clearly followed by Federico Gonzaga and his architect, Giulio Romano, in the design of the famous Palazzo del Te, begun in 1525. Its main halls are on the ground floor with an attic level for service quarters located over the centers of the facades, as seen in the north elevation ordered by Jacopo Strada for Albrecht of Bavaria in 1567 (pl. 118).[60] However, one can no longer confidently cite the Palazzo del Te as the "source" of Machuca's design, as did Pevsner and Grisieri, because new documentary evidence makes it clear that the north wing alone was planned in 1525 and only after February 1526 did Giulio Romano make a model for the construction of "three more wings in the guise of a palace," apparently meaning the three additional wings needed to form a block-design villa.[61] This means that the square plan was proposed in model form less than a year before Charles V ordered the design of a modern residence on the Alhambra in December 1526. Of course, news of the revision of the Mantuan project might have reached Luis Hurtado de Mendoza and Pedro Machuca, inducing them to propose a single-story villa with an attic for the emperor's new residence on the Alhambra, but the distinctive circular courtyard of the Spaniard's project suggests that Pedro Machuca and Giulio Romano independently derived their designs from common

Tuscan sources. The circular courtyard depicted by Giulio Romano in his *Holy Family with Saints* in Santa Maria dell'Anima in Rome, painted about 1523, seems to pertain to a single-story villa (pl. 169), though the arbitrary introduction of steps into the corridor on the left confuses both the disposition and function of the ruinous structure. It has also been suggested that a single-story structure was first planned by Raphael for the Villa Madama and by Peruzzi and Sangallo for the fortified villa of the Farnese at Caprarola, sometime after 1530; and the villa facade sketched by Peruzzi around 1530 seems to have had no more than a ground floor and an attic (pl. 122).[62] The palace of Charles V, as depicted by Ambrosio de Vico, would seem to be of this one-story type. Strikingly similar to several ground-floor elevations in Francesco di Giorgio's treatises,[63] Vico's one-story facades reinforce the speculation that he knew and depicted (perhaps in abbreviated form) the first ideal project of 1527. He even included the rare motive of paired pilasters framing the central archway, with single pilasters scanning the rest of the facade, and that stylar treatment is clearly indicated for the south facade in the large Royal Palace plan (pl. 107). From this web of similarities and associations, it would seem that Machuca's first project for a private villa was probably a one-story structure and, as such, pertained to the theoretical tradition of Tuscany as it was applied to princely villas by members of the Roman School in the first quarter of the sixteenth century.

The elevation of the all-sandstone facades, when raised to two stories, can be reconstituted by replacing the coupled half-columns of the marble *portadas* on both stories with paired sandstone pilasters like those at the ends of the facade, and by

[58] Francesco di Giorgio, *Trattati*, II, p. 355 and pl. 208 (Magliabechiano, II, I, 141, fol. 24v).

[59] Alberti, *Trattati*, I, p. 532 (bk. v, chap. 18).

[60] Egon Verheyen, "Jacopo Strada's Mantuan Drawings of 1567–1568," *Art Bulletin*, XLIX (1967), pp. 63-70. Renate von Busch (*Studien zu deutschen Antikensammlungen des 16 Jahrhunderts*, published dissertation, University of Tübingen, 1973, p. 205, n. 90) quotes a letter of 17 January 1568 in which Stopio stated that Jacopo Strada arranged for the making of these elevations by a young man named Hippolito di Andreasi.

[61] John Shearman, "Osservazioni sulla cronologie e l'evoluzione del Palazzo del Te," *Bollettino del Centro Internazionale di Studi dell'Architettura. Andrea Palladio*, IX (1967), p. 346. Kurt W. Foster and Richard J. Tuttle, "The Palazzo del Te," *Journal of the Society of Architectural Historians*, XXX (1967), pp. 270-

271.

[62] Heydenreich and Lotz, *Architecture in Italy 1400–1600*, p. 270, for Caprarola. Peruzzi's sketch is found on fol. 34v of his *Taccuino* in the Biblioteca Comunale in Siena; see Rosci, *Il trattato . . . di Sebastiano Serlio*, p. 71, fig. 167. An elevation of a villa with a ground floor and a tall attic, found in Codex S. IV, 7, fol. 24v, Biblioteca Comunale in Siena, has been identified by Frommel (in a plate caption) as a copy of a lost sketch by Peruzzi; see *Der römische Palastbau*, III, pl. 183b. Philibert de l'Orme's Château St. Maur of 1541 and his original 1564 design for the Tuileries in Paris had no more than a ground floor and an attic.

[63] Francesco di Giorgio, *Trattati*, I, pls. 159 and 175 (Saluzziano 148, fols. 86 and 94).

substituting the rectangular door with a rusticated arch surmounted by a Serliana window composed of white sandstone and white marble (figs. 7 and 8, pp. 62 and 68). While the horizontal was stressed by the regular concatenation of large rectangular windows and roundels on both stories, it was countered by pilasters that section both stories into equal bays, except for the wider central and narrower terminal units. Because of the dominance of the central bay and the distinction of the ends of the facade, Machuca's design can properly be called *hierarchical*. Again, there is no obvious model for Machuca's two main facades, so we must consider separately its distinctive features: monochromatic unity, horizontality, the near one-to-one proportions of its stories, the stylar articulation of its bays, its unusual length, the rhythmic disposition of pilasters to distinguish the central and terminal bays and, finally, its fenestration.

Machuca sought to maintain the monochromatic unity of not only the facades but also the round courtyard by restricting the materials to white sandstone for the facing, near-white limestone for horizontal courses, and white marble for the orders. His heroic opposition to the grey marble *portadas* and his compromise proposal of a one-story frontispiece in that material indicate that the monochromatic (if not monolithic) unity of a building was essential to his conception of architectural form. The homogeneity of color would have stressed not only the cubicity of the original block-design villa but also the dependency of the added forecourts and, as a result, the grand scale of the entire complex. It was by means of texture rather than color that he distinguished the two stories of the palace, with the smooth luminosity of the upper resting lightly on the strongly modeled rustication of the more massive lower story. The ornament on the main-story window crowns and the pedestals is carved of the same white sandstone as the membering and the wall facing, and so those parts, too, are distinguished from the mass of the building only by texture.

The principle of monochromatic unity has no evident precedents in stone construction in Spain. The most persistent characteristic of the exteriors of buildings in Spain is the contrast of the starkness of plain walls with the dense ornamentation on the portals and window frames and on the terminal features such as finials and *cresterías*, which are usually of a different material.[64] Even midcentury architects who designed buildings in the severe *estilo desornamentado* did not aspire to monolithic or monochromatic unity,[65] though Herrera in the Escorial and the cathedral of Vallodolid sought the appearance of architectural form cut from a common mass of granite. Of course, his sober architectural style had its roots in Italy, following Juan Bautista de Toledo, who returned to Spain in 1559. Already in the mid-fifteenth century, Brunelleschi designed a monolithic facade for the palace of the Parte Guelfa in Florence, and Alberti initiated another for the Rucellai palace in Florence; both have a common stone facing that unifies the wall and the membering. Also noteworthy is the fine, light-grey stone facing of the church of San Francesco in Rimini, which Alberti transformed at midcentury. Of course, the most effective stone for the unification of a building's surface is the travertine found in west central Italy. Its coarse, striated texture unifies wall and membering into a common mass. Around the turn of the century, the most impressive secular examples of that facing in Rome were the facades of the Cancelleria and the Castellesi da Corneto palace and, in the ecclesiastical architecture, Bramante's apse of St. Peter's, which must have had a sculptured form comparable to that of San Biagio in Montepulciano, begun in 1518 by Antonio da Sangallo the Elder.[66] Italian architects from Alberti through Bramante were impressed by travertine-faced structures such as the Colosseum and the Theater of Marcellus or the marble-faced arches of Titus and Trajan, and contemporary painters also envisioned the architecture of ancient Rome as faced with white, light-grey, or straw-colored stone or marble.[67] Theorists, such

[64] To cite a few contemporary secular examples: the University of Salamanca (1519), the Miranda palace in Peñaranda de Duero (1525), Casa de Castril in Granada (1539), and the palace of the count of Monterrey in Salamanca (1540); see Camón Aznar, *La arquitectura plateresca*, figs. 60, 110, 536, and 415.

[65] A rare example is the stylar facade of the Hospital de las Cinco Llagas in Seville, begun by Martín Gaínza in 1546, but

even here the window pediments are of a finer-textured stone than the coarse-sandstone walls and in time a white-marble *portada* was designed for the main entry; see Guerrero Lovillo, *Sevilla*, pp. 148-149, figs. 149-150.

[66] Portoghesi (*Rome of the Renaissance*, pp. 16-17) also noted the inclination to chromatic unity in the facing of High Renaissance buildings.

[67] Bramantino (*Le rovine di Roma*, p. 47, pl. XLVII) described

as Alberti, Francesco di Giorgio, and Filarete betray their preference for the white marble of Carrara—the material praised by the legendary Marcus Lucullus in antiquity for the facing of major buildings—but white or near-white stone, without blemishes or streaks, seems to have been an acceptable substitute.[68] Machuca's choice of white sandstone, straw-colored limestone, and white marble for the palace of Charles V and his persistent opposition to the intrusion of the grey marble *portadas* suggest that he also envisioned ancient Roman buildings as having a uniform, light-colored facing.

The uninterrupted horizontal membering of Machuca's original sandstone facade stresses the near one-to-one proportions of the two stories. The horizontal unity of the facade is, of course, a feature peculiar to Italy since the fourteenth century. Inevitably, special attention was paid to the relative proportions of successive stories, but there is a great deal of variation. Architects of the fourteenth and fifteenth centuries tended to diminish successive stories of a three- or four-story palace, making the ground floor very tall and reducing the top story to about two-thirds the height of the lower story, but toward the end of the fifteenth century, nearly equal heights became more frequent. Representative palaces around the turn of the century are the Cancelleria and the Castellesi da Corneto in Rome and the Strozzi in Florence; and, early in the sixteenth century, the Farnese in Rome and the Orsini di Gravina (pl. 123) and Marigliano in Naples. Bramante, Raphael, and their schools, however, tended to reduce the rusticated ground floor and to heighten the stylar main floor, with the result that one-to-one proportions were less frequent after 1520.[69] So the proportion used by Pedro Machuca was more characteristic of Ital-

ian palaces at the turn of the century than of those designed from the late 1520s.

In Spain, Machuca was preceded in the use of near-equal proportions by Lorenzo Vázquez, who returned from Italy about 1489 and three years later began the block-design palace of the Medinaceli at Cogolludo in the province of Guadalajara (pl. 115).[70] Its string course and terminal cornice (the latter surmounted by a *cresteria*) represent the first example of Renaissance horizontality in a secular facade in Spain; but, contrary to Italian practice, Vázquez raised the tympanum of the portal into the second story, thus breaking through the string course. Even so, his emphasis on the horizontal was not repeated in Spain for more than a generation, when stylar facades were designed for the convent of San Marcos in León in the far north and for the Town Hall or Casas Consistoriales in Seville in the south (pl. 117). The two facades cited are very different from one another and from the near-contemporary, all-sandstone facade of Pedro Machuca, but they share several unusual features. They have full (or nearly full) entablatures on both stories, thus stressing the horizontality of these exceptionally long facades, and the proportions of the stories are nearly one-to-one, if the socle is excluded. Also, there are marked variations in the intercolumniations of the pilasters scanning the three facades, but while Machuca's facade is rhythmically hierarchical, those at León and Seville are randomly irregular.[71] Although all three stylar facades seem to have been executed in the 1530s, Machuca's all-sandstone facades were already indicated in the large Royal Palace plan of 1528. The other two were probably designed about 1530 because the dates inscribed on the Léon facade range from 1533 to 1541 and those on the lower story of the Town Hall in Seville, from 1535 to 1539.[72]

and illustrated an ancient circular temple that he believed "era choperta de lastre de malmeria bia[n]cho." Among the painters, Andrea Mantegna, Piero della Francesca, Botticelli, Pinturicchio, Filippino Lippi, and Raphael are most notable. Vasari (*Le Vite*, ed. Ragghianti, I, p. 100) noted that the Romans faced most of their buildings with Travertine.

[68] Alberti, *Trattati*, I, pp. 135-137, 141-143 (bk. II, chaps. 8-9); Filarete, *Trattati*, I, pp. 69-73. Francesco di Giorgio, *Trattati*, II, pp. 309 and 313 (Magliabechiano II, I, 141, fol. 5 and Siena S. IV, 4, fol. 10).

[69] Wurm (*Der Palazzo Massimo alle Colonne*, p. 148) has also made this observation.

[70] Gómez-Moreno y Martínez, "Hacia Lorenzo Vázquez," pp. 18-22.

[71] The same can be said of the stylar facade of the château at Blois after 1520 and even that at Chambord (both as planned in 1519 and as altered in execution) because there also the pilasters were accommodated to the openings.

[72] A documented account of the renovation of the convent of San Marcos between 1513 and 1528 is provided by Waldo Merino Rubio (*Arquitectura Hispano Flamenca en León*, León, 1974, pp. 199-203). The record of the progress of the work in the *libros de visita* reveal that only the following parts were completed before 1528: the church and its sacristy, the chapter

Quite apart from the relative dates, the three fa-
cades seem to be wholly independent ventures in
the stylar treatment of a facade, and the three de-
signers seem to have become aware of the new
stylar format by way of different channels, since
they reflect not only different Italian schools of
architecture but also distinct phases of the Renais-
sance style. The Lombard character of the orna-
ment of the facade in León may be due to French
sculptors working there, as Chueca suggested, and
it is also true that the narrow bays and the fragile
membering of the facade are more reminiscent of
choir stalls than of the stylar facades in Italy.[73] The
pilasters do not "order" the facade; they simply
frame openings. The facade in Seville, on the other
hand, reflects the ornamental style of late fifteenth-
century Florence, for which some of the best extant
examples are found in ecclesiastical furniture or in
the settings of paintings by Ghirlandaio, Botticelli,
and Filippino Lippi. Some of the putti and *grotteschi*
carved on the pilasters and window crowns of the
Town Hall in Seville are so Florentine in style that
there is reason to suspect the participation of Tus-
can carvers. In contrast, Machuca's stylar facade is
fully Cinquecentesque in style, though its specific
artistic *milieu* must still be determined. Most sig-
nificant among the differences in the three facades
is the lack of regularity in the bays and of hier-
archical order in the Seville and León facades. In
view of these differences and the references to dif-
ferent phases of the Italian Renaissance style, it is
unlikely that the several architects could have in-
fluenced one another, and it is quite possible that
each was unaware of the projects of the other two.

In Italy the stylar palace facade had a long and
varied development, beginning with its appearance
in the architectural settings of narrative paintings
and sculptural reliefs, and in painted facades in the
second quarter of the fifteenth century. The type

was realized in stone only in the late 1450s by
Alberti in the Rucellai palace in Florence and Ros-
sellino in the Piccolomini in Pienza, and during
the last third of the century, graphic models were
illustrated in the treatises of theorists such as Fi-
larete, Francesco di Giorgio, and Fra Giocondo.[74]
In Rome at the turn of the century the orders were
usually restricted to the main story over a rusti-
cated basement; the High Renaissance version of
the type was formulated by Bramante in his Ca-
prini palace of about 1502–1505. That palace, later
owned by Raphael, is often cited as a model for
Machuca's facades (cf. pls. 31 and 119), though the
Caprini front lacks pilasters in the rusticated base-
ment and it has coupled half-columns (not pilas-
ters), equal bays (not distinctive central and ter-
minal bays), and uniform lintel crowns (not
alternating lintels and triangular pediments). Ob-
viously, this Roman invention provides the essen-
tial antetype for Machuca's main facades, but nei-
ther the Caprini nor any known Roman School
variant is sufficiently close in overall design and
component parts to be considered his model.

Machuca's enlargement of the south facade's en-
try bay to almost three times the width of the
regular bays resulted in an unprecedented stress on
the central axis of a stylar facade (fig. 7 p. 62).
In Italy the regularity of main-story fenestration
confined the central portal to the same width as
the window above it, but there are a few early
instances of a wider bay for the central portal.
Around 1450, Alberti noted that the ancients
sometimes increased the width of the central in-
tercolumniation of the portico in front of the portal
to the cella of a temple; and shortly after, he applied
the principle, rather timidly, to the bays with doors
in the stylar facade of the Rucellai palace in Flor-
ence.[75] Theorists Filarete and Francesco di Giorgio
maintained constant intervals in both stylar and

house, and nearly two sides of the cloister and its vestibule.
Because Merino's study was restricted to the Hispano-Flemish
style, he did not discuss the history of work beyond 1528, but
it is clear that the facade between the church and the main entry
was realized only in the 1530s and that major changes must
have been made in the original project for that front. Docu-
ments for the Ayuntamiento in Seville from December 1528
to June 1534 seem to refer only to the vestibule, staircase, and
chapter room—all works in the Isabelline style. That the Ren-
aissance exterior was not begun until the mid-1530s is indicated
by a document of June 1534 and the dates inscribed on the

membering of the facade. For documents, see Alfredo L. Mo-
rales, *La obra renacentista del Ayuntamiento de Sevilla*, Seville,
1981, pp. 29-79. For groundplan, illustrations, and discussion,
see Chueca, *Arquitectura del siglo XVI*, pp. 190-194.

[73] Chueca, *Arquitectura del siglo XVI*, pp. 311-312, fig. 293.

[74] Filarete, *Trattati*, II, pls. 33, 42, 103, 115, and 121. Fran-
cesco di Giorgio, *Trattati*, I, pls. 37 and 151 (Saluzziano 148,
fols. 21 and 82). Fra Giocondo, ed., *Vitruvius* (1511), fol. 4v.

[75] Alberti, *Trattati*, II, p. 561 (bk. VII, chap. 5). In this rec-
ommendation he followed Vitruvius, IV, 3, 4.

astylar facades, but Giuliano da Sangallo in 1495 designed a five-bay facade for the palace of the Della Rovere in Savona in which the central entry bay was slightly wider,[76] and Fra Giocondo in his 1511 and 1513 editions of Vitruvius followed the Albertian principle in his illustration of the stylar facade of a "Roman house" (pl. 136). The wider entry bay appeared about the same time in the stylar facade of the much-altered palace of the dukes of Vietri (now Corigliano) in Naples, designed by Giovanni Donadio (called Il Mormando),[77] but the Albertian idea had little following. If we put aside for the moment the Gonzaga villa known as the Palazzo del Te, the next instances of a wider axial bay are two palaces of about 1530, Antonio da Sangallo the Elder's odd Tarugi palace in Montepulciano and Sanmicheli's Pompei-Lavezola palace in Verona (pl. 116);[78] but, in these cases, the center bay is only slightly wider than the rest, whereas in Machuca's first all-sandstone south facade, the entry bay was 9.05 versus 3.37 meters for the regular bays. Even the boldest of the Italian examples, notably Fra Giocondo's Roman house and Mormando's Vietri palace in Naples, appear to be timid in contrast to the strong axial stress of Machuca's 1528 facades (figs. 7 and 8).[79]

While the wider center bay of the south facade had few precedents, the three-door triumphal-arch format of the west entry seems to have been even more of a rarity (fig. 8). The only precedent appears to be Raphael's entry to the residential block of the Villa Madama, as recorded in the ground-plan designated Uffizi A314, which was probably drawn by Antonio the Younger in 1519. In Raphael's three-door entry, the width of the center door is also twice that of the side doors (pls. 107-A and 110). While the projects of Machuca and Raphael have that common proportional relation, they differ in virtually every other respect. Machuca's entry is the centerpiece of an hierarchical stylar facade that is seen across a large forecourt, while Raphael's is set atop a broad staircase composed of four flights of about ten steps each.[80] Even so, Raphael's entry for the Villa Madama is the first known Renaissance use of the three-door triumphal-arch entry in secular architecture. The original stimulus may have been Francesco di Giorgio's recommendation of a three-door entry for a royal or noble palace, though he did not employ it in any of the plans illustrated in his treatise.[81] For that reason, it is not clear if he had in mind the triumphal-arch format or the three equal lanes used by the Sangallo in their projects for royal palaces (pl. 114). The first extant Italian example of the triumphal three-door entry is that of the Palazzo Grimani a San Luca in Venice, probably designed by Sanmicheli in the late 1550s.[82] Perhaps it was the regal association of the three-door entry with princes or

[76] Marchini, *Giuliano da Sangallo*, p. 46, fig. 5, pl. XIa.

[77] Roberto Pane, *Il Rinascimento nell'Italia meridionale*, Milan, 1977, II, pp. 246-248; and for a good illustration of the present state of the facade, see Gino Chierici, *Il palazzo italiano dal sècolo XI al sècolo XIX*, Milan, 1952, I, p. 159.

[78] Ibid., II, p. 163, for the Tarugi palace. Varied opinions on the date of the Pompei-Lavezola palace in Verona, together with convincing reasons for preferring 1530, are found in Gazzola, *Michele Sanmicheli*, pp. 108-110. The two leading mid-sixteenth-century theorists, Palladio and Serlio, did not foster a wider center bay in their treatises, but each designed a few stylar facades in which the bay of the central portal was slightly wider (Serlio, *Tutte l'opere*, bk. VII (1547), chaps. 17, 43, 44, and 50). For Palladio, see his elevations of the Valmarana and Barbaran palaces in Vicenza, of 1565 and 1570 respectively, in *I quattro libri dell'architettura*, Venice, 1570, bk. II, pp. 17 and 23.

[79] Portoghesi (*Rome of the Renaissance*, pp. 356-357 and figs. A-F) noted that Italians, until almost the mid-sixteenth century, used the orders in a series rather than in groups. In cases in which pairs of pilasters were used (as in the Cancelleria), the pair was contined as a series.

[80] A speculative elevation of that three-door entry is found in the wooden model made in 1984 for the exhibition of

Raphael's architecture at the Palazzo dei Conservatori in Rome; see Christoph L. Frommel, Stefano Ray, and Manfredo Tafuri, *Raffaello architetto*, Milan, 1984, p. 345.

[81] Francesco di Giorgio, *Trattati*, I, p. 70, pl. 29 (Saluzziano 148, fol. 17): "In prima le case reali e signorili debbano dinanzi a sé avere una magna e spaziosa piazza dove l'entrate delle publiche strade se riferischi. La faccia d'essa sopra due o tre gradi elevata, con una o tre porti nella sua apparienzia e fronte."

[82] Gazzola, *Michele Sanmicheli*, pp. 172-175, pl. 185. If the three-door facade Giuliano da Sangallo submitted in 1516 for the facade of San Lorenzo in Florence (Uffizi A279, pl. 158) was designed a few years earlier for the Palazzo dei Penitenzieri in Rome (as some believe), it would represent the earliest secular example of three *equal* rectangular doors; see Richard Pommer, *Drawings for the facade of San Lorenzo by Giuliano da Sangallo*, an unpublished Master's thesis submitted to New York University in 1957. Three equal arches were used in the 1530s by Sanmicheli for the Canossa palace in Verona and by Jacopo Sansovino for the Corner della Cà Grande in Venice. In 1588 Vignola used a triumphal-arch entry in his project for the facade of the Farnese palace in Piacenza (now in the Archivo di Stato in Parma; see *Mostra di Jacopo Barozzi, detto il Vignola, nel quatro centenario della morte 1573-1973. Catalogo, Vignola*, November 1973-January 1974, Bologna, 1973, illustration inserted after

signori that delayed its use in city palaces in Italy, but that reference was clearly appropriate for the palace of Charles I of Spain who was also Charles V of the Holy Roman Empire. If Machuca in 1528 proposed a second story composed of a window flanked by niches comparable to the one he designed in 1540 (and again in 1548) for the west facade, the two-story elevation could have been somewhat like the city gate illustrated in Serlio's book VI of 1551 (pl. 127).[83]

A wider bay for the central portal of a stylar facade in central Italy might be expected to have led to the use of a distinctive window above it but, surprisingly, that did not occur.[84] That development was realized primarily in astylar facades, usually above rusticated portals. Perhaps the earliest example was the one designed by Raphael around 1519 for the Tiber facade of the Villa Madama. Though the central part of that front was never built and reconstructions by modern scholars differ greatly, most believe that the portal was a rusticated archway slightly advanced from the wall plane (as it is delineated in Uffizi groundplan A273), and also that it supported a balcony for a large window or loggia above it.[85] Within the next decade, Antonio da Sangallo the Elder explored this motive on a smaller scale in several palaces in Montepulciano, most impressively in that of the Pecora (pl. 126). Its rusticated archway is advanced about forty

centimeters from the wall and is surmounted by a balustrade and an edicular window. While the latter still has the same-size opening as the rest on the main story, additional columns were placed (somewhat ineptly) on either side to support a pediment that is slightly wider than those of the other windows. Shortly afterwards, his nephew, Antonio the Younger, proposed a similar window over the portal of the facade of the Farnese palace in Rome.[86] This and the other distinctive center windows designed by members of the Sangallo family represent a logical extension of the vertical axis of a portal into the main story. The most developed example is a facade sketched by Antonio il Gobbo in the 1530s (pl. 125).[87] Closely related is the rusticated portal and loggia in Perino del Vaga's 1538 drawing of the *Raising of Lazarus*, which was to have been engraved on rock crystal (pl. 137).[88] Of course, the palace portal with a loggia was most often used in Veneto,[89] but that format must have been seen in Rome during the early sixteenth century by Jerónimo Vich, the Spanish ambassador to the Vatican from 1507 to 1525 because early in that period he sent a project from Rome for the building of his palace in Valencia and it had an arched portal surmounted by a large three-light window. Only the panels of the narrow side vanes of that window are indicated in the sketch of the facade made shortly before the palace was

p. 71. The triumphal entry of the Palazzo Convertendi in Rome (once on Piazza Scossacavalli and now on the Via della Conciliazione) pertains to the second half of the sixteenth century, and those of the Palazzo di Spagna and the Montecitorio are mid-seventeenth-century designs.

[83] The earliest of the three-door triumphal-arch formats among extant city gates is found on the inner side of the Porta San Giorgio inscribed (on the exterior) with the date 1525 and reasonably attributed to Sanmicheli. It has a large central arch and a pair of small rectangular doors on each side; see Gazzola, *Michele Sanmicheli*, pl. 25. A few years later, in 1533, Giulio Romano began the Porta della Cittadella in Mantua, which has a large central arch flanked by small rectangular doors; see Frederick Hartt, *Giulio Romano*, New Haven, 1958, figs. 415-417. Serlio included several model three-door city gates in this fourth book published in 1537 and his sixth of 1551; see *Tutte l'opera*, bk. IV, fols. 129v and 130, and bk. VI, fol. 17v.

[84] A unique example is the facade of the Roverella palace in Ferrara, usually dated about 1500-1510 and still in search of an author; see Chierici, *Il palazzo italiano*, II, p. 154.

[85] For Frommel's reconstruction of 1973 and two by Geymüller in 1885, and also for paintings of the Tiber facade dating from the early 1830s and 1930s, see Renato Lefèvre, *Villa Madama*, Rome 1975, pp. 87, 89, 190, and 263, pl. 6. The most

recent reconstruction of the Tiber facade is the wooden model displayed in the 1984 Raphael exhibition in the Palazzo dei Conservatori in Rome; see Frommel, *Raffaello architetto*, p. 343.

[86] James S. Ackerman, *The Architecture of Michelangelo*, London, 1961, I, p. 80, fig. 10, for a reconstruction of Antonio da Sangallo's facade.

[87] Giovannoni, *Antonio da Sangallo*, I, pp. 49, 167, and 323; II, figs. 22, 47, and 29.

[88] Ernst Kris, "Di alcune opere ignote di Giovanni dei Bernardi nel tesoro de San Pietro," *Dedalo*, IX (1928), p. 106, fig. e. For a similar portal, see John A. Gere, "Two late fresco cycles by Perino del Vaga," *Burlington Magazine*, CII (1960), p. 8.

[89] Josef Durm, *Die Baukunst der Renaissance in Italien* (Handbuch der Architektur, V), Leipzig, 1914, pt. 2, pp. 523-524. For the portal with loggia designed by Lorenzo da Bologna for the Palazzo Thiene in Vicenza in 1489, see Giovanni Lorenzoni, *Lorenzo da Bologna*, Venice, 1963, pp. 26-38, figs. 14-18, 125. We should note that the three-vane loggia above the rusticated arch of the villa on the Via Flaminia in Rome, begun by cardinal Antonio del Monte San Savino and continued by Pope Julius III, is now believed to have been added by Pirro Ligorio in 1561; see Coffin, *The Villa*, pp. 153-155, 171.

destroyed in 1859, but the courtyard portico (seen through the open door) is preserved and it employed a Serliana motive (pl. 130),[90] so that may have been the form of the window over the main portal. Because it is likely that Pedro Machuca returned to Spain in 1520 by way of Valencia, he could have seen the palace of Ambassador Vich, which was nearing completion at that time. While its Serliana window was of the Syrian type, its architectural membering differed from Machuca's and its portal was not rusticated. Rather, it is in the palaces and projects of the Roman School that we find precedents and analogies for the rusticated portal surmounted by a loggia that Machuca seems to have designed and constructed previous to 1535.

The Hispano-Moresque *portada* also had an influence on the evolution of the palace facade. For several centuries palace facades in Spain had been dominated by a large portal surmounted by small paired windows, blind arcades, or emblazoned panels enclosed within a rectangular frame (*alfiz*). Typical fourteenth-century examples are the portal of the former palace (now the convent of Santa Clara) at Tordesillas in the province of Valladolid, which was built around 1350 (pl. 129), and that of the old merchant's hotel, known as the Casa del Carbón, in Granada. In the early sixteenth century, variations are seen in the central panel of the Javalquinto palace in Baeza in the province of Jaén and the house on the Calle Montiel in nearby Úbeda.[91] On the Alhambra itself, there were several Nazaride examples, notably the Puerta del Vino and the portal of the Oratorio del Partal. Occasionally large loggia-like windows were placed above a doorway. A striking early example within this group is the portal of the palace of the counts of Luna in León (pl. 124), which was probably

designed in the fourteenth century;[92] and around 1500, a large single window was opened above the portal of the palace of the duke of Arcos, now preserved in the gardens of the *alcázar* of Seville. Not long after, around 1510, the main portal of the Vich palace in Valencia was provided with a Serliana window (pl. 130). While none of these Spanish portals provides a model for a Serliana window over a rusticated portal comparable to those designed for the palace of Charles V (figs. 7 and 8), the Spanish *portada* prepared Machuca to accept the Roman version of the portal surmounted by a window, whereas most of his Italian contemporaries ignored that new format until the third quarter of the sixteenth century.[93]

Another feature of Machuca's hierarchical facades are the paired pilasters at the ends of the facade, because they close the regular cadence of the bays framed by single pilasters. The earliest securely dated example known to me is again found among Francesco di Giorgio's speculative projects of the mid-1470s. It is a sketch of a five-bay, two-story stylar facade with the single pilasters replaced at the ends by a tightly coupled pair.[94] Another fifteenth-century example is the undocumented Cocchi-Serristori palace on the Piazza de Santa Croce in Florence, which is attributed to several architects and given dates that range through the latter half of the century, though a date toward 1500 would seem more reasonable.[95] While single pilasters mark the center section of that three-bay facade, the outer ends are closed by paired pilasters. In the mid-1520s, shortly after his return from twelve years of study in Rome, Falconetto used the same device on the three-bay facade of the Palazzina Cornaro (the Odeon) in Padua.[96] Several other architects who worked in Rome carried that motive to north-

[90] Juan Antonio Gaya Nuño, *La arquitectura española en sus monumentos desaparecidos*, Madrid, 1961, pp. 298-301. L. Tramoyeres Blasco, "El Renacimiento italiano en Valencia: Patio del Embajador Vich," *Cultura española*, no. 9 (1908), pp. 519-526.

[91] Chueca, *Historia de la arquitectura española*, I, p. 608, pl. 253a, for the Javalquinto palace; and Juan Paquan, *Biografía de Úbeda*, Úbeda, 1958, p. 206, fig. 66, for the house on Calle Montiel, dated 1510-1520.

[92] Lampérez, *La arquitectura civil*, I, p. 361, fig. 411.

[93] In Florence, Bartolommeo Ammannati was the most active proponent of the unification of the portal with the window above it. Major examples are the Grifoni-Gatai at Via de'Servi 51, after 1557; Giugni-Fraschetti on the Via degli Alfani, about

1560; and the Ramírez de Montalvo, Borgo degli Albizzi, 1568. Bernardo Buontalenti did comparable portals for the Nonfinito palace in Florence and the Granucci-Cancellieri in Pistoia toward the end of the sixteenth century. In discussing the "tall portal" of the Borghesi, or Del Giglio, palace in Rome, begun in 1560, Howard Hibbard stressed its extraordinary character and the lack of repetitions in Rome; see his *The Architecture of the Palazzo Borghese*, Rome, 1962, pp. 20-21.

[94] Francesco di Giorgio, *Trattati*, I, pl. 37 (Saluzziano 148, fol. 21), c. 1476.

[95] Giovanni Farnelli (*Firenze. Architettura e città*, Vallecchi, 1971, I, p. 151, II, pl. 54, fig. 301) attributes the design to Giuliano da Sangallo.

[96] Chierici, *Il palazzo italiano*, II, p. 177.

western Italy in the 1520s—most notably Giulio Romano in the Palazzo del Te in Mantua (pls. 118 and 121), Michele Sanmicheli in the Pompei-Lavezola palace in Verona (pl. 116), and Jacopo Sansovino in the Library of San Marco in Venice—and in the 1540s it appears in Serlio's books on architecture.[97] By midcentury, Palladio and others frequently used the doubled order at the ends of a stylar facade.[98] Because most of the examples cited postdate Machuca's departure for Spain in 1520, it is likely that he encountered the idea of the doubled order in the projects of Italian designers during the second decade of the sixteenth century.

The niche between paired pilasters is a familiar feature of wall tombs, tabernacles, and altarpieces in Italy, and by the 1490s, it was also used for ecclesiastical furniture in Spain; but the niche was rare in monumental architecture. To be sure, the Sangallo and Michelangelo used niches between addorsed columns in projects submitted in 1516 for the facade of San Lorenzo in Florence (pl. 131), and Antonio the Elder repeated that motive on the tower of San Biagio in Montepulciano, begun in 1518. Shortly after, it appeared in the lower story of the tower of the cathedral of Murcia begun by the Torni brothers of Florence (pl. 8). In palace facades, however, niches between paired pilasters were seldom used. The first example known to me is a model town house in the Saluzziano 148 version of Francesco di Giorgio's treatise in Turin, dated in the mid-1470s, and a drawing of a stylar building by Albrecht Dürer around 1495, presumably following an Italian model.[99] While the motive had been formulated in the last third of the fifteenth century, it was apparently little used, even after it appeared as a terminal unit in the west front of the Palazzo del Te, designed by Giulio Romano in 1526 (pl. 121).

The first known combination of all these components of the hierarchical stylar facade is, again, the Palazzo del Te in Mantua though its fronts have only a single story with an attic, while Machuca's have two stories with mezzanine and attic. In the case of the north front of the Mantuan villa, we now know that differences in the widths of the bays were due to the incorporation of an earlier building into that wing,[100] and it would seem that Giulio sought to hide those irregularities by means of a rhythmic disposition of the pilasters (pl. 118). The earlier building may account for the facade's unusually strong terminal unit, which is composed of three distinct elements: a pair of Doric pilasters with a niche between them, a two-light bay like the others, and, finally, a pair of Doric pilasters. In contrast to this concentration of stylar membering at the ends, the three-arch loggia in the wide central bay is framed by nothing more than single pilasters. As a result, the trabeation seems to be in firm control of the terminal bays but to have relinquished its dominion in the center of the facade. Perhaps Giulio himself was dissatisfied with the north front because a year later on the west he used paired pilasters with a niche between them to frame the central archway and then repeated the same motive near the ends of that facade, with an additional pilaster at the corner. It is, of course, this front that presents the closest affinity with Pedro Machuca's original south facade (cf. fig. 7 and pl. 121), but there are important differences. The smooth surface of Giulio's pilasters disengage them from the rusticated wall, whereas Pedro's pilasters are faced of the same stone as the wall. Because Pedro seems to have intended to frame the portal with paired pilasters like those at the ends of the facade, the central bay of the south facade was to have been the dominant element, while the terminal units represented a partial recurrence of the central motive. In contrast, Giulio's addition of

[97] Jacopo Sansovino in 1537 closed the extended arcade of the Library of San Marco with a Sangallesque combination of a half-column and a rectangular pillar (Heydenreich-Lotz, *Architecture in Italy 1400 to 1600*, pl. 239). Sanmicheli in 1530 used the same motive to close the stylar main story of the Pompei-Lavezola palace in Verona, and around 1554, in the Roncale palace in Rovigo, he closed the left end of the unfinished stylar facade with paired pilasters, whereas single pilasters separate the six completed bays; see Gazzola, *Michele Sanmicheli*, pp. 166-168, fig. 160. Serlio, *Tutte l'opere*, bk. III (1540), fols. 120v and 121v, and bk. VII (written in 1550), fols. 41 and 195.

[98] Palladio's stylar facades with a doubled order at the ends

include the Chiericati, Porto-Barbaran, and Thiene palaces in Vicenza. Major examples of the late sixteenth century are the Marino palace in Milan of 1558, the Salem Magnani in Bologna of 1577, and the Nonfinito in Florence of 1592. Illustrations of these facades are found in Chierici, *Il palazzo italiano*, II, pp. 227, 230, 234, 256, 280, and 307.

[99] Francesco di Giorgio, *Trattati*, I, pl. 36 (Saluzziano 148, fol. 20v, *lower right*). See Frankl, *The Gothic*, fig. 44, for Dürer's drawing in the Berlin Kupferstichkabinet, 1277v.

[100] See Shearman, "Osservazioni sulla cronologie . . . del Palazzo del Te," p. 346.

another pilaster on the outer side of the paired pilasters makes that terminal unit more than a reprise of the central unit and gives it a greater degree of independence. Thus, Giulio's west facade, designed in 1526, is less truly "hierarchical" than Pedro's south front of 1528. These several differences, together with the absence of any specific reflections of Giulio's architectural repertory in Pedro's palace, relegates the Mantuan villa to the status of an analogous work rather than a precedent for the facades of the palace of Charles V. Because Pedro and Giulio obviously drew on common sources and because Giulio was born and trained in Rome until he went to Mantua in 1525, it is virtually certain that the common sources were encountered in Rome.

This conclusion gains support from a palace designed by another alumnus of the Roman School, notably the Palazzo Pompei-Lavezola in Verona by Michele Sanmicheli. It has distinctive central and terminal units, though both are less boldly defined than Giulio's and Pedro's (cf. pls. 116 and 121, and fig. 7). Whether it was begun in 1530 or 1550, Sanmicheli's facade postdates Machuca's, but it is worth mentioning because the hierarchical facade was still a rarity and because Sanmicheli worked in central Italy for almost a decade before he returned to Verona in 1523. His combination of a rusticated basement and a stylar main floor clearly followed the format of Bramante's town house for the Caprini, begun in 1502–1505, which is reflected in the Caffarelli-Vidoni palace facade, now dated about 1522 (cf. pls. 116, 119, and 121); but, the outermost of the half-columns that scan the seven bays of the Pompei-Lavezola facade were reinforced by the addition of rectangular pillars (a Sangallesque motive), and the half-columns in the center were given a slightly larger intercolumniation. Even though the portal was given a wider bay than were the small ground-floor windows on either side, Sanmicheli diminished its effect by making

the central window over the portal the same width as the windows in the other six bays. As a result, the facade's center is weaker than its terminal motive, and that same effect was noted in the north facade of the Palazzo del Te. This is also true of the wide towerlike advances on each end of the 1503-1510 facade of the Fieschi-Sora palace in Rome, where the narrower central portal was given nothing more than a marble frontispiece of slight relief (pl. 135).[101] It would seem that while Italian designers of the High Renaissance employed some of the component elements of the hierarchical facade, they were more inclined to firmly terminate the cadence of a stylar facade than to stress its axial bay.

The hierarchical format was eventually adopted by Italian designers because it resolved problems posed by the ever-increasing length of palace facades, and Pedro Machuca's treatment of his fifteen-bay facade is best understood as an early example of that solution. We should recall that Alberti recommended a facade of no more than five to seven bays, apparently because the eye could not easily encompass more,[102] but later architects and architectural theorists, ignoring Alberti's admonition, conceived buildings with much longer facades. Some palaces proposed by Filarete, Francesco di Giorgio, and Giuliano da Sangallo had facades of thirteen or fourteen bays,[103] and the princely cardinals of Rome, in renovating the long-abandoned palaces of their titular churches, even surpassed that number. Repetition of the same bay or window effectively overwhelms the viewer when a series is extended beyond his arc of vision. Identified with Mannerism, these long facades result from the overextension of what Kaufmann called the "temple principle," which is characterized by the regular concatenation of like elements across a facade.[104] Inevitably that design principle came into conflict with the persistent Renaissance aspiration to see and comprehend the total form. To

[101] Frommel, *Der römische Palastbau*, I, pp. 97-98; II, 180-188; III, pls. 73-75. The palace itself may have been started as early as 1480.

[102] Alberti, *Trattati*, II, p. 801 (bk. IX, chap. 3).

[103] Most of Filarete's palace facades have from eight to fourteen equal bays, and in his plan for the main hospital of Milan, he extended the number of bays to twenty-eight on either side of the central entrance pavilion. Francesco di Giorgio consistently designed palace facades with an odd number of bays (in contrast to Filarete's even numbers), ranging from five to a

princely thirteen, with the number in one multicourt plan of a "villa" on the Pincio in Rome reaching about thirty; for the latter, see *Trattati*, I, pl. 154 (Saluzziano 148, fol., 83v). For the Sangallo projects for the king of Naples (pl. 114), and for the Medici on the Via Laura in Florence and on the Piazza Navona in Rome, see above, chap. 4, n. 35.

[104] Emil Kaufmann, *Architecture of the Age of Reason: baroque and post-baroque in England, Italy and France*, Cambridge, 1955, esp. pp. 80-87.

this end, architects employed repetitive fenestration as well as a common order and proportional scheme. Also facades with an uneven number of bays were favored because they could be seen as groups of three or four on either side of the axial entry bay. This device served well for five, seven, and even nine bays, but as the number was extended, it was increasingly difficult to relate the outermost to the axial bay, which was often differentiated from the rest only by the portal on its ground floor.

To resolve the problem of the fifteen-bay south facade, Machuca increased the central bay to almost three times the width of the intermediary bays, framed it with paired rather than single pilasters, and used a distinctive three-light window above the entry portal (fig. 7); then, following the logic of symmetry, he closed the ends on both levels with paired pilasters of the same kind. In the case of the original west facade, the dominance of its three-door unit was absolute (fig. 8). As we have seen, most of the component parts of both facades can be found in the sketches, projects, or extant palaces of earlier or contemporary architects in Italy; but, with the exception of Giulio Romano in the one-story Palazzo del Te in 1526, none of the Italians brought these features together to form a truly hierarchical facade until the mid-sixteenth century. Reluctance to violate the string course dividing the stories and a commitment to the "temple principle" restricted the imagination of Italian designers. Machuca was free of these restraints, and what is more important, he came from a tradition in which the portal dominated the fenestration by its size, distinctive material, and (usually) greater ornament (pls. 115, 129, and 130). The Renaissance style, although initiated in Italy, was often expanded and elaborated in similar ways by converts from other cultural areas because they saw new possibilities in architectural motives revived from antiquity or invented by Italians. Machuca's facade represents a High Renaissance solution as against a Mannerist one, in that he used

not an overwhelming extension of the bays, but rather, a visually comprehensible axial symmetry.

The fenestration of the two-story format of the all-sandstone facades was, of course, conditioned by the palace's four floor levels, as well as by the trabeation that distinguishes the central, terminal, and intermediary bays. At this point we are concerned only with the size, shape, and location of these openings. Four tiers of windows, different on each level and set at regular intervals, were interrupted only by the distinctive central bay of each front. In their regularity and openness, Machuca's facades departed from the Spanish tradition: in which windows were usually less numerous and varied in size and more freely distributed according to the need to light or ventilate the rooms of the residence. Again, Machuca's fenestration in the palace of Charles V represents an acceptance of Renaissance *dispositio* over medieval *utilitas*. To be sure, the four main-story windows of Lorenzo Vázquez's Medinaceli palace in Cogolludo have the same frames and are regularly (though widely) spaced across the astylar facade (pl. 115),[105] but in the two stylar facades cited previously, those of the convent of San Marcos in León and the Town Hall in Seville (pl. 117), the fenestration was determined primarily by the needs of the interior. Even in the 1560s, the regular fenestration of Vandelvira's palace for the Vázquez de Molina in Úbeda was an oddity;[106] thus, one can appreciate how strange Machuca's proposed elevations must have appeared to the Castilian advisers who were called upon by the emperor to judge them in the late 1520s.

The very large rectangular windows opening into the ground floor would have surprised most Spaniards because the few windows in the lower stories of Spanish palaces were small and placed high on the wall. This had been true of Italian palaces through most of the fifteenth century, but toward its end, ground-floor windows became more numerous and gradually increased in size, especially in Lombardy and Emilia.[107] The same trend

[105] Windows were also regularly spaced in the five-bay facade of the Colegio de Santa Cruz in Valladolid, initiated by the Gran Cardenal Pedro González de Mendoza about 1487 and supervised by Vázquez from about 1489; see Gómez-Moreno y Martínez, "Hacia Lorenzo Vázquez," pp. 9-10.

[106] Presumably the Úbeda facade was inspired by the "Roman house" illustrated by Fra Giocondo in his 1511 and 1513

editions of Vitruvius (pl. 136). Fernando Chueca (*Invariantes castizos*, p. 96) observed that stylar facades remained a rarity in Spain until the eighteenth century.

[107] Among the most important examples are the Fontane-Silvestre and Marliani in Milan, Bevilacqua in Bologna, Bottigella-Carminali in Pavia, Mozzanica in Lodi, Diamante and Roverella in Ferrara, and the Raimondi in Cremona.

can be detected in Siena, Urbino, and Rome, and in Florence and Naples by the second decade of the sixteenth century.[108] Though this feature represents another step in the gradual defortification of palatial residences begun in the fourteenth century, large ground-floor windows were not fostered by architectural theorists who encouraged other aspects of that trend. The larger openings in the ground floor are somewhat reminiscent of ancient Roman houses with shop openings surmounted by loft windows, a type that probably survived through the Middle Ages in central Italy.[109] The first step in its metamorphosis was the unification of the loft level to form a mezzanine floor, and that could be seen in Rome in about a dozen town houses designed from 1500 to 1525 by Bramante, Raphael, Giulio Romano, Peruzzi, and the Sangallo.[110] Toward the end of this period, the mezzanine level was introduced into major palaces to serve as servants' quarters and storage areas, but in most (as in the Farnese palace) no mezzanine windows were opened over the large windows of the ground floor. There is, however, a sketch of a one-story facade, reasonably attributed to Peruzzi around 1530 (pl. 122), in which he depicts a ground-floor fenestration somewhat like that of the palace of Charles V.[111] It is a rapid sketch of half of a nine-bay stylar facade, with banded half-columns marking four bays on either side of the central portal. Each of the side bays has a large rectangular window on the ground floor and a smaller rectangular attic window. While the latter

is not round and the architectural membering is quite different, this sketch presents the closest known analogy to Machuca's ground-floor fenestration. The two-light format is also found in the ground floor of two-story palaces such as the Canossa in Verona by Sanmicheli in 1530 and the Farnese in Gradoli by Antonio da Sangallo in 1540, but most extant examples date from after the mid-sixteenth century.[112] Within this context, Machuca's fenestration in the lower story reflects a trend that was quite new when he left Italy in 1520.

The repetition of rectangular and round windows in the fenestration of the upper story is probably unique, and the result, as Fernando Chueca observed, is "somewhat tiresome."[113] We should recognize, however, that the similarity between the two stories would have been modified by the projecting iron grilles almost certainly intended on the windows of the ground floor and the mezzanine. Salient grilles would have countered the deep splay of the attic windows but, even so, the beveled depth of the bull's-eye windows contradicts the essentially planar and linear character of Machuca's style. While I know of no model for Machuca's use of a roundel over a rectangular window on both floors, there are a few palaces, beginning with Brunelleschi's 1442 palace of the Parte Guelfa in Florence, in which roundels were used over round-headed main-story windows.[114] Filarete repeated the Brunelleschi motive in several of his model facades,[115] and this probably accounts for its appearance on the main story of palace facades

[108] Early examples include: the Spannocchi and Piccolomini in Siena; the ducal palace in Urbino; the Cancelleria, Castellesi da Corneto, Fieschi-Sora, and Baldassini in Rome; the Marigliano and Gravina in Naples; and the Pandolfini in Florence.

[109] Keith Thoreen (*The Italian Renaissance City Palace with Tabernae and its Antecedents*, Master's thesis, University of California, Berkeley, 1966) discussed *tabernae* or shop openings on the facades of city residences from antiquity through the Middle Ages and into the Renaissance.

[110] The first palace facade believed to have had shop openings and mezzanine windows is the Caprini palace designed in 1502-1505, followed by the Tribunal palace of 1507, both by Bramante. The shop and mezzanine window in the Caprini basement are enclosed within an arch and that format was repeated in the Alberini-Cicciaporci, Branconio dell'Aquila, and Riario-Corsini palaces in Rome. The unification of the two openings was further stressed by the patterned masonry of the rusticated basements of the Jacopo da Brescia, Stati-Maccarani-di-Brazza, Gaddi-Niccolini, and Caffarelli-Vidoni (pl. 120) palaces. Hibbard (*The Palazzo Borghese*, p. 18) noted that the commercial associations of shop openings made them inappropriate for major palaces and so they soon lost favor; even the windows

of the mezzanine level were sometimes suppressed.

[111] The elevation was identified as a copy of a lost sketch by Peruzzi by Frommel; see above, this chap. n. 62.

[112] Most notable among the palaces of the third quarter of the sixteenth century are the Salviati-Adimari alla Lungara in Rome, the Farnese at Caprarola and Piacenza, and the Borghese in Rome; see Hibbard, *The Palazzo Borghese*, p. 17, n. 59.

[113] Chueca, *Arquitectura del siglo XVI*, pp. 216-217.

[114] The top floor of the palace of the Parte Guelfa was constructed in 1442 during the second building campaign. The motive was repeated on the east facade of the audience hall of the Palazzo Vecchio in Florence which (according to Antonio Manetti) Brunelleschi designed. While the windows in the great hall were probably not splayed, true bull's-eye windows were used in the lunettes over the side aisles of San Lorenzo (completed after Brunelleschi's death) and they were intended in the lunettes under the dome of Santa Maria degli Angeli (if the drawing by Giuliano da Sangallo follows the wooden model). Brunelleschi may have been aware of Roman use of bull's-eye windows toward the Constantinian period—usually at the base of the domes of mausoleums on the outskirts of Rome.

[115] Filarete, *Trattati*, II, pls. 90-115, fols. 120 and 151.

in Lombardy and Emilia in the last third of the fifteenth century. A variation is found in the facade of the Orsini di Gravina palace in Naples, which was begun in 1513, but in this facade, the roundels are shallow niches for the sculptured busts of Roman emperors (pl. 123). The closest approximation to Machuca's main-story fenestration is Antonio da Sangallo the Younger's modernization of the Brunelleschian motive in a sketch of about 1525 for the upper story of the side facade of the Mint in Rome, now the Banca di Santo Spirito (cf. pls. 39 and 133).[116] Sangallo replaced the earlier round-headed window with a rectangular opening surmounted by a triangular pediment on brackets, and his sketch indicates that the attic roundel pierces a thick wall but the opening does not appear to be splayed.[117]

Within the general context of these precedents and analogies for the two-story format and the two-light bays of the main facades of the palace, we can now consider individual architectural elements, starting with those of the lower story: the limestone benchtable, the string course, the rusticated sandstone facing, and the bronze fixtures.

The benchtable was apparently not used on the facades of Spanish palaces,[118] though it was probably a familiar feature in the zaguán. Sometimes characterized as a "Florentine" motive, Machuca's benchtable recalls those of the Medici, Strozzi, and other major fifteenth-century palaces; but, that feature was used earlier and more widely in central Italy.[119] Benchtables were used in 1508 by Bramante for Julius II's Tribunal palace on the Via Giulia and by Antonio da Sangallo in 1517 for the Farnese palace in Rome, though only the upper part is still visible. Through the centuries benchtables were gradually removed along narrow streets to provide the space for carriage and then auto-

mobile traffic, and others were lost or removed with the raising of the level of the pavements of streets and sidewalks. Of course, the benchtable was reserved for the palaces of major families in central Italian cities and it served members of their entourage who gathered for discussions or to watch processions or festivities. Francesco di Giorgio Martini advised that "a royal or noble palace ought to have a benchtable (sossello) with one small step under it all around . . . ," and he cited Vitruvius as his authority, though the subsellia described by the ancient writer pertained to the elevation of theaters, not palaces.[120] Again, the central Italian tradition, both theoretical and practical, provides the most likely source of a major feature of Machuca's facades.

The string course terminating the lower story is a contracted entablature in that it is composed of two fascias, a cyma reversa, and a quarter-round molding under a strongly projecting corona. In Italy, the horizontal members of a stylar facade were usually full entablatures, while astylar facades had a simple molding, and the rusticated basements of the stylar facades of the Roman School in the early sixteenth century were terminated by a wide fillet or band, which was occasionally enriched by a fret pattern. In the innovative facade of the palace of the Branconio dell'Aquila in Rome, Raphael used a Doric order on the ground floor and (if we can trust the drawings of Heemskerck and G. B. Naldini) a contracted entablature composed of an architrave and a cornice.[121] Machuca, having chosen Tuscan pilasters for his rusticated lower story, apparently felt that they required more than the wide fillet usually used atop the astylar basements of Roman palaces, but that a full entablature would have marked too strong a division between the upper and lower floors, already dif-

[116] Giovannoni (Antonio da Sangallo, pp. 297-299) noted the inscription "per la Zecca dietro a Banchi" on the elevation (Uffizi A867). Frommel (Der römische Palastbau, II, p. 36) pointed out that, while repairs on the Mint were recorded in 1513, the present facade occupies the site of buildings not demolished until 1524.

[117] The bull's-eye window in secular architecture was admittedly rare in the Italian Renaissance, but it was used by Giuliano da Sangallo as early as the 1480s in the main hall of the Medici villa at Poggio a Caiano.

[118] The socle or stylobate of the near-contemporary facade of the Town Hall in Seville (1534-1539) is not deep enough to serve as a seat (pl. 117), so it does not qualify as a "benchtable."

[119] Although Schiaparelli (La casa fiorentina, p. 40, no. 1) considered the benchtable a typical feature of the Florentine palace,

they were cited in Pope Nicholas V's regulations for the city of Rome in 1452; see C. Scaccia-Scarafoni in "L'antico statuo dei Magistri stratiarum," Archivo Società Romana di Storia Patria, L (1927), p. 46.

[120] Francesco di Giorgio, Trattati, II, p. 344 (Magliabechiano, II, I, 141, fol. 17): "Ma per cominciare alle parte esteriori e prima, dico che el palazzo dia avere uno sosello con uno gradetto sotto di quello intorno, sopre li quall posi lo imbasamento."

[121] Giuseppe Marchini, "The Architect," The Complete Work of Raphael, New York, 1969, p. 467, fig. 72. Peruzzi also used a contracted entablature for the Doric portico and the stylar side walls of the courtyard of the Palazzo Massimo alle Colonne in 1532; see Wurm, Der Palazzo Massimo, p. 18.

ferentiated by textural contrast; so, the contracted entablature was a good solution.

The rusticated sandstone facing is sufficiently complex and varied to warrant a review of its essential features before attempting to identify precedents or analogies (pls. 31, 35, and 37). In each bay there are ten distinct pairs of blocks, together with three unique center pieces, including the keystones of the ground-floor and mezzanine windows, and there are five small and four large blocks that make up the pilasters and interlock them with the patterned masonry of the wall. Actually, each piece within a bay is unique because the heights of successive courses diminish gradually from about 55 centimeters at the bottom to about 50 centimeters at the top, and there is a comparable reduction in the saliences of these blocks, lending the impression of a slight batter to the wall. In the pilasters, where the higher relief makes the diminution more obvious, the lowest pieces project 26 centimeters and the topmost, 19 centimeters; and the alternating wide and narrow blocks also diminish in width, with the narrow block on the top differing from that on the bottom by about 7 centimeters. We are therefore dealing with an extremely subtle design in which each piece within a bay is unique. Because the pilasters are advanced from the plane of the wall, under a raking light they gain definition and clearly mark the vertical divisions of the bays, while in a frontal light they merge into the horizontal courses of the wall. Also, each individual block has a slightly convex chamfer[122] and a smooth, recessed band along the mortar line. The rest of the block was chipped or nicked with a chisel to texture the once-white sandstone. As we noted earlier, there is a bewildering variety of patterns in the chipping of the stone; but, early photographs of the south facade and my own notes on the palace in the 1940s (before the renovations of recent years) indicate that a granular texture predominated on that facade, which was faced under the direction of Pedro Machuca.

Machuca's stone facing has been described as Italianate, Tuscan, Florentine, and Bramantesque.[123] Of course, rustication was used in a great variety of forms for fortifications, city gates, *case-torre*, and civic buildings in Italy in antiquity and the Middle Ages, but it seems not to have been used on palace facades until the second half of the thirteenth century in Florence.[124] With its use on the Uzzani-Capponi palace of about 1410 and especially the Medici at midcentury, rustication became an attribute of the noble palace. In the Medici palace, the convex, rock-faced limestone blocks were uniformly about 60 centimeters high and laid in regular courses, but their lengths and protuberances varied greatly. These traits are reminiscent of rugged Etruscan or Republican Roman walls, particularly the type designated *Servian*; and, thus, they were probably associated during the Renaissance with strength and durability. Alberti at midcentury rejected massive masonry of this kind as more appropriate to the castle of a tyrant than the palace of a prince, and perhaps this attitude accounts for the indifference of theorists to rustication well into the sixteenth century.[125] Of course, the general trend toward refinement in Tuscan art during the latter half of the fifteenth century probably led to the replacement of the massive and rugged rustication of the Medici and Pitti palaces

[122] Some of the modern stonecutters who made the replacements seem not to have noticed that the chamfer of the original blocks had a slight convexity.

[123] No one has suggested reminiscences of the plaque-like *almohadillado* surface treatment of the Mudéjar tradition in Spain; see pl. 129.

[124] The fascinating history of rustication is still to be written, but there are several sketchy accounts: Emil Roth, *Die Rustika der italienischen Renaissance und ihre Vorgeschichte*, Vienna, 1917; A. Massa, "Bugnato," *Enciclopedia Italiana*, Rome, 1929-1937, VIII, p. 60; F. V. Arens, "Buckelquader," *Reallexikon der deutschen Kunstgeschichte*, Stuttgart, 1954, III, pp. 43-47; Ludwig Heydenreich, "Il bugnato rustico nel quattro- e nel cinquecento," *Bollettino Centro Internazionale di Studi d'Architettura. Andrea Palladio*, II (1960), pp. 40-41. Amado Belluzzi, "L'Opera Rustica nell'architettura italiano del prima Cinquecento," *Natura e artificio. L'ordine rustico, le fontane, gli automi nella cultura del Ma-*

nierismo europeo, ed., M. Fagiolo, pp. 137-143, Rome, 1979.

[125] Alberti, *Trattati*, II, p. 347 (bk. v, chap. 3). Rustication was used in Filarete's project for the facade of the cathedral of Bergamo, but he did not mention that treatment of the wall in his text; see *Trattati*, II, pp. 461-468, pl. 94. Francesco di Giorgio is silent on rustication, though he illustrated two house facades faced with rusticated blocks in courses and diamond-shaped studs, and he made a free drawing of the basement of the Claudianum near SS. Giovanni e Paolo in Rome; see *Trattati*, I, p. 85, pls. 36 and 144 (Magliabechiano, II, 1, 141, fols. 20v and 78v). Serlio, while responsible for the diffusion of many other architectural ideas of the Roman School, did not foster rusticated facing for palaces and town houses. Apart from the basements of two Venetian palaces and a city palace with shops in its ground floor, rustication was reserved by Serlio for city gates and portals; see *Tutte l'opere*, bk. IV (1537), fols. 155 and 156, and bk. VII (1547), fol. 63.

by the smaller, thinner, and smoother blocks used to face the palace of the Rucellai in Florence and the Piccolomini in Pienza and Siena, and the lightly convex and originally smooth blocks used in the Strozzi and Gondi palaces in Florence. Only rarely was Italian rustication gradually diminished in relief from the bottom to the top course, but that was done around 1460 in the Pitti palace facade and most subtly before 1500 in the Strozzi; and in the 1520s Antonio da Sangallo the Elder graded the rusticated courses of the palace of the Cardenal del Monte (now the Palazzo Comunale) in Monte San Savino (pl. 134) in that way.

Patterned rustication begins modestly in Florence in the upper story of the Pitti palace, faced around 1460, but Giuliano da Sangallo demonstrated its decorative possibilities in the facing of the upper story of the Gondi palace, begun in 1490 (pl. 149). Above the springpoint of the arch of the round-headed windows, Sangallo used ten distinctly shaped plaques between the keystone and the cruciform piece centered in the spandrels on either side, while the rest of the wall is faced with an alternation of stretchers and headers. In Rome, about 1502–1505, Bramante employed ten variously shaped blocks for the voussoir and spandrel pieces framing the flat arch of the shop openings and the semicircular arch enclosing the loft window of the Caprini palace (pl. 119). Somewhat less decorative than the Gondi palace, the rustication of the Caprini represents an important innovation in that its blocks were cast stone, *calcestruzzo*, a recently rediscovered Roman technique.[126] This technique enabled architects in areas without good local stone to simulate stone-faced masonry, and it provided an impetus to greater decorativeness in the variety of sizes and shapes of the blocks. Also, cast stone can be given a granular texture, with the result that the blocks appear to have both

mass and strength, qualities that had been relinquished in the smoothly surfaced and faceted forms used at the end of the fifteenth century. While regaining the appearance of strength and durability, the varied shapes and the ornamental disposition of the blocks relieved Bramante's rusticated basement of unwanted associations with the fortified castles of tyrants.[127] Raphael and his followers continued Bramante's patterned rustication, but they often replaced the forty-five-degree chamfer of Bramante's blocks with a steeper bevel that intensified the linearity of the pattern, as can be seen in the Caffarelli-Vidoni palace in Rome, now dated about 1522 (pl. 120).[128] The Raphael School also tended to increase the complexity of the patterns within each bay,[129] and Machuca's design clearly belongs to this late phase of High Renaissance rustication.

Although Machuca's blocks simulate masonry, they were clearly applied to the plane of the wall because each block was confined to one facade and none was allowed to bind a corner. As a result, the planes of adjacent fronts meet at the corners to form a sharp, uninterrupted arris (pl. 40). This was true of Italian *bugnati* in all phases of Renaissance rustication. Occasionally, the final plane of the wall was further stressed by a broad, smooth, recessed band along the mortar joints of the block, but normally that band is so narrow that it is hidden in the shadow between the projecting blocks. The most striking and perhaps the earliest example of the broad, smooth band is found along the mortar joints of the colossal stones of Bramante's rusticated basement for the unfinished Tribunal palace in Rome, designed for Julius II about 1508. Presumably Bramante and other Renaissance architects discovered this feature in the Servian walls of Republican Rome.

The granular or vermiculated texture was given

[126] See chap. 3, n. 57, for the rediscovery of cast conglomerates in the Renaissance. Bramante seems to be the first to use *calcestruzzo* for the rustication on his Porta Giulia in the Vatican and the basements of the Caprini and Tribunal palaces in Rome in the first decade of the sixteenth century.

[127] Bramante seems to have had Roman precedents for the symmetrical patterns of his stone facing. Bruschi (*Bramante*, p. 605, fig. 399) cited a drawing of the Roman forum (Uffizi A1534). The Forum of Augustus, the north side of the Septizodium of Septimius Severus, the basement of the Claudianum near SS. Giovanni e Paolo, and several walls from the Augustan period provide models for patterned rustication.

[128] Frommel, *Der römische Palastbau*, I, 108–109; II, p. 7; III,

pl. 1; and for the Caffarelli-Vidoni palace (now identified with Bernardino Caffarelli around 1522-1524 rather than with Antonio, who died in 1512), ibid., II, p. 59, and III, pl. 25. Also pertaining to this phase of Italian Renaissance rustication is the basement of the palace in which the pope was depicted blessing the faithful in the fresco of the *Fire in the Borgo*, by Raphael and Giulio Romano (about 1514), in the *Stanze* of the Vatican (pl. 140).

[129] The most complex pattern is that of the Alberini-Cicciaporci palace in Rome (1512), which has thirty-eight pairs of distinctly shaped plaques in addition to the two keystones (over the shop opening and the lunette) in each bay. Other examples are the town houses of Jacopo da Brescia and Caffarelli-Vidoni.

to the cast stone in rusticated basements during the High Renaissance. Lafrèry's engraving of Bramante's Caprini palace suggests that its rustication had a granular texture similar to that of the closely related Caffarelli-Vidoni palace (pls. 119 and 120) or Antonio da Sangallo the Younger's Regis di Baullari-Linotta or Banca di Santo Spirito facades. Outside Rome, this texture is found on the Pandolfini palace in Florence by Raphael, and on the Pompei-Lavezola palace in Verona (pl. 116) by Sanmicheli, and on the Zecca and the Palazzo Corner della Cà Grande in Venice by Jacopo Sansovino. Striations and chevron patterns were sometimes used to give an irregular but obviously man-made surface,[130] but the more "natural" granular texture predominated during the High Renaissance. Much more could be said about Italian rustication, but this brief historical sketch will serve to identify some specific examples and certain trends that might have influenced Pedro Machuca.

Machuca's blocks are set in courses of about 55 centimeters, so they are closer to those of the large palaces, such as the Medici, than to those of later town houses of the High Renaissance in Rome; but, of course, rustication is usually scaled to the size of the building. In shape, Machuca's blocks are more prismatic than the rounded forms favored by Italians previous to 1520, but the sharp arrises of his faceted blocks are in accord with the linear tendency of the Raphael School. At first glance, Machuca's blocks would seem to have had a simple forty-five-degree bevel like those of Sanmicheli's Bevilacqua palace in Verona (pl. 147) and Jacopo Sansovino's Corner della Cà Grande in Venice, both of the late 1530s; but as we noted, the chamfer of Machuca's original blocks had a slight convexity

reminiscent of the rounded form of the *bugnati* used in Rome during the first quarter of the century. The gradual reduction of the height and the salience of successive courses in Machuca's rustication has restricted precedents in the Pitti and the Strozzi palaces in Florence and an analogy in the contemporary palace of the Cardenal del Monte (pl. 134),[131] but I know of no graded *bugnati* as subtle and complex as that of the palace of Charles V. Of course, in his use of sandstone rather than cast or artificial stone, Machuca departed from contemporary practice in High Renaissance Rome, though it seems he attempted to simulate the open granular texture of *calcestruzzo* by chiseling the surface of the sandstone blocks. Even though he used costly stone, Machuca surpassed Italian contemporaries in the number of distinctly shaped blocks and the complexity of the design.

The integration of the pilasters into the complex pattern of the rustication is so unusual that it has been claimed as Machuca's invention, anticipating Vignola's use of that motive by almost a generation.[132] It is true that Italians previous to the 1520s tended to distinguish the engaged orders from the wall, either by contrasting a smooth pilaster with a rusticated wall, as in the Rucellai palace in Florence and the Palazzo del Te in Mantua (pls. 118 and 121), or by the use of banded pilasters that stand out against a smooth wall, as in Civitali's Bernardini palace in Lucca of 1510–1520, Formigine's Fantuzzi palace in Bologna, or Peruzzi's sketch for the facade of a suburban villa (pl. 122).[133] An elaboration of this type was designed around 1532 by Sanmicheli for the basement of the Bevilacqua palace in Verona; but, in this case, the bands continue the courses of the wall and cover all but the

[130] Vertical striations give texture to the *bugnati* of the town house of Jacopo da Brescia in Rome, now given to Raphael around 1515, and the facing of the Cervini palace (now the Banca Popolare) in Montepulciano, probably by Antonio da Sangallo the Elder in the 1520s. For an illustration of the latter, see Giorgio Torselli, *Palazzi di Roma*, Milan, 1965, p. 149. For the Giugni, see *Per conoscere Montepulciano. Cenni Storici. Guida turística*. Montepulciano, 1965, p. 41. Ribbed (along with chevron and lozenge) patterns are more characteristic of Carolingian than of ancient Roman rustication; see Durm, *Die Baukunst des Etrusker und Römer*, p. 111, fig. 55, g-e.

[131] The graduation was not recorded in the elevations of the palace of the Cardenal del Monte in Monte San Savino published by C. von Stegmann and H. von Geymüller (*Die Architektur der Renaissance in Toscana*, Munich, 1885-1908, v, pl. 17).

[132] Gómez-Moreno y Martínez, *Las águilas*, p. 129: "Como

novedad introdujo pilastras toscanas abajo, a modo de rafas . . . como las columnas vulgarizadas por Viñola más tarde, y que se pudo idear en vista del adarajado de la esquinas del palacio Pandolfini en Florencia." Chueca, *La arquitectura del siglo XVI*, pp. 216-217: ". . . introdujo Machuca una novedad incluso sobre lo italiano de entonces . . . anticipándose a Viñola y a los manieristas."

[133] For the Fantuzzi palace in Bologna, see Chierici, *Il palazzo italiano*, p. 156; and for the Bernardini in Lucca, see Eugenio Lazzareschi, *Lucca* (Italia Artistica 104), Bergamo, 1931, p. 112. Because we now know that the present surface of the Palazzo del Te in Mantua was applied in the eighteenth ceentury (see Forster and Tuttle, "The Palazzo del Te," p. 284), we can no longer cite it as evidence that Giulio Romano provided an early impetus to the "intermixture of rustication and the membratures of the orders," as Portoghesi claimed (*Rome of the Renaissance*, p. 360).

top of the pilaster (pl. 147). There are, however, a few instances in which the facing of the wall was also applied to the entire pilaster. The first is probably Bernardo Rossellino's Piccolomini palace in Pienza begun in 1459, though the pilasters are still distinguished because they are composed of alternate courses of oblong and pairs of square plaques, while the wall facing has no regular pattern. Twenty years later, around 1478, in the facade of San Michele in Isola in Venice (pl. 150), Mauro Codussi used square and oblong plaques in common courses to face both the pilasters and the wall surface. In the pilasters, the oblong plaques alternate with the square in pairs, whereas the rest of the wall is disposed in a strict stretcher and header bond, with the latter marking the axes of the three bays. Although Codussi's facing is made up of only two shapes and his pilasters are straight-edged, he incorporated the pilasters and the wall into a common pattern.

Pedro Machuca may have been familiar with ancient Roman examples, such as the portal in a rusticated section added by Claudius to the substructure of the Acqua Vergine near the Via del Bufalo in Rome, known to us by way of Piranesi's engraving (pl. 144).[134] The pilasters that frame that section are faced with *bugnati* of the same stone as the wall and in common courses with it. While the blocks that form the pilasters are irregular in width, there is no consistent alternation of wide and narrow pieces comparable to Machuca's. That idea may have been suggested by banded pilasters in antiquity, such as those found on the piers of the arcaded basement of the Claudianum alongside the church of SS. Giovanni e Paolo in Rome. The pilasters, from base molding to capital, are evident beneath the rusticated bands, but they are not as different from Machuca's rusticated pilasters as they might at first appear. In the Burlington elevation (which probably records his original project), the top thirty centimeters of the shafts along with the capitals were exposed in contrast to the present facade where that ambiguity was eliminated (cf. pls. 37 and 74). The partial exposure of the pilaster in the Burlington elevation marks a transitional

state between the alternate banding of the shaft and its complete replacement with alternating wide and narrow blocks, leaving only the capital visible. Thus, Machuca's extraordinary interlocked pilasters may be an inventive fusion of rusticated membering of the type in the Acqua Vergine portal and the banded pilaster.

While Pedro Machuca's interlocked pilasters seem to be unprecedented, those of Vignola and Covarrubias thirty years later are quite similar to the pilasters of the Acqua Vergine in that their component pieces vary only slightly in width (cf. pls. 31 and 144). Also their pilasters are not integrated into the complex pattern of the wall masonry. Vignola's are embedded in the piers of the rusticated three-arch entry at the base of the fortified villa of the Farnese at Caprarola, executed from 1559 to 1573,[135] and those of Covarrubias flank the arch on the exterior of the Puerta Nueva de Bisagra in Toledo (pls. 146 and 148). The specifications of the latter, signed in December 1559, state that the pilaster is to be Tuscan and that its shaft is to be composed of eleven alternating large and small blocks aligned with the pieces that frame the arch and form the outermost band of the facing.[136] Thus, the irregular silhouette of the pilaster and its integration into the masonry of the wall was expressly required. The Bisagra pilasters also frame an arch, not the bays of a fenestrated wall, and while the pilasters can be described as integrated into the masonry courses, the variation in width of the component pieces is even less than for those used by Vignola. The timidity and uncertainty in the design of these interlocking pilasters would suggest that both Vignola and Covarrubias invented or revived the motive independently and that not even Covarrubias was aware of Machuca's boldly articulated pilasters. It is, however, noteworthy that all three used the Tuscan order, which Serlio in 1540 pronounced best suited for combination with a rusticated wall.[137] Of the three solutions for the merger of the pilaster and the masonry of the wall, Machuca's is the most decisive and elegant.

The Ionic order of the upper story is surely one

[134] Giovanni Battista Piranesi's depiction may not be true in all details and only the upper half of the wall was visible in the eighteenth century, but there is no reason to doubt the common rustication of the pilasters and the wall; see Giuseppe Lugli, *Itinerario di Roma antica*, Milan, 1970, p. 110, fig. 61.

[135] Loren Partridge ("Vignola and the Villa Farnese at Ca-

prarola," *Art Bulletin*, LII [1970], p. 81, n. 3) says work on the ramp was begun in April 1559.

[136] García Rey, "El famoso arquitecto Alonso de Covarrubias," *Arquitectura*, X (1928), pp. 297-298, doc. 14, items ii, iii, and v.

[137] Serlio, *Tutte l'opere*, bk. IV, fol. 138.

of the most unusual features of Pedro Machuca's architectural repertory. The capitals, in particular, strike most viewers as whimsical oddity (pl. 153). The neck of the capital is plain, the echinus is decorated with the usual egg-and-dart and bead-and-spindle courses, and the familiar palmette extends back from the volute; but the form of the volute is strange indeed. In place of a spiral constructed of twelve quarter circles drawn from twelve different centers, Machuca's volutes have the appearance of a band of leather that runs over the top of the echinus and is tightly rolled on either side. The *rind*, as the ridge of the volute is called, takes four rather than the usual three turns and the width of the deeply cut channel is not tapered but remains constant; and the front faces of the volutes are parallel to the wall, whereas the volutes of the canonic Ionic capital are usually canted. Machuca also used this version of the Ionic capital on the lower story of the grey marble frontispiece of the south portal (pl. 55), which was completed in 1537, about the same time as the first sandstone pilasters of the upper story of the south facade were set in place.

Machuca's Ionic capitals, when shown to students of the classical orders, inevitably evoke descriptions such as "archaic," "degenerate," or "provincial," often with the sense of "hybrid." George Kubler described them as "awkward" and "strident Plateresque invasions of the Roman surface."[138] Of course, most architects of the Plateresque style favored capitals carved with fantastic combinations of human, animal, and vegetal forms, and carvers freely varied the designs of capitals within an architectural ensemble. Among the classical orders, they preferred the Corinthian and Composite, while the Ionic in any form was relatively rare, and none of the Ionic capitals used by

Plateresque architects are analogous to the leather-roll form of Machuca's volutes.[139] Unfortunately, when something unorthodox is found in Spain, it is usually ascribed to an innate anti-classical bias; but the parts of the palace of Charles V that are demonstrably Machuca's make impossible the attribution of that bias to him. More promising than the ethnic explanation is Fernando Chueca's observation that Machuca's capital is similar to one illustrated by Cesariano in his 1521 edition of Vitruvius (cf. pls. 151 and 153).[140] The rind of the Lombard's capital also makes four rather than the usual three turns and it is simply rolled, without tapering the channel or canting the volutes. Though Machuca's capital differs from Cesariano's in that his "leather-roll" is more tightly coiled and the thickness of the rind greater than that of the channel, the spiral—which is the distinctive feature of Machuca's capital—is formed in essentially the same way in both. The affinity between the two effectively refutes the association with the Plateresque style and the presumed provincialism of this odd form of the Ionic capital, and suggests that precedents will be found in the Italian tradition.

In Italy, the form of the Ionic capital remained a mystery to architects and theorists well into the sixteenth century. Their only literary source for its proportions and form was Vitruvius, but he did not clearly describe the construction of the all-important volute, and he further confused matters by saying at one point that the height of the capital should be half the diameter of the base of the shaft, and at another that it was only one-third.[141] Among fifteenth-century theorists, Alberti best understood Vitruvius, but even so, in discussing the Ionic capital, he explained that its volute was like a roll of tree bark.[142] That image describes Cesariano's version and that of the Spanish cleric and

[138] Kubler-Soria, *Art and Architecture in Spain*, p. 11.

[139] Diego Siloe used the Ionic order for the second story of the *portada* of the Colegio de los Irlandeses in Salamanca, designed about 1529, and, shortly after, in the portals and tabernacles of San Jerónimo in Granada. Juan de Marquina used it in the portal of San Cecilio in that city. In the 1530s and 1540s the Ionic order appears in the gallery of several courtyards: the Chancillería in Granada and the Hospital de San Juan Bautista a Fuera in Toledo and the Hospital de la Sangre in Seville.

[140] Chueca, *Arquitectura del siglo XVI*, p. 215; Cesariano, ed., *Vitruvius*, bk. III, fol. LVIII. For Cesariano, see Carol Herselle Krinsky, "Cesariano and the Renaissance without Rome," *Arte lombarda*, XVI (1971), pp. 211-218. Cesariano was born in Milan

in 1483, studied at the University of Ferrara, and worked as a painter in Emilia before returning to Milan in 1512, at which time he was given architectural and engineering assignments by the Sforza. For his appointments as architect to the emperor in 1528 and city architect of Milan in 1533, see Costantino Baroni, *L'architettura lombarda da Bramante al Richini*, Milan, 1941, pp. 117-118.

[141] Vitruvius, III, 5, and IV, I; see Rhys Carpenter, "Vitruvius and the Ionic Order," *American Journal of Archeology*, XXX (1956), pp. 259-269.

[142] Alberti, *Trattati*, II, p. 565 (bk. VII, chap. 6): ". . . ea re corticem arboris addidere, qui hinc atque hinc dependens et sese in anfractum convolvens latera lancium convestiret."

architectural theorist, Diego de Sagredo, who in 1526 described the spiral of the Ionic capital as comparable to "rolled parchment."[143] Though the volute in Sagredo's illustration of the Ionic capital has only two turns and is less tightly coiled than either Cesariano's or Machuca's, the three have much in common. This version of the Ionic capital was soon to be outdated when architects of the Roman School, most notably Raphael and his circle, undertook intense study of ancient orders during the first quarter of the sixteenth century.[144] That new understanding was passed on by Peruzzi to Serlio, who recorded the High Renaissance idea of the Ionic capital in his fourth book published in 1537. Using six points on a vertical line for the centers of the diminishing radii of the volute, Serlio came closer than any previous theorist or architect to the subtlety of the ancient form.[145] Vignola in 1562 represented a further clarification, but it was Palladio in 1570 who finally explained the twelve-center construction of the spiral.[146] Recognition of the prolonged confusion and the extraordinary delay in the understanding of the formation of the Ionic capital is essential to the proper evaluation of Renaissance examples. Of all the variants, the only one whose origin interests us is the leather-roll version depicted by Cesariano and Sagredo and used by Machuca in the palace of Charles V.

Cesariano seems to have modeled his form on an Early Christian version of the Ionic capital, which is best represented by the innermost circular colonnade that supports the drum of the dome of the church of Santo Stefano Rotondo, the colonnaded porch of SS. Giovanni e Paolo, and the toral arch of San Paolo fuori le Mura, all in Rome (cf. pls. 151 and 152). While the similarity would seem to support those who described Machuca's version as "degenerate" or "of the Vandal period,"[147] it is clear that some Italians in the fifteenth and sixteenth centuries thought that the Early Christian martyrium of Santo Stefano had been built by the Romans as an ancient temple dedicated to Faunus,[148] and so Cesariano and Machuca might have thought that the tightly coiled volute was an ancient version of the Ionic capital. Evidently, they were also persuaded that it was the form described by Vitruvius. They may even have known variations in Italy of the kind of capital used in the limestone pavilion at Leptis Magna, dated 8 B.C. (pl. 154). This rare Roman example lends credence to the acceptance of the leather-roll capital as the Vitruvian form. In the 1520s, the capitals of Cesariano, Sagredo, and Machuca represented honest attempts to resolve the puzzle of the Ionic capital.

The shaft of Machuca's Ionic pilasters on the upper story reflect contemporary uncertainty about another important feature of the classical orders—the entasis. The shaft is gradually narrowed from a base width of 58 centimeters to 50 centimeters at its neck, and its relief is diminished from 12 centimeters to about 8 centimeters, thus continuing in the upper story the batter of the lower (pls. 39 and 40).[149] Neither the frontal taper nor the backward inclination of the main story pilasters has been mentioned in print, though Byne and Stapley in 1917 noted the marked frontal taper of the pilasters supporting the triangular pediment of the south doorway (pl. 46) and they compared it to the exaggerated taper of an archaic Greek column.[150] But we need not look back that far, because Machuca's "refinements" differ in effect and presumably in purpose from those of Greek ar-

[143] Sagredo, *Medidas del Romano*, p. 19 (fol. Aviiiᵛ): "Línea espiral que por los griegos se dize línea hélyca: es la que sobre uno de sus cabos se rebuelve y enrosca a manera de caracol, sin jamás tocarse"; and p. 50 (Cviii): ". . . y [the capital] le fingeron estar cubierto con una gruessa corteza tan luenga: que los cabos que de una parte y de otra cayan se rollavan de si mesmos, como piel de pargamino."

[144] *Vitruvio e Raffaello. Il "De architectura" di Vitruvio nella traduzione inédita di Fabio Calvo Ravennate*, ed. V. Fontana and P. Morachiello, Rome, 1975, pp. 491-493, for the Ionic capital in an Italian translation undertaken at the behest of Raphael in 1514 and now in the Bayerische Staatsbibliothek in Munich.

[145] Serlio, *Tutte l'opere*, bk. III, chap. 7, fols. 158v-161v. See also Peruzzi's earlier drawings, Uffizi A464-A465.

[146] Giacomo Barozzi da Vignola, *Regola delli cinque ordini d'architettura*, Rome, 1763, pp. 44-47 (figs. XX and XXI); Palladio,

I Quattro libri, pp. 33-34.

[147] Admittedly some Visigothic capitals in Spain have tightly coiled volutes, but Sagredo and Machuca seem to have derived the volutes of their Ionic capitals from Cesariano rather than from Visigothic examples. The latter, if known to them, might have functioned as confirmations of the Italian theorist's model.

[148] Flavio Biondo, *De Roma Instaurata libri tres . . . de Italia Illustrata*, Venice, 1510, bk. I, fol. 11v (written in 1446).

[149] The upper story is set back 45 centimeters from the top of the lower story. This was also done in the Caffarelli-Vidoni palace in Rome, probably begun shortly after 1522.

[150] Byne and Stapley, *Spanish Architecture*, pp. 303-307. Greek, Roman, and Renaissance pilasters are conveniently discussed in Frank C. Brown, Frank A. Bourne, and John R. Coolidge, *Study of the Orders*, Chicago, 1948, pp. 7, 226, and 329-330.

chitects. The taper and the batter, or backward inclination, of Machuca's pilasters intensify the apparent convergence of their sides when seen from below, whereas Greek refinements were usually meant to counter or correct such optical illusions. Machuca did not attempt to compensate for the optical effect of perspective. He intensified it.

A more likely source of Machuca's tapered pilaster is the interpretation around 1500 of Vitruvian rules for the formation of the entasis of a column. The ancient theorist explained that the ratio of diminution from the base of a shaft to its top decreases with the height of the column.[151] For columns under 15 Roman feet (4.44 meters)—the category to which Machuca's 4.35 meter pilasters belong—the proper ratio of diminution is 5-to-6. Since the top and the bottom of the main-story Ionic pilasters measure 50 and 58 centimeters, respectively, Machuca stayed fairly close to the Vitruvian ratio. After noting the need to compensate for ocular deceptions "when the eye has to climb" to great heights, Vitruvius referred to a (lost) illustration of the entasis of the column used by the Greeks and observed that it showed how "agreeable and appropriate" the entasis can be. One could interpret his belated reference to the entasis of the Greeks as an indication that his previous comments on the tapered column pertained to a Roman practice, but his account obviously puzzled Renaissance theorists because their interpretations differ.

Alberti, in his treatise on architecture, which was nearly completed by 1452, described the entasis of a column as its "belly" (*venter*), and Filarete in the 1460s also noted that the column has to be a little fuller at the middle, with the diameter of the necking a little less than that of the base.[152] Francesco di Giorgio around 1476, in the Saluzziano version of his treatise, included illustrations of eight columns tapered from base to necking, with only two of them described as *colonne pulvinate*, that is, slightly enlarged around the middle;

and in his text he recognized that the Greeks employed the entasis, but he condemned the practice as *sozzo*, which is best translated in this case as "abhorrent" or "disgusting."[153] Perhaps he mistook Vitruvius' incidental mention of the Greek entasis to be an indication of disapproval, but he represents the distaste of the late fifteenth century for a column with a "belly." In the later Magliabechiano version of his treatise, now dated about 1492, Francesco di Giorgio illustrated the tapering of the columns, with no reference to the alternative form of the entasis.[154] A generation later, in 1511 and 1513, Fra Giocondo also illustrated the Vitruvian account with a simple taper.[155] Perhaps a few Roman examples, such as the slightly tapered Doric pilasters framing the door of the Pantheon, lent support to this reading of the ancient theorist. A decade later in 1521, Cesariano insisted on the true entasis, and illustrated it without even mentioning the simple taper as an alternative.[156] Diego de Sagredo in 1526 believed that the tapered column (*coluna retrayda*) could be diminished gradually from its base or from a point halfway up the shaft. In his illustration of the tapered column, Sagredo seems to have again followed Fra Giocondo's exemplar in the 1511 edition of Vitruvius without mentioning the alternative swell midway in the column.[157] Serlio, reflecting Peruzzian and Roman School ideas of the first quarter of the sixteenth century, noted in 1537 that the base diameter of a Tuscan column could be maintained for one-third the height of the shaft before beginning the taper toward the necking, which should be three-quarters the diameter of the base; and in 1540, he extended the same principle to all orders, although he seems to have had columns and not pilasters in mind.[158] Only in the treatises of Vignola in 1562 and Palladio in 1570 does the entasis become a fully understood and required feature of the Renaissance column.[159] Machuca, however, designed his Ionic pilasters much earlier, when turn-of-the-century theorists under-

[151] Vitruvius II, 3, 12-13. Gorham P. Stevens, "Entasis in Roman Architecture," *Memoirs of the American Academy in Rome*, IV (1924), pp. 121-152.

[152] Alberti, *Trattati*, II, p. 523 (bk. VI, chap. 13); Filarete, *Trattati*, I, p. 217 (bk. VIII, fol. 56v).

[153] Francesco di Giorgio, *Trattati*, I, pp. 45 and 61 (Saluzziano 148, fols. 12, 14v, 15r, and 15v).

[154] Ibid., II, p. 382, pl. 222 (Magliabechiano II, I, 141, fol. 34v).

[155] Fra Giocondo, ed., *Vitruvius*, bk. III, chap. 3, fol. 27. In

several other illustrations, however, the taper seems to be confined to the top third of the column (fols. 32, 33r, 33v, 34, and 39).

[156] Cesariano, ed., *Vitruvius*, bk. II, fols. LX and LXIII.

[157] Sagredo, *Medidas del Romano*, pp. 29-30 (Bv, r and v).

[158] Serlio, *Tutte l'opere*, bk. III (1540), fols. 127v-128, and bk. IV (1537), fol. 159.

[159] Vignola, *Regola delli cinque ordini*, pp. 70-71, fig. XXXIII; Palladio, *I Quattro libri*, bk. I, chap. 13.

stood Vitruvius to mean that a column under 4.44 meters should be tapered from base to necking by a ratio of 5-to-6.[160] Pedro Machuca extended that principle to pilasters.

The backward inclination of Machuca's pilaster could be seen as simply the third dimension of its taper and thus explained by the same interpretation of Vitruvius, but the inclination is somewhat steeper and the ratio of the relief of the neck to the base is 3-to-4, as against 5-to-6 for the frontal taper. I know of no comparable treatment of pilasters or engaged columns in Italian Renaissance buildings.[161]

The fielded panel on the face of the Ionic pilaster serves to emphasize its frontal taper and to stress the planar and linear character of the upper story (pls. 39 and 40). A cyma recta molding eases the passage from the rim of the pilaster into the narow channel, but the edge of the fielded panel itself is defined by a sharp arris. While not as rare as the leather-roll volute of the capital or the taper and backward inclination of the pilaster, the fielded panel is, nevertheless, another unusual motive. Apparently new to Spain, it had only a few scattered precedents in Italy. Lombard architects of the last third of the century favored pulvinated or pyramidal panels that projected well beyond the outermost molding framing the pilaster and were isolated by a wide channel,[162] and this type is found in a few buildings in Rome at the turn of the century.[163] Somewhat closer to Machuca's form is the fielded panel used on the portal of a house at 116-117 Via Montserrato in Rome; Kent thought it was

by Peruzzi around 1511, but that attribution has not been continued by recent scholars.[164] Strikingly similar fielded panels are found in Naples on the Corinthian pilasters of the main story of the Orsini di Gravina palace facade and on the pillars and responds of its arcaded courtyard and that of the closely related Sanseverino di Bisignano-Filomarino palace, both begun in the second decade of the sixteenth century (cf. pls. 39, 123, and 155). While in these instances the fielded panels are lightly beveled, the arris is sharp and only a narrow channel separates the panel and the rim of the pilaster. As we noted earlier, the Orsini di Gravina palace was probably designed by Giovanni Donadio, called Il Mormando, and begun about 1513 (although little seems to have been constructed until the 1530s); its sister palace, the Sanseverino di Bisignano, was begun in 1512 and is attributed to Mormando's follower, Giovanni Francesco di Palma.[165] Though Mormando identified the visiting Florentine architect, Giuliano da Maiano, as his mentor, he was clearly aware of the new Bramantesque palace facade in which a stylar main story is supported by a rusticated basement (pl. 119); so he might have seen in Rome pilasters with fielded panels like those of the portal on the Via Montserrato. That Rome was the center in which both Mormando and Machuca encountered that motive gains support from its use later by two alumni of the Roman School, Jacopo Sansovino and Sebastiano Serlio.[166] Some of these Renaissance architects may have known a few Hadrianic works in which the fielded panel was used, though pilasters in antiquity were usu-

[160] The upper third of the pilasters of the porch of the Palazzo Massimi alle Colonne taper from 60 centimeters to 50; see the elevations published by F. T. Suys and L. P. Haudebourt, *Palais Massimi a Rome*, Paris, n.d., pl. 9. In a drawing of the temple of Minerva in the Forum of Nerva (Uffizi A632), Peruzzi indicated a slight taper in the upper third of a pilaster; see Rosci, *Il trattato . . . di Sebastiano Serlio*, p. 18, fig. 18. Pilasters with a true entasis first appear in the second third of the century in the work of Michele Sanmicheli and Galeazzo Alessi.

[161] The late fifteenth-century painter of the *Città ideale*, now in Urbino, indicated a slight inward inclination to the addorsed half-columns of the round temple in the center of the panel, but I know of no other instances of such refinements in the Italian Renaissance; see Piero Sanpaolesi, "Le Prospettive architettoniche di Urbino, di Filadelfia e di Berlino," *Bolletino d'Arte*, XXXIV (1949), p. 326, fig. 5.

[162] For the Loggetta in the Castello Sforzesco, see Gianguido Belloni, *Il Castello Sforzesco di Milano* (L'Italia monumentale, 23), Milan, 1912, pls. 42 and 45. For the Rodari family, see Baroni, *L'architettura lombarda*, figs. 77 and 88.

[163] Tomei, *L'architettura a Roma nel Quattrocento*, p. 261, fig. 187, for the Casa Vacca. Frommel, *Der römische Palastbau*, III, pl. 74a, for the Fieschi-Sora palace; pl. 108b, for the Pichi palace; and pls. 4a and 4b, for the staircase of the Alberini-Cicciaporci palace of about 1512. Other early examples in Rome are found on the portal of the Fioravanti palace and the house of Cardinal Ascanio Sforza (formerly located at the corner of the Via dell'Anima and Via Sant'Agnese).

[164] Kent, *The Life and Works of Baldassare Peruzzi*, p. 24, pl. 23.

[165] Pane, *Il Rinascimento nell' Italia meridionale*, II, pp. 249-251, figs. 282-283, 285-286.

[166] Fielded panels were used on Corinthian pilasters by Jacopo Sansovino in the side chapels of San Francesco della Vigna in Venice, begun in 1534, and as retro-pilasters behind the freestanding columns of his Loggetta, executed in the 1540s. They were also used by Serlio; see *Tutte l'opere*, bk. VI (1551), fols. 3v, 15r, 15v, and 16. However, Mormando in Naples used the fielded panel with the Doric order, so the motive was not associated with a specific order.

ally fluted or plain rather than paneled. One example of the fielded panel on pilasters is the porch of the Temple of Hadrian at Ephesus, begun about A.D. 139 (pl. 157). Though its panel is beveled (while Machuca's is not), the recessed channel is narrow, and there is a sense of planarity and linearity that is somewhat similar. Although the pilaster with fielded panels may have been found in Roman ruins in Italy, Pedro Machuca's version seems to have been a personal variant of Renaissance examples in Rome and Naples.

The unusual base molding of the pilaster does not follow the turn-of-the-century form, which was derived from the Colosseum and the Theater of Marcellus. That standard form was composed of two torus moldings separated by a scotia, with the upper torus only two-thirds the size of the lower. By contrast, Machuca's base is closer to the one used for the Corinthian order in that it is composed (from top to bottom) of a large torus and two small scotia moldings separated by a double bead (pl. 39). In this deviation, Machuca seems to have followed an alternative base molding proposed by Cesariano in his 1521 edition of Vitruvius and by Sagredo in 1526.[167] Vignola in 1562 repeated the Cesariano form: although he mistakenly claimed that it followed the base molding of the Ionic order of the Theater of Marcellus, he probably had a dependable Roman model.[168]

The tall pedestal, rising 1.75 meters above the double plinth of limestone, has a height three times the diameter of the pilaster, and that is taller than most pedestals used in Italy during the first quarter of the sixteenth century. Still, at that time there was no authoritative proportion. Vitruvius had not defined the proper form of pedestals because they were not used in Greek and Republican Roman architecture.[169] Alberti seemed to regard them as optional and primarily a convenient way of raising a column to the desired height.[170] The several pedestals illustrated by Filarete in the mid-1460s are rather squat,[171] whereas those of Francesco di Giorgio from the 1470s have a greater range of proportion, and Fra Giocondo in 1511 and Cesariano in 1521 included illustrations of a colonnade on tall pedestals with balustrades or parapets between them.[172] As far as I know, Diego de Sagredo was the first theorist to recommend a pedestal taller than its width, though he recognized that there were no generally accepted rules for its proportion.[173] A decade later, in 1537, Serlio for the first time designated the pedestal an integral part of the orders and illustrated the height of the pedestals suited to each of the orders in a single comparative plate at the beginning of his fourth book; but, he noted that the prudent architect would proportion the pedestals according to the circumstances.[174] For the Ionic order, he recommended a pedestal twice as tall as its width; that is, the die itself was to have a height one and a half times the width of the pedestal and the top and bottom moldings were each to be one-quarter the width. That is approximately the proportion recommended by Sagredo in 1526 and used by Machuca in 1528 (if the limestone plinth is excluded), so it is likely that the two Spaniards and Serlio reflected a trend toward taller pedestals during the first two decades of the sixteenth century in Rome. The anonymous stylar facades of the Cancelleria (c. 1485) and the Castellesi da Corneto palace (c. 1499) have tall ped-

[167] Cesariano, ed., *Vitruvius*, fol. LVIIv; Sagredo, *Medidas del Romano*, p. 43. Shortly before, around 1517-1520, Antonio da Sangallo the Younger made a drawing (Uffizi A1194) for a similar base for the Ionic order in the courtyard of the Farnese palace in Rome.

[168] Frank Brown accepted Vignola's base as a valid record of a Roman base not known to us; see his *Study of the Orders*, p. 281, fig. 122 and pl. XIII. Finally, Palladio in 1570 held that the Colosseum-Marcellus base was the proper form.

[169] Ibid., pl. 258.

[170] Alberti, *Trattati*, II, pp. 560-561 (bk. VII, chap. 5); but pedestals were not mentioned in chapter 7, which is devoted to a detailed account of the plinths and bases of the several orders.

[171] Filarete, in *Trattati*, I, p. 245, pls. 39-41 (fols. 64-65), noted that almost all Roman architects placed columns on pedestals (*imbasamenti*) and the accompanying illustrations reveal that he conceived the pedestals as low, squat forms; but, in the nave arcade of the cathedral of Bergamo (pl. 28, fol. 51v), the columns were given pedestals twice as tall as their width.

[172] Francesco di Giorgio, *Trattati*, I, pl. 20 (Saluzziano 148, fol. 12v), and II, pp. 385-386, pl. 244 (Magliabechiano, I, II, 141, fol. 35v); Fra Giocondo, ed., *Vitruvius*, bk. III, fol. 55; Cesariano, ed., *Vitruvius*, bk. III, fol. LVII (incorrectly numbered XLVII).

[173] Sagredo, *Medidas del Romano*, pp. 47-48 (fols. C, viv-vii).

[174] Serlio, *Tutte l'opere*, bk. IV, fols. 158v, 159, and 161v. Of special interest is his comment on fol. 129: "Et perche nè Vitruvio, nè altro architetto, per quante ho veduto non ha mai date alcuna regola de'stilobati dette pedestalli: perche nell'antichità, per quanto si vede, queste tai (sic) cose furono fatte da gli architetti secondo i loro accidenti, & bisogni, o per alzare le colonne, o per scendere a'portici con i gradi, o per altri accompagnamenti." In 1562, Vignola held that the five orders were usually made without pedestals; see *Regola delli cinque ordine*, p. 8, fig. II.

estals incorporated into the continuous podium on which the slim pilasters rest; and tall pedestals were used during the next quarter-century in the stylar facades and in the piers of the porticoed courtyards designed by Bramante, Raphael, Peruzzi, Antonio da Sangallo, the Elder and the Younger, Sanmicheli, and Jacopo Sansovino (pls. 116 and 119). Precedents for the tall pedestal in central Italy have been stressed because it is usually considered a peculiarly Lombard feature and, when it is found outside of Italy, it is often taken to be evidence of Lombard influence.[175]

Machuca's tall pedestals are isolated from one another because their horizontal courses are interrupted by the window casings that rest on the limestone string course separating the two stories (pl. 31). By disrupting the horizontal line of the pedestals, Machuca departed from the continuous podium characteristic of Roman palaces of the first quarter of the sixteenth century. Probably introduced in the Cancelleria facade of about 1485, the podium formed an uninterrupted horizontal band on which both the pilasters and the window frames rested; but Bramante, in his Caprini palace facade of about 1502–1505 (pl. 119), lowered the main-story windows to the string course and replaced the continuous podium with individual pedestals for the coupled columns and stone balustrades for the windows.[176] Because the pedestals and the balustrades advance to a common plane and have the same height and the same terminal moldings, they combine to preserve the appearance of a podium. Raphael used this successful variation of the Cancelleria type for the facades of his Pandolfini and Branconio dell'Aquila palaces and a follower em-

ployed it in the Caffarelli-Vidoni palace in Rome (pl. 120); and it was continued in northern Italy by Jacopo Sansovino and then Galeazzo Alessi and Palladio. As the size of palaces increased during the sixteenth century, larger orders were required and their taller pedestals could no longer be made to coincide with the height of window balustrades, and so the horizontal continuity of the podium had to be interrupted. Already in 1503 in the fenestrated second story of the lower level of the Belvedere courtyard, Bramante employed an interrupted podium, in that his pedestals were 1.58 meters tall and the window railings could not have been much over a meter. Jacopo Sansovino in his Palazzo Corner della Cà Grande in Venice and Michele Sanmicheli in his Bevilacqua and Pompei-Lavezola palaces in Verona designed stylar facades with pedestals taller than the balustraded balconies, but these palaces were begun after 1530 (pls. 116 and 147).

The emblematic ornament carved on the die of the pedestals is another feature that isolates the pedestals and yet links them visually in a horizontal band across the facade (pl. 31). In the stylar facades of the Roman School, by contrast, the main-story pedestals are usually plain or modeled by recessed panels. For that reason and because he used a severe fielded panel on the pilaster, there is reason to suspect that Machuca initially intended a similar treatment of the pedestals.[177] In Spain by the late 1520s, pedestals had become an area for ornament, for both Italians and then Italian-trained Spaniards who executed sepulchers, retables, portals, and courtyard porticoes in the Renaissance style.[178] In central Italy, figural ornament had been suppressed in

[175] Tall pedestals were used for civic loggias, such as those of the Palazzo del Consiglio in both Verona and Padua (1474 and 1490s, respectively), and on the *ground floors* of some early stylar facades, such as the Raimondi in Cremona and the Carminali-Bottigella in Pavia, both of the 1490s. From the late 1480s Mauro Codussi and Pietro Lombardi occasionally used tall pedestals for portals or for the pillars in churches, and Alessio Tramello, Giorgio Spavento, and Falconetto continued the motive into the sixteenth century. However, the tall pedestal was not a peculiarly north Italian feature in the first two decades of the sixteenth century.

[176] In Mauro Codussi's Corner-Spinelli and Vendramin-Calergi palaces in Venice, the main-story windows interrupt the podium, but they have strongly projecting balconies that obscure rather than continue the line of the podium; see Chierici, *Il palazzo italiano*, I, pp. 107 and 116. The relation between the Codussi and Bramante facades must still be studied.

[177] We should recognize that a plain die is indicated for the

main-story pedestals in the Burlington elevation of the west facade, which seems to record a preconstruction project (pl. 74); but, fielded panels must have replaced the plain die or there would have been no stone in which to carve the emblems.

[178] Lombard sculptors with workshops in Genoa carved ornament on the pedestals of the portals and porticoes they made for the courtyards of the castles at Vélez Blanco and La Calahorra in southern Spain between 1506 and 1512; see Olga Raggio "El Patio de Vélez Blanco," *The Metropolitan Museum of Art Bulletin*, XXXII (Dec. 1964), figs. 17, 24, and 58. The Gaggini, Domenico Fancelli, and other Italian sculptors made monumental tombs that were shipped to Spain during the first quarter of the sixteenth century, and in most cases heraldic or ornamental motives were carved on the pedestals. But the main impetus came from returning Spaniards, notably Vasco de la Zarza (1499), Alonso Berruguete and Bartolomé Ordoñez (both 1518), and Diego Siloe (1519).

monumental architecture from Brunelleschi to Bramante, but it was readmitted in 1505 to 1520 with Michelangelo's huge figured tomb of Julius II, the marble enclosure of the Santa Casa in Loreto, Raphael's Chigi chapel in Santa Maria del Popolo in Rome, and especially in the Sangallo and Michelangelo projects for the facade of the church of San Lorenzo in Florence in 1516 (pl. 131). Sumptuous sculptural decoration evidently came to be accepted as a feature of the imperial Roman style by some architects and patrons in Italy and, even more assuredly, by partisans of the Plateresque style in Spain.[179] Diego de Sagredo, in his discussion of the orders in 1526, noted that pedestals could be carved with "medallions, arms, titles, and stories" (*medallas, escudos, títulos y storias*).[180]

Returning to the Ionic order itself, we must recognize that judgments of correctness cannot properly be made in a project of the late 1520s because there was still a great deal of uncertainty in respect to the proportions as well as the form of that little-used order, and most scholars agree that it was not properly understood until Vignola's account of 1562. His description does, however, serve to reveal the particularities of Machuca's Ionic order. While Vignola decreed that both the capital and the base molding should have the height of a half-diameter, Machuca gave slightly less to the base molding (25 centimeters as against the "radius," which is 29) and slightly more (32 centimeters) to the capital. In respect to the total height of the order, for which Vignola later recommended nine diameters, our architect used a pilaster width of 0.58 meter and a total height of 4.90 meters, which is a little over eight "diameters." Of course, some earlier Italian theorists, notably Filarete around 1464 and Cesariano in 1521, recommended a total height of only seven and a half times the diameter of the shaft, while Alberti around 1450, Francesco di Giorgio from the late 1470s, and Fra Giocondo in 1511 held that the Ionic column should be eight times its diameter.[181] In 1526 Diego de Sagredo was surprisingly early in recommending a height

of eight and a half diameters, and Serlio from 1537 illustrated examples of the Ionic order that ranged from seven and a half to eight and a half,[182] with Vignola and Palladio advancing the proportions to nine diameters after midcentury. Machuca, in using a pilaster with a height of slightly more than eight diameters in 1528, was again on the leading edge of a contemporary trend.

Because the entablatures of all orders (according to Vitruvius were to have a quarter the height of the order, Machuca's pilasters, which measure 4.90 meters, should have had an entablature of 1.24, but it is somewhat larger, 1.45 meters. He enlarged all three parts of the entablature with the greatest increase in the cornice. He may have noted that in the few extant Roman examples of the Ionic order, specifically the Temple of Fortuna Virilis and the Theater of Marcellus, the cornice was a good deal larger than Vitruvius advised; but, it is more likely that he was concerned about a formal problem that troubled Cinquecento architects. That was the dual role of this terminal member as both the entablature of the order of the upper story and the cornice of the entire two-story facade. It was, of course, the huge cornices of astylar Florentine palaces, from Michelozzo's Medici palace to Raphael's Pandolfini, that accustomed the eyes of contemporaries to a massive terminal member scaled to the whole building; and in virtually all stylar facades of the late fifteenth and early sixteenth centuries, the Vitruvian proportion persisted in the top entablature. There were, however, a few instances previous to 1528 in which the entablature was enlarged over the normative proportion. Bramante may have been the first in his Caprini palace facade, begun in 1502–1505 and recorded in the midcentury drawings of Palladio and Lafrèry (pl. 119), and around 1506 Peruzzi enlarged the frieze of the top entablature of his Villa Farnesina to accommodate attic windows. In 1515, Bartolommeo Buon increased the width of the top entablature of his extraordinary stylar facade for the Scuola di San Rocco in Venice, and so did Antonio da Sangallo in the palace of the Cardenal del Monte in Monte San Savino in

[179] Earl E. Rosenthal, "The Image of Roman Architecture in Renaissance Spain," *Gazette des Beaux-Arts*, LII (1958), pp. 329-346.

[180] Sagredo, *Medidas del Romano*, p. 48 (fol. Cvii).

[181] Alberti, *Trattati*, II, pp. 564-569 (bk. VII, chap. 6). Francesco di Giorgio, *Trattati*, I, pp. 57-58, pls. 24-25 (Saluzziano

148, fols. 14-15); II, pp. 373-376, 378, pls. 216-219 (Magliabechiano II, I, 141, fols. 31v-33). Fra Giocondo, ed., *Vitruvius*, bk. III, fols. 28v-29v.

[182] Sagredo, *Medidas del Romano*, pp. 24-26 (fols. Biii-Biv). Serlio, *Tutte l'opere*, bk. IV, fol. 161v.

the 1520s (pl. 134). The practice became more fre-quent in the 1530s, when Sanmicheli designed his Bevilacqua and Pompei-Lavezola palaces in Ve-rona (pls. 116 and 147); but his contemporary, Jacopo Sansovino, was even more decisive in the enlargement of the top entablature of his palaces in Venice, notably the Corner della Cà Grande, the Zecca (originally two stories), and the Library of San Marco. Machuca's top entablature clearly pertains to this trend in the Roman School.

Because the cornice of Machuca's entablature has corbels (pl. 39), it is sometimes described as "Corinthian," with the implication of confusion or ignorance of the proper cornice for the Ionic order; but again, we must recognize that the brack-eted cornice was not reserved for the Corinthian and Composite orders until the third quarter of the sixteenth century, and then primarily by Vi-gnola and Palladio. Earlier theorists, such as Al-berti, Filarete, Francesco di Giorgio, and Sagredo, made no such restriction;[183] and, as late as 1537, Serlio illustrated the Ionic order with a bracketed cornice, citing as his model a Roman ruin located between Sant'Adriano and San Lorenzo in Rome.[184] Of course, corbels or brackets had become a fa-miliar feature of the cornices of central Italian pal-aces since Michelozzo's invention of the cornice of the Medici palace, and Machuca followed that standard Italian form, but the rain spout in the form of a lion's head on the top molding is an imperial Roman feature that was not often used in the Italian Renaissance—though it is found in Ce-sariano's illustration of an Ionic cornice in 1521.[185] Usually reserved for richly ornamented buildings, the lions' heads were used on the Corinthian facade of the Scuola di San Rocco in Venice, begun in 1516, and on Jacopo Sansovino's palace known as Corner della Cà Grande and his Library of San Marco in Venice, both started in the late 1530s, and then on the cornice designed by Michelangelo in 1546 for the astylar facade of the Farnese palace

in Rome. From these observations, it is clear that in the late 1520s no one familiar with contempo-rary Italian Renaissance architecture would have considered Machuca's cornice inappropriate for the Ionic order, and the remainder of the entablature would also have been wholly acceptable.

The last aspect of the proportions of the Ionic order of the main story to be discussed here is the intercolumniation, or the width of the facade bays, and its possible relation to the overall proportions of the palace. With the base of the pilaster meas-uring 0.58 meter and the interval between the cen-tral axis of one pilaster and the next being about 3.37 meters, the intercolumniation of the facade bays is well over the five-diameter interval called araeostyle and considered by Vitruvius to be the maximum open span that could safely be used for temple peristyles.[186] Only the paired pilasters at the ends of the facades (and those that probably framed the central bays of the two main facades, figs. 6 and 7, pp. 62 and 68,) remain within the Vitruvian scheme, since their intercolumniation is two and a half diameters, or pycnostyle. Of course, in the wall membering, in contrast to free-standing colonnades, there is no concern for stability, so there was no need to restrict the intercolumniations to the five-diameter limit. Even the Rucellai palace designed by Alberti about 1458 surpassed the araeostyle since its facade has bays six times the width of the pilasters, and stylar facades at the turn of the century in Rome and Naples (pl. 123), and in northern Italy, usually had even wider bays.[187] The new stylar facades with rusticated basements in Rome, beginning with Bramante's Caprini pal-ace of about 1502–1505 (pl. 119), have somewhat narrower bays—their intercolumniations are usu-ally six to seven diameters—and they were reduced further to the araeostyle by Sanmicheli in his Pom-pei-Lavezola palace (pl. 116) and then by Galeazzo Alessi and Palladio.[188] Within this sequence, Ma-chuca's use in 1528 of a bay under six diameters

[183] Alberti believed that the Corinthians employed the en-tablature of the Ionians; see Trattati, II, pp. 586-599 (VII, 9). Filarete, in Trattati, I, pp. 242-245, II, pl. 38 (Magliabechiano II, I, 140, bk. IX, fol. 64), stated that brackets could be used on the last member of a cornice, without restricting it to the Cor-inthian. See also Francesco di Giorgio, Trattati, II, pp. 338-339, pl. 227 (Magliabechiano II, I, 141, fol. 37); Sagredo, Medidas del Romano, pp. 60-69 (fols. Dv-Ei).

[184] Serlio, Tutte l'opere, bk. IV, fol. 162.

[185] Cesariano, ed., Vitruvius, bk. III, fol. LX.

[186] Vitruvius, III, 3, 5.

[187] The list of palaces includes the Cancelleria and the Ca-stellesi da Corneto in Rome, the Carminali-Bottigella in Pavia, the Raimondi in Cremona, the Vendramin and the Scuola di San Rocco in Venice, the Roverella in Ferrara, and the Orsini di Gravina in Naples.

[188] Alessi's araeostyle facades include the Scassi, Peschiere, and Cambiaso villas near Genoa, while Palladio's are the facades of the Chiericati, Thiene, and Porto Barbaran palaces in Vi-cenza.

wide was in keeping with the tendency of the Ro-
man School to reduce the ample bays used around
1500 to six and, by midcentury, to the five di-
ameters recommended by Vitruvius.

An overall proportional scheme for the plan and
elevations of the palace of Charles V is inferred by
Luis Hurtado's praise for the "grace and propor-
tions" of the lost first project, but he may have
been referring to nothing more than the geometric
configuration that determined the width of the cir-
cular corridor and the enclosing wings of the palace
(fig. 5, p. 60), because there is no indication that
the geometry of the plan was reflected in its ele-
vations. One might also have expected the pro-
portions of the Tuscan and Ionic orders to be ex-
tended to the bays of the stylar facades, but that
was apparently not done because there is no evi-
dence for a consistent scheme in the measurements
of Pedro's south facade. None of the measure-
ments are clear multiples of the 58-centimeter di-
ameter of the Ionic pilasters. Not even the width
of the bays (at 3.37 meters for the intermediary
and 9.05 meters for the center) can be related to
standard intercolumniations of the order, and no
better results can be extracted from the Burlington
elevation (pl. 74). Of course, we know the palace
suffered many changes in both plan and elevation
during the design and construction phases, and so
an initial proportional scheme could have been
compromised again and again until it was totally
obscured.

The failure to find consistent proportions in the
plan and elevations of the palace of Charles V is
not unusual in the case of Renaissance palaces. To
be sure, Italian theorists stressed the importance of
proportionalità in architectural design, and propor-
tional schemes have been found in some Renais-
sance churches, but convincing evidence for such
schemes are rarely extracted from secular build-
ings.[189] Studies on proportions by modern scholars
are based less on extant buildings than on the writ-

ings and exemplars of theorists who discuss the
orders and arithmetic, geometric, and musical
schemes.[190] The intricacies of the musical propor-
tions are also found in contemporary philosophical
treatises, but they are usually discussed in the ab-
stract, quite independent of practical architectural
considerations. The sizes and placements of doors
and windows had to take into account security and
the disposition of the rooms. For these reasons,
most architectural theorists recognized that a pro-
portional scheme was nothing more than a point
of departure and that concessions would have to
be made for structural, technical, and functional
reasons.[191]

As to the membering of the main facades, the
feature that serves to relate the order to the wall
is the broad surround framing each bay. Its lower
part is bound to the pedestal of the pilaster by
common moldings, while its upper corners are
pierced by the volutes of the Ionic capitals, and its
vertical edge provides a plumb line for gauging
the taper of the pilasters. The top band of the sur-
round is "supported" by a bracket center in each
bay, and (on the south facade) the cyma reversa
molding that edges the surround breaks to pass
under the bracket as does the narrow channel be-
tween the surround and the fielded panel that frames
the bull's-eye window. Gómez-Moreno compared
this treatment of the wall to the facade of San
Bernardino in Aquila,[192] which has a bold, un-
molded surround framing each of its three bays,
with a bracket *under* it in the center bay and a pair
of brackets mounted *on* it in the side bays (cf. pls.
39 and 143); but we now know this church was
not begun until 1525, five years after Machuca's
departure from Italy, and (according to a lost in-
scription on the cornerstone) the facade of San Ber-
nardino by Cola dall'Armatrice was not started
until 1527.[193] We must therefore assume that Cola
and Pedro drew on common sources. Although
surrounds were already used in the fifteenth cen-

[189] The difficulty of finding convincing evidence for overall
proportional schemes is evident in the recent attempt to apply
the Vitruvian grid for the hypostyle Greek temple to the plans
and elevations of Florentine palaces; see George L. Hersey,
*Pythagorean Palaces. Magic and Architecture in the Italian Renais-
sance*, Ithaca and London, 1976.

[190] Rudolf Wittkower ("The Problem of Harmonic Propor-
tion in Architecture," *Architectural Principles in the Age of Hu-
manism*, Cambridge, 1967, pp. 101-154) depended almost to-
tally on the theorists, and so did Soergel (*Untersuchungen über
theoretischen Architekturentwurf von 1450-1550 in Italien*). P. H.
Scholfield (*The Theory of Proportion in Architecture*, Cambridge,

1958, esp. pp. 33-81) considered Renaissance architects unsuc-
cessful in their attempt to develop a practical theory of pro-
portions.

[191] Vitruvius (VI, 2, 5) advised the use of a module to govern
the proportional scheme of a building, but he added that one
need not hesitate to depart from it.

[192] Gómez-Moreno y Martínez (*Las águilas*, p. 131) consid-
ered the surround so personal a motive that he attributed to
Machuca the design of San Bernardino in Aquila.

[193] J. C. Gavini, *Storia dell'architettura in Abruzzo*, Milan and
Rome, n.d., II, pp. 300-302. The cornerstone inscription reads
MDXXVII COLA AMATRICIUS ARCHITECTOR IN-

tury,[194] Machuca's bold surround is closer to the form used by architects of the Roman School in the early sixteenth century. Most similar is the surround framing the windows in the stylar end bays or risalits of the northwest facade of the Fieschi-Sora palace in Rome, executed in 1503 to 1510 (pl. 135).[195] The broad surround is also open at the bottom of the bay because it continues down alongside the pedestal, and it is bound to the pedestal by a common molding at its base and by a molding comparable (not identical) to the cymatium at its top. There is also a central bracket; however, it is not placed under the surround, as it is in Machuca's south facade, but on the face of the surround, as it is in the side bays of the 1527 facade of San Bernardino in Aquila. In the latter, travertine stone was used for the surround, the Doric pilasters, the pedestals, and the entablature, while the wall is of brick. In Machuca's facades the surround serves to unify the wall and the trabeated elements because they are all of sandstone. The surround also appears on the third tier of the arcades enclosing the lower courtyard of the Belvedere (the part near the Braccio Nuovo of Sixtus V), where it is also bound by moldings to the pedestals of the pilasters of that story; but scholars disagree on both author and date: it is given to Bramante around 1510 and to Antonio da Sangallo the Younger around 1520–1525.[196] Another comparable surround was used on the main story of the facade of the Palazzetto Spada on the Piazza Caprettari in Rome, which most scholars have attributed to Peruzzi and, reasonably, dated close to his 1520 Ossoli-Missini palace.[197] While other examples in the works of the Roman School might be cited, the closest analogies are the surrounds of

the Fieschi-Sora palace, the Belvedere, and the Palazzetto Spada in Rome.

The use of the surround by Alonso Berruguete (on the stylar facade he designed for his house in Valladolid)[198] suggests that the two Italian-trained Spaniards were predisposed to accept that motive because of its similarity to the *alfiz* in the Hispano-Moresque architectural tradition. Essentially a rectangular frame that encloses the spandrels of an arched opening, the *alfiz* was rarely used in a stylar context. One such example frames the pointed horseshoe arch of the portal of the palace of Doña María de Molina in Valladolid, completed about 1295 and later turned over to the monastery of Las Huelgas (pl. 142). While the architectural repertory differs, the slim pilaster-strips with bracketlike capitals and the rectangular *alfiz* frame the blind arch in essentially the same way as the stylar elements and the surround used by Machuca and the Roman School. Again, it would seem that the similarity of a Renaissance motive pertaining to the Spanish tradition predisposed Machuca to admire a secondary feature in the architectural repertory of the Roman School.

The crowns of the main-story windows have been variously described as "strident Plateresque invasions of the Roman surface" and as "Roman palace windows,"[199] but no models for Machuca's main-story window crowns can be found in either of these architectural traditions.

Pediments and lintels supported by consoles were first used during the Renaissance for doorheads. Alberti revived the "Ionic door," which was described by Vitruvius[200] and known by way of ancient examples in Latium and Dalmatia.[201] By 1470, several portals following that format were exe-

STRUXIT. The second story was not completed until 1540 and the central portal, 1562. Arnoldo Bruschi and Mario Rotili believe that, while Cola worked primarily in Ascoli Picena, he had visited Rome and Florence around 1525 and that the Aquila facade reflects works of Raphael and Sangallo in those cities.

[194] Florentine painters from the 1430s to the 1520s articulated the bays of stylar walls in the backgrounds of their paintings by means of surrounds, which were often different in material or color; and, from the mid-fifteenth century, surrounds were also used in Florentine retables, altarpieces, tabernacles, and wall tombs. By the end of the century, the surround appears in architecture in central and northern Italy and by 1510 in Naples, but in all these examples the surround is lower in relief than those used by Machuca and Cola dall'Armatrice.

[195] Frommel, *Der römische Palastbau*, II, pp. 180–188; III, pls. 73–75.

[196] Deoclecio Redig de Campos, *I Palazzi Vaticani*, Bologna,

1967, p. 127; Bruschi, *Bramante architetto*, p. 352, fig. 115.

[197] Frommel (*Der römisches Palastbau*, I, p. 9) and Portoghesi (*Rome in the Renaissance*, p. 364) accepted Burckhardt's and Kent's attribution of the palace to Peruzzi.

[198] Our only record of the original appearance of the facade of the Berruguete's house is a drawing by Carderera; see Juan José Martín González, *La arquitectura doméstica del Renacimiento en Valladolid*, Valladolid, 1948, pp. 141-142.

[199] Kubler-Soria, *Art and Architecture of Spain and Portugal*, p. 11; Byne and Stapley, *Spanish Architecture*, p. 302.

[200] The first Ionic doors of the Renaissance are probably those on the facade and in the narthex of Alberti's church of San Sebastiano in Mantua in the 1460s. Vitruvius (IV, 6, 3-4) described it as an "Ionic" door, while Serlio (*Tutte l'opere*, bk. IV, fol. 173) called it "Corinthian."

[201] Several drawings of Ionic portals by Peruzzi (Uffizi A632-633) were identified as doorways in the Baths of Trajan (see

CHAPTER FIVE

cuted in Mantua and Naples.²⁰² Some examples must have been known to Lorenzo Vázquez previous to 1489 because on his return to Valladolid he employed a lintel on consoles over the portal to the library of the Colegio de Santa Cruz;²⁰³ but, I know of no repetitions of the type in Spain previous to Machuca's use of lintels and triangular pediments on consoles. Perhaps the first examples of "Ionic windows" are several drawings in the Saluzziano version of Francesco di Giorgio's treatise, dated about 1476. One of his facades has lintels and semicircular pediments on consoles over relatively small ground-floor windows, and in another facade that kind of crown was used for main-story windows.²⁰⁴ In High Renaissance facades, pediments and lintels usually rest on half-columns or pilasters, or directly on the window casing, but a few Italian contemporaries of Machuca may have followed Francesco di Giorgio's Ionic window in some projects unknown to us.

The alternation of window crowns has ample precedents, but usually the triangular pediment was combined with the segmental form, not the lintel. Filarete in the 1460s and Francesco di Giorgio in the 1470s used that combination in their model facades and in 1498 Simone del Pollaiuolo, called Il Cronaca, proposed alternating pediments for the top story of the Strozzi palace in Florence.²⁰⁵ The earliest extant architectural examples of the type are those of the Roman School, notably the main-story windows of the town house of Jacopo da Brescia, usually dated about 1514 and attributed to Raphael or his school, and also several palaces

designed by the Sangallo in the 1520s, specifically the Tarugi in Montepulciano by Antonio the Elder and the Ferratini in Amelia and the Regis ai Baullari in Rome by Antonio the Younger. More nearly comparable to Machuca's main story is the previously cited project for the side facade of the Mint or Banca di Santo Spirito in Rome, also designed about 1525 by Antonio the Younger (pl. 133). In addition to its round and deeply recessed attic openings, its main-story window pediments rest on consoles.

In contrast to Machuca's pedimented windows, Italian crowns are usually quite plain. Consoles are not leaf-faced and there is no bay-leaf roll or fruit swag between them, and ornament is rarely set on top of the pediment. Not only in the Roman School but in Italy generally, ornament of any kind was rare during the first third of the sixteenth century. Toward 1530 the pediments of interior doors were sometimes enriched with sculptural ornament, and members of the Roman School working for north Italian patrons often indulged in sumptuous decoration. One example is a doorhead sketched by Francisco de Hollanda and identified only as *em Genoa*, but its ornament clearly reflects the style of Perino del Vaga, who worked in Rome before going to Genoa in 1528 (pl. 159).²⁰⁶ The doorhead is composed of a segmental pediment on consoles with a bay-leaf roll suspended between them and sculptured figures reclining on the top of the pediment. Its bay-leaf swag has fruit (probably pears or figs) that project between the bay leaves and are aligned along the central axis. Serlio in 1537 also

Bartoli, *I Monumenti antichi di Roma*, II, p. 57, pl. 318), and other drawings are found in his sketchbook in the Biblioteca Comunale in Siena (IV, 7, fols. 38 and 45). Serlio cited models at Palestrina and near Split as the sources of his Ionic doorway (which he called Corinthian); see *Tutte l'opere*, bk. IV, fol. 173r and 173v. Antonio da Sangallo the Younger identified a drawing of this type of portal (Uffizi A1165v) as the doorway of the Temple of Hercules at Cori in Latium. A rare example is provided by the main portal of the cathedral of Salerno, dedicated in 1084; see Max Wegner, "Spoilen Miszellen aus Italien," *Festschrift Martin Wackernagel zum 75 Geburtstag*, Graz, 1958, p. 8, fig. 5.

²⁰² Luca Fancelli used the Ionic doorway for the entry to the Sala degli Sposi in the ducal palace in Mantua shortly after 1470, and it served as the frame for the main entries of the palaces of the Carrafa di Maddaloni (1466) and Antonello Petrucci on the Piazza San Domenico Maggiore (1470) in Naples; see Pane, *Il Rinascimento nell'Italia meridionale*, I, pp. 209-211, figs. 213 and 216. Another early proponent of the Ionic portal was Filarete in his mid-1460s use of that form for the side doors in his project for the facade of the cathedral of Bergamo; see

Trattati, pl. 94 (fol. 123).

²⁰³ Gómez-Moreno y Martínez, "Hacia Lorenzo Vázquez," p. 11, fig. 7. In place of the bay-leaf roll, Vázquez used a frieze with the anthemion motive.

²⁰⁴ Francesco di Giorgio, *Trattati*, I, p. 288, pl. 175 (Saluzziano 148, fol. 94). Corrado Maltese noted that these unidentified facades were included among drawings of Roman buildings and he suggested they were the facades of tombs.

²⁰⁵ Francesco di Giorgio, *Trattati*, I, pls. 36 and 37 (Saluzziano 148, fol. 20v and 21); Filarete, *Trattati*, II, pl. 124 (fol. 169v). Cronaca's model for alternating triangular and segmental pediments for the top-floor windows of the Strozzi palace is preserved in the palace itself. Cronaca used the same motive for clerestory windows on both the interior and exterior of the church of San Salvatore al Monte in Florence, begun about 1499. See Giuseppe Marchini, "Il Cronaca," *Rivista d'arte*, XXIII (1941), pp. 108-118, figs. 6, 7, 10, 12, and 13.

²⁰⁶ Elías Tormo, *Os desenhos das antigualles que vió Francisco d'Ollanda*, Madrid, 1940, fol. 47 and p. 208. Kruft's *Portali genovesi* (p. 18) identified Hollanda's model as a work in the style of Perino del Vaga.

used a fruit swag between consoles supporting the lintel of a model fireplace in his fourth book (pl. 160). In all the Italian examples, the weight of the swag was indicated by the slight sag from the points at which it is tied. That feature is also seen in the window swags in the Burlington elevation (pl. 74), so presumably the odd cylindricity and rigidity of the swag in the present windows may have been introduced by the carvers.

Of Machuca's two window crowns, only the lintel presents a problem in identifying precedents or even analogies. The problem is compounded by the fact that in the Burlington elevation this crown has the appearance of a sloping hood rather than a simple lintel (pl. 74); and if the sandstone portions of the elevation were copied from a pre-construction drawing, the reduction of the hood to a lintel must have been the result of heightening the opening of the main-story windows by about 28 centimeters. Therefore, we must consider the possibility that the hooded crown supporting three vases was Machuca's first idea and that it was transformed into a lintel with a small scrolled ledge. An early example of the hooded lintel (without ornament) is found on the ground and main-floor windows of the Palazzo Lante on the Piazza dei Carpretari in Rome (pl. 141). It was begun by Pope Leo X around 1514, with Giuliano da Sangallo and then Jacopo Sansovino as his architects, and then it passed to the Lante family in 1533.[207] It was, however, only during the latter half of the sixteenth century that the hooded lintel resting on consoles or directly on the window casing became popular in Rome.[208]

The description *Plateresque*, sometimes used for the window crowns of the palace of Charles V, is valid for some of the ornament, specifically the boys that emerge from leaves and hold baskets of fruit on their heads and the dolphins flanking a scallop shell (here attributed to Juan de Marquina), but the vases are less readily claimed for that style. Closely related motives, such as candelabra and torches, were standard on windows or portals (such as Luis de Vega's portal for the Dueñas palace in Medina del Campo in the late 1520s, pl. 9), but vases of the type used on the palace of Charles V only begin to appear in Spain around 1530. The earliest examples known to me are the vases on the lunette over the windows flanking the main entry to the Miranda palace at Peñaranda de Duero (Burgos), and the same format was repeated in a portal in its main hall, with the probable date for both being 1527–1530.[209] Furthermore, the mirror reversal of the ewers on either side of the vase in the center of Machuca's windows and the disciplined repetition of the same format on all the lintel crowns are at odds with the inclination of the Plateresque architects to variety and liveliness in ornament.

Machuca's symmetrical disposition of water ewers on either side of a vase has no known Renaissance precedents or analogies. At midcentury three equal vases were used on window crowns, sometimes on hooded lintels, by Serlio, Formigine, and Vignola,[210] but I know of no earlier examples, not even in Emilia where all three started their careers.[211] Under the circumstances, it is worth noting that the handles of the ewers in the Burlington

[207] Frommel, *Der römische Palastbau*, I, p. 100; II, 224-243; III, pls. 87b, and 148b, for the hooded lintels of the Palazzo della Valla, begun 1508-1515.

[208] Post-1550 Roman palaces with window crowns in the form of hooded lintels include the Lovatellie, Ruspoli-Caetani, Sacchetti, Lancellotti-Torres, and Monte di Pietà; see Giorgio Torselli, *Palazzi di Roma*, Milan [1965], pp. 156, 163, 189, 243, and 245.

[209] Byne and Stapley, *Spanish Architecture of the Sixteenth Century*, pp. 113-129, pl. XXI and fig. 39. Camón Aznar (*La arquitectura plateresca*, p. 82) suggested the date 1525-1530, primarily on the basis of the general repertory of decorative motives used in the palace. Representative later examples include the *portadas* of the church of San Salvador in Úbeda (1536), the Miranda palace in Burgos (1545), the main facade of the Hospital de la Sangre in Seville (1546) and its church (1560), the cathedral of Almería (1556), the Casa de los Villalones in Cordoba (1560), and the palace of the Counts of Robagorza in Benasque in Aragón (c. 1560). While candelabra and torches continued to be used alongside vases during the second third

of the century, all three were replaced by spheres during the Herreresque period.

[210] Prime examples are the main-story windows of Formigine's post-1515 Bentivoglio palace in Bologna, Serlio's 1546 château at Ancy-le-Franc, Vignola's midcentury Palazzo dei Banchi in Bologna, and the Lancellotti-Torres palace and Villa Giulia in Rome. Maria Walcher Casotti (*Il Vignola*, Trieste, 1960, pp. 61-63, 69-79) described Vignola's windows as "Bolognese," but no specific precedents were cited. The "odd crown of urns" was considered peculiar to Vignola by John Coolidge ("The Villa Giulia," *Art Bulletin*, XXV [1943], p. 199, n. 159).

[211] Vases were occasionally used to decorate pediments or roofline lunettes in northern Italy and Naples; see Filarete, *Trattati*, II, pl. 45 (fol. 70); Luigi Angelini, *Le opere in Venezia di Mauro Codussi*, Milan, 1945, pp. 46-51, fig. 18; and Carlo Pedretti, *Leonardo da Vinci. The Royal Palace at Romorantin*, Cambridge, Mass., 1972, p. 111, fig. 167 (Codex Atlanticus, 217v-b). Vases flank a scrolled central unit mounted above the portal of the Pozzobonelli palace in Savona (Liguria), dated about 1510-1515, and vases were placed on either side of Virtues on

elevation are turned outward, while those on the present window crowns are turned inward (pls. 39 and 74). Hence, the disposition in the Burlington elevation (taken to be the first design of 1528–1532) is closer to the symmetrically arranged vases on the grave stele of the Stoic philosopher Panaitios in the National Archeological Museum in Athens (pl. 158).[212] While Machuca is not likely to have known this unusual stele, he might have seen another ancient example using similarly disposed vases. However that may be, the mirror symmetry of Machuca's vase motive distinguishes it from subsequent Spanish and Italian examples.

The deeply splayed bull's-eye window, often identified with the Romanesque style, was also used by late Roman architects, and it was revived in the Renaissance, first in Italy and then in Spain, mostly for use in churches. Especially favored in Lombardy during the Renaissance, the bull's-eye window also appeared in Tuscan projects, notably those of Francesco di Giorgio, Leonardo da Vinci, the Sangallo, and Peruzzi.[213] Upon returning from Italy in 1519, Diego Siloe obviously accepted the bull's-eye window as congruent with the revival of the Roman style, because he used it in the church of San Jerónimo and the cathedral of Granada—works that he entered only in 1528, after Machuca's first projects were submitted. Apart from the relative dates, Siloe's windows are less deeply splayed and their moldings are more richly modeled than Machuca's. Apparently, the two major architects in Granada designed their bull's-eye windows independently of one another but under the common impetus of Italian models. In Spain that window was reserved for ecclesiastical architecture, but already in the 1480s in central Italy Giuliano da Sangallo used a lightly splayed roundel to illuminate the barrel-vaulted main hall of the Medici villa at Poggio a Caiano.[214] That secular example in the works of the Sangallo opens the prospect that the deeply recessed roundels over the

main-story windows on the side wall of the papal Mint in Rome were also meant to be bull's-eye windows (pl. 133) and, thus, a precedent for Machuca's main-story fenestration.

THE PORTALS

Of all the features of the palace, the portals and the distinctive center windows above them reveal most fully the conflict between the Spanish and the Italian architectural traditions. The peculiarly Spanish form is, of course, the *portada*. Advanced from the plane of the wall and distinguished from it by a difference in material and surface treatment, the *portada*'s frame usually includes a window or an emblazoned panel directly over the doorway. In some cases, the *portada* is enclosed by an *alfiz* well below the roofline and, in others, it rises to or breaks through the facade's terminal moldings (pls. 9, 14, 99, 115, 124, 129, and 130). In central Italy, Machuca encountered a very different attitude toward the main portal of a palace. Around 1510 there were four major types: the archway framed by rusticated voussoirs, the doorway surmounted by a lintel or a pediment on consoles, a pediment resting directly on the door casing, and the edicular frame composed of a lintel or a pediment supported by pilasters or half-columns. Usually the frame of the portal was kept well under the string course dividing the lower from the upper story, but occasionally that top molding of the door frame coincided with the string course and, thus, was keyed into the membering of the facade. The latter type will be referred to as a *frontispiece*.

Machuca's marble frame for the south portal in 1536 did not have the secondary pedestals on which the recumbent lions now rest nor the low reliefs of the spoils of war (pl. 44). Hence, the original one-story frontispiece was a broad rectangular frame composed of paired half-columns resting on com-

the portal at Via Orefici 7 in Genoa, attributed to the workshop of Gian Giacomo della Porta, probably in the 1530s; see Kruft, *Portali genovesi*, p. 17, pls. 56 and 72; and Pane, *Il Rinacimento nell'Italia meridionale*, II, figs. 269-271, for the 1519 facade of Santa Maria della Stella in Naples.

[212] Alexander Conze, *Die attischen Grabreliefs*, Berlin, 1893-1922, p. 228, no. 1062, pl. CCXVI.

[213] Bull's-eye windows are found in the facade and transepts of Francesco di Giorgio's church of Santa Maria del Calcinaio in Cortona, begun about 1484, and also in the drum of the

crossing domes of church projects in Leonardo da Vinci's Ms. B, fols. 22, 24 and 25, dated 1487-1490 (see Alberto Sartoris, *Léonard architecte*, Paris, 1952, pls. 123, 124, and 127). The motive was used by Giuliano da Sangallo in the drum of the crossing dome of Santa Maria delle Carceri in Prato, designed in 1485, and, shortly after, in the facade of Santa Maria dell'Anima in Rome, and it was employed about 1515 in Peruzzi's facade for *La Sagra* in Carpi.

[214] Marchini, *Giuliano da Sangallo*, pp. 85-86, pl. 3b.

mon pedestals and supporting a full entablature that is advanced as a common block above the columns. The entablature's width surpasses that of the string course of the facade by no more than the lowest of the three fascias of its architrave. The closest approximation to this format in extant Italian palace facades is the Sangallesque portal of the Fieschi-Sora palace (pl. 135), which was probably executed during the building campaign of 1503–1510. Its portal is composed of Doric pilasters that rest on tall pedestals and support an entablature that has top moldings that continue into those of the string course of the facade.[215] A more fully developed stone frontispiece was proposed about 1517 by Antonio da Sangallo the Younger for the Cancelleria in Rome (pl. 165).[216] Presumably of stone or marble, it would have contrasted with the mildly rusticated surface of the facade. Its three-bay format, an archway flanked by niches, is framed by Corinthian half-columns, with their capitals connected by a decorative band (a feature peculiar to the Sangallo at the time), while the cornice of the entablature coincides in width (but not in moldings) with the string course terminating the ground floor. The advance of the entablature over the archway supports a balcony for the window directly above the portal, and statues are set on the posts of the window's balustrade and also on those above the outermost columns.[217] While the Sangallo frontispiece differs from Machuca's in its general design as well as in its component parts, it provides a precedent for the Spaniard's project for the one-story marble frontispiece in 1549.

In the lower story of the south portal, Machuca used the odd form of the Ionic order and also the three-fascia casing that we have already discussed in the context of his all-sandstone facades. The Ionic pilasters of the edicular frame of the doorway itself have a taper greater than those of the main story, in that the ratio of the top to the base of the former is 4-to-5, in contrast to the near 5-to-6 of

the latter. Beause of the steep taper of the pilasters framing the doorway, its opening might appear to be trapezoidal in shape, but the jambs follow the plumb line. The pilasters support a contracted entablature, composed of a friezelike band of variegated marble and a cornice with egg-and-dart and dentil courses, and the same ornamental courses were repeated on the underside of the broadly proportioned pediment. Within its tympanum, Abundance holds fruit and stalks of grain in her outstretched arms in a manner strikingly similar to the half-figure of Ceres with fruit and grain tumbling from a cornucopia depicted in the pediment of an Ionic portal for a temple of that goddess in Cesariano's edition of Vitruvius (cf. pls. 46 and 164).[218] The two pediments have similar moldings, but Machuca used the egg-and-dart in addition to the dentil course on the undersides of the pediment and the lintel.

The doorway is enclosed by a broadly proportioned trabeated frame composed of coupled Ionic half-columns that support a common entablature block and rest on a common pedestal. This general disposition was indicated in the small Royal Palace plan of 1531, because pedestals broad enough for coupled columns were delineated on either side of the south portal (pl. 18); and two years later, Machuca executed a sandstone entry that was to be replaced in 1535 by the present marble frame. This frontispiece has sometimes been compared to the *portada* designed in 1527–1529 by Diego Siloe for the Colegio de los Irlandeses in Salamanca;[219] but the only similarity between the two portals is the use of coupled Ionic columns resting on common pedestals and supporting common entablature blocks. In all other respects, the portals differ markedly from one another. The one feature they share—the coupled columns with common pedestals and entablature blocks—is admittedly rare in the design of triumphal arches in both the Renaissance and antiquity.[220] The only extant example

[215] Frommel (*Der römische Palastbau*, II, p. 187) cites Sangallo's sketch of the Fieschi-Sora portal (Uffizi A895). Earlier examples of edicular portals with top moldings that coincide with the string course of the ground floor are the midcentury portal for the Banco Mediceo in Milan (as recorded by Filarete, *Trattati*, II, pl. 136) and the 1490s portal of the Mozzanica palace in Lodi; see Giacomo D. Bascapè and Carlo Perogalli, *Palazzi priviti de Lombardia*, Milan, 1965, p. 242, pl. 50.

[216] Giovannoni (*Antonio da Sangallo*, p. 412, fig. 24) listed this drawing (Uffizi A188) in his index without commenting on

the novelty of a frontispiece of this sort within the Italian tradition.

[217] Ibid., p. 433, fig. 23 (Uffizi A1062), for a closely related drawing of a Doric frontispiece given to Antonio's nephew, Battista da Sangallo.

[218] Cesariano, ed., *Vitruvius*, bk. IV, fol. LXIX.

[219] Gómez-Moreno y Martínez, *Las águilas*, p. 63; Chueca, *Arquitectura del siglo XVI*, p. 80.

[220] In most single arches (such as that of Titus in Rome, Trajan in Ancona, and Caracalla in Tebessa) the coupled col-

is the one at Pola in Istria (pl. 156),[221] and its earliest known reflection in the Italian Renaissance is the triumphal arch entry of the Castel Nuovo in Naples, begun about 1452. Since the Neapolitan portal has very tall proportions, there is little likelihood that it served as the model for Machuca's south entry or Siloe's Salamancan portal. Again, Sangallo drawings of ancient ruins and their projects of 1516 for the facade of San Lorenzo in Florence provide the best Renaissance precedents for common pedestals (cf. pls. 44, 131, and 132),[222] but, of course, we do not know how many earlier Renaissance architects designed ephemeral triumphal arches or painted facades that followed the format of the Roman arch at Pola.

The strict mirror reversal of the trophaic reliefs of the south portal was probably required by Pedro Machuca because (as we noted earlier) that principle was applied before Niccolò da Corte appeared on the Alhambra and it was continued after he left. Gómez-Moreno y Martínez in 1941 noted the unusual reversal of reliefs and described it as a simple ornamental device (*un simple tema ornamental*)[223] and several scholars have accepted that explanation of the principle, but it would seem to have had a more serious theoretical basis.

The mirror reversal of ornament in the *portadas* and window ornament of the palace of Charles V is not likely to have had Spanish precedents because it is at odds with the exuberant variety in ornament characteristic of the Isabelline and Plateresque styles. To be sure, Diego Siloe in several of his portals of the 1530s for the cloister of the convent of San Jerónimo in Granada employed *near* mirror re-

versals in spandrel figures and those reclining on the archivolts of portals, as well as in the geniuses holding the arms of the Gran Capitan on the exterior of the apse of that conventual church.[224] Since Siloe had also been in Italy previous to 1519, he and Pedro Machuca must have got the idea there. Still, most Italian designers were satisfied with a balance of similar configurations, without invoking a strict mirror reversal of images. They were often so skillful in their design of comparable configurations that, at first glance, the figures are taken to be reverse images, but closer attention reveals significant variations. Only in heraldic ornament are the Italians likely to design the human figure in near-reverse poses, as did Niccolò da Corte in the shield-bearing geniuses that flank the dedicatory inscription mounted in 1528 over the portal of the Doria palace on the Piazza San Matteo, and also in the wildmen on the portal of the Salvago palace on the Piazza San Bernardo, both in Genoa (pls. 47 and 51).[225] In the latter portal, the vignettes of armor on the pedestals are also almost mirror reversals. That tendency to symmetry was furthered in Genoa by Perino del Vaga, most notably in his allegorical figures holding the Doria arms atop the pediment of the portal of the Palazzo del Principe, designed in 1529.[226] The same can be said for the figural ornament designed in the 1530s by Sanmicheli in Verona and Jacopo Sansovino in Venice.[227] Since they, like Perino del Vaga, were trained in Rome during the first quarter of the sixteenth century, it is likely that the idea of heraldic symmetry in figural ornament was earlier favored there.[228] Still, the extension of mirror sym-

umns are given separate pedestals, and usually the advance of the entablature joins the innermost columns flanking the archway itself; that disposition was the one most frequent in the Italian Renaissance.

[221] Gustavo Traversari (*L'Arco dei Sergi*, Padua, 1971, p. 43) argued for its execution between 25 and 10 B.C. and reproduced Fra Giocondo's drawing of the arch at Pola of about 1515. Later, Serlio included the arch in *Tutte l'opere*, bk. III, fols. 109v and 110, but earlier he himself did not use the common pedestal (bk. VI, fols. 15v, 19r, 19v, and 21). The Trajanic arch at Bará (Tarragona) in Spain has paired Corinthian pilasters that rest on common pedestals, but the entablature is not advanced; see Chueca, *Historia de la arquitectura española*, I, pl. 21.

[222] The pertinent projects for San Lorenzo (Uffizi A277, 278, and 279) are illustrated in Marchini, *Giuliano da Sangallo*, pls. XXIIIb, XXIVa, and XXIVb. In some instances, such as Cola dall'Amatrice's facade for the church of San Bernardino in Aquila (pl. 143), coupled columns are given common pedestals, but there is no common advance of the entablature.

[223] Gómez-Moreno y Martínez, *Las águilas*, p. 134.

[224] Gomez-Moreno y Martínez, *Diego Siloe*, p. 35, pls. XCII, XCVIII, XCIX, and CII. Most of these portals were probably executed in the 1530s because Siloe replaced Jacopo Torni as architect in 1528 and directed the works until 1543.

[225] Kruft, "The Della Porta Workshop in Genoa," p. 925.

[226] Kruft, *Portali genovesi*, pl. 67, and also pl. 72, for an anonymous portal of about 1535 at Via Orefici 7 in Genoa.

[227] The major examples are spandrel figures in Sanmicheli's Cappella Pellegrini in San Bernardino and the Bevilacqua palace in Verona, the portico of Jacopo Sansovino's Library of San Marco (upper story), and over the main-floor windows of the Corner palace, and the central arch of the Grimani palace in Venice.

[228] A fireplace in the Bargello attributed to Benedetto da Rovezzano has very large winged youths seated with their backs to the unidentified arms centered over the mantle. A stucco frieze in a main-floor room near the Sala Grande of Andrea della Valle's palace in Rome (begun about a decade before he

metry from heraldic figures to figural ornament in the spandrels of windows or doors is not sufficient to explain the mirror reversal of the trophaic reliefs on the Alhambra because these reliefs are not simply heraldic or decorative figures or simple vignettes of arms and armor. Rather, they are perspective depictions of a field littered with the spoils of war.

The only precedent for the mirror reversal of pictorial reliefs known to me is the pair that flank the doors to the meeting hall and the pharmacy of the Scuola de San Marco in Venice, which are usually dated about 1490 and attributed to Tullio Lombardi, whose father Pietro, along with Giovanni Buora, renovated the *scuola* after the fire of 1485 (pl. 163).[229] The huge relief depicting the lion of Saint Mark in a barrel-vaulted recess is repeated in reverse image on either side of the door to the meeting hall, with the vanishing point of the architectural perspective located on the central axis of that portal at the entrant's eye level. Of course, in spite of the impressive architectural setting, it is still essentially an emblematic relief. The pair flanking the door of the adjacent pharmacy are narrative reliefs, with a different miracle of the saint depicted in each; so it is only the architectural setting—a long arcade covered by a coffered ceiling—that was repeated in mirror reversal. No precedents for these extraordinary reliefs have been identified,[230] and I know of no later examples of reversed perspectives of this kind. While each pair of the San Marco reliefs refers to the center axis of its portal, their great size and dramatic illusionism result in the dominance of the sculptural ornament over the architectural membering, whereas the reverse is true of the much smaller trophaic reliefs on the south frontispiece.

Perhaps it was the study of ancient Roman ar-

chitecture that led a few High Renaissance architects to conclude that the ancient designers extended the strict balance of architectural elements to figural ornament. Fortunately, in several recent studies of mirror reversals in antiquity, Cornelius Vermeule has gathered examples of that practice in the spandrels and pedestals of triumphal arches, notably those of Constantine in Rome and Augustus in Sepino (or Saepinum), and also in freestanding statuary disposed symmetrically in reverse images, primarily in civic structures such as gateways, theaters, baths, market halls, and fountains.[231] The best known are the *Dioskouroi* on the Quirinale in Rome, which are still found together, whereas most comparable pairs have been dispersed. The principle was also applied in sarcophagi—especially for the geniuses in reverse poses on either side of the door of death on sarcophagi in the Vatican and Conservatori museums.[232] Still, absolute mirror reversal of figural ornament in Roman architecture was probably rare, and that would account for the limited and belated use of the device by Machuca and by several Italians around 1530. Machuca was, however, more strict in the application of the principle than any of his contemporaries.

The best precedents for the general disposition of Machuca's west frontispiece are the Sangallo projects for the facade of the church of San Lorenzo in Florence in 1516. In several, the center door is larger than those on the sides, though the difference in size is not as great as it is in Machuca's frontispiece (cf. pls. 62 and 131), where the center is twice as large as the side doors.[233] While none of the Sangallo projects can be cited as the Spaniard's model, the similarity in general format suggests that, in 1549, when Machuca finally agreed to make a design for the marble frontispiece on

became cardinal in 1517) has large figures of Fame blowing trumpets in mirror reversal on either side of the cardinal's arms and, in addition, reversed winged females kneeling and attending the flames of candelabra; see Frommel, *Der römische Palastbau*, III, 151d.

[229] Sara Wilk (*The Sculpture of Tullio Lombardi*, New York, 1978, pp. 18-20) noted that by 1488 Andrea Rizzo and Mauro Codussi had been put in charge of the renovation, but she did not attribute the mirror reversal to them.

[230] None was suggested by Sara Wilk (ibid.), Giovanni Mariacher ("Pietro Lombardo a Venezia," *Arte veneta*, IX-X, 1955, pp. 50-51), John Pope-Hennessy (*Italian Renaissance Sculpture*, London and New York, 1971, II, p. 94), or John McAndrew (*Venetian Architecture of the Early Renaissance*, Cambridge, Mass.,

1980, pp. 187-189).

[231] Cornelius Vermeule, "Graeco-Roman Statues: Purpose and Setting I," *Burlington Magazine*, CX (1968), pp. 556-557; idem., *Greek Sculpture and Roman Taste: the Purpose and Setting of Graeco-Roman Art in Italy and the Greek Imperial East*, Ann Arbor, 1977, pp. 4-5, 27, and 37.

[232] Vermeule, "Graeco-Roman Statues," p. 556.

[233] Marchini, *Giuliano da Sangallo*, pls. XXIVb, XXV, a and b (Uffizi A276, 277, and 281). Antonio da Sangallo the Younger, in a project of about 1520 for the three-door entry to the atrium of St. Peter's in Rome, also made the center door only slightly larger than those at the sides (Uffizi A112); see Giovannoni, *Antonio da Sangallo*, I, p. 144, and II, fig. 122.

the west facade, he recalled projects seen in Florence and Rome thirty years earlier. Again, in the absence of an obvious model for the frontispiece as a whole, we must look to analogies for its component parts.

The frame of the central doorway (excluding the underscaled Victories added to its pediment by Antonio de Leval) follows the simple format of the Doric portal described by Vitruvius, Alberti, and most later Italian Renaissance theorists.[234] In its form and proportion and in its placement within the central bay, it is similar to the pedimented central door in several of the Sangallo projects for the facade of San Lorenzo (cf. pls. 62, 131, and 132). The apex of Sangallo's pediment also touches the lower edge of the architrave of the entablature, but there is no indication of ornament or sculptured figures in the restricted spandrel area above the pediment. All three of Machuca's doors have casings composed of a cyma reversa molding and three graduated fascias with small quarter rounds between them and, in the casing of the main door, the second fascia is enriched with the guilloche (pl. 68). That motive, used by Greeks and Romans, survived in Italy and Spain in a degenerate version in the Middle Ages,[235] but it regained its ancient form in the works of Brunelleschi and Alberti as an ornamental course, especially for door frames. Widely used in the Italian Renaissance, it was employed in Spain before 1508 in an ineptly cut version on the archivolt of the portal of the church of San Antonio in Mondéjar, for which the design was sent from Rome by Iñigo López de Mendoza,[236] but Machuca owes nothing to this early Spanish example, because his guilloche reflects the proper classical form used by contemporary Italians.

The side doors must be counted among the several unusual forms used by Pedro Machuca. Their pediments are supported by leaf-faced consoles that rest directly on the top of the casing, in contrast to the more familiar Ionic form in which the consoles are placed at the sides of the casing, as they are in the main-story windows. The format of the side doors first appears around 1518 when it was used by Baldassare Peruzzi for a window in the courtyard of the Fusconi-Pighini palace in Rome, and his pupil, Serlio, included an illustration of a portal of that type in book IV (cf. pls. 68 and 166).[237] Serlio admitted that he knew of no examples in antiquity or in previous architectural treatises, but he noted that this form had been used by Peruzzi, who (he believed) had either seen it in some ancient ruin or invented it.[238] Like Peruzzi's window in the Fusconi-Pighini palace courtyard, the front faces of Serlio's paired consoles are carved with the triglyph motive to relate them to the three triglyphs on the band between them. That triglyph-faced console was used in Pedro Machuca's project (as recorded in the Burlington elevation), though single rather than paired consoles support the pediment and only two rather than three triglyphs were placed between them. In executing the frontispiece, Luis replaced the outermost triglyph consoles with the leaf-faced versions. Incidentally, in the 1-to-2 ratio of the width to the height of the openings of the side doors, Machuca followed the proportions expressly recommended by Serlio in his text. So it would seem that Machuca, in designing the west frontispiece about 1549, drew on Serlio's book IV published in 1537.

Of the ornament that now enriches the three portals, only the swags hanging from carved rings on the ends of the pediments were delineated in the Burlington elevation (pl. 74). Ornament of this sort has precedents in antiquity since festoons of

[234] Vitruvius, IV, 6, 1-3; Alberti, *Trattati*, II, pp. 618-623 (bk. VII, chap. 12); Cesariano, ed., *Vitruvius*, bk. IV, fol. LXVIII. All three recommended the reduction of the top of the opening to one-fourteenth the lower. Presumably Luis followed his father's design for the doorways that (like the south doorway) were not tapered. The exaggerated diminution of the width of the east portal was the work of the seventeenth century and followed the completion of the facing of the interior of its oval vestibule. Added support for this argument might be claimed from the fact that the doorways of the west facade in the Burlington elevation were not diminished in width toward the top.

[235] The guilloche, or woven band, survived in Italy in the repertory of the Cosmati workers (in the floors of Santa Maria in Trastevere in Rome), and in Spain, in Visigothic ornament

(a window in San Juan de los Baños near Palencia) and in Islamic decoration (the ninth-century capitals at Medinat al-Zahrá near Cordoba and the *portada* of *alcázar* of Seville, built by Islamic masons for Peter the Cruel in the fourteenth century).

[236] Gómez-Moreno y Martínez, "Hacia Lorenzo Vázquez," pp. 23-25, pl. 36.

[237] Frommel, *Der römische Palastbau*, I, p. 159, pl. 77, d and e, for anonymous drawings in the Uffizi (A2732) and the Ashmolean Museum at Oxford.

[238] Serlio, *Tutte l'opere*, bk. IV, fol. 146v: ". . . non ho veduto nè antico, nè trovato scritto; ma Baldassar da Siena consumatissimo nelle antichità fosse ne vidde qualche vestigio, overo col suo bellissimo giudicio fu il trovator de questa varietà. . . ."

flowers were suspended from the doors of public buildings and private residences on festive occasions.[239] Though the motive was revived by Alberti in the mid-fifteenth century for the portals of San Francesco in Rimini and Santa Maria Novella in Florence, it seems to have been used less for monumental architecture than for ecclesiastical furniture such as altars, tabernacles, and funerary monuments during the latter half of the century. Within the Roman School, the motive was given Raphael's stamp of approval when suspended fruit clusters were painted alongside the window frames on the upper level of his *Logge* in the Vatican, begun in 1519, and Peruzzi used it in a quick sketch for a triumphal arch designed for the entry of Charles V into Rome in April 1536.[240] At midcentury, suspended fruit swags were painted alongside the small doors on the corridor wall of the semicircular garden portico of Vignola's Villa Giulia in Rome, and they were carved in relief along the main-story windows of several of Palladio's buildings (the Colleoni-Porto and Porto-Barbarano palaces and the Loggia del Capitano in Vicenza) during the third quarter of the century. In Spain, suspended fruit swags appear as early as 1492 alongside the portal of the Medinaceli palace in Cogolludo (pl. 115), suggesting that Lorenzo Vázquez discovered that motive in Italy during the 1480s; but, with the exception of an occasional use by Francisco de Colonia and Diego Siloe and their followers, suspended swags do not play as prominent a role in

Plateresque decoration as one might expect,[241] so their use on the west frontispiece does not necessarily represent an intrusion of Plateresque taste.

The Doric order of the frontispiece is surprisingly rich in contrast to that of the courtyard (which seems to have been modified by Luis only in the proportions), and it is even more sumptuously ornamented than the Ionic order of the south portal (pl. 62). The Doric capital follows a Roman type with rosettes on the necking.[242] That decorative motive was approved by Alberti and Francesco di Giorgio, and the latter included an illustration of the type in the Magliabechiano version of his treatise.[243] In the late 1480s, this type was used in the lower portico of the courtyard and in the staircase of the Cancelleria in Rome, and in 1516 it was proposed by the Sangallo for the facade of San Lorenzo in Florence (pls. 131 and 132); but it had appeared previously in several of Giuliano's sketches of the Baths of Diocletian and the north side of the Basilica Aemilia.[244] His nephew, Antonio, in 1515–1517 used that capital in the courtyards of the Lante-Medici and Farnese palaces in Rome, but in the latter the fleurs-de-lis were used in place of rosettes.[245] A few years later, Cesariano illustrated this version of the Doric capital in his 1521 translation of Vitruvius, and so did Serlio in his fourth book, published in 1537, with the observation that, while it differed from the one described by Vitruvius, it was found among Roman ruins.[246] Machuca's capital is close to one Serlio identified as

[239] Thomas L. Donaldson (*A Collection of the most approved examples of doorways, from ancient buildings in Greece and Italy . . . preceded by an essay on the usages of the ancients respecting doorways, etc.*, London, 1836, p. 4) also noted that doors draped with swags are sometimes seen in ancient reliefs (such as the Hadrianic relief of the *Sacrifice before a Temple* now in the Louvre).

[240] G. De Angelis d'Ossat, "Gli archi trionfali ideati dal Peruzzi per la venuta a Roma di Carlo V," *Capitolium*, XVIII (1943), p. 287, fig. 1.

[241] Fruit swags and clusters were frequently carved on the jambs and archivolts of doors and windows and on pilasters or columns in the first half of the sixteenth century in Spain, but they were not often suspended free of an architectural frame. Other than the portal of the Medinaceli palace, the earliest example of a swag suspended alongside a portal seems to be on Francisco de Colonia's 1516 Puerta de la Pellejería in the north transept of the cathedral of Burgos, while followers of the Colonia are assigned the portal of the Miranda palace in Peñaranda de Duero of 1525-1530 and the facade windows of the convent of Santiago in Uclés of about 1530. Heavy fruit clusters were supported by putti atop the pediment of the sec-

ond story of the tower of the cathedral of Murcia of about the same time, designed by Jerónimo Quijano, while the badly damaged swags of the portal of Sancti-Spiritus in Salamanca and the small and scrawny clusters of the entry to San Salvador in Granada by Diego Siloe belong to the 1540s. Occasionally trophies together with foliage and grotesques were suspended alongside a portal (as in the *portada* of the University of Salamanca of 1519). For these examples, see Chueca, *Arquitectura del siglo XVI*, figs. 31, 55, 68, 77, 156, and 192, and for Siloe's portal, Gómez-Moreno y Martínez, *Diego Siloe*, pl. CXXIX.

[242] Machuca's Doric columns pertain to the Roman tradition in their general proportions, the use of a base and pedestals, and the richness of ornament on the capital and base moldings. See Brown-Bourne-Coolidge, *Study of the Orders*, pp. 16-24.

[243] Alberti, *Trattati*, II, pp. 576-577 (bk. VII, chap. 8); Francesco di Giorgio *Trattati*, II, p. 387, pl. 226 (Magliabechiano, I, II, 141, fol. 36v).

[244] Sangallo, *Il libro*, pls. 16 and 28 (fols. 14v and 26).

[245] Frommel, *Der römische Palastbau*, III, pls. 44a, 88, 89.

[246] Cesariano, ed., *Vitruvius*, bk. IV, fol. 65; Serlio, *Tutte l'opere*, bk. IV, fol. 141v.

"type *A*," in that its necking has rosettes, an astragal molding below, and an echinus with petal-like ornament above, but the necking of Machuca's capital is shorter and the second of the three fillets under Serlio's echinus was replaced with a bead-and-spindle course. Even though it was usually included as an acceptable form in theoretical treatises, the necking with rosettes was rarely used by practicing architects. The garden loggia of the Palazzo del Te by Giulio Romano and the lower portico of the Library of San Marco by Jacopo Sansovino are among the few buildings of the second quarter of the sixteenth century in which this version of the Doric capital was used. Later, Vignola in 1562 and Palladio in 1570 lent their authority to this type,[247] but at the time Machuca studied in Italy and even until midcentury, the severe Vitruvian or Bramantesque form predominated.

Another unusual feature of Machuca's Doric order for the west frontispiece is the fluting of its shaft. The sober taste of the High Renaissance favored a plain shaft. Even Giuliano da Sangallo in his most sumptuous projects did not use fluted columns. Fra Giocondo and Cesariano illustrated both plain and fluted shafts for the Doric, calling the first "virile" and the second "matronly," and Serlio also included both types.[248] Italian architects of the second quarter of the sixteenth century seldom used a fluted shaft for the Doric order, but a rare example is found in the facade of Sanmicheli's Pompei-Lavezola palace (pl. 116). Machuca gave his half-columns nine flutes, following Vitruvius' recommendation of twenty on a free-standing column,[249] but he used square-headed rather than the more common round-headed flutes. While the square-head is more readily associated with the Doric order of archaic Greece, it was occasionally used with the plain Doric capital by the Romans, notably in the Tabularium in Rome, in the Doric hemicycle and the round temple on the upper level of the sanctuary at Palestrina (pls. 168 and 170), and in the circular Temple of Venus at Tivoli.[250] So for the square-headed fluting of his Doric columns, Machuca may have looked directly to ancient rather than Renaissance models.

The base molding of the column is unusually rich in ornament: it is composed of a plain fillet, a torus molding carved with the bay-leaf roll, a scotia with fluting, and a larger torus with the guilloche motive (pl. 68). Fully ornamented bases are frequently found in Giuliano da Sangallo's sketches of Roman monuments in the 1480s, and they were also illustrated in the treatises of Francesco di Giorgio Martini and in Cesariano's translation of Vitruvius, but they were usually associated with the Corinthian or Composite orders.[251] Sagredo in 1526 implied that the bases of all the orders could be enriched with ornament as long as their moldings were not deformed by the carving.[252] Even so, contemporary Spanish architects who favored elaborately carved capitals and shafts usually set them on plain base moldings,[253] so the rich ornamental detail of Machuca's base moldings cannot be explained as a reflection of Plateresque taste. It is more likely that he proposed this ornamental version of the Doric order for the frontispiece of the main facade in the hope that the emperor and his advisers would not feel the need to add figural ornament.

The Doric frieze that runs along the upper part of the die, immediately under the cap moldings of the pedestals is probably the oddest feature of Machuca's unusual treatment of the Doric order. That feature would be even more effective in stressing

[247] Vignola, *Regola delli cinque ordini*, pp. 18-19, fig. VII. Palladio, *I quattro libri*, bk. I, chap. XV. See also Brown-Bourne-Coolidge, *Study of the Orders*, pp. 16-28.

[248] Fra Giocondo, ed., *Vitruvius*, fol. 39 (IV, 3); Cesariano, ed., *Vitruvius*, bk. IV, fol. LXIII; Serlio, *Tutte l'opere*, bk. IV, fol. 141. Sagredo, in *Medidas del Romano*, pp. 24-25 (fols. Biii-Biv), seems to reserve fluting for the Ionic order without expressly excluding it from the Doric.

[249] *Vitruvius*, IV, 3, 9.

[250] Although fragments of the colonnade of the round temple at Tivoli were not assembled until about 1960, the structure was recorded in a plan of the site by Francesco Piranesi in 1781 (Bruschi, *Bramante*, p. 1016, n. 62), so it is possible that more than the present fragments were known to students of the site during the Renaissance. For the Palestrina examples, see Furio

Fasolo and Giorgio Gullini, *Il Santuario della Fortuna Primigenia a Palestrina*, Rome, 1953, I, p. 399, figs. 489-490.

[251] Sangallo, *Il libro*, pl. 17 (fol. 15). Francesco di Giorgio, *Trattati*, I, pl. 25 (Laurenziano-Ashburnhamiano 361, fol. 13v), pls. 183-187 (Saluzziano 148, fols. 99-100v). Egger, ed., *Codex Escurialensis*, fols. 23, 49v, and 51. Cesariano, ed., *Vitruvius*, bk. III, fols. LVII (incorrectly numbered XLVII) and LXIII, included illustrations of richly carved bases, but Cesariano did not foster such ornament.

[252] Sagredo, *Medidas del Romano*, p. 47 (fol. Cviᵛ).

[253] Alonso de Covarrubias is the only major Plateresque architect to use richly carved bases in monumental architecture: the staircase and portal of the Hospital de Santa Cruz and the Capilla de los Reyes Nuevos in the cathedral of Toledo.

the unity of the coupled columns if the die beneath it were plain, as it is in the Burlington elevation (cf. pls. 62 and 74). Fernando Chueca has observed that the Doric frieze was used on the round pedestal of a sundial included in Cesariano's 1521 translation of Vitruvius (pl. 167).[254] Its frieze has a variety of unorthodox metopes and beneath it are garlands and rinceaux decoration. A comparable treatment was given to a cylindrical pedestal of a portal depicted around 1542 in Paris Bordone's painting of *Bathsheba bathing*, now in the Wallraf-Richarts Museum in Cologne.[255] In ancient Roman examples, however, pedestals decorated with a Doric frieze have a plain die, as do the pedestals in the Burlington elevation. The most readily accessible example was the podium of a round temple in front of the right hemicycle on the upper level of the sanctuary at Palestrina near Rome (pl. 168) and also on the stylobate of the apsidal hall on its lower level.[256] Like Machuca's, the frieze on the podium of the temple occupies almost one-quarter the height of the die, but its metopes repeat a triad of motives (the patera, the ox skull, and a star-shaped rosette), whereas Machuca used only the patera. A pedestal dating from about 200 B.C. was found on the site of the Temple of Cora (modern Cori) in Latium, about sixty kilometers southeast of Rome; and several tombs, that of L. Cornelius Scipio Barbatus at Cori and two others at Norchia, have the Doric frieze over a plain die.[257] These Roman examples, rather than the Cesariano sundial, are more likely to have inspired Machuca's treatment of his pedestals (cf. pls. 62, 167, and 168).

The Doric entablature of the west frontispiece is distinguished by two unusual features, the tilting of the frieze and (in the Burlington elevation) the symmetrical disposition of its metopes. In the attempt to identify Luis' departures from his father's project for the frontispiece, we noted that no pre-

cedents were found for the forward inclination of the frieze in Spanish,[258] Greco-Roman, or Italian Renaissance architecture and that there were no clear references to that idea in the writings of Italian theorists. We concluded that Pedro may have tilted the unusually narrow frieze to make it appear to be wider to the viewer below and that, even after the entablature was made somewhat wider by Luis, the tilt was retained. Pedro Machuca clearly had an unusual interest in optical effects, so this solution to the problem of a narrow frieze would be wholly in character. Diego de Sagredo recommended that architectural elements above the capital should lean forward one-eighth their height, and Vitruvius may have been Sagredo's source, though he did not claim him.[259] The ancient author must be the stimulus for Machuca's interest in optical compensations and intensifications because I found no refinements of this kind in contemporary Italian or Spanish works.

The second unusual feature is the symmetrical disposition of the metopes of the Doric frieze in the frontispiece recorded in the Burlington elevation. In that elevation (but not the frontispiece itself), an ox skull was placed on the four advanced entablatures over the coupled columns and a pair of skulls was centered over the side bays, with a group of four skulls distinguishing the wider center bay (pl. 74). Expressed schematically, this is the disposition of the ox skull and the patera: V / O V V O / V / O V V V V O / V / O V V O / V. I know of no precedents for a symmetrical disposition of the metopes of a Doric frieze in antiquity, but in the frieze on the podium of the round temple on the upper level of the sanctuary at Palestrina, three motives (an ox skull, a patera, and a star) were freely disposed, without any evident pattern (pl. 168). Normally ancient designers simply alternated the ox skulls and patera, and most Renaissance architects followed that practice, but

[254] Cesariano, ed., *Vitruvius*, bk. I, fol. xxv; Chueca, *Arquitectura del siglo XVI*, p. 215.

[255] Giordana Canova, *Paris Bordon*, Venice, 1964, fig. 70. Triglyphs and lions' heads alternate in the frieze and garlands are draped over the fluted die of the pedestal.

[256] Fasolo and Gullini, *Il Santuario della Fortuna Primigenia a Palestrina*, I, pp. 43-44, 149-153, figs. 63, 224, 225, 229, and 230; II, pls. XXI and XXV. The pattern of the stylobate in the apsidal hall is a simple alternation of metopes (patera and a flower with pointed petals), whereas the podium of the round temple is more complex in that three motives were used, though

no fixed rhythm was maintained.

[257] Brown-Bourne-Coolidge, *Study of the Orders*, pp. 262-263, figs. 108 and 109. For a Hellenic altar at Siracusa, see Enrico Mauceri, *Siracusa antica* (L'Italia Monumentale), Milan, n.d., fig. 49.

[258] I have rejected the prospect that the tilted frieze may have been inspired by the tilted bands of inscriptions (*letreros*) that encircle some Spanish churches, such as the Royal Chapel in Granada; see Torres Balbás, *Arquitectura gótica*, p. 343.

[259] See chap. 3, nn. 68 and 70.

there are a few Renaissance precedents for this disposition and more later analogies.[260] The best precedent is found in one of the projects submitted in 1516 by Giuliano da Sangallo for the facade of San Lorenzo in Florence (cf. pls. 74 and 132). Giuliano placed an ox skull over the advanced entablature at the ends of the facade and a pair over the side bays, but because his central unit was not as wide as Machuca's, only a pair of skulls marks the central axis. That disposition produces this pattern: V / O V V O / V O V V O V / O V V O / V. Around 1520 Andrea Sansovino is believed to have designed the Doric portal of the chapel of San Giovanni in Monte San Savino, with this unusual disposition of the metopes: O V O V O O V O V O.[261] A few years later, in 1527, Cola dall'Amatrice used about seven motives in a symmetrical disposition of the metopes of the first entablature of the facade of San Bernardino in Aquila, but only the axis of the central bay of the facade was stressed (pl. 143). In 1532, the Della Porta and Corte applied the principle of symmetry to the previously cited Doric portal of the Salvago palace on the Piazza San Bernardo in Genoa (pl. 47). Toward midcentury, Sanmicheli, Galeazzo Alessi, and other north Italian architects occasionally replaced the traditional alternation of patera and ox skull with a symmetrical disposition.[262] Because the new motive was brought to the north by architects

trained in or familiar with the artistic *milieu* of Rome during the first quarter of the sixteenth century, it is likely that Pedro Machuca encountered the idea in Rome before 1520.

Pedro Machuca's 1549 project for the three bays over the west entry included a three-light opening—perhaps a Serliana window like the one over the south portal, which was probably designed as early as 1528, then redesigned, first in 1537–1539 and again in 1548. Composed of an arched central opening and rectangular side vanes, the type was used in antiquity from at least the Hellenistic period, and it seems to have survived through the Middle Ages into the Renaissance.[263] Its earliest form, the "Hellenistic" version, has lintels over the side vanes and a separate archivolt over the central opening that rests on the two lintels (pl. 143). A later version, first found in Syria in the first century B.C.,[264] is an arcuated lintel in that the moldings of the side lintels continue into the archivolt. That type forms the porch of the Temple of Hadrian at Ephesus (pl. 157) and also the windows at the center and both ends of the seaside facade of Diocletian's palace at Split (pl. 161).[265] In Italy, during antiquity and the Middle Ages, the Serliana seems to have been little used in either form;[266] there are very few Renaissance drawings that record the motive, and fifteenth-century Italian theorists did not foster it.[267] Even so, the Ser-

[260] Francesco di Giorgio, *Trattati*, I, p. 282, pl. 150, for his elevation of an ancient building with the two motives disposed in this pattern: O V / O O / V O.

[261] The portal was attributed to Sansovino by G. Haydn Huntley (*Andrea Sansovino, Sculptor and Architect of the Italian Renaissance*, Cambridge, Mass., 1935, p. 92). A project for a wall sepulcher for Leo X in the Victoria and Albert Museum, London (fig. 72), has a similar rhythmic disposition of the metopes.

[262] For Sanmicheli's Doric friezes on the fortress of San Niccolò near Sabenico, the Arsenal and the palaces of the Cornaro a San Paolo and the Bragadin a Santa Marina in Venice, and the Saibante palace in Verona, see Gazzola, *Michele Sanmicheli*, figs. 220, 223, 227, and 238. Additional examples are the edicular portal of the Salvago palace in Genoa by the Della Porta and Corte in 1532 (pl. 47), the Doric gateway that dominates the frontispiece of Giovanni Battista Caporali's publication of his Italian translation of Vitruvius published in Perugia in 1536 (*Vitruvio e Raffaello*, pl. 49), the facade of a palace in Bugiardini's *Martyrdom of St. Catherine* in Santa Maria Novella in Florence, probably painted in the 1530s (Bernard Berenson, *Italian Pictures of the Italian Renaissance Florentine School*, Greenwich, Conn., 1963, II, fig. 1263), the ground floor of the south side of the Cortile della Cavallerizza in the ducal palace in Mantua, executed 1556-1561, by Giovanni Battista Bertani (Hartt,

Giulio Romano, pp. 186-188, fig. 408), and the portal of the Cambiaso palace in Genoa by Galeazzo Alessi in 1552 (Chierici, *Il palazzo italiano*, II, 242). Other midcentury examples are found in the works of Bartolommeo Ammanati and Andrea Palladio.

[263] No thorough study of this important motive has been undertaken, but there are several brief accounts: Stanislaw Wilinski, "La Serliana," *Bollettino. Centro Internazionale di Studi d'Architettura. Andrea Palladio*, VII (1965), pp. 115-125. Fiorio Franco, "Serliana," *Enciclopedia italiana*, Milan and Rome, 1929-1937, XXI, pp. 442-443.

[264] Luigi Crema ("La formazione del frontone siriaco," *Scritti in onore di Mario Salmi*, Rome, 1961, I, pp. 1-13) cites a frame for a relief in Hadrian's villa (fig. 13) and the fronts of several small temples (figs. 1, 12, and 14).

[265] D. F. Brown, "The arcuated lintel and its symbolic interpretation in late antique art," *American Journal of Archeology*, XLVI (1962), p. 394. On the seaside facade, the central Serliana window has disappeared but it is clear there were at least three on that long facade because one on the left end is still preserved.

[266] Two prominent examples are porticoes: the arcuated lintel of the Canopus of Hadrian's villa at Tivoli and the porch of the cathedral at Città Castellana of 1210.

[267] Cyriacus d'Ancona in the 1430s made a sketch of a Serliana that he identified as the *Aqueduct of Hadrian near the Temple of*

liana was revived in its Hellenistic form at mid-century, especially for church windows, galleries, and retables,[268] but it usually had three *equal* vanes. In 1506–1509 Bramante used the Hellenistic form for windows in the Sala Regia of the Vatican and the transepts of Santa Maria del Popolo, and again in his nymphaeum for the Villa Colonna at Genazzano.[269] In 1514 Raphael depicted Pope Leo I in a Serliana window of that type in the *Fire in the Borgo* in the *stanze* of the Vatican (pl. 140), and the Hellenistic form was also used by Cola dall'Amatrice in his facade for San Bernardino in Aquila, initiated in 1527 (pl. 143). The first known example of the Syrian type dates from about 1520—the loggia over a nymphaeum painted by Giulio Romano on the embrasure of a window in the Sala di Costantino in the Vatican (pl. 138). Giulio used that form again in his project for a gateway dated in the 1540s.[270] In both instances there are three equal vanes in contrast to the wider center of Machuca's Syrian Serliana, and there are no similarities in the architectural membering.

In Spain, the Syrian form of Serliana was used previous to 1520 in the courtyard portico and probably the window over the main portal of the lost palace of Jerónimo Vich in Valencia (pl. 130). For-tunately, we have a sketch of 1859 that shows what remained of the pedestals of the columns that framed the window and also the small panels that closed its side vanes. Because several arches of the porticoes of the courtyard (seen through the portal in the sketch and still preserved in the Real Academia de Bellas Artes) follow the Syrian version of the Serliana, it is quite possible that the window over the entry was also of that form. Vich sent the project for his palace from Rome, not long after he arrived there as ambassador to the Vatican in 1507, and the palace seems to have been finished by 1525,[271] so Machuca could have seen it near completion if he returned from Italy by way of the port of Valencia in 1520. Of course, we do not know if his 1528 and 1537 designs for the south window followed the Valencian example, but the present window, designed in 1548, is not reminiscent of any of its architectural elements or proportions. The Valencian *portada* and a small frame for the arms of Charles V on the facade of the church of San Sebastián in Antequera in the 1540s are the only Spanish examples of the Syrian form known to me,[272] so it is likely that Machuca encountered it in Italy previous to 1520. Even though the first known Italian use of the type was Giulio

Giove Olimpico; see the series of lettered plates (tavole d'agiunta) at the end of the text volume of Huelson's facsimile edition of *Il Libro di Giuliano da Sangallo*, p. 96, pl. "M" (Berlin, Codex Hamiltonius, fol. 85v). Francesco di Giorgio, shortly after 1482, made a drawing of a tabernacle in the form of a Serliana in the Temple of Clitumnus (now San Salvatore) near Spoleto, south of Perugia; see Allen S. Weller, *Francesco di Giorgio Martini 1439-1501*, Chicago, 1943, p. 261, fig. 112 (no. 321 in the "Taccuino del Viaggio" in the Uffizi).

[268] For the extraordinary 15-meter frontispiece of the chapel of San Giovanni Battista in the cathedral of Genoa, firmly dated in 1448, see Orlando Grosso, *Genoa* (Italia artistica, 91), Bergamo, 1926, p. 54. In 1460 Alberti probably intended to use a Serliana window in the Hellenistic form with three equal vanes for the windows of three arms of his Greek Cross church of San Sebastiano in Mantua, begun about 1460, but construction on the walls of the arms was delayed until the 1490s. A Serliana window was used on the facade of Sant'Andrea in Camoggiano, which was completed by 1470 and is sometimes attributed to Michelozzo. In northwestern Italy during the latter half of the fifteenth century (apart from the 1448 chapel of San Giovanni Battista in the cathedral of Genoa), the Serliana was used in the apse window of Santa Maria della Passione in Milan (begun 1489), the triforium of Santa Maria del Miracoli at Saronno (1498), and the gallery of San Maurizio in Milan (begun 1503); see Baroni, *L'architettura lombarda*, figs. 50-52, 61, and 68.

[269] The best illustration of the Vatican window is found in Baroni, *Bramante*, fig. 120; the other two examples are found in Bruschi, *Bramante*, figs. 304, 305, 477, and 480. Bruschi (p. 913, n. 10) described the Serliana as "una tipica invenzione bramantesca," because it reflects Bramante's fascination with the "travata ritmica," but he recognized that examples of the motive were found in earlier Bramantesque and Amadean buildings in Lombardy (presumably some of the examples cited in our n. 268). A reflection of Bramante's Hellenistic form of the Serliana is found in Cola dall'Amatrice's facade for San Bernardino in Aquila, initiated in 1527; see above, this chap., n. 193, pl. 143.

[270] Hartt, *Giulio Romano*, p. 40, fig. 75, for the embrasure; and p. 253, fig. 525, for the late drawing of a loggia of the Serliana type over a rusticated gateway (Albertina, Vienna, Ital. Arch. Rom. no. 341). Around 1518 Giulio or Raphael used the Hellenistic version with three equal vanes for the loggia of the Villa Lante on the Janiculum in Rome, and then it was used for the grotto and *loggetta* of the Palazzo del Te in Mantua (figs. 118, 302, and 355).

[271] Gaya Nuño, *La arquitectura española en sus monumentos desaparecidos*, pp. 298-300.

[272] For the La Calahorra portal (now in the palace of the duke of Infantado in Madrid), see Andrée de Bosque, *Artistes italiens en Espagne du XIVme siècle aux rois catholiques*, Paris, 1965, p. 440. The small Serliana niche over the south portal of the cathedral of Málaga may have been designed by Diego Siloe but it was probably not executed until the 1540s. A tabernacle for the imperial arms on the facade of the church of San Sebastián in Antequera, dated 1540-1547, follows the rare Syrian type

Romano's painted loggia in the window embrasure of about 1520 in the Hall of Constantine, it is likely that Machuca saw an earlier example among the sketches or projects of some member of the Roman School.[273]

The third entry to the palace, the edicular frame of the east portal, is the most Italian of the palace's entrances. It seems to have been designed by Pedro and executed by Luis, but the door casing and the plaque above it appear to date from about 1600. The Doric edicule, when relieved of the later features, is wholly in accord with a High Renaissance type favored by Tuscan designers. The closest affinity is found in the side doors of one of the Sangallo projects submitted for the facade of San Lorenzo in Florence in 1516 (pl. 132). These edicular frames also have broad proportions, stubby blocks for pedestals, a tall necking on the Doric capitals, and a full Doric entablature with a triangular pediment. Essentially the same type was delineated by Peruzzi about 1525, and it was used for a Doric portal and a retable in Serlio's fourth book in 1537.[274] Still, several features of the east portal are idiosyncratic, notably the forward inclination of the Doric frieze and the symmetrical disposition of its metopes.

While the edicular form of the east portal is readily understood within the Italian tradition, the south *portada* is not, because Pedro Machuca surpassed known Italian examples. For the three-door entry on the west, the emperor's Castilian advisers apparently had in mind the taller format of a *portada* like the one erected by Pedro the Cruel in 1364 for the entry to the *alcázar* in Seville (pl. 99),[275] but Machuca countered with a one-story marble frontispiece reminiscent of several earlier projects by the Sangallo. For the second story in white sandstone, Machuca seems to have anticipated a format later used by Serlio for a city gate, published in 1551 (cf. fig. 8 on p. 76, and pl. 127). While it is possible that lost Italian projects provided models for both the south and west entries, it would seem that the Hispano-Moresque *portada* provided the tradition that enabled Machuca to surpass his Italian contemporaries.

THE ROUND COURTYARD

Among Italian precedents for the round porticoed courtyard, we cited the theoretical designs of Francesco di Giorgio and several early sixteenth-century projects by Bramante and the Sangallo (probably for Raphael), and we noted that some of these porticoes were double colonnades like the one proposed by Machuca (fig. 10). Although the colonnaded portico encircling the Tempietto was not built, Machuca is likely to have known its elevation from Bramante's wooden model, on which Serlio depended in 1537 for his groundplan of the Tempietto and its circular courtyard (pl. 108). Of course, the colonnade was still retained in the revised plan of spring 1528 (pl. 107), but in the compromise plan of 1531, an arcade on sturdier square pillars replaced the colonnade (pl. 18).

The colonnade, rejected in 1531 and revived surreptitiously by Pedro in 1539, was not unknown in Spain. Even though arcades on columns or pillars were commonly used for the courtyards of major palaces, monasteries, and seminaries, a post-and-lintel construction was used for less pretentious houses and for galleries, but in that case, brackets, or *zapatas*, were added on either side of the capitals to extend their support of the lintel.[276]

and has a very wide center vane, but none of its component parts suggest that it was derived from those of Siloe or Machuca (assuming he first designed a Serliana loggia over the south portal in 1528 or 1537). Equally independent of the previous examples mentioned are the impressive main-story Serliana windows of the Ayuntamiento (Cárcel) in Baeza, which date from the mid-1550s. For the examples cited, see Camón Aznar, *La arquitectura plateresca*, figs. 85, 147, 151, and 164.

[273] No closer analogies are found in windows over rusticated doorways designed by Serlio, Palladio, or other midcentury architects; see Serlio, *Tutte l'opere*, bk. IV, fols. 155 and 156 (within format of Venetian palace facade); and bk. VII, chap. 33 (among examples of types of windows) and chap. 62 (over a rusticated portal on an astylar facade). In *Il sesto libro* (facsimile ed.), Serliana windows were indicated over the main entry on

only three of his model facades: a royal villa, a city palace for a nobleman, and a residence of a governor or president (fols. 42, 53, and 63). Perhaps the first Serliana window over the entry of an Italian palace was that of the Gattai palace on the Via dei Servi in Florence, begun about 1550, with a more loggia-like version used over the rusticated portal of the Signoria in Lucca, designed in 1576 by Bartolomeo Ammanati; see Chierici, *Il palazzo italiano*, III, pp. 331 and 336.

[274] Frommel, *Der römische Palastbau*, III, pl. 77f.; Serlio, *Tutte l'opere*, bk. IV, fols. 146 and 150.

[275] Leopoldo Torres Balbás, *Arte Almohade. Arte Nazarí. Arte Mudéjar*, p. 314.

[276] Examples of the post-and-lintel support with *zapatas* on both stories of a courtyard are the fifteenth-century palaces of the Fuensalida in Toledo and the Gutierre de Cárdenas in Ocaña

In contrast to the broad silhouette of a capital flanked by *zapatas*, the unaccompanied Doric capital on shafts of 5 meters set at intervals of 3.50 meters must have seemed a rather fragile construction to Castilian architects, and that impression was certainly increased by the superimposition of a second tier of columns for the gallery.

The double colonnade itself remained primarily theoretical in the Italian Renaissance until the middle of the sixteenth century, and the porticoes of palaces, town houses, and cloisters were almost always arcades. These arcades were usually supported by columns in the fifteenth century and by pillars or piers in the sixteenth. Around 1450, Alberti fostered the double, and even triple, colonnade as the more noble form, relegating the arcade to the houses of men of lesser social status,[277] but not even theorists followed his lead. Francesco di Giorgio made "reconstructions" of several Roman colonnades, and as we noted, at least one of his porticoed round courtyards was to have employed that support system because he identified it with "a building in old Tivoli," presumably the colonnaded circular casino in Hadrian's villa (pls. 103, 104 and 173).[278] He described the upper story of these courtyards as an open loggia of columns on parapets or as closed with windows.[279] The only known colonnaded courtyards in Italy previous to the mid-sixteenth century are single, not double,

and they are found in the modest rectangular courtyards of several Italian convents.[280] We should note that three-vane double colonnades were used on the entry side of the courtyards of a few town houses in the early sixteenth century,[281] but the first four-sided double colonnade constructed in the Renaissance may be that of the rectangular courtyard of the Scuola del Bo (now the University) in Padua, begun by Antonio Moroni about 1546.[282] Above the massive Doric entablature of its lower colonnade, the Ionic columns of the gallery rest on tall pedestals joined by a balustrade, whereas Pedro Machuca's elevation would have had a lighter and more open appearance because he planned to use Ionic columns that rose the full height of the gallery. Presumably Machuca intended to use a modest wrought-iron railing because it would have been less obtrusive and less disruptive of the silhouette of the gallery colonnade.[283] The original effect would have been closer to that of a Hellenistic stoa or the side aisles of a Roman basilica, such as the Aemilia (which he could also have known by way of coins), or the seaside porticoes of Roman villas (perhaps known from depictions in decorative frescoes);[284] but, there is no evidence that he was aware of any of these ancient antecedents. So it is more likely that Machuca knew the double colonnade as a theoretical type postulated by theorists such as Alberti and

and, in the first half of the sixteenth century, the palaces of Antonio de Mendoza in Guadalajara, the Miranda in Burgos, the Poletino in Ávila, and the Arco in Segovia; see Lampérez, *Arquitectura civil española*, I, pp. 373-377, figs. 429-435, 518, 523, and 531.

[277] Alberti, *Trattati*, II, pp. 808-809 (bk. IX, chap. 4).

[278] Francesco di Giorgio, *Trattati*, I, p. 286, pl. 164 (Saluzziano 148, fol. 88v): "edifitie in tiboli vecchio." Because of his predilection for circular colonnades, Francesco is likely to have designed the double colonnade that encircled a garden pavilion of the duchess of Milan recorded by Leonardo da Vinci in his Ms. B, fols. 11v and 12; see Pedretti, *Leonardo architetto*, p. 66, who suggests Brunelleschi as the designer.

[279] Francesco di Giorgio, *Trattati*, II, p. 346, pl. 194 (Magliabechiano II, I, 141, fol. 17v).

[280] Two of these courtyards pre-date that of Machuca: Santa Maria Maddalena dei Pazzi in Florence, begun in 1492, and the Santissima Trinità in Viterbo of 1514. Shortly after 1529, a colonnade was constructed in the courtyard of Santo Stefano in Venice. Although the Doric order was used in the courtyards in Viterbo and Venice, it bears no similarities to Machuca's. We should note the extraordinary fourteenth-century double colonnade that forms the portico of the Reggia dei Carraresi (now the Accademia Patavina) in Padua. Though its gallery rests on a parapet, it has a light and open elevation because the

columns on both levels are tall and slim.

[281] The lost house of Branconio dell'Aquila had on its entry side a Doric portico and, perhaps, an Ionic gallery above it; see Frommel, *Der römische Palastbau*, II, pp. 19-20, and III, pl. 7c, who presents evidence for its construction in 1515-1520. A similar portico was used in a Bramantesque house on the Via Pignola in Bergamo, probably begun before 1525, and also in the Lambertini palace in Bologna, which is attributed to Peruzzi, around 1523; see Wurm, *Der Palazzo Massimo*, pp. 120, 178. Peruzzi's sketch for this portico (Uffizi A352) bears the notation ". . . le colone tonde secondo le costume deli buoni antiqui non possano tenere archi e crosiera," which would seem to be a belated reflection of Alberti's admonition against arcades on columns.

[282] Diego Valeri, *Padova. i secoli, le ore*, Bologna, 1961, p. 457.

[283] References to a balustrade are missing not only for the gallery but also for the south window, where he might have used it, so it may be that the balustrade was not in Pedro Machuca's repertory. That feature was used elsewhere in Spain for galleries, most notably in the courtyards of the castle at La Calahorra, the Dueñas palace in Medina del Campo (pl. 10) and the Miranda palace in Peñaranda de Duero.

[284] Within the context of his discussion of villas and palaces, Vitruvius (IX, 4) recommended a proportional scheme for the

Francesco di Giorgio, but not realized in Italy until midcentury by Moroni and Palladio.[285]

In the design of the component parts of the Doric colonnade, Luis Machuca seems to have departed little from his father's design. It is likely that the model column designed by Pedro had approximately the same diameter as the present, that is about 0.57 meter, and a height of about 5.10 meters, with a resulting proportion of 1-to-8.5. While that proportion exceeds the Vitruvian 1-to-7 for the Doric order, it is in accord with the trend toward 1-to-8 and even 1-to-9 in the works of Bramante, Raphael, and Peruzzi.[286]

A notable peculiarity of the Doric entablature is the construction of its architrave and frieze in the form of a "flat" arch. Machuca could have constructed a lintel of bricks between two wedge-shaped blocks of limestone and then faced it with sandstone,[287] but instead, he used five large blocks of sandstone. Pyramidal pieces were placed di-

rectly over the columns, and between them, two voussoirs were locked in place by a keystone; then the two fascias of the architrave and the triglyphs and metopes of the frieze were carved into them. The flat arch was stabilized by the placement of pieces of the cornice directly over the joints of the flat arch. No Italian Renaissance examples of this construction are known to me, but the early sixteenth-century draftsman of the Codex Destailleur B sketched a comparable flat arch composed of five pieces, presumably from an ancient model.[288] It differs from Machuca's only in that the flat arch was surmounted by a single slab of stone rather than the four blocks that form the Spaniard's cornice. Somewhat similar flat arches were used in the courtyard of a house in Pompei and in the one known as the Courtyard of the Fluted Pillars in Hadrian's villa, though there they are composed of only three pieces—that is, pyramidal blocks over the supports and a single broad keystone between

successive colonnades of a three-story portico, but most of the known colonnaded Roman courtyards are believed to have had only one story. The only Roman three-tier colonnade still standing in the Renaissance was the porticoed facade of the Septizodium, which was located on the edge of the Palatine, facing the Via Appia, until it was destroyed in 1588. Drawings and arbitrary reconstructions of this ruin were made by students of antiquity from Francesco di Giorgio and Giuliano da Sangallo in the fifteenth century to Maarten van Heemskerck, Francisco de Hollanda, and Giovanni Antonio Dossi in the sixteenth. For depictions of the Septizodium and the double-porticoed Roman villas, see Axel Boethius and John Ward-Perkins, *Etruscan and Roman Architecture* (The Pelican History of Art 32), Harmondsworth, 1970, pls. 94, 95, and 143. For coins depicting the double colonnade of Roman basilicas after the restoration of 80 B.C., see John B. Ward-Perkins, *Roman Architecture*, New York, 1974, p. 51, fig. 57.

[285] No double colonnades were included among Serlio's model courtyards. The two round courtyards in his *Sesto Libro* (facsimile ed., fols. 25v-27) were to have had porticoes that alternated the archivolt and the lintel to form a Serliana-like continuity reminiscent of the Canopus of Hadrian's villa at Tivoli. At least the first of the two princely villas (fol. 26) was to have had only a single portico with an uncovered passage on the second story. Cataneo (*I quattro primi libri*, bk. IV, chap. xii) indicated that the portico of his round courtyard could be a colonnade: "ornandolo intorno con colonnati, o pilastri, con suoi cornici, fregi, & architravi per diverse maniere." Palladio (*I quattro libri*, bk. II, chaps. iii and vii) used double colonnades for his reconstructions of the "atrio toscano," the "casa privata degli antichi Romani," and (bk. III, chap. xvi) the "piazze dei Greci." Of course, he frequently used double colonnades for porticoes and porches on the facades of his projected palaces and villas, but in the courtyards of the palaces he actually built,

only the entry portico of the Bonin-Thiene palace in Vicenza is a double colonnade.

[286] Among Italian Renaissance theorists, Alberti (c. 1450), Fra Giocondo (1511), and Raphael and Fabio Calvo (c. 1514) held to the Vitruvian range of 1:6.5 to 1:7. Filarete's 1464 account is confused and his vocabulary is ambiguous, but Francesco di Giorgio (c. 1480) and Cesariano (1521) recommended 1:7 to 1:7.5, with Serlio (1537) ranging from about 1:6.7 to 1:7.3 while admitting that some ancient architects sometimes used taller proportions. Later, Vignola (1562) and Palladio (1570) preferred 1:8. Within this general trend toward taller proportions in the Doric order from the mid-fifteenth to the mid-sixteenth century, individual architects sometimes used a surprisingly wide range of proportions for columns of different sizes and functions.

[287] An ancient lintel constructed in this way was recorded in a drawing (Uffizi A1537v) attributed to Fra Giocondo and dated about 1510. A similar construction combining brick and stone was used for a colonnade alongside the ancient theater at Siracusa. In 1955 this technique was used for the reconstruction of a segment of the Ionic colonnade of the circular casino in Hadrian's villa (pl. 173). For intercolumniations of the maximum width, Vitruvius recommended the use of wooden beams with stone facings, but most Renaissance architects used stone beams, as Alberti noted the ancients had done. There are even instances (the round Doric Temple of Venus at Tivoli) in which curved stone beams formed the lintels of the peristyle, but that structural device was limited to relatively small intercolumniations.

[288] Codex Destailleur B, fol. 57v, Library of the Museum of the Hermitage, Leningrad. Heinrich von Geymüller, "Trois albums des dessins de Fra Giocondo," *Mélanges d'archéologie et d'histoire. École Français de Rome*, XI (1891), pp. 137-144. Matteo A. Gukovskj, "Ritrovamento dei tre volumi di disegni attribuiti

them.[289] It would seem that Pedro Machuca, confronted with the unusual problem of constructing a widely spaced circular colonnade, recalled this rare Roman structural technique.

The square pillars indicated in the small Royal Palace plan were apparently a compromise proposed by Pedro Machuca in 1531, after his colonnade had been rejected. The pillars were three Castilian feet or 84 centimeters square and, assuming that the arcade was to have been surmounted by an entablature somewhat less massive than the present one, the arched openings would have had a broad proportion of 2-to-3 (fig. 13). About the wall of the corridor we know only that its bays were scanned by pilasters of the same width as the square pillars, but we have no idea of the support system Machuca intended to use for the gallery of the 1531 project. So the only identifiable motive of that penultimate project for the courtyard is an arcade of approximately 2-to-3 proportion supported by square pillars. The first reference to the square pillar in the Renaissance seems to be Alberti's admonition that *columnae quadrangulae* were the only proper supports for an arcade that he conceived as an "interrupted wall."[290] Though Filarete, Francesco di Giorgio, Cesariano, and Serlio included rectangular pillars among their illustrations,[291] most architects preferred arcades supported by columns. Perhaps the rarity of rectangular pillars in antiquity accounts for the failure of most theorists and practicing architects to follow Alberti's recommendation, although Giuliano da Maiano employed them in 1487 in the spectacle courtyard of Poggio Reale, the famous Neapolitan villa of Alphonso II of Aragon.[292] They were used again around 1499 in the important palace of Adriano Castellesi da Corneto (later Giraud-Torlonia) on the Via Alessandrina leading to the piazza in front of Saint Peter's in Rome.[293] Its arched openings also have the broad 2-to-3 proportions of our elevation of Machuca's courtyard recorded in the small Royal Palace plan (pl. 18). Shortly after, rectangular pillars of somewhat taller proportions were employed by Raphael and his school for the arcaded porticoes of several town houses, notably the Alberini-Cicciaporci and the Caffarelli-Vidoni palaces,[294] and they were also used in the round courtyard depicted in the background

a Fra Giocondo," *Italia medievale e umanistica*, VI (1963), pp. 263-269. A similar disposition is sometimes found in architraves over addorsed columns, such as the wall of the Temple of Fortuna Virilis in Rome; see Durm, *Die Baukunst der Etrusker, Die Baukunst der Römer*, p. 233, fig. 244.

[289] Ibid., p. 299, fig. 235, and p. 231, fig. 239.

[290] Alberti, *Trattati*, II, p. 643 (bk. VII, chap. 15).

[291] Filarete, *Trattati*, II, pls. 95 and 121 (fols. 123v and 161); Francesco di Giorgio, *Trattati*, I, pl. 51 (Saluzziano 148, fol. 28); Cesariano, ed., *Vitruvius*, bk. IV, fol. LXV, and bk. VII, fol. LXXXXVII; Serlio, *Il sesto libro* (facsimile ed.), fols. 13 and 19, and *Tutte l'opere*, bk. VII, fol. 27.

[292] Poggio Reale is known to us primarily by way of the (probably idealized) plan and section published by Serlio (*Tutte l'opere*, bk. III, fol. 122) and several later sketches and descriptions; see George L. Hersey, *Alphonso II and the artistic renewal of Naples, 1485-1495*, New Haven, 1969, pp. 63-64.

[293] The designer of this palace is unknown, but an old attribution to Bramante has recently been reaffirmed by Bruschi (*Bramante*, pp. 849-857). Frommel (*Der römische Palastbau*, II, pp. 213-214; III, pl. 82b) stressed the relationship of its facade to the Cancelleria, but he believes that Bramante might have provided the project for the courtyard in 1503-1506.

[294] Ibid., I, pp. 154 and 161; III, pls. 2, 26a, and 27c.

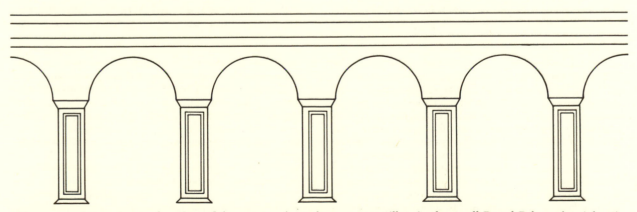

FIGURE 13. Approximate elevation of the courtyard arcade on square pillars in the small Royal Palace plan (pl. 18)

of Giulio Romano's *Holy Family with Saints* of about 1523 (pl. 169) and in the round and pentagonal courtyards proposed between 1515 and 1535 by Baldassare Peruzzi and Antonio da Sangallo the Younger for the fortified villa of the Farnese at Caprarola.[295] If Pedro Machuca intended fielded panels on the pillars as well as the responds along the wall of the corridor, the closest analogies would be found in the courtyard porticoes of several Neapolitan palaces begun in the second decade of the sixteenth century, notably the Orsini di Gravina, Sanseverino di Bisignano-Filomarino, and Pinelli palaces (cf. fig. 13 and pl. 155).[296] As we noted earlier, the fielded panels of these examples have the sharp arrises and narrow channels used by Pedro, though the motive may have been brought (perhaps by Mormando) from Rome. Apart from the fielded panel, which may or may not have been intended by Pedro, his rectangular pillars in the small Royal Palace plan reflect a form that existed primarily as a theoretical type until its use around 1500 in Rome and its environs.

The Tabularium pier, found in the Archive plan and apparently in the wooden model for the palace (fig. 3, p. 30), was clearly opposed by Pedro Machuca. Of course, that support was quite new to the Roman School in the early sixteenth century, and of all the people involved in the palace, Machuca is the one most likely to have known of it. He may have proposed the Tabularium pier in one of the several projects sent to the emperor in 1527, although those projects would have been for a palace with a rectangular courtyard. A variation of the type—that is, a rectangular pillar faced with a pilaster—was indicated in the Royal Palace plans as the support for the arcades that were to surround the west and south forecourts (pls. 17 and 18); but, quite understandably, Machuca considered the Ta-

bularium pier ill-suited to a round courtyard. Although the pier was not totally unknown in Spain (an ornate version was used by Bartolomé Ordóñez on the *trascoro* of the cathedral of Barcelona in 1517 and by Diego Siloe in the courtyard of the Colegio de los Irlandeses in Salamanca around 1529), the massive form indicated in the Archive plan and presumably executed in the wooded model reflects the Tabularium type proposed by Bramante for the courtyard of the huge Tribunal palace, begun about 1508 for Pope Julius II, and then used by Antonio da Sangallo the Younger in the courtyard of the influential Farnese palace, begun in 1517.[297] In recognizing that Pedro Machuca probably introduced this pier to the Alhambra, we are simply adding another motive that links him with the Roman School of the early sixteenth century.

The pilasters, or responds, on the wall of the corridor in the two Royal Palace plans were also quite new features (pls. 17, 18, and 107), having been introduced into the porticoes of Italian Renaissance courtyards during the first two decades of the sixteenth century. Previously, most Italian architects used brackets to support the vaults along the wall of a portico. Ancient Roman architects occasionally used responds on the porches of temples and along the passages of amphitheaters or the aisles of basilicas, and the motive was continued in Byzantine basilicas, but it is seldom found in the Early Christian churches of Italy. The respond reappeared in a few fourteenth- and fifteenth-century paintings[298] and, of course, in Brunelleschi's basilicas and in the porch of the Pazzi Chapel, built by his followers in the 1460s. Among the theorists, Filarete in the 1460s depicted an arcaded porch with pilasters along the wall, and Francesco di Giorgio in the mid-1470s indicated responds along the corridors of several porticoed courtyards in ground-

[295] Walcher, *Il Vignola*, I, pp. 156-157; II, figs. 133 and 134 (Uffizi A775 and 506).

[296] Pane (*Il Rinascimento nell' Italia meridionale*, II, pp. 249-251, figs. 282, 284-286) believes Giovanni Donadio, called il Mormando, proposed this paneled pillar for the Gravina palace in 1513 and that his follower Di Palma then used it for the Sanseverino di Bisignano-Filomarino courtyard, but the building chronologies of these related palaces must still be determined.

[297] This type of pier (found on the Tabularium or the gallery of the Hall of Records that overlooks the Roman Forum, as well as on Roman arenas, porticoes, and theaters) was revived in the 1460s in several important but anonymous porticoes in Rome: the Loggia of Benediction of Saint Peter's, the porch of

the church of San Marco, and the courtyard of the adjacent Palazzo Venezia in Rome. These early piers have rather slim proportions in contrast to the massive piers indicated in Bramante's plan for the Tribunal palace (Uffizi A136, probably drawn by Antonio di Pellegrino) and seen in Sangallo's courtyard for the Farnese.

[298] Responds are found in several murals in the Campo Santo in Pisa, especially Antonio Veneziano's *Return of St. Raynerius to Pisa* of about 1377 and Benozzo Gozzoli's *Drunkenness of Noah* and *Curse of Ham* of 1467; see Roberto Papini, *Pisa* (Catalogo delle cose d'arte e di antichità d'Italia), Rome, 1912-1914, nos. 448, 468, and 469, pl. XII.

plans identified as ruins in the environs of Rome, while Giuliano da Sangallo in 1492 used them in a project for the Sapienza in Siena.[299] At the turn of the century, responds were employed in the courtyard of the important Castellesi da Corneto palace in Rome, also in Bramante's cloister of Santa Maria della Pace, and, during the following decade, in the portico on the lower level of his Belvedere courtyard and on the wall of the corridor of the colonnade that was to encircle his Tempietto (pl. 108). After 1510, responds were used by Antonio da Sangallo the Younger in the courtyards of the Baldassini and Farnese palaces in Rome,[300] and they were depicted around 1523 along the corridor of the circular courtyard in the background of Giulio Romano's *Holy Family with Saints* in Santa Maria dell'Anima in Rome (pl. 169). Baldassare Peruzzi consistently used responds, beginning with his Villa Chigi-Mieli near Siena of about 1505 and continuing in the Ossoli palace in Rome, the cloister of San Martino in Siena, and his project of about 1530 for the Orsini palace on the Baths of Agrippa in Rome (pl. 109).[301] To this Roman group we should add the courtyard of the Orsini di Gravina, palace in Naples (pl. 155), designed about 1513 by Mormando, who must have been in Rome shortly before. While Tuscan architects and theorists must be credited with the revival of the respond, the first extant examples in porticoed courtyards are found in Rome around 1500, and Machuca must have seen it there.

Another unusual feature of Machuca's corridor is the rhythmic disposition of its three distinct bays: a large archway *A* for the major openings on the cardinal and intracardinal axes, a smaller rectangular doorway *b* with a round panel above it, and, between them, a closed bay *c* with a niche surmounted by an oblong panel. The resulting disposition of the several openings (*A c b c A c b c A*) served to stress the cardinal and intracardinal axes and the central symmetry of the round courtyard. If Machuca planned to use large spiral staircases in the northwest and southeast corners, access would have required no more than the large archway used on the other intracardinal points, and the rhythmic disposition would have been interrupted only by the three-door passage to the west vestibule. Nothing like it had been done previously in Spanish courtyards, not only because the intercolumniations of the porticoes had not been reflected on the walls of corridors but also because Spanish designers seldom recognized the axes of a courtyard portico in their placement of door or window openings. In Italy, where the use of responds became common only after 1500, the rhythmic disposition of the bays of a corridor remained rare until the middle of the sixteenth century; but, Francesco di Giorgio around 1474 used a three-bay sequence composed of doors on the cardinal axes, semicircular niches on the intracardinal, and rectangular niches between them. If *a* represents the doors, *b* the rectangular and *c* the semicircular niches, its rhythmic pattern is *a b c b a b c b a*.[302] Serlio provides our only record of Bramante's rhythmic treatment of the wall of the circular courtyard he designed in 1502 to enclose the Tempietto (pl. 108). The three distinct bays of the plan include large (probably arched) openings for the corner recesses and narrower (probably rectangular) doorways on the cardinal axes, with small semicircular niches between them. If *a* represents the entrances and *C* the larger niches, Bramante's bays follow this pattern: *a b C b a b C b a*, while in Machuca's much larger courtyard the large arched openings *A* are located on both the cardinal and intracardinal axes, and the small doors *b* flanked by niches *c* occupy the three bays between them. This produces a slightly different scheme: *A c b c A c b c A*. A simple alternation of niches and doorways is seen along the stylar corridor of Giulio Romano's *Holy Family with Saints*, painted in 1523 (pl. 169); but a full three-bay sequence is found in Peruzzi's round courtyard for the Orsini palace, dated about 1530 (pl. 109).[303] Its large semicircular corner niches are

[299] Filarete, *Trattati*, II, pl. 46 (fol. 70v). Francesco di Giorgio, *Trattati*, I, pls. 17, 22, 151, and 155 (Saluzziano 148, fols. 11, 13, 82, and 84). *Il Taccuino senese di Giuliano da Sangallo*, fol. 21, and Uffizi A1666 (plan for the Sapienza in Siena).

[300] Giovannoni, *Antonio da Sangallo*, figs. 97, 148, 246, and 300, for the Baldassini and Farnese palaces of 1510 and 1517, and also for the Pucci palace in Orvieto and the portico of the *Ostaria* of the ducal palace at Castro of the 1530s.

[301] Bartoli, *I monumenti antichi di Roma*, II, p. 56, pl. CLXXV, fig. 310 (Uffizi A456).

[302] Francesco di Giorgio, *Trattati*, I, p. 282, pl. 151 (Saluzziano 148, fol. 82).

[303] The rhythmic motive of the Orsini courtyard (Uffizi A456) was also used by Peruzzi, perhaps in collaboration with Sangallo, in a project of 1520-1535 for the Farnese Castle at Caprarola (Uffizi A506), except that the small rectangular and

separated by small rectangular niches from the large doorways on the cardinal axes, thus forming a rhythm similar to that of Bramante's enclosure for the Tempietto. Again, it would seem that the idea was introduced by Francesco di Giorgio, probably under the stimulus of the rhythmic alternation of recesses in ancient sepulchers and nymphaeums (pl. 112), and later confirmed by Bramante and continued by architects usually classified as Mannerists, Baldassare Peruzzi and Giulio Romano.

The large arches of Machuca's round courtyard are framed by a molding composed of a large fillet and two graduated fascias edged by small fillets. That molding continues from the archivolt into the jambs without an indication of the springpoint of the arch, and at the bottom, the molding turns inward as if it were meant to close the base of the opening, but there it is severed by the opening (pl. 82). A continuous molding of this type was popular among Florentine architects from the mid-fifteenth century;[304] but, with the exception of several palace portals and a few sketches by Cronaca, Fra Giocondo, Peruzzi, and Antonio da Sangallo the Elder,[305] it seems to have lost favor during the High Renaissance. Architects of the early sixteenth century tended to articulate the molding that separates the jambs from the archivolt. In Spain, the Renaissance version of the continuous molding appeared around 1489 in Lorenzo Vázquez's main portal for the Colegio de Santa Cruz in Valladolid and then, in 1509, it was used by Michele Carlone

for a doorway under the staircase of the courtyard of the castle at La Calahorra. In both cases, the lower part of the frame has been replaced because of the corrosion of the stone from dampness, and the present molding does not turn inward. During the next decade the continuous frame of an arched opening became popular in Castile, with Gothic reminiscences often evident in the moldings and their ornamental courses, and also in the stress on their linear vitality.[306] Presumably the motive would have been considered somewhat old-fashioned by most members of the Roman School around 1520, but it probably appealed to Pedro Machuca because continuous moldings enhanced the majestic size of the arches in contrast to the smaller rectangular doors and, also, he could avoid a springpoint molding that would have introduced an isolated horizontal with no counterpart in the rectangular portal or the niches of the other two bays in the rhythmic sequence.

The rectangular door frame is composed of three graduated fascias with narrow fillets between them, while the shallow roundel above it is surrounded by a small fillet, a large cyma reversa, and another fillet. The 3-to-5 proportion of the doorway is taller than the 2-to-3 or sesquialter proportion that Kubler and Chueca consider typical of the Platersque style in Spain.[307] Early Italian theorists, such as Alberti and Filarete, recommended proportions of 2-to-3, $\sqrt{2}$, or 1-to-2, while Francesco di Giorgio and Serlio preferred openings with a propor-

semicircular niches and the doorways are irregularly disposed along the wall of the corridor of the pentagonal courtyard; see Walcher, *Il Vignola*, II, fig. 134.

[304] Brunelleschi or his immediate followers had used an archway with a continuous molding in the side chapels of San Lorenzo, Santo Spirito, and Santa Maria degli Angeli in Florence, and in the Badia in Fiesole; and it was repeated in the archway to the chapel of the Cardinal of Portugal in San Miniato and in the main entries of the Medici, Pazzi-Quaratesi, and Strozzi palaces in Florence, as well as in several archways of the Cancelleria courtyard in Rome and the Porta Capua in Naples. Francesco di Giorgio, *Trattati*, II, pls. 238 and 239 (Magliabechiano, II, I, 141, fols. 48v and 44) included a round-headed window with a continuous molding among his nine examples of door and window frames. Neither Fra Giocondo (1511) nor Cesariano (1521) in their illustrations of the treatise of Vitruvius fostered round-headed openings or continuous moldings, and the motive is not found in the many model portals published by Serlio in his fourth and sixth books in 1537 and 1551.

[305] Among the rare examples of the early sixteenth century are the arched doorway of the Sienese villa known as *Le Volte*,

designed by Peruzzi in 1505, and the entry portals of the Alberini-Cicciaporci palace in Rome and the Tarugi in Montepulciano. Drawings of the motive by contemporary architects were published in Bartoli, *I monumenti antichi*, I, pl. X, fig. 22, pl. XLVII, fig. 75, and pl. LXXXII, fig. 146.

[306] Continuous moldings (without the inward turn at the bottom) were used for portals (the Puerta da la Pellejería of the cathedral of Burgos, begun in 1512, the main portal of the cathedral of Plasencia, designed by Juan de Álava in 1517-1522, and the convent of Corpus Christi in Salamanca, begun shortly after 1538) and porticoes (the cloister of the cathedral of Santiago de Compostela, 1521, and the courtyard of the Miranda palace in Peñaranda de Duero, 1525-1530). While admitting Gothic reminiscences in these door frames, we must recognize that in Italy the archway with a continuous molding also survived in a Renaissance version into the early sixteenth century.

[307] Kubler-Soria, *Art and Architecture of Spain and Portugal*, p. 9. The inclination of Spanish architects toward more squat or "virile" proportions and their tendency to diminish the taller proportions characteristic of the Italian Renaissance was also noted by Chueca (*Invariantes castizos*, pp. 82-83).

tion of 1-to-2 or even taller ones, but most recognized that a doorway was a feature whose proportions might vary with the context.[308] A tabulation of the proportions of doorways in Spain would, I suspect, demonstrate that Spanish architects had the same attitude.

The roundel over a rectangular door was a motive new to Spain in the 1520s, and even in Italy there are only a few precedents in decorative ensembles and courtyards. In 1510, Antonio da Sangallo the Younger designed four doorways with unframed concave roundels above them in the entry portico of the courtyard of the Baldassini Palace in Rome. Presumably they are intended to house sculpted busts.[309] A later variation of the idea is found in doorways along the passage connecting the front porch and the courtyard of the palace of Pietro Massimo alle Colonne in Rome, begun about 1533 by Baldassare Peruzzi.[310]

In respect to the intermediary bay, composed of a semicircular niche with a shell-faced half-dome and an oblong panel above it (pl. 82), there is little point in attempting to identify Machuca's models. As we noted earlier, this ubiquitous motive was used in Italy from the fourteenth century and remained popular through the sixteenth. It was introduced into Spain around 1500 (perhaps by way of Domenico Fancelli's sepulcher for Pedro González de Mendoza in the cathedral of Toledo), and it was used shortly after by Spanish sculptors such as Vasco de la Zarza, Damian Forment, Ordóñez, Berruguete, and Siloe, so it was a well-established motive in sepulchers and retables by the late 1520s.

Also, Machuca followed the marked preference of Plateresque designers for the positioning of the shell so that its hinge is at the bottom and its gores radiate upward and, thus, its cusped edge coincides with the semicircular arch of the niche. In Italy, this disposition is found about as often as its reverse, even though the scallop shell with its hinge at the bottom was characteristic of Syria and Asia Minor in antiquity and the shell with the hinge at the top was used predominately in the Italian peninsula from at least the Augustan period.[311] Incidentally, the Syrian form was used in Visigothic Spain and then used in Islamic buildings, and that may explain the marked preference of Spanish architects for the Syrian form.[312] The placement of a cartouche above the niche is also a familiar device (one of the earliest examples was provided by Francesco di Giorgio),[313] but the closest analogy is the intermediary bay of Francisco de Hollanda's sketch of an exedra that seems to be a late 1530s version of Bramante's on the upper level of the Belvedere courtyard, designed in 1503.[314] Hollanda delineated an oblong panel above a semicircular niche with a shell-faced half-dome in bays that alternate with large arches. If the motive was not found in Bramante's exedra, Hollanda must have seen examples in Rome in the 1530s because the primary purpose of his trip was to bring back drawings of model works in the new style to Portugal, his homeland.

For the annular vault there are no extant Renaissance precedents, but Francesco di Giorgio in the 1470s noted that a circular portico could be

[308] Alberti, *Trattati*, I, pp. 82-85 (bk. I, chap. 12); Filarete, *Trattati*, I, pp. 82-85 (fol. 60); Francesco di Giorgio, *Trattati*, II, pp. 406-408, pls. 238-239 (Saluzziano 148, fols. 43v and 44). Proportions of 1:2 or taller predominate in the relatively few facades included among Francesco's illustrations; see I, pls. 37, 143, 144, and 173 (fols. 21, 78r, 78v, and 93). Serlio consistently used taller proportions, but in 1540, in his book III, fol. 53, he illustrated the approximately 3:5 proportion of the portal of the Pantheon.

[309] Giovannoni, *Antonio da Sangallo*, II, fig. 246. A roundel was also placed over each of the side doors in Antonio's project for the three-door entry to the atrium of St. Peters in Rome (Uffizi A112, fig. 122), but in that case there is a reference to the Roman triumphal arch. As early as 1435, Ghiberti had used a roundel over a rectangular door on the left side of his relief of the *Meeting of Solomon and the Queen of Sheba* in the doors of the baptistry of Florence, but the motive was seldom used until the sixteenth century. Perhaps we should note that the doors surmounted by roundels painted on the end walls of the

Hall of Psyche in the Villa Farnesina in Rome were executed long after Pedro Machuca left Italy.

[310] Wurm, *Der Palazzo Massimo alle Colonne*, pl. 16a.

[311] D. S. Robertson, *Greek and Roman Architecture*, Cambridge, 1969, p. 230, n. 1. Maria Bratschkova, "Die Muschel in der antiken Kunst," *Bulletin de l'institut archéologique bulgare*, XII (1938), pp. 14-15.

[312] An example of the Syrian type is a seventh-century marble niche in the Museo Arqueológico in Mérida. Islamic examples of the Fatimid period in the twelfth century were cited by Derek Hill (*Islamic Architecture in North Africa*, Hamden, Conn., figs. 33 and 37).

[313] Francesco di Giorgio, *Trattati*, I, p. 284, pl. 159 (Saluzziano 148, fol. 86). The theorist noted that it was a "hedifitio apresso Sam Marcho" and Corrado Maltese observed that it was reminiscent of the sepulcher of Publicius Bibulus on the Via Lata in Rome.

[314] Tormo, *Os desenhos das antigualhas que vio Francisco d'Ollanda*, pp. 89-93 (Escorial, Codex 28-I-20, fol. 19v.)

covered by a ceiling or a vault and he illustrated the latter,[315] but there are no extant Renaissance examples until the mid-sixteenth century. The annular vault of the semicircular garden loggia of the Villa Giulia in Rome was designed by Vignola in 1550 (pl. 171), and shortly after, he used a segmental form for the circular corridor and gallery of the round courtyard of the fortified villa of the Farnese at Caprarola. Apparently, they were both cast of a combination of cement and a lightweight aggregate comparable to that of the damaged barrel vault over the circular corridor of Giulio Romano's painting of the *Holy Family with Saints* of about 1523 (pl. 169). Still, previous to 1520, the only examples Pedro Machuca is likely to have seen were ancient Roman structures. Among the most accessible of the Roman vaults were those of Santa Costanza in Rome and the small colonnaded hemicycle on the seventh level of the Sanctuary of Fortuna at Palestrina (pl. 170).[316] The annular vault of the latter is semicircular in section and coffered like the one in Giulio Romano's painting. We do not know if fragments of the covering of the colonnaded portico of the circular casino in Hadrian's villa at Tivoli survived into the sixteenth century, but Renaissance architects (like the archaeologists who reconstructed a segment of the corridor in 1955) may have assumed that it had an annular vault (pl. 173).[317]

The last feature of Pedro Machuca's round courtyard to be discussed is its high level—about 1.80 meters above the vestibule and the ground-floor rooms. Even though no steps from the lower vestibules to the courtyard were delineated in the three early groundplans (pls. 17, 18, and 19), we are assured that the courtyard was at its present level because twenty-eight steps were indicated in the northwest staircase in these plans, and that was the number of treads ordered in 1612 and then used in the present staircase. Of course, if the villa proposed in 1527 was a one-story structure like Vico's depiction of the palace (pl. 22), it would not have

had a raised courtyard. The high level of the courtyard may have been an ad hoc solution to the problem of adjusting the double colonnade to the elevation of the wings, which by 1528 were composed of ground and main floors of almost equal height with a subsidiary floor over each. The Ionic colonnade of the gallery needed to be no taller than the main-floor rooms because the lean-to roof (over either a flat ceiling or an annular vault) coincided with the attic level, whereas if the courtyard had been located on ground level, the Doric colonnade would have had to rise through both the ground floor and most of the mezzanine. That elevation would have required Doric columns of at least 22 Castilian feet as against the present 18, and that 22-foot column would have been disproportionately tall in relation to the 16-foot Ionic columns intended by Pedro for the gallery. Faced with this problem, Pedro may have looked to the raised courtyard of the Spanish tradition for the solution.

Courtyards in the Hispano-Moresque tradition were usually raised from three to ten steps above the floor of the vestibule, which is invariably at street level. Among the highest are the late fifteenth-century courtyards of the Fuensalida palace in Toledo, the Casa de las Conchas in Salamanca, and, to cite examples in Granada dating from the 1530s, the old university (now the Curia Eclesiástica), the Chancillería, and the Casa Castril. The courtyard in Spain was usually a source of light and air, and it also provided passage from one room to another. As the intimate center of the household, the *patio* was protected from the view of entrants into the *zaguán* by means of a zigzag pattern of movement from the street through the vestibule and into the courtyard, and also by raising the courtyard.

The high level and relative seclusion of the round courtyard would, at first, appear to follow that Spanish custom, but the courtyard does not serve to connect the surrounding rooms because most of them are on the level of the vestibule. A few

[315] Francesco di Giorgio observed that "colle circular logge" one could use "volte e tetti co'suoi ornamenti compartito, in mode che tutte le linie al centro abbin corrispondenza . . ." and he included a sketch of an annular vault; see *Trattati*, I, pp. 79 and 283, pls. 33 and 155 (Saluzziano 148, fols. 19 and 84). Because of the small size of the circular portico that was to have enclosed Bramante's Tempietto alongside San Pietro in Montorio, it is not likely that he would have used an annular vault over its narrow corridor. A beamed ceiling would not

only have served better in this case but it would have been more congruent with the peristyle of the Tempietto. The other round courtyards of the Renaissance previous to midcentury are also known to us only by way of groundplans.

[316] Fasolo and Gullini, *Il Santuario della Fortuna Primigenia*, p. 236, fig. 322.

[317] Salvatore Aurigemma, *Villa Adriana*, Rome, 1961, p. 73, fig. 48.

rooms were provided with access to the courtyard by way of a small passage and several steps, but those passages seem to have had nothing more than a service function. The main halls on both levels are connected to one another by doors, most of them aligned along the *outer* wall of the palace. Furthermore, no windows open on the courtyard, not even on the upper level. The rooms take their light and air from the exterior. On special occasions the octagonal chapel would have been entered from the corridor of the round courtyard but access for daily services for members of the two households was provided from the rooms alongside the chapel. Although distinguished visitors would have used the main staircase, movement within the palace would have depended on lesser staircases (probably of wood) connecting the mezzanine and attic levels with the ground and main floors, while the "secret" spiral staircase in the southwest corner was to serve for passage from the private quarters of the imperial couple to other floors and to the courtyard. Hence, unlike the Spanish *patio*, neither the courtyard of 1527 nor that of 1528 functioned as the intimate center of the household or the source of light and air for the surrounding rooms. Lázaro de Velasco in 1580 (when he was consulted about the rebuilding of Santa María de la Alhambra) observed that the round courtyard of the palace of Charles V was so "useless and inconvenient" for the disposition of rooms and halls that the palace would never be finished.[318]

Machuca's disengagement of the round courtyard from the residence is also at odds with the other royal residences in Madrid and Toledo, which were renovated in the late 1530s, as well as with the royal hunting lodge near Madrid known as El Pardo, which was begun in 1547. In those, doorways and windows open directly on the courtyard (pls. 11, 15, 16), and in contrast to the high level of the Granada courtyard, those of the Castilian residences were raised less than half a meter. Furthermore, the vestibules of the latter open on to their courtyards by way of large arches (two in Madrid and El Pardo and three in Toledo) and these archways have spans of 2-to-3 meters, whereas the central archway in Granada is only about a

meter and a half in width and the rectangular doors on either side are half as wide as that. In addition, the three doorways (in the two Royal Palace plans) have intrados of almost a meter in depth and the side doors are angled to align them with the radii of the round courtyard, with the result that the view from the vestibule was further reduced. To these differences we must add the probability that, in contrast to the open arches in the other royal residences, the three doorways in the Granada palace were to have been fitted with folding wooden leaves (housed in the recesses indicated in the intrados of the two Royal Palace plans) so that the courtyard could be completely closed off from the vestibule. Of course, in the enlarged palace of 1528, offices and guest quarters, as well as most public functions such as receptions, tournaments, and festivities, were provided for in the forecourts and thus separated from the residential block, whereas in Madrid and Toledo most of the official functions had to be accommodated within the confines of the palace itself. Hence, the raised courtyard in the Granada residence separates itself from the Spanish tradition in that it neither fulfills the functions of the Hispano-Moresque *patio* nor those of the more public courtyards of contemporary royal residences in Spain.

Still, the raised level of the round courtyard is surely the least Italian feature of Pedro Machuca's Italianate palace because it is not found in major palaces or even theoretical projects previous to the mid-sixteenth century in Italy. Some palace courtyards are (or were) as much as half a meter above street level, but (with the exception of town houses that have steps) the higher level is often not noticed because an entry ramp makes a gentle transition between the two. Around 1500 in Italy the courtyard seems to have served primarily as an atrium and, in larger palaces, as a private *piazza* for festivities and receptions, and the most distinguished visitors were permitted to dismount from horses in the courtyard at the foot of the main staircase. Later, the entry of horses into the courtyard was discouraged by Serlio in his unpublished sixth book and also his seventh (both compiled toward the middle of the sixteenth century), and he consistently recommended raising the courtyards of pal-

[318] Gómez-Moreno y Martínez, "Juan de Herrera y Francisco de Mora en Santa María de la Alhambra," p. 7: "La casa Real de Granada es tan chica y tan breve y de figura tan inútil el patio redondo para pieças y salas, que nunca será más, y la yglesia es más necesaria. . . ."

aces and villas about five steps above ground level.[319] He may have held that idea earlier, but he rarely described his plans for residences in the first five books. While the levels of some streets have been raised throughout the last four centuries, it is not likely that Machuca in his youthful years in central Italy had seen major palaces with courtyards raised more than a meter and a half above ground level. Also at odds with the Italian palatine tradition is the failure to use the round courtyard as a source of light and air for the surrounding main-floor rooms. So it would appear that its function differed from that of the courtyards of Italian city palaces as much as those of Spain.

Within the Italian tradition there is also a garden courtyard that served primarily as a secluded retreat. The most conspicuous extant example is the large Giardino di San Marco begun by Cardinal Pietro Bembo before 1464 as an addition to his palace in Rome, known since the late sixteenth century as the Palazzo di Venezia. Described by contemporary documents as a garden, it is porticoed and raised about 3 meters above ground-level stables and, before its removal to a new site in 1911, it was somewhat trapezoidal in plan.[320] No windows opened on to this courtyard from the rooms of the palace or those constructed along its east portico, and the courtyard could only be entered by way of the private apartments of the cardinal. Planned as a cloister-like garden, it served as a private retreat and a secluded place for receptions and entertainment. When he became Pope Paul II in 1464, Bembo constructed a similar *hortus secretus* alongside the papal apartments, and it is known to have served on occasion for banquets.[321] Small, raised "secret" gardens were probably fre-

quently part of princely residences during the Renaissance, but only the irregular enclosure of the *giardino pensile* of the ducal palace in Mantua has survived, and it dates from the late sixteenth century.[322] The raised level and seclusion of the round courtyard of the palace of Charles V leads one to suspect that it, too, was a garden retreat.

The round shape of the courtyard would in itself have suggested a garden function. Several Italian theorists considered geometric forms ideal shapes for an enclosed garden. Alberti noted that circles and semicircles were the best forms for not only the courtyards of villas but also their gardens.[323] Francesco di Giorgio chose circular and polygonal forms for the central courtyards of princely villas, which he described as *case artificiose* (pl. 21), so a "decorative" shape is a good indication that a courtyard served a private function, usually recreation or retreat. In the 1470s, Francesco recommended the enclosure of gardens with circular walls and in the 1490s he was more explicit: "Because gardens are made principally for the enjoyment of the person who orders them to be made . . . the inventor should endeavor to give them a perfect form, such as the circular, square, or triangular [form]," and he added, "after these, the best are pentagonal, hexagonal, or octagonal."[324] It is difficult to imagine any other than a garden function for the round courtyard in the sketch of the villa "in Spain" (pl. 20). The same is true of the round courtyard of the Villa Madama designed by Raphael in 1516–1519 (pl. 172).[325] Because of the rarity of round gardens in the Renaissance, we should mention two midcentury examples for which we have graphic records. The botanic garden at the University of Padua, designed by Andrea Mo-

[319] Serlio, *Il sesto libro* (facsimile ed.), fols. 25, 26, 27, 29, and 31; and *Tutte l'opere*, bk. VII, p. 2. A word should be said about the raised courtyards of Genoese palaces. For some midcentury Genoese palaces that are built into a hillside, the raised courtyard is the result of the terrain. The purpose was not privacy but scenic effect along the axis from the entry to the staircase at the rear of the courtyard.

[320] Torgil Magnuson, *Studies in Roman Quattrocento Architecture* (Figura IX), Stockholm, 1958, pp. 277–284, figs. 43–45.

[321] Ibid., p. 284.

[322] Giovanni Paccagnini, *Storia di Mantova. Le Arti*, Mantua, 1963, III, p. 77, n. 44.

[323] Alberti, *Trattati*, II, p. 807 (bk. IV, chap. 4): Accedent et orti plantarumque delitiae, et porticus ortensis, qua soles, qua item umbras captes. . . . Praeterea et cicli et emicicli, et quae descriptiones in areis aedificiorum probentur, ex lauro ex citro ex iunipero deflexis ac sese mutuo complectentibus ramis con-

cludentur."

[324] Francesco di Giorgio, *Trattati*, I, p. 245, pl. 127 (Saluzziano 148, fol. 68), and II, p. 348, pl. 195 (Magliabechiano, II, I, 141, fol. 18v): "Perché li giardini principalmente si fanno per dilettazione di chi fa edificare, et ancora sicondo la comodità del loco, però pare superfluo assegnare la figura loro; pure si debba il compositore ingegnare di redurla a qualche spezia di figure perfetta, come c[i]r[c]ulare, quadra o triangulare; dopo queste più apparenti la pentagona, esagona, ortogonia, etcetera si pono applicare." A contemporary of the Sienese theorist, Francesco Colonna, described the garden of Venus as round in his *Hypnerotomachia Poliphili*.

[325] Terry Comito (*The Idea of the Garden in the Renaissance*, New Brunswick, N.J., 1978, p. 171) suggested that it was a secluded garden. Most students of the architectural history of the Villa Madama have not speculated on its function.

roni in 1545, was composed of four round plots within a circular enclosure.[326] Two or three years later, the Soderini transformed the ruinous round Mausoleum of Augustus into a raised garden with radial parterres within its circular cavity. We know the original state of the garden by way of a sketch of 1550 by Van Cleef and an engraving of 1575 by Étienne Dupérac.[327] While the extant examples are not numerous, there is sufficient evidence in the writings of architectural theorists and also in contemporary literature to affirm an association of round courtyards or enclosures with gardens. Not surprisingly, the only suggestions of a garden function for the round courtyard of the palace of Charles V were made by two students of gardens, Gothein and Villiers-Stuart.[328]

The kind of garden that Pedro Machuca and Luis Hurtado might have had in mind is a matter of speculation. Work on the double portico of the round courtyard was not completed before the funds ran out in the 1630s, so there was no chance to lay the water pipes that might have provided clues to the kind of garden they intended. The mysterious tunnel that extends almost to the center of the courtyard from the lower chamber under the octagonal chapel might have housed the main part of the hydraulic system, since it has no other evident purpose. Normally the best indication of the function of a courtyard is the way in which it is surfaced, but this courtyard was used as a storage and work area for stonecutters and carvers and was never paved. Even complete paving, as in the royal residences in Toledo and Madrid,[329] would not have precluded its use as a garden: plants and shrubs could have been potted in tubs, with some clipped to assume the shapes of people and animals. Another prospect—the planting of paterres in a radial disposition comparable to the Soderini garden in the Mausoleum of Augustus in Rome—would have

served to accent the cardinal and intracardinal axes of the circular courtyard, already marked by the large archways originally intended at all these points along the wall of the corridor, and one assumes that the center of such a garden would be occupied by a fountain, pavilion, or statue.[330] Of course, a centrally symmetrical garden of this type is more likely to have been designed as a showpiece and as the setting for ceremonious promenades of courtiers and their ladies rather than as a place for private functions.

Exotic plants from his worldwide empire might have been used in Charles' garden. Such a display within the circular enclosure would have symbolized the global expanse of his Spanish and Habsburg empires and the universality of his rule, and it certainly would have provided a conversation piece for members of the cosmopolitan court. We know that Charles, like many of his generation, had an intense interest in botany, and when he retired to the Hieronymite monastery at Yuste in 1557, he planned the gardens himself and obtained plants from several parts of his dominions.[331] From Tunis, the scene of his greatest victory against Islam, he brought laurel trees and a flower known as an *Indian pink*.[332] Philip II planned an imperial botanic garden at Aranjuez in 1555, and shortly before, Charles' brother, Ferdinand, did the same in Vienna.[333] For his famous residence in Surrey, which came to be known as the Nonsuch Palace, Henry VIII gathered exotic plants in the early 1540s.[334] This kind of garden, like so many Renaissance ideas, seems to have started with the Medici in their villa at Careggi, and through the following years, the botanic garden came to be associated with princely residences.[335] More than to any other ruler of the first half of the sixteenth century, the symbolism of such a garden was suited to Charles V, who ruled an empire nearly as large

[326] *La città di Padova. Saggi di analisi urbana*, Rome, 1970, p. 276, fig. 210.

[327] Bartoli, *I monumenti antichi di Roma*, v, pl. CDVII, fig. 739 (Uffizi A1750); Lugli, *Itinerario di Roma*, pp. 455-459.

[328] Marie L. Gothein, *A History of Garden Art*, trans. Archer Hind, New York, 1928, I, p. 358. Constance Mary Villiers-Stuart, *Spanish Gardens, Their History, Types, and Features*, London, 1929, p. 24.

[329] Martín González ("El alcázar de Madrid," p. 3) noted that Gómez de Mora in 1626 described the patio de la Reina as "enlosado con piedra berroqueña."

[330] Francesco di Giorgio recommended the placement of a fountain in the center of a circular garden (*Trattati*, I, pp. 245-

246, pl. 127, Saluzziano 148, fol. 68) and that was done in the case of the square courtyard of the castle at La Calahorra; see above chap. I, n. 41.

[331] Gothein, *A History of Garden Art*, I, p. 359; William Stirling-Maxwell, *The Cloister Life of the Emperor Charles V*, 4th ed., London, 1891, p. 223.

[332] Ibid., cited René Rapin, *Hortorum liri quatuor*, Paris, 1665, lib. I, v, 952-954.

[333] Gothein, *A History of Garden Art*, I, pp. 361-362; II, p. 12.

[334] John Dent, *In Quest of Nonsuch*, London, 1962, pp. 114-115.

[335] Comito, *The Idea of the Garden*, pp. 7-8, n. 41.

as that of the Romans and still expanding in the already fabled lands of Central America. It is tempting to entertain the idea of the planting of representative flora from two empires in the round courtyard—an expression of the universality of Charles' rule.

The garden might have had a paved surface with channels to conduct water to plots in which small trees such as box, myrtle, laurel, or citrus could have been planted. Even if the channels followed a radial rather than the usual rectilinear disposition, the irregularity of the trees would result in a less formal effect, and there would be more flexibility of movement through a garden with plots than one composed of parterres. Of interest in relation to the kind of tree that might have been chosen is Charles' special fondness for the Court of Lions, where (according to the inscription on the large Royal Palace plan) he enjoyed eating his meals in majestic solitude. That courtyard was apparently a citrus garden: Antoine Lelaing, who visited the Alhambra in 1502, said there were six orange trees and other small plants.[336] We should also note that the citrus garden was not peculiar to Islam in the early sixteenth century because an anonymous Venetian envoy to the Vatican in 1523 described part of the upper level of the Belvedere as "paved in squares of tiles, laid on end, and in every square a beautiful orange tree grows out of the pavement, of which there are a great many, arranged in perfect order," and he continues, "On one side of this garden is a most beautiful loggia, at one end of which is a lovely fountain that irrigates the orange trees and the rest of the garden by a little canal in the center of the loggia."[337] We know that citrus trees were planted in the gardens of the *alcázar* of Seville, and also at Yuste[338] where Charles V retired after his abdication, so there is reason to sup-

pose that type of garden in the round courtyard on the Alhambra.

Although the kind of garden remains speculative, it is highly probable that the round courtyard was to have been a secluded garden that would serve the emperor as a retreat and as a place to dine and entertain small groups of selected members of the imperial court. This kind of Renaissance garden, as Terry Comito observed, represents the merging of the classical idea of pastoral retirement from *negotium* (in Charles' case the burden of governing his diverse realms) and the monastic tradition of "contemplation in search of the soul's homeland."[339] Apparently these were the functions of the round courtyard in the villa originally proposed in 1527 and then retained as the residential core of the expanded official palace. Because all the usual administrative and ceremonial functions of a regal or imperial palace were accommodated to the forecourts and the large vestibules, the round courtyard remained a secluded place. The garden function provides the key to the typology of Charles V's palace. It was not a block-design Italian city palace incongruously placed within the citadel of the Alhambra, but rather, a square villa with a round peristyle garden at its center. Only Carl Justi in 1891 suggested that the model for the palace of Charles V might be found in the villa rather than the palace tradition in Italy.[340] To be sure, Machuca's first project for a villa was transformed into an official palace, with a stylar facade of the kind used for city palaces in Rome around 1500; and because the forecourts were never completed, the palace became a block-design residence angled inexplicably into the old Nazaride palaces. These ambiguities of location, plan, and elevation have often misled scholars in their search for a model for the palace of Charles V.

[336] Navagero, *Viajes*, I, pp. 474-475. Navagero commented on the beautiful citrus garden in the cloister of San Jerónimo in Granada; see chap. I, n. 5.

[337] James S. Ackerman, *The Cortile del Belvedere* (Studi e documenti per la storia del Palazzo Apostòlico Vaticano, III), Vatican City, 1954, pp. 34 and 145: "Da una parte di questo giar-

dino vi è una bellisima loggia, a un capo della quale vi è una bellisima fontana, che per un canaletto per mezzo alla loggia va ad adacquare gli aranci e il resto del giardino."

[338] Samuel Tolkowsky, *Hesperides*, London, 1938, p. 194.

[339] Comito, *The Idea of the Garden*, pp. 78f.

[340] Justi, "Anfänge der Renaissance," pp. 186-187.

VI

THE TRAINING AND ART OF PEDRO MACHUCA

THE PERSONAL STYLE of an architect can be characterized more confidently when the artistic ambience in which he was formed is known. In the case of Pedro Machuca we know only that he was born in Toledo and returned from Italy to Spain in 1520. No documentary evidence for his activities previous to that date has been found so nothing is known of the architects with whom he studied, where he traveled in Italy, or how long he was there. The only evidence for his study of architecture in Italy are the autograph parts of the palace. For that reason, I have isolated about seventy distinctive features that can be related to buildings or projects he is likely to have known and subsequently recalled in the design of his only major work. This study revealed surprisingly few reflections of Spanish architecture in autograph parts of the palace. Hence, it is likely that he had little or no training in architecture previous to his trip to Italy. The preponderance of Italian precedents and analogies indicates that his idea of architecture was formed there, but it is still necessary to consider the distribution of these precedents and analogies in the several chronological and geographical classifications used here to determine whether they suggest an individual or a group of architects with whom Pedro Machuca studied.

Of the approximately seventy motives considered in the previous pages, about thirty can be identified with Rome in 1500 to 1520. To that group we can add the twenty-two associated with Tuscan theory and practice previous to 1500 because they could also have been encountered in Rome during those two decades. Turn-of-the-cen-

tury variations and elaborations of these Tuscan motives were brought to Rome by architects from Florence, Siena, and Urbino, who by then were part of a common artistic culture. Rome at that time had no active architectural school of its own. There was no local tradition to provide solutions for technical and formal problems nor a common idea of architectural design within which a young architect could confidently formulate his personal style. Rome did, however, have many impressive ruins of ancient Roman buildings that served as ready models for architects intent on recovering the architectural forms and design principles of antiquity. Of equal importance were the imperial aspirations of Julius II and Leo X and the expansive cityscape of Rome itself. The amplitude of available space, together with the desire for *grandezza*, encouraged architects to design palaces and villas that were truly Roman in scale as well as in form. It is, of course, the scale and grandeur of Renaissance Rome that was reflected in the multicourt palace designed by Machuca for the Holy Roman Emperor on the Alhambra in Granada. That Machuca's facades provide the greatest number of analogies to the Roman School is due to the fact that the round courtyard and its double colonnade remained theoretical postulates not then realized in Rome or elsewhere. It is true that the half-dozen motives that might have been derived directly from ancient monuments could have been revived earlier by Italians whose works or projects are unknown. As to the dozen analogies in the works designed after 1520 by members of the Roman School in Rome and its environs, and also in north-

western Italy, especially in Mantua, Verona, and Venice, it is reasonable to assume that they were already used in Rome during the first quarter of the sixteenth century, since it is unlikely that those architects (primarily Sanmicheli, Giulio Romano, and Jacopo Sansovino) and Pedro Machuca independently invented the common motives. Among the relatively few motives that cannot be identified with Rome, three or four seem to depend on illustrations in Cesariano's 1521 translation of Vitruvius, which was published only after Machuca returned to Spain. In a few other cases, such as the ornament on the main-story window crowns, there is reason to suspect the motive was required and not freely chosen by Machuca. Even if these features alien to Rome are assigned to him, the overwhelming concentration of precedents and analogies in Rome of 1500-1520 would be sufficient to support the conclusion that his idea of architectural design was formed there.

Several features or aspects of the present palace that are at odds with central Italian theory and practice are sometimes cited as evidence of Lombard or Plateresque influences, but most of them can be shown to be alterations of Pedro Machuca's project or additions to it, or simply the result of changes brought about by time. One example of the latter, which has misled many scholars in their attempts to characterize Machuca's architectural style, is the drastic change of the color of the sandstone from white to gold. This has resulted in a deepening of all the shadows in the rusticated blocks of the ground floor, the deeply undercut ornament of the main-story window crowns, and even the emblems in half-relief on the pedestals. Originally, when the stone was a luminous white, strong relief and deep undercutting were needed to attain enough of a range of values to articulate the shapes of the component parts of the facades. Even the deepest crevices and the undersides of the *bugnati* would have been well lighted by reflection.[1] But, since most critics of the now gilded palace have accepted it as it is today, they see its great range of light and shade as evidence of a "pictorialism" that is alien to central Italy and more akin to Lombardy. Judged in that false context, the sculptural orna-

ment of the window crowns, pedestals, and marble frontispieces also appears to be Lombard or Plateresque in style. Of course, we now know that much of the figural ornament of the *portadas* was intruded into Pedro's sober projects, and there is good reason to suspect that the peculiarly Plateresque ornament added to the vases on the lintel crowns is due to Juan de Marquina. Also, it is likely that the imperial emblems were carved into fielded panels that originally served as the only ornament on the main-story pedestals. If Pedro Machuca is relieved of responsibility for this added ornament, Lombard and Plateresque reminiscences are greatly diminished, but even what remains (the vases on the hooded crown and the pomegranates on the triangular pediments, with Burgundian emblems in the tympanum) is more decoration than was normally used on window crowns in central Italy. Pedro Machuca may have been more willing to admit heraldic ornament than were his Italian contemporaries, but I am inclined to believe that the sobriety of the catafalque of Mary of Portugal (pl. 6) is representative of his own severe classicism and that the original all-sandstone facades had little more than niche statuary and emblematic ornament on the window crowns. Whether or not my sober image of Pedro Machuca's style is accepted, the reduction in the ornament attributable to him and our recognition of the luminosity of the original all-white palace diminish the basis for claims of pictorialism in his style.

For many scholars, tall pedestals are also clear signals of Lombard training, but as we noted, tall pedestals were used in Rome before 1520, especially within the main-story podium of stylar facades. The hooded lintel surmounted by three vases is another feature that might be associated with northern Italy because it was used in the late 1540s by several Emilian architects who may have continued a local type. But, the Emilians tended to use three vases of the same kind, whereas Machuca characteristically stressed symmetry by using a double-handled vase flanked by two single-handled water ewers with their handles turned outward, as in the Burlington elevation, or inward, as on the present facade (cf. pls. 39 and 74). After

[1] If the stone of the palace were still white, the rusticated blocks would not be judged as too high in relief, as they were recently by Roberto Pane in "Gli scambi con la Spagna: scultori e architetti," *Firenze e la Toscana dei Medici nell'Europa del Cin-* *quecento. Il potere e lo spazio. La scena del principe*, Florence, 1980, p. 116: ". . . il bugnato è troppo alto per la sua funzione di basamento."

these exclusions, there is little basis for claims of Lombard or even Plateresque influence on Pedro Machuca himself.

In recent years the term *Mannerist* has gained favor in descriptions of certain features of the palace of Charles V.[2] The designation seems to be used more with its meaning of the 1920s (anticlassical revolt, irrationality, tension, and the bizarre) than with that of the 1960s (virtuosity, variety, complexity, and inventiveness).[3] Apparently classified among the caprices of Mannerism are several asymmetrical dispositions in the palace of Charles V, with some students accepting asymmetry as a principle of Mannerist design. This explanation for the asymmetrical disposition of the window crowns on the west facade, however, is discredited by the discovery that the work directed by Pedro never reached the upper story and that the error in the sequence of the crowns occurred under Luis. Rather than the deliberate application of a design principle, the asymmetry was probably the result of delay in raising the center of the facade and the decision to interrupt work two bays south of the central unit and to transfer the masons to the windows on its north end, where they inadvertently followed Pedro's original disposition of the window crowns (seen in the Burlington elevation) rather than the revised scheme initiated by Luis on the south end. Another instance of asymmetry is the marked disalignment in the small Royal Palace plan of the archway on the west side of the main forecourt and the center portal of the palace itself, but as noted above, that plan is less representative of Pedro Machuca's ideas than is the large Royal Palace plan in which he clearly tried to minimize awareness of that displacement by leaving nine arches to the south and eight to the north of the triumphal archway (cf. pls. 17 and 18). That disposition resulted in no more than a 2.23-meter displacement in contrast to the 4.45 meters of the later plan, which apparently incorporated instructions from Castile. So the evident indifference to axial alignment would seem to be that of the Castilian advisers, not of Pedro Machuca. An example

of asymmetry, known only to insiders, was found in the trabeation on either side of the archway from the west vestible to the round courtyard. The paired pilasters originally stood on a section of the benchtable that extended farther toward the archway than it did in the other direction. That extension was removed by Torres Balbás in 1926 when he constructed the flight of steps to the round courtyard, so the unit is now perfectly symmetrical (pl. 93). Several scholars (in conversation) have cited the original asymmetry of the benchtable under these pilasters as another evidence of Pedro's Mannerist inclinations, but we now have good reason to think he never intended a stylar treatment in the west vestibule and we know that the present membering on the long wall was executed in the 1560s by his son Luis. With the elimination of this example, three favorite Mannerist features of the palace are removed from consideration with respect to Pedro Machuca's personal style. Even without documentary evidence, Pedro's evident devotion to the principle of bilateral and radial symmetry should have given pause to those who attributed asymmetries of this sort to him. Also related to the question of axial symmetry is the articulation of the side wall of the west vestibule, which now has a huge panel on its central axis and small rectangular doorways on either side (pl. 94). To be sure, the stress on the ends rather than on the center of a wall is properly identified with Italian Mannerism, but the membering of the side walls was done in the 1590s by Minjares, whereas Pedro Machuca indicated a single centered door in both of the Royal Palace plans. The change in the doors probably occurred in the late 1570s when a solid wall was needed to support the fireplace Herrera ordered for the audience hall (immediately above the vestibule), which had not yet been extended from the original three to the present five facade windows. Another factor in the association of Pedro Machuca with Mannerism is the use of the word *oval* to describe the east vestibule, but neither of the constructions indicated in his ground plans follows any of the four methods used by Peruzzi and

[2] Mannerist references were encountered primarily in conversations with scholars in Granada and elsewhere, and Jesús Bermúdez Pareja related observations of this sort made by scholars who visited the Alhambra. Alfonso Rodríguez Gutiérrez de Ceballos suggested that the Mannerist phase of architecture in Spain should be extended as far back as the palace of Charles

V; see his "La arquitectura del Manierismo," *Revista de ideas estéticas*, xx (1962), p. 26.

[3] For the older view, see Walter Friedlander, *Mannerism and Antimannerism in Italian Painting* [1925], New York, 1957, pp. 3-42; and for the more recent view, see Shearman, *Mannerism*, esp. pp. 135-170.

illustrated by Serlio and therefore identified with Mannerism.

Several features of the main facades have also been associated with Italian Mannerism. The fifteen-bay length is sometimes cited, but Machuca's original sandstone facades differ from Italian examples previous to midcentury in the clear articulation of the center and end bays. Evidently, Machuca meant to facilitate the viewer's visual comprehension of the entire facade as a symmetrical unit, whereas early Mannerists usually sought to overwhelm the viewer by a seemingly endless extension of bays on either side of an undifferentiated or weak center bay. Perhaps the feature of the facades that most scholars would immediately accept as Mannerist in style is the rusticated pilaster composed of wide and narrow blocks and integrated into the patterned masonry of the wall. That association is due to its later use by Vignola for the lower entry to the fortified Villa at Caprarola around 1559, but we have seen that the Italian's pilasters are essentially those of the Acqua Vergine portal (cf. pls. 144 and 148), while the Spaniard's seem to be an inventive combination of that ancient type and the banded pilaster. Vignola's embedded and Machuca's interlocking pilasters were both solutions for the problem of the combination of the orders with a rusticated wall. It is only happenstance that the first (known) example in Italy was designed in 1559. One last tenuous claim for a Mannerist inclination in Pedro Machuca's facades—that is, the "tension" introduced by the disruptive marble *portadas*—can be quickly dismissed because we now know Pedro vehemently opposed them. In sum, there is no basis for classifying Pedro Machuca as a Mannerist.

The role of the Spanish architectural tradition in Pedro Machuca's design of the palace should also be evaluated. Anyone familiar with Spanish palaces is likely to identify the broad shape of the west vestibule with the Hispano-Moresque *zaguán*, but that format probably pertained to Pedro Machuca's initial project for a villa derived from the speculative plans of Francesco di Giorgio. Thus, the broad shape represents a coincidence of the Spanish *zaguán* and the type of vestibule contemporary theorists considered to be Roman. The raised level of the courtyard with respect to the vestibule is another feature readily associated with Spanish pal-

aces; however, a difference in level would not have been found in the first villa plan if it had no more than a ground floor and an attic. The higher level may well have been adopted later to avoid a disproportionate rise of the Doric colonnade through the ground and mezzanine floors, while the Ionic gallery was limited to the height of the main floor because the lean-to roof over its ceiling coincided with the attic level. A third feature sometimes thought to follow a Hispano-Moresque design principle is the broken axis between the center portal of the west facade and the archway indicated on the west side of that forecourt in the two Royal Palace plans,[4] but (as I noted in denying its association with Mannerism) Pedro clearly tried to diminish that displacement, not to accentuate it. Furthermore, the purpose of the broken axis of entry in Islamic and Hispano-Moresque architecture is defense or privacy and neither applies to the path of movement from that archway to the portal of the palace because the archway is a sham. The only true entry to the west forecourt (other than the arch connecting it to the south forecourt) is the gateway on its south end. Often described as "Spanish" are the *portadas* of the two main facades, and the association is undeniable. They are advanced from the wall and faced with a different material, and they rise through two stories to the roofline. However, it is now clear that that traditional form was fostered by the Castilian advisers of the emperor over the opposition of Pedro Machuca.

While denying that Pedro consciously or unconsciously applied the design principles of the Hispano-Moresque tradition, I suspect that his preference for certain motives in the repertory of the High Renaissance in Italy can be explained by analogous Spanish forms. They include: the surround, which is reminiscent of the *alfiz*; the coffered wooden ceiling, which differs little from some forms of the Moorish *artesonado*; the rusticated facing of the ground floor, which was preceded by the *almohadillado* treatment of surfaces; the unification of a portal with a window above it, which is in essence a *portada*; and the octagonal plan of the chapel and the cubic form of the block-design palace, which are both in keeping with the Hispano-Moresque inclination to geometric forms. Perhaps one can add the colonnade because the

[4] Chueca, *Invariantes castizos*, pp. 44, 58-63, figs. 23-25, 27.

post-and-lintel construction of porticoes was frequent in Spain, though usually for less pretentious courtyards. This claim for a preparatory or conditioning role for the Spanish tradition gains credence when it is recognized that (with the exception of the coffered ceilings) none of these Italian forms won early acceptance elsewhere in Europe. Only in a generic or typological sense can one claim that a Spanish form made Machuca more responsive to its Italian counterpart, because he did not alter the Italian to accord with the Spanish. While his responses were probably conditioned by comparable Spanish forms, he was not deeply rooted in his native architectural tradition. What is more, he remained absolutely faithful to the architectural repertory he acquired in Italy, with no suggestion of the process of "rehispanization" that occurred in the work of most contemporary artists returning from study in Italy—notably, Diego Siloe, Alonso Berruguete, and Fernando Yañez.

The final style influence to be considered is that of antiquity itself. I often referred to ancient antecedents for Italian Renaissance forms used by Machuca, but his are usually closer to the latter than to the former. This is true of the orders and their ornament, the rustication, the stylar treatment of the facade, and the ideal of monochromatic unity in a building. He may have drawn the structural principle of the flat arch for the entablature of his colonnade directly from ancient models, but at least one contemporary Italian made a sketch of a comparable flat-arch entablature. Also, his principle of strict mirror reversal of figural ornament may have gained more impetus from ancient than Renaissance works, but precedents in both are rare. The plain die beneath the Doric band on the pedestals of the west frontispiece (as recorded in the Burlington elevation) is more in keeping with ancient Roman examples of that motive than with the decorated Renaissance version. For the optical compensations and intensifications used by Pedro Machuca, no Italian Renaissance counterparts were found and therefore I speculated that he might have extracted that principle from Vitruvius; still, the instances of direct dependence on the ancient author are too rare to describe the artistic culture in which Machuca was formed as "Vitruvian," unless it is used to mean a preference for the orthodox

and decorous. Pedro Machuca certainly knew Vitruvius' treatise and he must have made many sketches of ancient ruins, but those sources were merely supplementary to his study of contemporary Italian projects and buildings. Like other foreigners converted to the classical style, he found many ancient Roman forms and principles of design already recovered and adapted by Italians to the architectural needs of contemporary Europe.

As to the question of the architect or group of architects with whom Machuca might have studied in Rome previous to 1520, the only Italian contacts for whom we have sixteenth-century sources are Jacopo Torni and his brother, Francesco, who had a workshop in Rome, but that relationship is of little help because Machuca and the Torni brothers represent opposite ends of the range of ideas of classicism in architecture around 1500. Jacopo and Francesco continued the slimly proportioned and richly ornamented Corinthian and Composite orders of their native Florence at the turn of the century, whereas Pedro favored the Doric and Ionic, together with more massive forms, a bolder scale, and a minimum of ornament. Of all the palace motives studied, only one, the window swag composed of fruit and flowers, has a counterpart in a work of the Torni—the wreath at the base of the sacristy in the cathedral of Murcia, begun by Francesco and continued by his older brother, Jacopo—but the fruit and flowers are of a generic kind widely used in Tuscany. The association with the Torni brothers is important, however, because they seem to have had many professional and social contacts, including Michelangelo, whom Jacopo Torni seems to have assisted briefly in 1508 in the early phase of work on the Sistine ceiling. As noted above, Lázaro de Velasco, the son of Jacopo Torni, stated that Pedro Machuca had been a *discípulo* of Michelangelo,[5] but that claim has not been taken seriously by students of his painting, and there is no reason to do so for his architecture.

Another Spanish artist in central Italy during the same years was Alonso Berruguete, the painter and sculptor from the province of Valladolid who was trained in Toledo about 1505–1510 and then studied in Florence and Rome until 1518, when he returned to Spain.[6] Because he had spent several

[5] See chap. 1, n. 52.

[6] Azcárate, *Alonso Berruguete*, pp. 29-52; Longhi, "Comprimarj spagnoli della maniera italiana," pp. 3-15.

years in Toledo, Machuca's home town, and then gained prominence in Italy, scholars have assumed Berruguete knew Machuca and facilitated his study abroad. On the assumption that they were companions in Italy, Gómez-Moreno speculated that Machuca returned to Spain in 1520 to help Berruguete execute the cycle of frescoes that the Catholic Monarchs had wanted in the Royal Chapel in Granada, but that is unlikely because the contract was not signed until 1521.[7] Unfortunately, we do not know the relative ages of Alonso and Pedro or the precise year in which either went to Italy. Machuca may have been a few years the older and he may already have left for Italy by 1505 when Berruguete (then in his late teens) came to Toledo; but, even if they did not know one another there, they are likely to have met as members of the Spanish community in Italy. Because they were both *hidalgos*, there would have been no class barrier to a friendship as artists abroad.

Alonso Berruguete became well known in the artistic circles of Florence and Rome. He (not Machuca) was known to Vasari, who cited him five times—a distinction granted to few foreigners. He may be the "young Spaniard" for whom Michelangelo wrote to Florence in 1508 to arrange for his study of the Cascina battle cartoon because in another letter of 1512 he inquired about the "young Spanish painter who is called Alonso."[8] The second letter was written to his father in Florence at the request of "a young friend or relative" of Alonso who was in Rome and wanted to know if he had recovered from an illness. It is tempting to suggest that the friend in Rome was Pedro Machuca, but there is no way of proving it. Vasari also tells us that Berruguete, along with young Jacopo Sansovino, Zacchi, and Varignana, participated in the competition of 1508 for the restoration of the statue of the Laocoon discovered in 1506. Also, according to Vasari, Berruguete completed a painting left unfinished by Filippino Lippi, who had died a decade earlier, and Longhi identified that work as the *Coronation of the Virgin* from the church of San Giròlamo alla Costa San Giorgio, now in the Lou-

vre.[9] On the basis of this commission and other attributions in Italy, Longhi claimed a major role for Berruguete in the formation of the early Mannerist style in Florence. While that might be overly generous, Alonso Berruguete had important contacts in central Italy, and clearly, he could have been of great help to Pedro Machuca. In the absence of early sources confirming their friendship, Longhi cited an "affinity of temperament" as an indication that they had been companions in Italy.[10] To be sure, the *furia* of Berruguete's figures is approached by the impetuosity of some of Machuca's, especially in the *Descent of the Holy Ghost* (pl. 5), but the only strong similarity is the Berruguete-like Christ-child in Machuca's *Holy Family* in Jaén (pl. 4). In general, their pictorial style is different enough to assure us that the two Spaniards reflected different schools. The sculpture and painting of Berruguete reveal strong reminiscences of the art of Michelangelo and Donatello and the impact of the recently discovered Laocoon and, thus, he is properly classified as a partisan of early Mannerism in Florence, while Pedro Machuca seems to have been trained as a painter in the Raphael workshop in Rome. In respect to architectural form, the two Spaniards are even farther apart. The fragile and ornate "orders" of Berruguete's retables bear no similarities to the correct and sober forms of Machuca's palace. Thus, Pedro Machuca seems to have acquired his training in classical architecture without the guidance of Alonso Berruguete.

To identify the artistic circle to which Machuca belonged in Rome, we must depend on the distribution of precedents and analogies for his architectural repertory among contemporary Italian architects who worked there. Only about a dozen architects were cited for multiple associations. If Pedro had any practical experience in architectural design or construction, it would presumably have been with one or more of this group. They include the Sangallo (Giuliano and Antonio the Elder and the Younger) and Andrea and Jacopo Sansovino from Florence, Francesco di Giorgio and Baldassare Peruzzi from Siena, Fra Giocondo and Michele

[7] Gómez-Moreno y Martínez, *Las águilas*, pp. 111-112.

[8] Longhi, "Comprimarj spagnoli della maniera italiana," pp. 3-5. The reference of 1508 is: "L'aportatore di questa sara uno giovine spagnuolo, il quale viene costà per imperare a dipingiere a àmmi richiesto che io gli facci vedere il mio cartone che io cominciai alla Sala; però fa' che tu gli facci aver le chiavi a ogni modo a se tu puoi ajutarlo di niente, fallo per mio amore, perche

è buon giovane"; and that of 1512: "Ancora vi prego mi facciate un servizio; e questo è che gli è costà un garzone spagnuolo che à nome Alonso che è pittore, el quale comprendo che sia amalato: e perchè un suo o parente o amico spagnuolo che è qua, vorrebbe sapere come gli sta."

[9] Ibid., pp. 6-7.

[10] Ibid., p. 11.

Sanmicheli from Verona, Raphael and Bramante from Urbino (though the first had an important formative experience in Florence and the second, a prolonged period of activity in Milan before coming to Rome), and finally Giulio Romano, who was the only one born in Rome. Two theorists, Cesariano from Milan and Sebastiano Serlio from Bologna, were probably known only through their publications after Pedro returned to Spain.

Among the architects listed in our tabulation, Peruzzi was credited with the greatest number of similarities—about sixteen—but most associations are *analogies* rather than precedents because they are found in sketches, projects, or works that probably postdate Machuca's departure from Italy and, in some cases, even his design of the palace of Charles V in 1527. Peruzzi and Machuca were near contemporaries and they were in Rome during approximately the same years. Peruzzi is thought to have been there most of the time from 1505 to 1522, and we have reasoned that Machuca arrived between 1505 and 1510 and returned to Spain in 1520. As a Sienese artist, Peruzzi was well aware of Francesco di Giorgio's speculative projects, which have been cited so often as typological antecedents of Pedro Machuca's architectural motives, beginning with the initial plan of 1527. Portoghesi has stressed the profound effect of the theorist on Peruzzi and he has suggested that this influence explains why Peruzzi differs from most other members of the Roman School.[11] Certainly it explains Peruzzi's penchant for plans that combine basic geometric shapes (the circle, polygon, oval, and even the triangle), as well as his inclination to speculative inventions and his predilection for exceptions or oddities within the classical repertory. In view of this, it is not surprising that analogies were found in the works of Peruzzi for some of the most unusual of the motives used in the palace of Charles V, including the tapered pilaster, the staircase composed wholly of winders, the doorhead that rests on triglyph brackets set directly on the door casing, and the three-bay rhythm of the wall of the round courtyard. The east vestibule can not be cited because Machuca did not follow any of Peruzzi's methods for the construction of an oval.

Machuca, like Peruzzi, was inventive within the classical idiom, but he did not seek novelty for itself. Rather, Machuca seems to have started with an orthodox form and then accommodated it to the particular needs of the architectural circumstance. Of course, his projects were often disrupted by intrusions and additions recommended by the Castilian advisers of the emperor, and in attempting to regain the formal integrity of a design, he sometimes found novel solutions. But one can not say of Machuca (as Lotz and Portoghesi did of Peruzzi) that he had a predilection for exceptions within the classical style. In most cases Machuca avoided the architectural cliché without seeking the odd or the bizarre, and for that reason he is not a true Mannerist. Having recognized these differences, the affinity of Peruzzi and Machuca is that of contemporaries who shared the common legacy of Francesco di Giorgio's theoretical projects and the richly varied and stimulating artistic ambience of Rome in 1505 to 1520. There, each formulated his own idea of classicism.

While Peruzzi leads in analogies to Machuca's repertory, three of the most prominent members of the Roman School previous to 1520—Giuliano da Sangallo, Bramante, and Raphael—were each cited for about a dozen. If we tally the analogies and precedents in the sketches and works of the Sangallo family, the total is about twenty-five, which places them well ahead of Bramante, Raphael, and even Peruzzi; however, these precedents, like most of those cited, are of a typological sort, with only a few sufficiently close to identify them as models. Of course, the quantitative tabulation presented here has its limitations, but it is more objective than attempts to identify Machuca's master or mentor on the basis of a central trait or spirit that is taken to be the touchstone of his style, and the distribution of precedents among so many architects effectively negates claims that he was the pupil or imitator or even collaborator of any one of them. Still, the marked Raphaelesque character of Machuca's paintings and the fact that he returned to Spain shortly after the master's death oblige us to review reminiscences of Raphael's architecture in the palace of Charles V and to evaluate the role that the master or his school might have played in Machuca's study of classical architecture.

Surprisingly few features of Machuca's architectural repertory have been found in projects or

[11] Portoghesi, *Rome of the Renaissance*, p. 38.

buildings designed by Raphael. One that has is the west forecourt's arcade on piers with a large archway centered on each side (pl. 17-P). A comparable arcade and archway was proposed in 1519 to screen the stables of the Villa Madama. Because that disposition seems to be without precedent or immediate successor in Italy, it is likely that Machuca knew that very groundplan of 1519 (pl. 110-C). Also found in that plan is a three-door entry in which the center door is twice as wide as those on the sides. Although the entry was to have been approached by a broad staircase of about forty steps (pl. 110-A), it is the only known instance of the use of that triumphal format in a secular building previous to Pedro Machuca's design of the all-sandstone facade of 1527–1528 (pls. 18 and 107). Another portal of the villa, one opposite the stables on the basement level in groundplan Uffizi A273, is framed by an advance of the rusticated wall. It may be (as some have suggested) the model for the rusticated archway surmounted by a distinctive window, later used by the Sangallo in several palaces (pl. 126) and, thus, a possible precedent for Machuca's first south entry (fig. 7, p. 68). The only other potential precedent for the palace of Charles V to be found in the final project of the Villa Madama is the diameter of the round courtyard. If completed, the unporticoed courtyard of the Villa Madama would have been approximately 31 meters and that is close to the 30.30-meter diameter of the *clearing* between the porticoes of the courtyard of Machuca's palace. But that reference is placed in doubt by the fact that the clearing in the three extant plans of 1528–1531 is about 4 meters wider because their corridor was narrower than that of the present palace. Machuca in 1527 may have proposed a 42-meter courtyard with a near 31-meter clearing, then increased the clearing when the corridor was reduced (at the insistence of the Castilian advisers), and finally, in 1539, the willful architect may have reinstated the original dimensions when he revived the double colonnade. Even if that was the case, the comparison of the diameter of an unporticoed courtyard to the clearing of a porticoed courtyard is a loose reference at best. More significant, I believe, is the common measure of 42 meters for the porticoed round casino in Hadrian's villa and the courtyard of the palace of Charles V. There remains one more possible referent for the revised plan of the palace in 1528: the

sketch for a villa with a porticoed round courtyard that is often assigned to an early phase of the design of the Villa Madama (Uffizi A1054, pl. 105). It also followed a geometric construction based on the successive circumscription of circles and squares known to have been used by Raphael around 1514, apparently following the practice of Francesco di Giorgio and Bramante (cf. fig. 6, p. 62).

The only clear reminiscence of the Villa Madama in the palace of Charles V, then, is the arcaded screen interrupted by an archway. The three-door entry and the rusticated archway surmounted by a window are more remote prospects. This conclusion will disappoint scholars who have assumed a closer dependence of Machuca's palace on Raphael's villa because it is the only known earlier attempt to realize a round courtyard and because it was designed and its construction begun while Machuca was in Italy. Machuca's original courtyard, however, differed from both the porticoed form of Uffizi A1054 and the unporticoed one of Uffizi A314. Again, the only relationship would seem to be a common dependence on the speculative projects of Francesco di Giorgio. Even so, there is every reason to believe that Raphael's use of a round courtyard in his design for the most ambitious project for a villa since antiquity provided the impetus for Machuca's choice of a circular form for the courtyard of the imperial residence on the Alhambra. Also, Machuca's use of a string course in the form of a contracted entablature may depend on Raphael's authority, since the Italian used that unusual form on the facade of the Branconio dell'Aquila palace in 1516–1519 and also in the membering on the interior of San Eligio degli Orefici, both in Rome. We should add that, while Raphael became more active as an architect in his last seven years, there was no increase in his use of architectural settings in his murals or panel paintings, and the several instances there are provide no precedents for the architectural repertory used by Machuca in the palace of Charles V. We must, I believe, conclude that, while the paintings of Machuca can be described as Raphaelesque, the architectural style of his palace is that of an independent artistic personality within the Roman School. He may have learned to paint in Raphael's workshop but his idea of classical architecture was formed in the wider arena of Rome.

How, then, did Pedro Machuca gain so clear an

understanding of the classical style in architecture without practical experience in an Italian workshop? How, under these conditions, did he become a better architect than painter in the Renaissance idiom? If his primary purpose in Italy was to study painting, his interest in architecture may have developed only after his arrival in Rome, and then it was pursued as an avocation. Other members of the Spanish community in Rome with interests in Roman antiquities and architecture (people like Cardinal Bernardo López de Carvajal and Ambassador Jerónimo Vich) may have introduced him to the classical style. He may even have had a Toledan cleric or nobleman as a patron, who aided him in the way that Cardinal Jean du Bellay helped Philibert de l'Orme a generation later.[12] As time went by, Machuca's interest in architecture must have intensified because he apparently gained entry to building sites and workshops. One may have been the Tempietto alongside San Pietro in Montorio, which had been initiated by the Catholic Monarchs. His many Spanish compatriots could have helped him, and members of Raphael's painting workshop could have introduced him to Bramante and other architects working on Saint Peter's and the Villa Madama. Since most of the architects cited above for eight to twelve analogies were consultants or assistants in works designed or constructed under the supervision of Raphael, his circle could have provided the necessary contacts. Elderly Giuliano da Sangallo and Fra Giocondo were consultants in the works of Saint Peter's after Raphael took charge in 1514, and Antonio da Sangallo the Younger served him as chief draftsman in that enterprise since 1516 and in the project for the Villa Madama from early in 1519. Baldassare Peruzzi first came to know Raphael in 1510 in connection with the fresco decoration of the villa designed for Agostino Chigi, now designated the Farnesina, and Raphael appointed Peruzzi an assistant in the works of Saint Peter's in 1514. Contacts with the works of the Vatican would have led to a more intimate knowledge of the legacy of Bramante. Of course, Antonio da Sangallo the Younger could have made Machuca aware of the works of his uncle, Antonio the Elder, and Peruzzi could have introduced Machuca to the treatises of Francesco di Giorgio and shown him some of his own current projects, such as those for the Fusconi-Pighini palace in Rome.

The confirmation of Rome, and specifically Raphael's circle, as the artistic milieu in which Pedro Machuca independently studied classical architecture and our discovery of the unsuspected difficulties that he encountered in the design and construction of the palace provide a reliable context for the description of his personal style; and, since we reduced the autograph parts to about half of those formerly accepted as his, the configuration of his artistic personality as an architect must inevitably change.

A description of the architectural style of Pedro Machuca might well start with recognition of the high level of craftsmanship required for the cutting and setting of the sandstone facing and the carving of moldings and ornament. Since he was the only one on the Alhambra who could have provided accurate models for these features and for the Tuscan, Doric, and Ionic orders, he must be credited with making these unfamiliar forms clear to Spanish craftsmen not accustomed to working in the classical style. In fact, several of the refinements in Machuca's architectural design—the tapered pilasters, the gradual diminution in the height of the courses, and the salience of the rusticated blocks—placed demands on the Spanish stonecutters seldom required of their Italian counterparts. Machuca's concern for craftsmanship is particularly surprising in a designer-architect with no known training as a mason, or even as a sculptor. His essentially theoretical preparation might have led to a primary concern for *concetto*, with relative indifference to execution, as happened with some Italian Mannerists and with his own countryman, Alonso Berruguete. Because architects in Spain were expected to closely supervise the execution of works, Pedro probably found it necessary to supplement his theory with practical knowledge. Of course, as Gómez-Moreno pointed out, Pedro had the advantage (even over his Italian contemporaries) of the Spanish tradition of excellence in stone masonry.

Pedro Machuca also understood the several classical orders, and he obviously was concerned with correctness in the shape and proportions of their component parts and the appropriateness of their

12 Blunt, *Philibert de l'Orme*, pp. 4-8.

ornament. His use of the Doric order was, of course, well suited to the august patron for whom he designed the palace and the wall fountain, but he also used a very plain Doric for the catafalque of two queens, Charles V's wife, Isabel, and Prince Phillip's first wife, Mary of Portugal (pl. 6). The Doric gave way to the more severe Tuscan order in the ground floor of the palace because that is the proper order for a rusticated surface. The Ionic was then required for the second story; but, having used the Ionic order for the marble frame of the south portal, he had to frame the window above it with the Corinthian, even though that order is at odds with the sobriety and boldness of scale in the rest of the palace. From the little that we have to represent him, the sober Doric would seem to be emblematic of his architectural ideal, and as we suggested earlier, the sumptuously ornamented Doric proposed for the west frontispiece in 1549 probably represents an attempt to provide sufficient magnificence in the architectural ornament itself that figural decoration could be kept to a minimum. That purpose, rather than a "development" of his style, would seem to explain why it differs from the more sober Doric orders of the courtyard and the east portal, both probably executed by Luis on the basis of Pedro's designs. The correctness Pedro sought in his classical orders cannot be denied to the Ionic, odd as the concentric volutes of his capitals appear to us today, because that order was still a puzzle to contemporaries. Furthermore, he followed the form published in the most recent treatises, those of Cesariano and Sagredo, in 1521 and 1526, respectively. In view of this, one cannot claim that Pedro Machuca sought to break through a restrictive norm in the design of the Ionic capital and to replace it with a bizarre invention. The same must be said of his tapered pilasters, in which he applied current rules for the entasis of the column to the pilaster. Orthodoxy seems to have been his aim, even though theorists were uncertain about the correct form of many parts of the classical orders. In the round courtyard, where he insisted on the double colonnade instead of the more prevalent arcade on columns, pillars, or piers, his personal preference brought him closer than most contemporary Italians to classical form as we understand it today.

His persistent use of the stylar wall reveals that Pedro Machuca thought the wall had to be "or-

dered," that is, scanned and proportioned by the orders. Initially, the proportional schemes of the Tuscan and Ionic orders may have been extended to the facade walls and the building itself, but it appears that the original ratios were gradually compromised and finally lost as a result of the many changes that were made in the length of the facades and the number of bays, the integration of the added forecourts, and the persistent requirement to enlarge various parts of the palace. That Machuca started with an overall proportional theme is suggested not only by his consistent concern for correctness but also by the coincidence of the present groundplan with the geometric scheme constructed of successively circumscribed circles and squares (fig. 6) and the governor's praise of the "grace and proportion" of the original free-standing villa (doc. 2). Returning to the stylar treatment of the wall, it is clear that Pedro Machuca recognized a fundamental problem of the Renaissance style in architecture: the relation of the orders to the wall and its fenestration. Each generation explored new solutions for that formal problem, but no definitive answer was found. In the upper story of Machuca's palace, the pilasters (and probably their pedestals) were given fielded panels with narrow channels and sharp arrises to stress their common planarity with the wall. The severe surrounds in each bay served as a step from the plane of the wall to that of the pilaster, with these successive layers articulated by their sharply defined edges. The linear and layered format of the membering was also maintained in the three graduated fascias that form the window casings and the architrave of the main-story entablature. In addition to the planarity and linearity of the wall, the casings, and the membering, the component parts were bonded together by a common facing of fine-grained white sandstone. In the lower story, Pedro gave a linear articulation to the rusticated blocks by way of the sharp arrises of their chamfered faces. Both the pilasters and the blocks facing the lower story were given a granular texture, and they were set in common courses. But the most effective and novel feature is his use of wide and narrow blocks to form the pilasters and, in this way, to interlock them with the complex pattern of the drafted masonry of the wall. In attempting to integrate the order and the rusticated wall, he confronted a problem seldom posed by Italian Renaissance ar-

chitects. Most were satisfied to contrast one with the other, but Pedro characteristically sought to relate the two. There is no reason to think he was attempting to contrive a bizarre or anticlassical form, but rather, it seems he was trying to resolve the difficult problem of the rusticated stylar wall. In all the Renaissance, no more elegant solution was devised than Machuca's for the ground floor of the palace of Charles V.

Machuca's inclination to interlock and integrate clearly articulated individual forms into a larger pattern must be understood in relation to his evident effort to facilitate our visual comprehension of the totality of the cubic palace and its several facades and enclosures. To design a form that is first seen as a whole and then as composed of parts that are related to one another and also to the whole is a truly Renaissance ideal. Perhaps its ultimate inspiration was the Vitruvian concept of a common proportional scheme governing the relations of all parts of the classical orders. In the first half of the sixteenth century, few non-Italians were able to appreciate that sense of totality, even in respect to the orders, let alone to the building as a whole.[13] Most converts to the Renaissance style continued to assemble independent parts that could only be seen one by one, whereas Pedro Machuca had the capacity to conceive an enclosure or a facade as a whole and to facilitate our seeing it as such. I know of no one outside of Italy at the time who surpasses him in this respect.

The frames of the doors and the windows are, in the main, as orthodox as the orders because Pedro tended to use up-to-date versions of known types. The edicular frame in its High Renaissance form was used for the east portal, and the small rectangular door with a roundel over it in the corridor of the round courtyard was another relatively new motive. More readily associated with the late fifteenth century, but still used in the early sixteenth, is the arched opening framed by a continuous casing, unbroken at the springers of the arch and turned inward at its base as if it were intended to close the frame at the bottom. The only portals in the palace that might be considered unorthodox are the side doors of the west frontispiece, which were designed in 1549 (pl. 74). Characterized by

triglyph brackets that rest precariously on the door casing and support a triangular pediment, they are quite close to a portal illustrated by Serlio but invented by his master Peruzzi around 1520; so Pedro might have seen a door of this kind a quarter of a century earlier in Italy. Even so, the instability suggested by the pediment raised on these triglyph brackets is at odds with his usual preference for solid and stable forms, like the Doric portal in the center of the west frontispiece. Both the triangular pediment and the hooded lintel, which are used as the main-story window crowns on consoles, were well-established forms in Rome. The usual combination was the segmental and the triangular, which contrasted without being too different in form, whereas neither the hooded lintel (of the Burlington elevation) or the present lintel interact well with the much stronger form of the triangular pediment. If this combination (which has no precedents or following) was Pedro's invention, it represents a rare instance in which he departed from the orthodox and failed in a formal sense. There is, however, the possibility that he started with the usual combination of triangular and segmental pediments and then was required to replace the latter with a hooded lintel that, by the time of execution, became a simple lintel of the type used by Plateresque designers. The round windows of the mezzanine and attic levels are both established types in the Italian Renaissance, but neither was used in this way. Perhaps Pedro was required to transform simple roundels into bull's-eye windows to reduce the openings on the interior to a diameter better suited to the size of the attic rooms. Whatever the reason, the revelation of the depth of the wall is somewhat at odds with the planar, linear, and layered format of the upper story of Pedro's facade.

While inclined to start with orthodox forms, Pedro Machuca seems to have thought of them as susceptible to alteration in the process of according one part to another and integrating each into the whole. In fact, it is in the accommodation of parts within the larger composition that he is most inventive, with the result that the parts, while usually orthodox in form, are not commonplace quotations from the works of others. The most striking

[13] Italians learned to see the totality of a form not only by way of *proportionalità* in architecture and sculpture but also monocular or "legitimate" perspective in painting. They learned to see the whole simultaneously rather than the parts successively; see Dagobert Frey, *Gotik und Renaissance als Grundlagen der modernen Weltanschauung*, Augsburg, 1929, pp. 38 and 75.

instance is his accommodation of the rusticated Tuscan pilasters to the wall by using wide and narrow blocks in common courses with the patterned masonry of the wall. His inventiveness was put to test whenever the Castilian advisers intruded a disruptive element into his project since they usually posed problems for which there were no ready solutions within the Renaissance style. The expansion of the octagonal chapel into one corner of the courtyard required the closure of all the corners and the articulation of the intracardinal as well as the cardinal axes of the circular wall of the corridor. Some features of his solution are found in plans by Francesco di Giorgio and Peruzzi, but there is no precedent for the total design. The required addition of the forecourts to the original residential block led to the adoption of a number of devices, most of which have no known precedents but which serve to join the arcades to the stylar facades. The most dramatic example of inventiveness is, of course, the southeast staircase in the small Royal Palace plan (pl. 18). When a Castilian adviser (probably Luis de Vega) inserted the square format of a newel staircase into the triangular well between the enclosing wings and the circumference of the circular corridor, Pedro Machuca replaced the two flights and landing with a continuous flow of winders. Wholly rational from a formal point of view, it is an original and even elegant solution, though the necessary adjustments to the curve of the corridor at the top and bottom would likely have resulted in a staircase awkward to mount and descend. In this instance, as in the others, Pedro Machuca did not set out to invent a novel form; he simply resolved an intolerable incongruity. He seems to have thought of "invention" in essentially Vitruvian terms, that is, as the resolution of a difficult formal problem[14] rather than as a Mannerist for whom an unusual form seems to have been of interest for its novelty alone.

Admittedly, Pedro Machuca did choose unusual forms for the palace of Charles V. The circular courtyard, the double colonnade, the "oval" vestibule, the tapered and battered pilasters, and the tilted Doric frieze are especially so, but they may have been chosen for reasons other than novelty. His preference for geometric shapes is evident in the square block-design residence and the octag-

onal chapel as well as the more rare circular courtyard and oval vestibule. As for the optic compensations and intensifications, it is likely—given his inclination to orthodoxy—that he sought correctness rather than novelty: he extended to the pilasters the "entasis" of the column as it was defined by contemporary theorists, and in the case of the tilted frieze, he seems to have wanted it to appear correct in proportion to the rest of the entablature. In the main, the unusual forms of the palace are more readily understood in the context of theory or symbolism than in that of aesthetics.

Most singular is the constancy of Pedro Machuca's architectural and ornamental repertory over the near quarter-century that he worked on the palace of Charles V. He continued to prefer the Doric order, which he used in its most sober form, the closely related Tuscan, and, in its most sumptuous form, the imperial Roman version. He used the Doric order not only for Charles V, for whom it was clearly appropriate, but also for the catafalques of the two queens, although most of his contemporaries would probably have chosen the Ionic order for women of that status.[15] He never abandoned the leather-roll version of the Ionic capital, and he repeatedly used the same moldings (cyma reversa, torus, scotia, and three graduated fascias) and the same ornamental courses (egg-and-dart, dentil, bead-and-spindle, leaf, and guilloche). He remained resolutely faithful to the classical style he had learned in Italy, holding himself aloof from the Plateresque taste for rich ornament, which was represented in Granada by its leading exponent, Diego Siloe. His attention was focused on Italy: he was clearly aware of the publication of Cesariano's translation of Vitruvius in 1521 and Serlio's fourth book in 1537. When it was time for his son's study trip in the late 1540s, he sent him to Italy, whereas there is no evidence of a comparable trip through Spain. On that trip to Italy, undertaken twenty-five years after Pedro had returned, Luis seems to have seen nothing that caused him to depart significantly from his father's architectural repertory in the palace, so the son must have been well founded in the theory of his father's style. It would seem that intellectual conviction accounts for the constancy of Pedro Machuca's style.

Machuca returned from Italy with an idea of the

[14] Vitruvius, *De Architectura*, I, 2, 2: "Inventio autem est quaestionum obscurarum explicatio ratioque novae rei rigore mobili reperta. Hae sunt terminationes dispositionum."

[15] The anonymous *túmulo* designed for Empress Isabel in the cathedral of Seville in 1539 employed the Ionic order; see, Lleo Cañal, *Nueva Roma*, p. 181.

role of an architect that differed from contemporary practice in Spain. He clearly considered himself the final arbiter of architectural form. Since there is no evidence of arrogance or stubbornness in his relations with other officials or workers on the Alhambra or in his personal life, his professional acts of defiance must be taken as further evidence of the strength of his conviction that he had a superior understanding of the classical style in architecture.

While that style was based on rules for proportions, orthodox shapes, and appropriate ornament, it did not exclude—as Machuca understood it—the infusion of personal sensibilities and idiosyncracies. Ample evidence of this is found in his insistence on the monochromatic unity of the palace and the mirror reversal of its figural ornament, and in his use of optic refinements, such as the tilted Doric frieze, the tapered and batttered pilasters, and the subtly graded courses and saliences of the rusticated blocks. These unusual features and his marked preference for linear, layered, and faceted forms give the palace the stamp of a personal style. Perhaps that is what Byne and Stapley had in mind when they compared the "pedantic classicism" of Juan Bautista de Toledo in the Escorial with "the sentiment which Machuca infused into his early classic attempt in Granada."[16] His was a unique personal synthesis within the High Renaissance phase of the revival of the classical style.

To have formulated so personal a version of the classical style during a decade of study in Italy and then to have sustained it in Spain away from Italian and ancient Roman models, Pedro Machuca must have had an extraordinary capacity for formal analysis and synthesis and a very sure sense of integrity in architectural form. He must also have had a

tenacious memory that enabled him to recall vividly ten and twenty years later the classical motives he had seen in Italy. These capacities for analysis, recollection, and synthesis are essential to an artist who becomes a convert to a style formulated in a cultural area other than his own and then returns to work in his native land. An architect must be able to analyze exotic architectural elements and to perceive the essential character of each—that is to say, he must understand them typologically—and he must gain a clear idea of the design principles that govern the relations of these forms. After making a synthesis of his initial understanding of a new style and his previous architectural experiences, he usually finds that he must make painful concessions to the taste of his compatriots and to the functional types and structural practices of his native tradition, and so he must sustain a continual process of formal analysis and synthesis. It is the lack of this capacity for continual synthesis, not an obstinate national spirit, that usually explains the formal failures of early converts to an alien style. For Pedro Machuca the conflicts were somewhat less intense for several reasons. He seems to have had no previous architectural training in Spain, so it was only his youthful experience of his native Castilian architecture that had to be accorded with the new classical style, and on his return from Italy, he worked for a most sympathetic patron, Luis Hurtado de Mendoza, within the royal precinct of the Alhambra. Machuca's personal inclination to sobriety and restraint and his uncompromising and even rigid nature enabled him to accept the discipline of the classical style. These qualities—stereotypically Castilian—may have been the major contribution of his Toledan upbringing to his mastery of the classical style in Italy and his capacity to maintain it after his return to Spain.

[16] Byne and Stapley, *Spanish Architecture of the Sixteenth Century*, p. 390.

VII

THE SIGNIFICANCE
OF THE PALACE

THE INFUSION OF THE
RENAISSANCE STYLE

THE PALACE of Charles V is more than the embodiment of the artistic personality of a major architect. It provides some insights into the artistic *milieu* of Rome as it was known to Pedro Machuca before 1520 and the reception in Spain of the architectural style he formed there. It is, in fact, a well-documented case study in the diffusion of the Renaissance style outside Italy and, as such, it has something to tell us about that process in Spain and Europe generally. Our detailed knowledge of its design and construction provides a specificity of circumstance and cause that liberates us from dependence on the usual generalizations about the Renaissance style and its development and the "constants" of the Spanish spirit and architectural tradition.

Because Machuca's style was formed primarily in Rome previous to 1520, his palace and its component parts provide evidence of some of the architectural ideas and aesthetic values that he discovered there. Incidentally, we should note that he seems to have been the first non-Italian architect to recognize that Rome had become the leading center of the new style. In Rome he apparently observed that Italian architects were concerned about correctness in the form, proportions, and ornament of the orders, as well as propriety in their use, but he seems to have found no general agreement on most classical forms. For some forms,

such as the Ionic order, uncertainties were due to the ambiguity of Vitruvius' account and the paucity of Roman examples; but, for others, such as the proportions of the triangular pediment for which the ancient theorist gave clear instructions, there was still a surprising amount of variation in the projects of contemporary Italian architects. Even the Doric order, less problematic than the Ionic, posed many problems. There was no firm consensus on the height of its shaft relative to its diameter or the formation of its entasis, and Vitruvius left no instructions on the proper proportions of its pedestal. Although the architects of the early sixteenth century were more knowledgeable and sophisticated than those of the fifteenth, most parts of the classical repertory were still under investigation and subject to considerable speculation. Greater uncertainties attended the application of the orders to late medieval architectural types, such as the multistoried and fenestrated palace facade or the interior of a traditional basilican church. Machuca found no authoritative solutions for problems of this sort.

Machuca can be said to have embraced what has been called "the Doric state of mind." But that attitude should not be equated with the High Renaissance style itself since it represents only the sober end of a range of modes then prevalent in Rome, with the opposite being the Corinthian. To be sure, the latter order is usually identified with the fifteenth century, when it seems to have been accepted as emblematic of the Roman style, but it was still favored by leading architects of the High

Renaissance.[1] Some of them also fostered the use of a great deal of statuary, sculptural ornament, and polychromy in architectural works. Because the sober mode adopted by Machuca is surprisingly free of Bramantesque features, it is clear that Machuca's "Doric state of mind" was not cast in a Bramantean mold, and this adds to rising doubts about the "Bramante synthesis" that is supposed to have served as the basis for the High Renaissance style.[2] It would seem that Machuca was no more aware of a reigning style synthesis than he was of authoritative versions of the several classical orders or definitive models for their application to modern buildings. Instead, he seems to have found uncertainty and speculation and, thus, invention, variety, and individuality. Evidently this encouraged him to continue research on the orders and the design principles of antiquity and also to speculate on their adaptation to modern architectural types. As we noted, several of his formal solutions in the palace of Charles V are similar to those used in the 1530s and 1540s by other alumni of the Roman School, so it is likely that they all drew on the common legacy of Rome previous to 1520. Hence, High Renaissance rather than Mannerist origins can be claimed for features such as the tapered pilaster, the pilaster integrated into a rusticated wall, the hierarchical facade, and the portal united with a window above it, and it would seem that the High Renaissance was a more speculative and inventive period than some scholars have assumed.

Machuca's experience in Rome would not support the usual characterization of the High Renaissance as a period of stable orthodoxy in contrast to the compulsive inventiveness of Mannerism. Apparently invention occurred in both periods, though there may have been a shift of emphasis. Mannerists certainly continued High Renaissance

speculation on features and formal solutions for which there were no accepted classical models, but they became increasingly intent on inventing novel and even bizarre forms as a measure of personal fantasy. While the quest for a recognizable personal *maniera* is rightly attributed to Mannerists, the artistic ambience of Rome previous to 1520 clearly encouraged architects to develop markedly different and very personal styles. Machuca's experience in Rome suggests that the architects of the High Renaissance anticipated many more aspects of Mannerism than students of the latter phase of the Renaissance style would have us believe.

When Machuca introduced his severe architectural style to Spain in the palace of Charles V, it engendered conflicts that are not only well documented but also evident in the building itself, and so we know something of their causes. Surprisingly, they are not the kinds of conflicts that are usually assumed to have impeded the diffusion of the Renaissance style in Spain and elsewhere in Europe. We know about these conflicts simply because Pedro Machuca was unusually persistent in his resistance to changes in his project, whereas most proponents of the classical style outside Italy gave in more easily to local taste and building practices.

Although Charles and his Castilian advisers had probably never seen a project like the centrally symmetrical villa proposed by Machuca in 1527, they expressed no reservations of a stylistic nature. Charles simply required the addition of forecourts, stables, offices, and facilities for other services needed in an official palace. We do not know if he wanted a multicourt palace from the beginning or made that decision later, but the typological change from a private villa to an official palace had nothing to do with style. The addition of forecourts and the expansion of the chapel make it clear that Charles

[1] Erik Forssman (*Dorisch, jonisch, korinthisch: Studien über den Gebrauch der Säulenordnungen in der Architektur des 16. und 18. Jahrhunderts*, Stockholm, 1961, p. 18) repeated the standard explanation for the prevalence of the Corinthian order in the fifteenth century—that is, its predominance among surviving ruins, primarily buildings of the Imperial period when the Corinthian and Composite orders were favored. Because the Doric order was used more frequently after 1500, it has been taken by some to be representative of the High Renaissance, but the Ionic also gained favor at that time. It seems that practicing architects finally began to do what the theorists had been recommending for half a century, and that was to use the full range of ancient orders, selecting the one appropriate for the function of a building and the social status of the patron.

[2] Serlio (*Tutte le opere*, bk. II, fol. 18, and bk. III, fol 64v) was apparently the first to designate Bramante the culture-hero who single-handedly "resuscitated the good architecture" that had been entombed for centuries. Modern scholars have tended to restrict his role to the formulation of the High Renaissance or Cinquecento style. That idea has been repeated in most surveys of Renaissance architecture and it was reaffirmed by Wolfgang Lotz; see Heydenreich and Lotz, *Architecture in Italy 1400–1600*, p. 164: "Obviously, this [High Renaissance] style must be regarded as Bramante's personal achievement."

and his advisers did not fully appreciate the central symmetry of the geometric plan, but their insensitivity was due to a lack of familiarity with ideal plans of this sort. Even more bewildering to them was the design procedure in which the geometric configuration of the plan was determined first and the functions of the various halls and enclosures assigned later. Charles (and most patrons outside Italy at the time) expected an architect to provide first the areas and halls required for specific palatine functions and then to accommodate them to an overall plan. If Luis Hurtado and Pedro Machuca had recognized these practical concerns from the beginning, they could have avoided the dispute over procedure since Charles simply wanted to be assured that the chapel and the main audience hall would be conveniently located and large enough for his needs. Even if Charles was unable to appreciate the "grace and proportion" of the initial plan, there was no evident conflict about its style but, rather, a difference in priorities. The same difficulty must have been encountered by other advocates of the Renaissance style outside Italy, and in some of those cases, we may have mistaken a disagreement on planning procedures to be native resistance to the new classical forms.

The double colonnade of the round courtyard seems to have been another disputed feature in the design of the palace of Charles V because two other support systems were indicated in the early plans—an arcade on Tabularium piers (apparently preferred by the Castilian advisers) and an arcade on square pillars (probably a compromise proposed by Machuca). But, since all three support systems were used by Renaissance designers, the dispute was not of a stylistic nature. We found no opposition to the Doric order or to the colonnade itself, but rather, uneasiness about the stability of widely spaced columns subjected to the continuous thrust of the annular vault. Of course, if a cast conglomerate had been used (as Machuca probably suggested), the thrust would have been considerably less than that of the present stone masonry vault. Opposition to the new cast conglomerate was probably due to a greater trust in masonry construction and the acceptance of stone as more noble material and, thus, better suited to the palace of so exalted a personage as Charles V. Having decided on the masonry vault, the Castilian advisers wanted a sturdy support system, and so they re-

quired an arcade on massive Tabularium piers. Again, it would seem that opposition to Machuca's colonnade had less to do with style than with structural stability.

The *portadas* were another major source of friction because of two of Pedro Machuca's design principles: the maintenance of the monochromatic unity of the white sandstone building and the restriction (if not exclusion) of figural ornament. Of course, these principles were peculiar to Machuca and not characteristic of the High Renaissance style, but they led him to oppose the traditional Spanish *portada*, which was usually made of a material distinct from that of the wall and enriched with sculptural ornament. The *portada* was, however, too firmly entrenched in Spain to be replaced by a simple rusticated arch, and so, as a compromise, Machuca may have proposed a one-story marble frame on the south as he did later on the west. He had to design a second story in marble on the south, but neither he nor his son made that concession on the west front. This was clearly a conflict of a typological rather than a stylistic nature because Machuca eventually designed the marble frames in the Renaissance style; and again, the insistence on the traditional format was due primarily to a sense of decorum; from a Spanish point of view a palace of this category had to have a *portada*.

Notably lacking is evident opposition to Machuca's project because of its alien or Italian or specifically classical character, though many features of that project would have been strange to Charles and his Castilian consultants. The central symmetry of the initial groundplan, the regular fenestration, the severe Tuscan and Doric orders, and the stylar treatment of the facades and the corridor of the round courtyard were wholly at odds with the Spanish tradition. They represent classical discipline in its strictest form. None of these features was reflected in the architectural works of Spain for more than a generation, but there is no indication that any of the consultants were sufficiently possessed of the presumed "Baroque spirit" of Spain to oppose Machuca's design because of its classical style. Missing also is evidence for opposition from the stonecutters who fashioned the individual parts of the classical membering of Machuca's palace or the carvers who cut the cyma reversa and scotia moldings and the egg-

and–dart and dentil ornament, though the component elements of the Doric and Ionic orders were certainly new to most of the Spanish craftsmen working on the Alhambra. Even more surprising, there are no instances in which these features are transformed to approximate a more familiar native form. There is, however, one possible example of a misunderstanding of a classical form—the rigid fruit swag between the brackets that support the main-story window crowns. As we noted, a naturalistic sag of the garland from the points of attachment is found in Italian models and also in the Burlington elevation, whereas Ruberto and Martín Cano, the first carvers, seem to have deliberately ignored that feature in order to give the swag the rigidity and strength appropriate to tectonic ornament (cf. pls. 41 and 74). The surprising ease with which the stonecarvers executed the new repertory of architectural and decorative elements is a testimony to the high level of the skill of stoneworkers in Spain as well as the close supervision of Machuca. Certainly, their accuracy in the execution of classical forms was rare elsewhere in Europe, even in later stages of the diffusion of the Renaissance style.

It would therefore seem that the main opposition to Machuca's project was typological and technological in nature and often involved a sense of decorum, but there is little indication of opposition to the classical style itself. In fact, Spaniards seem to have been more at ease with that style, even in its severe "Doric mode," than proponents of ethnic or national constraints are willing to grant.

Unique as it is, the palace is, nevertheless, representative of the Spanish Renaissance patronage in contrast to that of the rest of Europe. The choice of the classical style for the palace by Luis Hurtado rather than by Charles himself was wholly in accord with the primary role of Spanish noblemen in the introduction and support of the new architectural style in Spain. The Catholic Monarchs continued to favor architects of the Gothic style and Charles left the choice of style and architect to local officials who supervised royal works in Spain. Elsewhere in Europe, princely rulers and their highest ministers were the first to discover the classical style and to use it almost exclusively for their seignorial palaces and country houses.[3] In Spain, the earliest patrons were clerics assigned to the Vatican and noblemen who had served as ambassadors in Italy, most notably members of the Fonseca and Mendoza families. As early as 1487, the Gran Cardenal Pedro González de Mendoza began the symmetrically planned Colegio de Santa Cruz in Valladolid and soon after he assigned its supervision to Lorenzo Vázquez, who had been in Italy during the 1480s. In 1492, the cardinal seems to have recommended the same architect for the design of the Medinaceli palace in Cogolludo. Sometime before 1508, the church of San Antonio in Mondéjar was begun on the basis of plans sent from Italy by Ambassador Iñigo López de Mendoza, so clearly the Mendozas did not associate the new style with noble residences as exclusively as did courtiers elsewhere in Europe. As a result, the classical style was used in Spain for all categories of architecture and that provided a broad base for the diffusion of the style. While Lombard designers with workshops in Genoa made courtyards for the castles of La Calahorra and Vélez Blanco and the palace of Jerónimo Vich in Valencia, Spanish converts to the classical style were adding Renaissance portals to Gothic churches as well as to palaces, and by the 1520s, they initiated towers, monasteries, cathedrals, and city halls in the new style. Thus, by the time Charles asked Luis Hurtado to build a new residence on the Alhambra, the classical style had been fostered by Spanish clerics and noblemen for several decades in many parts of Spain and for all kinds of architectural commissions. This preparation makes less surprising Luis Hurtado's choice of that style for the palace of Charles V and its acceptance by the emperor's Castilian advisers, and it makes the palace more typical of the Renaissance in Spain than one might have supposed.

That a Spaniard, rather than an Italian, was the designer of the palace is also representative of the Spanish Renaissance. The earliest non-Italian architect to work in the Renaissance style outside Italy was a Spaniard—the Castilian-born Lorenzo Vázquez, who studied in Italy in the 1480s and returned to work in Spain for Pedro González de Mendoza around 1489. His work in the new style, together with the importation from Genoa of the several courtyards mentioned above and the monumental tombs by Fancelli and the Gaggini, led to

[3] Rosenthal, "The Diffusion of the Italian Renaissance Style in Western European Art," p. 35.

the gradual adoption of Renaissance elements by architects trained in the Isabelline style, most notably the Colonia family, Juan de Álava, and Enrique de Egas. The decorative repertory was fostered in altar retables by Spanish sculptors such as Vasco de la Zarza, Damián Forment, and Bartolomé Ordóñez, and also by some mysterious sculptors with French names who carved the ornament of portals in northwestern Spain.[4] Added impetus was provided in 1517 by Francesco Torni l'Indaco, who worked in the Corinthian mode in Murcia and Granada and was followed in those centers by his brother, Jacopo, in 1520. They were, however, the last Italian architects to work in Spain until Philip II employed Francesco Paciotto and Giovanni Battista Castello in the early 1560s.[5] By 1519 Diego Siloe had returned from Italy, and during the 1520s, he and Alonso de Covarrubias (who never went to Italy) formulated a peculiarly Spanish style that was to dominate Spain until at least midcentury. They fostered Corinthian, Composite, and fantastic orders as well as sumptuous decoration on pilasters, pedestals, friezes, and the frames of doors and windows. This style in the 1520s was identified

with that of the ancient Romans by Diego de Sagredo and many of his compatriots.[6] While modern students of Spanish architecture have replaced the designation *a lo Romano* with the somewhat pejorative term, *Plateresque*,[7] it is significant that this is the only Renaissance architectural style outside Italy previous to the mid-sixteenth century that is considered sufficiently different from that of Italy to warrant its own designation.[8] Spanish precocity in the activity of native architects and in the formulation of a national style provides a context in which we can better understand the highly personal and up-to-date style of Pedro Machuca. Elsewhere in Europe, the kings and their ministers depended wholly on Italians to design residences in the new style, and in most cultural areas that dependence lasted until midcentury.[9] Apart from Spaniards, the first native architects to employ some Renaissance architectural motives in their homelands were the Bohemian-German architect Benedict Ried from around 1501, and two Frenchmen, Gilles Le Breton and Pierre Chambiges, who used some elements of the classical orders around 1528.[10] French dependence on Italian architects diminished

[4] Camón-Aznar (*La arquitectura plateresca*, p. 334) noted that two French carvers, Martín de Blas and Guillén Colás, contracted to work on the *portada* of the hospital at Santiago de Compostela in 1520, and he suggests (p. 232) that other French carvers may have been involved in the facade of the University of Salamanca in 1519.

[5] Paciotto accompanied Philip II to the Lowlands in 1558, but he did not come to Spain until 1561 when he was consulted on the church of the Escorial. Castello was first employed in 1563 on the interior of the *alcázar* in Madrid and in 1567 he made the design for the main staircase of the Escorial; see George Kubler, *Building the Escorial*, Princeton, 1982, pp. 25, 47-50, 52. In 1564, Castello provided the designs for the typically Genoese disposition of the Bazán palace at El Viso del Marqués (Ciudad Real), though the construction was supervised by the Alberti brothers of Genoa.

[6] Rosenthal, "The Image of Renaissance Architecture in Renaissance Spain," pp. 333-336.

[7] John B. Bury ("The stylistic term 'Plateresque'," *Journal of the Warburg and Courtauld Institutes*, XXXIX [1976], p. 200) identified Diego Ortiz de Zuñiga's 1677 description of the Town Hall in Seville as the first use of the word *plateresque* to describe architecture in stone (as against Lope de Vega's earlier reference to stuccoists as *plateros de yeso*).

[8] The so-called Fontainebleau School pertains more to painting, sculpture, and interior decoration than to architectural design, and that school was formed in the 1530s and 1540s primarily by Italians, notably Giovanni Battista Rosso, Francesco Primaticcio, and Niccolò dell'Abbate. The Antwerp School of the third quarter of the sixteenth century produced model books for ornament that could be used on ecclesiastical furniture,

tombs, or architecture. Elsewhere, vernacular styles (such as the decoration of gabled house fronts in Bohemia) represent popular adaptations of the Renaissance repertory to a traditional architectural form; but previous to the mid-sixteenth century, nowhere is there a national style comparable to the Plateresque used for all classes of architecture.

[9] Rosenthal, "The Diffusion of the Italian Renaissance Style in Western European Art," pp. 35-37.

[10] Benedict Ried's birthplace is apparently unknown but he worked mostly in Prague from 1493 to 1543, when he died. Although there is no evidence he ever went to Italy, he designed edicular frames for doors and windows, using pilasters and columns and a limited repertory of Renaissance ornament; grand-scale designs of total buildings are unknown. See Jan Białostocki, *The Art of the Renaissance in Eastern Europe. Hungary. Bohemia. Poland*, Ithaca, New York, 1976, pp. 15-16, 64, and 73. We do not know the names of the designers of the early châteaux of the Loire valley, but their buildings followed traditional French types, with the Renaissance elements serving as ornament, especially for portals. The first personality to emerge among French architects working in the new style was Gilles Le Breton, who helped his father in the building of the château at Chambord before he was assigned in 1527-1540 to Fontainebleau, where most of his extant works are found. His modest stylar treatment of facades along the Cour de Cheval Blanc and the Porte Dorée (finished by 1530) represents a sober and very personal version of the Renaissance style. His contemporary, Pierre Chambiges, is a more mysterious figure because his contributions to the Gothic cathedrals of Troyes (1509-1511), Beauvais (1511-1518), and Senlis (1518-1525), and to the Town Hall of Paris from 1534 (with Jacques Coriasse) are

rapidly after the return from Italy of Philibert de l'Orme in 1536 and then the work of Pierre Lescot at midcentury. In the interim, Florentine and Bolognese Mannerists in all the arts implanted a style at Fontainebleau and Paris that was later diffused in England, the Lowlands, and western Germany. While the superiority of the French Renaissance over that of Spain in the eyes of some modern scholars is probably due in great part to France's important role in the diffusion of the Renaissance style in northern Europe at midcentury, there is no reason to lose sight of the extraordinary vitality and independence of the earlier Renaissance in Spain. It was formulated primarily by Spanish architects and supported by a broad spectrum of Spanish society; according to some estimates, as many as seven hundred works were commissioned in the Plateresque style.[11] In no other area of Europe in 1527 was the Renaissance style sufficiently well-founded to have made possible phenomena such as Pedro Machuca and his palace. Anywhere else in Europe, a royal palace in the Renaissance style

would inevitably have required the services of an Italian designer.

Several distinctions of a formal nature can also be claimed for the palace and its architect. The palace was probably the first High Renaissance building outside Italy, and also the first to contribute to a current phase of the style.[12] Previous Renaissance buildings outside Italy usually reflected an earlier phase, often that of a previous generation, even when the designer was an Italian, because those who went abroad were often masons or engineers from secondary centers and they usually worked in an outdated style. In most instances, their projects followed local architectural types to which Renaissance trappings were added,[13] so these projects are seldom formally coherent and rarely represent advances in the Renaissance style. By contrast, Pedro Machuca in 1527–1533 designed and began to construct an ideal plan whose circular courtyard and double colonnade had existed only in the imaginations of Italian theorists, and he advanced the design of the hierarchical stylar facade

difficult to identify; of his châteaux near Paris of 1539–1544, La Muette is lost and St. Germain in Laye is much altered and provides little evidence of a well-developed Renaissance style. See Ulrich Thieme and Felix Becker, *Allgemeines Lexikon der Bildenden Künstler*, Leipzig, 1907–1950, VI, p. 348 (for Chambiges); XXII, p. 508 (for Le Breton). See also Anthony Blunt, *Art and Architecture in France 1500 to 1700*, Harmondsworth, 1957, pp. 2, 23-27, pls. 19B and 20A, fig. 2. Blunt observed that Le Breton and Chambiges "remained pure craftsmen in the medieval manner." Neither Le Breton in 1528 or Chambiges in 1539 equaled the command of the Renaissance style evinced by Diego Siloe in 1519 to 1530 or Pedro Machuca who returned in 1520 but did not design the palace until 1527. Only Philibert de l'Orme, after 1536, can be classed with the two Spaniards.

[11] Camón-Aznar, *La arquitectura plateresca*, p. 10.

[12] The cruciform burial chapel designed in 1517 for Sigismund I of Poland in the cathedral of Cracow has been described as "High Renaissance" in style because of the bold relief of the membering of its stylar interior and its coffered dome, but the latter was already used by Bramante in the 1480s for the crossing of the church of Santa Maria presso San Satiro in Milan and the stylar membering is richly carved with foliate and figural ornament in a manner reminiscent of Florence in the 1480s and 1490s. Bartolomeo Berrecci, the Florentine designer of Sigismund's chapel, was formed in the same ambience as the Torni brothers who designed and executed the ground floor of the tower of the cathedral of Murcia, begun in 1519 (pl. 8). That robust, decorative style had been implanted in Spain a few years earlier when Lombard sculptors made the portico of the courtyard in the castle at Vélez Blanco in 1506–1515. The only challenge to the claim that Machuca designed the first

High Renaissance building outside of Italy comes from the handsome courtyard made in Genoa by Michele Carlone in 1509–1511 for the castle at La Calahorra, also in southern Spain; but, of course, it was designed by an Italian and made in Italy, whereas the palace of Charles V was designed by a Spaniard and built by Spanish masons.

[13] Very little remains of the elevation of the villa at Visegrád built for Matthias Corvinus in 1480–1483, but a portico with pointed arches suggests that the lost royal residences built or renovated for him in Budapest and its environs were also essentially Gothic structures with Renaissance ornament; see Białostocki, *The Art of the Renaissance in Eastern Europe*, p. 14, pls. 36-39. We have no record of the four-tower palace designed by Andrea Sansovino for the king of Portugal in the 1490s so we do not know to what degree he was able to transform that medieval type. Nothing survives of Charles VIII's ambitious work at Amboise, but Blunt assumed it was even less advanced stylistically than Louis XII's work at Blois in 1498–1504. The traditional medieval form of the French château was retained even by Italian designers, such as Leonardo da Vinci at Romorantin in 1515 and Domenico da Cortona at Chambord in 1519. In England, the new decoration was applied to traditional architectural types until almost the mid-sixteenth century. The first church north of the Alps to reflect the Renaissance style was that of Saint Michael the Archangel in Moscow shortly after 1504, but it follows Byzantine models; and in France, the churches of Saint Pierre at Caen in 1528 and Saint Eustache in Paris in 1532 display Renaissance ornament, but they are Gothic in structure. This cannot be said of the cathedral of Granada, begun by Diego Siloe in 1528, if it is recognized that the vaults intended by Siloe were "in the Roman style" and were not the rib vaults executed in the early seventeenth century.

and the marble frontispiece, to mention only the major features in which he surpassed known Italian examples. Thus, unlike most non-Italian architects, Machuca was not merely a follower at a generation's distance, but an active member of the avant-garde in respect to several important Renaissance forms. That can be said of no other non-Italian architect previous to the 1540s.[14]

The independence and inventiveness of Pedro Machuca and of contemporary Spanish architects who created the Plateresque style suggest that they did not think of themselves as followers of an Italian style, as they have been designated by most modern students of the Renaissance period. Of course, sixteenth-century Spaniards were innocent of the modern view of the Renaissance style as a

manifestation of the cultural conditions of Italy in the fourteenth and fifteenth centuries and seem to have accepted classical architecture as "good architecture" in absolute terms, free of time and place. They believed that it had been invented by the Greeks, perfected by the Romans, and revived after a millennium of "Germanic" architecture by the Tuscans, but there is no evidence they considered the classical style exclusively Roman or described it as "Italian." To be sure, Spaniards usually identified the new style as *a lo Romano* or, occasionally, *a l'antigua*, just as French-speaking proponents referred to it as *à l'antique* and the English as *Anticke* and *Romagne*.[15] These designations indicate that the Europeans recognized that the ultimate models for the new style were to be found in the "good ar-

[14] Among possible competitors for the honor assigned here to Pedro Machuca are several Spaniards and Frenchmen. Enrique de Egas in the first two decades of the sixteenth century realized the cruciform hospital plan in Santiago de Compostela, Toledo, and Granada, apparently following Filarete's general disposition of the 1450s for the Ospedale Maggiore in Milan and the T-shaped version of Santo Spirito in Rome of the 1470s; but, it is likely that Pedro González de Mendoza first suggested the cruciform disposition for the hospital in Toledo and that Egas then followed that type in the hospital in Santiago, where he began construction a few years earlier. Diego Siloe must be credited with developing the basilican church in its Renaissance guise (that is with classical piers and, originally, domical vaults). Even though he followed the speculative projects of Francesco di Giorgio and Leonardo, Siloe surpassed known architectural precedents: the cathedrals of Pienza of 1460 and Pavia of 1488, and Santa Maria dell'Anima in Rome, begun in 1500. He and other Spaniards continued the development of the Granada version of the classicized basilica in other cathedrals in Andalusia and Latin America. In France, the unknown designer of the Château de Madrid in 1528—if he was a Frenchman—must be recognized for his development of the symmetrical villa with a central hall or courtyard, like those of Poggio a Caiano near Florence of 1480 and Poggio Reale near Naples of 1487. While Frenchmen were certainly involved in the elevation of the Château de Madrid, the strict symmetry of its groundplan suggests that the designer was an Italian. In Poland, following Berrecci's design in 1517 of a cruciform burial chapel for Sigismund in the cathedral of Cracow, Polish architects perpetuated that type in about eighty cruciform chapels constructed in the sixteenth and seventeenth centuries, but there was no significant architectural advance over the original Italian model.

[15] The description of the Renaissance style as "antique" or "Roman" was naturally more frequent in architecture than it was in painting or interior decoration in most parts of Europe. In Spain, the designation *a lo Romano* was apparently in use before Diego de Sagredo employed it in the title and text of his *Medidas del Romano* of 1526 since he felt no need to explain it; and shortly after, in 1529, it was used to describe the style of Diego Siloe in the cathedral of Granada. *Romano* or *antiguo* were the designations employed by Cristóbal de Villalón in

1539, Felipe Guevara in 1560, and Padre José de Sigüenza in the 1590s; see Rosenthal, "The Image of Roman Architecture in Renaissance Spain," pp. 329-346. Much earlier, in 1483, the Italian Humanist Antonio Bonfini d'Ascoli compared the new courtyard and halls of the castle of the king of Hungary at Buda to the magnificence of ancient Roman buildings, though he knew they had been renovated by Italians; see László Gerevich, *The Art of Buda and Pest in the Middle Ages*, Budapest, 1971, pp. 104 and 112, for his observation that the court of Matthias Corvinus was evidently striving to attain the style of antiquity. According to I. Vandevivere (*Renaissance Art in Belgium*, Brussels, 1973, pp. 18, 22, and 31), the term *antique* was usually used in the Lowlands. He cited Remy DuPuys famous description of one of the arches made for young Charles' entry into Bruges in 1515: ". . . un arc triomphal a l'antique et selon questoient coustume de faire aux Romains pour honorer leur princes victorieux. . . ." He also noted that the carvers of ornament who worked with Rombaut Kelderman around 1519 were called (in Flemish) *antieksnyders*. In England, according to J. Lees-Milne (*Tudor Renaissance*, London, 1951, pp. 24-25, 43, and 49, n. 1), the designations used to describe Renaissance decoration at Hampton Court and the Nonsuch palace were *anticke* and *Romagne work*. Quite understandably, Charles VIII of France (who was wholly unprepared for the new style he discovered during his 1494–1495 campaign in Italy) explained that he brought Italian craftsmen to his château at Amboise "pour édiffier et faire ouvraiges à son devis et plaisir, a la mode d'Italie"; see Eugene Müntz, *La Renaissance en Italie et en France a l'époque de Charles VIII*, Paris, 1885, p. 511, no. 2. Charles VIII probably referred to decorative rather than architectural works but, even so, the identification of the new style with Italy rather than with antiquity is most unusual. The expressions most consistantly employed by Frenchmen in descriptions of the triumphal arches and entry decorations for the French king in Italy in 1498 and later in France are *à l'antique* and *romain*; see Joséphe Chartrou, *Les entrées solennelles et triomphales à la Renaissance (1484–1551)*, Paris, 1928, passim. By the time of Philibert de l'Orme (who studied Roman ruins in Provence, and in 1533–1536 in the environs of Rome), the new style in architecture was clearly identified with the "good architecture of the ancients."

chitecture" of the ancients. Furthermore, Tuscan theorists believed that classical orders and design principles were based on the unchanging laws of nature and the proportions of man, and that the proportional themes of the orders reflected the harmony of the universe. Hence, they claimed universal validity for the classical style. God's creations and His laws were, of course, unaffected by time and place. Belief in the universality of the classical style was also an important factor in its diffusion to the rest of Europe, and it helps to explain the enthusiastic acceptance of the style in the cultural areas in which there was the strongest sense of national identity, namely Spain, France, and England.[16] The very essence of a universal style is its applicability to all times and places, and thus its susceptibility to variation and elaboration. First Italians and then other Europeans seem to have concluded that, while "good architecture" had been known in several past periods, its full potential had not yet been exploited. Outside Italy, Spaniards may have been the first to grasp the implications of this view, and foremost among them were Luis Hurtado and Pedro Machuca.[17]

Extraordinary as it is within the Spanish and European Renaissance, the palace of Charles V had surprisingly little effect on the course of the style in Spain or elsewhere. As far as I know, the only serious attempt to discover reminiscences of the palace was made by Fernando Chueca in his 1953 survey of sixteenth-century architecture in Spain. Dominant among the examples he noted were the plain portals and facades of the 1540s through the 1560s, but he invariably qualified them as "vaguely reminiscent of" or "somewhat influenced by" the palace of Charles V.[18] It was the sobriety of the forms rather than motives reminiscent of Machuca that led to Chueca's citations. For the same reason, several scholars have assumed that Machuca's Doric mode contributed to the formation of the trend designated *el estilo desornamentado*. If relieved of the marble *portadas* and the sculptural ornament intruded by others, Machuca's palace would be more readily recognized as a very early example of unornamented architecture.[19] Its sobriety was peculiar to Pedro Machuca at the time, because the Plateresque style dominated the second quarter of the sixteenth century;[20] but, it is difficult to claim a

[16] E. D. Marcu, *Sixteenth Century Nationalism*, New York, 1976,. 25-27, 57-88.

[17] Cristóbal de Villalón in 1539 compared the achievements of contemporary Europeans to those of the ancients in the sciences and the arts and he concluded that in virtually all the countries there were scholars, architects, and painters who not only equaled but, in some cases, surpassed the ancients. In the arts, it is clear he thought of ancient and modern artists competing within the same universally valid style; see his *Ingeniosa comparación entre lo antiguo e lo presente* [1939] (Sociedad de Bibliofilos Españoles XXXIII), Madrid, 1898, pp. 168-172. Lázaro del Velasco, in his account of Vitruvian principles written between 1550 and 1564, expressed the belief that ". . . ninguna arte ay que aya llegado a tanta perfección ni esté tan sumblimada que no tenga algo que desechar y añadiendo los tiempos se le pueda acrecer mejoría. . . ." and it is evident that he includes that of antiquity; Sánchez Cantón, *Fuentes*, I, pp. 205-206. The idea was most clearly expressed by Padre José de Sigüenza (ibid., p. 348) in his praise for the Escorial in the 1590s: ". . . y que podemos cotejarla con las más preciosas de las antiguas, y tan semejante con ellas, que parecen parto de una misma idea. En grandeza y magestad excede [ancient works] a quantas agora conocemos. . . ." Essentially the same attitude is evident in the title of Philibert de l'Orme's treatise of 1561: "Les Nouvelles Inventions pour bien bastir et à petitz frais"; and it is clear that wholly new forms and even a new architectural order—the "French"—could be invented within the "good style" of the ancients.

[18] Chueca, *Arquitectura del Siglo XVI*, pp. 166, 201, 232, 249, 253-254, 258, 263, 269, and 279. As we argued earlier, it is unlikely that Machuca's south portal served as the model for

Siloe's 1529 *portada* for the Colegio de los Irlandeses in Salamanca as Gómez-Moreno suggested (*Las águilas*, p. 163) because the marble frame of the south portal was not designed until about 1536. Machuca's round courtyard may have inspired the cloister of the friary of N.S. da Serra do Pilar at Vila Nova de Gaia in Portugal, designed perhaps as early as 1550 though not executed until 1576-1583; see George Kubler, *Portuguese Plain Architecture between Spices and Diamonds, 1521-1706*, Middletown, Conn., pp. 65-68, fig. 18, pl. 41. Apart from its circular form, the portico of the Portuguese courtyard differs from Machuca's in that it is single rather than double and has 36 rather than 32 columns; and, of course, the order is Ionic and not Doric, so the similarity is greater in groundplan than in elevation.

[19] René Taylor quite properly distinguished the sobriety of the palace of Charles V from the "absolute austerity" of the period of Philip II; but, still, it must be recognized that much of the "alegría" that for Taylor makes the former more representative of the period of Charles V was ornament added by others. See Taylor's expanded translation of Nikolaus Pevsner's *Outline of World Architecture*, under the title *Esquema de la arquitectura europea*, Buenos Aires, 1957, pp. 174-176.

[20] George Kubler (*Art and Architecture of Spain and Portugal*, p. 10) has speculated that the Plateresque style was viewed as "an untutored provincial extravagance" by Spain's "courtly class," whose taste (he believes) is represented by the palace of Charles V and the hospital of San Juan Bautista, or Afuera, in Toledo. While some members of the cosmopolitan *imperial* court are likely to have approved the severe style of the palace of Charles V, members of the royal court in Castile in the 1530s preferred works in the Plateresque style.

major role for the palace of Charles V in the formation of *el estilo desornamentado*. That severe trend seems to have been rooted in the grave forms of old Castile and to have received an early impetus from the very plain architectural style that Padre Bartolomé de Bustamante brought back from Italy in 1537, and then, in the 1540s, by the reduction of ornament in the mature works of architects such as Luis de Vega, Hernán Ruiz, and Alonso de Covarrubias.[21] Of course, we know that Vega saw the earliest projects for the palace of Charles V in 1527–1528 and we have speculated that he was consulted on later revisions because he was the only court architect who knew the site.[22] Still, there are no reminiscences of Machuca's architectural repertory in Vega's works, so it is unlikely that the palace influenced Vega to reject the Plateresque ornament found in earlier buildings such as the Dueñas palace in Medina del Campo. If Vega was unaffected by Machuca's palace, it is difficult to claim its influence on other partisans of *el estilo desornamentado* who seem not to have seen it. Apart from Luis Machuca, who remained fairly faithful to his father's style, the only architect who adopted some of Pedro's motives was his son-in-law, Juan de Orea, but that did not occur until the mid-1550s in Almería. There, it is not just the sobriety of the forms but an obsessive use of Pedro Maduca's fielded panel that identified the palace as Orea's model. The influence of Machuca's palace in members of his family who succeeded him in the works of the Alhambra is very little to claim for a building so impressive in form and so advanced in style.

The most obvious explanation for the limited influence of the palace is its location within the royal fortress of the Alhambra, which was reserved for the administrators and militia of Andalusia. Perhaps, if Charles and his court had returned to Granada around 1540 when the south facade was nearing completion, the palace would have become better known. Even so, the projects and the palace itself were seen by at least a dozen contemporary architects. Beginning with Luis de Vega in 1528, many architects were asked to give their opinions on plans and elevations sent to Charles in Castile, and after the formation of the Junta de Obras y Bosques in the mid-1540s, court architects were regularly consulted on current projects for royal works. Already in the mid-1530s, Diego Siloe was invited to appraise the sculptural ornament made for the palace, and as we suggested, he may also have been consulted on the south portal and other aspects of the architecture. Then, during the third quarter of the sixteenth century, especially after Siloe declined to come up to the Alhambra, his follower Juan de Maeda was often consulted on architectural matters, but neither repeated any of Machuca's architectural motives. In 1551 Bartolomé de Bustamante visited the Alhambra to review the state of the works for Prince Philip. Though Bustamante probably admired Machuca's Doric mode, he had been using an even more severe architectural style for about fifteen years. While one would reasonably expect the palace to have won some following in the 1540s or 1550s, architects who knew the palace or reviewed its projects during that time seem to have been unresponsive to Machuca's architectural repertory.

An even more likely explanation for the limited influence of the palace is its severity at a time when the sumptuous Plateresque style was gaining favor in most of Spain. That ornamental version of classicism was more accessible than Machuca's Doric mode to architects and patrons accustomed to the Isabelline style. Within the artistic ambience of the Plateresque, his Doric and Ionic pilasters with fielded panels (instead of fantastic carvings) and the disciplined cadence of his stylar facades must have struck most patrons as inappropriately plain for a regal building; and some of his contemporaries

[21] The designation *estilo desornamentado* is used here to refer to a tendency toward sober architectural design that preceded and, to a degree, prepared for the Escorial or Herreresque style, although some students of Spanish architecture (Byne and Stapley, Bevan, and Kubler) seem to equate the *estilo desornamentado* with the Herreresque, and others (Camón-Aznar, Chueca, and Wilkinson) see a gradual evolution from the Plateresque to a more severe classicism, with the architectural designs of Juan Bautista de Toledo and Juan de Herrera under Philip II being an abrupt advance in the sobriety of architectural forms. Kubler, in his study of the Plain style (or *estilo chão*) in Portugal,

concluded that it was derived from military architecture, and he expressed the belief that the same may be true of *el estilo desornamentado* in Spain, but Bevan recognized the Castilian roots of the style, citing the frequent use of granite in Castile as a partial explanation for the gravity of Castilian architecture there.

[22] Luis de Vega may have visited the works on the Alhambra during one of his several trips to Úbeda in the 1530s or 1540s when he checked on the progress of the palace of Charles' secretary, Francisco de los Cobos; see Keniston, *Francisco de los Cobos*, pp. 150-151, 193, and 226.

must have known that his theoretical position was even more severe than the palace itself. Furthermore, the Plateresque style had already appropriated the designation *a lo Romano* by the 1520s and it continued as the dominant style into the 1560s, leaving little chance for Machuca's sober style to gain a following. By the time his palace was seen by Bartolomé da Bustamante in 1551 and its elevations were reviewed by Juan de Herrera in 1574, the sobriety of Machuca's original project had been compromised by the intrusion of the richly sculptured *portadas* and other figural ornament. So his palace was too severe for his contemporaries and too rich for partisans of the more astringent Herreresque style two generations later. Its discrepancy with both contemporary and later taste would seem to explain the majestic isolation of the palace of Charles V within the Spanish tradition.

THE ICONOGRAPHY OF RULERSHIP

The palace of Charles V is unique in yet another respect. It is the only extant official princely palace in the Renaissance style from before 1540, and, as such, it is our best record of the architectural motives considered to be symbolic of rulership. Although we do not have all of the official palace planned in 1528–1531, since the two forecourts were not built and the decorative programs of the main halls and the corridor of the round courtyard were never executed, the forecourts, at least, are easily reconstituted from the early groundplans. Because the palace was designed for the leading monarch of the age, its designers could employ the most august symbols of rulership. Other than this palace, for this period we have only speculative groundplans for noble and royal palaces in the treatises of Filarete and Francesco di Giorgio and the project for the king of Naples by Giuliano da

Sangallo (pl. 114). Unfortunately, we have no record of the palaces Sangallo designed for the king of France and the duke of Milan nor of the four-towered residence planned by Andrea Sansovino for the king of Portugal.[23] Italian architects had little opportunity to design, let alone to build, royal palaces in Italy; but, Tuscan theorists made speculative projects for all categories of contemporary buildings, even when there was little prospect that they would be commissioned. Eventually, their ideal plans served as models for more powerful European monarchs with greater incomes than the *signori* of Italy. The latter could do little more than add triumphal portals or porticoed courtyards to the medieval castles in which they lived, and the same was true for the king of Hungary at Buda in the 1470s and the king of Poland at Cracow in 1502. Of course, the huge fortified hunting lodge at Chambord was a new building begun in 1519 by Domenico da Cortona for Francis I; but even though it was symmetrically planned around a central staircase and its fortress-like character was to have been compromised (in the first project) by external porticoes and stylar ornament, it is essentially a traditional French château with round towers.[24] Similarly, the temporary palace built for Henry VIII on the Field of the Cloth of Gold in 1520 and his fabulous Nonsuch palace, begun in 1538, were also medieval structures in Renaissance dress, and they were essentially pleasure palaces, not official residences.[25] In contrast, the palace of Charles V was built anew as an official palace on the basis of a distinctly Renaissance plan, and its stylar elevations and component parts were wholly in the Renaissance style.

References to rulership in the architectural forms at the palace of Charles V are not difficult to discover or to interpret because most of the symbolic forms were common currency in court circles of the early sixteenth century. Furthermore, the prince

[23] Vasari, in *Le Vite* (ed. Ragghianti, II, pp. 114 and 116), reported that Giuliano made a model for Lodovico il Moro, the duke of Milan, in 1492, and another in 1494, which he described as "marvelous" for a royal palace that could house the entire court of Francis I. See Marchini, *Giuliano da Sangallo*, pp. 88, 92, and 101; Huntley, *Andrea Sansovino*, p. 36; and above, chap. 5, n. 37.

[24] Pierre Lesueur, *Dominique de Cortone, dit Le Boccador, du château de Chambord a l'hotel de ville de Paris*, Paris, 1928, pp. 38-55, pl. III. Francis I's château at Romorantin, begun by

Leonardo in 1515 but never completed, retained the essential features of the traditional château; see Pedretti, *Leonardo da Vinci. The Royal Palace at Romorantin*, figs. 111, 149, and 160. The suburban villas near Paris (such as the Château de Madrid of 1528 and La Muette of 1539) were pleasure palaces, not residences.

[25] John Dent, *The Quest for Nonsuch*, London, 1962, pp. 1, 5-7. Sidney Anglo, "Le Camp du Drap d'Or et les entrevues d'Henry VIII et de Charles V," *Les Fêtes de la Renaissance*, vol. II, Paris, 1960, pp. 113-134, pl. VIII.

for whom the palace was built as an occasional official residence is one of the best-known personalities of the period. We also have a great deal of information about the planning of the palace and the several compromises made during its design and execution. Known, too, is the artistic ambience in which the architect selected the architectural forms used in the palace and the stratum of society that would have been admitted to the royal precinct—a special group composed of members of the royal and imperial courts, usually noblemen or gentry, and humanists, mostly well educated and widely traveled. More than any other social class at the time, they were familiar with palatine residences and festivities, and with the classical style because outside Italy previous to the mid-sixteenth century that style was used almost exclusively for princely residences. They were also schooled in a sense of decorum that led them to expect that the residence of a ruler would assert his princely status in its architectural and decorative forms. For more than a century they had become accustomed to the claim of Humanists that the heroic grandeur of the ruins of ancient Rome testified to the great and elevated spirits (*animi grandi*) of the patrons of those buildings.[26] Of course, Vitruvius and Renaissance theorists also fostered the metaphoric use of architectural forms in seignorial residences, and architectural theorists such as Filarete and Francesco di Giorgio provided model plans in hierarchical order for the residences of all social classes from the lowly farmers and artisans to noblemen and princes.[27] As a result of these treatises, and also of

the palaces built in Italy over several generations, we have a fair idea of the meanings then associated with most classical forms. Thus, an interpretation of the iconographic import of the palace is facilitated by our knowledge of all the essential factors. Stated in the terms of rhetoric, we know the rhetoricians (Pedro Machuca and Luis Hurtado de Mendoza), the subject (Emperor Charles V), the occasion (an official royal or imperial palace), and the audience (members of the royal and imperial courts).[28]

Of all these factors, we have said least about the subject, Charles I of Spain who was Charles V of the Holy Roman Empire. Earlier, we noted experiences that conditioned his taste in the arts previous to 1526. He was, however, not the designer of the palace, and it was not his idea of the imperial dignity but, rather, that of Luis Hurtado and Pedro Machuca that determined the rhetorical devices used in the design of the palace. Perhaps the most widely held idea about the Holy Roman Emperor was that he was unique among the rulers of the day and that, theoretically at least, he was above them all. He represented the pinnacle of European aristocracy, even though his title gained him little income and his German empire was a loose federation of disparate realms scattered over much of Europe. He was identified with a long line of Holy Roman Emperors, who were accepted by many as the successors of the ancient Roman emperors, and was therefore part of the longest succession among European rulers. He was, however, the first emperor in many centuries who was more than a figure-

[26] Georg Weise (*L'ideale eròico del Rinascimento e le sue premesse umanistiche*, Naples, 1961, pp. 124-129) cited Italian authors from Boccaccio through Giorgio Vasari who believed the buildings of Rome provided the best evidence of the *grandezza* and *magnanimità* of the ancient Romans. Baldassare Castiglione, the papal nuncio of the imperial court in the mid-1520s, held that the ruins "son gran testimonio del valor di quegli animi divini"; see *Cortegiani* (Biblioteca classica economica), ed. Corio, Milan, 1927, p. 265.

[27] Vitruvius (I, 2, 9; VI, 5, 3) stressed the importance of planning a house in accordance with the social position of the resident, and in his preface he pointed to the effective way in which the majesty of empire was expressed in the dignity of Rome's public buildings. These ideas were repeated around 1450 by Alberti in *Trattati*, I, pp. 332-348 (bk. V, chaps. 1-3), and II, pp. 778-794 (bk. IX, chaps. 1-2); and then in 1461-1464, Filarete discussed and illustrated projects for various kinds of upper-class residences; see *Trattati*, I, pp. 493-599, pls. 94-121 (fols. 132-161v). Around 1492, Francesco di Giorgio included houses for all social classes; see *Trattati*, II, esp. pp. 342-349,

pls. 192-202 (Magliabechiano, fols. 16v). Serlio was the only midcentury theorist to illustrate housing for all classes; see Serlio, *Il sesto libro*, compiled during the 1540s. Throughout this study, I have referred to the 1966 facsimile edition of the Munich version, but another in the Avery Library, Columbia University, New York, has been published in reduced facsimile: *Sebastiano de Serlio on Domestic Architecture*, ed. Myra N. Rosenfeld, Cambridge, Mass., 1978.

[28] I prefer the specificity of these factors as a point of departure for the discovery of meaning, since architectural forms are not *signs* that a society codifies into a *system of signification* as semiologists would claim. Rather, viewers associate meanings and values with architectural forms and those associations are subject to many variables. Most important among these variables are the specific factors that conditioned the program of the palace of Charles V. It is not that its architecture *speaks*, but the Renaissance viewers (according to their learning and architectural experiences) invested the component parts of classical architecture with meanings that varied with the subject and the occasion.

head, and this was due primarily to his inheritance of Spain, which was then the wealthiest and most powerful country in Europe with an expanding empire in the New World. Because of his imperial title and his power base in Spain, Charles V embodied for many Europeans the prospect of unifying the Christian community and turning back the Turks, who were advancing through the Balkans and Hungary on their way to Vienna and were harassing shipping in the western Mediterranean. With the Christian community united and Islam effectively countered, some envisioned peace and prosperity, while others looked forward to the recovery of the Holy Land and the propagation of the Christian faith to the ends of the earth. These great expectations, as well as reverence for the imperial dignity, were expressed by contemporaries in hundreds of eulogies, orations, and poems, and in entry and festival decorations all over Europe. By 1526, there had been a full decade of such expressions, which started in 1515 in Flanders when Charles came of age and was already recognized as the likely successor to his two grandfathers, Ferdinand of Spain and Maximilian I of the Holy Roman Empire.[29] From the beginning many marveled at the extraordinary fortune that resulted in these good prospects, and as they came true, it was taken by some to be evidence of a divine plan for Christian rule over the entire earth. It was widely accepted that Charles V equaled and would probably surpass the ancient Romans in the extent and universality of his empire and the magnitude of his power. His only counterparts were the fabled ancient Roman emperors, so praise for him and his prospects were usually expressed in Roman metaphors. While these eulogies were formulated in all parts of Europe, the same metaphors were used, with the result that the Romanized image of Charles V was common to most of Europe.

That image of Charles as the successor to the ancient Roman emperors was clearly held by Luis Hurtado, perhaps because, as a member of the Mendoza family, he was at ease with Roman references. Already at the end of the fourteenth century, his forebears studied the Latin language and began to read the literature and the political and military history of Rome; like the Humanists of Italy, they gradually imbibed Roman ideas, methods, and philosophy.[30] Even after the main Infantado branch of the family in Castile turned from the Latin to the chivalric model of the court of the duke of Burgundy in Flanders around 1485, the Tendilla branch (which later came to Granada) remained resolutely faithful to the older Latin orientation of the family.[31] A few instances serve to reveal their continued commitment to *Romanitas*. When making recommendations to the Crown (such as allowing the Moriscoes to maintain their traditional dress or establishing an office of censor to monitor writers of the history of Spain), the Mendozas of Granada cited Roman practice to support or validate their proposals.[32] Helen Nader noted that the Mendozas "admired the Roman ability to combine worldly careers with aristocratic sensibilities, and they consciously cast themselves and their ancestors as the spiritual heirs of the ancient Romans in Spain—men of arms and letters."[33] The degree to which the Roman past permeated their thought is evident in the inscription on the tomb of Luis Hurtado's father, Iñigo López de Mendoza, the first governor of Alhambra. It identifies him as "the prefect of the Acropolis of Illiberis," the Roman town then thought to have been the site of Granada.[34] In view of this attitude toward the Alhambra and the long-standing family commitment to *Romanitas*, it is no surprise that Luis Hurtado was sympathetic to the Roman style in architecture. Inevitably he accepted it as appropriate for the residence of Charles V, the successor to the Roman emperors. Accustomed to drawing on Ro-

[29] Rosenthal, "The Invention of the Columnar Device of Emperor Charles V," p. 201, n. 15, for Charles' 1515 entry into Bruges, and pp. 221-223, for Luigi Marliano's oration on 26 October 1516, when Charles became master of the Order of the Golden Fleece in Brussels. The expectations of contemporaries may have been heightened by the twelfth-century prophecy of Joachim of Flora that "the last emperor," who would be "a second Charlemagne," would unite Christendom, reconquer the Holy Land, convert the Moslems, and realize the ideal state of one fold under one pastor. That prophecy was associated with Charles as early as 1505 (when he was five years old) and again by one of the seven *Kurfürsten* who elected him

Holy Roman Emperor in 1519; see Marjorie Reeves, "Joachimist Influences on the Idea of the Last World Emperor," *Traditio*, XVII (1961), pp. 353-355.

[30] Nader, *The Mendoza Family*, pp. 56-75.

[31] Ibid., pp. 126-127, 192. The split was increased after 1504 when the Tendilla branch did not follow the Infantado line in their support of Philip the Fair for succession to the crown of Spain.

[32] Ibid., pp. 92, 187-188, and 208, n. 2.

[33] Ibid., p. 3.

[34] See chap. 1, n. 35.

man comparisons in political, historical, moral, and aesthetic matters, Luis Hurtado must have relished the opportunity to employ architectural metaphors of *Romanitas* in the design of an imperial residence.

By the early sixteenth century the classical style itself had gained metaphoric value in that it was associated with the ancient Romans, and when used for princely residences or honorific entries, it identified a ruler with the Roman emperors, whose skill in both administration and war was legendary. The association of the classical style with rulership came about as a result of the channels through which the style was diffused, first in Italy and then in Europe. Initiated in republican Florence around 1420, the new classical style was at first characterized by the chaste and sober forms of Brunelleschi and Michelozzo. Their works would seem to be in keeping with republican values and also with the recent revision in the legend of the origins of their city, which held that Florence had been founded in the republican rather than imperial period of ancient Rome.[35] By midcentury, however, Tuscan architects and theorists discovered, as humanists had several generations earlier, that there was more demand for their services in the courts of the *signori* than in the councils of the republics. Inevitably, they turned to the more sumptuous models of imperial Rome for the renovation of princely residences and the design of decorations for court festivities and honorific entries. It was primarily in the courts of Italy that ambassadors of European princes became aware of the classical style and the ways in which it could be employed to lend the aura of imperial Rome to new ruling dynasties.[36] Much of the import of that style came from the growing belief, in Italy and throughout Europe, that the culture of ancient Rome was superior in virtually all respects to that of the fifteenth century. Since Tuscan humanists first recognized the superiority of Roman Latin, literature, and law, their admiration was gradually extended to ancient philosophy, mathematics, medicine, optics, and the arts. As a result, the classical style in architecture came to be charged with the many positive values associated with the whole civilization of ancient Rome. In fact, contemporaries seem to have accepted architecture as the best evidence of the heroic qualities of ancient Rome—grandeur, majesty, triumph, and magnificence.[37] Hence, the Roman style, when used for the palace of a Renaissance prince, attributed to him the heroic virtues associated with Roman emperors—magnificence, majesty, courage, clemency, magnanimity, justice, and prudence, together with invincibility;[38] and, in addition, the style was inevitably reminiscent of the stability and durability of the empire.

The universality associated with the Roman empire was also attached to its architectural style. That reference was, of course, more appropriate to Charles V than to any other monarch of his day because he ruled not only the Holy Roman Empire

[35] Until around 1400, Florentines firmly believed their city had been founded by Caesar; but during the 1380s, humanists became increasingly uneasy about the legendary imperial origins of their beleaguered republic. Salutati, Bruni, and others discovered ancient and medieval sources that indicated Florence had been founded by veterans of Sulla's army and, thus, their origins were republican. The maxims and moral values of republican Rome sustained the Florentine republic, and that set of mind may account for the gravity and simplicity of the architecture of Brunelleschi and Michelozzo and their avoidance of the more sumptuous models of imperial Rome. For the change in the legend of the founding of Florence, see Hans Baron, *The Crisis of the Early Renaissance*, Princeton, 1966, pp. 58-78, and Nicolai Rubenstein, "The beginning of political thought in Florence. A study of medieval historiography," *Journal of the Warburg and Courtauld Institutes*, v (1942), pp. 198-227.

[36] The centers that adopted the new architectural style before 1450 were ruled by *signori*, specifically Lionello d'Este of Ferrara, Federico da Montefeltro in Urbino, Alfonso I of Aragon, the king of Naples, and the princely Pope Nicholas V in Rome.

They were followed by the principalities of Rimini, Mantua, and Milan, and the republics of Siena and Venice.

[37] Weise (*L'ideale eròico del Rinascimento*, esp. pp. 124-129) noted that from the fourteenth through the sixteenth century, Italian humanists used essentially the same adjectives to characterize the civilization, rulers, and architecture of ancient Rome—*grande, magno, magnifico, maestoso, triunfal, superbo, pomposo*, and *glorioso*—and this vocabulary was diffused with the new values and attitudes of the humanists and the new classical style.

[38] Felix Gilbert ("The Humanist Concept of the Prince and 'The Prince' of Machiavelli," *Journal of Modern History*, XI (1939), pp. 449-483) reviewed the idea of the prince from the treatise of Egidio Colonna to that of Machiavelli and noted the stress on *liberalitas, magnificentia*, and *majestas*. M. P. Charlesworth ("The Virtues of the Roman Emperor, Propaganda and the Creation of Belief," *Proceedings of the British Academy*, XXIII [1937], pp. 107-127) observed that the cardinal virtues of rulership from the time of Augustus were *virtus, clementia, justitia*, and *pietas causa*, with *providentia* added later in the time of Trajan and Hadrian. Constantine took the title *Victor* to replace *Invictus* used by previous emperors.

in Europe but also the expanding dominions of Spain in the New World, and in both empires, many realms and diverse ethnic groups were brought under common rule. The aspiration to universal empire was deeply rooted in the tradition of the Holy Roman Empire, and that prospect was expressed relative to young Charles, even before he was crowned at Aix-le-Chapelle in 1520. In 1516, when he was installed as master of the Order of the Golden Fleece, the likelihood of his election to the imperial dignity and his inheritance of the throne of Spain lent credibility to the prospect of universal rule.[39] Because the Mendozas were more sensitive than most Spaniards to parallels between sixteenth-century Spain and the Roman empire, it is likely that Luis Hurtado favored the "universal" style of ancient Rome for the palace of Charles V on the Alhambra.

The metaphoric value of the classical style was keynoted by its most distinctive feature, the column. Though the column had gradually lost its original function as a free-standing support during the early Middle Ages, Romanesque architects added columnar shafts to piers and to splayed openings, so the column never lost its association with structure. The column also survived as a symbol of strength, fortitude, and nobility[40] because Christians reserved it for the most elevated of functions: the *Beau Dieu* stood on a column between the twin doors of many Gothic churches, and saints and apostles were sometimes placed on shafts along the splays of church portals; even the Virgin deigned to appear to Saint James Major on a column when she asked him to build a church for her on the shores of the Ebro River at modern-day Saragossa.[41] In addition, civic symbols were sometimes mounted on free-standing columns erected in public squares.[42] Thus, around 1500, even neophites in the mysteries of the classical orders would have accepted the column as a symbol of dignity and nobility as well as of strength.

Contemporaries familiar with the architectural treatises of Vitruvius and Italian Renaissance theorists would have recognized that two of the orders

used by Machuca—the Tuscan on the rusticated basement, and the Doric on the west frontispiece and in the round courtyard—conveyed a virile and even heroic idea of strength and the gravest kind of dignity. Theorists also identified the Doric order with the most majestic and powerful of the gods, notably Jupiter and Mars, and the most virile of heroes, Hercules;[43] therefore, its use for the exalted and august personage of the Holy Roman Emperor, the grave and pious Charles, was particularly appropriate. While the Doric order would have been recognized in the 1520s by most members of the court, it was not often seen in modern buildings and so was likely to have evoked direct association with ancient Rome. The only feature that might have been considered inappropriate for Charles V was the fluting of the Doric columns of the west frontispiece—plain shafts were considered more virile, while the fluted were thought to be better suited to goddesses such as Juno or Minerva[44]—but in the west frontispiece, the fluting was probably used to increase the magnificence of the main ceremonial entry of the palace. The fluting of the shaft of the Ionic order of the south portal would have seemed more appropriate to courtiers when they learned that it was to be the entry to the household of Empress Isabel in the southeast corner of the palace. The choice of the Corinthian order to frame the window above the south portal was likely dictated less by iconographic considerations than by the "Colosseum principle," which required that the Doric be followed by the Ionic order and then the Corinthian, in accord with the diminishing strength associated with each. In respect to decorum, however, few courtiers would have found fault with Machuca's choice of orders in the palace of Charles V.

The classical orders were also used to articulate the strict bilateral symmetry of the main facades and the cross axes of their forecourts, and the resulting sense of control and order conveys an idea of dignity, power, and authority appropriate to the resident prince. By the use of paired pilasters to frame the axial entry bays as well as the ends

[39] For the oration of Luigi Marliano on that occasion, see "De Ordine Velleris Aurei," *Rerum Germanicarum Scriptores*, ed. Marquand Freher, Strasbourg, 1717, III, pp. 146-149.

[40] Tervarent, *Attributs et symboles*, cols. 106-108.

[41] Manuel Trens, *María. Iconografía de la Virgen en el arte es-*

pañol, Madrid, 1946, pp. 586-595.

[42] See Werner Haftmann, *Das italienische Säulenmonument*, Leipzig and Berlin, 1939.

[43] Forssman, *Dorisch, jonisch, korinthisch*, pp. 50-52.

[44] See chap. 5, n. 248.

of the original sandstone facades (figs. 7 and 8), Machuca created an organization in which all parts are given their places within a hierarchical order that is dominated by the central axis. It is, in fact, a striking symbol of the stratification of aristocratic society under centralized authority. Since no one would have seen hierarchical facades of this sort until almost midcentury, their impact would have been all the greater. The dominion of the three entry bays on the west front was to have been extended to its forecourt because the pilasters on the piers of its arcade continued the intercolumniation of the regular bays of the facade. The sense of unity was probably enhanced by the continuity of the rusticated white sandstone of the lower story of the facade into the arcade and by the repetition of the format of the central door (of the first all-sandstone facade) in the archways centered on the other three sides of the forecourt. The repetition also served to stress the longitudinal and transverse axes of the forecourt and to direct the movement of entrants from the south entry toward the portal of the palace. Most members of the court would have recognized that this huge enclosure had been conceived as a whole, following a master plan, and the novelty of the master plan and the hierarchical facade would have sharpened the allusion of the palace to rational control, centralized power, and authority.

The rusticated treatment of the palace's ground floor and (very probably) the arcades surrounding the forecourts conveyed an idea of strength and impregnability as well as authority and nobility. All those associations had accumulated as a result of the varied uses of rustication in the past. Strength, durability, and invincibility were evoked by the irregular cyclopian blocks, originally used in Late Republican walls and then from 1300 for fortified town halls in Tuscany, thus adding an association with civic authority. From about 1400, rustication was used on the facades of major Florentine palaces, such as those of the Uzzani-Capponi, Medici, and Pitti. With the rediscovery about 1500 of *calcestruzzo*, or artificial stone, the strength of palace

facades was expressed in the bold relief and coarse granular texture of the cast blocks, while refinement was suggested by the varied shapes of the blocks and the complex decorative pattern of the simulated masonry of the rusticated wall. Alberti had rejected cyclopian raw rock, as more appropriate to the castle of a tyrant than to the residence of a beneficent prince. He insisted that a ruler's palace ought to be elegant or refined (*elegans*) rather than haughty and imposing (*superbia*).[45] Evidently, other theorists agreed with him because they tended to reserve raw rock for fortifications and city gates.[46] In the palace of Charles V, the great size and bold relief of the rusticated blocks effectively express strength, while the unusually subtle and complex pattern testifies to the refined sensibilities of the resident prince.

The rusticated blocks also serve as a link between the scale of Man and that of the gigantic palace. Of course, literate men all over Europe were predisposed to admire heroic grandeur in architectural works because for almost two centuries humanists had praised ancient Roman ruins as *grande, magno, imponente, pomposo, eròico*, and *superbo*.[47] Charles' huge palace—63 meters long and 17 meters high, with a forecourt that measures 42 by 70 meters and arches with a span of 3.60 meters in the surrounding arcade—would have overwhelmed a viewer, were it not for the size of the rusticated blocks. At 55 centimeters, the lowest courses are about a third the height of a man, and since that is a size that does not menace the viewer, these blocks substitute for the human body as a measure of the huge architectural enclosure. Perhaps Renaissance designers, in accord with the new understanding of the dignity of Man, sensed that architectural forms which diminished or demeaned men evoked the image of a tyrant. If the rhetoric of classical forms was to work its magic, it had to affect men so that they felt enlarged to the heroic scale of the palace and attributed that grandeur to the princely builder. Humanist rhetoric was a necessary preparation for the Renaissance sense of the heroic, but we should note that Spaniards had de-

[45] Alberti, *Trattati*, I, p. 347 (bk. v, chap. 3): "Nam regum quidem aedes in media urbe aditu facilis, ornatu venusta, lautitie elegans magis quam superba sit condecet; tyranno autem non aedes magis quam arx locanda est, ut sit neque in urbe negue ex urbe." Also, in *Trattati*, II, p. 809 (bk. IX, chap. 4), he repeated his association of a fortress-like appearance with the castle of a tyrant.

[46] See chap. 5, n. 125.

[47] Weise, *L'ideale eròico del Rinascimento*, pp. 127-128. Cristóbal de Villalón in 1539 was impressed with the sheer size of ancient architectural works in Rome, and also in Spain, where the bridge at Alcántara and the aqueduct at Segovia were cited.

veloped, quite independently, an innate sense of *grandeza*—the result of several centuries of success in the war against Islam and good fortune in traversing the western sea and conquering, with very few men, vast stretches of the distant New World.[48] So, while the monumentality of the palace of Charles V was in accord with the High Renaissance style in Italy, its grandeur was expressive of Spain's heroic self-image during the first two-thirds of the sixteenth century.

The other major enclosure of the palace, the secluded round courtyard, would have surprised privileged courtiers by its size—about 42 meters in diameter—and even more by its novel form and airy double colonnade. It presents a unique experience for most visitors. If full columns (without pedestals) and iron railings (rather than balustrade or parapet) had been used, as Machuca intended, the double colonnade would have had the lightness and openness of a Greek stoa—a type of portico rarely employed, even in the later Renaissance (fig. 10, p. 113). Double porticoes in rectangular and even polygonal courtyards can not match the sense of absolute enclosure that results from the seamless continuity of the circular colonnade. Centricity was further stressed by the alignment of the free-standing columns with responds on the corridor wall and by the large arched openings that accent its cardinal and intracardinal axes and dominate the three-bay rhythm of the circular wall. The articulation of the main spokes of the radial order of the courtyard gives anyone at its center the feeling

that he dominates the space, and even that the space is dependent on him, because its axes converge toward him or radiate from him. These feelings of Adamic sovereignty, along with the sense of complete seclusion, are well suited to the probable function of the courtyard as a paradisaic retreat and a place to entertain a few favored courtiers. Of course, the insistent centripetal disposition of the round courtyard is as expressive of order and dominion as the bilateral symmetry of the main facades and the cross axes of the forecourts.

Only upon entering the round courtyard would the visitor have recognized that the residential block was composed of the two most perfect geometric forms, the square and the circle, and that these contrasting forms were interlocked by the articulation of their cardinal and intracardinal axes. From the time of Alberti and Francesco di Giorgio through that of Sebastiano Serlio and Pietro Cataneo, the circle and the square were reserved by theorists for the most elevated functions, that is, for churches and chapels and for the halls and courtyards of noble and princely residences.[49] The reservation of geometric forms for the upper classes was based on the theory that a man was most comfortable in the setting suited to his station in life, and that theory, in turn, was based on the belief that a man's faculties ranged from the technical to the speculative.[50] The first principle dominated the lives of farmers and craftsmen and so their houses were in great part determined by the requirements of their labor. Alberti concluded there was no need for

[48] The formulation of the Spanish identity within the context of their heroic fight against infidels and heretics and their aspiration to universal Christian rule was proposed in 1937 by Ramón Menéndez Pidal (*La idea imperial de Carlos V*, 2d ed., Buenos Aires, 1941) and elaborated since 1954 by Américo Castro (*La realidad histórica de España*, Mexico City, 1966, esp. pp. 89-101).

[49] Alberti and Filarete gave less attention to the circle or polygon in secular architecture, but Francesco di Giorgio discussed round courtyards and houses and his illustrations reveal that bilateral symmetry was used only in plans for professional and noble classes, while central symmetry was the prerogative of philosophers (humanists) and kings; see *Trattati*, I, pp. 79-80, pls. 33-34 (Saluzziano 148, fols. 19r-19v and Laurenziano, fol. 18v and 19). Serlio did not often use round or polygonal forms in secular architecture; but in *Il sesto libro* of the 1540s, he reserved round central halls and courtyards for the villas of princes and kings; see *Sebastiano Serlio on Domestic Architecture*, pls. XX, XXVII, XXXI, XXXII, XXXVI, and XL. Cataneo (*I quattro primi libri di architettura*, bk. IV, chap. 1) held that central sym-

metry and four axial entrances were particularly suited to a regal palace, and he thought that the *sala maggiore*, the most honored part of a noble palace, should be round and recommended (bk. IV, chap. 12) a circular house with a circular courtyard as used in antiquity. Diego de Sagredo in 1526 observed several times that "Todas las obras de arte romana son ordenadas sobre el redondo o sobre el quadrado"; see *Medidas del Romano*, pp. 14, 37 (fols. Avi, Cii).

[50] Francesco di Giorgio, in *Trattati*, II, pp. 324-348 (Siena, fols. 45v-68 and Magliabechiano, fols. 10-16v) held that a man's intellect was his most noble faculty and (citing Petrarch) explained that, because the intellect is domiciled in a bodily prison, men suffer "disquietude." Men of lesser intelligence are not as easily disturbed as the more intelligent and speculative, and thus he concluded the residences should be made for each "secondo la intenzione sua," because "ogni cosa naturalmente appetische il luogo a se conviniente e in quello si quieta." Nobles and princes—"quali al mondo studiano vivere con anore senza molte cure"—need "a casa arteficiosa."

"delight" in their houses and Filarete expressed the same view by noting that there was little reason for the expenditure of "art."[51] On the other end of the social scale, the decorous lives and great responsibilities of princes and noblemen required the use of Man's highest faculty, the speculative. Men of this class were more sensitive to their environments and were more easily disquieted. They had to have a *casa arteficiosa* that was characterized by bilateral and even central symmetry because plans following these geometric principles were the most perfect. Surely, theorists from Alberti to Pietro Cataneo would have approved Machuca's combination of the square and the circle and especially the centripetal disposition of the round courtyard for the palace of the Holy Roman Emperor on the Alhambra.

The metaphysical and allegorical implications of the circle and the square would inevitably have been invoked by the more philosophically minded of the courtiers. Of course, the meanings associated with the square and the cube have less range than those attributed to the circle. Fundamental to the square or cube is the idea of stability, constancy, and *virtù*, but there is also a secondary association with the earth and the terrestrial.[52] The symbolism of the circle includes eternity, endless continuity, autonomy, and perfection, but it is likely that most entrants to the round courtyard would have recalled the association of the circle with the globe of the earth, over which the emperor had been given dominion.[53] At his first coronation in 1520, he had already held the orb, symbol of the earth.[54] In Charles' case, the fiction of universal rule became more plausible as his Spanish subjects advanced in the New World. If the round courtyard was to have been a peristyle garden and its plants imported from all over his two empires, the pertinence of the circular form of the courtyard to his claim to global rule would have been very clear. If that was the case, the shape of the garden into

which he retreated would have symbolized the burden from which he withdrew for relaxation and renewal. One other symbolism of the circle could hardly be avoided and that is Charles V as the unique and immobile center of a circle to which the whole refers.

Because of the rarity of the round courtyard, only a few ambassadors at the imperial court are likely to have recalled formal precedents or associated that shape with a particular function, but Italians, such as Baldassare Castiglione, could have told other members of the court about Francesco di Giorgio's models for princely residences in which a porticoed round courtyard was enclosed within a block-design format and about the role of the round courtyard in the prolonged design process of the Villa Madama outside Rome (pl. 110). Many courtiers would have known Pliny the Younger's description of his Laurentian villa with an atrium or court in the form of an O, though they would have recognized that his villa was a smaller and more modest building than the one planned for Charles V. The antetype that certainly would have been cited by Italians such as Castiglione and Navagero is the circular portico enclosing Hadrian's retreat in the villa at Tivoli. Although its order is Ionic, not Doric, and it has a single, not a double, colonnade, it was the only circular courtyard known to have survived from antiquity. Some ambassadors who had visited Tivoli might even have sensed that Charles' round courtyard was about the same size as Hadrian's. If they were told that the diameter of both courtyards was about 42 meters, most would have assumed a deliberate reference to the ancient retreat. The replacement of the Ionic order in Hadrian's casino with the Doric in the lower colonnade of the palace would probably have been considered appropriate because the strength and austerity of the Doric order were better suited to the personage of the emperor. Once visitors had identified Charles' round courtyard with Hadrian's

[51] Alberti, *Trattati*, I, pp. 270-271 (bk. IV, chap. I) believed that architecture had developed through three stages—necessity, convenience, and pleasure—and that the houses of farmers and artisans pertained to the first stage, those of professionals to the second, and the palaces of nobles to the final stage. See also Filarete, *Trattati*, I, p. 331 (bk. XII, fol. 86).

[52] Ripa (*Iconologia*, p. 482) explained that "una base quadrata" symbolized "la stabilitá constant e salda apparenza delle cose." See above, chap. 2, n. 148, for Ripa's identification of the cube with Truth and Luca Contile's association of it with "virtù

ferma e ben fondata"; see also George Ferguson, *Signs and Symbols in Christian Art*, New York, 1961, p. 153.

[53] Tervarent, *Attributs et symboles*, cols. 64 and 65.

[54] Earl E. Rosenthal, "Die 'Reichskrone,' die 'Wiener Krone' und die 'Krone Karls des Grossen' um 1520," *Jahrbuch der Kunsthistorischen Sammlungen in Wien*, N.F., XXX (1970), pp. 7-48. Because Maximilian I died before Charles was crowned king of the Romans in 1520, he properly holds the *Reichsapfel*, the symbol of the earth, in contemporary depictions of his coronation at Aachen.

circular retreat, they would have understood two of its peculiarities: its raised level and its seclusion. Even if the courtyard had not yet been planted as a garden, these traits and the reference (by way of shape and diameter) to the circular casino of Hadrian would have signaled a private function.

The regal associations of several other features of the palace would also have been recognized by most courtiers. The very size of the main forecourt—42 by 72 meters—indicated the princely scale of ceremonial receptions, equestrian games, and other festivities that were to take place there. The regal manner in which these festivities were to be staged would have been underscored by the unusually handsome bronze tie rings, by the torch standards in the form of human arm (once mounted at the corners of the palace), and, presumably, by other fixtures for flags and torches on the main story, where they were probably inserted in the incised rectangle between the pedestals and the window casings (pl. 39). Some of these lesser fixtures might have been made of wrought iron, but even so, none of the courtiers are likely to have seen a palace with so many bronze accessories, not even in Italian cities such as Siena, Florence, Milan, and Bologna, where figural forms in bronze were first used. The handsome arcade that screened the stables from view not only expressed a new sense of decorum but would also have accommodated many spectators, and presumably there was a terrace above it from which others could have watched events in the forecourt. On that level, above the stables, there was probably an attic devoted to offices and other services that would have facilitated diplomatic exchanges and the enactment of court business. In the north wing of the forecourt, a hall measuring 10 by 32 meters (the *quarto para fiestas*

in the large Royal Palace plan, 1.17-C) would have been recognized as a hall for banquets, performances, dances, and other court festivities. On the whole, the 1528 project for the west forecourt would probably have been accepted by members of the imperial court as the best-organized administrative, service, and festive complex in Europe at that time.[55]

The main entries to the residential block also proclaimed the elevated status of the resident prince. The three-door entry of the west front—in both the original all-sandstone facade and the later marble frontispiece—would inevitably have recalled Roman triumphal arches because the central door is twice as large as those on the side. Previous to midcentury, no one would have seen a Renaissance palace with a triumphal entry of this sort, so a direct association with antiquity was likely, and the inference of victory and honorific entry inevitably follows. Even those who were not aware of Francesco di Giorgio's identification of the three-door format with regal palaces would certainly have found it appropriate because it provided separate entries for people of different social status, and thus, it nicely reflects the elaborate etiquette of a royal or imperial court. The original all-sandstone facade, in which the three doors must have been framed by rusticated voussoirs, would have expressed a noble restraint and gravity, while the later marble frontispiece (as Pedro intended it) would have conveyed the idea of *magnificentia* appropriate to an imperial palace.[56] In addition to the richly ornamented imperial Doric order and the Doric band on the pedestals of the marble frontispiece, there were garlands suspended from the ends of the pediments of the three doors—a distinctly Roman note of celebration on the west facade.[57]

[55] Among the rulers of Italy, only the duke of Milan in his medieval Castello Sforzesco had a forecourt (the vast Piazza d'Armi) that provided comparable services in the wings surrounding that enclosure, but its great size (about 100 by 180 meters in contrast to the Alhambra palace's 42 by 70 meters) and its lack of convenient vantage points for spectators would have made it less suitable for most receptions and festivities; in addition, the enclosing walls of the Milanese forecourt are less handsome than Machuca's arcades in white sandstone. At Chambord in 1519 the king of France planned a huge forecourt, about 106 by 30 meters, with extensions to each side of the castle, but work centered on the château itself until 1537, so the forecourt had not yet been constructed when Machuca made his plans. The open-ended Cour du Cheval Blanc of the château of Fontainebleau was under construction from at least 1527,

but it was not completely enclosed and it was too large to serve most of the functions intended for the west forecourt of the palace on the Alhambra. Even the important kings of Hungary, Poland, Bohemia, and Naples had no comparable forecourts in their royal residences, and nothing of the sort was found at Innsbruck, the imperial residence of Charles' grandfather, Maximilian I. Of course, the royal palaces designed by Giuliano da Sangallo for the king of Naples and for the Medici in Florence and Rome (and probably those for the king of France and duke of Milan) were to have had very large and handsome forecourts.

[56] Alberti, in *Trattati*, II, pp. 779–781 (bk. IX, chap. 1), observed that men of the greatest prudence and modesty avoid extravagance in their residences, but that decorum required splendor and magnificence in a royal palace.

[57] See chap. 5, n. 239.

Perhaps the most striking feature of the west entry would have been the large central window over the main door, which was apparently intended by Machuca and retained by Juan de Orea in his projects of the mid-1570s. The great size and distinctive three-light format of that window and its location on the axis of the facade and the main audience hall signaled the special function of a "window of appearances," which had long been a feature of imperial and regal palaces. Rulers of the Ptolemaic period are known to have appeared in a golden loggia above a gateway, especially when celebrating victories. That ceremony was continued in several variations in Hellenistic and Roman areas and then in Byzantium, Islam, and medieval Europe,[58] but the constant feature throughout is a loggia-like window in which a ruler appeared to his people. In Diocletian's palace at Split, a large Serliana window in the seaside facade was centered on the main floor near the ceremonial chambers (pl. 161), and presumably it served as a window of appearances for arrivals and departures by sea. The early eighth-century palace of the Exarchs in Ravenna has a large recess (most scholars believe it was a three-light loggia) over the advanced frame of the portal (pl. 128). At Aix-la-Chapelle, the three-light window over the entry to Charlemagne's palatine chapel is thought to have been modeled on that of the Ravenna palace, and it is known that he appeared at that window to as many as seven thousand people who crowded into the courtyard.[59] On the west front of the papal palace at Avignon, which was realized in the 1330s, a small, two-light window served for papal appearances to pilgrims gathered immediately in front of the main portal, while a larger and higher-placed opening must have been used when people filled

the entire square in front of the palace.[60] Italian cardinals sometimes had large and distinctive windows over the portals of their palaces; notable among extant examples are the Vitelleschi palace in Tarquinia (Corneto) of the 1430s, and the Farnese in Rome, begun in 1517, though its central window was probably designed in the 1530s.[61] In Spain, the large window over the main entrance of the royal residence in Madrid, contracted for in 1543 (pl. 14)[62] would seem to have had the same function as the three-light window planned for the west facade of the palace of Charles V.

Presumably that window in the Machuca and Orea projects was a Serliana like the one used over the south entry.[63] The large center arch flanked by smaller rectangular vanes would have been a novelty to most members of the court previous to midcentury because that kind of window had not been used very much. Among the Serliana windows most likely to have been known and recalled were two in the Vatican: Bramante's small window in the Sala Regia and the one in which Pope Julius II was depicted blessing the faithful in the *Fire in the Borgo*, probably designed by Raphael and executed by Giulio Romano in 1514 (pl. 140); and some courtiers might also have seen the windows on the seaside facade of Diocletian's palace at Split. Upon seeing Charles V framed by the central arch of such a window, a few courtiers might have recalled depictions of ancient Roman or Early Byzantine emperors seated within a "frontispiece of honor" in the form of a Serliana (pl. 139). Also designated a "glorification gable," the arcuated lintel is believed to have represented the *palatium sacrum* and to have been a symbol of power.[64] But those associations would not have been necessary, because the axial position, great

[58] E. Baldwin Smith, *Architectural Symbolism of Imperial Rome and the Middle Ages*, Princeton, 1956, pp. 22, 182-183, figs. 5 and 6.

[59] Kenneth J. Conant, *Carolingian and Romanesque Architecture 800-1200* (The Pelican History of Art 13), Harmondsworth, 1959, p. 15.

[60] Paul Frankl, *Gothic Architecture* (The Pelican History of Art 19), Harmondsworth, 1962, p. 245, pl. 184B.

[61] For the Vitelleschi palace, see Carroll William Westfall, "Alberti and the Vatican Palace Type," *Journal of the Society of Architectural Historians*, XXXIII (1974), p. 107, fig. 6. Ackerman (*The Architecture of Michelangelo*, p. 70) observed that Antonio's facade projects for the Farnese (Uffizi A998 and 1109) have a central window comparable to the form realized after 1546 by Michelangelo. In the case of the famous window over the east

portal of the Palazzo Venezia in Rome, the present frame was made in 1715, but it is known to have replaced one executed under Paul III shortly after 1534.

[62] According to Margarita Estella ("Encargo a Gregorio Vigarny de la portada principal del antiguo Alcázar de Madrid," *Archivo español de arte*, LIII [1980], pp. 124-125) on 31 January 1543, stone mason Juan de Perea contracted to construct the "portada principal con ventanas y galería."

[63] The central window on the south facade may have been intended to serve, on occasion, for appearances of the empress, but its primary purpose seems to have been that of a glazed loggia for the empress and her ladies to enjoy the warmth of the winter sun.

[64] Dyggve, *Ravennatum Palatium Sacrum*, pp. 32-38, 47-48, figs. 31-34, for a discussion of the Serliana as a symbol of

size, and distinctive shape of the west window would have been sufficient to identify its function as a window of appearances for the Holy Roman Emperor.

The west window may have been enhanced by another regal symbol—a pair of recumbent lions. We know that Leval made two in grey marble in 1564–1566, apparently for the west entry. Since there was no evident place for them in the frontispiece itself, we reasoned that they were made for the upper story because most of its component parts in white sandstone and marble had already been delivered. The lions may have been placed on the ledge of the advanced entablature over the paired Doric columns framing the center portal, in which case they would have been set on either side of the base of the three-light Serliana window. They may also have been set atop the side lintels of that window or on the crest of its arch, as are the lions on the arcuated lintel of the loggia depicted by Giulio Romano in the window embrasure of the Sala di Costantino (pl. 138). Whatever their placement, the grey marble lions would have been silhouetted against the white sandstone and marble frame of the central window. Although lions had acquired a wide range of meanings by the sixteenth century, only those pertinent to a princely ruler need be mentioned. Among the qualities associated with the king of beasts were strength, fortitude, courage, and majesty; but, when lions are recumbent and presented as a pair, they are also guardians and symbols of watchfulness because they were thought to sleep with their eyes open.[65] That symbolic function would have been appropriate for a window in which the emperor was to appear to subjects and ambassadors gathered in the forecourt.

A noble palace also required direct and easy movement from the main entry to the audience hall, which in this case was on the main floor in the center of the west facade. Since the main portal has a height of 5.30 meters, one could enter the west vestibule on horseback and (since it was originally surfaced with cobblestones) dismount there.

Alongside the vestibule (probably on the right), there must have been a guard room, and (if the original plan of 1527 had two stories) the main staircase probably occupied the hall on the left side. A staircase of the dog-leg type in that position would have provided access to the main-floor room immediately north of the audience hall. In contrast, the newel staircase (probably proposed by Luis de Vega) for the northwest corner of the courtyard would have opened into the gallery corridor and, thus, required the visitor to pass through several rooms in the northwest corner of the palace in order to reach the audience hall. That roundabout path would have seemed less regal to most courtiers and it is quite at odds with normal practice, even in the palaces of lesser persons. Of course, if Pedro intended (as Juan de Maeda later suspected) a spiral staircase in the northwest corner, it could have started from the ground level room north of the west vestibule and terminated in the room next to the audience hall. That would have provided direct passage from entry to audience hall and preserved the privacy of the round courtyard.

At some point during their stay, members of the court would have become aware of the disposition of two households in opposite corners of the block-design palace. The dual residences were, of course, indicative of the elevated status of the resident couple because that arrangement was usually reserved for rulers of ducal and regal rank. The south forecourt and vestibule were smaller than their counterparts on the west and had a single-portal entry, the south side would therefore have been recognized as the distaff side of the palace, and that would have been affirmed by the Ionic order of the portal and the elegant staircase composed completely of winders that Pedro Machuca designed for the southeast corner of the courtyard. The restricted group of courtiers received in the private chambers of the emperor or empress would have realized that the royal bedrooms were side by side in the southwest corner and that they were served by a "secret" spiral staircase in that corner of the courtyard.[66] The other

power. Fikret K. Yegül, "A Study in Architectural Iconography: Kaisersaal and the Imperial Cult," *Art Bulletin*, LXIV (1982), p. 23. Geza de Francovich, *Il Palatium di Teodorico a Ravenna e la cosidetta "architettura di potenza,"* Rome, 1970, esp. pp. 18–29, figs. 17–19, for emperors seated within a Serliana frame.

[65] Tervarent, *Attributs et symboles*, cols. 242–247; Ferguson, *Signs and Symbols*, pp. 21–22.

[66] Alberti, *Trattati*, I, pp. 340–341 (bk. V, chap. 2) observed that the fundamental difference between the house of a private citizen and that of a prince was the separation of the household of the prince from that of his spouse, but he added that their

juncture of the two households would have been evident to courtiers attending Mass in the octagonal chapel, because they would have been aware of the emperor and his attendants in the tribune on the left (to the northwest) and the empress in the one on the right.

The octagonal chapel, which could be entered from the round courtyard and also through the ground-floor rooms on both sides, was to have had full services, a privilege granted only to princes and the highest nobility.[67] Of course, the two-level elevation of the chapel with separate tribunes follows a type used in ducal and royal palaces to permit the resident to attend Mass without joining the household on the lower level. Because that type had been in France from the thirteenth century and then in Spain and elsewhere from the fourteenth, the functions of the tribunes would have been understood immediately by courtiers. The projected domical vault and the wall membering of the chapel would almost certainly have evoked Roman octagons with radial recesses and, for some visitors, the Mausoleum of Diocletian in the palace at Split or the legendary Golden Octagon begun by Constantine in 326 in the imperial palace at Antioch in Syria. These ancient antecedents and Charlemagne's octagonal chapel at Aix-la-Chapelle may have led the Sangallo in 1488 to choose that form for the palatine chapel of the king of Naples (pl. 114).[68] By its octagonal plan, size, two-level format, and domical vault, Charles' chapel would have asserted his regal and imperial status.

Many courtiers would have thought several other unusual architectural forms chosen for the palace to be unique since they had been developed only in speculative drawings or unrealized projects: the round courtyard with its double colonnade and the rhythmic disposition of its corridor bays, oval vestibule, the staircase composed completely of winders, and even the domed octagonal chapel in its

classical guise. Before the middle of the sixteenth century, no one could have seen a hierarchical facade comparable to the west front, or a three-door entry with a large Serliana window in the center of a palace facade. The ornamental, grey marble frontispiece finally added to the west facade might have been reminiscent of ephemeral arches or facades of plaster and canvas, but I know of none in stone or marble. The unusual number of rare forms assembled in the palace of Charles V suggests that Machuca deliberately chose novel if not unique forms.[69] For those who stressed the uniqueness of the imperial dignity among the princes of the world, the rarity of these forms would certainly have been considered appropriate. Machuca's sense of decorum evidently required the rejection of the trite and commonplace in the palace of the singular Holy Roman Emperor. Closely related is Machuca's orthodoxy and his up-to-date High Renaissance style, which would have been wholly new to many members of the imperial court. Most would have agreed that it would not be proper for Charles' palace to have been built in a retarditaire mode. His palace had to be distinguished by its singularity.

Thus far, we have discussed only the meanings associated with architectural features of the palace, without reference to its figural ornament—an approach admittedly at odds with most inquiries into the iconographic program of a building, but appropriate for the palace of Charles V for several reasons. First, only a small part of the intended sculptural and pictorial decoration of the palace was realized because the building was never covered and, therefore, never finished in the interior. Certainly the main halls and the private chambers would have been decorated with murals and tapestries and perhaps sculpture. Clearly, statuary was intended for the niches of the west vestibule and the round courtyard,[70] and frescoes were to have

bedchambers should be adjacent rooms. For a comparable spiral staircase in the royal residence in Toledo, see above, chap. 1, n. 146.

[67] Aloysius H. Feldhaus (*Oratories*, Washington, D.C., 1927, pp. 48-49) outlined the differences between "oratories" and "chapels" and noted that the difference in privileges was sometimes ignored during the Renaissance but that the distinctions were reaffirmed by the Council of Trent. See above, chap. 5, n. 42.

[68] Krautheimer, *Early Christian and Byzantine Architecture*, p. 33, fig. 13; W. Eugene Kleinbauer, "Charlemagne's Palace Chapel at Aachen and its Copies," *Gesta*, IV (1965), pp. 2-11. Char-

lemagne's chapel has a span of 14.60 meters, which is about 65 centimeters more than Charles' expanded chapel.

[69] Chueca (*Arquitectura del siglo XVI*, p. 166) made this observation in a short but incisive summary of the iconography of the palace: "Un palacio para el Emperador debía ser algo distinto de lo demás, debía apoyarse en formas nuevas y aristocráticas, debía respirar grandeza romana."

[70] Ancient sculpture had been collected by 1564, when Niccolò de Corte was paid for repairing some statues; see AGS, CMI, Leg. 1023. Perhaps Mendoza intended to use statuary of ancient origin in the niches of the courtyard. In the eighteenth

decorated the annular vault and the round and oblong plaques of the corridor; but we have nothing more than the heraldic reliefs on the sandstone facades and the sculpture on the marble *portadas* and the wall-fountain. Second, much of this decoration was not part of the original program proposed by Luis Hurtado and Pedro Machuca, since most of the sculpture was introduced by Iñigo López (as acting governor) and two foreign sculptors, Niccolò da Corte and Antonio de Leval. In addition most of the sculpture was added haphazardly, without any sense of program or evident reference to Charles V. Only the representation of the battle at Mühlberg and, of course, the columnar device and the emblem of the Order of the Golden Fleece refer specifically to Charles; and presumably they provide the key to the initial program.

The paired emblematic reliefs on the main-story pilasters may have been required by Charles himself because the same pair is found on several contemporary architectural works commissioned in his name.[71] They were also repeated on the wall-fountain, but Niccolò da Corte's original reliefs were replaced by Alonso de Mena in 1624. While the columnar device was used on the tie ring held in the jaws of a lion, it is composed of nothing more than the two columns and the motto *Plus Oultre*. So the most complex and dependable versions of the personal device and the emblem of the Order are those on the main-story pedestals.

The columnar device differs from the several versions used by Charles after its invention in 1516 (pl. 34).[72] It has the two columns linked by a banderole inscribed with the original French form of his motto, *Plus Oultre*, but between them and somewhat forward of them is an eagle with his talons spread over the top of a globe of the world. Because the globe is sectioned by an equatorial and a quartering band, it is clear that it follows the type of world map known as the *T-O*, or *wheel*, format. That symbol embodied the belief of Roman and early medieval geographers that the world was a disk composed of three large land masses, with Europe and Africa each forming a quadrant and Asia occupying the other half.[73] The *T-O* form persisted as a symbol of the world even after the disk gave way to the globe. When held by Christ as the Lord of the Earth or by the Holy Roman Emperor in Majesty, the quartering band is at the *top* and surmounted by a cross. The inverse banding of the globe in Charles' device on the main-story pedestals makes it clear that the talons of the imperial eagle spread possessively over the Antipodes, that is to say, the hemisphere of Asia. Significantly, it is the *Roman* imperial eagle, not the double-headed Habsburg eagle, that makes claim to Asia, or "the Indies," as the Spaniards called it. Of course, the motive of the eagle atop a globe was used on the coinage of Roman emperors, especially those of Augustus, Vespasian, and Domitian. That ancient precedent was even more closely followed in several medals struck for Charles from 1547 to 1554, most notably on the reverse of a silver medal dated 1552.[74] The eagle on this medal, unlike the one on the pedestal, holds thunderbolts and an olive branch while the imperial miter crown of the Habsburgs was placed over its head, and it hovers over a part of the globe that would seem to represent Europe and part of Asia, with the

century, various statues believed to be ancient works were discovered by Granadine painter Diego Sánchez Sarabia. He reported to the Academia de San Fernando in Madrid that he had seen life-size statues of Apollo and Venus and smaller ones of Mercury and a satyr. A corroborating 1761 report of a member of the academy, José de Hermosilla, is found in the Academia de San Fernando, Armario 1°, Leg. 37, pieza 3, and the matter was discussed at a meeting on 12 September 1762. Richard Ford in 1831–1833 saw statues that he described as two nymphs, a Leda, and a Jupiter in the rooms beneath the Tower of Comares; see his *Granada*, p. 207.

[71] In the 1530s the columnar device and the emblem of the Order were also used in the first courtyard on the left of the Royal Hospital in Granada and on the facades of the Town Hall in Seville and the University of Alcalá de Henares, but after that decade he rarely used the Burgundian emblem in the decoration of exteriors or in the main courtyards of royal residences or civic buildings renovated or initiated by him in Spain.

[72] Rosenthal, "The Invention of the Columnar Device," esp. pp. 198-211.

[73] Leo Bagrow, *History of Cartography*, Cambridge, Mass., 1969, I, pp.42-43. For the use of the *T-O* world maps during the Middle Ages in Spain, see G. Menéndez-Pidal, "Mozárabes y Asturianos en la cultura de la Alta Edad Media en relación especial con la historia de los conocimientos geográficos," *Boletín de la Real Academia de la Historia*, CXXXIV (1954), pp. 137-291.

[74] Giulio Capaccio, *Delle Imprese*, Naples, 1592, fols. 96v. William Stirling-Maxwell (*The Chief Victories of the Emperor Charles V*, London, 1870, p. 47, n. 15) gave the date of 1547 to a medal of this sort. A similar image is found on the reverse of a bronze medal celebrating the Peace of Passau in 1552, now in the Museo Arquelógico Nacional in Madrid; see Adolfo Herrera, *Medallas españolas*, Madrid, 1889-1910, vol. xx, no. 2.

lower quarter representing Africa, admittedly out of reach by 1552. The inscription on the medal clarifies the meaning of the imagery. It reads SUUM CUIQUE ("To each his own"). Applying this inference to the device on the pedestals of Charles' palace, where the imperial eagle grasps the half of the globe representing Asia, it would seem Charles meant to reassure Spaniards that he would carry the imperial banner ever "further beyond the Columns of Hercules" into Asia or the Indies, as Ferdinand the Catholic had pledged him to do.[75] Of course, the use of the Roman eagle on a globe also invited a comparison of the fabled empire of ancient Rome with that of Charles V, which included the Antipodes not even known to the Romans. Thus, the columnar device on the pedestals promised that Charles would expand still further Spain's dominions in the Indies.

The component parts of the Burgundian emblem are familiar but their combination is unusual. The panel on the main-story pedestals is dominated by the decussate cross of Saint Andrew and over its center are the fire steel and sparking flint stone—all emblems of the Burgundian Order of the Golden Fleece (pl. 36). Andrew was the patron saint of the dukes of Burgundy and, thus, the Order; the fire steel and flint stone were emblems taken by John the Fearless (Jean sans Peur) in 1396, when he was released from imprisonment by the Turks.[76] At that time he pledged that he or his descendants would carry on the battle against Islam until the Holy Land was recovered. The instruments for striking sparks, which he took as emblems, were meant to express the fervor of his faith and his resolve in the fight against Islam. At the top and sides of the cross are pomegranates, which are symbols of the city of Granada.[77] Since that city had not been recovered by the knights of the

Order of the Golden Fleece, it is likely that Charles meant to equate Spain's centuries-old war against Islam with the stated aims of the Burgundian Order. Atop the whole is the cross-arch crown, which is the one artists persistently used as a symbol of the Holy Roman Empire and which, I believe, was the crown placed on Charles' head at Aix-la-Chapelle in October 1520.[78] This version of the emblem of the Burgundian Order identified Charles as Holy Roman Emperor, king of Spain, and master of the Order of the Golden Fleece—inevitably the duke of Burgundy—and by these titles the viewer is reminded of the many realms Charles could call upon to do battle against Islam. A somewhat similar message is found in the ornament on the triangular pediment of the main-story windows: deep within the tympanum is the cross of Saint Andrew and the steel and flint of the Order, and the remainder of the area is filled by an uninscribed banderole; above, on the outer ends of the pediment, are huge pomegranates split open to reveal their seeds (pl. 41); so, the recovery of Granada is again identified with the aims of the Burgundian Order. Another variation on that theme was presented on the fireplace in Charles' bedchamber in the suite of rooms constucted for him in the old palace in 1528–1533 (pls. 24 and 25). There, Charles' columnar emblem is centered on the mantle and linked by an elaborate banderole to windlasses on either side. Evidently the latter were references to the maritime prowess of Portugal, to which Charles was allied by his marriage to Isabel. In the center, the Habsburg eagle embraces a globe dominated by the continent of Africa, which for contemporary Spaniards and most Europeans represented Islam, and so the whole ensemble can be interpreted as Charles' pledge that he, together with his ally Portugal, would drive

[75] A letter written by Ferdinand to young Charles was published in Augsburg, apparently in 1516. A copy is preserved in the New York Public Library under the title *Epistola Ferdinandi Catholici Regis Arragonum, etc., ad Carolum Regum Castiliae, etc. Nepotem* [leaves 2 and 3]; see also Ferdinand's testament in Alonzo de Santa Cruz, *Crónica del Emperador Carlos V*, Madrid, 1920–1925, p. 389.

[76] Victor Tourneur, "Les origines de l'Ordre de la Toison d'or et la symbolique des insignes de celui-ci," *Bulletin de la Académie royale des Sciences Belgique, Classe des Lettres*, 5e serie, XLII (1956), p. 307; Rosenthal, "The Invention of the Columnar Device," pp. 204-211.

[77] While the pomegranate had gathered many and varied associations by the sixteenth century, the pertinence of its ref-

erence to the city of Granada in this case would seem to be beyond dispute. According to Münzer in 1494 (Pfandl, "Itinerarium," p. 47), Iñigo López de Mendoza told him that the last king of Granada had used no other symbol than a helmet in the form of a pomegranate with the inscription *Sólo Dios es Vencedor* ("God alone is Victor"). Also it seems that both Fernando V and Enrique IV of Castile had used the pomegranate to indicate their intention to retake the city and, of course, it was inserted by the Catholic Monarchs at the base of the royal arms after the occupation of Granada in January 1492; see Ignacio Vicente Cascante, *Heráldica general y fuentes de las armas de España*, Barcelona-Madrid, 1956, pp. 465-467.

[78] Rosenthal, "Die 'Reichskrone,' die 'Wienerkrone' und die 'Krone Karls des Grossen' um 1520," pp. 7-28.

south and east against Islam. While the emblem over the fireplace looks to the future, that of the main-story pedestals celebrates a past victory of transcendental importance.

The unusual imagery of the emblem of the Order suggests that it was intended to further Charles' campaign to gain greater Spanish participation in the Order. In 1516, when Charles became master, the only Spanish member was his grandfather, Ferdinand the Catholic. Charles immediately gained the approval of the Order and the pope to expand the membership from thirty to fifty and thus make possible a greater international participation and, in particular, the admission of ten Spanish nobles.[79] Charles was to learn that the reaction of many Spaniards would be similar to that of the count of Benevente, who in 1519 declined an invitation to become a member, with the sharp retort that he was "very Castilian and had no desire for Burgundian insignia." Further, he reminded Charles that Castile had orders "as old and as honored and more successful (más provechosas)" than the Golden Fleece.[80] This was a derisive reminder that in the ninety years of its existence the Burgundian Order had not rewon any territory from Islam, while over the centuries the Spanish knights of the Orders of Santiago and Calatrava had taken the Spanish peninsula. It is, of course, true that the dukes of Burgundy had nothing more to show than a series of aggressive devices and mottoes, but Charles' use of their emblem on the palace reveals the importance he still attached to the chivalric Order in the realization of his imperial mission in Europe.

The interrelated themes of triumph and abundance predominate on the south facade and its *portada*. While they evidently refer to Charles V, no specific triumphs or achievements are cited. The theme of well-being is most clearly conveyed by the half-figure of Abundance in the tympanum of the pediment of the south portal. The amply proportioned woman with one bared breast, a stalk of grain in one hand and fruit in the other, is reminiscent of the figure identified as Ceres in the tym-

panum of a model portal published by Cesariano in 1521 (pls. 46 and 164). The same allusion was probably intended in the rigid swags between the double-voluted consoles that support the main-story windows because they are composed of pomegranates, pine cones and, along the center axis, several large flowers. Later, on the west facade, cucumbers (*pepinos*) and occasionally grapes were added, but I found no hybrid American corn, which is sometimes said to have been included. Also expressive of abundance are the baskets of fruit carried on the heads of the boys that emerge from leafy scrolls on the ends of the lintel crowns, but those boys appear to have been added by Marquina to Machuca's original ornament, which was probably restricted to the three vases seen in the Burlington elevation (pls. 39 and 74). While the meaning of the vases remains unclear, the boys, the rigid swags, and the tympanum figure of Abundance convey an idea of the well-being that will result from Charles' triumphs and his prudent and beneficent rule.

The first program of the south portal probably included no more than the inscription of his name and motto on the frieze—P[LVS] V [LTRA] IMP[ERATOR] KAR[OLVS] V. P[LVS] V[LTRA]—and traditional Victories in low relief in the spandrels over the pediment. The Siloesque sculptor of the first Victory on the left probably enlarged the figure and gave it a laurel branch and crown as well as an attendant genius, and Niccolò da Corte followed this model in his rendering of the Victory on the right, though he replaced the laurel with a palm branch. That initial reference to triumph was extended by Corte's addition of trophaic reliefs on the pedestals. His juxtaposition of ancient and modern trophies would seem to compare the victories of Charles V with those of the ancient Roman generals, even though the spoils depicted in the modern panel can not be identified with a specific battle. Apart from a Moorish dagger and a leather shield, the arms and armor of the modern panel are of the Milanese type used earlier

[79] Baron von Reiffenberg, *Histoire de l'Ordre de la Toison d'Or, depuis son institution jusqu'à cessation des chaptres généraux*, Brussels, 1830, pp. 222, 304-305, and 317. The papal bull (no. 135 in the archives of the Order, now deposited in the Haus-, Hof- und Staatsarchiv in Vienna) was first published by Rudolf Payer von Thurm (*Der Orden vom Goldenen Vlies*, Zürich, 1926).

[80] His acrimonious refusal was recorded by Prudencio de Sandoval, "Historia de la vida y hechos del Emperador Carlos

V," p. 171 (bk. 26, chap. 5): "Aunque el conde de Benavente no la quiso, enviándosela el emperador, diciendo que él era muy castellano y que no quería insignias de borgoñones, que Castilla las tenía tan antiguas y tan honradas, y más provechosas; que la diese su majestad a quien quería más el collar de oro que a las cruces coloradas y verdes con que sus abuelos havían espantado tantos infieles."

by Corte as purely ornamental motives in Genoa.

A decade later, when the subjects for the reliefs on the upper-story pedestals were chosen, the reference to triumph at sea was no more specific. The panel of *Neptune Calming the Tempest* was probably intended to assert Charles' rule of the seas, but the other major panel, *The Marriage of Neptune and Amphitrite*, is out of place in a reference to sea power. While this panel might be taken as a reference to the emperor's beloved wife on the portal that was to have served as the entry to her household, the subject of the relief was not chosen until almost a decade after her death. It would therefore seem that Corte employed the Neptune story as a general reference to Charles' rule of the seas. But the failure to refer directly to his campaign against Tunis is surprising, since it was a major victory at sea and, at midcentury, still an incandescent triumph in the memories of most Europeans. Furthermore, the subjects of these reliefs were chosen by Iñigo López, whose father, Luis Hurtado, had been grievously wounded in the battle for Tunis. Perhaps Iñigo López trusted that the generic reference to Neptune would recall the Tunis campaign; more likely, he may have intended to refer to it by inscriptions on the tablets held by History and Fame over the arcuated lintel of the south window, but unfortunately that was not done. We are assured by the placement of History's foot on a cube that she relates the truth and, by her upward gaze, that the deeds she records were of a transcendent nature. Because the *vaso* at the feet of History and Fame was cited in the contract, it must have had some significance. Earlier, we reasoned that it may be "the vase of all virtues" and, thus, a reference to the princely and Christian virtues that enabled Charles V to achieve his elevated position and his great deeds and would bring him fame and glory forever. The south *portada*, as it was elaborated over more than a decade, would seem to state, in somewhat abstract terms, that Charles' victories on land and sea would assure the well-being of his subjects.

The project of 1549 for the west frontispiece (probably recorded in the Burlington elevation, pl. 74) had no figural sculpture. Of course, "histories" might have been planned for the huge roundels over the side doors, but it is more likely that they were intended to display the imperial arms because no other place had been reserved for them. When

Charles required the representation of his recent victory at Mühlberg, Machuca evidently chose to use the front face of the pedestals, but he still retained the Doric band that was to have been their sole ornament. In September 1551, Leval's reverse copy of Orea's second panel was identified descriptively rather than thematically as *ciertas victorias y espolios de armas*. But we identified the campaign on the basis of Orea's first panel of the battle itself. The depiction of German foot soldiers (*Landsknecht*) indicates that it was a campaign against Protestant princelings, and the representation of Charles in laminated armor (still preserved in the Royal Armory in Madrid) assures us that it was the Battle of Mühlberg in 1547. It was not only the most recent but, as it turned out, the last battle in which he led his troops. In 1548–1549, when the subjects for the reliefs of the west frontispiece were chosen, it still seemed that peace among Christians had been achieved. The companion relief depicts a field strewn with trophies of war and, in the center, allegories of Peace are seated on either side of a globe of the earth (pl. 61). They each hold a column alongside the globe with one hand and, with the other, an olive branch. Another pair of female figures sounding trumpets—probably figures of Fame rather than Victories—are in full flight above the allegories of Peace, and on either side, geniuses put the trophies of war to the torch. It is very clear in its meaning and seems to be a composition invented for the occasion. In any case, it effectively conveys the hope, apparently held by Charles and many others, that the Augsburg *Interim* would provide the opportunity for reconciliation between German reformers and the Church (a theme suggested by the olive branch) and that his attention could now be turned from fighting dissident Christians to the propagation of the Faith into Africa and the New World and, ultimately, from pole to pole. This aspiration was expressed in the left relief by the careful delineation of the continents, together with the longitudes and latitudes that show that the Columns of Hercules had been removed from the Straits of Gibraltar to the poles of the earth (pl. 63).

Some of the same themes are found in the four allegories in roundels of the wall-fountain known as El Pilar de Carlos V (pls. 48 and 49), and that would seem to support our assumption that Alonso de Mena, in his 1624 replacements of Corte's 1547

reliefs, had followed the imagery (if not the style) of the originals. We should recall that we are dependent on Bermúdez de Pedraza for the inscriptions that were once located beneath each of the roundels and also for the identification of the subjects,[81] which in several cases might not be clear in the corroded reliefs known to us today. The two outermost, representing Hercules and the Hydra and Alexander the Great, are readily associated with Charles V. The first, on the left, was accompanied by the inscription *Non memorabitur ultra*, recalling by means of the last word the Latin version of Charles' personal motto, *Plus Ultra*. Assuming this reference was intended, the contracted inscription and the imagery can be interpreted to mean "They [the deeds of Hercules] will be lost to memory [surpassed by those of the emperor]." If, in addition, we take Hercules and the Hydra to be a reference to victory over evil and heresy, as it usually was in the late Middle Ages and early Renaissance, the governor in 1545–1547 could have had in mind the emperor's long struggle against the Protestant German princelings, who were truly hydra-like in that, after a diplomatic or military victory over one of them, the emperor would find himself confronted by another.[82] He had been in his German realms since the summer of 1543, and by 1546, he was preparing for the military campaign, that culminated in the Battle of Mühlberg

in April 1647, which then seemed to be a decisive victory. The other roundel with a ready reference to Charles V is the one on the far right (pl. 48), representing a youthful soldier on horseback, reasonably identified by Bermúdez de Pedraza as Alexander the Great on the basis of the legend *Non sufficit orbis* ("The globe [of the earth] is not big enough"). This reference was more appropriate to Charles V in 1545 than to young Philip IV for whom the roundels were renovated in 1624,[83] and it also states the essential meaning of Charles' columnar device, particularly the version I have called global. It pledged that the emperor would extend his realms beyond the Columns of Hercules in all directions, to the very ends of the earth. Learned visitors to the Alhambra might have seen a parallel between Alexander's conquest of India and Charles' conquest of the Indies, and there was also a comparable aspiration to universal empire. Comparisons of Charles and Alexander must have been frequent because the ancient conqueror of Asia, mounted on Bucephalus, was already depicted among the decorations for young Charles' entry into Bruges in April 1515, and Cristóbal de Villalón in 1539 claimed that Charles' victory over the pirate Barbarossa—"the greatest enemy mankind ever had"—surpassed any of Alexander's deeds.[84]

Themes of victory over heretics and universal

[81] Bermúdez de Pedraza, *Historia eclesiástica*, fol. 36.

[82] For the general association of the hydra with evil, see Jean Seznec, *The Survival of the pagan gods: the mythological tradition and its place in Renaissance humanism*, New York, 1953, p. 36. In the mid-1540s, when the fountain was made for Charles V, Iñigo López de Mendoza is more likely to have intended a reference to the hydra-like heresies of the German protestants than to the transgressions of the local Moriscoes (as Diego Angulo Iñiguez suggested in *La Mitología y el arte español del Renacimiento*, Madrid, 1952, p. 20, n. 1). The representation of the Morisco heresies as hydra-like on the title page of the 1612 publication in Rome of Fonseca's *Justa expulsión de los Moriscos de España* belongs to a post-Rebellion period, almost seventy years after the carving of the Labor on the fountain; but, also, the Mendozas of the Alhambra were too well disposed toward the Moriscoes of Andalusia to foster such a charge against them. They might, however, in the mid-1540s have thought of the Turkish pirates who menaced the Spanish and Italian coasts as hydra-like. Whatever the specific association, the Herculean Labor probably referred to Charles V's heroic battle against heresy in its many guises on several fronts.

[83] Rosenthal, "*Plus Oultre*: The *Idea Imperial* de Carlos V," pp. 85-93. Alexander tamed his father's unmountable horse Bucephalus and, on this magic steed, set off to conquer the

known world. Contemporaries probably thought of Charles as propagating Christianity in the way Alexander spread Hellenism in the third quarter of the fourth century B.C. The comparison of a Spanish king with Alexander would not have been new to Spaniards, because Charles' grandfather, Ferdinand the Catholic, had taken as his device the knot tied by Gordius and severed by Alexander. Since the Greeks had said that whoever undid the knot would be master of Asia, there was (after 1492) a ready analogy between Alexander and Ferdinand in the "Indies," though it should be noted that Ferdinand took the device at least twenty years before the discovery of America, when his ambitions still centered on the retaking of Andalusia and the conquest of the north coast of Africa on the way to the Holy Land.

[84] Robert Withington, *English Pageantry. An Historical Outline*, Cambridge, 1920, II, pp. 172-173; Cristobal de Villalón, *Ingeniosa comparación entre lo antiguo y lo presente*, p. 166. There is also an undated coin, probably belonging to the mid-1540s, of which the obverse bears the bust of Charles V with the inscription KAROLUS ROMA INPERA[TOR] and the reverse has a bust identified as ALEXANDER MACEDO[NIS]; see Max Bernhart, *Bildnismedallien Karls V*, Munich, 1919, p. 63, no. 119, though no collection was cited for this coin.

empire are easily given Carolian interpretations, but the subjects of the other two roundels—the Rape of Europa, and Apollo and Daphne—are puzzling because they have no obvious relation to the previous two and because they are rarely found in programs dedicated to Charles V. The roundel alongside the Labor of Hercules was identified as the Rape of Europa by Bermúdez de Pedraza in 1640 and that would seem to be confirmed by early photographs in which one can still identify the figure and animal as a woman on a bull crossing the sea (pl. 48). While more often depicted in the context of the metamorphoses of the gods by Renaissance artists, the ancient legend of Jupiter in the form of a bull carrying off Europa had been moralized by at least the fourteenth century to represent themes as varied as *Chastity succumbing to Love* and *Christ transporting the human soul to Heaven*.[85] Of course, Europa also represented the continent—the only significance cited by Cesare Ripa.[86] The inscription accompanying this roundel, *Imago mysticae honoris* ("Image of mystic honor"), would seem to point to a pagan theme, the honor paid to a mortal by a god. Applying this complex of associations to Charles V in the mid-1540s, one could reasonably propose that the bull represented the emperor and Europa, the continent, with the result that Europe was honored by his domination and had been saved for the true faith by his victory over the Protestant princelings in 1547. A somewhat similar meaning was inferred a few years earlier in a *tableau vivant* designed for the entry of Charles V into Paris in 1540. *The Rape of Europa* was represented between the Golden Fleece and an angel brandishing a sword and trampling a serpent underfoot. The court poet, René Macé, identified Europa with the continent and observed the Jupiter (that is, Charles V) "deigned to love her well."[87] The sword of the angel signified *Final Truth*, according to Macé, and the inclusion of the Golden Fleece inferred that the serpent represented the evil of heresy, which Charles, as the master of the Order, had vowed to eradicate. This explanation of comparable imagery in Paris in 1540 supports our interpretation of the roundel and its inscription as a representation of Europe saved from heresy by Charles V.

The last roundel on the wall-fountain depicts Apollo and Daphne at the moment he was about to overtake her and she was transformed into a laurel tree (pl. 48). The event is presented in a typical High Renaissance manner, with the trunk of the tree only beginning to form around her legs and only her fingers and flying hair sprouting branches. The inscription, according to Bermúdez de Pedraza, was *A Sole fugante fugit* ("She flees from the sun who puts her to flight"). Apollo apparently represents the sun, which was then understood to represent Truth, Wisdom, Hope, Charity, Light, and even Christ. This elevated significance of Apollo-Sun introduces an inference of perversity rather than virtue in the flight of Daphne. Evidently we are not to think of her as a frightened maiden fleeing from the amorous embraces of young Apollo—a personification of Chastity, which was the primary significance of Daphne from the fourteenth century through the seventeenth.[88] Within the context of these roundels, Daphne may have

[85] Seznec, *The survival of the pagan gods*, p. 109; Erwin Panofsky, *Meaning in the Visual Arts*, Garden City, New York, 1957, pp. 52-53.

[86] Ripa, *Iconologia*, p. 332.

[87] The pertinent lines of René Macé's poem describing the *tableau vivant* are 255-268 and 286-296: "On avoit mis, au carfour qu'on appelle / Porte Baudet, une monstre tres belle / D'ung ange armé et d'ung mouton doré, / Et nymphe entr'eulx de vraire asseuré, / Qui sur son bras portoit ce mot: 'Europe.' / Icelle fille oza jadis, en croppe / D'ung fier taureau, oultrepasser la mer, / Et Jupiter la daigna bien aymer, / Tant estoit noble; et encor du nom d'elle / Le tiers du monde, en memoire eternelle, / Est appelé. . . . Voyez aussi ce celeste esprit, / Le glaive en main, et ceste grand bellue / Qu'i foule aux piedz de tous venins pollue: / La glaive, c'est finale Verité, / Et le serpent vielle Cupidité, / De tous pechez la mere originale, / Mouvant les gens a guerre criminele. / O! soit a tant tenue ainsi soubz pied, / Que les vivans vivent en amytié, / Tel est le sens de

l'ung et de l'aultre order / Que Guerre a mis souvent en gros desordre." See *Voyage de Charles-Quint par la France. Poëm historique de René Macé*, ed. Gaston Raynaud, Paris, 1879, pp. 12-15. Inexplicably, Macé identified the Golden Fleece with serenity and peace and suggested that the serpent trampled by the angel represented the greed that leads to war; but, in view of the context, it is more likely that most of the people who viewed the *tableau* in 1540 recalled the customary associations of the serpent and the Golden Fleece with the fight against the evil of heresy. In the 1580s, in the lunettes of the Imperial Room of the Bohemian castle of Bučovice, the *Rape of Europa* was depicted alongside a representation of Charles V on horseback in battle; see Jiřina Horjsé, *Renaissance Art in Bohemia*, London-New York, 1979, p. 104, fig. 71.

[88] Wolfgang Steckow, *Appollo und Daphne*, Berlin, 1932, pp. 13-26, 66-68; Tervarent, *Attributs e symboles*, cols. 30-31; Seznec, *The survival of the pagan gods*, p. 271, n. 42.

represented pagans, heretics, and Protestants who fled from Christian Truth and from Christ himself, symbolized by Apollo. Though this interpretation requires a considerable extension beyond the usual Renaissance significance of the event, the suggested admonition to accept the true Faith, defended and propagated by the Roman Church and the Christian emperor, would seem to be in accord with the themes of the other roundels—the aspiration to universal empire (Alexander), the salvation of Europe from heresy (Europa), and the fight against heretics (Hercules and the Hydra).

The iconographic program of the roundels is more subtle and complex than that of any other part of the palace, but it is still in accord with the pledge conveyed by the columnar device and the emblem of the Order of the Golden Fleece, which (together with the imperial arms held by the Habsburg eagle) made up Machuca's simple heraldic program. In the absence of other evidence, we must assume that the serious program for the roundels was devised by the new governor, Iñigo López de Mendoza, and his Italian sculptor, Niccolò da Corte, but the latter must also have been responsible for the intrusion of the more trivial motives of the boys pouring water from vases and hugging dolphins.

The original program of the west frontispiece was compromised by another sculptor, Antonio de Leval, who probably suggested the addition of recumbent figures over the pediments of the three doors. The pertinence of the Victories over the center door depends on the lost symbol that they once held between them, while the boys with garlands over the side doors would seem to stress the theme of abundance and well-being, which was already conveyed by the swags that hang from the ends of the pediments of the three doors. But the depiction of the cavalry (presumably the *jinete* of the Alhambra) in the huge roundels over the side doors has no evident relation to the Battle of Mühlberg, because the famous *Cien Lanzas* did not take part in that campaign. Of course, the Labors of Hercules could be the referent for any victory, but they were not chosen until 1590 and they flank the arms of Philip II. Not all the later accretions are at odds with the original program, but they tend to be generic or commonplace ornament that is less specific in its reference to Charles V or his deeds. The figures of Peace and Abundance that

hold the imperial arms over the Puerta de las Granadas (pl. 92) was probably the last decoration approved by Pedro Machuca because he seems to have secured that commission for his young son-in-law, Juan de Orea.

While much of the sculptural ornament is the result of accretion rather than a single unified program, its themes are in general accord with the symbolism of the architectural forms of the palace. Although ideas of abundance and peace are not readily conveyed by architecture, the most fully elaborated theme of the sculptural ornament—Victory—is effectively represented by the triumphal-arch format of the two main entries of the palace and the gateways of its main forecourt as well as the huge Puerta de las Granadas that was to serve as the entry to the Alhambra from the city. The most forceful declaration of Victory is the construction of the palace within the fortified heights of the Alhambra, the last stronghold of Islam in western Europe. By building a residence there, Charles commemorated the famous victory of his grandparents, the Catholic Monarchs. No symbol of triumph was so universally understood as the construction of a new residence for a conqueror on the ruins of that of the vanquished. In Spain, the fortified sites of the Romans were occupied by the Visigoths, then by the Moors, and finally by the Christians. Charles, however, differed from most previous rulers in Spain and elsewhere in that he built his new residence alongside the Nazaride palaces. This was in accord with the wishes of the Catholic Monarchs that future kings of Spain preserve it as the main prize of their transcendent victory. Even without that directive Charles would probably have spared it because he had greatly enjoyed dining in the secluded citrus garden of the Court of Lions. Furthermore, notices of the great charm and curious workmanship of both the courtyards and halls of the Nazaride palaces probably figured prominently in the reports of most ambassadors to their rulers in 1526, so the propaganda value of this extraordinary trophy would have been quickly recognized. But Charles' building a palace on the Alhambra was motivated by more than custom and the commemoration of a past victory. It provided a signal to worried Spaniards in Andalusia that he intended to defend the south of Spain from Turkish incursions. Many Spaniards understandably feared that the Turks

would retake portions of the southern coast of Spain, arouse the Moriscoes, and then supply them with arms for the reconquest of Andalusia for Islam. But Spaniards were not the only ones threatened by the Turks. The eastern realms of the Holy Roman Empire, especially Hungary, Dalmatia, and Bohemia, were alarmed by the advance of the Turks. By building a palace in the southernmost part of his realms, Charles reassured Spaniards and other Europeans that he intended to hold the territory recovered from Islam, unify the Christian community, defeat Islam and, in the period of peace and well-being that followed, carry the Christian Faith beyond the Columns of Hercules in all directions to the ends of the earth. These aims represented the essence of his *idea imperial*, his sense of mission as emperor. That idea was first defined by Luigi Marliano in 1516 on the occasion of Charles' assumption of the mastership of the Order of the Golden Fleece, and shortly after it was elaborated by Mercurino Gattinara and Dr. Mota.[89] The palace of Charles V on the Alhambra embodies a fully developed statement of that *idea imperial*.

Charles' power was judged to be as great and his victories as glorious as those of the ancient Roman emperors and that comparison was most effectively conveyed by the juxtaposition of ancient and modern trophies on the primary and secondary pedestals of the south portal. Also, in the columnar device on the main-story pedestals,

Charles was portrayed in the guise of the imperial Roman eagle that spreads its talons over the portion of the globe that represents the Indies. In this device, as in most of the imagery of the palace, the imperial dignity, rather than the regal, was stressed;[90] furthermore, a comparison of Charles to Roman emperors is implicit in the grand scale of his palace and the choice of the severe Roman style. By way of the architectural metaphor, the designers of the palace brought to mind a wide range of princely qualities. Apart from uniqueness, which was peculiar to Charles V among contemporary rulers, the palace evoked ideas of order, control, hierarchy, triumph, dominion, and universality, as well as austerity, gravity, strength, invincibility, and grandeur. Not only were these qualities intended to impress members of the royal and imperial courts, but (according to contemporary theorists) they would have a positive effect on the resident prince himself. The palace of Charles V is, I believe, one of the most successful metaphoric buildings of the Renaissance because of the unique and exalted personage that served as its theme and the restricted audience of courtiers who were well schooled in the iconography of rulership and because the designers, Pedro Machuca and Luis Hurtado de Mendoza, had a clear idea of *Romanitas* and full knowledge of the rhetorical devices of the Roman style.

[89] Rosenthal, "The Invention of the Columnar Device," p. 222; Menéndez Pidal, *La idea imperial de Carlos V*, pp. 15-30; Frances A. Yates, "Charles Quint et l'idée d'Empire," *Les Fêtes de la Renaissance*, ed. Jean Jacquot, Paris, 1960, II, pp. 57-97.

[90] Gómez-Moreno (*Las águilas*, p. 134) noted the stress on the imperial dignity, but one cannot say that "obedezca todo a un plan de exaltación imperial."

APPENDIX: DOCUMENTS

THE DOCUMENTS are numbered and arranged in chronological order from 1527 to 1625. In each case the date is followed by a brief description of the document and its location. About a dozen important documents previously published by Llaguno y Amirola, Manuel Gómez-Moreno y Martínez, and Antonio Gallego y Burín have been included among the hundred and seventy-two comprising this appendix. Where the document could be found, the transcription was reviewed and the original spelling of the document reinstated if it had been changed, and minor errors were corrected. For readers who are not acquainted with the erratic spelling of the Spanish language in the sixteenth and seventeenth centuries, I should say that letters were often interchanged, most notably *b* and *v*, *x* and *j*, *x* and *z*, *g* and *j*, *z* and *s*, *z* and *c*, *m* and *n*, *i* and *e*, and even *l* and *r*, and *rr* was often simply *r*. Although the original spelling was retained in my transcriptions, I extended abbreviations, capitalized proper names and titles, and added modern diacritical marks.

1. 30 November 1527, letter from Charles V to Luis Hurtado de Mendoza, third count of Tendilla, copy by Ibáñez de Segovia, *Historia de la Casa de Mondéjar*, Biblioteca Nacional, Madrid, MS 3315, fols. 294r and 294v. (A slightly different version of the letter, formerly in the archive of the count of Tendilla and the Marquis of Ariani, was published by Gómez-Moreno y Martínez, *Las águilas*, pp. 123-124.): Marqués de Mondéjar, pariente, mi capitán general del Reyno de Granada. Las traças que me embiastes de lo que se ha de adelantar y edificar [Gómez-Moreno: acreçentar y hedificar] de nuevo en la casa real del Alhambra, las he detenido hasta aora esperando embiaros resoluçión y determinaçión de lo que se ha de hazer, y al cabo he acordado remitírselo a vos para que lo hagáis como mejor os pareçiere. Sólo os quiero dezir que la sala delantera sea grande y que en ella aya capilla para dezir y oír misa, y que lo demás de los aposentos que se han de hazer se junten con la casa. Vos lo ordenad y hazed todo como mejor os pareciere, que con remitíroslo pienso que se açierta en lo mejor. [Gómez-Moreno noted the following sentence was written in another hand in his source.] Digo que, si se pudiere, sea la capilla de manera que de arriba y de abaxo y por entrambas partes se pueda oír misa. Yo he por bien de consignar para esta obra, desde luego, diez e ocho mill ducados, como está platicado lo del servicio de los noventa mill ducados, querría que fuera que éstos y los demás se cobrassen más brevemente, se repartiessen en menos años de los ocho que está otorgado [Here Gómez-Moreno terminated his copy.] por la orden que se ha dicho lo de los dos años primeros que agora corren aya aquel respecto. Ved si llevará camino, y pareçiendoos que se puede hacer, escrividme el despacho que ha menester para ello, para que conforme a la orden que allá diéredes se haga. . . . [The version copied by Gómez-Moreno included the following: "Dé Burgos a xxx de Noviembre de mill e quinientos e veynte y syete años. Yo el Rey, por mandado de su magestad, Françisco de los Cobos," whereas Ibáñez's copy was simply headed "Burgos 1527."]

2. 27 February 1528, letter from Luis Hurtado de Mendoza, the third count of Tendilla, to Charles V, AGS, Estado, Leg. 16, fol. 401 (published by Gómez-Moreno y Martínez, *Diego Siloe*, p. 79): S[acra] C[esárea] C[athólica] M[ajestad]. Recebí la carta de Vuestra Magestad con Luys de Vega sobre lo que toca a la casa que en esta Alhambra manda hedificar, y hele mostrado las traças, y platycado con él lo que dellas entiendo, y héchole mostrar el sitio y dispusiçión donde se ha de hazer el edifiçio. Todo lo lleva muy bien visto y entendido para que, si Vuestra Magestad fuera servido, le pueda dar razón dello y acá me ha dicho lo que a él le pareçe asy çerca de la capilla grande que Vuestra Magestad manda que se haga en el quarto delantero como en todas las otras cosas que tocan al dicho hedifiçio, y antes que se comiençe, haré hazer un modelo de madera para que mejor se vea la graçia y proporçión que ha de tener, y se entienda y conozca lo que agora por la traça no se pareçe tan caro. Guarde Nuestro Señor, ensalçe, y prospere la S.C.C. persona de Vuestra Magestad.

De esta Alhambra a veynte y siete de febrero de 1528, de Vuestra Magestad servidor y vassallo, que sus manos besa, Marqués [!] de Tendilla. [*on the back*] A Su Mag[estad] del Marqués de Mondéjar sobre la casa y capilla que Su Magestad le manda hazer en la Alhambra.

3. 22 April 1528, AGS, CM 1, Leg. 1278, Consignment of funds for the "quartos nuevos": El Rey. Nuestro reçeutor que es o fuere del serviçio de los ochenta mill ducados que nos otorgaron los christianos nuevamente convertidos del Reyno de Granada, estando yo en la dicha çibdad para ayuda a mi casamiento. Yo vos mando que de lo que se ha de repartir e cobrar del dicho serviçio, los quatro años venideros de quinientos e veynte y nueve e quinientos e treynta e quinientos e treynta y uno e quinientos e treynta y dos, deys e pagéis a Francisco de Biedma, que tiene cargo de cobrar lo que está consignado para las obras del Alhambra, e de pagar lo que en ella se gastare, diez y ocho mill ducados, que montan siete quentos e çiento e veynte y çinco mill maravedís, en esta manera, los tres mill y quiniento ducados, que montan un quento e trezientas e doze mill e quinientos maravedís, en el dicho año venidero de quinientos e veynte e nueve, e el año siguiente, de quinientos e treynta, çinco mill y quinientos ducados, que montan dos quentos e sesenta y dos mill y quinientos maravedís, y en cada uno de los dichos años de quinientos e treynta y uno e quinientos e treynta y dos, quatro mill y quinientos ducados, que montan un quento e seiscientas y ochenta e siete mill y quinientos maravedís, que montan los dichos quatro años, los dichos diez y ocho mill ducados, los quales son para el edifiçio de çiertos quartos e aposentos que yo mando labrar en la Casa Real de la dicha Alhambra, e tomad su carta de pago, u de quien su poder obiere, con la qual, e con el traslado signado d'esta mi çédula, mando que vos sean reçebidos e pasados en quenta, en cada un año de los dichos quatro años, la dicha suma, sin otro recaudo alguno, e por ésta, mi çédula, mando al dicho Francisco de Biedma que reçiba y cobre los dichos diez y ocho mill ducados en los dichos quatro años en la manera susodicha, e que pague d'ellos todo lo que se comprare e fuere menester gastar, e se gaste, para el edifiçio e obras que se han de hazer en la dicha casa, por nóminas e libramientos firmados del Marqués de Mondéjar, nuestro capitán General del dicho Reyno de Granada e que por virtud d'e-

llos, o desta mi çédula, o de su translado signado de escrivano público le sea reçebido e pasado en quenta todo lo que conforme a ellos diere e pagare e gastare sin otro recaudo alguno. Fecha en Madrid a veynte y dos días del mes de abril de quinientos e veynte y ocho años. Yo el Rey. Por mandado de su magestad, Francisco de los Cobos. Conçertado con el traslado signado de la dicha çédula que quedó en el libro de Don Juan Manrrique.

4. 23 November [1529], letter from Gaspar de Ávalos, archbishop of Granada, to Isabel of Portugal, acting as regent, AGS, Estado, Leg. 12, fol. 31 (published by Gómez-Moreno y Martínez, *Diego Siloe*, pp. 79-81): S[acra] C[esarea] C[athólica] Ma[jestad]. Beso las manos de vuestra magestad. . . . Después de la çédula de vuestra magestad, me dieron otra carta suya en que manda que dé mi consentimiento para que se tome la iglesia del Alhambra, para la casa real que mandan allí hacer. Yo quisiera que estoviera en mi mano para hazerlo liberalmente conforme al deseo que tengo para su servicio, pero porque fué la primera iglesia colegial que aquí ovo, e después que esta çibdad se ganó, siempre ha sido iglesia, y en ella ay sepultados muchos cuerpos. Hanme certificado que sólo el papa puede dispensar en ello para que se profane e torne a usos humanos, el qual lo hará facilmente escriviéndole vuestra magestad, no embargante que si se tomase mi consejo sería de parecer que vuestra magestad mandase dexar la iglesia para el culto divino a que fué dedicada, tomando enxemplo en los christianíssimos e cathólicos Constantino y Theodosio emperadores, y las cathólicas emperatrizes, sus mugeres, que de propias casas hizieron yglesias, y nunca tomaron yglesias para moradas suyas, y que estando en gloria do espero en el señor que han de tener mayor corona que la que les ha dado acá en la tierra, tenían grand plazer e gloria accidental de ver que han hecho lo que digo, y no lo contrario, pero no obstante ésto se ha de hazer lo que vuestra magestad fuere servida en todo pecho por tierra. . . . de Granada a xxiii de noviembre, de V.S.C.C.M., menos y más humilde hechura y capellán que sus imperiales manos besa. [*on the back*] A la S.C.C. Mag. de la emperatriz Reyna nuestra señora, del arçobispo de Granada.

5. 23 May 1534, letter from Charles V to Alonso de Toledo referring to the consignment of 50,000 ducats for the building of the new palace 1533-

1538, AGS, CM 1, Leg. 1278: El Rey. Alonso de Toledo, nuestro reçebtor del serviçio de los çinquenta mill ducados, con que los christianos nuevamente convertidos a nuestra santa fée cathólica dese Reyno de Granada nos syrvieron para la obra de la casa Real, que mandamos hazer en el Alhambra desa dicha çibdad de Granada, en seys años que començaron a correr el año pasado de quinientos y treynta y tres años, e se cumplirán a fin del año venidero de quinientos y treynta y ocho años, o otro qualquier reçebtor que fuera del dicho serviçio en los dichos seys años. Yo vos mando que deys y paguéys a Francisco de Viedma los dichos çinquenta mill ducados, dádselos a los plazos que avéys de cobrar los ocho mill e trezientos y treynta e tres ducados e un terçio de ducado cada uno de los dichos seys años, para que él los gaste en la obra de la dicha casa por libramientos del marqués de Mondéjar, nuestro capitán general en el dicho Reyno de Granada, y el primero año y los otros quatro años syg[u]ientes, tomad el traslado desta mi çédula con carta de pago del dicho Francisco de Viedma, y el postrero año, tomad el original con su carta de pago, con los quales recabdos mandamos a los nuestros contadores mayores de quentas, que vos resçiban y pasen en quenta los dichos çinquenta mill ducados syn otro recabdo alguno. Fecha en Toledo, a veynte e tres días del mes de mayo de mill e quinientos e treynta y quatro años. Yo el Rey. Por mandado de su magestad Juan Vázquez. [on the back] El dicho Francisco de Biedma. Cédula de su magestad por donde la mandó librar L. U ducados para las dichas obras de la Casa Real, con los quales le sirvieron los nuevamente convertidos del Reyno de Granada en los años de DXXXIII fasta DXXXVIII en cada uno dellos VIII. U.CCCXXXIII ducados y un terçio.

6. 4 June 1537, payment for centering of the [south] portal, AA, Leg. 2, 2a: A Aº [Antonio] de Moreales, carpintero, aziendo la çimbra para el trasdos de la puerta de la casa nueva, dos reales.

7. 7 June 1537, payment for centering of the south portal, AA, Leg. 2, 2a: A Pedro Cruz, friçador de un pontefis de la portada, VII ducados, que fué tasado ante Rivera, escrivano.

8. 5 September 1537, payment for limestone for the [relieving] arch of the south portal, AA, Leg. 2, 2a: Más, de v pieças grandes de tova para el arco de la puerta a [sic] 892 y medio con v carretadas, a 177 y media la carretada.

9. 5 September 1537, payment for the pediment of the south portal, AA, Leg. 2, 2a: Más, al dicho Juan García, de un frontis friçio de la portada, 55 reales, que monta 1870 maravedís.

10. 15 November 1537, payment to Niccolò da Corte for one of the Victories of the south portal, AA, Leg. 2, 2a (published by Gómez-Moreno y González, "El Palacio de Carlos V," p. 210, n. 2): Que se pagó a Nycolaso de Corte 120 ducados de una figura que yzo para la portada de la piedra de la Sierra Helvira, que fué tasada por Diego de Siloe y Julio de Aquiles y Pedro de Machuca, que es la figura intitulada la Fama, lo qual juraron y declararon ante Francisco de Ribera, escribano del Alanbra. . . .

11. 23 November 1537, payment for columns for the [south] window, AA, Leg. 2, 2a: A Laravia, cantero, porque aguzó las herramientos XII días, en la cantera que estuvieron X oficiales sacando las columnas de la ventana y otras pieças, cada día son dos reales, 816.

12. 28 November 1537, payment for the cart needed to deliver the columns [of the south window], AA, Leg. 2, 2a: Lo que se dió por 30 rrayos grandes, 600 maravedís para hazer un carretón grande para traer las columnas.

13. 1 February 1538, payment for carving the inscription on the [south] portal, AA, Leg. 2, 2a: Batista en las letras de la portada, dos reales. [Similar entries were made on 4 to 9 February and 16 March 1538.]

14. 8 February 1538, payment to Niccolò da Corte for a trip to the quarry [of the Sierra Elvira], AA, Leg. 2, 2a: A Nicolao, que fué 10 días a buscar las canteras, por mandado de su señoría.

15. 1 March 1538, payments to carvers working on the [south] portal, AA, Leg. 2, 2a: Ruberto en la talla de la portada, tres reales. Martyn Cano en la talla de la portada, tres reales. Pedro de Prado en la talla de la portada, tres reales. Lucas Caron en la talla de la portada, dos reales y medio. Pedro Ximénez en la talla de la portada, dos reales y

medio. [Similar entries persist through March and April.)

16. 9 March 1538, payment to laborers digging the trenches for the foundations of the chapel, AA, Leg. 2, 2a: A los muchachos que echan tierra de las çanxas de la capilla, vinyeron de aver 371 [maravedís]. [Similar entries were repeated throughout March, April, and May.]

17. 15 March 1538, payment for four marble panels [for trophy reliefs of the south portal], AA, Leg. 2, 2a: A G[regori]o Hurtado, vezino de Purchena, porque truxo 4 pieças de vasas y sobasas de mármol, que pesaron xxx arrobas y medio, a real cada una arroba, y mas 12 reales del maestro que los sacó, que monta todo lo que se pagó por las quatro, 1,345 [maravedís].

18. 30 April 1538, payment of a third of salary to Machuca, Lorca, and Marquina, AA, Leg. 2, 2a: A Pedro Machuca, maestro de las obras d'este tercio d'este año de 1538, del primero hasta en fin de Abril, 12,500 [maravedís] a razón de cien ducados cada un año. A G[onzal]o de Lorca por la dicha razón de obrero de las dichas obras del tercio primero d'este año de 1538. A Juan de Marquina d'este dicho tercio de 1538, 5,000 maravedís por aparejador de las obras. [Similar entries are found in April, August, and December through 1550.]

19. 15 July 1538, payment for limestone for the vault of the chamber beneath the chapel, AA, Leg. 2, 2a: A Godios, cantero, sacador de 77 pieças de quadradas para la bóveda de la capilla, de las canteras de Alfacar, a 102 cada una, monta 7,857 [maravedís]. Al dicho Godios, de 103 pieças de los rincones de la dicha bóveda, de las dichas canteras, a 136 maravedís cada pieça, que monta 14,008 maravedís. Más, al dicho Godios, de 177 varas y media de dovelas, de las dichas canteras, a real y medio cada vara, que monta 9,052 maravedís. [A similar entry was recorded on 29 July 1538.]

20. 16 August 1538, payment to a carpenter for the construction of the centering for the lower chamber, AA, Leg. 2, 2: A Juan Ruiz, carpintero, haciendo la çimbra de la capilla, 2 reales y medio. [Comparable payments were made to several carpenters during the latter half of August through

September and, after a gap in the documents, from 1 January through 20 May 1539.]

21. 7 March 1539, payment to carver Ruberto for work on the [wooden] model of the palace, AA, Leg. 2, 2b: Ruberto, entallador, que yzo en el modelo, tasóselo 153 [maravedís].

22. 15 March 1539, payment to carpenter Pierre for work on the model of the palace, AA, Leg. 2, 2b: A Pierre, carpintero, en el modelo, medio día, un real.

23. 2 May 1539, payments to Pierres and Juan Barros for work on the model, AA, Leg. 2, 2b: A Pierres, carpintero, de 5 días, que anduvo en el modelo, a dos reales y medio cada día, monta 340 [maravedís]. A Juan Garros, carpintero, de 5 días, que anduvo en el modelo, a dos reales y medio cada día, monta 425 [maravedís].

24. 9 May 1539, payment for twenty columns for the model, AA, Leg. 2, 2a: De 20 colunnas para el modelo formadas, 102 [maravedís].

25. 14 October 1539, payment for closing the [south] portal with masonry, AA, Leg. 2, 2a: 6 peones, con un cantero, cerra[n]do la portada para que no se estruge, 204.

26. 22 December 1539, payment for grey marble for the south window, AA, Leg. 2, 2b: A Pedro Muñoz, cantero, 199,034 maravedís, que obo de aber, por la piedra que sacó para la portada que al presente está fecha en la casa real, de piedra negra de la Sierra d'Elvira, e por ciertas pieças de la dicha piedra, que ha sacado para la ventana, que se ha de haçer sobre la dicha portada, porque por el proceso de pleito, que sobre el valor de todo ello se tasó entre el dicho Pedro Muños y Gonzáles de Lorca, obrero de la dicha casa real, a sentençia que en él se dió, fué declarado que se le diese el dicho preçio en que la piedra de las dichas portada y ventana fue tasada e moderada.

27. 18 February 1540, payment for a length of wire to measure the round courtyard, AA, Leg. 2, 2b: De 14 onças de hilo de yerro para las medidas del redondo de la casa, 56 maravedís.

28. 28 February 1540, payment for gravel for the foundations of the round courtyard, AA, Leg. 2, 2b: A Hernán Sánchez, de 2,780 arrobas de piedra de guixarro para las çanxas de los redondos de la casa, a maravedís la arroba, monta 2780. [Similar payments were made to six other dealers in gravel on the same day.]

29. 14 June 1541, payment to Martyn Cano for carving [scallop] shells for the west entry, AA, Leg. 2, 2c: A Martyn Cano, entallador, en unas veneras para la portada principal, dos reales y medio. [Similar payments were made during all the months for which the account ledgers are preserved through March 1542.]

30. 30 June 1541, payment to Domingo de Orende for sandstone for the portals [of the west facade], AA, Leg. 2, 2c: Al dicho Domingo de Orende, de diez y ocho piezas para las portadas de la casa real, a 4 reales cada una, del sacar de las canteras de Santa Pudia, son setenta y dos reales. [While deliveries of sandstone were made by Domingo de Orende from 24 December 1540 to 17 March 1542, only the pieces delivered on 30 June, 2 August, 11 October, 14 November, and 13 December 1541 were identified as for the doorways.]

31. 1 August 1541, payment for sandstone for niches and [scallop] shells, AA, Leg. 2, 2c: A Domingo de Orende, de 7 pieças para nichiles de Santa Pudia, a 153 maravedís cada pieça del sacar, 1,233 maravedís; más, al dicho Domingo, de 12 pieças de las veneras de Santa Pudia, a 187 maravedís cada una del sacar, 2,243 maravedís. [During the seven months of 1541 for which account ledgers are preserved, thirty-nine pieces for niches and twenty-one for shells were delivered.]

32. 4 August, 1541, payment for limestone for the benchtable for the [west] facade, AA, Leg. 2, 2c: Más, al dicho Domingo, 4 poyos de la piedra franca de las canteras de Alfacar, a 238 maravedís cada uno, que monta 852. [Comparable payments were made through April 1542 to Domingo and other quarriers.]

33. 8 November 1541, payment to masons building a new house for the abbots, AA, Leg. 2, 2c: Maestro Diego y Martyn de Mendoça en el edifiçio que se les aze a los abades, que le tomaron su casa para la casa real, 119 [maravedís]. [Payments of this sort continue through 24 December 1541.]

34. 1 December 1541, payment for carving corbels [for the cornice of the south facade], AA, Leg. 2, 2c: Martyn Cano, en la talla de las mínsolas, 93 maravedís. [Similar entries were recorded through December 1541 and Cano, Ruberto, and others were paid the same daily wage for unidentified work in the few accounts that have survived from the following decade, with the task again identified as mínsolas in the Nóminas for 1 to 20 September 1544.]

35. 26 January 1542, payment for lead to affix tie rings on the facade of the new palace, AA, Leg. 2, 2c: Que se compraron de Luis, vezino de Dalias, veynte arobas y 17 libras de plomo, para asentar unas argollas en la casa real nueva, a dos ducados quintal, que monta 3,879 [maravedís].

36. 6 March 1542, payment for sheet tin to carry a plan of the palace to the court, AA, Leg. 2, 2c: De una caxa de oxa de Mylan, para llebar la traça al emperador de la casa, 119 [maravedís].

37. 2 to 9 December 1542, payments for tile to cover the new [west] entry, AA, Leg. 3, 5: A Magarrafa, 775 tejas para cubrir la portada nueva, a 800 del millar, que monta 170 [maravedís].

38. 18 December 1542, payment for a cart to carry large columns, AA, Leg. 3, 4: Que se dió a Francisco de Morales, porque izo un carretón para traer columnas grandes, de destaxo, 1500 maravedís de sus manos.

39. 30 April 1546, payment for preparing the foundations for the Fountain of Charles V, AA, Leg. 3, 5: 4 peones abriendo la çanxas donde se a de azer el pilar, 136 [maravedís]. [Similar entries are found through 29 July 1546.]

40. 31 May 1546, payment for carving garlands of main-story window pediments, AA, Leg. 3, 5: A Ruberto, entallador, en unos festones de las ventanas, 93 maravedís, a Martyn Cano, en estos festones de las ventanas, 93 maravedís, a Morales, en

estos festones de las ventanas, 93 maravedís. [Comparable payments were made to these carvers and also Juan de Orea and Pedro de Alles from the beginning of April through the end of December 1546.]

41. 31 July 1546, duties of major officials in Work Rules written by Iñigo López de Mendoza, fourth count of Tendilla, and recorded in a copy of 13 May 1549, AGS, CSR, Leg. 265, fols. 13-16. (A later copy in the Sección Obras y Bosques, Granada, which has more modern spelling but no significant differences in the text, was published in the *Archivo español de arte y arqueología*, XI, 1935, pp. 209-216.): *Ynstruçión de lo que a de hacer el obrero.* Ha de recebir todos los oficiales asentadores, canteros, entalladores, alvañires y carpinteros, y maestros de açulexos y yesería, que fueren neçesarios, así para la obra de las casas reales bieja y nueba, como para otro qualesquiera obra de su magestad que por horden del conde se hiciere en el Alhambra, o fuera d'ella. Antes que reciba ninguno de los oficiales, se a de ynformar bién, si tiene el avilidad que conbiene, y subfiçiençia que se requiere, para servir en la dicha obra, y estando satisfecho d'esto, reçibillo ha, con parecer de maestro mayor de las obras, y de otra manera no; y concertará, en entrando, el jornal que se le a de dar conforme a conciencia, no añadiendo a ningún ofiçial, ni peón, más jornal de lo que se suele dar hordinariamente en las dichas obras, sin consultallo con el conde, y saber lo que manda, y avisarán al que escribe, dél que nuebamente entrare en la dicha obra, y del jornal que a de ganar, para que lo asiente en el libro. Si le pareçiere que alguno de los dichos ofiçiales, que al presente andan en la dicha obra no tiene en su ofiçio la abilidad y subfiçiençia que se requiere, o supiere que es holgaçán, reboltoso, o viçioso, o está en algún pecado público, despedillo, avisando primeramente d'ello al que tiene cargo d'escrevir los que trabaxan en la dicha obra, para que le quite del libro y no gane jornal dende el día que se despidiere. Vendrá el dicho obrero por las mañanas a la dicha obra, antes que se avía de entrar en ella, y dará, a cada asentador y alvañir, los peones que con él an de trabaxar, de manera que ninguno llebe más ni menos de los que ubiere menester, y hará que baya cada uno a la obra donde trabaxa a la hora que está ordenada; y si alguno tardare algo d'ella, le halle a la pena que al maestro mayor le

paraçiere, y avisará al que escribe para que lo asiente así, y se le baxe al tienpo de la paga. Ha de andar continuamente en las obras, y visitallas, y ver lo que cada maestro o ofiçial a menester, y hazer lo traer brebemente de manera que por faltalle lo necesario, no pare. Ha de tener gran cuidado que todo lo que se hiciere y labrare en la dicha obra, así de cantería, y de alvañería, y carpintería, açulexos y yesería, vaya hecho con la diligençia y cuidado que se requiere para la perfiçión y perpetuydae [sic] d'ello, y si en alguna cosa le pareçiere que ay falta, procurará que se enmiende, y avisará d'ello al conde para que se ponga el remedio que conviene. Si en la obra se hallare algún oficial parado, o fuera d'ella, no teniendo justa escusa, echalle a la pena que le pareçiere por la primera vez, y por la segunda doblada, y por la terçera sea despedido. No dará niguna obra a destaxo sin colsultallo con el conde, y en caso que el conde mande que se dé, hará el dicho obrero las condiçiones que fueren neçesarias, que conbinieren para que se remate en buen preçio, y no se rematará sin hacello saber el conde. . . . De los materiales y madera y otras cosas que, para la dicha obra, se conpraren, abisará al pagador de las dichas obras para que lo pague en tabla ante escrivano, el sábado primero siguiente quando se hiçiere la paga a la jente que trabaxa en la obra, a las personas que lo an de aver. Hará entregar toda la madera y clavaçón, heramientas y espuertas, texa, ladrillo y açulexos al tenedor d'ello para que ponga a recaudo, y abisará al qu'escribe de la cantidad que se trae, para que le haga cargo d'ello, y quando algo fuere menester para la dicha obra, lo dé por cédulas firmadas del dicho obrero y maestro mayor de las obras, en las quales declaren la cantidad que a de dar, y para donde es, y con este recaudo se le cargue y reçiba en quenta lo que diere, de hotra manera no. Tendrá cuidado de visitar la casa real bieja continuamente, y ver si algunas de las paredes hace sentimiento, y entendido de lo qu'es, avisarán al conde para que se remedir, y en el entretanto, haçello apuntarlar si fuere menester.

Lo que ha de haçer el pagador: Ha de venir cada sábado a la obra, antes que sea hora de dexar de trabaxar, y visto el libro que tiene el qu'escribe, de las personas que aquella semana an trabaxado en las obras, pagará en tabla a cada uno, los jornales que a de aver de los días que ubiere trabaxado, ante el escrivano que, para esto, tiene nonbrado el conde,

para que pueda dar fée de la dicha paga, y dar sinadas las copias d'ellas. Así mismo, hará la dicha paga en presençia del maestro mayor de la casa real, y la persona que escribe, y obrero, y tenedor, para que se haga más justificadamente; y quando el maestro mayor, o otro de los suso dichos, no pudiere hallarse presente a la dicha paga, haçella a ante los hotros; y si estubieren ausentes los dos d'ellas, avisarán al conde para que nonbre persona, porque no se puede hacer la paga no estando, demás del dicho escrivano, tres personas que asistan a ella. Pagará así mismo en tabla al dicho escrivano y personas suso contenidas: a los carreteros, madereros, hereros, ladrilleros, texeros y yeseros, maestro de azulexos, y hotras personas que ubieren bendido algo para la dicha obra, lo que, [en] el libro dél que escribe, pareçiere que, aquella semana, se a conprado para la dicha obra, y entregallo al tenedor d'ellos; y si algún socoro se ubiere de dar a alguno de los suso dichos, parezca en quenta de lo que an de aver, dalle a el dicho, y ante el dicho escribano para que pueda dar fee d'ello, y de otra manera, no le será reçebido en quenta. No dará a ninguna persona de las que dicho es, cédula para que el receptor, ni otra persona, le pague los maravedís que a de aver, o de su xornal otra cosa alguna que le ubiere bendido para la dicha obra, si no pagallo a todo en tabla, como dicho es el día de la paga. No dará a ningún ofiçial, maestro ni peón, seda ni paño, trigo ni cevada, ni hotra cosa alguna en quenta de su paga, porque sienpre se presume que la xente reçiben gaño en ello, aunque no lo reciba con aperçebimiento, que si otra cosa se hize, no le será recebido en quenta lo que ubiere dado.

El maestro mayor de las dichas obras a de traçar y hordenar todo lo que en la dicha obra de la casa real, que en esta Alhanbra se edifica, se a de haçer, conforme a la traça que el marqués, mi señor, dexó; y a de dar a los entalladores y canteros y otros ofiçiales,, que en ella trabaxan, los dibuxos, y dé deseños de lo que an de hacer, con sus proporçiones y tamaños precisos, conforme al arte del arquitectura; y antes que a los dichos ofiçiales, los mostrará el conde, para que añada, o quite, o enmiende en ellos lo que pareçiere que conbiene. Tendrá el dicho maestro mayor gran cuidado de visitar, cada día, la obra, y ver si los ofiçiales, que en ella andan, trabaxan bien, y se le pareçiere que algún entallador, o cantero, o otro ofiçial no trabaxa bien,

deçillo al obrero para que lo despida, y si alguno de los que suelen trabaxar bien, le hallare fuera de la obra, sin justa causa parado, abisará al dicho obrero, para que le quite la parte del jornal de aquel día, que al dicho maestro mayor y obrero les pareçiere. No se a de recebir ningún ofiçial en la dicha obra que primero no se presente ante el maestro mayor, y bea si tiene el abilidad y sufiçiençia que se requiere para serbir en la dicha obra, y pareçiéndole que la tiene, deçillo al dicho obrero para que lo reçiba. Tendrá cuidado de ver, si la madera, clavaçón, y materiales, y heramientas de la dicha obra se pone a buen recaudo, y si le pareçiere que alguna d'estas cosas no la ay, abisar al conde, para que en ello probea lo que conbiene. Si al dicho maestro mayor le pareçiere que el obrero, o sobrestante, o aparexador, del que tiene cargo la madera o clavaçón, materiales y heramientas de la dicha obra, no haçe cada uno su oficio, lo que es obligado o por negligençia, o por maliçia, abisará al conde para que en ello probea lo que le pareçiere. Quando se ubiere de haçer algún conçierto con careteros, caleros, texeros, sacadores de piedra, o herreros, o con otra alguna persona necesaria a la dicha obra, haçerse a en presençia del dicho maestro mayor, y procurará que lo que se conprare, así en el preçio, como la bondad d'ello, no reciba engaño su magestad, y lo mismo hará, quando se ubiere de hacer algún remate; y si el obrero conprare, o conçertare algo en ausençia del dicho maestro mayor, abisará d'ello al conde para que probea sobre ello lo que conbenga. Tendrá muy gran cuidado de saber si, alguno de los que andan en la dicha obra es reboltoso o holgazán, biçioso, o amançebado está en otro pecado público, y, si alguno lo supiere, abisará al obrero para que lo despida. Tendrá cuidado de saver si los que trabaxan en la dicha obra, bienen a ella, y se ban de labor, a las horas que les está ordenado. Conbiene a saber, del mes de mayo hasta el mes de setienbre, entrarán quando sale el sol, y holgar desde onçe hasta un, y salir a la ora que se pone el sol, y desde el mes de setienbre hasta el de mayo, entrar quando sale el sol, holgar desde doze a una, y salir a la ora que se pone el sol. . . . [Following the instructions for each post there is a notarized statement that the official involved had seen and signed the orders.]

42. 2 August 1546, payment for laying the foundations of the Fountain of Charles V, AA, Leg. 3,

5: Dyez y nuebe peones con los asentadores y en el pylar, que monta 647 [maravedís]. [Similar entries were repeated through August and, with the records missing for September and October, from 1 to 19 November 1546.]

43. 5 November 1546, payment for [main-story] window centering, AA, Leg. 3, 5: Moreno carpintero, en una zymbra para las ventanas, dos reales. [Similar payments were made to several capenters through 27 November.]

44. 22 December 1546, payment for marble for the geniuses and arms of the wall fountain, AA, Leg. 3, 5: A Miguel de Velustegy, de dyez pyeças de la Syrerra d'Elvyra, para el pylar, las armas, y nyños, dyez ducados.

45. 26 October 1548, specifications for the window over the south portal, AA, Leg. 3, 11, fols. 1-2v (partially published by Gómez-Moreno y Martínez, *Las águilas*, p. 228, citing old Leg. 228): Condiçiones con que se a de hazer la ventana, que su señoría manda hazer de piedra de la Sierra d'Elvira, para la casa real de su magestad, es lo syguiente: Primeramente, a de llevar la estilóbata neçesaria toda la ventana, recuadrada de molduras con el molde que está hecho, en todo la obra de piedra blanca de las estilóbatas que están hechas, que conquerda con la dicha ventana, e de su mesma altura. Yten, en estas susodichas estilobatas, an de yr quatro ystorias de medio relievo de lo que su señoría mandare; asy mysmo, a de llevar los seys encuentros de los lados d'estas dichas estilóbatas, de talla de medio relievo, de lo que su señoría mandare. Más, ençima d'estas dichas estilóbatas an de yr quatro colonas corintias con sus basas e capiteles; los troncos d'estas quatro colonas an de yr estriadas con las estrías neçesarias a su orden corintia; los capiteles d'estas dichas colonas an de yr labrados con sus ojas, cartochos, e lo que conviniere a su órden, muy galán; las vasas d'esta dichas colonas corintyas, llanas, y estas quatro colonas an de llevar sus trasdoses de la misma piedra, con dos [fol. 1v] devisas em medio de cada colona, pequeñas, en un redondo. Más, a los lados d'estas dichas colonas, en medio, an de yr otras quatro colonetas pecueñas de medio relievo, revestydas como está en la traza, con sus basas e capiteles jónicos, entallados basas y capiteles. Más, encima d'estas colonetas, a de yr

un alquitrave, friso e cornisa, e un arco, e dos quadrados, entallados todos los myenbros d'esta dicha cornisa los neçesarios; e en el papo del arco, e quadrados, recuadros de molduras con çiertas rosetas por el dicho papo, o otra cosa que convenga. Más, ençima d'este dicho arco an de yr dos vitorias de la grandeza que convinyere, de medio relieve, con dos vasos a los pies, e con dos ventanas redondas, recuadrados de molduras, por de fuera, e por de centro, como están apuntaladas en la traza, con una ménsula entallada, con sus ojas muy rica en medio. Yten, a de llevar ençima de las quatro colonas, su epestilio e zoforo e corona con sus ménsulas, las neçesarias entalladas, estas dichas ménsulas con sus ojas e molduras, e en medio de cada, entallada una roseta, o otra cosa que más convenga [fol. 2]. Y en todo este cornijón, entallados óvolos, y denteles, y fusayolos, y en la çimasa de la corona, entalladas çiertas cabeças de leones, a trechos e horadadas, las que convinieren para despedir el agua. Toda la piedra de la Sierra de Elvira que pasare la pared, siendo neçesaria a la dicha ventana, a de ser labrada, y dada de asperón, y hechos los encasetes para puertas e vidrieras. Más, que toda esta ventana, así molduras como talla, a de yr tanbién labrada, y a guarda, y derecha, y linipia, como es la portada que está hecha debaxo, a vista de maestros que del arte sepan. Es condición que le an de dar al maestro que la hiziere, la piedra sacada, y carreteada, y puesta donde la carreta la pudiere descargar mas çerca de su taller, que arriba se le señalare. Es condición que la obra la a de asentar, con tanto que el maestro esté presente, y corte, y juste sus piedras, e todo lo que ubiere menester; y que no se le a de dar más que el asentador, y subir las piedras y materiales y peones. Yten, más que toda esta obra a de ser hecha con los moldes y debuxos y entalles que para esto le fuere dado por el maestro, sin salir cosa ninguna. Yten, es condiçión que toda la piedra d'esta sobre dicha ventana, a de ser de la Sierra de Elvira de [fol. 2 v] la suerte que es la portada de abaxo, para que concuerde con la portada, que no haga diferençia. Yten, que el maestro vaya a la cantera con los sacadores, en quien se rematare la saca d'esta dicha piedra, y que el maestro escoja, e trayga a su voluntad, la piedra que sea buena, e linpia, e sin ninguna cosa que haga fealdad y con sus medidas a propósito a su voluntad. Yten, es condición que, porque su señoría dava a maestre Niculao, mill e

çient ducados por toda esta obra, conforme a estas condiçiones que aquí van declaradas, y el dicho maestro Niculao no quería menos de mill quatro çientos ducados, es condición que, después de hecha y acabada la dicha obra, a contento de su señoría, que se vea toda la obra susodicha por dos maestros, Diego Siloe e Pedro Machuca, con juramento que para ello les sea tomado, que si más valiere de los mill e çient ducados, que le sea dado al dicho mastre Niculao, con tanto que la tasación no pase de los mill e quatro çientos ducados, e si menos valiere de los mill e çient ducados, que le sea quitado de los mill e çient ducados, y no le sea dado más de lo que se tasare.

46. 26 October 1548 contract with Niccolò da Corte for the execution of the south window, AA, Leg. 3, 11, fol. 4: En el Alhambra de Granada, veynte e seys días del mes de otubre de mil e quinientos e cuarenta e ocho años, maestre Francisco de las Maderas, obrero de la casa real de su magestad, en nombre de su magestad, otorgó, e se obligó que los mil e cient ducados contenidos en estas condiçiones, o lo que fuere tasado como se declara en ella, le serán pagados al dicho Nicolao de Corte, a los plazos, e según de la manera que se contiene en la escritura que el dicho Niculao de Corte hizo e otorgó ante mí, el dicho escribano, de hazer e cumplir lo contenido en las dichas condiçiones; los quales se le pagarán en tabla, como es costumbre en esta manera: 30 ducados en fin de cada un mes, que será la primera paga a primero día del mes de noviembre d'este presente año, de la fecha d'esta carta. Testigos que fueron presentes: Esteban de la Barba e Pedro Machuca e Juan del Campo, veçinos de la Alhambra, y el dicho Joan Gante. Lo firmó de su nombre . . . Andrés Ruiz de Carrión, escribano público.

47. 26 October 1548, obligation of Juan del Campo as the bondsman of Niccolò da Corte, AA, Leg. 3, 11, fol. 5: En el Alhambra de la çiudad de Granada, veynte e seys días del mes de Otubre de mill e quinientos e quarenta e ocho años, Juan del Campo, vedriero, vezino d'esta Alhambra, se constituyó por fiador del dicho Nicalao de Cortes, y, juntamente con él, de manocomún, se obligó que el dicho Nicalao de Cortes harán la dicha obra, conforme a las dichas condiçiones, las quales guardará e cumplirá, como en ellas se contiene, e dará

acabada la dicha obra, al tiempo que está obligado . . . e si así no lo hiziere e cunpliere, que él, como su fiador e prençipal pagador, haziendo de deban agena, propia suya, sin que se haga escursion de bienes contra el prinçipal, ni otra diligençia alguna, hará e cumplirá lo contenido in las dichas condiçiones e obligaçión, que por birtud d'ellas tiene hecha e ortorgada el dicho Nicalao de Corte. . . .

48. 23 August 1549, copy of contract with Pero Franco and Lucas Mateo for marble for the south window, AA, Leg. 5, 20 (partially published by Gómez-Moreno y Martínez, *Las águilas*, p. 230): En la çibdad de Granada, veynte y tres días del mes de agosto, año del naçimiento de Nuestro Salvador Ihesú Christo, de mil e quinientos e quarenta y nueve años, en preçensia de mí, el escrivano e testigos yuso escriptos, Pero Franco y Lucas Mateo, canteros, vezinos del Alhanbra, dixeron que por quanto en ellos, como en mas baxos ponedores, fué rematada la piedra, que se a de sacar de la Sierra d'Elvira para la ventana que se a de hazer en las casas reales que se haze en la dicha Alhanbra, en presçio de dozientos y setenta y ocho ducados, con çiertas condiçiones que para ello se hizieron, que son las siguientes: Condiçiones, con que se a de sacar la piedra de la Syerra d'Elvira para la ventana, que su señoría manda hazer para la casa real de su magestad, son las siguientes: Para las baxas de las estilóbatas, quatro pieças, de a tres pies y medio de largo, y tres pies y un quarto de ancho, y dos pies y dos dedos de alto, desbastadas en sus contramoldes. Para las baxas de dentro, otras quatro pieças, de a tres pies en quadrado de largo y ancho, y de galga dos pies y dos dedos de alto. Para los planos del estilóbato, dos pieças de seys pies y quatro de pie de largo, y quatro pies de ancho, y un pie otorgado de grueso [fol. 1v]; más, otras dos pieças de çinco pies y medio de largo y quatro pies de alto y un pie en grueso. Más, otras dos pieças de çinco pies y medio de largo, y quatro pies de ancho, y un pie en grueso. Para las baxas de las colonnas, quatro pieças de a tres pies de ancho y largo, que sean quadradas, y un pie y tres dedos de alto. Para las baxicas chicas, dos pieças de çinco pies y medio de largo, y dos pies otorgados de lecho, y un pie de alto. Para las colonnas chicas, más dos pieças de a nueve pies de largo, y dos pies otorgados en ancho por una parte y un pie y tres quartos de pie por la otra. Las colonas

chicas, medias , más otras dos pieças de a nueve pies de largo y un pie y un quarto por una parte, y dos pies otorgados por la otra. Para los dinteles d'estas colonas, dos pieças de a çinco y medio de largo y dos pies y medio de ancho, y dos pies otorgados de alto. Para las figuras, dos pieças de çinco pies en ancho por [fol. 2] la una parte y siete pies y medio por la otra parte y un pie en grueso, y desbastadas conforme a la traza. Para a par de la ménsula, una pieça de siete pies de largo, y un pie de grueso, y tres pies y medio de ancho. Para a torno de los dos redondos, dos pieças de largo, tres pies y un pie y tres terçios [sic: quartos] de pie en ancho, y dos pies otorgados de grueso: otras dos pieças de quatro pies y medio de largo, y un pie y tres quartos de pie de ancho, y dos pies otorgados de grueso. Para los bolsores del arco, otras çinco pieças de bolsores de a dos pies y medio de ancho, y dos pies y medio de largo, y dos pies de grueso. Para una colonna grande, más una colonna conforme en grosez y anchura y largura de las qu'están sacadas aquí en la obra. Para las entre colonnas, más ocho pieças de a diez pies de largo, y un pie y quarto de pie en quadrado; más, otras quatro pieças de a diez pies de largo, y dos pies otorgados en ancho, y un pie de grueso [fol. 2 v]. Para los capiteles grandes, quatro pieças de dos pies y medio de ancho, y dos pies de alto, en quadrado otros dos pies. Para el epestilio, más diez y syete pieças de a pie y medio de alto, y dos pies de ancho, y tres pies y medio de lecho. Para el zoforo, otras diez y syete pieças de a pie y quarto de alto y dos pies de ancho, y quatro pies y quarto de lecho. Para la corona, más diez o ocho pieças de a pie y medio escasos de alto, y dos pies y medio de ancho, y quatro pies y medio de largo; más, otras diez o ocho pieças de a pie y medio de alto, y dos pies y medio de ancho, y seys pies de largo. Es condición que toda esta piedra sea muy bien desbastada por los contramoldes que para ello les darán. Más, es condición que la an de dar a el maestro que se encargare de sacar toda esta piedra, la ha de dar puesta en cargaderos. Es condición que toda esta piedra a de ser de la mejor que ubiere en la Syerra d'Elvira, qu'esté sana y limpia, syn raça, ni pelo, ni carrunbre ninguna, por manera que sea a contento del maestro y aparejador. Ytem, es condición que dentro de un mes [fol. 3], se ha de sacar la colonna grande, después de començar a sacar en la cantera. Ytem, es condición que ha de ser de

la piedra pardilla de la mas cerrada y sana, eçepto la colonna, que ha de ser conforme a las otras que están sacadas. . . .

49. 18 August 1550, petition of Isabel Machuca Horozco for payment for the loss of her husband's horse, AA, Leg. 111, 3 (published by Gómez-Moreno y Martínez, *Las águilas*, p. 122): Ysabel de Horozco, muger de Pedro Machuca, difunto que santa gloria aya, y en nombre de los menores, beso las manos de vuestra señoría, y digo que Pedro Machuca, mi marido, tenía un caballo con el cual servía, y servió seis años, y estaba metido en el arca, y al tiempo de su muerte, el dicho caballo tenía un cuarto y estaba enfermo, y un mes antes que mi marido muriese, le salió otro cuarto en otra mano y quedó enfermo de un muermo, del cual murió, y no estuvo para poderse vender, de lo cual pido y suplico a vuestra señoría que mande a los alcaldes del arca que tomen información, y lo manden librar, y en ello hará vuestra señoría justicia y a los menores mercedes. 18 de agosto de 1550.

50. 11 December 1550 to 11 January 1551, record of an investigation of unauthorized cutting of stone at the king's quarry in the Sierra Elvira, AA, Leg. 5, 51, fols. 1-19, under the title: El veedor, Sebastián de Peñalosa, contra los canteros que estaban en Sierra Elvira, por haber sacado piedra para particulares, siendo la cantera de Su Magestad, sobre que se les condene en la restitución de jornales abían perçibido . . . [fol. 14, letter from Licenciado Luz to overseer Peñalosa]. Sebastián de Peñalosa, veedor de las obras reales d'esta Alhambra, premisas las solenidades del derecho, acuso criminalmente ante vuestra merced, a Domyngo de Paguagua y a Martyn de Alquiça, y haziendo relación del caso, digo que es ansí, que los suso dichos, por mi acusados, fueron por mayordomos y canteros a las canteras del rey, que están en la Siera Elvira, y llevaron otros nueve oficiales para sacar piedras para la portada de la casa real d'esta Alhambra, a los quales canteros y mayordomos, el rey les pagava sus jornales, a Domyngo de Paguagua y Martín de Alquiça, a tres reales, y a los otros nueve oficiales, a dos reales cada día. Y es ansí que, estando sacando de las dichas canteras reales la dicha piedra para la obra real, el dicho Domingo de Paguga y Martyn de Alquiça hurtaron de las dichas canteras, dos pilas grandes y un mármol, con su

basa, y un chapitel y quatro losas grandes que están en la cantera, y otras dos losas grandes que truxeron a la iglesia mayor d'este cibdad y, añadiendo delito a delito, hurtaron a el rey los jornales de dos meses que se ocuparon en façar y labrar las dichas pieças, el dicho Martyn de Alquiça y Domingo de Paguagua, y los otros oficiales que, por mandado, labraron y sacaron las dichas pieças, por lo qual an caido y incurrido en muchas y muy graves penas civiles y criminales, las quales pido sean exsecutadas en sus personas y bienes y incidentes de su muy noble ofiçio, el qual para ello inploro en veynte y quatro ducados que, llevaron de jornales a el rey, de dos meses que se ocuparon en sacar las dichas pieças que ansí hurtaron ellos y los otros oficiales que todo lo qual son ellos obligados a pagar porque, como mayordomos, los ofiçiales eran obligados a obedeçellos, para lo qual juro, y en ayuda de mi parte, que esta acusación no la pongo de maliçia. El Liçençiado Luz. 11 enero 1551.

51. 26 March 1551, letter from the queen (elderly Joanna of Castile) to the governor of the Alhambra (Luis Hurtado de Mendoza, acting for his father, Iñigo López de Mendoza) to inform him of the visit of Bartolomé [de Bustamante] de Herrera, AGPM, CR, 1, años 1545–1555, fol. 100: El Rey. Conde de Tendilla, pariente nuestro, Capitán General del Reyno de Granada, porque queremos sea informada del estado en que están las obras de esa Alhambra, de lo que resta de hacer en ellas, havemos acordado de embiar a Bustamante de Herrera, que es persona plática en lo de esta facultad, para que él lo vea y mire todo, y nos traiga relación particular de ello, por ende nos vos rogamos, y encargamos que le hagáis mostrar todas las dichas obras, assí las que están hechas, como las que se hacen, y que se le dé razón de las que se han de hacer y de la orden y traças que para ello ay, y de todo lo demás a esto concerniente, y que vos platiquéis y conferáis con él lo que os paresciere convenir para el dicho efecto, porque nos pueda traer mejor, y más cumplidamente relación de todo, que en ello nos haréis placer y servicio. Fecha en Cigales a 26 días del mes de Março de 1551. La Reyna, refrendad de Joan Vázquez.

52. 4 June 1551, report on the difficulty in transporting the large pieces of marble for the figures over the south window, AA, Leg. 5, 16d, 1 (doc-

ument transcribed by María Angustias Moreno Olmedo): Pedro Franco y Lucas Mateos, canteros, besamos las manos a vuestra señoría y decimos que nosotros nos obligamos, por un contrato de dar sacadas en las canteras de la Sierra Elvira, ciento y veynte e cinco piedras para la obra de la ventana que vuestra señoría mando fazer sobre la puerta del mirador de la casa real, y esto habemos cumplido y se sacaron otras muchas piedras más, y a nuestro cargo era y fué solamente sacar las que fuesen buenas y bien desbastadas, y puestas a cargadero para que allí, los carreteros que los oviessen de traher, las cargasen sin tener nosotros obligación de las cargar, segúnd esto consta por el conçierto y contrato y condiçiones dél, y porque el carretero, que por ellas yva, no las quería, ni podía cargar, embiaron el maestro y veedor a cargar dos piedras para dos figuras, gente que las cargasen, y viendo esto que a su magestad le era mucha costa y trabajo, embiar gente para cada piedra que se oviese de cargar, Pedro Machuca nos importunó y rogó que, pues nosotros teníamos gente en la cantera sacando la piedra, que con ella y nosotros, ayudásemos a cargar y cargásemos toda la dicha piedra, y que se nos pagaría y satisfaría todo lo que justamente meresçiese el haberla cargado toda, y con este conçierto y en confiança que seríamos d'ello satisfechos, pues lo hazíamos sin ser obligados, la cargamos toda y excusamos más de çinquenta ducados de costo que se gastaran en pagar la gente que cada día se enbiaba a la cargar, y por nuestra parte, se ha pedido se nos pague y satisfaga, lo que por la aver cargado, debamos, y no se a hecho. . . . Suplicamos a vuestra señoría ilustrísima, la mande reçibir y que, constándole ser como lo deçimos, mande que seamos pegados. [on the reverse in another hand] En el Alhambra, a cuatro días del mes de junio del mill e quinientos cinquenta y un año, ante el conde de Tendilla, mi señor, capitán general del reino de Granada, paresçió Lucas Mateas y Pedro Franco, canteros, a presentaron esta escritura, signada de mí, el escribano. Su señoría habiendo visto lo susodicho, mandó que debía confirmar [?] y vista que dé lo justo.

53. 8 September 1551, appraisal of Antonio de Leval's first pedestal relief the *Triumph of Peace*) for the west frontispiece, AA, Leg. 5, 19, fol. 3 (published by Gallego y Burín, "Antonio de Leval," p. 64, doc. 1, 4, citing old order Leg. 228): En la

çiudad de Granada, ocho días del mes de setiembre de mill e quinientos e çinquenta e un años, los dichos Diego de Siloe y Nicolao de Corte, juraron en forma de derecho so cargo, del qual prometieron de fazer dicha tasaçión bien e fielmente a lo que alcanzaren, sin açesión de persona alguna, e dixeron qu'ellos an visto la estilobata que labró Antonio Flamenco, la qual es de la piedra de la Sierra Elvira, con çiertas vitorias y espolios de armas, segúnd que por ella parece, y visto y cotejada con la que primer labró Juan de Orea, se halló ser entrambas labradas por un mismo dibuxo y de un mismo tamaño, y tener tanta obra la una como la otra, ecepto que la del dicho Antonio Flamenco, está más costosa de obra, pos causa que se detuvo más en algunas diligençias que hizo, en el empomedar y bruñir, y dar lustre a la dicha pieça, como por ella pareçe, lo qual les paresçió que vale y tiene de costo, más que la otra, que labró Juan de Urea, diez ducados, por manera que vale la dicha lavor de la dicha estilobata noventa ducados, y que éste es su justo valor a lo que alcançan so cargo del dicho juramento, y lo firmaron. Diego Siloe. Nicolao de Corte.

54. 13 September 1551, payment to Leval for his relief the *Triumph of Peace*), AGS, CM1, Leg. 1278: A Antonio Flamenco, noventa ducados, que valen treynta y tres mill y seteçientos e cinquenta maravedís, que los uvo de aver por la estilobata que labró para la puerta principal de la casa real, la qual fué tasada en los dichos noventa ducados por Diego de Siloe y Nicolao de Corte, como pareçió por testamento signado del dicho Luis de Ribera, por librança del dicho conde de Tendilla. Fecha en el Alhambra, a treze de Setienbre del dicho año de 1551, con fée de la paga del dicho Luis de Ribera. [Another record of the payment is found in AGS, CM1, Leg. 1120.]

55. 20 September 1551, Orea's objection to appointment of Siloe as appraiser of his sculpture, AA, Leg. 187, 13 (transcribed by María Angustias Moreno Olmedo): Juan de Orea, criado de vuestra señoría, digo, que yo labré una estilobata, y para lo que se me debe de mi trabajo, el veedor nombró por tasador a Diego de Siloe, a el qual yo tengo por odioso y sospechoso, y por tal lo recuso, y juro a Dios y a esta cruz, que esta recusación es cierta y verdadera y no la hago con malicia, suplico

a vuestra señoría, mande con brevedad, que se nombre otro, juntamente con él que yo tengo nombrado, para que yo sea pagado, de lo que se me debe, para lo qual el muy ylustre oficio de vuestra señoría ymploro. Juan d'Orea. A veynte de setiembre 1551 años. Su señoría dixo, que no ha lugar lo que pide, e que se haga lo que se a mandado. Ribera.

56. 29 November 1551, payment to Juan de Orea for a pedestal relief (the Battle of Mühlberg) for the west frontispiece, AGS, CM1, Leg. 1120: En veynte e nueve de noviembre del dicho año libró a Juan de Orea, escultor, quarenta mill maravedís, de una estilóvata y de la manifatura d'ella, que labró para la portada prinçipal de la casa real, la qual fue Diego de Syloee, maestro mayor de la Santa Yglesia de Granada, nonbrado por el conde de Tendilla, y Niculas de Corte, nonbrado por el dicho Juan de Orea, 40,000 marávedís.

57. 6 December 1551, payment for marble for the south window, AGS, CM1, Leg. 1278: A Pero Franco y Lucas Mateo, seis mill maravedís, que los ovieron de aver por cargar la piedra que se truxó para la ventana de la casa real de la dicha Alhambra, en las canteras donde se sacó, y otras piedras que hasta seis de diziembre se llevaron a la dicha Alhambra, como paresçió por fée del dicho veedor, Juan Arias de Mansilla, por libramiento del dicho conde de Tendilla. Fecha a seis de diziembre del dicho año de 1551, con fée de la paga del dicho Juan Arias y Luis Ribera.

58. Shortly before 16 January 1552, recommendation of a claim against the estate of Niccolo da Corte, because he had not finished the south window, AA, Leg. 3, 11, fol. 7: Muy magnífico señor. El capitán Juan Arias de Mansilla, veedor de las obras Reales del Alhambra d'esta cibdad de Granada, como tal veedor y en nombre de su magestad, digo que por el mes de otubre del año pasado de myll y quinientos y quarenta y ocho, Nicolao de Corte, escultor, como principal, y Juan del Campo, vidriero, como su fiador, se obligaron a su magestad, y a quién por él lo obiese de aver de hazer, y que, dicho Nicolao de Corte hará una ventana de piedra de la Sierra d'Elbira para la portada qu'está hecha de la dicha piedra en la casa real de su magestad, conforme a çiertas condiciones, la

qual dará acabada dentro de año y medio a toda perfiçión, y a contento del señor conde de Tendilla y vista de ofiçiales, según que todo más largamente consta por estas escrituras, condiçiones y obligaçiones siñadas de Andrés Ruyz, escribano público del Alhambra, de que hago presentación; y es así qu'el dicho Nycolao de Corte no a hecho, ny cumplido, lo que era obligado según y como devía, y es pasado el dicho año y medio, y muchos días más, y el dicho Nycolao de Corte tiene reçebidos, para en quenta de la dicha obra y de lo que por ella avía de aber, [blank] ducados, sin aver cumplido como dicho es lo que era obligado, ni hecho la dicha obra. Por tanto, en aquella vía e forma que mejor dé derecho lugar aya, y al derecho de su Magestad convenga, pido y suplico a vuestra merced, mande dar su mandamiento de execución contra los bienes del dicho Nicolao de Corte y contra el dicho Juan del Campo, su fiador, por los dichos maravedís que tiene recibidos, dexando el derecho de su magestad a salvo en lo que más costaré la dicha obra de los maravedís, porque era obligados a hazelle el dicho Nicolao de Corte y su fiador conforme a la dicha escriptura . . . Otrosí, pido y suplico a vuestra merced, para que a vuestra merced conste de los maravedís qu'el dicho Nicolao de Corte tenía recebido, mande dar su mandamiento para que Çebrian de León, contador y pagador de las dichos obras, del libro que en su poder está, saque las partidas qu'el dicho Nicolao de Cortes tiene recebido, y los maravedís que ella la reçibió, para lo qual, etc. El Licenciado Palacio.

59. 26 March 1552, payment to Juan de Orea for two "boys" [for the side doors of the west frontispiece] and three pomegranates and a crown for the Puerta de las Granadas, AGS, CMI, Leg. 1120: En veynte e seys de março del dicho año de 1552 años, libró a Juan de Orea, escultor, honze mill maravedís, que los uvo de dos niños y tres granadas, que labró en piedra, [y] una tiara para la puerta de los Gomeles, 11,000 maravedís.

60. 14 May 1552, payment for lintels of the doors of the west frontispiece, AGS, CMI, Leg. 1120: En catorce de mayo del dicho año, libró al Valenciano, carretero, vezino de Granada, ochenta e quatro y seys carretadas y media de piedra que truxó a las dichas obras, en las quales entran seys pieças grandes de la cantera de Santa Pudia, y ciento

y cinquenta y dos varas y media de syllares de la dicha cantera, cada carretada a ocho reales, y cada vara de syllares a seys reales, y de un lintel para una de las puertas menores de la portada principal que se tasó en nueve myll maravedís, y de otro lintel grande para la puerta principal que se tasó en veynte e ocho myll e ochenta y seys maravedís, y de subir diez pinos de la puerta Elvira a las dichas obras, a quatro reales y medio cada uno, que montan myll e quinientos e treynta maravedís, 84,204 maravedís.

61. 21 May 1552, payment to Esteban Sánchez for appraising ornament, AGS, CMI, Leg. 1120: En el dicho día, veynte e uno de mayo del dicho año, libró a Estevan Sánchez, entallador, vezino de Granada, dos escudos de dos tasaçiones que hizo de un escudo de armas ynperiales, de tres granadas, y dos niños e una tiara, 700 maravedís.

62. 2 July 1552, payment for the delivery of two columns for the west frontispiece, AGS, CMI, Leg. 1120: En dos de julio del dicho año, libró al Valenciano, vezino de Granada, veynte e dos mill quinientos e ochenta maravedís, que los uvo de aver por la trayda de dos colunas de la puerta principal, de la Syerra Elvira a las dichas obras, 32,280 maravedís.

63. 5 November 1552, payment for swags alongside one of the side doors of the west frontispiece, AGS, CMI, Leg. 1120: En çinco de nobienbre de 1552 años, libró a Juan de Orea, escultor, siete mill e tres çientos e quarenta y quatro maravedís, que los uvo de aver de la manifatura de dos colgantes que hizo, en piedra dura, de los pies derechos de la una de las dos puertas, que aconpañan la puerta prinçipal de las dichas casas reales, en que fueron tasadas por Estevan Sánchez y Juan de Maheda, aparejador, 7,343 [maravedís]. [A similar payment for the swag of the other door was made on 9 September 1553.]

64. 6 November 1552, payment for limestone from Alfacar for the chapel, AGS, CMI, Leg. 1120: En seys días del mes de noviembre del dicho año, libró a Estevan de Falconete, sacador de piedra, en las canteras de Alfacar, y vezino de Granada, diez myll y quinientos y quarenta y dos maravedís, que los uvo a aver, los çinco myll e treynta e un mara-

vedís, de quarenta e tres pieças de ochavos de rincones de piedra para la capilla de la casa real, a preçio, cada pieça de çiento y diez y siete maravedís, y los çinco myll y quinientos e quarenta y dos a cunplimiento a los dichos diez myll y quinientos e honze maravedís, de treynta pieças para esquinas de las dichas ventanas de la dicha capilla, a çiento y ochenta y siete maravedís cada una, 10,542 [maravedís]. [Similar payments were made to the same carrier at least once a month until December 1554.]

65. 8 January 1553, payment for four columns of grey marble and other pieces of stone, AGS, CM1, Leg. 1120: En ocho de hebrero de 1553 años, libró al Valenciano, carretero, noventa e nueve myll y docientos e setenta y seys maravedís, que los uvo de aver de trecientas y setenta y tres carretadas de piedra que trujo a las dichas obras de las canteras de Santa Pudia . . . y un myl e quatro cientos e cinquenta e siete maravedís, de ochenta y tres carretadas del dicha cantera de Alfacar . . . y trecientos e sesenta y cinco maravedís de ciento y siete varas de syllares . . . y diez y seys mill e setecientos y cinquenta maravedís, los quarenta y quatro ducados de quarenta y quatro pares de mulas que ocupó en traer quatro colunas de las canteras de la Syerra Elvira, y los seys ducados restantes, se los dieron por el trabaxo de su persona, que vino con ellas, y por las mulas, que venían hundidas cabo el caxo del carretón, que venían más a peligro, que montan todas estas dichas partidas, docientas y honze myll e setecientos. . . .

66. 26 April 1553, appraisal of Leval's battle relief for the west frontispiece, AA, Leg. 5, 19, fol. 5 (published by Gallego y Burín, "Antonio de Leval," pp. 344-345): En Granada, a veynte e seys días del mes de abril de mill e quinientos e cinquenta e tres años, Diego de Siloe, maestro mayor de la obra de la santa Yglesia de Granada, dixo quél a visto la segunda estilobata que labró el dicho Antonio Leval Flamenco, que contiene en sí, çiertas figuras de a cavallo e otras de a pié, en manera de batalla, la qual vysta y saminada, y la labor y perfición della, y lo que en ella ay añadido de más figuras, e de otros ornatos de más de lo que fizo Juan d'Orea en otra estilóvata, segunda quél labró para la dicha casa real, le paresçe que vale seys mill maravedís más que la que por sí labró el dicho Juan

d'Orea, por manera que vale la dicha estilobata y la tasa en quarenta e seys mill maravedís, e éste es su paresçer a lo que alcança, y es la verdad por el juramento que fizo en forma de derecho e firmólo de su nombre. Diego Siloee.

67. 13 May 1553, payment to Leval for his second pedestal relief (the battlepiece), AGS, CM1, Leg. 1120: En treze de mayo de 1553 años, libró a Antonio de Leval, escultor, quarenta e syete myll e quinientos maravedís, de una estilovata que labró para la portada prinçipal de la casa real, la qual tasó, por parte de Su Magestad, Diego de Syloee, maestro mayor de la yglesia mayor de Granada, y por parte del dicho Antonio de Leval, Florentín Geralton, vezino de la villa de Saviote, 47,500 maravedís.

68. 9 June 1553, payment to Leval for the casing of the side doors of the west frontispiece, AGS, CM1, Leg. 1120: En el dicho día nueve de junio del dicho año, libró a Antonio de Leval, escultor, veynte myll e ochocientos y treynta maravedís, que los uvo de aver de la labor de un lintel y dos pies derechos para una de las puertas açesorias de la portada principal de la casa real, la[s] qual[es] fueron tasadas por dos personas nonbradas, por cada una de las partes, una.

69. 4 October 1553, payment to Juan del Campo for work on the south window, AGS, CM1, Leg. 1120: En quatro de octubre de 1553 años, libró a Juan del Canpo, vezino de Granada, digo, del Alhambra, de cientos ducados de succoro para en quenta de la manifatura de la ventana de mármol negro que haze en la puerta açesoria de la dicha casa real, que encomeçó a labrar maese Nycola de Corte, que falleció, con los quales les tiene recibidos quatro cientos ducados, porque de los otros docientos, le dió el conde de Tendilla otra libranças, estando en Málaga, 75,000 maravedís.

70. 5 January 1554, payment for limestone for the chapel, AGS, CM1, Leg. 1120: En cinco días del mes de henero de 1554 años, libró a Estevan de Falconete, treynta mill y quatro cientos e treze maravedís, que los uvo de aver de treynta y siete bolsores de los menores, para la capilla de la casa real, a seys reales y quinze maravedís cada uno, y de diez pieças de salmeres, a siete reales y quinze

maravedís cada una, y de diez esquinas para la dicha capilla, a cinco reales e medio cada uno, y de diez esconces para los ochavos, a ciento y diez y siete maravedís cada uno, y de docientas e setenta y nueve varas e syllares, a sesenta maravedís cada vara de saca, 30,313 maravedís. [Similar payments were made on 3 February, 12 May, 9 June, 10 September, 13 October and 22 December.]

71. 3 February 1554, appraisal of two returns of a pedestal of the west frontispiece, AA, Leg. 5, 19, fol. 8 (published by Gallego y Burín, "Antonio de Leval," p. 67): En tres de hebrero de 1554, tasamos Diego Siloe y Esteban Sánchez, dos retornos de las estilóbatas de la piedra de Sierra Elvira, que tenía labradas Antonio del Valle, escultor, para la portada prinçipal de la real casa del Alhambra, y visto y esaminado, por vista de ojos los dos dichos retornos de las dichas estilóbatas, en las quales están esculpidas çiertos espojos de guerra y tiros de artillería, allamos que valen entramas a dos sesenta ducados, e lo firmamos de nuestros nombres. Diego Siloee, Esteban Sánchez.

72. 10 February 1554, payment to Leval for two returns of a pedestal of the west frontispiece, AGS, CMI, Leg. 1120: En el dicho día, libró a Antonio de Leval, escultor, sesenta ducados, que los uvo de aver por la hechura de dos retornos de una estilóvata de la portada prinçipal, los quales tasó, por parte de Su Magestad, Diego de Syloe, maestro mayor de las obras de la yglesia mayor de Granada, e por parte de Antonio de Leval, Estevan Sánchez, entallador, 32,500 maravedís.

73. 10 August 1554, payment for a column and other pieces of marble from Macael, AGS, CMI, Leg. 1120: En el dicho día, diez de Agosto del dicho año, libró a Sebastián Lizana, cantero, de una coluna con su vasa e capital labrada de picola, cinquenta ducados, puesto en las canteras de Macael, y de nueve pieças para la portada prinçipal, todo de mármol blanco de las dichas canteras de Macael, en sesenta ducados, puesto todos en las dichas canteras, e de traer la dicha coluna a las dichas obras de la casa real, ciento y setenta ducados, e de traer las dichas nueve pieças con la vasa e capitel de la dicha coluna, treze myll e ciento y veinte y cinco maravedís, y del tiempo que ocupó en traer la dicha coluna y adobios del carro, y en quartas y madera

que conpró para tiradores, treynta ducados, que monta la dicha librança . . . 84,029 maravedís.

74. 20 August 1554, specifications for columns from Macael for the round courtyard, AA, Leg. 5, 220: Condiçiones con que se a de rematar la saca de las colunnas de mármol de las canteras de Macael para la casa real d'esta Alhambra son las siguientes: Primeramente, se an de sacar sesenta y tres colunas, la medida de las quales abaxo yrá declarado. Así mismo, se trairán, para cada coluna d'estas, dos pieças para basas y capiteles, por manera que serán por todos, çiento y veynte y seys, las medidas de las quales son las siguientes: Las colunas mayores an de ser treynta y una, y an de tener, de altura de tronco, dieziseys pies, y de grueso, por la parte baxa, dos pies [*added above in another ink*: y dos dedos] otorgados de diámetro sin el filete baxo, las quales an de traer desbastadas en el mismo tronco el filete baxo y alto, conforme a la coluna que está traída en esta Alhambra para el mismo efeto, y, así mismo, las an de dar desbastadas y labradas a picola, conforme a una regla cerca que para ella le será dada. Los mienbros d'estas colunas para las baxas an de tener de alto pie y medio otorgados y [fol. 1v] an de ser treynta y una pieças; y las otras treynta y una para los capiteles an de tener a pie y dos dedos de alto; y todas estas pieças en este capítolo contenidas así baxas como capiteles, an de tener, por todos los lados, enquadrado a tres pies y un quarto. Las otras treynta y dos colunas altas an de tener a doze pies de tronco, y de grueso por la parte baxa, pie y medio otorgado; y estas dichas colunas an de venir labradas y desbastadas, conforme como está dicho en el capítulo [de] las colunas mayores; y así mismo se les dará otra cerca por donde se labren. Las otras sesenta y quatro pieças restantes para las baxas y capiteles d'estas colunas, la medida de las quales será yguales en esta manera, que tengan de alto a tres quartos de pie, y más dedo y medio, y de ancho en quadrado dos pies y dos dedos. Es condición que todas aquestas pieças las an de dar puestas en cargadero, y sanas, y sin desportillas y de muy buen mármol blanco y vetas, ni levantes. Luis Machuca. [fol. 2] En XX de agosto de MDLIII años, yo el señor Juan Arias de Mancilla, veedor de las obras de las casas reales d'este Alhambra, entregó a mí el escrivano yuso escripto, estas condiciones para que las haga pregonar nueve días en la plaza Bibarambla, y que

la obra de la Santa Iglesia de Granada asiente los pregones e reciba las posturas que se hizieren.

75. 13 October 1554, payment a keystone and two springers (for an arch) in the grey marble of the Sierra Elvira, AGS, CM1, Leg. 1120: En el dicho día treze de otubre del dicho año, libró al Valenciano, carretero, ciento y diez ducados, que los uvo de aver por la trayda de dos salmeres y una clave de mármol puesto de las canteras de la Syerra Elvira, 41,250 maravedís.

76. 13 October 1554, payment for the top molding of the chapel, AGS, CM1, Leg. 1120: En treze de otubre del dicho año, libró a Estevan de Falconete, honze myll e noveçientos e quarenta maravedís, que los uvo de aver de sesenta pieças de los sobrados de la capilla, a carretada cada pieça, a çiento y diez y siete maravedís cada una, de saca de las canteras de Alfacar, y de ochenta e dos varas de syllares, a sesenta maravedís la vara de saca y trayda, que dió el mes de septienbre pasado d'este dicho año.

77. 13 April 1555, payment to Leval for the returns of a pedestal of the west frontispiece, AGS, CM1, Leg. 1023: A Antonio Leval, Flamenco, escultor, sesenta ducados, que montan veinte e dos mill e quinientos maravedís, que los ovo de aver por la labor de dos retornos d'estilóbatas, esculpidos de despojos de guerra que hizo para las dichas casas reales, que fueron tasados en los dichos maravedís por Juan de Cubillana, entallador, persona nonbrada por el dicho veedor y por Diego de Aranda, ymaginario, por el dicho Antonio Lebal para lo susodicho, por librança del dicho conde de Tendilla. Fecha a 13 de abril del dicho año de 1555 años, y testimonio de la dicha tasación questa signada del dicho Luis de Rivera, escrivano y fée e la paga.

78. 18 May 1555, appraisal of the south window by Siloe and Luis Machuca, AA, Leg. 5, 32 (published by Gallego y Burín, "Antonio de Leval," p. 344, with several errors corrected here): En el Alhambra, a diez y ocho de mayo de mill e quinientos e cinquenta e cinco años, los dichos Diego de Siloe, maestro maior de las obras de la santa yglesia de Granada, e Luys Machuca, maestro maior de las obras de las casas Reales d'esta Alhambra,

dixeron que ellos an visto la dicha ventana de piedra prieta de la Syerra Elvira, e ansí mismo, an visto la escriptura e condiciones de como se avía de hacer y la traça della y atento que la dicha ventana está hecha y acabada, conforme a las dichas escripturas, e condiciones, e traça, y en toda la perfición que se requieren para el lugar donde está, les parece que vale la manifatura della, syn la piedra e syn el asiento, mill y dozientos e noventa ducados, que montan quatrocientos e ochenta e tres mill y setecientos cinquenta maravedíses. E que esto es su parecer, y lo que vale a lo que alcançen, só cargo del juramento que primeramente hizieron ambos en forma de derecho, de hacer la dicha tasación bien, a fielmente a lo que alcançasen, syn tener acessión de persona alguna, e firmáronlo de sus nombres. Luis Machuca. Diego Siloe.

79. [19-24] May 1555, rejection of the Siloe-Machuca appraisal of the south window by Juan del Campo, AA, Leg. 5, 32, fol. 3 (published by Gallego y Burín, "Antonio de Leval," pp. 344-345): Juan del Campo, veso las manos de vuestra señoría y digo que, por mandado de vuestra señoría, Diego de Siloe y Luys Machuca tasaron la manifatura de la ventana de piedra prieta que yo acabé para la casa Real, y la tasaron en mill y doçientos y noventa ducados, y no embargante que la labor de la dicha ventana monta y vale muchos maravedises más que la dicha tasación, y que yo los he gastado en harta cantidad y por el grande agravio que recibo en la dicha tasación, e querido reclamar della, pero por otra parte, teniendo respeto al servicio de vuestra señoría, por cuyo mandado yo acabé la dicha ventana, e tenido, por más acertado, dexallo en manos de vuestra señoría, para que vuestra señoría fuere servido, atento [a] la razón que yo tengo, me mande hazer alguna gratificacíon, y me mande librar lo que obiere de aver con brebedad, porque estoy muy alcançado y adeudado, que de lo que vuestra señoría fuere servido, soy yo muy contento y recibo muy gran merced.

80. 25 May 1555, payment of sum of Siloe-Machuca appraisal to Juan del Campo, AA, Leg. 5, 32, fol. 3 (published by Gallego y Burín, "Antonio de Leval," p. 345, with several errors corrected here): En la Alhambra, a veynte et cinco de mayo de mill e quinientos et cinquenta e cinco años, la presentó ante su señoría, el dicho Juan del Campo.

Su señoría, syéndole leyda la dicha petición, mandó que se le libre lo que se a tasado y si quisiere pedir alguna costa, siga su justicia. Diósele libramento que lo pidió el dicho Juan del Campo. [Later statements on 21 and 26 June 1555 indicate that Juan del Campo asked that the sum be reconsidered but it was not changed; see AGS, CMI, Leg. 1120.]

81. 26 June 1555, final payment to Juan del Campo for completing the south window, AGS, CMI, Leg. 1023: A Juan del Campo, estante en la dicha Alhanbra, mill e dozientos nobenta ducados, que montan quatro çientas y ochenta y tres mill e siete çientos e çinquenta maravedís, que ovo de aver en que fue tasada la manifatura de la ventana de piedra prieta qu'el y Nicolao de Corte, escultor defunto, hizieron para las dichas obras de las casas reales, e dieron acabado conforme a la escritura que, sobre ello, otorgaron ante Andrés Ruis de Carrión, escrivano de la dicha Alhanbra, por librança firmada del dicho conde de Tendilla. Fecha 26 de junio del dicho año 1555 años; en la qual dize, que los dichos 180,000 maravedís d'ellos, que por certificación del dicho beedor de las dichas obras, paresçió qu'el dicho pagador dió e pagó al dicho Nicolao de Corte, en diferentes vezes, hasta que fallesçió, de socorros para en quenta de la fechura de la dicha ventana, no teniendo librança sin otro recabido alguno, por razón de una escriptura que se otorgó ante Francisco de Santa Cruz, escribano de su magestad, después de difunto el dicho Nicolao de Corte, por su heredero, y por el dicho Juan del Canpo, en que se conçertaron que el dicho Juan del Canpo tomase la dicha ventana en el estado que la dexó el dicho Nicolao de Corte quando fallesçió, e la acabase, e la perdia o ganançia fuere suya, como paresçe por la dicha librança e por las dichas escrituras, por lo qual se le resçiven aquí en quenta, los dichos 1290 ducados.

82. 20 December 1555, payment on account for marble for four boys (over the side portals) and two roundels of the west frontispiece, AGS, CMI, Leg. 1023: A Savastián de Liçana, cantero en las canteras de Macael e Filabres, doze ducados, que montan quatro mill e quinientos maravedís, que ovo de aver de socorro para en quenta de lo que ha de aver, por quatro mochachos que sacó en las dichas canteras, y dos redondos para la portada prinçipal de la dichas obras, como paresçe por otra

librança del suso dicho. Fecha a 20 de deziembre del dicho año de 1555 años, y por certificación del dicho beedor, con fée suia de a paga del dicho Luis de Rivera, escrivano.

83. 8 January 1556, payment to Leval for two returns of a pedestal of the west frontispiece, AGS, CMI, Leg. 1023: A Maestre Antonio, escultor, nobenta ducados, que montan treinta e tres mill y siete çientos y çinquenta maravedís, por otros tantos en que fueron tasados y apresçiados por personas para ellos nonbrados, dos retornos de una estilibota a donde están esculpidas unas batallas de unas figuras, de una batalla, que hizo e labró para la puerta principal de la dicha casa real, por librança firmada del suso dicho. Fecha el dicho dia 8 de henero del dicho año de 1556, con fée de la paga de los susodichos. [Another payment was made on 30 May 1556.]

84. 4 April 1556, payment to Juan de Cubillana for carving part of the Doric frieze of the west frontispiece, AGS, CMI, Leg. 1023: Al dicho Juan de Cubillana, entallador, diez ducados, que montan tres mill y siete çientos y çinquenta maravedís, que ovo de aver de socorro para en quenta de lo que ha de ver, de la hechura de un resalto del frisço que haze para la portada prinçipal de la dicha casa real, como paresçe por librança firmada del dicho don Pedro de Bovadilla, que servía ofiçio de capitán general del dicho reino de Granada, por poder del dicho conde de Tendilla. Fecha a quatro de abril del dicho año de 1556 años, con fée de la paga. [Other payments for his work on the frieze were made to Cubillana on 8 May, 5 July, 1 August and 8 November 1556.]

85. 16 April 1556, payment for marble from Filabres for the boys over the side portals of the west frontispiece, AGS, CMI, Leg. 1023: A Pedro Marín, cantero, veinte e quatro mill maravedís, que los ovo de aver por la traída de quatro pieças de mármol blanco que truxo desde la Sierra de Filabres a las dichas obras para los niños de los postigos de la puerta prinçipal de la dicha casa real, a presçio, cada una pieça, de 6,000 maravedís, como paresçe por otra librança firmada de don Pedro Bovadilla. Fecha a 16 del dicho mes de abril del dicho año de 1556 años y por çertificaçión del dicho

veedor Juan Arias de Mansilla, con fée suia de la paga del dicho Luis de Rivera, escrivano.

86. 30 May 1556, payment to Leval for two reliefs accompanying the battle relief, AGS, CM1, Leg. 1120: En treynta de mayo de 1556 años, libró Antonio de Leval, escultor, çinco myll e seys çientos maravedís, que los uvo de aver de la echura de dos retornos de estilobata, esculpidos en batalla para la portada principal, demás de los seys mill maravedís que se le libró en quatro de abril d'este dicho año.

87. August 1556, payment to Tomás de Morales for carving part of the Doric entablature of the west frontispiece, AGS, CM1, Leg. 1120: Al dicho Tomás de Morales, entallador, tres mill y çiento y noventa e seis maravedís, en cunplimiento de 4,692 maravedís, que ovo de aver de la hechura de las dos pieças de la corniça dórica que labró para la portada prinçipal de las dichas casas reales. . . . Fecha primero de Agosto del dicho año de 1556 años, con fée de la paga. [An earlier payment on 5 July was probably for the same work.]

88. 17 August 1556, payment for pieces of the sandstone frieze for the upper story of the west entry, AGS, CM1, Leg. 1023: Al dicho Sebastián Días, Valençiano, carretero, hochenta y quatro mill y seys çientos y sesenta maravedís, que ovo de aver por la piedra que truxó a las dichas obras desde la dicha cantera de Santa Pudia en esta manera: 45,500 maravedís d'ellos de 61 pieças d'ellas de los pies derechos de a dos carretadas cada una, e las otras 10 pieças de los frisadis para aconpañamiento de la portada prinçipal de tres carretadas la pieça, e las seys pieças restantes para cunplimiento a las dichas 61, y fueron de los friscados de los pieças menores y tenía cada una, dos carretadas y media, que fueron todas 45 carretadas, a preçio cada carretada de diez reales. . . .

89. 26 September 1556, payment for delivery of a column [for the courtyard] from Turro, AGS, CM1, Leg. 1120: A çietros carreteros contenidos en una çertificaçión firmada del dicho veedor Juan Arias de Mansilla, fecha a 26 de Septiembre del dicho año de 1556 años, veinte e un mill e seteçientos y sesenta maravedís, que los ovieron de aver por el tiempo que cada uno d'ellos se ocupó

con sus mulas y carros en traer, para las dichas obras, desde las canteras del Turro, una coluna de jaspe, que se entregó en ellas a Bartolomé Ruiz, tenidor de materiales, como paresce por la dicha çertificaçion e por librança del dicho conde de Tendilla. Fecha a 26 de setienbre del dicho año, 1556 años.

90. 26 September 1556, payment for the delivery of a column from Turro, AGS, CM1, Leg. 1120: En veynte e seys de septienbre del dicho año, libró a Francisco de Arague y otros carreteros, veynte e un myll y seteçientos e sesenta maravedís, que los uvo de aber de la trayda de una coluna de xaspe para el patio de la casa real, lo que se repartió entre doze carreteros que la trujeron. . . . [Comparable payments for the delivery of columns were made on 16 June 1556, 10 July, 13 September and 5 November 1557, 8 September 1558 and 17 January 1559.]

91. 5 December 1556, payment for standstone for shells (shell-faced half-domes), AGS, CM1, Leg. 1120: En çinco de dizienbre del dicho año libró a Martín Durenda, sacador de piedra, tres myll e quarenta e tres maravedís, que los uvo de aver de quarenta e nueve varas e syllares a real y medio cada vara de saca, y de dos pieças para las veneras, de a dos carretadas cada una, a preçio e ocho reales de saca cada una. [Comparable payments were made on 3 January and 5 February 1557.]

92. 22 May 1557, instructions for the delivery of columns from Turro for the round courtyard, AA, Leg. 5, 43: Condiçiones con que su señoría manda traer las colunas del Turro: Primeramente, es condiçión que el que se obligare de traer estas dichas colunas, las quales son treynta y dos, las ha de traer dende la cantera del Turro, donde se sacan, asta ponerlas dentro en la obra real d'esta Alhambra, donde se suelen descargar junto al taller donde labran los ofiçiales de la piedra dura, con que se an de descontar las que estubieren traídas. . . . En la Alhambra de veynte e dos de mayo de myll e quinientos e çinquenta y siete, el capitán Juan Arias de Mansylla, veedor de las obras de las casa reales d'esta Alhambra, dió y entregó a my, Luys de Ribera, escribano de su maestad . . . [illegible] contenidas para que las haga pregonar en la obra de la santa yglesia de Granada y en las plaças della,

y reciba las posturas que hicieren. [Pedro de Astiaço contracted to deliver the columns on 11 July, but he must have withdrawn from it, because Gabriel Ramírez signed a contract for the columns on 18 July; see Leg. 5, 41.]

93. 4 June 1557, payment to Leval for the carving of the four boys over the side portals of the west frontispiece, AGS, CMI, Leg. 1120: En quatro de junio de 1557 años, libró a maese Antonio de Leval, escultôr, docientos ducados, por quatro figuras de muchachos que labró en mármol blanco para la portada prinçipal, los quales tasó Diego de Syloee por la parte de su magestad, y por la de maese Antonio, Estaban Sánchez, entallador.

94. 22 December 1557, payment for white marble tympanums of the pediments of the three doors of the west frontispiece, AGS, CMI, Leg. 1120: En veynte a dos dizienbre del dicho año, libró a mase Antonio de Leval, escultor, treze myll e çiento e veynte e çinco maravedís, que los uvo de aver por la manifatura de los tres ténpanos de mármol blanca para frontes espicios para la portada prinçipal, que fueron tasados en el dichon precio por dos personas, por cada una de las partes una, que montan los dichos maravedís.

95. 10 July 1558, payment for white marble for the pedestals [of the upper story] of the west frontispiece, AGS, CMI, Leg. 1023: A Sevastián de Lizana, vezino de Granada, veynte e dos ducados y medio, que montan ocho mill e quatro cientos e treynta e siete maravedís y medio, que los ovo de aver por otros tantos qu'el pagó de la trayda de los dos retornos de mármol blanco, que se concertó con él que truxese para la puerta principal de las dichas casa reales a los carreteros de Macael donde sacaron, como paresce, por otra librança del dicho conde de Tendilla. Fecha a 10 de julio del dicho año 1558 y por certificación del dicho veedor.

96. 3 September 1558, payment on account to Leval for the carving of the two Victories of the center portal of the west frontispiece, AGS, CMI, Leg. 1023: A Antonio de Lebal, escultor, treinta ducados, que valen onze mill y docientas y çinquenta maravedís, de socorro, para en quenta de lo que ovo de haver por la hechura de dos figuras de mugeres de mármol blanco que estaba haziendo

para la portada prinçipal de la dicha casa real, los quales son demás de otros treinta ducados que se le dieron de socorro para en quenta de lo susodicho, como paresçe por otra librança del conde de Tendilla.

97. 9 September 1559, payment on account for the lintel of the center door of the west frontispiece, AGS, CMI, Leg. 1023: A Juan de Cubillana, entallador, diez y seis ducados que montan seis mill maravedís, que se cedieron de socoro para en quenta de lo que obo de aver de las manifaturas de lintel, que estava labrando para la portada prinçipal de las dichas casas reales, por librança firmada de don Luis Hurtado de Mendoza. Fecha nueve de setienbre de 1559 años, los quales resçivió el mismo. [A similar payment on account was made on 9 September 1560.]

98. 9 December 1559, specifications for additional grey marble needed to complete the west frontispiece, AA, Leg. 5, 45, fol. 1: Condiçiones con las quales se a de sacar la piedra negra que falta en la portada prinçipal es la siguiente: Ocho pieças que tengan seys pies y dos dedos, por un lado, y por el otro lado, cuatro pies y dos dedos, y por el otro lado, a se derobar y dar destabastado conforme al contramolde, tiniendo de galga un pie otorgada. Así mismo, se an de sacar otras dos pieças para cornisas que tengan a çinco pies y quadrado, digo quadradas tiniendo de galga pie y medio y una pulgada, Toda esta dicha piedra a de ser de la Sierra Elvira, de las mas negra, que ni sea de la parda, y que no tengan ni ningún levante, ni pelo y en la bonded de la piedra, y así mismo, en su desbasto, a de venir a contento de los sobrestante d'esta obra real. Luis Machuca.

99. 23 December 1559, payment for materials needed to assemble the west frontispiece, AGS, CMI, Leg. 1023: A Gómez Yzquierdo, caldero, quatro mill y ocho çientos e nobenta y siete maravedís y medio, que los ovo de aber por treze arrobas e libra y media de plomo labrado en planchas, que dél se conpraró para conmençar asentar la portada prinçipal de las dichas casas reales, a preçio de 15 maravedís la libra, como paresçe por certificación del dicho behedor Mansilla y por librança del dicho don Luis Hurtado de Mendoça. Fecha en el Alhanbra a 23 de diziembre del dicho

año de 1559. [Comparable payments were made on 8 and 23 September 1559 and 2 September 1560.]

100. 17 March 1560, payment for equipment to lift columns into place in the west frontispiece, AGS, CMI, Leg. 1120: El dicho día, diez y seys de março del dicho año, libró a Pedro Valero, cordonero, nueve myll y ochoçientos e quarenta maravedís, que los uvo de aver de tres guindaletas de cañamo que dél se conpraron para las dichas obras, que pesaron nueve arrobas y veynte e una libras, a quarenta maravedís la libra, que fueron para subir las colunas de la portada principal.

101. 29 May 1560, report on payments on account to Ramírez for the delivery of the twenty-nine columns from Turro, AA, Leg. 5, 46, fol. 7: Respondiendo, a lo que por vuestra señoría me es mandado, açerca de la quenta de Gavriel Ramírez, digo que a él se le deven la trayda de veynte y nueve colunas a sesenta ducados cada una, que montan seis çientos y çinquenta y dos myll y quinientos maravedís. Héselos pagado en esta manera, como pareçe por el libro de paga. [He lists thirty-eight payments from 21 August 1557 through 26 November 1558.] Ansí que pareçe que ha reçebido el dicho Gavriel Ramírez en estas treynta y ocho partidas, seisçientos y çinquenta y un mil, novecientos y un maravedís, como parecçe por el libro de paga a que me refiero, y esto es lo que tengo desir y no otra cosa. Ciprián León.

102. 1 June 1560, agreement to deliver the capitals and bases for the columns of the courtyard, AA, Leg. 206, 3: En el Alhambra, primero de junio de mill e quinientos e sesenta años Gavriel Ramírez, vezino de Granada en la colación de Santa Ana, dixo que ponía, e puso la trayda de las sesente e quatro vasas y capiteles para el patio que se an de traer desde la cantera del Turro a estas obras reales, que son de jaspe, en catorze ducados cada pieça, una con otra, y obligose de las traer en el dicho preçio siéndole rematadas. Para ello obligó su persona y bienes, abidos y por aver, y otorgolo como de sentençia pasada en cosa juzgada, y firmolo de su nombre, Bartolomé Ruiz e Yñigo de Cariga, vezinos de la dicha Alhambra Gavriel Ramírez.

103. 16 July 1560, payment for sandstone lintels for the frame of the window [above the west fron-

tispiece], AGS, CMI, Leg. 1023: Veinte y nueve mill y syete cientos y diez y seis maravedís por otros veynte y tres cornijas para la portada prinçipal, a razón de 38 reales cada una, la qual hera de piedra franca de Santa Pudia. Nueve mill y ciento y cinquenta maravedís por quinze tranqueros para el aconpañamiento de la ventana, que eran de piedra franca, de 18 reales cada uno.

104. 21 August 1560, payment for the delivery of the bases and capitals of the columns of the courtyard, AGS, CMI, Leg. 1120: En veynte e uno de agosto, libró a Pedro Astiaço, carretero, ochenta myll y quinientos y doze maravedís, que los uvo de aver de la trayda de las sesenta y quatro vasas y capiteles de xaspe de las canteras del Turro para las dichas obras, a precio de treynta e siete reales cada pieça en que le fueron rematadas de trayda.

105. 13 March 1561, Leval's objection to the appraisal of his Victories for the west frontispiece, AA, Leg. 5, 19, fol. 4 (published by Gallego y Burín, "Antonio de Leval," p. 73): Muy yllustre señor: Antonio de Lebal, escultor, digo que a mí se me notificó la tasación que se hizo de las dos figuras de mujer de mármol blanco que e hecho para la puerta principal de la casa real d'esta Alhambra, la qual tasaron en çien ducados por cada figura, en la qual dicha tasación yo resçibo notorio agrabio, porque las dichas dos figuras mereçe la manifatura d'ellas mas de quinientos ducados, por manera qu'el agrabio que, de la dicha tasación, resçibo es muy eçesibo, y los tasadores que lo tasaron, como es obra tan sotil e imaterial que no usan cada día, no están tan instrutos para poder tasar lo que mereçían de hechura. Por tanto a vuestra señoría, suplico mande nombrar otros tasadores de çiençia y conçiençia que entiendan vien que yo sea desagrabiado, pues la obra es tal que lo requiere, para lo qual etc. En Granada, treze de março de 1561 años, la presentó ante mi, el escribano, el dicho Antonio de Leval. [Notary's signature is illegible.]

106. 24 July 1561, payment to Leval for the two Victories of the west frontispiece, AGS, CMI, Leg. 1023: Al dicho Antonio de Lebal, escultor, setenta y tres mill y seteçienta çinquenta maravedís, que ovo de haver de resto de 85,000 en que fué retasada la manifatura de las dos mugeres de mármol blanco

que labró para la portada prinçipal de las dichas casas reales, como paresçe por çertificaçión del dicho veedor y por librança del dicho don Luis. Fecha 24 de Julio del dicho año de 1561. . . .

107. 30 August 1561, payment for limestone blocks placed beneath the columns of the round courtyard and sandstone for the wall of the corridor, AGS, CM1, Leg. 1120: En postigo de agosto del dicho año, libró a Martín de Valastiguin, sacador de piedra, çinquenta e un myll y quatro çientos e treynta e tres maravedís e medio, que los uvo de aver de senta [sic] y çinco pieças quadradas de tova de las canteras de Alfacar, para debaxo de las colunas del patio, a nueve reales cada una de saca, y de 119 varas y media de dobelas de tova a dos reales y media cada una, y de saca de treynta y siete pieças de las canteras de Santa Pucia, entre salmeres y bolsores, a 17 reales cada pieça como se contiene una librança de 24 Septienbre d'este dicho año. [Similar payments were made through November 1565.]

108. 6 June 1562, payment on account to Leval for his work on the two medallions of the west frontispiece, AGS, CM1, Leg. 1023: Antonio de Lebal, escultor, quarenta y çinco ducados, que montan diez y seis mill y ocho çientos y setenta y çinco maravedís, que los ovo de aver de socorro, para en quenta de la manifattura de dos espejos redondos de mármol blanco que estava haçiendo para la portada prinçipal de la dicha casa real, por librança firmada del dicho conde de Tendilla. Fecha 6 de junio de 1562 años, y los dichos maravedís resçivió el mismo.

109. 24 September 1562, payment for stone for the colonnade and corridor of the courtyard, AGS, CM1, Leg. 1023: A Pedro de Astiazo, vezino de Granada, noventa y nueve mill y quatro çientos y setenta y çinco maravedís y medio, que obo de haver por el acareto de la piedra que llebó con sus bueyes y carros para las dichas obras de la casa real del dicha Alhambra, en los preçios y cantidad siguiente, en esta manera: treinta y çinco mill y treçientos sesenta maravedís, por sesenta y çinco pieças quadradas de toba de Alfacar, para debaxo de las colunas del patio, a preçio de 16 reales cada una pieça y trayda. Veinte y seis mill y seis çientos y veinte y dos maravedís, por veinte y siete bolsores de las canteras de Santa Pudia de piedra franca,

para las corredores del patio, a preçio de 29 reales cada una de trayda. Catorze mill y noveçientos y sesenta maravedís, por siete cornijas y tres salmeres de piedra franca de Santa Pudia, en preçio de quarenta y quatro reales cada pieza de trayda. Veinte y dos mill y quinientos y treinta y tres maravedís y medio, por çiento y veinte baras y media de dobelas de piedra de toba de Alfacar, para los corredores, a çinco reales y medio cada babza [sic]. Que son los dichos noventa y nueve mill y quatro çientos y setenta y çinco maravedís y medio, como paresçe por certificaçión del veedor de las dichas obras, y por librança firmada del dicho conde de Tendilla. Fecha el dicho día 24 de Setienbre del dicho año de 1562, y conoçimiento del dicho Bartolomé Ruiz, tenedor de materiales, del reçivo de la dicha piedra, y los dichos maravedís resçivió el mismo en presençia de los suso dichos. [A comparable payment was made on 7 April 1563.]

110. 3 October 1562, appraisal of Leval's first round cavalry relief for the west frontispiece, AA, Leg. 5, 19, fol. 35 (published by Gallego y Burín, "Antonio de Leval," p. 78): En la çiudad de Granada, de tres días del mes de octubre de mill e quinientos e sesenta e dos años, los dichos Estevan Sánchez, tasador nombrado por parte del dicho maestre Antonio Leval, e Toribio Liévana, nombrado por el dicho veedor Juan Arias de Mansilla, aviendo jurado como primeramente juraron en forma de derecho, de hazer esta tasaçión bien y fielmente a lo que alcançaren, sin respeto ni asçesion de personas, dixeron que ellos an visto el dicho redondo de mármol blanco, que lleva tres figuras a cavallo y un soldado a pié, que a labrado el dicho Antonio Leval, y atento que está bien hecho a acabado en perfisión, les pareçe, a el dicho Estevan Sánchez, que vale çiento y ochenta ducados, y a el dicho Torivio de Liévana, çiento y quarenta ducados, y esto es su pareçer, porque no se an podido conformar por el juramento que hizieron y firmáronlo de sus nombres. Estaban Sánchez, Toribio de Liévana.

111. 26 November 1562, final payment to Leval for disputed round cavalry relief, AGS, CM1, Leg. 1023: Al dicho Antonio Lebal, escultor, veynte y seys mill dozientos y çinquenta maravedís, con los quales y con los treynta mill maravedís que antes tenía reçividos de socorro por otras dos libranças, la una de 24 de julio de 1559 y la otra de 16 de

junio d'este año qu'esta antes d'esto, se le acavaron de pagar çiento y çinquenta ducados en que se tasó la manifatura del redondo de mármol blanco que hizo para la portada prinçipal de las dichas casas reales, como pareçe por testimonio de escrivano y çertificaçión del veedor de las dichas obras y librança firmada del dicho don Luis Hurtado de Mendoça, fecha a 26 de noviembre del dicho año [1562], los quales reçivió el mismo.

112. 1 December 1562, payment for limestone for the annular vault of the courtyard and sandstone for the Doric entablature of the colonnade, AGS, CM 1, Leg. 1023: Al dicho Martín de Berastigui, diez y seis mill y nove çientos y diez y seis maravedís y medio, que obo de aver los doze mill y treçientas y treinta y siete maravedís d'ellos por la saca de çiento y quarenta y çinco baras y media de dobelas de toba de la canteras de Alfacar, para el corredor del patio, a dos reales y medio cada bara, y los 4,624 restantes por seis cornixas y dos bolsores que sacó de las canteras de Santa Pudia a 17 reales cada pieça, como paresçe por çertificaçión del veedor de las dichas obras, en que dize que no se haze cargo d'esta piedra al tenedor de las materiales, por quanto se le hazía por otro librança que se dió al dicho Pedro de Astiazo, de la trayda de la dicha piedra por librança, firmada del dicho don Luis Hurtado de Mendoça. Fecha a primero de diziembre del dicho año de 1562 y los dichos mismo resçivió el mismo. [Similar payments were made in most months for which account records are preserved through August 1567.]

113. 21 January 1563, payment for Maeda's appraisal of Leval's second round cavalry relief, AA, Leg. 5, 19, fol. 40 (published by Gallego y Burín, "Antonio de Leval," pp. 81-82): En Granada, a veynte e un días del mes de henero de mill e quinientos e sesenta e tres años, el dicho Juan de Maeda, terçero nombrado por su señoría, dixo quél vió ayer el dicho segundo redondo de mármol blanco de que agora se trata, que a fecho el dicho Antonio Leval, el qual es él de la mano derecha como entran en la puerta donde se a de poner, el qual está hecho e acabado con toda perfiçión conforme al otro redondo primero, y aún con alguna más obra qu'el otro, y atento a lo susodicho bale de hechura, los çiento e zinquenta ducados que se pagaron por el otro primero redondo, qu'es el preçio en que éste,

que declara como terçero que fué, lo tasó, e questo es la verdad al que alcançe por el juramento que hizo primeramente en forma de derecho de fazer la dicha tasaçión bien y fielmente a lo que alcançase, e firmólo de su nombre. Juan de Maeda. [Comparable payments on account were made on 22 January and 26 February 1564 and 16 February 1566.]

114. 7 April 1564, payment for grey marble for two lions for the west frontispiece, AGS, CM 1, Leg. 1023: Mill y docientos y veinte y quatro maravedís por dos piedras negras de la Sierra Elvira para dos leones para la portada principal, 18 reales cada una. . . . Fecha a siete de Abril del dicho año de 1563.

115. 12 October 1563, payment for a column in white marble from Macael, AGS, CM 1, Leg. 1023: A Sebastián de Lizana, vezino de Granada, çinquenta ducados que montan diez y ocho mill y seteçientos y çinquenta maravedís, que los obo de haver por la saca de una coluna de mármol blanco labrada a punta de pico, la con su basa e capitel que sacó, a su costa, de las canteras de Macael, en el dicho preçio como paresçe por librança, firmada del dicho conde de Tendilla, Fecha a doze de otubre del dicho año de 1563, los quales resçivió el mismo en presençia de los suso dichos.

116. 14 October 1564, payment for the delivery of ten columns from Turro for the courtyard, AGS, CM 1, Leg. 1120: En catorze de octubre del dicho año libró a Pedro de Astiaço, carretero, sesenta e siete mill y quinientos maravedís, que los uvo de aver de la trayda de diez colunas de xaspe para los corredores del patio, a diez y ocho ducados cada una de trayda. [Other columns were delivered on 25 November and 14 December 1564.]

117. 5 May 1565, payment for columns from Turro for the gallery of the courtyard, AGS, CM 1, Leg. 1023: Al dicho Pedro Astiasu, çiento y diez y ocho mill y nueve çientos y setenta y dos maravedís, que los hubo de aver por la piedra que da en esta çertificaçión, firmada del dicho veedor Juan Arias de Mansylla, que acarretó con sus bueyes y carros, para las obras de las dichas casas reales de la dicha Alhanbra, desde primero de julio de 1564

años hasta fin de agosto dél, a los preçios sygientes, en este manera: Y çiento y ocho mill maravedís, por diez y seys colunas de jaspe de las canteras del Turro, para los corredores altos del patio de las dichas casas reales, a 18 ducados cada una. 9,000 por çinco cornijas y un salmer de piedra franca de las canteras de Santa Pudia, a quatro ducados cada pieça. 11,972 por dos bolsores de la dicha piedra franca, a 29 reales cada bolsor. Que son los dichos çiento y diez y ocho mill y nueve çientos y setenta y dos maravedís, como paresçe por la dicha çertificaçión por librança del dicho conde de Tendilla. Fecha a nueve de septiembre del dicho año, que dize que la dicha piedra se entregó al dicho Bartolomé Ruiz, segund pareçe por un conoçamiento, y los dichos maravedís resçivió él mismo, a çinco de mayo del mismo año de 1565. [Further deliveries were made on 6 April, 1 June, and 26 September 1566.]

118. 27 November 1565, payment for the entablature in white sandstone for the central window of the west facade, AGS, CM 1, Leg. 1023: Al dicho Pedro de Astiasu, çiento y un mill y çiento y noventa y dos maravedís, que los hubo de aver por el acarreto de la piedra contenida en una certificaçión del dicho veedor, que adelante yrá declarada, que llebó desde las canteras de Santa Pudia y Alfacar a las dichas obras del Alhambra, a los preçios siguientes, en esta manera. 19,380, por quinze cornijas de piedra franca de las canteras de Santa Pudia, para el acompañamieto de la ventana prinçipal, a razón de 28 reales por cada pieça. Cinco mill y quinientos y ocho maravedís por nueve batientes de piedra franca de la dicha cantera de Alfacar, para la dicha ventana, a diez y ocho reales cada batiente. Nueve mill y nueve çientos y noventa y seys maravedís, por diez y seys varas y una terçia de alquitrabe y frisço de piedra de la dicha cantera de Santa Pudia, a 18 reales cada vara. . . . Fecha a veynte y syete de noviembre del dicho año de 1565. . . . [Separate payments were made to Astiasu and Velastigui on 6 and 10 April and 25 September 1566 for deliveries of pieces of architraves (alquitrabe), frieze (frisos), and cornice (cornixas) in white sandstone for the same window.]

119. 6 April 1566, payments for materials for the courtyard and the central window on the main

story of the west facade, AGS, CM 1, Leg. 1023: En seis de abril del dicho año, se libró a Pedro de Astiaso, carretero, vezino de Granada, quarenta mill setezientos y çinquenta varas de dobelas de toba, que trujo a las obras reales desde las canteras de Alfacar . . . y de otras tes cornixas de la dicha de piedra franca de Santa Pudia para los corredores . . . y de otras tres cornixas de la dicha piedra, para aconpañamiento de la ventana prinçipal . . . y de çinco pedestales de xaspe para los corredores del patio . . . y de treze varas de alquitrabe y frisos de piedra franca, para aconpañamiento de la ventana de la puerta prinçipal . . . y de dos colunas de xaspe, para los corredores del patio, a diez y ocho ducados cada una, que montan treze mill y quinientos maravedís, todo lo qual trujo en los meses de henero y hebrero y março d'este año. [Payments for comparable materials were made on 26 September 1566 and 7 June 1567.]

120. 28 February 1567, payment for wood for the centering of the annular vault of the courtyard, AGS, CM 1, Leg. 1023: En veinte y ocho de hebrero, se libraron quarenta y çinco ducados, por treinta y un almos, que se campraron del Soto de Roma para tablones y çinbras para el asiento de los corredores, de Diego de Soria. [Comparable payments for wood for centering were made throughout 1567 and 1568 without expressly identifying its use as centering for the construction of the annular vault.]

121. 31 August 1567, payment for sandstone lintels of the main-story windows and other materials for the west facade and the courtyard, AGS, CM 1, Leg. 1023: Este dicho día, se libró a Pedro de Astiaso, veynte y tres mill y trezientos y setenta y siete maravedís, por la traída de quarenta y siete varas de dobelas de piedra toba, a medio ducado la vara, e diez y ocho varas de frisos e alquitrabe de piedra franca, a diez y ocho reales la vara, e por quatro tranqueros de Santa Pudia para las ventanas, a diez y ocho reales cada uno, e de dos vasas para las colunas, a dos reales cada vasa del Turro. [Payments for pieces of window lintels were also recorded on 31 October 1567 and 24 January and 24 December 1568.]

122. 2 September 1567, letter from Philip II to Iñigo López de Mendoza relative to the salary of

Luis Machuca (published by Llaguna, *Noticias*, I, pp. 222-223): El Rey. Marqués de Mondéjar, primo, nuestro capitán general del reino de Granada. Por parte de Luis Machuca, maestro mayor de las obras de la Alhambra de Granada, nos ha sido hecha relación, que, entre su padre y él, ha cuarenta años que sirven el dicho oficio con solos ciento cincuenta ducados de salario al año. Suplicándonos que, atento a que con la careza de los tiempos no se puede sustentar con ellos, fuésemos servido de mandárselos acrecentar, para que mejor se pueda entretener, o como la merced fuese. Y porque queremos saber, que tanto hace que sirve de maestro mayor de las dichas obras, y el salario que se le da, y con qué obligación sele paga, y si la tiene de residir de ordinario en ellas, o se ocupa en otras de particulares; y para el caso que se le hubiésemos de mandar acrecentar, qué tanto os parece que sería justo, teniendo respeto al trabajo y ocupación, que en las dichas obras tiene, y a su suficiencia y habilidad, os encargamos y mandamos nos enviéis particular relación de ello, y de lo que más cerca d'esto debiéramos saber, la cual, firmada de vuestro nombre, cerrada y sellada, nos la enviaréis, para que visto proveamos en ello lo que fuéremos servido. Yo el Rey. Pedro de Hoyo.

123. 15 October 1567, letter from Iñigo López de Mendoza in Vélez advising his son to see that the officials of the Alhambra follow the Work Rules, AGS, CSR, Leg. 265, fols. 31-32: Don Iñigo López de Mendoça, marqués de Mondéjar, señor de la provincia de Almoguera y de la villa de Fuentenovilla, capitán general de su magestad en este reyno de Granada, e hago saver a vos, don Francisco de Mendoza, mi hijo, que de presente residís en mi lugar, en la çiudad de Granada, y Alhambra d'ella, que su magestad me a escrito una carta firmada de su real mano y sellada con el sello real, refrendada de Pedro de Hoyo, su secrettario, según por ella paresçía su tenor del qual es este que se sigue.

El Rey. Marqués de Mondéjar, primo nuestro, capitán general de Granada, porque holgaré de saver como de an proseguido, y prosiguen las obras del Alhanbra de la çiudad de Granada, y lo que en ellas se va haziendo y acavando, y el estado en que al presente están, y el dinero que para ello tenemos consignado, y si aquello se gasta todo cada año, o lo que d'ello sobra. Os encargamos enbiéis particular relación d'ello, y entretanto y para lo de ade-

lante, para que en ellas aya toda buen prissa, y se prosigan por la orden que conviene y tenemos proveido y hordenado por nuestras provissiones e instruçiones. . . . De Madrid a dos de septienbre de mill e quinientos y sesenta y siete años. Yo el Rey. . . .

Yo como quiera que residiendo yo en esa çiudad, se a tenido especial cuydado de los officiales, maestros e peones de las obras de las casas reales . . . , e para que no huviesse descuydo se les notificó por orden mía, diversas vezes al beedor, maestro mayor e pagador, obrero y aparejador, y otros offiçiales que asisten en ellas con salario de su magestad, que, cada uno en lo que le tocava, guardase las instruçiones hechas por mí, en treynta e uno de julio del año pasado de quinientos e quarenta y seis, tocantes a las dichas obras, qu'están confirmadas por su magestad, demás visitallas yo, por mi persona cada día hordinariamente. Paresçe que, con mis largas y continuas ausencias, deve de haver havido algunas faltas, para cuyo remedio su magestad me a escripto lo contenido en la dicha carta. . . . y vos de vuestra parte, durante mi ausencia y de don Luis Hurtado de Mendoça, mi hijo, conde de Tendilla, e alcaide de la dicha Alhambra, tenéis espeçial cuydado de que se haga así, sin dar lugar a que por ninguna vía se exceda. . . . Hecho a Vélez a 15 de otubre de 1567 años, el marqués por mandado de su señoría ilustrísima, Luis de Ribera, escrivano.

124. 22 February 1568, royal letter raising Machuca's salary to 200 ducats, AGS, CM 1, Leg. 1120: El Rey. Marqués de Mondéjar, primo nuestro, capitán general del reyno de Granada, por parte de Luis Machuca, maestro mayor de las obras del Alhambra de la çiudad de Granada, nos a sido suplicado que, teniendo respeto a los muchos años que su padre y él an servido en el dicho cargo, y que, con los çiento y çinquenta ducados que tiene con él de salario, no se puede sustentar, lo fuésemos de mandárselo acreçentar; y aviéndose visto cierta relación, que por nuestro mandado embiastes, en que dezís que el dicho Luis Machuca sirve el dicho ofiçio de maestro mayor de las dichas obras desde el año de çinquenta, que Pedro Machuca su padre falesció, que así mismo fué maestro maior d'ellas veynte y tres, o veynte y quatro años con cien ducados de salario al año, y un cantero aprendiz que se permitía traer en las dichas obras,

y que al dicho Luis Machuca se le dieron los dichos cien ducados y se le quitó el cantero aprendiz, y que con ellos sirvió el dicho oficio hasta el año de sesenta y tres, que se le acrescentaron çinquenta ducados, y desde entonces a llevado e lleva çiento y çinquenta [ducados]. . . . Fecha en Madrid, a veynte e dos de hebrero de mill y quinientos y sesenta y ocho años. Yo el Rey, por mandado de su magestad. Juan Vázquez de Salazar.

125. 2 May 1568, testimony that Juan del Campo replaced the top moldings of the pedestals of the [south] window, AA, Leg. 46, 6: Testigo. En el Alhambra, honze días del més de mayo de mill e quinientos e sesenta e ocho años, el dicho Juan del Campo presentó por testigo a Luis Machuca, maestro mayor de las obras de las casas reales d'este Alhambra, e aviendo jurado e siendo preguntado çerca de lo lus dicho, dixo: que lo que sabe es que: como Juan del Campo fué fiador [del] maese Nicolao, a cuyo cargo estuvo el hazer de la ventana de la casa real. Este testigo como maestro mayor mandó que no se pusiesen ciertas piedras en la dicha ventana, respeto de estar herradas y ser pequeñas, que fueron las cornisas de los pedestales, y el dicho Juan del Campo, a cuyo cargo estaba el acabar de la dicha obra como fiador del dicho mase Nicolao, sacó otras piedras, e las labró, e las asentó a su costa in la dicha ventana, a donde agora están puestas, por manera que las que este testigo mandó que no se pusiesen, por la cabsa que tiene dicha, se la quedaron [a el dicho] Juan del Campo como cosa suya, que su Magestad, ni sus reales, ni tienen en ellas cosa ninguna, eçepto que este testigo en el acarreo d'ellas, no sabe si lo pagó el dicho Juan del Campo o su Magestad, e que es, lo sé la verdad e lo que sabe, so cargo del dicho juramento que hizo e lo firmó de su nombre, e qu'es de hedad de más de treynta años e no le tocan las generales. Luis Machuca.

126. 29 March 1569, payments relative to the closing of the quarries at Santa Pudia and Turro, AGS, CM 1, Leg. 1023: Al dicho Martín de Belastigui, carretero, mill y ochoçientos y treinta y dos reales y ocho maravedís, que montan sesenta y dos mill y dozientos y noventa y seys maravedís, que los hubo de aver por el acarreto de la piedra contenida en otra çertificación del dicho veedor, que adelante yrá declarada, que llebó desde las can-

teras de Turro e Santa Pudia a las dichas obras, desde 23 de dizienbre [del] dicho año de 1568, hasta tres de março del de 1569 . . . Fecha a veinte y nueve de março de mill y quinientos y sesenta y nueve maravedís, y fée de la paga del dicho veedor, Juan Arias de Mansylla.

127. Summer 1571, proposal by Luis Machuca for the reduction of the work force to the minimum number needed for the conservation of the buildings on the Alhambra, AGS, CSR, Leg. 265, fol. 136: S[acra] C[athólica] R[eal] M[agestad]. Luis Machuca, maestro mayor de las obras de las casas reales de vuestra magestad en Granada, dize que, haziendo lo que deve y es obligado al serviçio de vuestra magestad, avisa de las cosas que neçesariamente vuestra magestad debría poveer para el sustento y conservación del Alhambra, y casas reales, y fortaleza, y torres del mauro, y casa de ginalarife, son las siguientes: Primeramente, vuestra magestad debría proveer de alguna situaçión de maravedís con los quales las obras se continuasen, porque, de parar las dichas obras reçibirían notable daño, así lo hecho y asentado por estar imperfecto, como las muchas piedras que están labradas y por asentar, las quales an costado harta suma de maravedís, porque son treinta y dos colunas de jaspe, y sesenta y quatro basas y capiteles y más algunos pedestales y cantidad de cornisas, y todo esto bendría en quiebra y desminuyçión respeto de desportillarse y andar rodando por el suelo. Solía haver para estas obras 10 mil ducados desituado, los quales pagavan los moriscos. [in the margin: Este mirará quando se dieren orden en las demás cosas de aquel reyno, y en el entretanto, se proveerán 2 mil ducados librados a la quinta de los 4 mill que se tomaron, que se entretengan los oficiales y no cesse la obra.] Así mismo, los offiçiales escogidos y aprovados de mucho tiempo, faltandoles el entretenimiento, y ellos siendo gente de neçesitada, esfuerça que se ayan de yr a otras partes a buscar su remedio. Esto resulta en daño, que quando vuestra magestad fuere servido que las dichas obras se prosigan, nos harán gran falta. Paréçele que, mientras se assientan las usas de allá, se entretengan 6 offiçiales, los mejores en aquellas obras, cuyo salario y del maestro mayor, y un sobrestante y materiales, montan a 400,000 al año. Es así mismo neçesaria la dicha situaçión de maravedís, porque si en las casa reales viejas que fueron de los reyes

moros, que con razón por todo el mundo tan nombradas, son las quales para aver de hazer vuestra magestad otras como ellas, sería menester hazer un ecesivo gasto si en las dichas casas les es neçesario hazer algun reparo, como siempre en todas las del mundo lo an menester; pues a vuestra magestad consta que sola una gotera es bastante para destruir y aruinar un edifiçio no remediándola y no tiniendo con que; ya vuestra magestad entenderá en que vendrán a parar las dichas casas reales. Paréçele que sería menester para ésta, y el cañero y dos muchachos que le introduzcan, porquél es viejo, y si muere no entiende, ni sabe nadie aquello; 500 ducados al año. Es así mismo neçesaria la dicha situaçión de maravedís para poder mantener demás de un cañero, que está ya muy viejo, otros dos muchachos o mançebos, los quales sean instruidos y administrados del dicho cañero viejo, porque si el dicho falta, y no aviendo instruido a otros en los dichos caños, porque en solas las dichas casas reales ay más de treinta y dos fuentes que corren agua, separadas unas de otras, tiniendo sus madres y alvañares que son en mucha cantidad, y faltando el dicho cañero queda todo confuso y a escuras. [In the following sections, Machuca stressed the necessity of maintaining the irrigation ditches that provide water to both the Alhambra and the Generalife, and he suggested that the proceeds of property confiscated from rebellious Moriscos might sustain the works for a while.] Todo lo contenido en este memorial, me fué mandado por el conde de Tendilla, que a vuestra magestad sinificase, para ve sobrello ello [sic] proveye e en el remedio de todo. [*on the reverse*] Luys Machuca, maestro mayor de las obras de las casas reales de Granada [*and added by the same hand in a lighter ink*: es muerto]. Que Gaztelu se informe de Machuca y de lo que le pareçe que conviene, y que después lo veo todo el doctor Velasco, y se avise de lo que resultaré a su magestad. Que se saque una relaçión d'esto para consultarlo con su magestad, bisto que lo aya y dicho su pareçer el doctor Velasco.

128. Spring 1576 (?), Maeda's estimate of the cost of completing the masonry work of the palace of Charles V, AGS, CSR, Leg. 265, fol. 129: Pareçer de Juan de Maeda en lo que toca al valor y obra que está por acabar en la casa real de el Alhanbra de Granada, hasta la igualaçión de las paredes y ultima cornisa, que es donde an de venir las corrientes de los texados del edifiçio, ecepto la ca-

pilla, que a de subir más respeto de su grandeza y capaçidad y intento que el edifiçio lleba, lo qual yo e hecho, por mandado del illustríssimo don Pedro de Deza, presidente de esta Real audiencia de Granada.

a. Primeramente, se midieron todos las paredes de los lienzos y de los quartos y así mesmo las paredes de los portales y entradas de todo este edifiçio, en el qual ubo mil y quatro zientas tapias de paredes y reguladas, más y menos tubieron de grueso, todas las suso dichas, dos pies y medio, son de piedra de toba mui bien labrada y asentada, conforme a lo que está labrada y hecho en el dicho edifiçio, vale cada tapia siete ducados, que monta nuebe mil y ocho zientos ducados.

b. Yten se midieron en el edifiçio de la capilla de esta real casa, y ai por labrar en ella, sete çientas tapias de paredes hasta el último remate y cornisa de ella; tienen de grueso las paredes nuebe pies, lo que está hecho, ba mui bien labrado de piedra de toba, la mayor parte de piezas; edificándose lo que está por hazer como lo hecho, vale cada tapia veinte y seis ducados, que montan diez y ocho mil y doçientos ducados. Esto es, y se entiende, en lo que toca a las paredes, que an de ir labradas de piedra de toba como las demás que están hechas.

c. Están por labrar, nuebe estilobatas de xaspe, que son para los corredores, balen labradas, conforme a las que están hechas con el bruñir y poner en perfiçión, mil ducados. Yten, valen dos estilobatas que están por sacar en la cantera, y treze cornisas para estas estilobatas, y las que están labradas, de sacar y carretar y labrar conforme a lo hecho, quinientos ducados. Valen de asentar esta orden de colunas, con todo el ornato que entrando en ello, el arquitrabe e friso y cornisa, en que entran los cerramientos que son en regla, tres mil ducados. Yten, se tasó de sacar y carretear y labrar los dinteles arquitrabes, frisos y cornisas de este corredor, lo qual es de piedra franca, dos mil y ocho zientos ducados. Moderáronse los antepechos de este corredor, que an de ser de piedra dura, convendrá dos mil ducados.

d. Valen las ocho ventanas que están por hazer las quatro d'ellas a los lados de la delantera prinçipal de este edifiçio, que es a la parte de el poniente, y las otras quatro, a la parte aposita del poniente; tienen de alto, con los espexos y sobre ventanas, más que treinta pies, van mui bien adornadas y labradas, valen, como dicho es, doze mil ducados.

e. Vale el postigo que está a la parte del oriente, lo que está por hazer, en él que es el segundo cuerpo, tiene de ancho quarenta pies y de alto treinta pies i medio, labrándose de piedra dura, conforme a la delantera que le va aconpañando, ocho mil ducados. Vale conforme a la tasaçión de lo que está hecho en la delantera prinçipal de esta casa, que es a la parte del poniente, como está dicho que es el segundo cuerpo de la portada prinçipal y entrada d'esta reales casas, veinte y çinco mil ducados, siendo de piedra dura y mármol como lo que está edificado, porque tiene de ancho sesenta pies y de alto treinta pies i medio, va mui ricamente adornada y labrada, esta partida se tasó mui por menor y con cuidado en la cantidad dicha. Tasóse el arquitrave, friso y cornisa de este edificio lo que está por hazer en él, tomando en quenta la piedra labrada, que está hecha, en tres mill ducados.

f. Por manera que monta todo lo suso dicho, ochenta y çinco mil y treçientos ducados, y esto se entenderá sin los salarios de los ministros de la dicha obra, y tanbién sin los reparas de la casa real, muros y casas de la dicha Alhambra, que no se pueden dexar de gastar en esto, cada año, muchos maravedís, que todo valdrá, según lo que se a visto, más que çien mil ducados, haziéndose este gasto en seis o siete años; y esto es lo que, Illustrísimo señor, çerca de esto me pareçe. Juan de Maeda.

129. Spring (?) 1576, Maeda's report on the state of the palace of Charles V, AGS, CSR, Leg. 265, fol. 124: [*on the reverse*: Paresçer de Maeda, sobre el edifiçio de la casa del Alhanbra de Granada, *with addition*, este Maheda ha muerto] Después de aver tasado los edifiçios que están por hazer en la casa real del Alhanbra de Granada, vuestra señoría illustrísima me manda que declare si, en todo el suceso de este edifiçio, me pareçe que aya alguna falta notable de que se aya de hazer algún caso; a esto digo que, en un edificio tan grande y donde an concurrido tantas cosas, y aunque los maestros que lo intentaron y los que lo an proseguido ayan sido mui espertos, no sería maravilla que ubiesen yncurrido en alguna falta, como las ai en lo que todos hazemos, y en ésto, yo soi el primero. Machuca el viexo, que fué el primer maestro que intentó los edificios de esta real casa, era pintor mui ecelente, y el hixo que le suçedió, tanbién, y estos tales, en conponer y adornar una delantera y acabarla, hizieron lo mui bien; y así pareçe por lo que

en esta real casa está edificado y en lo demás, que son los repartimientos ataxos gruesos de paredes, y considerar el edifiçio hecho y acabado, devieron de tener algunas faltas, teniendo en poco el discurso de la xeumetría, no dando los gruesos y tamaños que convenía a las paredes, ni haziéndolas bastantes ansí para reçebir los entibos de las bóbedas que a ellas se arimasen, como para reçebir el peso de lo alto, y otras muchos cosas que, çerca de esto, se avían de considerar çerca de los edifiçios de esta casa, la qual es reçibimiento y entrada de la casa real, que los moros labraban mui señaladamente, y lo mexor que se a visto y puesto y edificado en gran superiordad de la ziudad Albaizín y Alçazaba, con todo lo demás que le perteneçe; y así mesmo tiene grandíssima vista de toda la comarca, ansí de la sierra Nebada, como de la vega y billas y lugares que están alderredor, demás de los xardines, puertos xenalarife, rio de Darro, y bosque, que todo es cosa de gran contentamiento, con el rio de Xenil que pasa por medio de la dicha vega; y éste es lugar saníssimo, por partiçipar de mui buenos aires y frescos y por tener estremadas aguas como tiene; y bolbiendo al propósito del edifiçio de la dicha casa, digo que es un edifiçio quadrado por la parte de fuera, llebando dentro de sí, unos quartos que tienen a veinte y siete y veinte y ocho pies de grueço; lleban sus paredes en razón ab le grueso, que antes les falta que les sobra, pero por estar mui bien edificado me pareçe que están bastantes; dentro de estos cuartos, se haze una pared redonda que viene a star con los dichos quartos, en él, un cantón a la parte del oriente está la capilla de la dicha casa real, que tiene de grueço çincuenta y dos pies; tiene bastantes paredes porque son nuebe pies de grueso; y por ir mui bien labrado y edificado, la pared redonda del patio me pareçe mui delgada, porque quasi tiene çiento y cincuenta pies de grueço, y las paredes tienen menos de dos pies y medio de ancho, de suerte que los tres rincones tienen alguna flaqueza; y no me pareze que tienen mucha perpetuidad, lo uno, porque van reçibiendo lo bóbeda del corredor baxo, que tiene diez y ocho pies de grueço, y lo otro, para reçebir el peso de lo alto, parezeme mui poca cantidad, demás tener en ella mucha avertura y puertas que la ayudan a enflaquezer; de manera que, ni por el hueco de la planta tiene el grueso que a menester, ni por el estribo de el corredor tanpoco, ni menos por el altura porque a de tener de alto zincuenta y çinco pies, Estos son

trés términos por donde por qual genera d'ellos se le podrá dar el grueso que era menester; y por todos le falta demás del peso y carga que a de tener. Los dos rincones de estos están asignados para hazer las escaleras, que hasta el corredor abrán menester subir con treinta escalones con sola una mesa en medio, son los tiros largos y las salidas y entradas angostos, y no ayuda la dicha al edifiçio y flaqueza de la dicha pared. Sería yo de parezer que se mudase la intençión del hazer de las dichas escaleras, haziéndolas redondas, porque, según el sitio, se podrían hazer grandes y mui descansadas, y de mui mayor autoridad que se pretenden, dando la puerta de la escalera por en medio, y con las paredes d'ella quedarían aquellos partes, que agora son más flacas, las más fuertes del edifiçio; y por ser en fortaleza, soternía por mexor que de otra ninguna manera; porque demás de hazerse el benefiçio que se a dicho, el remate y cobertura de esta escalera quedará mui mexor porque encubre, siendo de cantoría zierta fealdad que los texados por aquella parte harán por alargarse a desechar el agua, disimulando la corriente al peso de los corredores. Tanbién me pareçe que en los zerramientos de los corredores, por ser en regla y no tener las colunas por la alto más que un pie y un quarto, y tener de grueço doze pies, y ir en torre cabada, abrendo de reçibir enmaderamientos, porque de bóbeda no se puede hazer, si no es con nueba orden, que es harto inconveniente para un edificio de tanta magestad; ésto causa aver movido la sustançia y traza del modelo, porque era primero con sus colunas aconpañadas por los lados con los pies derechos y movimientos sobre que se çerraban los arcos redondos. Devió les de pareçer que ésto enbaraçaba, haziéndose en lo baxo y alto, y así se hizo de colunas redondas de xaspe, y así van los dentiles todos en regla, los baxos que están cerrados y labrados están buenos, porque las colunas tienen dos pies y un terçio, y éste las ayuda a perpetuar; y como las altas son de lo grueso que e dicho, es menester hazerse con mucho cuidado, porque es cosa que está por hazer; lo digo para que se haga lo que más convenga. Yo lo e comunicado con el conde de Tendilla y con el capitán Mansilla, que es obrero mayor y persona que desea que esto si açierte mucho tanbién Juan de Orea, que es la persona que agora sirbe esta plaza y maxisterio de esta obra, y es abil y mui onbre de bien; y creo yo abrá dado cuenta a su maxestad de estas cosas y de otras que, por

estar hechas, no ai que dezir, para que lo viesen y le desengañasen de lo que conviene. Vuestra illustrísima puede avisar a su magestad, que demás de los maestros que ai en corte, que serán muí aventaxados del pareçer de Rodrigo Xil y de Andrés de Vandelvira. Se podrá confiar esto y todo lo demás y de presente. No se me ofreçe otra cosa de que informar a vuestra señoría, illustrísimo señor, criado de vuesta señoría. Juan de Maeda.

130. 6 July 1576, letter of the governor to the king relative to funds for the conservation of buildings on the Alhambra, AGS, CSR, Leg. 265, fol. 76: C[athólica] R[eal] M[agestad]. Dos años a que embié a Juan de Orea, maestro mayor de las cassas reales del Alhambra, a que diese a vuestra magestad quenta del estado d'ellas y de los reparos de que tenía necessidad y las cassas y murallas y torres de la dicha Alhambra; y aunque estuvo muchos días en Madrid y dí a vuestra magestad quenta de todo, no se probeyó nada zerca d'ello y agora, viendo que la cassa real ba destruyéndose, por estar los texados casi todos ora dados, y los caños de las fuentes rotos de manera que reciven las bóbedas notable daño, y que las cassas que vuestra magestad tiene en la dicha Alhambra se ban cayendo casi todas; y de una torre se a caydo la mitad, a benido avissarme de lo que passa, suplico a vuestra magestad, pues aquello costó tanto número de dineros ganarse y tanto de sustentarse, sea servido de mandar probeer de dineros para que aquello se repare, porque si con brevedad no se haze, costará mucho después, o se a de dexar perder todo; y con dar a vuestra magestad aviso de lo que ay, y suplicalle lo que me parece que a su serviçio conbiene, quedo descargado para lo que adelante puede suzeder; y porque él en particular dará a vuestra magestad quenta de todo, no me alargo yo en esta ensalçe, y prospere Nuestro Señor la Católical Real persona de vuestra magestad de la gante a 6 de julio 1576.

131. 14 November 1579, royal notice of termination of income from the Moriscoes, AA, Leg. 104, 5, 5: El Rey. Por quanto con la rebelion de los moriscos de nuestro reino de Granada y la salida de ellos, ha cesado la paga de los doze mil ducados que teníamos consignados en cada año para el reparo y continuación de las obras de nuestro Alhambra y casa reales de la ciudad de Granada, puestos y cobrados los diez mil de ellos sobre la rente

de la farda que solían pagar los dichos Moriscos, ocho cientos sobre la de los haviçes. . . . 14 de noviembre de 1579 años.

132. 10 June 1580, work orders issued by Juan de Herrera, AA, Leg. 21, 3 (published by Laguno, *Noticias*, II, pp. 330-332, though he used a copy in the Archivo General de Simancas that differs slightly from the copy published here): Órden para que se prosigan las obras, y el como, particulares. Relación de las cosas que su magestad quiere mudar en el hazer y proseguir la obra de la casa real del Alhambra de Granada, las quales van señaladas y acoladas en las traças que Juan de Orea truxo a Badajoz a mostrar a su magestad por su mandado, y son las siguientes:

a. Primeramente, que en los nichos que están en la delantera prinçipal en la segunda hórden, se hagan dos ventanas, de manera que le queden a la sala alta çinco ventanas.

b. Yten, que ençima de la puerta prinçipal, donde está en la traça tres luzes en el medio, que no aya más de una.

c. Yten, que todo lo que falta por levantar de todos los lienços de la fábrica, se levante y vaya prosiguiendo con la mesma horden que está hecho lo demás, teniendo en quenta que se vaya alivianando [sic] todo lo que fuere posible de la talla.

d. Yten, que el tejado se haga y prosiga con la horden y forma que se verá en un modelillo de papel que para él se hizo y se mostró a su magestad, y va firmado de Juan de Herrera, su architecto mayor.

e. Yten, los tejados an de ser cubiertos de plomo, y en ellos a de aver aposentos para mujeres, con ventanas en los tejados, [*inserted*; como se vee en el perfil] que cargan hazia la parte del patio y de fuera, de la manera que está hecho en Aranjuez y el Escorial.

f. Yten, an de estar las maderas de los camaranchones y tejados cubiertas y blanqueadas de yeso, como se vee agora en Aranjuez.

g. Yten, en los dichos camaranchones por la una parte d'ellos, que es hazia el patio, a de aver compartimentos de celdas, y por la parte de hazia fuera a de aver un callejón ansí como se vee, y está señalado en el perfil.

h. Yten, por parte de dentro del patio que se a de çerrar en redondo, a de andar una cornijeta de tres pies de alto, con su friso y un boçel y filete en lugar de alquitrave, a modo de capitel dórico, ansí como se vee en el dicho perfil. En lo alto de la dicha cornija viene á rematar el tejado del quarto hecho en la forma ya dicha, y debaxo de la dicha cornija, junto al filete, enpieça la corriente del tejado del corredor alto que otrosé se cierra en redondo, cubriendo al dicho corredor como se vee en el dicho perfil.

i. Yten, es la voluntad de su magestad que se hagan las chimeneas, que van señaladas en la planta, que truxo Juan de Orea de la casa real del Alhambra a esta çibdad de Badajoz, las quales son todas en lo alto, eçeto dos de las dichas chimeneas que caen debaxo del arco que salba la bóbeda grande, donde se mata la cal, porque el dicho arco se a de çerrar, y las dos chimeneas se an de elegir desde ençima de la bóbeda baxa y an de subir hasta lo alto, donde a de aver otras chimeneas en los mesmas cañones, por manera que estas dos chimeneas an de ser dobles, y ansí estas, como las demás que están señaladas en la dicha planta mano de su magestad, se entiende, que pués no están elegidas en las paredes que están hechas, que se elijan en lo que falta por subir, para que de allí abaxo se vengan ronpiendo.

j. Yten, en el zaguán que salle al quarto de Comares, estava determinado que en la planta alta se metiese el zaguán en una pieça como está señalada con líneas roxas desde la H a la I; después mudó su magestad de propósito y qyiere que, como están los atajos baxos, estén los altos, y que en la pieça de junto á la capilla aya una chimenea en alto en derecho de la ventana que salle al zaguán que está señalada con la letra A.

k. Yten, se an de hazer las tres escaleras en los rincones señaladas con letras C, D [y] E, las quales an de subir desde el suelo del patio hasta los camarachones, todos tres, y todas las pieças del suelo alto, que juntaren con las dichas escaleras, an de tener puertas para servirse de las dichas escaleras, como van señaladas en la dicha planta, y también las dichas escaleras an de servir a los entresuelos.

l. Yten, lo primero que se a de enpeçar a fabricar en la casa real del Alhambra, aviendo proveido su magestad, offiçiales de veedor y pagador, y aviendo cobrado el dinero corrido de la consinaçión, çerrar el portillo de la puerta prinçipal lo primero, y lo segundo, çerrar el otro portillo del lienço del levante; y a bueltas d'esto se an de ir subiendo las demás paredes de los atajos que faltan por subir de sillaría; y ansí mesmo se a de acabar la capilla como

está en la traça, y quando vaya en término que dentro de un año se pueda acabar, aquel año antes se prevenga la madera para cubrir los quartos, porque lo primero que se a de hazer de madera en la dicha casa real a de ser cubrir los tejados y cubiertos, se an de ir haziendo los suelos y todas las demás cosas de madera.

m. Yten, es la voluntad de su magestad que no se eçeda, ni haga otra cosa, ni se inove, ni altere en la obra de la dicha casa real, más de lo contenido en esta relaçión, y lo que va acotado y señalado en las dichas traças, sin que se comunique con su magestad, o con sus ministros; y si alguna mudança o ofreçimiento se ofreçiere, que el maestro mayor de la dicha obra, dé notiçia y razón d'ello a su magestad o a sus ministros y no a otra persona alguna; y si alguna cosa eçediere o hiziere el dicho maestro mayor, contra lo arriba declarado, que sea a su costa, porque su magestad no quiere que en sus obras se hagan remiendos ni alteraçiones, ni se añada, o quite cosa de lo que él uviere determinado que se haga, ni que nadie tenga que mandar al maestro mayor, ni a los demás ofiçiales de las obras del Alhambra que inoven, ni alteren, ni hagan por su contenplaçión, cosa ninguna más de lo que su magestad se a resuelto y determinado. Fecho en Badajoz, a diez de junio de mill y quinientos y ochenta años. Juan de Herrera. [*added to the orders*] Las traças que Joan de Orea, maestro mayor de la Alhambra de Granada, trujo á Badajoz y su magestad bio y en ellas resolvió lo arriva contenido, son seis y todas seis van firmadas de mi nombre. Juan de Herrera.

133. 19 November 1583, appointment of Juan de Minjares to replace Orea as architect of the Alhambra, AA, Leg. 104, 5, 3: Por quanto por fallecimiento de Joan de Orea, nuestro maestro mayor que fué de las obras del nuestro Alhambra y cassas Reales de la çiudad de Granada, está vaco el dicho offiçio; y por conbenir a nuestro secretario que aya persona que le usse y exerça y tenga cargo y cuydado de la conserbaçión de las dichas obras, y de todo lo demás a ellas anexo y conçerniente, y acatando la sufficiençia, havilidad y diligençia que, con espieriençia se a conoçido en vos, Juan de Minjares, aparejador de las obras de canteria de la fábrica del monasterio de San Lorenço el Real, y lo bien que nos avéys servido, y esperamos nos serviréys adelante, os avemos elegido y proveeydo.

. . . Fecha en el Pardo, el diez y nueve de nobiembre de mill y quinientos y ochenta y tres años. Yo el Rey. Por mandado de su magestad, Matheo Vázquez. [*with added notation*] Tomose la razón d'esta çédula de su Magestad en postrero de henero de mill quinientos y ochenta y quatro años en los libro de la contaduría de las obras reales d'esta Alhambra, y presentose Joan de Minjares este dicho día, mes y año, que es el contenido en esta çédula de su magestad. Alonso Arrias Riquelme.

134. 12 March 1585, payment to Juan de la Vega for service as aparejador since 14 May 1584, AA, Leg. 240: En el Alhambra de Granada, en doze de março de mill y quinientos y ochenta y çinco años, en presençia y con intervençión de mí, Alonso-Arias Riquelme, vehedor de las obras de el Alhambra y casas reales d'esta çiudad de Granada, por su magestad, y de Joan de Mijares, maestro mayor de las dichas obras, don Gaspar de León, pagador d'ellas, pagó de el dinero de el arca de tres llaves de su magestad . . . a Joan de la Vega, maestro de cantería y aparejador de las dichas obras, treçientos y quarenta y nuebe reales y medio, que balen onze mill y ocho çientos y ochenta maravedís, que los ubo de aber por razón que desde catorze de mayo de el año pasado de quinientos y ochenta y quatro que començó a serbir de aparejador de las dichas obras . . . y en el entretanto se le abían ydo dando de socorro quatro reales y medio cada día a buena quenta de lo ubiese de aber hasta aora. . . .

135. 8 August 1587, the first of many payments for columns and other pieces of the marble of the Sierra Elvira for the upper story of the west *portada*, AA, Leg. 240: En el Alhambra de Granada, sábado, ocho de agosto de mill y quinientos y ochenta y siete años, con mi ynterbención y de Juan de Mijares, maestro mayor de las obras reales d'esta Alhambra, don Gaspar de León, pagador de las dichas obras, del dinero del arca de su magestad, pagó a Bartolomé Sánchez y a Juan de Torres y a Juan de Montoya, carreteros, vezinos de Granada, sesenta y ocho ducados en reales, que valen veynte y cinco mill y quatro cientos y treynta y dos maravedís, por razón de dos colunas que truxeron de la Sierra Elvira y las entregaron en estas obras reales, las quales colunas y otras pieças se remataron en los sus dichos por más baxa postura . . . en ocho de julio del dicho año, a razón de a treynta y quatro

ducados cada coluna, puestas a su costa en esta Alhambra en las obras reales para su continuación. [Payments were made through 16 January 1588 for eight columns and their capitals and pedestals as well as the components of the entablature and the casing of the windows with occasional references to the "portada principal" or "las ventanas principales."]

136. 17 October 1587, payment for timber to cover the corredor of the round courtyard, AA, Leg. 240: En el Alhambra, en diez y siete de otubre de quinientos y ochenta y siete años, con yntervención de mí, Alonso Arias Riquelme, vehedor de las dichas obras, y de Joan de la Vega, aparejador, don Gaspar de León, pagador d'ellas, de el dinero de su magestad, pagó una librança su fecha en este dicho día, mes y año de cantidad de setecientos y veinte y nueve reales y catorze maravedís, que valen veinte y quatro mill y ocho cientos maravedís, a Melchor Rodríguez, maderero, vezino d'esta ciudad, que los ubo de aver por razón de dozientas alfarxias largas de pino que se compraron de el suso dicho por más baxo precio, con la suso dicha nuestra yntervención, a razón [de] tres reales y veinte y dos maravedís cada una, para cubrir los corredores de las casas reales nuevas de la dicha Alhambra. . . .

137. 9 September 1589, payment for equipment for lifting columns to the main story of the west frontispiece, AA, Leg. 21, 4, 2: En el Alhambra de Granada, en nuebe de setiembre de mill y quinientos y ochenta y nuebe años, con yntervençión de Alonso Arias Riquelme, vehedor de las dichas obras, y de Joan de Mijares, maestro mayor d'ella, don Gaspar de León, pagador de las dichas obras, del dinero de el arca de su magestad, pagó a Joan Carrasco, cordonero, vezino d'esta çiudad, una librança su fecha en este dicho día, mes y año de cantidad de veinte y nuebe mill, quatro çientos y quarenta y çinco maravedís, que los ubo de aber por razón de una partida de cáñamo labrado . . . es, a saber, una maroma de canal que pesó doçientas libras, a razón de çinquenta y seis maravedís cada libra, y dos hondas de canal y churrón, que pesaron doçientas y veinte çinco libras, a çinquenta maravedís cada libra, y quatro guindaletas de churrón, que pesaron çiento y treinta y dos libras y medio, a quarenta y seis maravedís cada libra, todo

lo qual es para subir las columnas y las demás pieças de la fachada prinçipal de las dichas casas reales, y se entregó a Joan de Bargas, tenedor de materiales. Resçíbesele en quenta al dicho pagador, la dicha partida. [Comparable payments were made on 16 September and 7 October 1589.]

138. 27 April 1591, payment for the carving of ornament on the main story [of the west facade], AA, Leg. 52, 1: A Juan Darta, entallador, de labrar dos remates de dos ventanas de piedra franca, que es una que lleva las granadas por remate y la otra tres jarros con una venera, todo rebestido de talla, noventa y seys reales, por los quales fué conçertado el labrar la dicha talla, tres mill y dozientos y sesenta y quatro maravedís.

139. 15 June 1591, payment for delivery of models of the roundels for the upper story of the west *portada*, AA, Leg. 52, 1: A Pedro Hernández, correo, que despachó el maestro mayor de Sevilla a Granada con los modelos de los espejos de la fachada prinçipal d'estas obras, de venida y buelta y estada, quarenta y dos reales, mill y quatro çientos y veinte y ocho maravedís.

140. 30 August 1591, payment to Ocampo for the three roundels of the upper story of the west *portada*, AA, Leg. 210, 5: En el Alhambra de Granada, en postrero día de agosto de 1591 años . . . pagó a Andrés de Ocampo, escultor, vezino de Sivilla, una librança su fecha este dicho día, mes y año de cantidad de mill y treçientos y treynta y un reales, que valen quarenta y çinco mill doçientos y cinquenta y quatro maravedís, que los ubo de aber por razón de averse conçertado con él, porque así convino, la manifatura de relieve del escudo prinçipal de las armas reales, y las dos ystorias de Hércules de los espejos colaterales del dicho escudo de la sigunda ordenança de la fachada prinçipal de las dichas cassas reales nuevas, en piedra mármol blanco, el qual conçierto hizo con el suso dicho, en la dicha çiudad de Sivilla, Joan de Mijares, maestro mayor de las dichas obras, por comisión que para ello tubo de don Miguel Ponce de León, teniente de alcayde de la dicha Alhambra, y de Alonso Arias Riquelme, veedor de las dichas obras, por convenire así que se buscase ofiçial tal qual requiere la perfecçión de la dicha obra d'escultura . . . y por quanto entre las condiçiones de la dicha escritura

son, que avía de dar pulimento al dicho escudo y espejos, y averse acordado que no se dé el dicho pulimento por llevarle los espejos de la primera ordenança, ni las demás pieças de mármol blanco que van en la dicha fachada, se le vajan viente ducados, en que se tasó el dicho pulimento, de los quatro çientos y treynta ducados en que se conçiertó la dicha manifactura, y así mismo se le vajan tres ducados por averle aguzado las hierramientas, con que labró el dicho escudo y espejos, el herrero que su magestad tiene en las dichas obras; y porque así mismo fué condición que, acabada la dicha obra, la viesen ofiçiales de escultura, si está conforme a las dichas condiçiones, se nombró a Pablo de Rojas, escultor, vezino d'esta çiudad, para que con juramento declarase si el dicho Andrés de Ocampo avía cumplido con ellas; el qual, en presençia de los dichos ofiçiales mayores y escrivano, declaró estar acabada la dicha obra conforme la dicha escritura y condiçiones; se le libró la dicha cantidad con la qual, y con çiento y seis mill noveçientos y sesenta y quatro maravedís que tiene resçividos por buena quenta de la dicha manifactura por dos libranças . . . se le acabó de pagar la dicha partida por entero.

141. 31 August 1591, payment for clamps used to lift the three roundels into position on the upper story of the west *portada*, AA, Leg. 52, 1: A Gaspar López, herrero, de dos hierros que hizo para subir el escudo de las armas reales y historias de los lados de la fachada prinçipal, que pessaron ambos veynte y quatro libras, a sesenta maravedís la libra, que montan quarenta y dos reales y doze maravedís, mill y quatro çientos y quarenta maravedís.

142. 6 June 1592, payment for material used to lift the marble cornice into position on the upper story of the west *portada*, AA, Leg. 52, 1: A Andrés de Sivilla, de ocho libras de clavos gemales, para hazer unos bancos grandes para subir las cornisas de piedra negra de la dicha fachada prinçipal, a real y dos maravedís la libra, ocho reales y seys maravedís, dozientos y ochenta y ocho maravedís.

143. I August 1592, payment for a rope to level the round courtyard, AA, Leg. 52, 1: A Carrasco, cordonero, de seys onças de cordel para nibelar el patio redondo d'estas obras, un real y veinte maravedís, y más ocho maravedís para dos belas para hazer la paga, que son por todos, un real y veynte y ocho maravedís, sesenta y dos maravedís.

144. 22 August 1592, preparation for reopening the quarry at Turro, AA, Leg. 52, 1: A Cristóval García, alquilador de mulas, de dos cavalgaduras que alquiló por dos días para el aparejador d'estas obras, y otra para un cantero que fueron a mostrar y veer la cantera de Turro, doze reales, quatro cientos y ocho maravedís. A Juan López Marmex, cantero, que se ocupó dos días en yr a mostrar la cantera del Turro, a quatro reales por día, ocho reales, dozientos y setenta y dos maravedís.

145. 29 August 1592, payment for chisels in preparation for the renewal of work at the quarry near Turro, AA, Leg. 52, 1: A Mendoça, mercader, de un quinta de azero en barretas para hazer zinzeles para la cantera del Turro, que se conçertó por çiento y quarenta y siete reales, quatro mill y nobeçientos y nobenta y ocho maravedís.

146. 26 September 1592, payment on account to the quarrier of sandstone for the ends of the west vestibule, AA, Leg. 52, 1: En el Alhambra de Granada, en diez y seis días de setiembre de mill y quinientos y noventa y dos años . . . don Gaspar de León, pagador de las dichas obras, de el dinero de el arca del rey, nuestro señor, pagó a Joanes de Loyola, sacador de piedra, vezino de Granada, a Sant' Elifonso, una librança su fecha este dicho día, mes y año de cantidad de ocho çientos reales, que valen veynte y siete mill y doçientos maravedís, que los an de aver por razón de socorro y buena quenta de una partida de piedra franca de las canteras de Santa Pudia . . . es a saver, ochenta pieças de a quatro pies y media de largo y dos pies y tres quartos de ancho, y media vara y dos dedos de grueso, y otras veynte y quatro pieças de diferentes medidas, todas las susodichas a razón de veynte y un reales cada una, y así mismo treynta y dos varas de cornisa a treze reales a vara, y más quatro pieças grandes para quatro dinteles de puertas a çinquenta y dos reales cada una, todo lo qual, sacado, desbastado y traydo a su costa por los dichos preçios a las dichos cassa reales, para los testeros del zaguán prinçipal d'ellas. [Similar payments were made on 23 January, 7 and 28 August, 16 and 20 October, 6 November and 24 December 1593.]

147. Shortly before 3 October 1592, specifications for the limestone for vault of the west vestibule, AA, Leg. 6, 36: Las condiçiones que se an de guardar los [*torn*] de sacar la piedra tova de las

canteras de [*torn*] la bóveda del zaguán d'estas [*torn*] Alhambra son las siguientes: Primeramente, se an de obligar de sacar y desbastar y traer a las dichas casas reales 230 baras de dobelas, muy bien desbastadas, con un contramolde que se les dará para plantar por las caveças de las dichas dobelas, y con otro contramolde que a de ser puesto en el largo por la dobela que los dichos dos contramoldes le serán mostrados y entregados a los que así se encargare de sacar y traer la dicha piedra. Otrosí, se an de sacar otras 200 baras de dobelas para la dicha bóveda, con otro contramolde que así mismo le será mostrado y se le entregará para de ser plantado por las caveças de las dichas dobelas, y an de tener de largo una vara poquito más o menos, de suerte que la que menos tubiere, tenga de tres quartas adelante y quanto más largas fueren será mejor. Otrosí, se an de sacar otras quarenta varas de dobelas para la dicha bóveda, con otra contramolde que asimismo se a de plantar por las caveças de las dichas dobelas, y que tengan de largo cada una vara poquito más o menos. Es condiçión que toda la dicha piedra se a de sacar de las canteras de Alfacar, que sea piedra mui serrada y dura y que no tenga ningún género de tierra ni caliches, sino que sea mui buena a contento de los ofiçiales de las obras reales del Alhambra, le qual an de sacar y desbastar y traer y dar la puesta a su costa en estas casas reales, sin que por ello se les de [*torn*] alguna más qu'el preçio en que se le remataren. . . . [*signed*] Juan de la Vega. [The contract for this stone was signed with Alonso Martínez on 3 October and its delivery was completed by 24 December 1592.]

148. 3 October 1592, payment for the delivery of tools to the quarry at Turro and of two pieces of pedestals [for the gallery] from Turro to the Alhambra, AA, Leg. 52, 1: Al dicho [Juan de Hontoya] de llevar dos carretadas de herramientos y peltrechos a las canteras de Turro para sacar la piedra que falta para las corredores d'estas cassas reales, treynta y seys reales, mill y dozientos y veinte y quatro maravedís, [y] de traer dos pieças de los pedestales de las canteras del Turro a estas cassas reales, dé dicho Juan de Hontoya, a treynta reales cada pieça, sesenta reales, dos mill y quarenta maravedís.

149. 28 November 1592, payment for the benchtables of the end walls of the west vestibule, AA,

Leg. 52, 1: En el Alhambra, en veynte y ocho de nobiembre de mill y quinientos y nobenta y dos años . . . don Gaspar de León, pagador de las dichas obras, de el dinero del arca del rey, nuestro señor, pagó a Martín Falconete, vezino de Alfacar, una librança su fecha este dicho día, mes y año, de cantidad de quinientos y ochenta y çinco reales, que valen diez y nueve mill ocho çientos y nobenta maravedís, que los ubo de aber por razón de una partida de piedra franca de la cantera de Alfacar . . . es, a saver, trece pieças de la dicha piedra de a quatro pies y medio de largo cada una, y una bara de ancho, a razón de a quarenta y cinco reales cada pieça sacada, desbastada y trayda a su costa por el dicho preçio, las quales entregó el día de la fecha d'esta, con la dicha ynterbençión a Juan de Bargas, tenedor de materiales, las quales pieças son para los poyos de los testeros del zaguán prinçipal de las dichas cassas reales.

150. 12 June 1593, payment for conglomerate stone for the parapet of the gallery of the round courtyard, AA, Leg. 52, 1: A Blas Enríquez, carretero, vezino de Granada, de traer pieças de piedra jaspe de las canteras del Turro a éstas cassas reales, es, a saber, ocho pieças de las bassas de los antepechos, y dos pieças del témpano de en medio del dicho antepecho, y tres pieças del antepecho alto, que todas treze pieças tubieron çiento y treynta y tres pies y medio quadrados, que a tres reales y medio cada pie enquadrado conforme a como se le remató, montaron quatro çientos y sesenta y siete reales, que valen quinze mill y ocho çientos y setenta y ocho maravedís . . . y toda la dicha piedra es para los antepechos de los corredores altos del patio prinçipal d'estas cassa reales. [Similar payments were made on 19 and 26 June and 9 October 1593, and 7 May and 10 June 1594.]

151. 7 August 1593, payment for sandstone facing of the end walls of the west vestibule, AA, Leg. 52, 1: En el Alhambra, en siete días de agosto de mill y quinientos y noventa y tres años . . . don Gaspar de León, pagador de las dichas obras, de el dinero del arca del rey, nuestro señor, pagó a Juanes de Loyola, como prinçipal, y a Alonso de Pineda, como a uno de sus fiadores mancomunados, una librança su fecha este dicho día, mes y año de cantidad de mill y çiento y quatro reales, que valen treynta y seis maravedís, que los ubo de aver por razón de una partida de piedra franca de

las canteras de Santa Pudia . . . es, a saber, ochenta piezas de a quatro pies y medio de largo, y dos pies y tres quartos de ancho, y media vara y dos dedos de grueso, y otras veinte y quatro piezas de diferentes medidas, todas las susodichas a razón de veynte y en reales cada una, y, así mismo, treynta y dos varas de cornisa a treze reales la vara, y más quatro piezas grandes para quatro dinteles de puertas, a cinquenta y dos reales cada una, y es, a saber, que fué condición en la escritura que los susodichos hizieron, que avían de dar a los dichos preçios todas las demas pieças y cornisas que se les hordenase, y por aver sido neçesario para los testeros del çaguan prinçipal. . . . [In preparation for this delivery, payments on account were made to Juanes de Loyola on 26 September 1592 and 23 January 1593. On 16 October 1593, Xines Hernández was paid for sixteen pieces of sandstone facing for the vestibule.]

152. 28 August 1593, payment on account for the quarrying of the jambs of the side doors and the recess of the central portal of the west facade, AA, Leg. 52, 1: En el Alhambra, en veynte y ocho de agosto de mill y quinientos y noventa y tres años . . . don Gaspar de León, pagador de las dichas obras, del dinero del arca del rey, nuestro señor, pagó a Sebastián Pérez, cantero, vezino de esta çiudad, como prinçipal, y a Blas Enríquez, cantero, y a Juan Martínez, cantero, y a Juan de Hontoya, carretero, vezinos de la dicha çiudad, como fiadores mancomunados, quinientos y çinquenta reales, que valen diez y ocho mill y seteçientos maravedís, que los ubo de aver por razón de socorro y buena de una partida de piedra franca de las canteras de Sancta Pudia . . . es, a saver, setenta y dos pieças de la dicha piedra para los pies derechos de las xanbas de las puertas colaterales con las pilastras que ban con ellas, y más siete pieças para el capialçado de la puerta principal, y, así mismo, ochenta pieças para la continuaçión del çaguan prinçipal. . . . [A second payment on account was made to the same group on 6 November 1593.]

153. 6 August 1594, specifications for grey marble for the cornices of the upper story of the west *portada*, AA, Leg. 6, 39: Las condiçiones que se a de sacar y desbastar la piedra parda de la Sierra Elvira para el cornizamento de la segunda orde-nança del patio del quarto nueba son las siguientes: Primeramente, el offiçial o offiçiales que se encargaren de sacar y desbastar la dicha piedra, la an de sacar y desbastar conforme a los contramoldes que para ello se les darán, que an de ser de los primeros contramoldes en que bienen al alquitrabe y frisso, çiento y veynte y ocho pieças. Más, se an de sacar, para la corona del dicho cornizamento, sesenta y quatro pieças conforme a los contramoldes que para ello se les darán, las quales, ellas y las de ariba dichas, an de yr desbastadas cada una d'ellas con tres contramoldes que se darán a entender a la persona o personas que se encargaren de sacar la dicha piedra. Es condición que la dicha piedra a de ser toda de un color grani menuda, sin que tenga vetas ningunas, blancas, ni de otra color, y sin pelos ni levante ni atronadura, muy bien desbastada, derecha y esquadria, sin ninguna desportilladura, todo muy bien entregado, de piedra dura, a contento, y si alguna piedra no fuere de reçibir, y se truxere a la dicha Alhambra, pagarán lo que costare de traer [*added above*: y no se les reçivirá la dicha piedra] y, en rematandosele la piedra, an de hazer luego escritura y dar fianças a contento del veedor de la dicha fábrica y lo an de començar a sacar luego, y no an de alçar mano d'ello hasta averlo acabado. En el Alhambra de la çiudad de Granada, a seis días del mes del agosto del mill e quinientos e noventa y quatro años, Alonso Arias Riquelme, behedor de las obras reales d'esta Alhambra, y Juan de Mijares, maestro mayor d'ellas, mandaron que García López, pregonero público de Granada, pregone la piedra contenida en las condiçiones de arriba. . . . En la dicha Alhambra, el dicho día pareçió Juan Hernández, cantero, vezino de Granada, a Sant Juste, y dixo que pone cada piedra de las grandes a ocho ducados y las chicas a tres ducados cada una, y siéndole rematadas, las sacará y desbastarán en el tiempo que se le ordenare conforme a las condiçiones. . . .

154. 20 August 1594, first payment on account for sandstone for the four remaining windows [on the east facade], AA, Leg. 52, 1: En el Alhambra en Granada, en veynte días de agosto de mill y quinientos y noventa y quatro años . . . don Gaspar de León, pagador de las dichas obras, de el dinero de el arca del rey, nuestro señor, pagó a Blas Enríquez, cantero y sacador de piedra, vezino de Granada, una librança su fecha este dicho día,

mes y año, de cantidad de mill y çien reales, que valen treynta y siete mill y quatro çientos maravedís, que los ubo de aber por razón de socorro y buena quenta de una partida de piedra franca de las canteras de Santa Pudia . . . es, a saber, çiento y ochenta baras de frisos y alquitraves, a razón de siete reales y medio la bara, y, así mismo, ciento y diez pieças de cornijas, y tres pieças para basas de pedrestales y otras tres pieças para los pedrestales, y veinte y quatro pieças para los pies derechos de las ventanas, y más quatro pieças para los quatro capitales de los pedrestales y diez y seis pieças para los salmeres de las ventanas, y ocho pieças para las claves de las dichas ventanas, y una pieça para un compartimiento, y doze pieças para las ventanas redondas, y quatro pieças para los capiteles de las quatro pilastras, y más çinquenta pieças para las pies derechos de las pilastras, que por todas las que se nombran pieças, son dozientas çinquenta pieças a razón cada una d'ellas, una con otra, de a diez reales y medio, y, así mismo, doçientas y çinquenta varas de sillares de la dicha piedra, a razón de tres reales cada bara. . . .

155. 19 August 1595, payment for carving two pedestals of the upper story of the east facade, AA, Leg. 52, 1: A Diego de Aranda, escultor, de labrar la talla de dos predestales de piedra franca para la fachada de hazia lebante que se va prosiguiendo, a razón de quarenta y quatro reales cada pedestal, ochenta y ocho reales, dos mill y nobeçientos y nobenta y dos maravedís. [Payment for a third pedestal was recorded on August 26.]

156. 26 October, 1595, payment for carving ornament of the windows of the east facade, AA, Leg. 52, 1: Juan de Vera, que labra la talla de las ventanas de la fachada de lebante, quatro días y medio, a seys reales al día, veinte y siete reales, nobeçientos y diez y ocho [maravedís]. [Payments to Vera and Pierres Morell are recorded every week until 25 May 1596.]

157. 12 October 1596, Minjares' report on what remains to be done in the east wing of the palace, AA, Leg. 52, 1, fol. 1v: En lo del quarto nuebo se yrá çerrando el portillo, donde será la contaduría, hasta ygualar con el alto de la pared de hazia la capilla, donde se heligirá una esquina, quedando

el gruesso de la pared de hazia la capilla como está la pared de la demás capilla, y allí se recogerá hazia el portillo dicho con el gruesso de la pared del quarto que ya está subido y , echado el cornijamento, cerrando el arco y forma como lo tiene entendido Juan de la Vega, con la cornijilla que anda donde solía ser la contaduría, y si pareçiesse que falta piedra de Alfacar para levantar las paredes hasta donde viene el cornijamento, o, assí mismo, faltasse piedra de las canteras de Santa Pudia para acabar de çerrar el dicho portillo, se passarán los offiçiales que labran bien piedra dura, a labrar los antepechos de los corredores del patio, entreteniendo los mejores labrantes de la piedra blanda en la piedra de Alfacar y de Santa Pudia, de manera que algunos, los mejores labrantes, tengan que hazer en lo que se fuere trayendo, y los demás se despidan antes que entre el ynbierno, porque no se les haga mala obra. Y si pareçiere que Blas Enríquez pudiere cumplir con la piedra que está a su cargo de sacar y desbastar de la cantera de Santa Pudia, se le podía encargar que saque y destaste la cornija de la capilla por sus baras, a tanto cada bara como quedará aquí señalados los preçios. Podrásele dar por la bara de la corona, con tres pies y medio de lecho y dos pies menos dos dedos de alto, a diez reales, y por la bara del alquitrabe, con un pie y diez dedos de alto y tres pies de lecho, a siete reales. Esto mandaren vuestras merçedes veer y proveerán en ello lo que fueren servidos. Joan de Minjares.

158. 30 June 1611, announcement that the delivery of sandstone for the cornice was open for bids by carriers, AA, Leg. 210, 1, 30: Todas las personas carreteros que se quisieren obligar a traer a las obras reales del Alhambra, desde la cantera de Santa Pudia, una partida de piedra franca, de treçienta y tantas caras [sic] de cornisas y sillares que se está sacando por quenta de Blas Enríquez y Alonso Balconete, en quien se rematado la saca de la dicha partida, acuda a las dichas obras y ofiçiales mayores d'ellas que le reçibirán las posturas y bajas que hiçiere, y se a de rematar en el menor ponedor, el domingo que biene, que se contarán diez de Julio d'este presente año; mándase pregonar porque benga a notiçia de todos. Fecha en la dicha Alhambra, a treynta días de junio de mil y seyçientos y onçe años. Don Gaspar de León. Juan de la Vega. [After some difficulties, that contract was given to Pedro Gil on 22 December, and the last

stone of that order was not delivered until 22 June 1613.]

159. 20 September 1614, reference to the placement of the last stone of the parapet of the gallery, AA, Leg. 153, 1: A Pedro de Yeste, treçe reales, que gastó en lo que se conpró para dar de merendar a los asentadores y canteros d'esta obra el juebes pasado [18 September], por aber asentado la clabe en el antepecho de los corredores de la casa real nueba, sigún costunbre que con ellos se tiene en semejantes çerramientos, quatro cientos y quarenta y dos maravedís.

160. 24 December 1619, letter acknowledging the death of Pedro de Velasco, AA, Leg. 104, 5, 15: Por carta de vuestra merçed de diez y siete d'este [December 1619], se a entendido la muerte de Pedro de Velasco, maestro d'estas obras, y para que en la provisión de la persona que le ubiere de suçeder en este ofiçio se pueda andar con el açierto que se dessea, por todo lo que vuestras merçedes refieren que ymporta esto. Combiene que vuestras merçedes propongan las personas que se les ofreçe más apropósito para esto, y que sea quanto con más bevedad se pudiere, para que con ella se trate d'esta provisión y se acuda aya lo que pide su erçerçiçio. Dios guarde a vuestras merçedes como puede. De Madrid, beynte y quatro de diziembre de mill y seis çientos y diez y nueve años. Tomás de Angulo.

161. 14 January 1620, candidates for the post of chief architect proposed by officials of the Alhambra, AA, Leg. 104, 5, 8: Las personas que se nos offreçe proponer a vuestra magestad, en cumplimiento de lo que se nos manda por la carta ynfra escrita, que nos pareçe tienen sufiçiençia para proseguir la fábrica d'estas cassas reales del Alhambra, guardando el modelo y traças antiguas hechas, y dadas por tan grandes maestros mayores como en ellas a avido, no ynovando en nada sin consulta a vuestra magestad, conferida primero por los ofiçiales reales, son: Juan Fernández del Palaçio. Juan Fernández del Palaçio, cantero, cortista, es persona apropósito para el dicho ofiçio, y a serviçio, y a servido de cantero en las dichas obras reales y a hecho en esta çiudad algunas de consideración y tiene buena edad y sujeto. Miguel del Castillo,

cantero, cortista, artillero d'esta Alhambra, y las tiene entendidas, y al presente es aparejador de la yglesia mayor d'esta çiudad, y es apropósito para el dicho ofiçio y buen sujeto. Cristóval de Vilchez, cantero, cortista, es grande maestro de su offiçio, y mereçía el mejor y primer lugar en esta relación, si no le hiçiera contrapesso el ser hombre de más de setenta años. Miguel Guerrero. Miguel Guerrero, cantero. cortista, a hecho en esta çiudad algunas obras de cantería de que a dado satisfaçión y tiene buen sujeto. Vernave de Gauiria. Bernaue de Gauiria, ensamblador, escultor y arquitecto, es persona muy apropósito y a hecho algunas obras de su ofiçio y de buen sujeto. Y ansimismo nos pareçe, siendo vuestra magestad servido, que a qualquiera d'ellos que se eligiere, se le dé solo título de aparejador haziendo ofiçio de maestro mayor en el interín, en la forma que lo tubo Juan de la Vega tantos años, que fué grande oficial d'este arte, con el mesmo jornal de ocho rreales y medio cada día de trabajo, porque, siendo ansí, les obliga y obligará a asistençia personal continua como estas fabricas lo piden; y título de maestro mayor y salario rreal paresce que les dá libertad de hazer ausencias y trater de otras fábricas y obras por sus intereses, con que forçoso abrán de hazer falta a las de vuestra magestad, y la esperiençia a mostrado estos yncombinientes. Don Fernando de Contreras, teniente de alcaide d'ella, solo dice que combiene que la persona, que vuestra magestad fuere servido de elejir, traiga título de maestro mayor en propiedad, por algunos yncombenientes y caussas que a conoçido por la larga esperiençia que tiene de las dichas obras reales, y de las caussas que ay y tiene dado quenta a vuestra magestad d'ellas. Vuestra magestad proveerá en todo lo que más a su real serviçio combenga, siendo servido de que sea con brevedad por lo que ymporta al serviçio de vuestra magestad, pues por falta de maestro mayor se deja a pagar la gente laborante y por neçesidad que pasan van dexando las obras rreales por acudir a otras donde ganan de comer. Cuya persona real nuestro señor guarde, de Granada, catorçe de enero de mill y seis çientos y veynte. Gaspar Fernández de Prado. Juan de Guevara. Gaspar Guerrero. Melchor Ruiz Callejón. Mateo Sánchez.

162. 1 April 1620, report by Gómez de Mora to the Junta on the examination of the candidates for

architect of the Alhambra, AGS, CSR, Leg. 303: Ase hecho el examen de los maestros que pretenden el ofiçio de aparejador de las obras del Alhambra de Granada en presençia del señor secretario Thomás de Angulo, y echóles las preguntas neçesarias para la demonstración y sufiçiençia de cada uno, según las partes que ha de tener para servir el dicho ofiçio, y la buena quenta y razón que ha de administrar la persona puesta por su magestad para servirle.

1. Examinose a Francisco de Potes, maestro de obras, y se alla ser persona en quien concurren las partes neçesarias por dar muy buena quenta de todo lo tocante a Geometría y Arismética, por cuyo medio se alcança todo género de medidas, y por ellas el valor de todo y partes de la obra, así para la baluaçión de la saca y partes de piedra labrada y asentado d'ella tanteos para los destajos y compras de materiales, que todo se alcança por medio de la quenta y raçón, y demás cosas forçosas al ejerçiçio d'este ofiçio, así en lo tocante de cantería y cortes, albañería, yesería, y carpintería, de que a dado muy buena quenta, y por su persona traça vastamente lo neçesario, y en quanto a la execución a echo muchas obras en esta corte, en Valladolid y otras partes, por cuyas raçones pareçe ser apropósito para el dicho ofiçio y para todo lo que se puede ofrezer al serviçio de su magestad, ansí en Granada como en las demás partes de aquel Reyno.

2. Juan Fernández de Palaçios, maestro de cantería, el qual no save de medidas ni quenta cosa ninguna, que es el prinçipal fundamento en que consiste la rraçón y arte de fabricar, ni de traça, no açe por su mano lo neçesario para el dicho ofiçio, que es una de las partes que se requieren para el buen despidiente d'este ofiçio, por tocarle traçar en forma grande las partes de la arquitetura para los moldes y contramoldes por donde se han de seguir los demás ofiçiales que están debajo de su govierno, como todo consta de la preguntas que se le han hecho y en quanto a su ministerio de cantería, hará lo ordinario, y no más.

3. Christóbal de Vilches, maestro de cantería, se halla que a executado por su mano todo lo tocante a su profesión de cantería, pero, en quanto a las medidas neçesarias, ni lo preçiso de arismética, no aze cosa ninguna, siendo esto tan forçoso para la persona que ha de tener su cargo la distribuçión y govierno donde puede faltar el govierno de su magestad, y tanbién al de las obras por no traçar lo forçoso para la execuçión d'ellas.

4. Miguel Guerrero, cantero, se le hicieron las preguntas neçesarias, i no a tratado de otro género de obras, ni traça lo neçesario, ni en quanto jiometría y arismética no save cosa ninguna.

5. Bernavé de Gavina, es su profesión escultor, y así para su ministerio y para poner en obra qualquier retablo traça de su mano lo forzoso, pero para cantería no tiene prática ninguna, ni tanpoco del género de fabricar, faltándole en ésto toda la quenta y raçón de las medidas, por cuya causa no se alla capaz para el dicho ofiçio, porque no tan solamente se deve considerar que la persona a quien se le diere sepa la teórica del arte, pero tanbién la plática con que se viene al conoçimiento y inteligençia del valor de los materiales y su bondad, calidad, peso y medida, avançes y tasaçiones y destajos y pagas de los ofiçiales de diferentes ministerios, de que se compone el poner en ejecuçión qualquiera obra, que sin el conoçimiento de las cosas dichas, es fáçil faltar a las partes de que deve ser adornado la persona a quien se encargare el ofiçio de aparejador, siendo la guía por donde se goviernan todas las personas de ofiçiales canteros, carpinteros, albañires y la distribuçión de la Haçienda, y de la jente que deve estar devajo de su orden. Este es mi pareçer y lo firmé en Madrid a primero de abril de 1620. Juan Gómez de Mora.

163. 20-30 May 1621, notes for a report to the king on the vaults of the three vestibules, AA, Leg. 206, 3: Consulta al Consejo de Obras sobre las informaçiones que se hiçieron sobre la vóveda de la casa real nueva que mira a mediodía. Señor: El teniente de alcáide del Alhambra de Granada, y el veedor y pagador de las obras reales d'ella, diçen que aviendo vuestra magestad cometido al liçençiado don Luis Gudiel, oydor de la real audiençia y don Alonso de Loayssa, vuestro regidor de Guadis y juez y alcayde del Soto de Roma, la averiguaçión y essamen de si la bóveda del çaguán de la cassa real nueva, que mira a la parte de mediodía, la llevava herrada Francisco de Potes, aparejador de las dichas obras, según se avía entendido y declarado por los dichos de Ambrosio de Vico, maestro mayor de las obras y fábrica de la yglesia mayor d'esta çiudad, y Miguel de Castillo, su aparejador, y Cristóbal de Vilches, todos ombres muy grandes maestros en el arte de cantería, y por declaración de Juan de Landeras, asentador de las dichas obras reales, y Françisco Gonçales, carpintero d'ellas, que

a más de treinta años que travaja en las dichas obras y las tienen mui entendidas, que todos, cinco con juramento, declaran ir herrado y no ser capás, ni sufiçiente el dicho Françisco de Potes para proseguilla, no para continuar el ochavado y cubierta de la capilla, que está empessada en la dicha cassa real, ni otras cossas que ay que acavar en ella, que requiere se hagan con gran perfeçión, como lo están las empessadas por tan grandes maestros mayores que aquí acudo, como todo pareçe por la informaçión que orginaron. [fol. 1v] Pareçe que los dichos comisarios, aviendo ordenado que el dicho Françisco de Potes hiçiese traça y modelo de la dicha bóveda, para que por él se juzgasse si llevava açertada, y ni más ni menos, la del ochavado de la capilla real de otra media naranja, que se a de haçer para cubrir otra puerta de la dicha cassa real que mira al levante; aviendo hecho los dichos tres modelos, los dichos comisarios a los 19 de este presente mes se juntaron en la casa real, y, en nuestra presençia, se vieron los dichos tres modelos por los dichos tres maestros de cantería que a hecho la capilla mayor de la iglesia de la dicha compañía d'esta çiudad, qu'es una de las grand cosas de cantería que ay en ella, y tanvién por otros quatro maestros de cantería qu'el mismo Francisco de Potes trujo para su avono; y todos ocho, los quatro que los dichos comisarios nonbraron y los quatro que él trujo, para su defenssa, visto los dichos modelos, decla[rar]on todos, conformes y con juramento que ninguno d'ellos estava bueno, ni en la perfiçión que convenía para las dichas bóvedas se pudiesen proseguir por ellas; y repreguntádoles si la otra fuese de qualquier de ellos, si la fiarían del dicho Françisco de Potes, dijeron que no; ni era justo que su magestad fiasse dél obra tan grandiossa, y aviéndolo llamado a él mismo para que diesse satisfaçión de lo que se avierten, [fol. 2] no la supo dar bastante, y como todo pareçerá por la relaçión; y antes que los dichos comisarios harán a vuestra magestad, que siendo anssí, será fuerça que, para que se prosiga la cantería de la dicha casa real, que está parado todo hasta la determinaçión del hierro d'esta bóveda, mande vuestra magestad nombrar maestro que la prosiga; y siendo servido avertir que aviendo vuestra magestad mandado, por muerte de Pedro de Velasco, maestro mayor que fué de las dichas obras del corregidor de Granada, y a los dichos tenientes de alcayde y veedor y pagador nombrassen personas las más capases que se ha-

llasen para el dicho ofiçio, para que vuestra magestad eligiesse el que fuesse servido. Aviendo hecho muchas diligençias para satisfaçerse de los demás de opinión, se nombrar todos los que se opusieron, y d'ellos se eligieron acá, los tres primeros, que yrán nombrados por más capaçes, para que vuestra magestad fuesse servido de elegir uno d'ellos, agora suplicamos lo mismo, o que sea la persona que vuestra magestad fuere servido como sea cantero cortista, qu'es lo que en la dicha casa real ay neçesidad. . . . Y aunque los dichos modelos que hiço el dicho Francisco de Potes se dieran por buenos, y él por capas para su ofiçio, no conviene a el serviçio de su magestad tenelle en [fol. 2v] las obras reales, porque realmente es falta de juiçio y por su mala condiçión, término y sovervia, porque no tiene el respecto que deve a los demás sus compañeros, y a despedido de las obras al asentador y carpintero porque dijeron sus dichos contra él, aviendo servido en las dichas obras más de treinta años con gran cuydado y satisfaçión, y a los demás peones y lavorantes los trata mal de obra y palabra, que algunos se despiden por no sufrirle, y el avañil que travaja en los dichos reparos, diçe qu'él no save lo que se ordena en ellos, ni los deja haçer enteramente, ni con la perfiçión que conviene, y deja los más forsossos por haçer los que él quiere, demás de que es iudiçiosso aplicado para si [*crossed out*: en lo que toca a las instruciones para proseguir esta obra]. . . . Por no entrarlas al consejo y emvaraçar en cossas pocas, y siendo vuestra magestad servido de que aya y se guarden algunas instruçiones, se podrá enbiarlas que se an dado para las demás obras reales de vuestra magestad, con que todo andará muy ajustado, y cada un oficial sabrá más enteramente lo que deve haçer. Y en lo que toca a lo que se manda acusar del estado de las obras y lo que de presente se ofreçe de que dar quenta, algunas relaçiones largas se an enviado, ansí en tiempo de el liçençiado Juan de Ybarra, como en él del don Tomás de Angulo, y agora de presente se va prosiguendo la obra de la cassa real nueva y los reparos de las viejas, al passo que permite la poca consinaçión que ay para ello; si otra cosa se ofreçiere, se yrá dando quenta a vuestra magestad. Y en lo que toca a que se avisse quantas leguas de Granada se hallará piçarra que sea apropósito para cubrir la casa real y lo qu'en esto será vien haçer, como el maestro mayor es él que se a de ynterar de lo uno y de lo otro para que con

nuestra pareçer, aviéndonos informado, se pueda haçer relaçión, çierta, y con la puntualidad que se deve, esto se hará siendo vuestra magestad servido quando aya maestro mayor. Pues, él que agora haçe este ofiçio, no es capas para ello, y ay alto tiempo para que se haga la eleçión de lo que conviene cubrir, pues ay mucho que haçer primero con que sea satisfecho a lo que vuestra magestad a sido servido de que se informe, vuestra magestad mandará prover en todo lo que mas a su real servicio convenga.

164. 24 September 1621, recommendation that no material be ordered until the king determines which projects are to be executed first, AA, Leg. 206, 3, fol. 4: El dicho pagador, Pedro Arias Riquelme, dando su paresçer, dize que por aver dado paresçer Francisco de Potes, aparejador de las obras reales de la Alhambra, que haze offiçio de maestro mayor d'ellas, que convenía cubrir un quarto de la cassa real nueva. Paresçe se truxo en pregones çierta partida de madera para el dicho efecto, que dizen montará quarenta mill reales poco más o menos . . . ; y aviéndose hecho diligençias y auttos para ello, que están en poder de Anton Garçía, escrivano, se remató la dicha partida en Francisco Ruiz, vezino de Sigura, con çiertas condiçiones a que me refiero. Y porque después de lo susodicho, el dicho aparejador Francisco de Potes fue a la villa de Madrid y dió a su magestad un memorial diziendo, entre otras cossas, que la cassa real nueva estava en disposiçión de cubrirse, y, asimismo, enpeçar a enmaderar los suelos de madera quadrados, que convenía se determinase si an de ser guarneçidos de madera, o se sean de hazer de bovedillas, o suelos rasos, o bovedas de cañas, y paresçe que aviéndose visto el dicho memorial por los señores de la Junta de Bosques y Obras, en veinte y seis de junio d'este presente año, mandaron que los offiçiales de las obras se junten con las personas más prácticas que ubiere en Granada, hallándose presente Potes, y avisen de lo mejor que les paresçiere. En cumplimiento de lo qual se junctaron, por primera y segunda vez, con los maestros más practicos que se hallaron en Granada, presente el dicho Francisco de Potes, los quales aviendo visto, una y muchas vezes, la dicha cassa real, y el estado que oy tiene la fábrica d'ella, conjuramento declararon que, atento a que ay en la dicha cassa real quatro bóvedas prinçipales por cerrar, y, asi-

mismo, la capilla real, y subir algunas paredes que ygualen con las demás, y a aver de hazer primero toda la coronaçión de la dicha cassa real, conbiene al serviçio de su magestad que todo lo susodicho se haga primero, para su seguridad y firmeza, por ser las paredes delgadas y no convenir cargarlas antes de travallas, y que no conbiene en ninguna manera tratar de enmaderar ni cubrir, primo que esto se haga. Y les paresçió que con la consignaçión que oy tienen de dinero las obras reales, aviéndose de hazer, como conbiene, primero todo lo susodicho de cantería. No se podrá tratar en enmaderar en veinte años todo lo cual, otras cossas contiene la dicha declaraçión que original está en poder del presente escrivano, cuyo traslado autorizado se enbió a su magestad, y hasta agora no consta que se aya mandado, clara y distintamente, que se aya de hazer y proseguir primero, lo que toca a cantería o maderamiento. . . . En Granada en 25 de septiembre de seis cientos y veinte y un años. Pedro Arias Riquelme de Ariasco.

165. 30 November 1621, report on the dispute over the vault of the south vestibule, AGS, CSR, Leg. 330, fol. 253: Señor. Haviendo visto los papeles y informaciones que vuestra magestad nos a mandar remitir, y en cumplimiento de lo que fué servido envirarnos a mandar cerca de la obra del quarto nuevo de la Casa Real del Alhambra, que se pretendía iba herrada, y de la sufiçiencia de Francisco de Potes, aparejador de las obras que haze oficio de maestro maior, llevando con nosotros los maestros de cantería que avían declarado en una y otra información, y otros, que de nuevo nombramos, de quien podernos también informar çerca de lo susodicho, fimos [sic] a ver aquella obra, y en quanto lo primero, del ierro que se pretende que lleva, lo que podimos entender, después de aver examinado y oydo largamente a todos los maestros que allí se juntaron, es que sólo consiste en no ir çerrándose la bóveda que aora se ba labrando, con el primor y adorno que, conforme a el rigor del arte, se devía hazer y conforme pareçe estar labrada la bóbeda de la puerta prinçipal que sale al poniente, con quien deve hazer correspondençia, de lo qual solos los entendidos del arte, que atentamente se pusieren a considerar la traça y artefiçio del çerramiento de entrambas bóbedas, podrán juzgar la impropiedad, pero en quanto a la labor y asiento de la piedra y a la seguridad y

perpetuidad del edificio, en lo que hasta aora está labrado y hecho dél, si bien no es lo más dificultoso, todos se conformaron en que la ora verdaderamente no iva herrada, ni era neçesario volverla de nuevo a hazer. Entendido esto, para poder saver y juzgar con certidumbre si Françisco de Potes tenía la sufiçiencia que es neçesaria para podérsele fiar la prosecuçión de la obra començada en la dicha bóbeda, y el çerramiento de otras dos que están por çerrar y cubrir en la misma Casa Real, de gran dificultad por ser de arquitectura extrahordinaria, nos pareçió ordenarle que hiziese los modelos de las dichas bóbedas, dentro del término que le fué señalado, y porque no se pudiese aiudar de nadie y valer de agena industria, se le ordenó asistiese a fabricar los dichos modelos, en çierto aposento de la dicha Casa Real, y que los fuese fabricando en presençia de persona de satisfacçión, que se le puso por guarda, y aviéndolo hecho, volvimos otra vez con todos los maestros que se juntaron la primera, los quales después de vistos los modelos, con juramento declaron que no estaban buenos, ni con la puliçia y curiosidad que convenía a semejante obra, y que no tenían al dicho Françisco de Potes por tan capaz y sufiçiente para poderla proseguir como hera menester que lo fuera, y que ninguno de ellos, si corriera por su quenta averla de acabar con toda perfecçión, se la fiara, y a las objecçiones y defectos, que en presençia nuestra y del dicho Françisco de Potes, los demás maestros pusieron a sus modelos, no nos pareçió que respondió, ni satisfiço bastantemente, porque no pudo negar no estar con perfecçión ni curiosidad obrados, y sólo dió por respuesta que aunque no podía obrar también de manos, como le harían otros más moços, pero que lo sabría ordenar, y que sería fácil en lo que supiese informarse. Supuesto lo dicho, y que las casas Reales de la Alhambra de vuestra magestad son, sin duda ninguna, de las más grandiosas y suntuosas que vuestra magestad tiene en todos su Reynos, y que, en dificultad y artifiçio, las obras que están por hazer exceden notablemente a todas las hechas, o a la maior parte d'ellas, no pareçe que será cosa açertada fiarlas de persona de cuio credito y sufiçiençia en su arte dudan todos tanto, sino que quien tenga general aprobaçión y se pueda tener satisfacçión, que con toda perfiçción las aya de proseguir a su Real serviçio, cuia católica y Real persona guarde Dios muchos años. Granada y noviembre postrero de 1621 años. Don Luis Gudiel y Peralta. S. Alonso de Loaysa Messía.

166. 1622, report by Callejón on the vault of the south vestibule, AA, Leg. 203, 3: Sobre la obra de la bóveda. 1622. Muy ilustre señor: Melchor Ruiz Callejón, maestro de arquitectura y alarife de la çiudad de Granada, y uno de los maestros nombrado para las nivelaçiones que se hiçieron para el riego de Lorca y Cartajena, por nombramiento del liçençiado Gregorio López Madrera y Bohques de buestra Real Consejo, y ansí mismo maestro que saque la traça para el pantano que se trata de hacer en aguel reyno para la fertilidad dél, qu'estuvo en mano de su magestad, del rey don Felipe Terçero, nuestro señor, qu'esté en el cielo, digo que como maestro que tengo notiçia de la fábrica de la casa real del Alhambra, de los nombrados para la eleçión de maestro mayor, digo que en la dicha obra se va fabricando una bóveda en el çaguán prinçipal de cantería cuya çimbra cargan sobre el releje y estribo, qu'el maestro antiguo dejó hecho con diferente yntento de que solo los arcos mayores fuesen de cantería y las lunetas de los entremedios a lo lijero y la tabla de la bóbeda de tabiques doblados con ladrillos gruesos hechos apropósito, en la forma que los tenplos modernos se fabrican, que tienen fortaleça y poca costa, y mas bistoso por los guarniçiones y hornato, que con mas faliçidad se aplican, y las paredes en que restrivan trabajan menos, por cuya causa las d'este edifiçio se fundaron, no con la fortaleça que se requiere para ser todo de cantería, de que podría resultar biçio en la obra y aún riesgo, y muncha mayor costa, doy abiso a vuestra alteza y haré bueno lo que propongo para que vuestra alteza mande lo que más ynporte a su real serviçio. Melchor Callejón.

167. 22 April 1623, recommendations of Potes with annotations by Crescenzi and Gómez de Mora (as copied on 29 April 1644), AA, Leg. 152, fol. 3: Y tanbién dió el mesmo Françisco de Potes un papel de algunas advertençias tocante a estas obras y dudas que se le ofreçían en lo que se mandó por la relaçión referida, y haviéndose visto en la Junta, y las anotaçiones que hiçieron a él, Juan Bautista Cresençio y Juan Gómez de Mora, maestro y traçador de las obras de su magestad que ban en la margen [*here set in brackets*] que es como se sigue: Advertençias que dió Françisco de Potes de algunas cosas, en que diçe conviene se tome resoluçión y dudas que se le açen en lo acordado por el rey don Felipe Segundo, nuestro señor que está en el cielo,

para la continuaçión de las obras de la Alhambra de Granada.

1. Que respeto de estar toda la casa enraspada, todas las paredes principales y todos los más atajos y hecha la vóveda del quarto prinçipal, y ser obra de piedra franca y que están enchando a perder las cornijas por la blandura de la piedra, su pareçer es que se cubra luego, enpeçando desde el quarto prinçipal que cae al poniente por estar acabado en toda perfiçión en la forma que su magestad del señor Felipe segundo acordó en la çiudad de Badajós. [added by Crescenzi and Gómez de Mora: Que se haga assí, y que se cubra este quarto primero, prosiguiendo con la de más obra conforme lo acordado por su magestad.]

2. Assí mismo le pareçe que, respeto de estar las paredes subidas treinta pies de alto, declara por las artes de a dentro desde el quarto segundo suelo hasta la cornija, que el maderamiento que se a de echar, que sirve de tirantes y armadera, sea tosco, y de bajo del se hará una vóveda de çinco pies de buelta y uno de cornija, la qual sea de cordel y se jaharrará y blanqueará y dócil con sus brutescos, como está de presente oy la sala que [fol. 3v] a hecho de nuevo sobre la porta prinçipal de el alcáçar de Madrid, y d'esta manera de vóveda se harán todos los quartos altos, porque correspondan uno con el otro en todo el dicho quarto. [added by Crescenzi and Gómez de Mora: Que se hagan los techos de vóvedas blancas de ladrillo tavicado y doblado, haçiendo algunas según la calidad de la pieças, unas con lunetas y otras esquilfadas por ser obra más vistosa.]

3. Assí mismo le pareçe que los pasos de las escaleras sean de piedra parda de la Sierra Elvira, que es la que toca más en mármol, y ser la mejor, y que sean los pasos enteros, y que en los gruesos de las paredes en las entrados de la escalera principal y salidas arriva el corredor, se pongan tres pasos en cada grueso de pared, como lo muestra un pedaço de planta, porque d'esta manera quedará mas dócil y llana la dicha escalera. [added by Crescenzi and Gómez de Mora: Que la escalera se haga como se dice y se execute la planta que va firmada de Juan Gómez de Mora, maestro y traçador de las obras de su magestad, haçiendo la correspondençia de puertas como se ve en ella, y lo mesmo se haga en las puertas que se an enmendado en la planta vaja a la redonda del patio como lo lleva entendido Françisco de Potes, por estar en mejor forma que antes estaba traçado.]

4. Que respeto de no aver en toda la obra formado los gueços en los gruesos de las paredes de las chimeneas y ser delgadas, conviene se deshagan las cantidades necesarias y se buelban a elegir y subir las dichas paredes conforme al memorial que su magestad hiço en Badajós. [added by Crescenzi and Gómez de Mora: Que se hagan estas chimeneas conforme lo acordado por su magestad que aya gloria, cortando de las paredes para los cañones lo neçesario.]

5. Assí mismo, le pareçe que todos los postigos que están en las traviesas están más bajos que el nivel del suelo de las ventanas, que se alçen a el dicho nivel, y los agujeros que están bajos para los maderamientos del suelo, se alçen a el dicho nivel dejando los más bajos el grueso del suelo de los ladrillos de que a de ser solado. [added by Crescenzi and Gómez de Mora: Que se haga assí y se execute el perfil que va firmado que es conforme a la órden antigua.]

6. Que se acuerde la forma que a de tener el techo de la escalera prinçipal. [added by Crescenzi and Gómez de Mora: Esta sobre escalera se hará de cielo raso, con algunos conpartimientos y tajas que sigan la forma del sitio con cornissa corrida de yeso a la redonda.]

7. Que se prosigan en la obra de la capilla conforme a las traças hechas. [added by Crescenzi and Gómez de Mora: Que prosiga con esta obra conforme a la traça antigua que ba firmada, y la nueva planta de la bóveda, y en quanto a el cuerpo que falta por la parte de a dentro, se haga algún conpartimiento de farjas, y que esta mesma órden se guarde en la vóveda que a de tener esta capilla, executando la traça que va firmado de la vóveda, y por fuera d'ella en la cúpula, se haga algún ornato de fajas que correspondan a las pilastras de abajo, y en las pilastras de abajo y en las pilastras se pongan sus vasas.]

8. Que se le dé la forma con que se a de cubrir el çaguán aobado. [added by Crescenzi and Gómez de Mora: Que la vóveda del çaguán aovado se haga conforme a la traça que va firmado.]

9. Que se le dé la órden como ba de rematar el ángulo opuesto a él de la escalera prinçipal, para que en todo se guarde la órden que su magestad fuere servido. [added by Crescenzi and Gómez de Mora: Que haga en este ángulo lo nuevamente señalada en la planta.] [added by the secretary of the Junta de Obras y Bosques] Se ha acordado que la obra se continúe en conformidad de lo que mandó el

rey don Felipe segundo, nuestro señor, por la re- lación y de las anotaciones que van en las dudas de Françisco de Potes, que todo va señalado en las traças firmada de Juan Gómez de Mora, y que el correjidor de la çiudad de Granada, el teniente de alcayde de el Alhambra y los oficiales de las obras no alteren, ni permitan innovar ni alterar cosa al- guna, sin órden de su magestad, y, si el aparejador o maestro mayor que es, o fuere, lo hiçieren, y el veedor se lo permitiere, sea por su quenta y a su costa, y para qu'esto se cumpla y execute pun- tualmente, quedando esta orijinal en los papeles del cargo del veedor, se dará copia autoriçada d'ella a Françisco de Potes y a los que sirvieren el ofiçio de aparejador o maestro mayor, y assí mesmo en- tregará Françisco de Potes las traças orijinales, fir- madas de Juan Gómez de Mora, para que se guar- den en los papeles del ofiçio del veedor, quedando él con copia d'ellas para lo que se hubiere de ex- ecutar. Fecha en Madrid, a 22 de abril de mill sey- çientos y veinte y tres años. Pedro de Hoff Huerta.

168. 17 June 1623, specifications for sandstone blocks to continue the vault of the south vestibule, AA, Leg. 210, 1, 42: Las condiçiones con que se a de pregonar y rematar çiento y çinquenta varas de piedra de las canteras de Santa Pudia, para la vóbeda de la casa nueba que mira a la parte del mediodía. Primeramente, las dichas piedras an de tener media bara de alto, y de lecho una terçia, y tres pies de largo, y a este respeto se a de reduçir las pieças que se trugeren. Yten, es condiçión que sean las pieças de dos terçias de lecho, y de una bara de largo, y más y menos en el largo, con media bara de alto con un dedo de ventaja, conforme a la galga que se les diere. Yten, con condiçión que, sy se pidiere alguna pieça de más lecho, se trayga pagándolo, como diçe la primera condiçión. Yten, es condiçión que no an de tener gabaros ni salitre. Yten, con condiçión que an de benir galgadas a regla y esquadra como se acostunbra en esta obra y las demás de Granada, y en todo a satifaçión del maestro mayor. Fecha en diez y seys de junio de seyçientos y beynti tres años. Francisco de Potes. [The work was put up for bids on 2 July but the contract was not signed by Rodrigo Alonso until 21 November. Even so he may have withdrawn from the project because the only payments for stone for the vault were made to Alonso de Fal- conete on 2 and 16 March 1624. All pertinent doc- uments are found in Leg. 44, 4.]

169. 25 February 1625, specifications for the spi- ral staircase in the southwest corner of the round courtyard, AA, Leg. 206, 3, 5: Condiçiones con que se an de sacar los pasos de la escalera secreta, que se a de haçer en el ángulo opuesto al de la escalera prinçipal de las casas reales nuevas. Pri- meramente, an de ser de la Siera d'Elvira de piedra parda, sin pelos ni tronaduras, de a çinco pies de largo cada uno y una quarta de grueso y medio vara de lecho, bien desbastados, sin desportillos, descuadra y borneo. Y con condiçión que el ma- estro, que desto se encargare, a de sacar treynta y seis pasos de la dicha medida a toda costa de saca y a careto hasta ponellos en el patio de la dicha cassa real, o a donde se le ordenare y a satisfaçión todo del maestro mayor de las dichas obras. Y con condiçión que se an de sacar y entregar dentro de seis meses desde el día del remate. Y las pagas de la dicha obra an de ser en esta manera: la terçera paga del lo que montare, luego, en haciendo la escritura y dan[n]do fianças, y la otra terçera parte, abiendo entregado la metad de los dichos pasos, y la otra terçera parte, en acabando de entregar toda la dicha partida. Francisco de Potes. [*added in the hand of don Gaspar de León*] Y bista se acordó que se trayga en pregones esta partida de piedra en las partes acostumbradas y se asine el remate para diez y seys días del mes de março que biene, de este presente año, y ansí se probeyó en la Alhambra beynti çinco de febrero de mill y seyçientos y beynti çinco años. don Gaspar de León. Francisco de Potes.

170. 14 September 1625, advice on the construc- tion of the roof of the palace, AA, Leg. 206, 3: En la Alhambra, fortaleça de la çiudad de Granada, catorçe días del mes de septienbre de mill y seys çientos y veynte y çinco años, pareçieron Diego de Bliches y Benito de Bilches, hermanos, ofiçiales de cantería, veçinos de la dicha çiudad de Granada, y dixeron que ellos en cumplimiento del auto [of 9 September 1625] d'esta otra parte probeydo por su excelençia del marqués de Mondéjar, mi señor, an bisto la casa real nueba del dicho Alhambra y dispusición d'ella porque la an andado, y les pareçe que, para poderse cubrir a ley de buena obra, tiene necesidad para que puedan desaguar los an . . . [*torn, perhaps* ángulos que] descansan desde los quartos prinçipales [*torn*] pared de la çircunferençia del patio de lebantar sobre las paredes, que están fechas en las dichas casas nuebas, dos baras con gruesos d'estribos y tirantes, porque a esta altura

se cubrirán los quartos prinçipales, y para que esta altura no le cause fealdad alguna por qualquiera de las delanteras de la dicha casa real, a de llebar su coronaçión o claraboyas y remates, y con esta altura tiene bastante corriente para poderse desaguar las dichos triángulos, y con ésto les pareçe será muy buena obra, y la mejor que les pareçe, y esto es su pareçer que se hagan torres o no, socargo del juramento que tienen fecho y firmaron de sus nombres. Diego de Bilches. Benito del Bilches. ante mí, Antón García, escribano público.

171. 9 December 1625, request that a column of Filabres marble on the Alhambra be given to the city of Granada, AGS, CSR, Leg. 332, fol. 693: Señor. La çiudad de Granada suplicó a vuestra magestad, por un memorial, se sirviese vuestra magestad de hazerle merced de una coluna de mármol blanco que vuestra magestad tiene en este Alhambra con su basa y capitel, para hazer un tabernáculo en debozión de la linpísima conçepçión de Nuestra Señora. Vuestra magestad fue servido de remitirme este memorial a los 25 de nobiembre de 625, para que consultase a vuestra magestad lo que se me ofreçía açerca d'esto. Digo, señor, que abrá más de 70 años se truxo esta columna, la qual tiene 16 pies de altura, y con basa y capitel tendrá 18, y de diámetro tiene dos pies y un quarto, y sacose en la sierra de Filabre, 30 leguas d'este Alhambra, y aunque no parezen oy papeles para saber lo que costó puntualmente, por tradizión y memorias de hombres ançianos, e ajustado que en aquellos tiempos costó a vuestra magestad mas de 800 ducados, y pareçiéndole al marqués de Mondéjar, mi bisabuelo, que era grande el gasto, ordenó que se trajesen otras colunas de jaspe de la sierra de Turro, seis leguas de este Alhambra, del mismo diámetro y altura que es la de mármol blanco, con las quales se edificó el patio y corredores altos, y costaron, según e averiguado, a 400 ducados cada una, dizen los ofiçiales que la de mármol blanco costará oy de traer aquí 1 U 400 ducados, porque es linda pieza. Conforme a ésto, podrá vuestra magestad mandarme lo que fuese servido, tiniendo consideraçión a los serviçios que esta ciudad a hecho, y los que, yo espero, continuará en serviçio de vuestra magestad, cuya católica y real persona guarde Nuestro Señor, como la cristiandad a menester. Del Alhambra y diziembre 9 de 1625. El Marqués de Mondéjar. [added] Resolución: En Madrid a 10 de enero 1626. Dese la çiudad, atendiendo al efecto

para que lo pide y lo que ha servido y sirve a su magestad.

172. 14 December 1625, proposal for the addition of a third story and corner towers, AA, Leg. 206, 3: Deçimos nos, Juan Gómez de Mora, maestro mayor de las obras de su magestad, y Pedro de Liçargarate, aparejador de ellas, y Mygel del Valle y Aguilar, maestro de cantería y alarife d'esta villa de Madrid, que en presençia del señor conde de los Arcos de la cámara de su magestad, y su mayordomo, y de la Junta de las Obras y Bosques, emos visto las traças y modelos que se an hecho para la demostraçión de diferentes pareçeres y yntentos que en la çiudad de Granada an dado los maestros, para cubrir y acavar la fábrica de la casa real de la Alhambra de Granada, aviendo visto todos los papeles, así plantas, alçados, cortes, modelos, presentados por Vartholomé Fernández de Lechuga, y oydo su pareçer en raçón d'ellos y, en particular, la traça y modelo que enseñó para lebantar la fábrica un cuerpos [sic] más a la redonda de toda ella con sus ventanas y hornato a la parte de fuera y dentro, y, ansí mismo, la traça fecha para levantar dos tores de la fachada prinçipal que mira la parte de poniente; se an visto todas las traças antiguas y horden que se dió para acavar la dicha fábrica por su magestad del señor rey don Phelipe 2°, en Vadajos, en 10 de junio del 1580 años, y también las advertencias que se dieron el año pasado de 1624, por parte maestro de las obras de la Alhambra, que se dieron en la Junta de Obras y Vosques, que se remitieron por los señores d'ella al marqués de Malpiça, y se le respondieron a la marjen con la última resolución de lo que se havía de executar de la dicha obra. Y haviendo considerado lo uno y lo otro, y el estado en que, al presente se halla la fábrica, les pareçe que lebantar el terçer suelo d'ella conforme a la traça del dicho Lechuga quedaría de más vuena altura y hornato, añidiendo [sic] a esta cassa el dicho quarto, y más se acreçentará la vivienda con la dicha nueba traça en que se gastará 25,250 ducados, que según los preçios que allá se acostunbran de la compra y labor de los materiales, que an sido ynformados de los dichos Francisco de Potes y Vartolomé Lechuga en el tanteo que d'ello se a hecho, montan los dichos 25,250 ducados, les pareçe que este terçer suelo todabía se puede escusar siendo su magestad servido, pues dy modo para cubrir de ploma la cassa real sin ynconveniente ninguno, que esté conforme

al modelo que a hecho el dicho Vartholomé de Lechuga, que aunque es como el que a hecho y traído Françisco de Potes, tiene mejor despidiente para las aguas, advirtiendo en él que en la execuçión se suban las paredes de en medio, que se forman en los ángulos por la parte de a dentro, que se an señalado en el modelo que emos firmado, por la parte de avajo de nuestros nombres, subiendo las paredes dichas hasta resçivir los maderamientos, haçiendo para ellos, primero, la armadura a dos aguas de los quartos, y sobre ella, en los ángulos, formar otra segunda armadura perdida para hechar el agua fuera, por parte de los dichos ángulos, como va señalado en el dicho modelo con las letras "A." Otrosí, que en los dichos tejados se hechen guardas a plomo de las ventanas de avajo para dos efectos, el uno para la hermosura y hornato de los tejados y fábrica, lo otro para la comodidad, luz y ayre de los aposentos que se pueden formar en los desvanes, y para la conservaçión de las mismas armaduras, haciendo tanbién guardas por la parte de dentro del patio prinçipal, que guardan su hornato y correspondençia de los medios y claros de los yntercolunios de abajo, y haçiendo todo lo dicho, se quedaron los texados de muy buena forma, y rematándolos por la parte de dentro y fuera con su balustres, pedrestales y volas conforme a la hórden antigua, con lo qual se ahorrará la cantidad de los 25,250 ducados, y se abreiva la fábrica ocho años del tiempo de lo que se delatará, aviendo de subirse el tercer suelo. Otrosí, les pareçe que el hazer las dos torres traçadas por Vartholomé Lechuga en la fachada prinçipal no convienese hagan, respeto que en la primera yntençión de esta fábrica, según pareçe, no se traçaron, y assí lo que está fabricado, está dispuesto a cubrirse sin subir las dichas torres; y haviendo de haçerse, no pueden corresponder a su labor a lo que oy está labrado en correspondençia de las ventanas de abajo como en las pilastras de los lados, ni puede ser fuerte la obra, y se ahorrarán 9,000 ducados, que a montado el tanteo que se a hecho costarán acavarse en toda perfeçión todo lo tocante a cantería, albañilería y chapiteles demás de la dilaçión del tiempo. Y en lo tocante a la execuçión de la escalera prinçipal, se siga la traza de Vartholomé Lechuga, guardando, en quanto a su planta, la traza y planta antigua, y éste es su pareçer, hecha en Madrid, a 14 de diziembre 1625. Juan Gómez de Mora. Pedro de Lizargarate. Miguel del Balle y Aguilar.

BIBLIOGRAPHY

Alberti, Leone Battista. *De re aedificatoria* (Trattati di architettura I), ed. R. Bonelli and P. Portoghesi. 2 vols. Milan, 1966.

Alizeri, Federigo. *Notizie dei professori del disegno in Liguria dalle origini al sècolo XVI.* Vol. v. *Scultura.* Genoa, 1877.

Ardila y Esquivias, Gabriel Rodríguez de. "Historia de los condes de Tendilla," ed. R. Foulché-Delbosc. *Revue Hispanique,* XXXI (1914), pp. 63-131.

Aurigemma, Salvatore. *Villa Adriana.* Rome, 1961.

Baroni, Costantino. *L'architettura lombarda da Bramante al Richini.* Milan, 1941.

Bartoli, Alfonso. *I monumenti antichi di Roma nei disegni degli Uffizi di Firenze.* 5 vols. Rome, 1914-1922.

Bermúdez de Pedraza, F. *Antigüedad y excelencias de Granada.* Madrid, 1608.

Bermúdez Pareja, Jesús. "Obras del Cuarto Dorado." *Cuadernos de la Alhambra,* I (1965), pp. 101-105.

Bermúdez de Pareja, Jesús, and María Angustias Moreno Olmedo. "Documentos de una catástrofe en la Alhambra." *Cuadernos de la Alhambra,* II (1965), pp. 77-87.

Bevan, Bernard. *History of Spanish Architecture.* London, 1938.

Bonet Correa, Antonio. "Túmulos del emperador Carlos V." *Archivo español del arte,* XXXIII (1960), pp. 55-60.

Bramantino (Bartolomeo Suardi). *Le Rovine di Roma al principio del sècolo XVI. Studi del Bramantino,* ed. G. Mongeri. Milan-Pisa-Naples, 1880.

Brown, Frank C., Frank A. Bourne, and John R. Coolidge. *Study of the Orders.* Chicago, 1948.

Bury, John B. "The stylistic term 'Plateresque.'" *Journal of the Warburg and Courtauld Institutes,* XXXIX (1976), pp. 199-230.

Byne, Arthur. *Decorated wooden ceilings in Spain.* New York and London, 1920.

Byne, Arthur and Mildred Stapley. *Spanish Architecture of the Sixteenth Century.* New York-London, 1917.

Calzada, A. *Historia de la arquitectura española.* Barcelona-Buenos Aires, 1933.

Camón Aznar, José. *La arquitectura plateresca.* 2 vols. Madrid, 1945.

Carande Thobar, Ramón. *Carlos V y sus banqueros.* Madrid, 1943.

Caro Baroja, Julio. *Los moriscos del reino de Granada (Ensayo de historia social).* Madrid, 1957.

Carrera Pujal, Jaime. *Historia de la economía española.* 5 vols. Barcelona, 1943-1947.

Catalogue. Exhibition of Italian Old Master Drawings, November 16 to December 3, 1971. London, 1971.

Cataneo, Pietro. *I quattro primi libri d'architettura* (facsimile edition of Venice 1554). Ridgewood, New Jersey, 1964.

Caveda, José. *Ensayo histórico sobre los diversos géneros de arquitectura empleadas en España desde la dominación Romana hasta nuestros días.* Madrid, 1848.

Ceán Bermúdez, Juan Agustín. *Diccionario histórico de los más ilustres profesores de las Bellas Artes en España.* Madrid, 1800.

Cepeda Adán, José. "Andalucía en 1508. Un aspecto de la correspondencia del Virrey Tendilla." *Hispania,* LXXXV (1962), pp. 3-45.

————. "El Conde de Tendilla, primer Alcayde de la Alhambra." *Cuadernos de la Alhambra,* VI (1970), pp. 21-50.

————. "El palacio de Carlos V, símbolo de una frustración." *Cuadernos de la Alhambra,* II (1966), pp. 53-58.

Cevera Vera, Luis. "Carlos V mejora el Alcázar madrileño en 1540." *Revista de la biblioteca, archivo y museo del Ayuntamiento de Madrid,* no. 5 (1979), pp. 57-125.

Chierici, Gino. *Il palazzo italiano dal sècolo XI al sècolo XIX.* 3 vols. Milan, 1952-1957.

Chueca Goitía, Fernando. *Arquitectura del siglo XVI* (Ars Hispaniae XI). Madrid, 1953.

————. *Casas reales en monasterios y conventos españoles.* Madrid, 1966.

————. *Historia de la arquitectura española. Edad Antigua y Edad Media.* Madrid, 1965.

————. *Invariantes castizos de la arquitectura española.* Madrid-Buenos Aires, 1947.

Cloulas, Annie. "Charles-Quint et le Titien. Les

premiers portraits d'apparat." *L'information d'histoire de l'art*, IX (1964), pp. 213-221.

Coffin, David. "The plans of the Villa Madama." *Art Bulletin*, XLIX (1967), pp. 111-122.

———. *The Villa in the Life of Renaissance Rome.* Princeton, 1978.

Comito, Terry. *The Idea of the Garden in the Renaissance.* New Brunswick, New Jersey, 1978.

Contreras, Rafael. *La Alhambra. El Alcázar y la gran Mezquita de Occidente.* 3d ed. Madrid, 1885.

Dacos, Nicole. *Le Logge di Raffaello.* Rome, 1977.

Dantyszek, Jan. "El embajador polaco en la corte de Carlos V 1524-1527." *Viajes de estranjeros en España y Portugal desde los tiempos más remotos hasta fines del siglo XVI*, vol. I, pp. 791-834. Madrid, 1952.

Durm, Josef. *Die Baukunst der Etrusker und Römer* (Handbuch der Architektur II, 2). Stuttgart, 1905.

Dyggve, Ejnar, *Ravennatum Palatium Sacrum. La basìlica ipetrale per cerimònie* (Det Kgl. Danske Videnskabernes Selskab. Archaeslogiskkunsthistoriske Meddelelser, III, 2). Copenhagen, 1941.

Egger, Herman, ed. *Codex Escurialensis. Ein Skizzenbuch aus der Werkstatt Domenico Ghirlandaios.* Vienna, 1906.

Fasolo, Furio, and Giorgio Gullini. *Il Santuario della Fortuna Primigènia a Palestrina.* 2 vols. Rome, 1953.

Félez Lubelza, Concepción. *El Hospital Real de Granada.* Granada, 1979.

Filarete (Antonio Averlino). *Trattato di architettura* (Trattati di architettura II), ed. A. M. Finoli and L. Grassi. Milan, 1972.

Ford, Richard. *Granada.* Granada, 1955.

Foronda y Aguilera, Manuel de. *Estancias y viajes del Emperador Carlos V.* Madrid, 1914.

Forssman, Erik. *Dorisch, jonisch, korinthisch: Studien über den Gebrauch der Säulenordnungen in der Architektur des 16-18 Jahrhunderts.* Stockholm, 1961.

Foster, Philip. "Raphael on the Villa Madama: the text of a lost letter." *Römischen Jahrbuch für Kunstgeschichte*, XI (1967-1968), pp. 308-312.

Frommel, Christoph L. *Der römische Palastbau der Hochrenaissance.* 3 vols. Tübingen, 1973.

Frommel, Christoph L., Stefano Ray and Manfredo Tafuri. *Raffaello architetto.* Milan, 1984.

Furguson, George. *Signs and Symbols in Christian Art.* New York, 1961.

Gachard, Louis P. *Retraite et morte de Charles-Quint au monastère de Yuste, lettres inédites.* 3 vols. Brussels, 1854-1855.

Gallego y Burín, Antonio. *La Alhambra.* Granada, 1963.

———. *Granada. Guía artística e histórica de la ciudad.* Madrid, 1961.

———. "Unas obras conocidas y un maestro desconocido: el escultor Antonio de Leval." *Cuadernos de Arte*, VII-IX (1942-1944), pp. 55-83.

———. "Documentos relativos al entallador y vidriero Juan del Campo." *Cuadernos de arte*, I (1936-1937), pp. 341-350.

Gallego Morell, Antonio. "La corte de Carlos V en la Alhambra en 1526." *Miscelánea de estudios dedicados al profesor Antonio Marín Ocete*, vol. I, pp. 267-294. Granada, 1974.

García Chico, Esteban. *Medina del Campo* (*Catálogo monumental de la provincia de Valladolid*, III). Valladolid, 1960.

———. "El Palacio de los Dueñas de Medina del Campo." *Boletín del Seminario de Estudios de Arte y Arqueología* (Universidad de Valladolid), XVI (1949-1950), pp. 87-110.

García Gómez, Emilio, and Jesús Bermúdez Pareja. *La Alhambra: la Casa Real* (Forma y Color 10). Granada, 1966.

Gaya Nuño, Juan Antonio. *La arquitectura española en sus monumentos desaparecidos.* Madrid, 1961.

Gazzola, Piero, ed. *Michele Sanmicheli. Mostre d'arte della Città di Verona.* Palazzo Canossa, May-October 1960, Venice, 1960.

Giorgio Martini, Francesco di. *Trattati di architettura, ingegneria e arte militare* (Trattati di architettura III), ed. C. Maltese. 2 vols. Milan, 1967.

Giovannoni, Gustavo. *Antonio da Sangallo il Giovane.* 2 vols. Rome, 1959.

Gómez-Moreno y González, Manuel. "Palacio de Carlos V." *Revista de España*, XVIII (1885), pp. 191-225.

———. "Los pintores Julio y Alejandro y sus obras en la Casa Real de la Alhambra." *Boletín de la Sociedad Española de Excursiones*, VI (1919), pp. 20-33.

Gómez-Moreno y Martínez, M. *Las águilas del Renacimiento español.* Madrid, 1941.

———. "En la Capilla Real de Granada." *Sobre el Renacimiento en Castilla*, pp. 1-40. Madrid, n.d.

———. *Diego Siloe.* Granada, 1963.

———. *Guía de Granada*. Granada, 1892.

———. "Hacia Lorenzo Vázquez." *Archivo español de arte y arqueología*, I (1925), pp. 1-40.

Gonzaga da Borgoforte, Luigi. *Crònaca del soggiorno di Carlo V in Italia dal 26 luglio 1529 al 25 aprile 1530*, ed. G. Romano. Milan, 1892.

Gothein, Marie L. *A History of Garden Art*. Trans. A. Hind. 2 vols. New York, 1928.

Griseri, Andreina. "Berruguete e Machuca dopo el viaggio italiano." *Paragone*, XV, no. 10 (1964), pp. 3-19.

———. "Nove schede di manierismo ibérico." *Paragone*, X, no. 113 (1959), pp. 33-44.

———. "Perino, Machuca, Campaña," *Paragone*, VIII, no. 87 (1957), pp. 13-21.

Gutiérrez Coronel, Diego. *Historia geneológica de la Casa Mendoza*. 2 vols. Madrid, 1946.

Hartt, Frederick. *Giulio Romano*. 2 vols. New Haven, 1958.

Haupt, Albrecht. *Geschichte der Renaissance in Spanien und Portugal*. Stuttgart, 1927.

Haverkamp-Begemann, Egbert. "The Spanish views of Anton van den Wyngaerde." *Master Drawings*, VII (1969), pp. 375-399.

Henríquez de Jorquera, Francisco. *Anales de Granada*, ed. Antonio Marín Ocete. Granada, 1934.

Heydenreich, Ludwig. "Über Oreste Vannocci Biringucci." *Mitteilungen des Kunsthistorisches Instituts in Florenz*, III (1929-1930), pp. 434-444.

Heydenreich, Ludwig H., and Wolfgang Lotz. *Architecture in Italy 1400-1600* (The Pelican History of Art 16). Harmondsworth, 1974.

Hibbard, Howard. *The Palazzo Borghese in Rome* (American Academy in Rome. Memoirs, vol. 27). New York, 1962.

Hoag, John D. *Rodrigo Gil de Hontañón*. Unpublished doctoral dissertation, Yale University, 1957.

Horn, Hendrik J. *Charles V's "Conquest of Tunis": Cartoons and Tapestries by Jan Cornelisz Vermeyen*. Unpublished doctoral dissertation, Yale University, 1977.

Ibáñez de Segovia, Gaspar. *Historia de la Casa de Mondéjar*, 1613 (Biblioteca Nacional, Madrid, MS. 3315).

Iñiguez Almech, Francisco. *Casas reales y jardines de Felipe II*. Madrid, 1952.

Jacquot, Jean, ed. *Les Fêtes de la Renaissance*. Vol.

II, *Fêtes et Cérémonies au temps de Charles Quint*. Paris, 1960.

Juste, Théodore. "Charles-Quint et Marguerite d'Autriche. Étude sur la Minorité, l'émancipation et l'avènement de Charles-Quint à l'Empire." *Mémoires couronnés et autres mémoires publiés par l'Académie Royale de Belgique*, VII (1858), pp. 1-165.

Justi, Carl. "Anfänge der Renaissance in Granada." *Jahrbuch der königlich preussischen Kunstsammlungen*, XII (1891), pp. 173-192.

———. "El Renaciemiento en Granada." *Estudios de arte español*, vol. I, pp. 175-202. Madrid, n.d.

Keniston, Hayward. *Francisco de los Cobos, Secretary of the Emperor Charles V*. Pittsburgh, 1958.

Krautheimer, Richard. *Early Christian and Byzantine Architecture* (The Pelican History of Art 24). Harmondsworth, 1965.

Kruft, Hanno-Walter. "Concerning the date of the Codex Escurialensis." *Burlington Magazine*, CXII (1970), pp. 44-45.

———. *Portali genovesi del Rinascimento*. Florence, 1971.

Kruft, Hanno-Walter, and Anthony Roth. "The Della Porta Workshop in Genoa." *Annali della Scuola Normale Superiore di Pisa* (Classe de Lettere e Filosofia, ser. 3), III (1973), pp. 893-954.

Kubler, George. *Building the Escorial*. Princeton, 1982.

Kubler, George, and Martin Soria. *Art and Architecture in Spain and Portugal and their American Dominions 1500 to 1800* (The Pelican History of Art 17). Harmondsworth, 1959.

Lafuente y Alcántara, Manuel. *Historia de Granada*. 4 vols. Granada, 1845.

Lampérez y Romea, Vicente. *Arquitectura civil española de los siglos I al XVIII*. 2 vols. Madrid, 1922.

———. *Historia de la arquitectura cristiana española en la edad media según el estudio de los elementos y los monumentos*. Madrid, 1909.

———. "Los palacios de los reyes de España en la Edad Media." *Arte español*, III (1914), pp. 213-235.

Lannoy, Guillebert de. *Oeuvres de Guillebert de Lannoy, voyageur, diplomate et moraliste*, ed. C. Potvin. Louvain, 1878.

Lefèvre, Renato, *Villa Madama*. Rome [1973].

Llaguno y Amírola, Eugenio. *Noticias de los arqui-*

tectos y arquitectura de España, desde su restauración, acrecentadas con notas, adiciones y documentos por D. Juan Agustín Ceán-Bermúdez. Madrid, 1829.

Longhi, Roberto. "Ancora sul Machuca." *Paragone*, XX, no. 231 (1969), pp. 34-39.

———. "Comprimarj spagnoli della maniera italiana." *Paragone*, IV, no. 43 (1953), pp. 3-15.

Loukomski, George. "The Palace of Charles V at Granada." *Burlington Magazine*, LXXXIV (1944), pp. 119-124.

Lugli, Giuseppe. *Itinerario di Roma antica*. Milan, 1970.

Marchini, Giuseppe. *Giuliano da Sangallo*. Florence, 1942.

Marías, Fernando. "El problema del arquitecto en la España del siglo XVI." *Boletín de la Real Academia de Bellas Artes de San Fernando*, LXVIII (1979), pp. 179-216.

Martín González, Juan José. "El alcázar de Madrid en el siglo XVI (nuevos datos)." *Archivo español de arte*, XXXV (1962), pp. 1-19.

———. *Monumentos civiles de la ciudad de Valladolid* (Catálogo monumental de la provincia de Valladolid, XIII). Valladolid, 1976.

———. "Nuevos datos sobre la construcción del alcázar Toledo." *Revista de archivos, bibliotecas y museos*, LXVIII (1960), pp. 271-286.

———. "El palacio de Carlos V en Yuste." *Archivo español de arte*, XXIII (1950), pp. 27-51.

———. "El Palacio de 'El Pardo' en el siglo XVI." *Boletín del Seminario de Estudios de Arte y Arqueología*, XXXVI (1970), pp. 4-41.

Martínez Ruiz, Juan. "El taller de Juan de Orea." *Cuadernos de la Alhambra*, I (1965), pp. 59-73.

Mazarío Coleto, María del Carmen. *Isabel de Portugal*. Madrid, 1951.

Mélida, José R. "Informe acerca del projecto para protección y conservación de cubiertas y pisos del palacio de Carlos V, formado por el arquitecto-director de las obras de la Alhambra de Granada, Sr. Torres Balbás." *Anales y boletín de la Real Academia de Bellas Artes de San Fernando*, XXIV, no. 95 (1930), pp. 90-92.

F.A.M. Mignet. *Charles-Quint, son abdication, son séjour et sa mort au Monastère de Yuste*. Paris, 1854.

Moreno Olmedo, María Angustias. *Heráldica y genealogía granadinas*. Granada, 1976.

———. "Un documento del Archivo de la Alhambra, pieza básica sobre los Mendozas de la Al-

hambra." *Cuadernos de la Alhambra*, IV (1969), pp. 89-98.

Morreale, Margherita. "Apuntes para la historia del término 'arquitecto'." *Hispanic Review*, XXVII (1959), pp. 129-136.

Münzer, Hieronymus. "Viaje por España y Portugal en los años 1494 y 1495." *Boletín de la Real Academia de la Historia*, LXXXIV (1924), pp. 32-197.

Museo de Arte de Ponce. Fundación Luis A. Ferré, Catalogue I. Paintings of the European and American Schools. Ponce, Puerto Rico, 1965.

Museo del Prado. Catálogo de las pinturas. Madrid, 1963.

Nader, Helen. "The Greek Commander Hernán Núñez Toledo, Spanish Humanist and Civic Leader." *Renaissance Quarterly*, XXXI (1978), pp. 463-485.

———. *The Mendoza Family in the Spanish Renaissance 1350-1550*. New Brunswick, New Jersey, 1979.

———. "Noble Income in Sixteenth-Century Castile: The Case of the Marquises de Mondéjar, 1480-1580." *Economic History Review*, 2d ser., XXX (1977), pp. 411-426.

Navagero, Andrea. "Viaje por España del magnífico Micer Andrés Navagero." *Viajes de extranjeros por España y Portugal desde los tiempos más remotos hasta fines del siglo XVI*, vol. I, pp. 839-893. Madrid, 1952.

Palladio, Andrea. *Il Quattro libri dell'architettura* (facsimile edition of Venice, 1570).

Pane, Roberto. *Il Rinascimento nell'Italia meridionale*. 2 vols. Milan, 1977.

Paz y Meliá, Antonio. "El embajador polaco Jan Dantisco en la Corte de Carlos V." *Boletín de la Real Academia Española*, XI (1924), pp. 54-69; XII (1925), pp. 73-93.

Pfandl, Ludwig. "Itinerarium Hispanicum Hieronymi Monetarii 1494-1495." *Revue Hispanique*, XLVIII (1920), pp. 1-178.

Pluchart, Henry. *Musée Wicar, Notice des dessins, cartons, pastels, miniatures et grisailles exposés*. Lille, 1889.

Portoghesi, Paolo. *Rome of the Renaissance*. Trans. P. Saunders. London, 1972.

Post, Chandler R. *A History of Spanish Painting*. Vol. X, *The Early Renaissance in Andalusia*. Cambridge, Mass., 1950.

Prieto Moreno, Francisco. "La conservación de la Alhambra." *Revista nacional de arquitectura*, I, no. 3 (1941), pp. 49-53.

————. "Obras recientes en la Alhambra y Generalife: Resumen del año 1966." *Cuadernos de la Alhambra*, III (1967), pp. 129-133.

————. "Obras recientes en la Alhambra y Generalife: Resumen del año 1967." *Cuadernos de la Alhambra*, IV (1968), pp. 129-133.

————. "Obras recientes en la Alhambra y Generalife: Resumen del año 1968." *Cuadernos de la Alhambra*, V (1969), pp. 125-128.

————. "Obras recientes en la Alhambra y Generalife: Resumen del año 1970." *Cuadernos de la Alhambra*, VII (1971), pp. 81-83.

Ripa, Cèsare. *Iconologìa, overo descrittione di diverse imagini cavato dall'antichità, e di propria inventione* (facsimile edition, Rome, 1603). New York, 1971.

Rivera Blanco, José J. *El Palacio Real de Valladolid (Capitanía General de la VII Region Militar)*. Valladolid, 1981.

Rodríguez de Ardila y Esquivias, Gabriel. "Historia de los Condes de Tendilla," ed. R. Foulché-Delbosc. *Revue Hispanique*, XXXI (1914), pp. 63-131.

Rodríguez Villa, Antonio. "El emperador Carlos V y su corte." *Boletín de la Real Academia de la Historia*, XLIV (1904), pp. 465-507.

————. *Etiquetas de la Casa de Austria*. Madrid, 1913.

Rosci, Marco. *Il trattato di architettura di Sebastiano Serlio*. Milan, 1967.

Rosenthal, Earl E. *The Cathedral of Granada, A Study in the Spanish Renaissance*. Granada, 1961.

————. "The Diffusion of the Italian Renaissance style in Western European Art." *Sixteenth Century Journal*, IX (1978), pp. 33-45.

————. "The Image of Roman Architecture in Renaissance Spain." *Gazette des Beaux-Arts*, LII (1958), pp. 329-346.

————. "The Invention of the Columnar Device of Emperor Charles V at Court of Burgundy in Flanders in 1516." *Journal of the Warburg and Courtauld Institutes*, XXXVI (1973), pp. 198-230.

————. "The Lombard Sculptor Niccolò da Corte in Granada from 1537-1552." *Art Quarterly*, XXIX (1966), pp. 209-244.

————. "The Lost *Cuarto de las Helias* in the Arabic Palace on the Alhambra." *Miscelánea de estudios dedicados al profesor Antionio Marín Ocete*, vol. II, pp. 933-943. Granada, 1974.

————. "A Neapolitan Architectural Motive in the Andalusian Renaissance." *Familiare '82. Studi per le nozze d'argento Jurlaro Ditonno*, pp. 163-174. Brìndisi, 1982.

————. "Niccolò da Corte and the Portal of the Palace of Andrea Doria in Genoa." *Festschrift Ulrich Middeldorf*, ed. Antje Kosegarten and Peter Tigler, pp. 358-363. Berlin, 1968.

————. "*Plus Oultre*: the *idea imperial* of Charles V on the Alhambra." *Hortum Imaginum. Essays in Western Art*, ed. R. Enggass and M. Stokstad, pp. 87-93. Lawrence, Kansas, 1974.

————. "*Plus Ultra, Non Plus Ultra* and the Columnar Device of Emperor Charles V." *Journal of the Warburg and Courtauld Institutes*, XXXIV (1971), pp. 204-228.

————. "Die 'Reichskrone,' die 'Wiener Krone,' und die 'Krone Karls des Grossen' um 1520." *Jahrbuch der Kunsthistorischen Sammlungen in Wien*, N.F., XXX (1970), pp. 7-48.

————. "A Sixteenth Century Drawing of the West Facade of the Palace of Charles V in Granada." *Miscelánea de estudios dedicados al Profesor Emilio Orozco Díaz*, pp. 137-147. Granada, 1979.

Sagredo, Diego de. *Medidas del Romano necessarias a los oficiales que quieren seguir las formaciones de las basas, colunas, capiteles y otras pieças de los edificios antiguos* (facsimile edition, Toledo, 1526). Madrid, 1946.

Sánchez Cantón, Francisco Javier. *Fuentes literarias para la historia del arte español*. 5 vols. Madrid, 1923-1941.

Sandoval, Prudencia de. "Historia de la vida y hechos del emperador Carlos V." *Biblioteca de autores españoles*, LXXX-LXXXII. Madrid, 1956.

Sangallo, Giuliano da. *Il libro di Giuliano da Sangallo, Còdice vaticano Barberiniano latino 4424*. 2 vols. Leipzig, 1910.

San Pedro de Galatino, Julio Quesada-Cañaveral y Piédrola, duque de. "Instrucciones para las obras en la Alhambra (1546-1549)." *Archivo español de arte y arqueología*, XI (1935), pp. 209-216.

Santa Cruz, Alonso de. *Crónica del emperador Carlos V desde el año 1500 hasta el 1550*, ed. R. Beltrán y Rózpide and A. Blázquez y Delgado Aguilera. 5 vols. Madrid, 1920-1925.

Sebastiano Serlio on Domestic Architecture, ed. Myra N. Rosenfeld. Cambridge, Mass., 1978.

Serlio, Sebastiano, *Sesto libro delle habitationi di tutti li gradi degli homini* (facsimile edition, Cod. Icon. 189, Bayerische Staatsbibliothek, Munich). Milan, 1966.

———. *Tercero y quarto libro de architectura*. Trans. F. de Villalpando (facsimile edition of Toledo, 1552). Valencia, 1977.

———. *Tutte l'opere d'architettura*. Venice, 1584.

Soergel, Gerda. *Untersuchungen über den theoretischen Architeckturentwurf von 1450-1550 in Italien*. Published dissertation, University of Cologne, 1958.

Stirling-Maxwell, William. *Annals of the Artists of Spain*. London, 1891.

Swinburne, Henry. *Travels through Spain the years 1775 and 1776*. London, 1779.

Tervarent, Guy de. *Attributs et symboles dans l'art profane 1450-1600*. 2 vols. Geneva, 1958.

Tomei, Piero. *L'architettura di Roma nel Quattrocento*. Rome, 1942.

Tormo y Monzó, Elías. "El brote del Renacimiento." *Boletín de la Sociedad Española de Excursiones*, XXV (1917), pp. 51-65.

———. *Os desenhos das antigualhas que vio Francisco de Ollanda pintor português (1539-40)*. Madrid, 1940.

Torres Balbás, Leopoldo. "El ambiente mudéjar entorno a la Reina Católica." *Curso de conferencias sobre la política africana de los Reyes Católicos II*, pp. 81-125. Madrid, 1951.

———. *Arquitectura gótica* (Ars Hispaniae VII). Madrid, 1952.

———. "Diario de obras en la Alhambra: 1924." *Cuadernos de la Alhambra*, II (1966), pp. 89-111.

———. "Diario de obras en la Alhambra: 1925." *Cuadernos de la Alhambra*, III (1967), pp. 125-152.

———. "Diario de obras en la Alhambra: 1927-1929." *Cuadernos de la Alhambra*, IV (1968), pp. 115-121.

———. "La mexquita real de la Alhambra y el baño frontero." *Al-Andalús*, X (1945), pp. 196-214.

———. "El Museo Arqueológico de la Alhambra." *Al-Andalús*, IX (1944), pp. 236-241.

———. "Paseos por la Alhambra: la Torre del Peinador de la Reina o de la estufa." *Archivo español de arte y arqueología*, VII (1931), pp. 193-212.

———. "Plantas de casas árabes en la Alhambra." *Al-Andalús*, II (1934), pp. 380-387.

Tourneur, Victor. "Les origines de l'ordre de la Toison d'Or et la symbolique des insignes de celui-ci." *Bulletin de la Académie royale des Sciences Belgique, Classe des Lettres*, 5e série, XLIII (1956), pp. 300-323.

Twiss, Richard. *Travels through Portugal and Spain in 1772 and 1773*. London, 1775.

Tyler, Royall. *The Emperor Charles the Fifth*. London, 1956.

Urrea Fernández, Jesús. "El Palacio Real de Valladolid." *Boletín del Seminario de Estudios de Arte y Arqueología*, XL-XLI (1975), pp. 241-258.

Vales Failde, Francisco Javier. *La Emperatriz Isabel*. Madrid, 1917.

Valladar y Serrano, Francisco de Paula. *La Alhambra: su historia, su conservación y su estado en la actualidad*. Granada, 1907.

———. *Guía de Granada*. Granada, 1906.

———. *El incendio de la Alhambra*. Granada, 1890.

———. "Planos de Juan de Herrera y Pedro Machuca." *Arte español*, I (1912-1913), pp. 49-50.

Valli, G. "Un recuerdo de los Reyes Católicos en Roma." *Boletín de la Universidad de Granada*, XVI (1944), pp. 337-340.

Varni, S. "Delle opere di Gian Giacomo e Guglielmo della Porta e Nicola da Corte." *Atti della Società Ligure di Storia Patria*, IV (1866), pp. 35-78.

Vasari, Giorgio. *Le Vite de' più eccellenti pittori, scultori e architettori nelle redazioni del 1550 e 1568*, ed. by R. Bettarini and P. Barocchi. 3 vols. Florence, 1966-1971.

———. *Le Vite dei più eccellenti pittori, scultori e architetti*, ed. by C. L. Ragghianti. 4 vols. Milan-Rome, 1942-1949.

Vasco y Vasco, José. *Memoria sobre la Alhambra* [1875]. Granada, 1890.

Velasco, Lázaro de. "Traducción de los diez libros de arquitectura de Vitrubio." *Fuentes literarias para la historia de arte español*, ed. F. J. Sánchez Cantón, vol. I, pp. 183-221. Madrid, 1923.

Velázquez de Echevarría, Padre Juan. *Paseos de Granada y sus contornos o descripción de sus antigüedades y monumentos*. 2 vols. Granada, 1764.

Viajes de extranjeros por España y Portugal desde los tiempos más remotos hasta fines del siglo XVI, ed. J. Garcia Mercadal. 3 vols. Madrid, 1952-1962.

Vicente Cascante, Ignacio. *Heráldica general y fuentes de las armas de España*. Barcelona-Madrid, 1956.

Vignola, G. Barozzi da. *Regola delli cinque ordini d'architettura* [1962]. Rome, 1763.

Villalón, Cristóbal de. *Ingeniosa comparación entre lo antiguo e lo presente* [1539] (Sociedad de Bibliófilos Españoles, XXXIII). Madrid, 1898.

Vitruvius Pollio, L. *De Architectura*, ed. Fra Giocondo. Venice, 1511.

Vitruvius Pollio, L. *De Architettura libri dece traducti de Latino in Vulgare affigurati*. Trans. B. Mauro da Bèrgamo and B. Jovio da Comasco, with commentary and illustrations by Cèsare Cesariano (facsimile edition, Como, 1521). Bronx, 1968.

Walcher, Maria Cassotti. *Il Vignola*. 2 vols. Trieste, 1960.

Wilkinson, Catherine. "Juan de Mijares and the Reform of Spanish Architecture under Philip II." *Journal of the Society of Architectural Historians*, XXXII (1974), pp. 122-132.

Wurm, Heinrich. *Der Palazzo Massimo alle Colonne*. Berlin, 1965.

INDEX

Library of Congress Cataloging in Publication Data

Rosenthal, Earl E., 1921-
The palace of Charles V in Granada.

Bibliography: p. Includes index.
1. Palacio de Carlos V (Granada, Spain) 2. Granada
(Spain)—Palaces. 3. Architecture, Italian—Spain—
Granada. 4. Charles V, Holy Roman Emperor, 1500-1558—
Palaces—Spain—Granada. I. Title.
NA7776.G76R67 1985 725'.17'094682 85-3366
ISBN 0-691-04034-6 (alk. paper)

PLATES

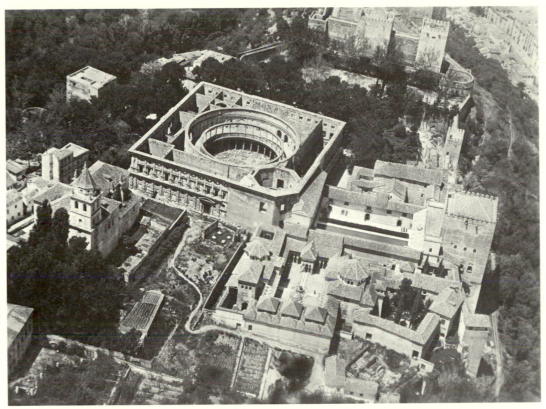

PLATE 1. Air view of the Alhambra, Granada, 1920 (Foto: Torres Molina)

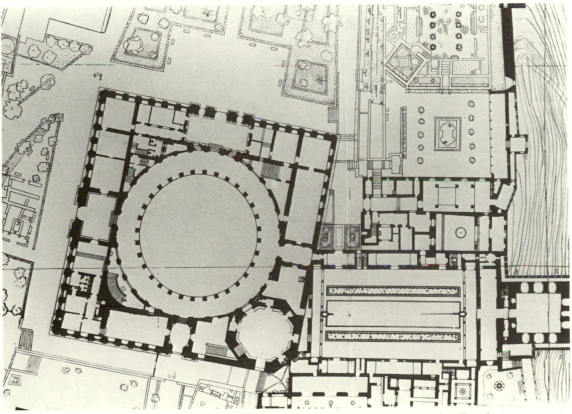

PLATE 2. Groundplan of the Alhambra, Granada, c. 1960 (Patronato de la Alhambra)

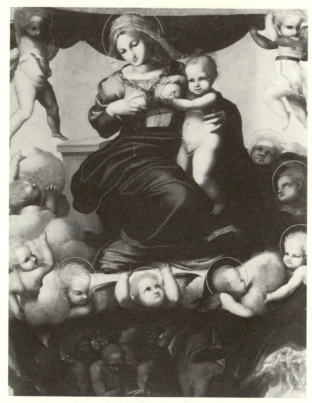

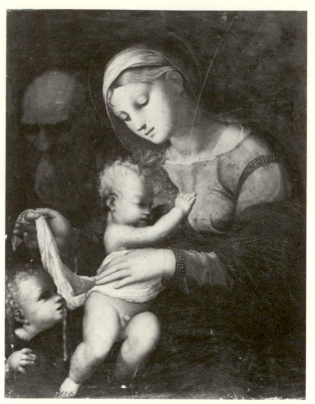

PLATE 3. *Madonna del Suffragio*, Pedro Machuca, 1517, Museo del Prado, Madrid (Foto Mas)

PLATE 4. *Holy Family*, Pedro Machuca, 1520s, cathedral of Jaén (Foto Mas)

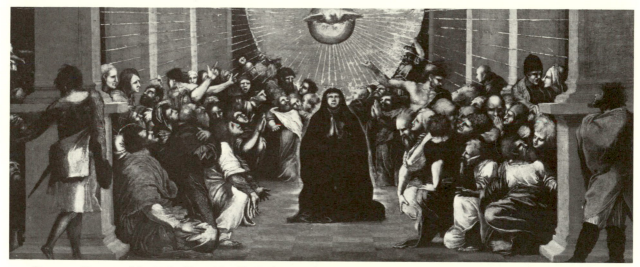

PLATE 5. *Descent of the Holy Ghost* (detail), Pedro Machuca, Museo de Arte de Ponce, Puerto Rico (Foto Mas)

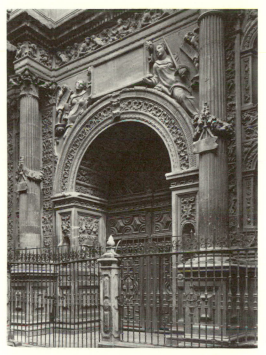

PLATE 6. Sketch for catafalque of Mary of Portugal in the Royal Chapel, Granada, Pedro Machuca, 1549, Archivo de la Alhambra (Patronato de la Alhambra)

PLATE 7. Puerta del Perdón, cathedral of Granada, Diego Siloe, c. 1536 (Foto Mas)

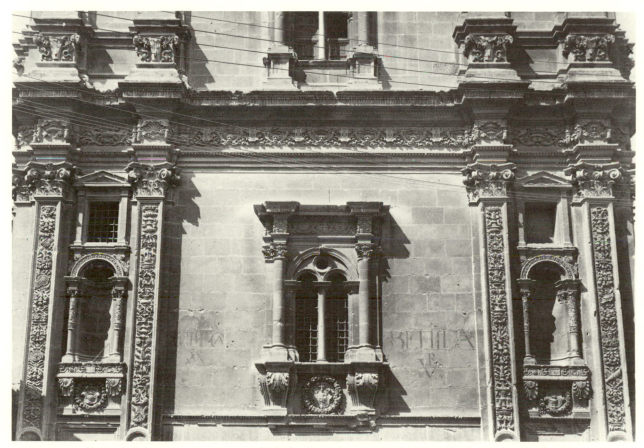

PLATE 8. Lower story, tower, cathedral of Murcia, Francesco Torni, l'Indaco, 1519 (author)

PLATE 9. Portal, Palacio de los Dueñas, Medina del Campo, Luis de Vega, c. 1527 (Foto Mas)

PLATE 10. Courtyard, Palacio de los Dueñas, Medina del Campo, Luis de Vega, c. 1527 (Foto Garay)

PLATE 11. Groundplan, Juan Gómez de Mora, 1626, El Pardo, near Madrid, begun by Luis de Vega in 1543 (Foto Biblioteca Vaticana)

PLATE 12. Courtyard, Palacio Real, Valladolid, Luis de Vega, c. 1527 (Martín González)

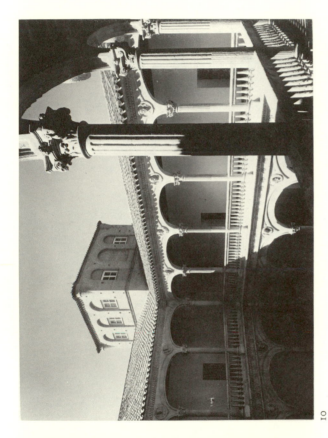

10

9

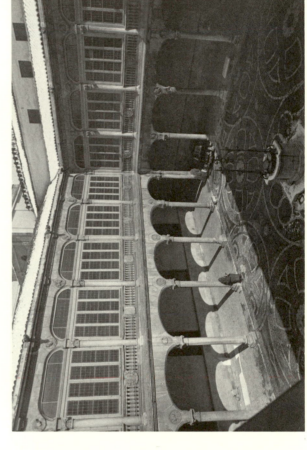

12

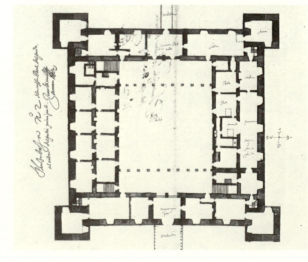

11

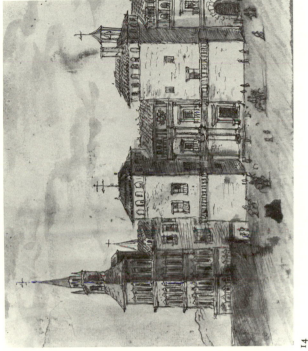

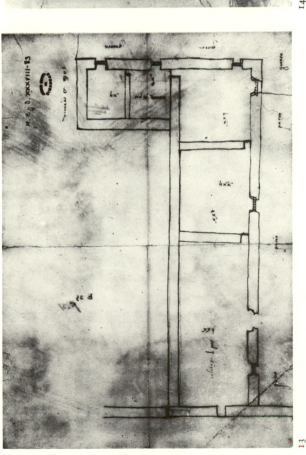

PLATE 13. Groundplan of proposed addition to Palacio de los Cobos, Úbeda, Luis de Vega, c. 1530 (Archivo General de Simancas)

PLATE 14. Sketch (detail), Anton van den Wyngaerde, c. 1562, south facade, *alcázar*, Madrid, renovated by Luis de Vega in 1543 (Cod. Min. 41, fol. 73, Österreichische Nationalal-Bibliothek, Vienna)

PLATE 15. Groundplan, Juan Gómez de Mora, 1626, *alcázar*, Madrid, Luis de Vega, 1543 (Foto Biblioteca Vaticana)

PLATE 16. Groundplan, Juan Gómez de Mora, 1626, *alcázar*, Toledo, Alonso de Covarrubias, 1537 (Foto Biblioteca Vaticana)

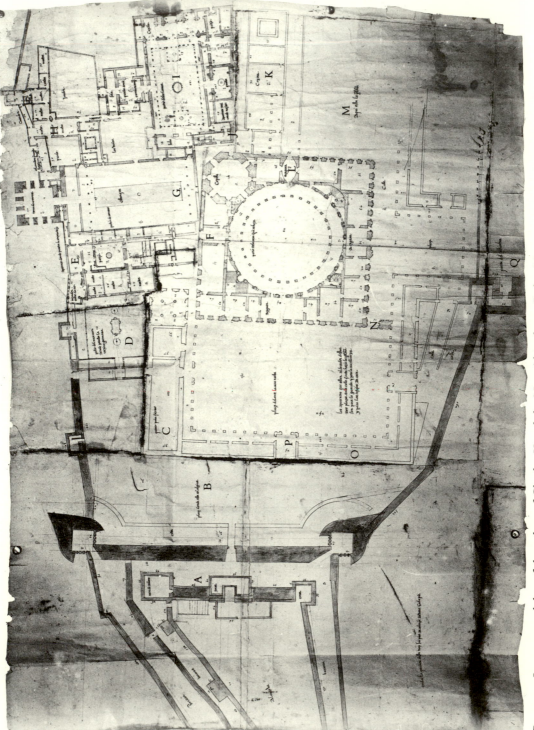

KEY TO PLATE 17

A. Proposed fortifications
B. Water storage tank
C. Festival hall
D. Patio de Machuca
E. Cuarto dorado
F. North staircase
G. Court of Myrtles
 (or Comares)
H. New Quarters
I. Court of Lions
J. Christian entry to
 Nazaride palaces
K. Kitchen
L. East entry
M. Santa María de la Alhambra
N. Arch connecting
 two forecourts
O. Location of Puerta Real
P. West gate
Q. Puerta de Justicia

PLATE 17. Large groundplan of the palace of Charles V and the Nazaride palaces, Pedro Machuca, 1528 (Photograph furnished and authorized by the Patrimonio Nacional)

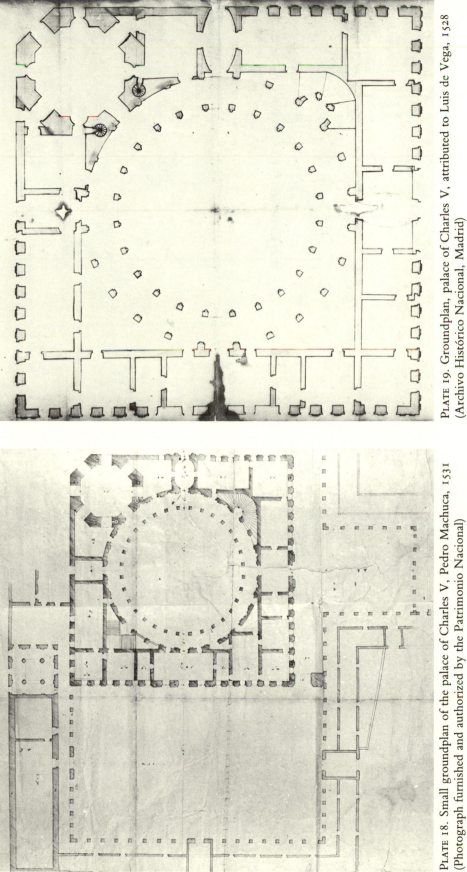

PLATE 19. Groundplan, palace of Charles V, attributed to Luis de Vega, 1528 (Archivo Histórico Nacional, Madrid)

PLATE 18. Small groundplan of the palace of Charles V, Pedro Machuca, 1531 (Photograph furnished and authorized by the Patrimonio Nacional)

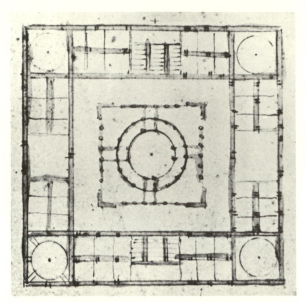

PLATE 20. Plan of a villa in Spain, Aristotile da San-
gallo, c. 1535 (Musée des Beaux-Arts, Lille)

PLATE 21. Princely villa, Francesco di Giorgio Mar-
tini, c. 1492 (Cod. Magliabechiano, II, I, 141, fol.
24, Biblioteca Nazionale, Florence)

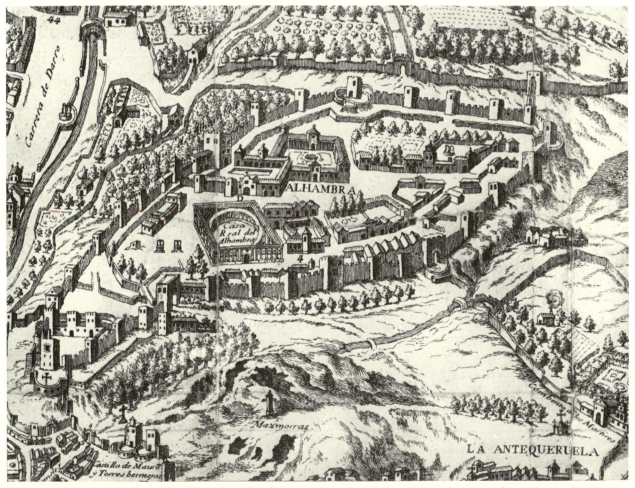

PLATE 22. Perspective-plan of the Alhambra (detail), engraving of 1612, based on a drawing of 1596 by Ambrosio
de Vico (Foto: Torres Molina)

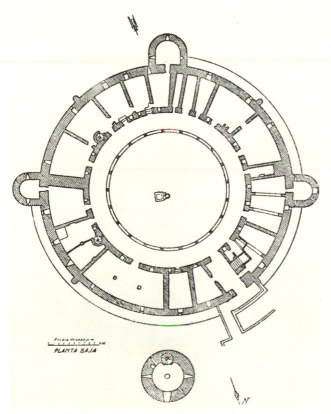

PLATE 23. Groundplan, Bellver Castle, Palma de Mallorca, c. 1309 (after Reynés)

PLATE 24. Habsburg eagle holding the globe, detail of plate 25 (author)

PLATE 25. Fireplace, bedchamber of Charles V, New Quarters, the Alhambra, c. 1532 (author)

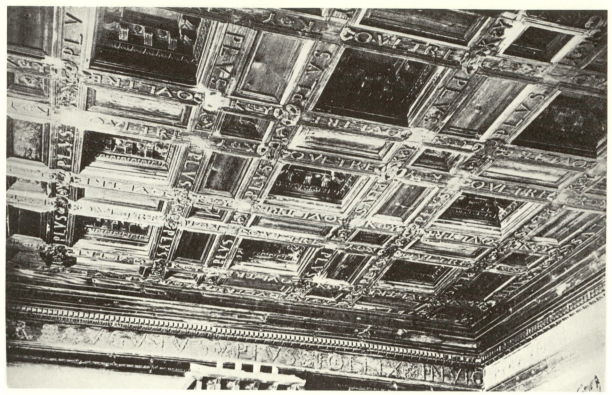

PLATE 26. Coffered ceiling of the "office of Charles V," New Quarters, the Alhambra, c. 1532 (Byne and Stapley)

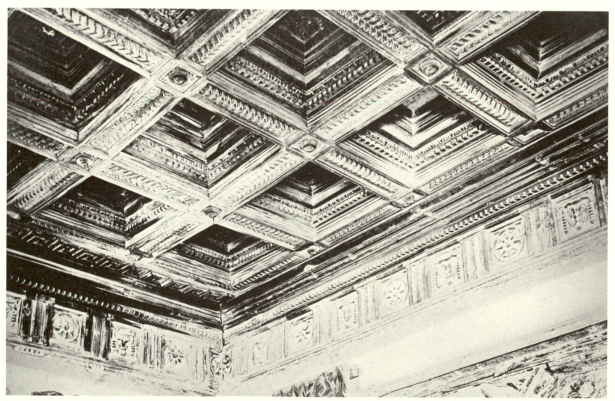

PLATE 27. Coffered ceiling of the anteroom, New Quarters, the Alhambra, c. 1532 (Byne and Stapley)

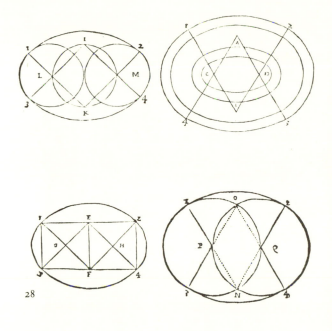

28

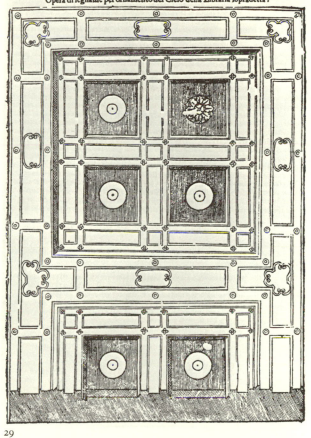

29

PLATE 28. Geometric constructions of the oval form, Serlio, bk. I, 1545

PLATE 29. Coffered ceiling, Serlio, bk. IV, 1537

PLATE 30. Coffered ceiling, southeast staircase, Hospital Real, Granada, Juan de Plasencia, 1559 (Foto Mas)

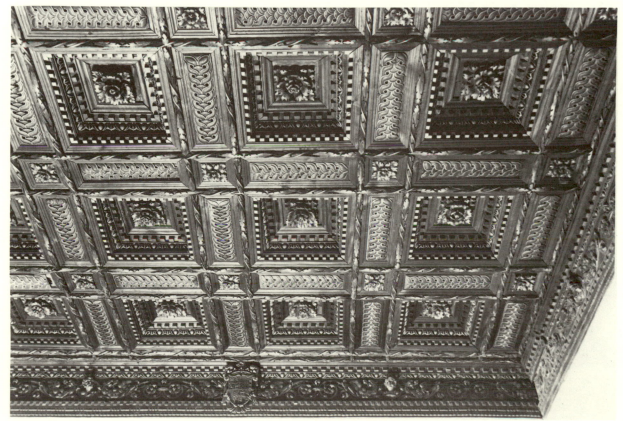

30

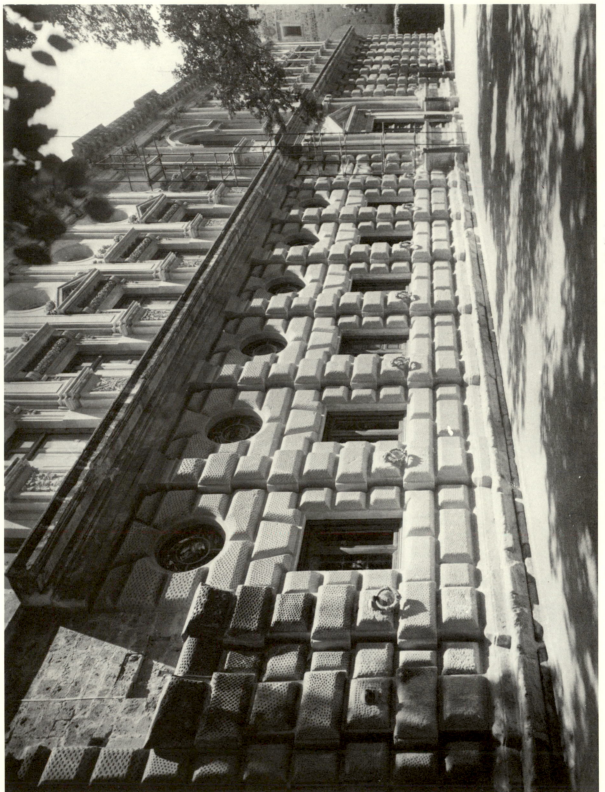

PLATE 31. South façade, palace of Charles V (Foto: Torres Molina)

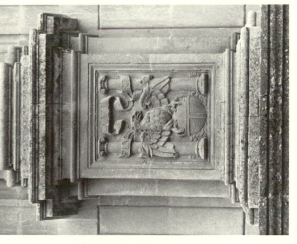

34

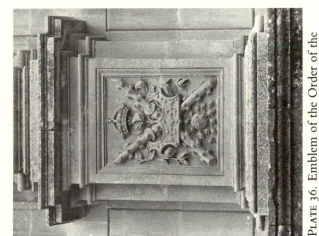

33

32

PLATE 32. Bronze tie ring held in the jaws of a lion, south facade, palace of Charles V, c. 1540 (Foto Mas)

PLATE 33. Bronze tie ring held in beak of an eagle, south facade, palace of Charles V, c. 1540 (Foto Mas)

PLATE 34. Columnar device of Charles V, main-story pedestal, south facade, palace of Charles V (Foto Mas)

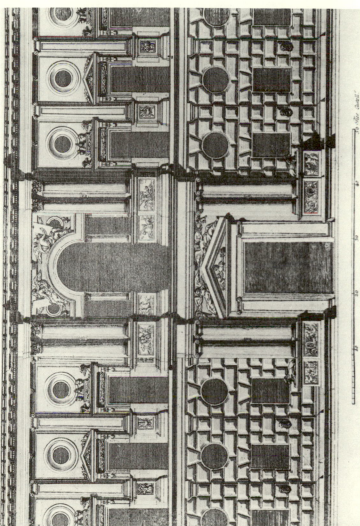

PLATE 35. Engraving of south facade, palace of Charles V, José de Hermosilla, 1767 (Academia de San Fernando, Madrid)

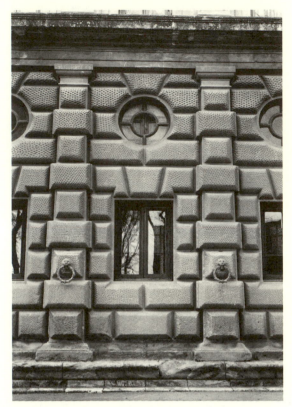

PLATE 37. Bay of lower story, south facade, palace of Charles V (Foto Mas)

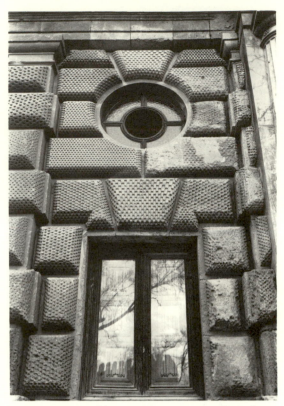

PLATE 38. Bay of lower story, west facade, palace of Charles V (Foto Mas)

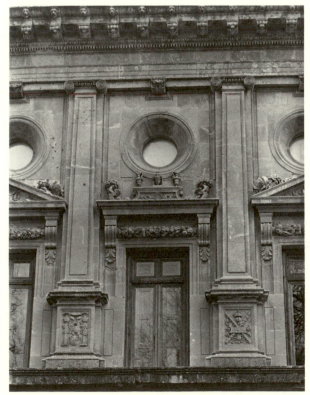

PLATE 39. Main-story windows, south facade, palace of Charles V (Foto Mas)

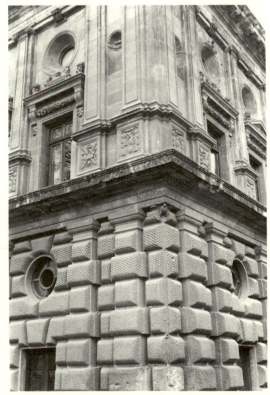

PLATE 40. Southeast corner, palace of Charles V (Foto Mas)

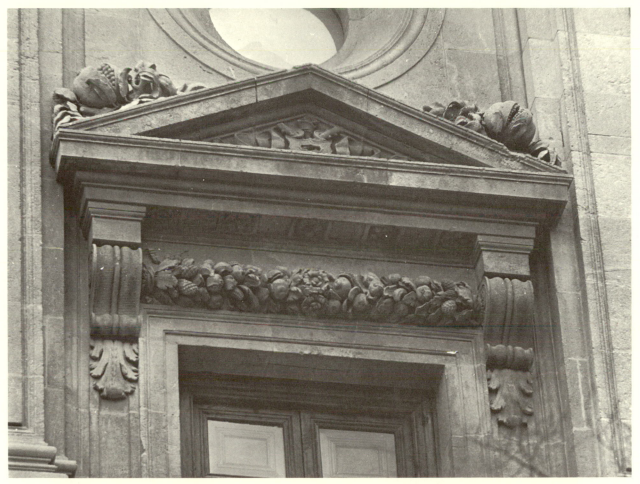

PLATE 41. Triangular pediment, main-story window, south facade, palace of Charles V (Foto Mas)

PLATE 42. Window over portal, Colegio de las Niñas Nobles, Granada, Juan de Marquina, 1532 (Foto Mas)

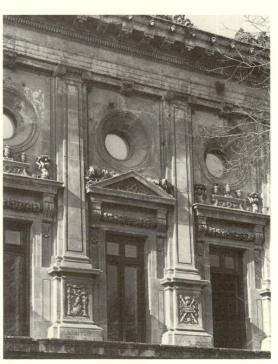

PLATE 43. Main-story windows, east facade, palace of Charles V (Foto Mas)

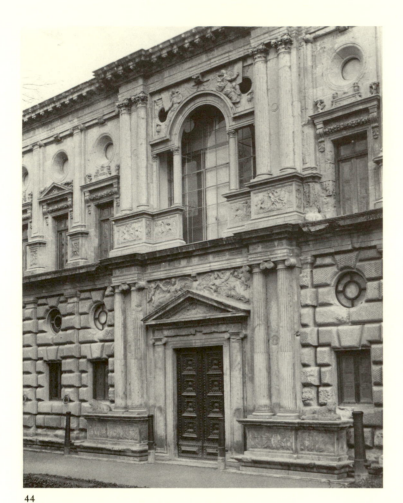

44

PLATE 44. South *portada*, palace of Charles V (Foto Mas)

PLATE 45. Trophy reliefs, left pedestals, south *portada*, palace of Charles V, Niccolò da Corte, 1539–1540 (Foto: Torres Molina)

PLATE 46. Door of south *portada*, palace of Charles V (Foto Mas)

PLATE 47. Portal, Agostino Salvago palace, Piazza San Bernardo, Genoa, Della Porta and Corte, 1532 (Foto Alinari)

PLATE 48. Fountain of Charles V, the Alhambra, 1545–1548 (Foto Mas)

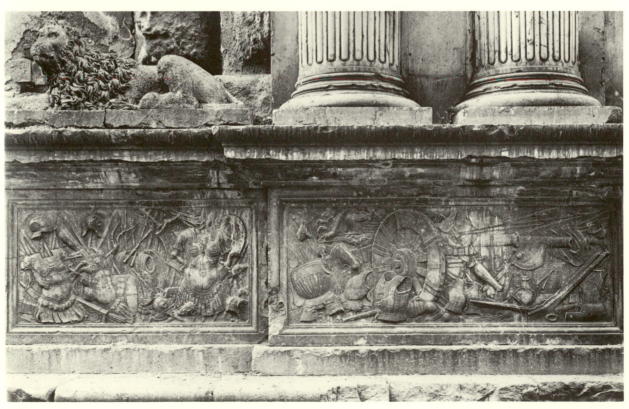

45

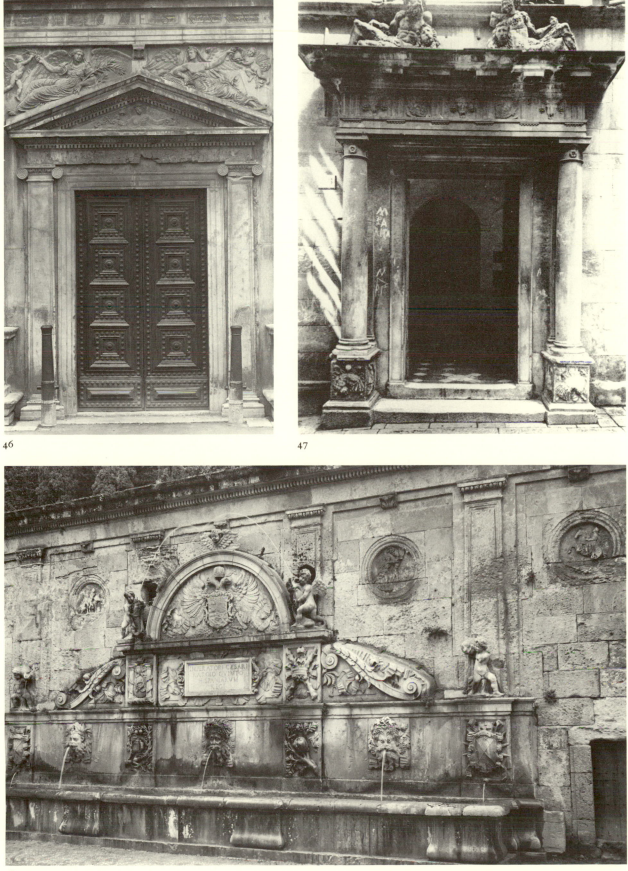

46

47

48

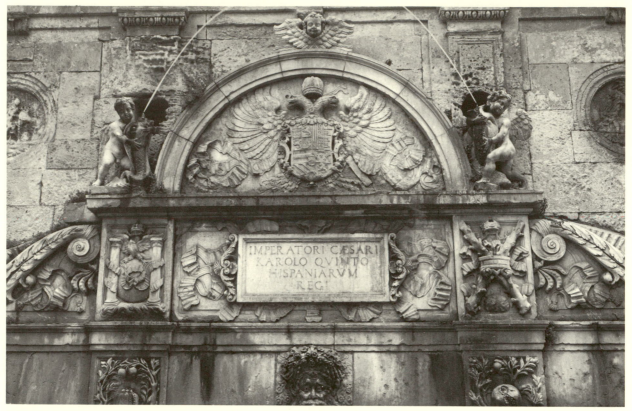

49

50

PLATE 49. Central unit, Fountain of Charles V, the Alhambra, Niccolò da Corte (Foto Mas)

PLATE 50. *Fame*, left side, upper story, south *portada*, palace of Charles V, assistant to Corte (Foto Mas)

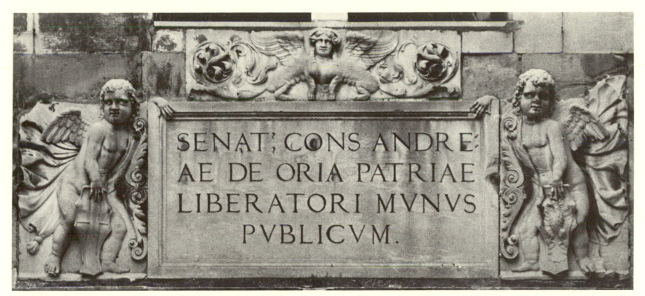

PLATE 51. Inscription over portal, palace of Andrea Doria, Piazza San Matteo, Genoa, Niccolò da Corte, 1528 (author)

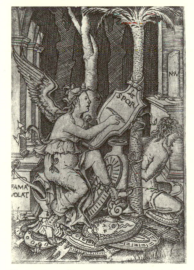

PLATE 52. *Fame*, engraving, Nicoletto Rosex da Modena, 1510 (Rosenwald Collection, National Gallery of Art, Washington, D.C.)

PLATE 53. *History*, right side, upper story, south *portada*, palace of Charles V, 1549–1551 (Foto Mas)

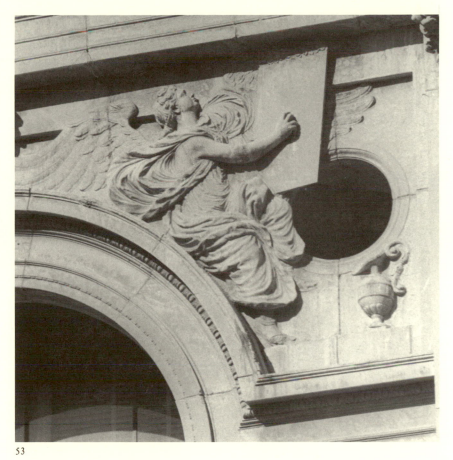

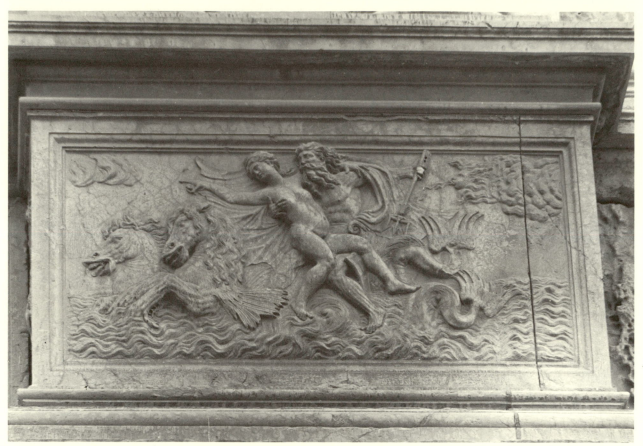

PLATE 54. *Marriage of Neptune and Amphitrite*, right pedestal, second story, south *portada*, palace of Charles V, Nic-
colò da Corte, 1548–1552 (Foto Mas)

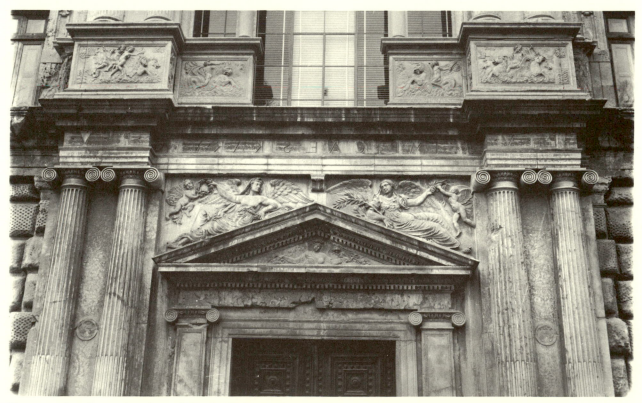

PLATE 55. South portal, palace of Charles V (Foto Mas)

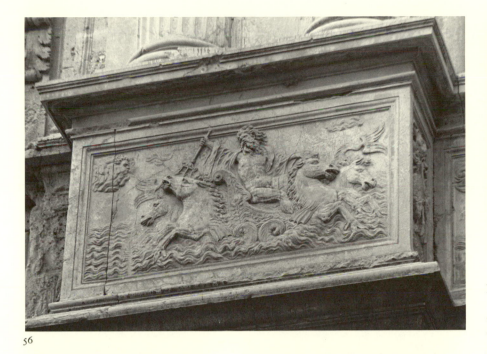

56

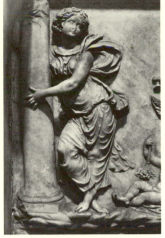

57

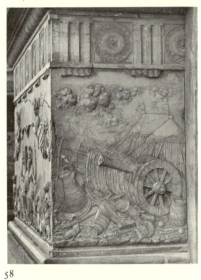

58

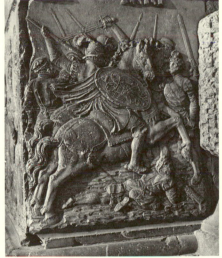

59

PLATE 56. *Neptune Calming the Tempest*, left pedestal, second story, south *portada*, palace of Charles V, assistant to Corte (Foto Mas)

PLATE 57. *Fortitude*, Altar of the Apostles, cathedral of Genoa, Niccolò da Corte, 1533–1537 (author)

PLATE 58. Return with field cannon, left pedestal, west *portada*, palace of Charles V, Antonio de Leval, 1554 (author)

PLATE 59. Return with soldiers, left center pedestal, west *portada*, palace of Charles V, Antonio de Leval, 1554 (author)

PLATE 60. Engraving of west facade, palace of Charles V, José de Hermosilla, 1767 (Academia de San Fernando, Madrid)

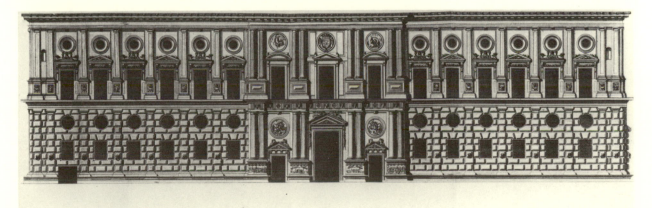

60

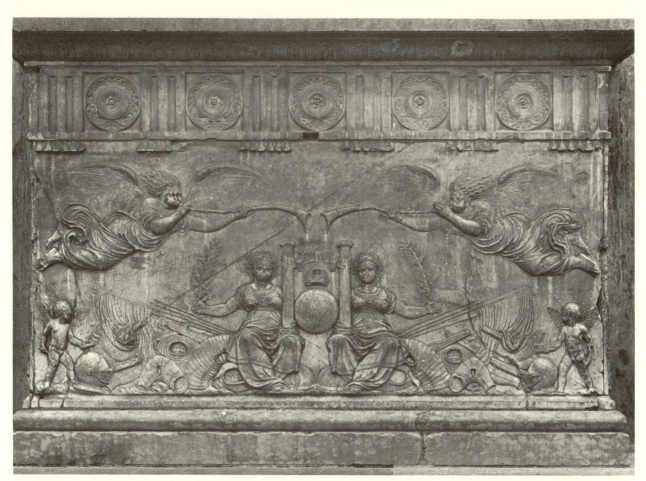

PLATE 61. *Triumph of Peace*, left pedestal, west *portada*, palace of Charles V, Juan de Orea, c. 1551 (Foto Mas)

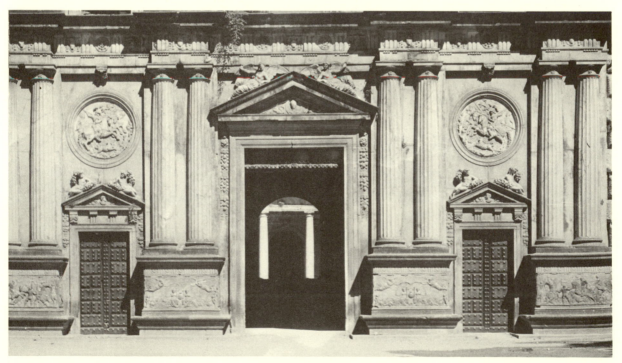

PLATE 62. West *portada*, palace of Charles V, 1549–1561 (Foto: Torres Molina)

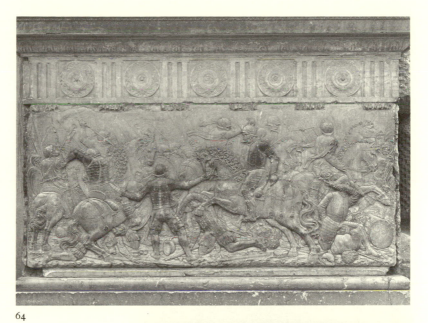

63

64

PLATE 63. The globe held by figures of Peace, detail of plate 61 (author)

PLATE 64. *Battle of Mühlberg*, right center pedestal, west *portada*, palace of Charles V, Antonio de Leval, 1553 (Foto Mas)

PLATE 65. Sculptural reliefs over bishop's chair, choir stalls, cathedral of Almería, Juan de Orea, 1558–1561 (Foto Mas)

PLATE 66. *Battle of Mühlberg*, left center pedestal, west *portada*, palace of Charles V, Juan de Orea, 1550 (Foto Mas)

65

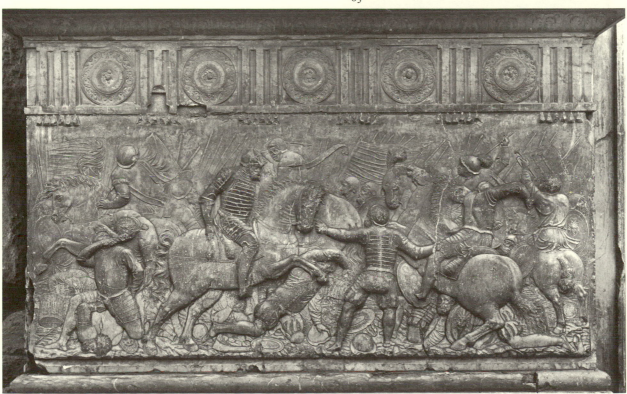

66

PLATE 67. Boys with garlands, left door, west *portada*, palace of Charles V, Antonio de Leval, 1557 (Foto Mas)

PLATE 68. Left side, lower story, west *portada*, palace of Charles V (Foto Mas)

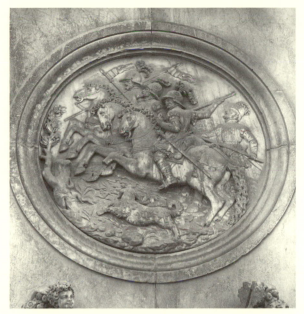

PLATE 69. Sketch of the Alhambra (detail), Anton van den Wyngaerde, c. 1567 (Cod. Min. 41, fol. 55, Österreichische National–Bibliothek, Vienna)

PLATE 70. Roundel with cavalry theme over left door, west *portada*, palace of Charles V, Antonio de Leval, 1563 (Foto Mas)

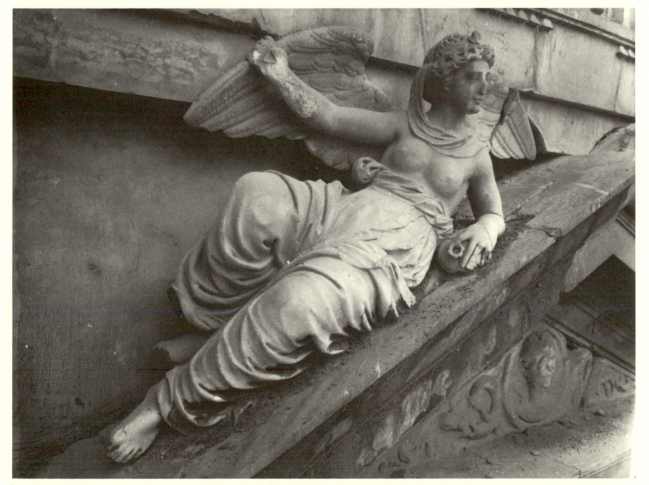

PLATE 71. *Victory*, center door, west *portada*, palace of Charles V, Antonio de Leval, 1561 (Foto: Torres Molina)

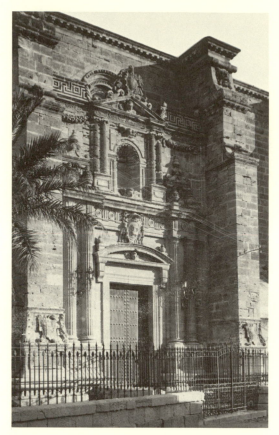

PLATE 72. West portal, cathedral of Almería, Juan de Orea, 1556 (Foto Mas)

PLATE 73. Second story, tower, cathedral of Granada, Juan de Orea, 1577–1580 (author)

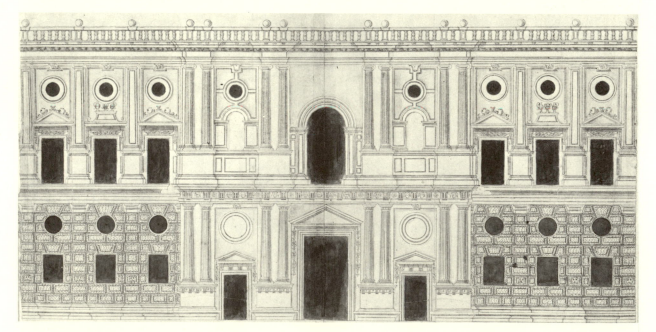

PLATE 74. Burlington elevation, west facade, palace of Charles V, 1574–1580 (Department of Prints and Photographs, The Metropolitan Museum of Art, New York)

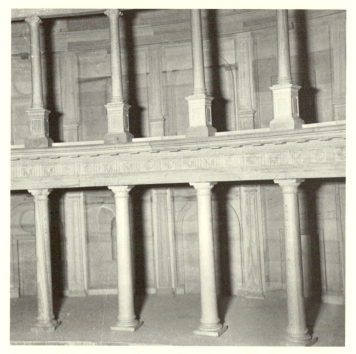

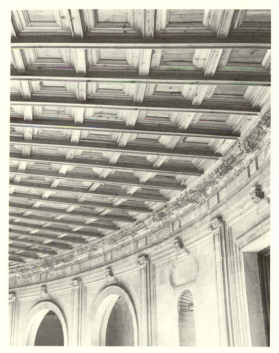

PLATE 75. Modern wooden model, palace of Charles V, 1960s (Patronato de la Alhambra)

PLATE 76. Modern coffered wooden ceiling, gallery, courtyard, palace of Charles V, 1967 (Patronato de la Alhambra)

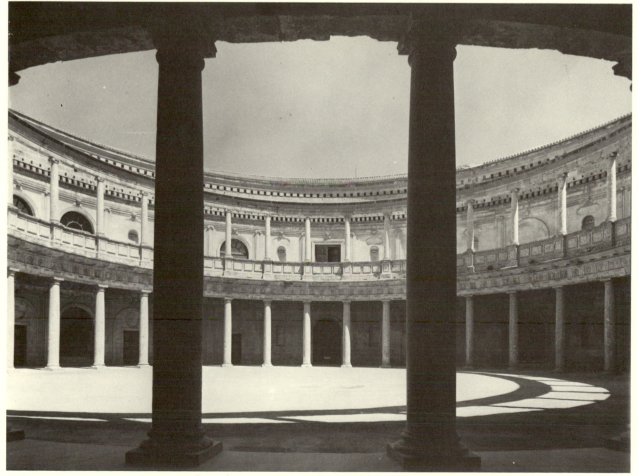

PLATE 77. Round courtyard, palace of Charles V (Foto: Torres Molina)

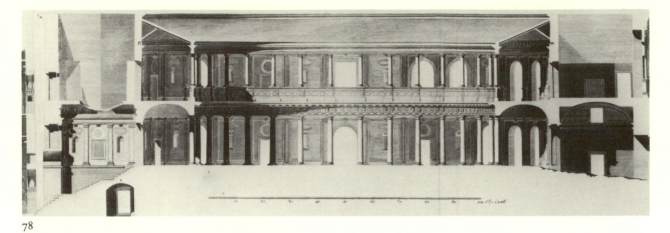

78

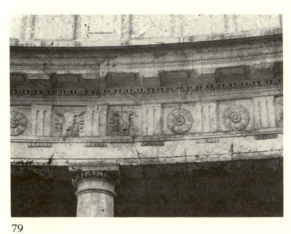

79

PLATE 78. North-south transverse section of the courtyard, palace of Charles V, José de Hermosilla, 1767 (Academia de San Fernando, Madrid)

PLATE 79. Entablature of the Doric colonnade, courtyard, palace of Charles V (Foto Mas)

PLATE 80. Circular corridor, courtyard, palace of Charles V (Foto Mas)

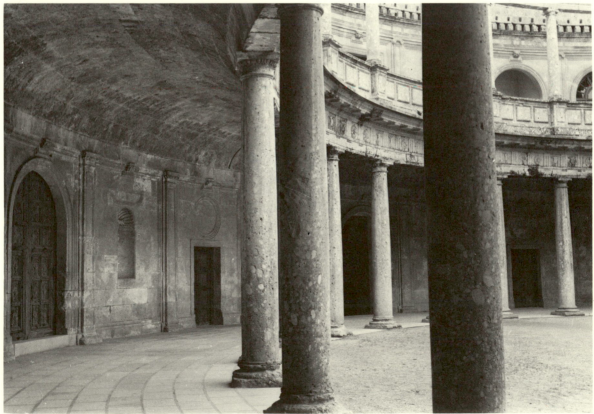

80

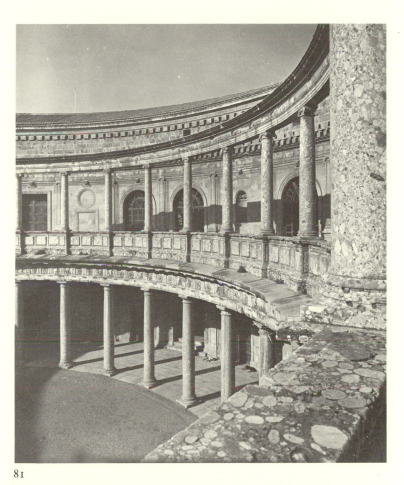

81

PLATE 81. Double colonnade, courtyard, palace of Charles V (Foto Mas)

PLATE 82. Corridor wall, courtyard, palace of Charles V (Foto Mas)

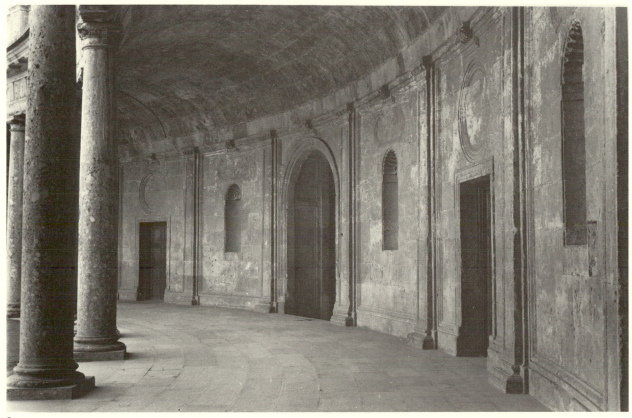

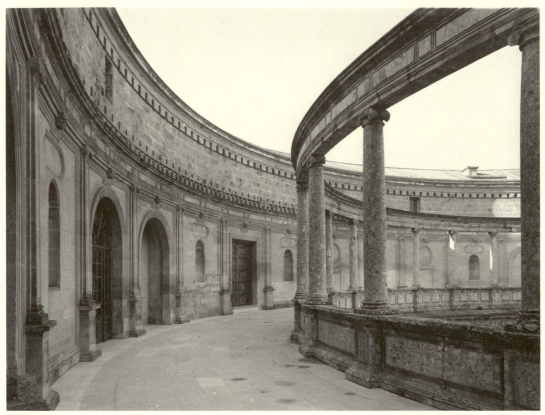

PLATE 83. Gallery, courtyard, palace of Charles V (Foto Mas)

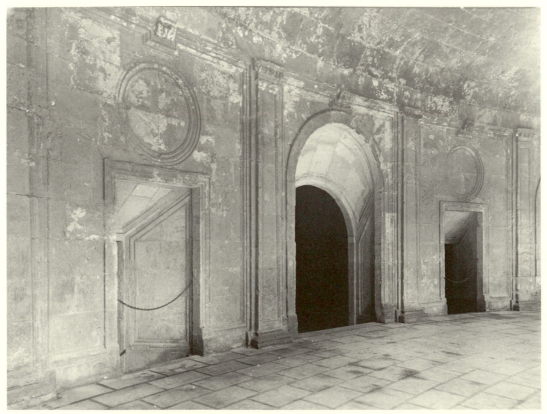

PLATE 84. Three passages from courtyard to west vestibule, palace of Charles V (Foto Mas)

PLATE 85. North portal, basement level, palace of Charles V (Foto Mas)

PLATE 86. Center of east facade, palace of Charles V (Foto Mas)

PLATE 87. North facade of the palace of Charles V from the Patio de Machuca (Foto Mas)

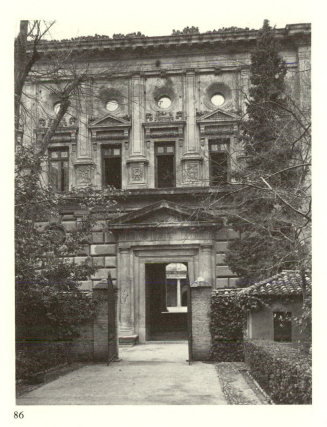

86

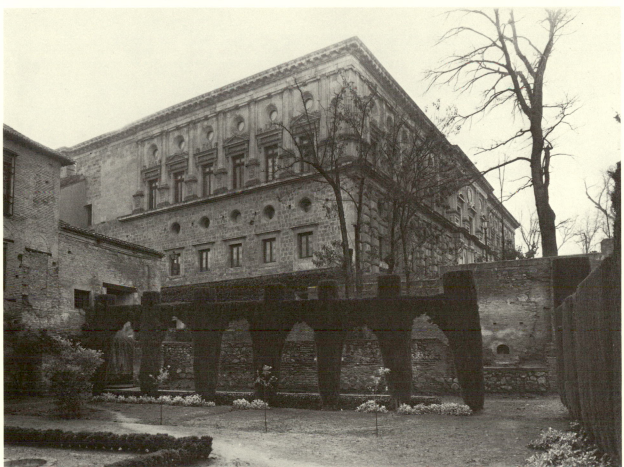

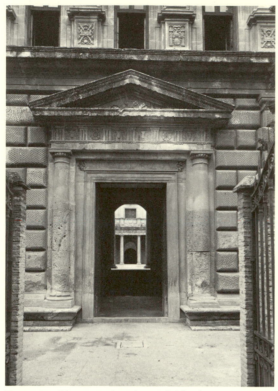

PLATE 88. East portal, palace of Charles V (Foto Mas)

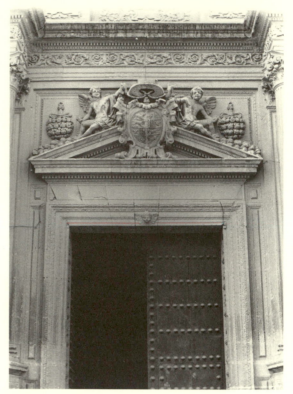

PLATE 89. North portal, cathedral of Almería, Juan de Orea, 1555 (author)

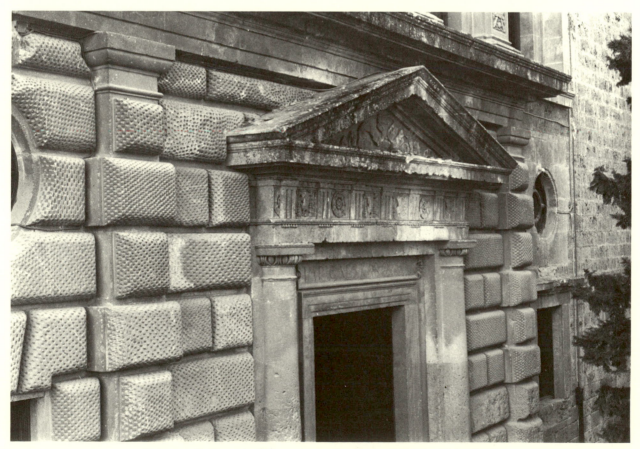

PLATE 90. Pediment of the east portal, palace of Charles V (author)

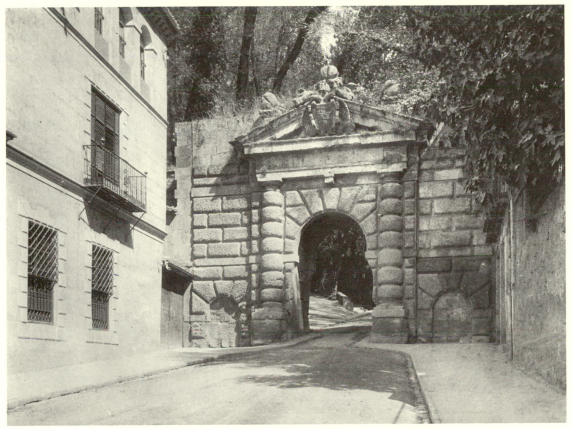

PLATE 91. Puerta de las Granadas, the Alhambra (Foto Mas)

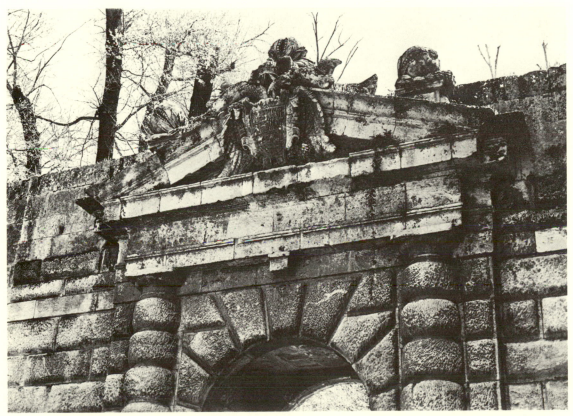

PLATE 92. Heraldic ornament on pediment, Puerta de las Granadas, Juan de Orea, 1552 (author)

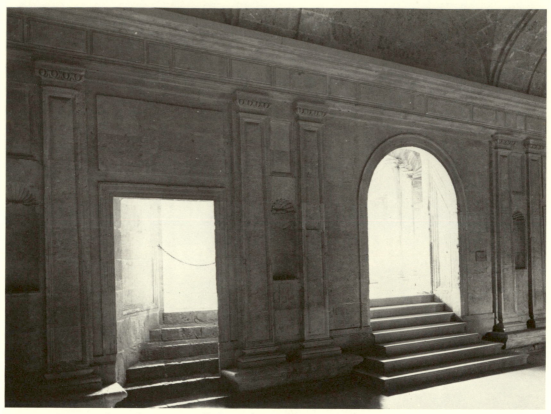

PLATE 93. Passages from the west vestibule to the round courtyard, palace of Charles V (Foto Mas)

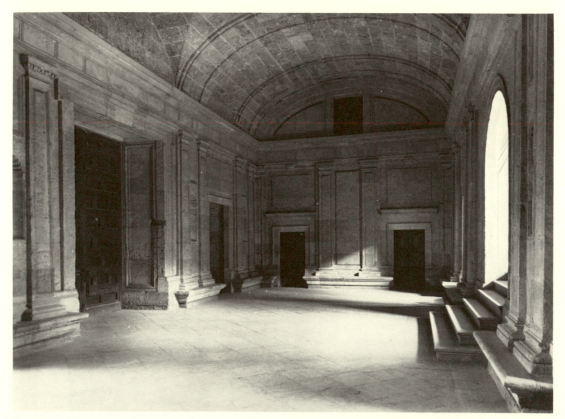

PLATE 94. View toward north wall, west vestibule, palace of Charles V (Foto Mas)

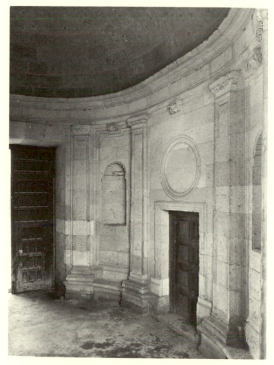

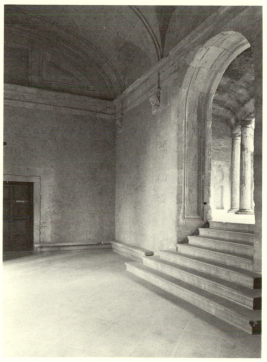

PLATE 95. East vestibule, palace of Charles V
(Foto Mas)

PLATE 96. South vestibule, palace of Charles V
(Foto Mas)

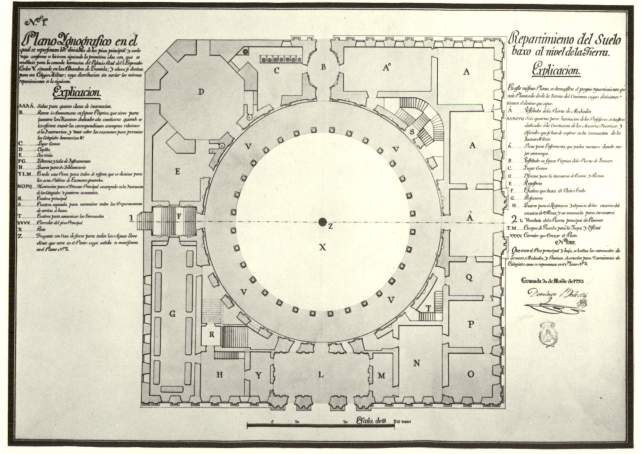

PLATE 97. Groundplan, palace of Charles V, Domingo de Velestá, 1793 (Academia de San Fernando, Madrid)

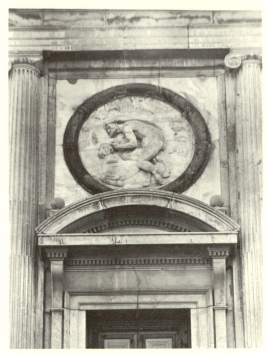

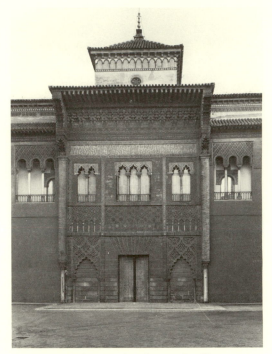

PLATE 98. *Hercules and the Cretan Bull*, upper story, west *portada*, palace of Charles V, Andrés de Ocampo, 1591 (Foto Mas)

PLATE 99. Main *portada, alcázar*, Seville, 1364 (Foto Mas)

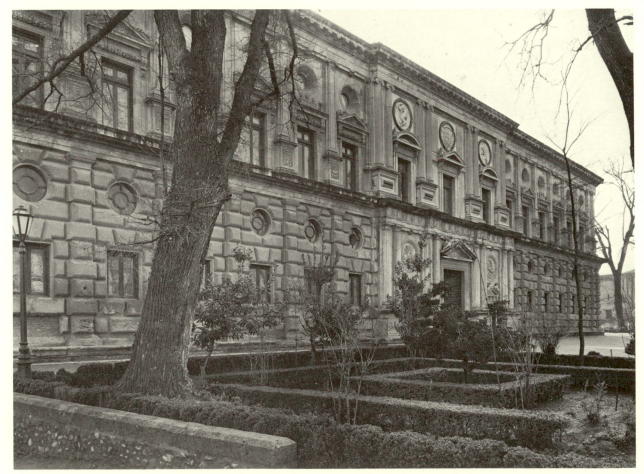

PLATE 100. West facade, palace of Charles V (Foto Mas)

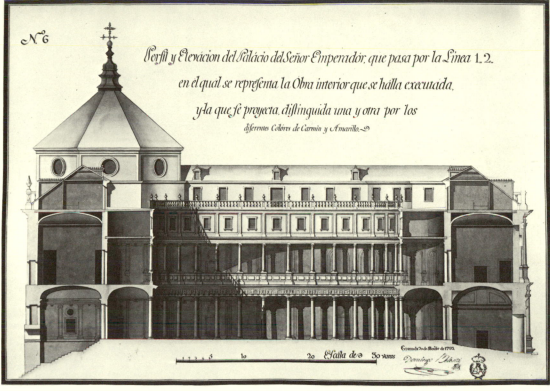

PLATE 101. North–south transverse section of the courtyard, palace of Charles V, Domingo de Velestá, 1793 (Academia de San Fernando, Madrid)

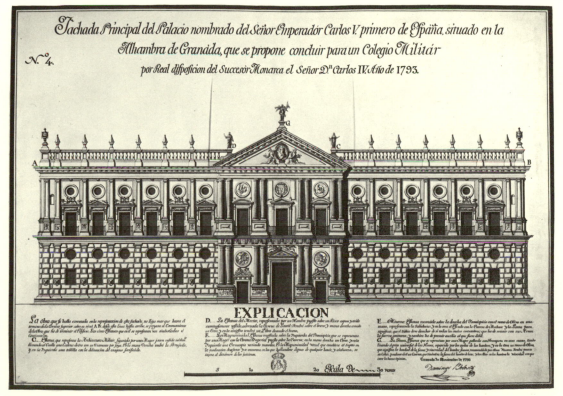

PLATE 102. Elevation of west facade, palace of Charles V, Domingo de Velestá, 1793 (Academia de San Fernando, Madrid)

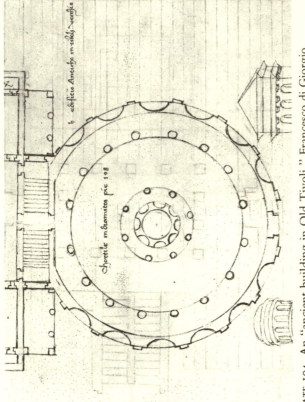

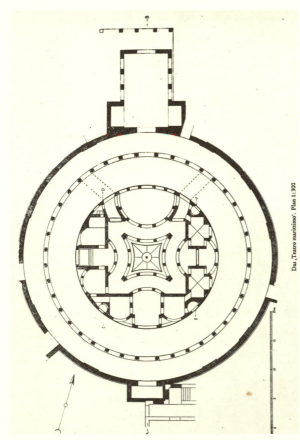

Das „Teatro marittimo". Plan 1:300

PLATE 103. Groundplan of the circular casino, Hadrian's Villa, Tivoli (after Käh-ler, Gebr. Mann Verlag)

PLATE 104. An "ancient building in Old Tivoli," Francesco di Giorgio Martini, c. 1476 (Cod. Saluzziano 148, fol. 88v, Biblioteca Reale, Turin)

PLATE 105. Early project for the Villa Ma-dama (Uffizi A1054), Antonio da Sangallo the Younger, c. 1516 (Gab. Fotografico, Sopraintendenza Beni Artistici e Storici di Firenze)

PLATE 106. Project for a convent (Uffizi A350), attributed to Baldassare Peruzzi, c. 1530 (Gab. Fotografico, Sopraintendenza Beni Artistici e Storici di Firenze)

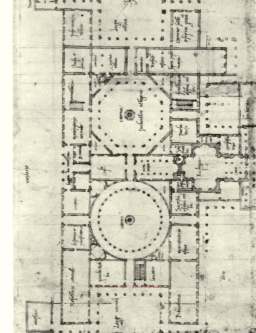

106

105

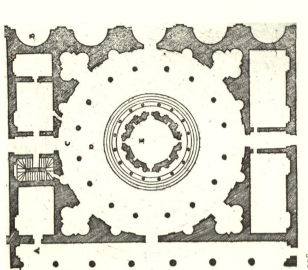

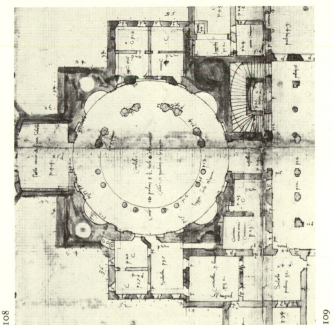

108

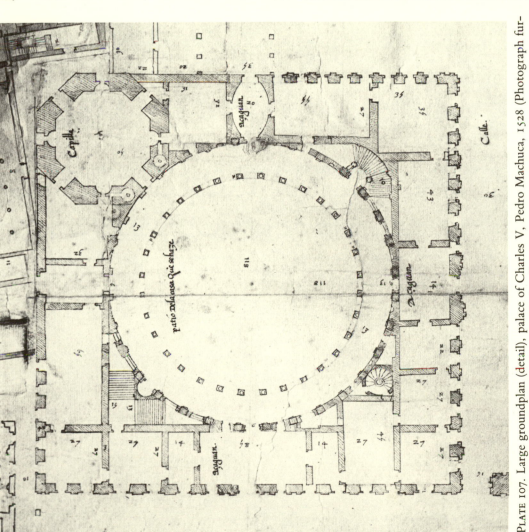

109

PLATE 107. Large groundplan (detail), palace of Charles V, Pedro Machuca, 1528 (Photograph furnished and authorized by the Patrimonio Nacional)

PLATE 108. Groundplan of Bramante's Tempietto, San Pietro in Montorio, Rome, after Serlio, bk. III

PLATE 109. Project for the Orsini palace in Rome (detail, Uffizi A456), Baldassare Peruzzi, c. 1530 (Gab. Fotografico, Soprintendenza Beni Artistici e Storici di Firenze)

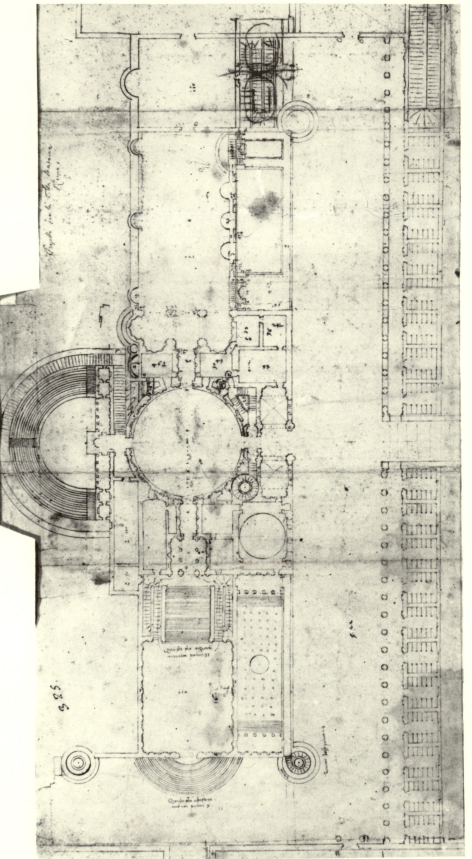

PLATE 110. Project for the Villa Madama, Rome (Uffizi A314), Raphael and Antonio da Sangallo the Younger, c. 1519 (Gab. Fotografico, Sopraintendenza Beni Artistici e Storici di Firenze)

PLATE 112. Nymphaeum, upper level, *domus Augustana*, Palatine, Rome (after Crema)

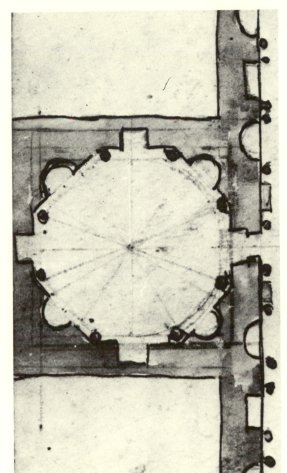

PLATE 113. Octagonal chapel, detail of plate 114

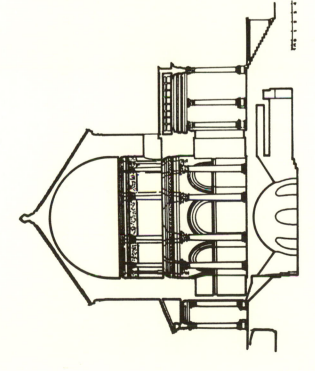

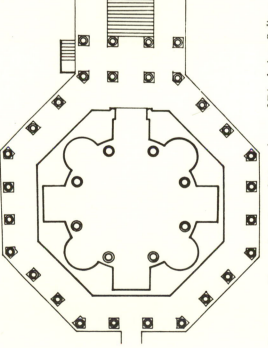

PLATE 111. Plan and section of Mausoleum of Diocletian, Split, c. 300 (after Dyggve)

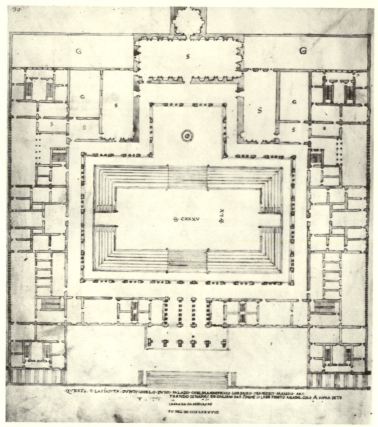

PLATE 114. Project for royal palace for the king of Naples, Giuliano da Sangallo, c. 1488, Cod. Barb. Lat. 4424, fol. 41v (Foto Biblioteca Vaticana)

PLATE 115. Facade, Medinaceli palace, Cogolludo, Lorenzo Vázquez, 1492 (Foto Mas)

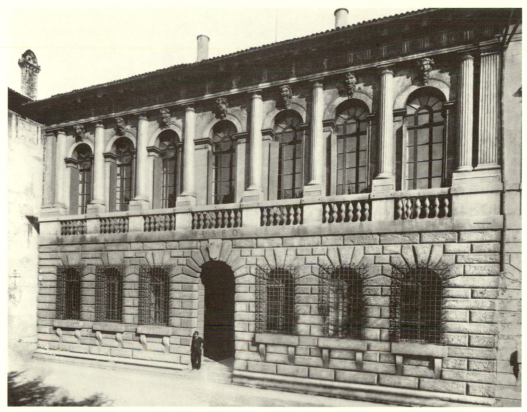

PLATE 116. Facade, Pompei–Lavezola palace, Verona, Sanmicheli, c. 1530 (Photo Alinari)

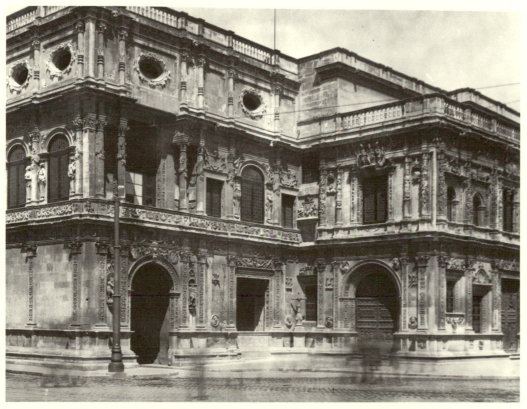

PLATE 117. Facade, Casas Consistoriales, Seville, 1535–1540 (Foto Mas)

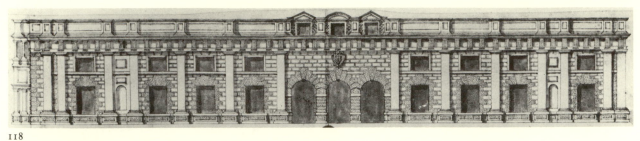

118

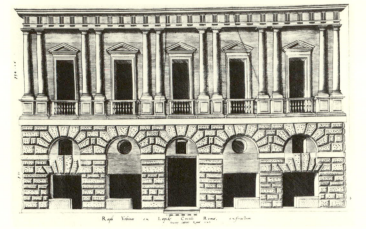

119

PLATE 118. Drawing, 1567, north facade, Palazzo del Te, Mantua, Giulio Romano, 1525 (Photo: Landesbildstelle Rheinland)

PLATE 119. Engraving, 1545, Lafrèry, facade, Caprini palace, Rome, Bramante, c. 1502 (Fototeca, Bibliotheca Hertziana, Rome)

PLATE 120. Facade, Caffarelli-Vidoni palace, Rome, c. 1522 (Photo Alinari)

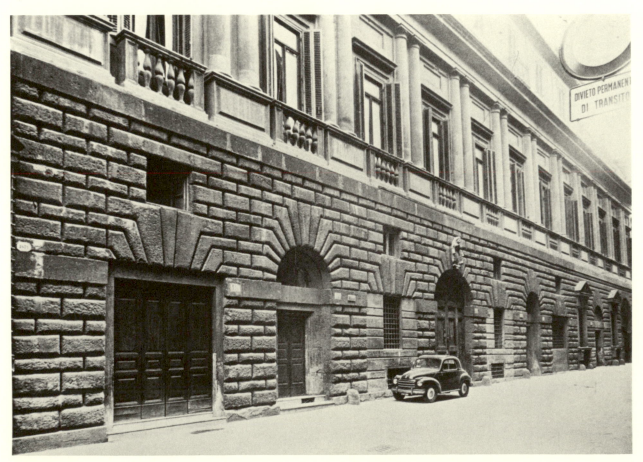

120

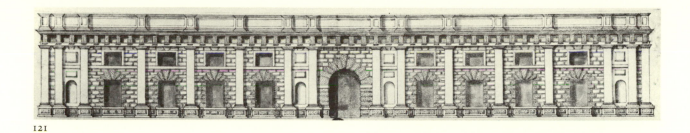

121

PLATE 121. Drawing, 1567, west facade, Palazzo del Te, Mantua, Giulio Romano, 1526 (Photo: Landesbildstelle Rheinland)

PLATE 122. Sketch for facade of a villa, Baldassare Peruzzi, 1530s (Biblioteca Comunale, Siena)

PLATE 123. Facade, Orsini di Gravina palace, Naples, Mormando, begun 1513 (Photo Alinari)

122

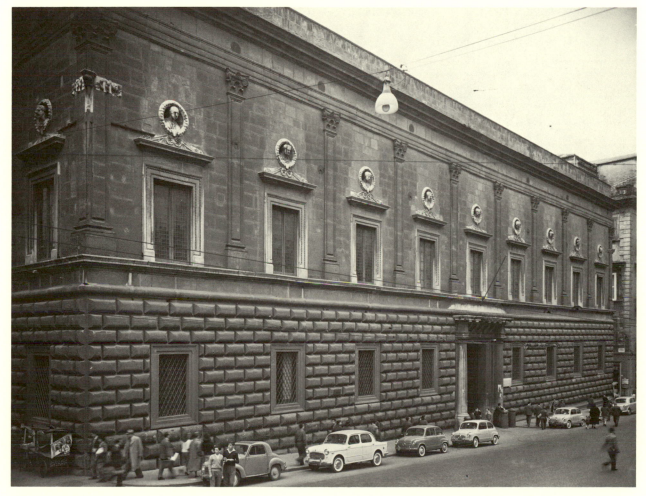

123

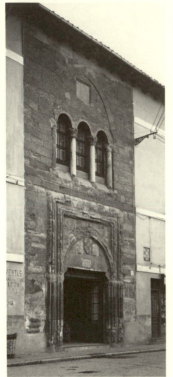

PLATE 124. Portal, palace of the Conde de Luna, León, c. 1350 (Foto Mas)

PLATE 125. Sketch of a palace facade (Uffizi A1859), Antonio da Sangallo il Gobbo, 1530s (Gab. Fotografico, Sopraintendenza Beni Artistici e Storici di Firenze)

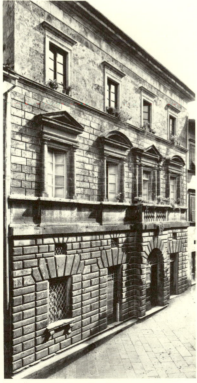

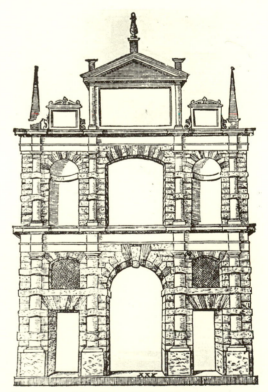

PLATE 126. Facade, Pecora palace, Montepulciano, Antonio da Sangallo the Elder, 1520s (Photo Alinari)

PLATE 127. City Gate, Serlio, bk. VI, 1551

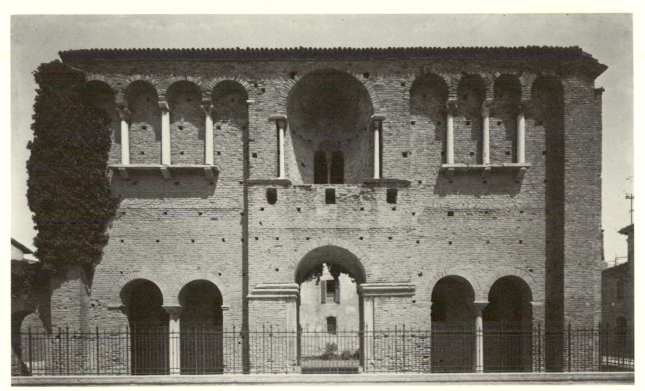

PLATE 128. Facade, palace of the Exarchs, Ravenna, after 712 (Bildarchiv Foto Marburg)

PLATE 129. Portal, convent of Santa Clara, Tordesillas, c. 1350 (Foto Mas)

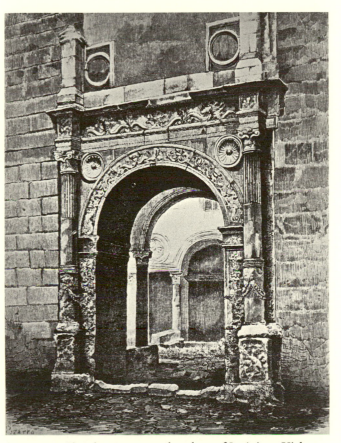

PLATE 130. Sketch, 1859, portal, palace of Jerónimo Vich, Valencia, 1507-1525 (from *El Museo Universal*, 1860)

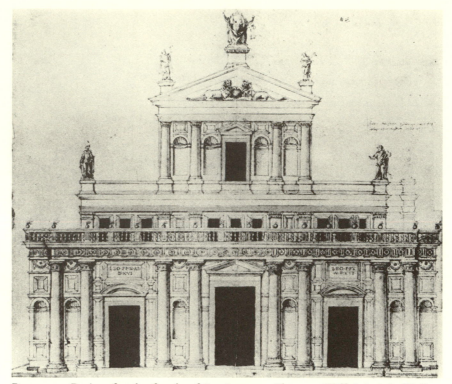

PLATE 131. Project for the facade of San Lorenzo, Florence (Uffizi A281), Giuli-
ano da Sangallo, 1516 (Gab. Fotografico, Sopraintendenza Beni Artistici e Storici
di Firenze)

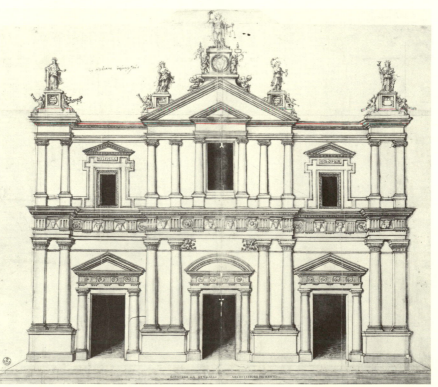

PLATE 132. Project for the facade of San Lorenzo, Florence (Uffizi A279), Giuli-
ano da Sangallo, 1516 (Gab. Fotografico, Sopraintendenza Beni Artistici e Storici
di Firenze)

PLATE 133. Sketch for the side facade of the Mint in Rome (Uffizi A867), Antonio da Sangallo the Younger, c. 1523 (Gab. Fotografico, Sopraintendenza Beni Artistici e Storici di Firenze)

PLATE 134. Facade, palace of the Cardenal del Monte (Palazzo Comunale), Monte San Savino, Antonio da Sangallo the Elder, 1520s (Photo Alinari)

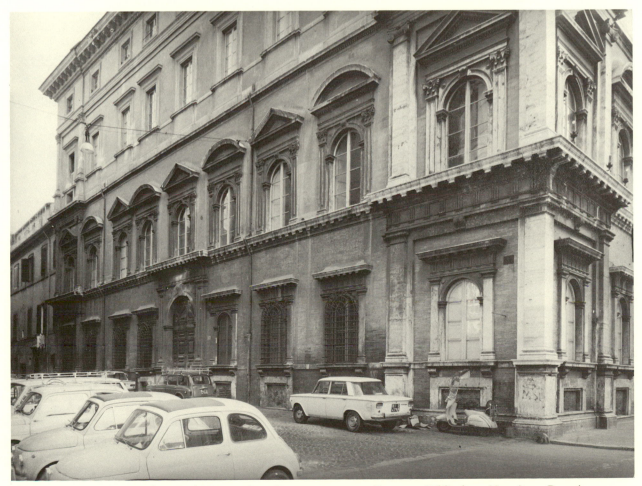

PLATE 135. Facade, Fieschi-Sora palace, Rome, 1503–1510 (Fototeca, Bibliotheca Hertziana, Rome)

PLATE 136. Facade of a Roman house, Fra Giocondo, 1511 edition of Vitruvius

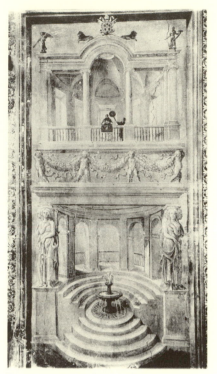

PLATE 138. Window embrasure, Sala di Costantino, Vatican palace, Giulio Romano, c. 1520 (Musei Vaticani, Archivo Fotografico)

PLATE 137. *Raising of Lazarus* (detail), Perino del Vaga, 1538, Cabinet des Dessins, Louvre (cliché Musées Nationaux, Paris)

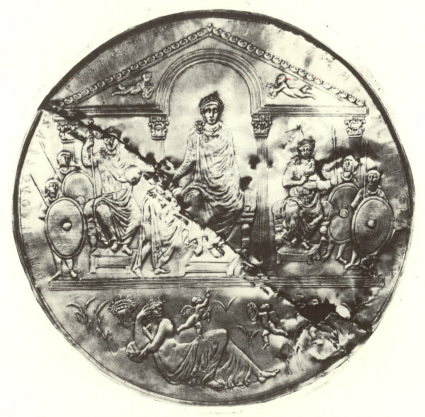

PLATE 139. Silver plate of Theodosius I, 388 (Academia de la Historia, Madrid)

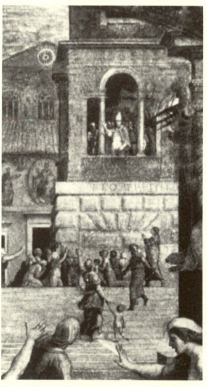

PLATE 140. *Fire in the Borgo* (detail), Stanza del Incendio, Vatican palace, Raphael and Giulio Romano, c. 1514 (Photo Alinari)

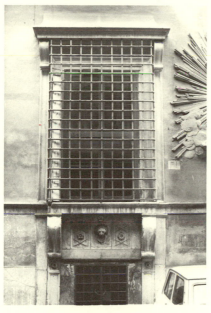

PLATE 141. Lower-story window, Medici-Lante palace, Rome, c. 1513 (Conway Library, Courtauld Institute of Art)

PLATE 142. Portal, Convento de las Huelgas, Burgos, before 1295 (Foto Mas)

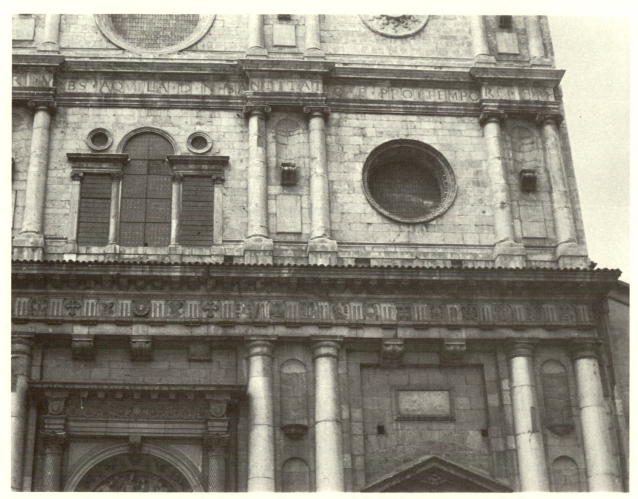

PLATE 143. Facade, San Bernardino, Aquila, Cola dall'Amatrice, 1527 (author)

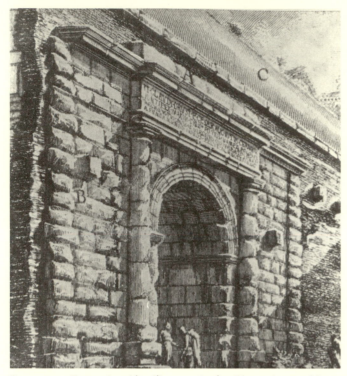

PLATE 144. Engraving (detail), c. 1760, by Piranesi, portal in the Hadrianic portion of the Acqua Vergine, Rome

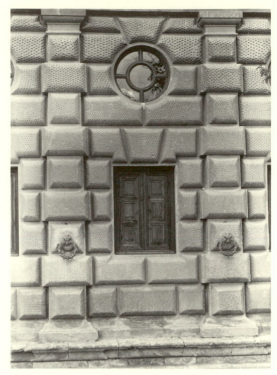

PLATE 145. Bay of lower story, south facade, palace of Charles V (Foto Mas)

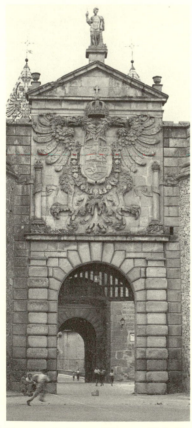

PLATE 146. Puerta Bisagra, Toledo, Alonso de Covarrubias, 1558 (Foto Mas)

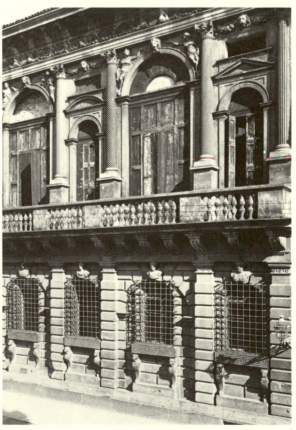

PLATE 147. Facade, Bevilacqua palace, Verona, Sanmicheli, c. 1530 (Photo Alinari)

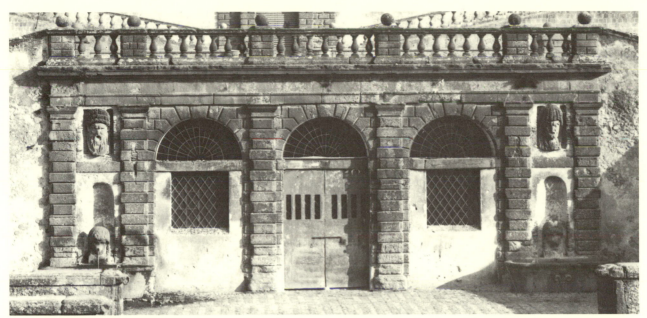

PLATE 148. Lower entry, fortified villa at Caprarola, Vignola, 1559 (Photo Alinari)

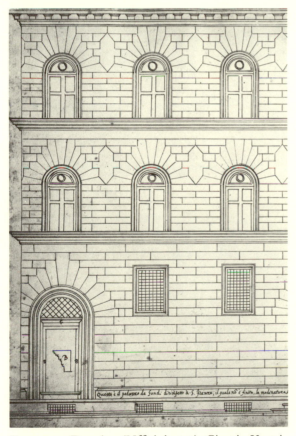

PLATE 149. Drawing (Uffizi A4940), Giorgio Vasari the Younger, facade, Gondi palace, Florence, begun in 1490 (Gab. Fotografico, Sopraintendenza Beni Artistici e Storici di Firenze)

PLATE 150. Facade, San Michele in Isola, Venice, Mauro Codussi, c. 1478 (Photo Alinari)

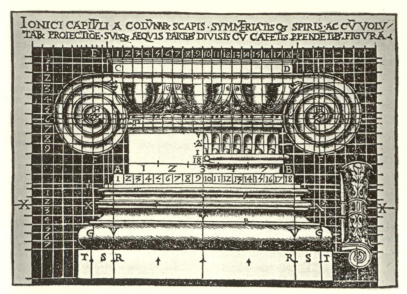

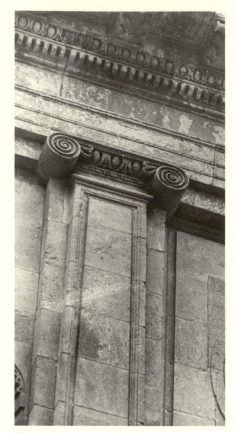

PLATE 151. Ionic capital, Cesariano, 1521 translation of Vitruvius

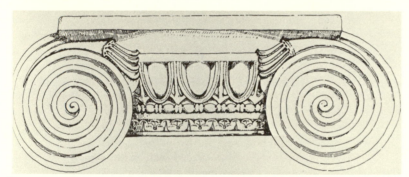

PLATE 153. Ionic capital, upper story, south facade, palace of Charles V (Foto Mas)

PLATE 152. Drawing of Ionic capital of San Paolo fuori le Mura, Rome, c. 385 (after Tschira, Römische Mitteilungen des Deutschen Archäologischen Instituts, Rome)

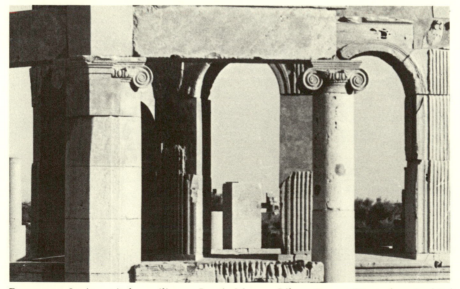

PLATE 154. Ionic capital, pavilion at Leptis Magna, Libya, 8 B.C. (Deutschen Archäologischen Instituts, Rome)

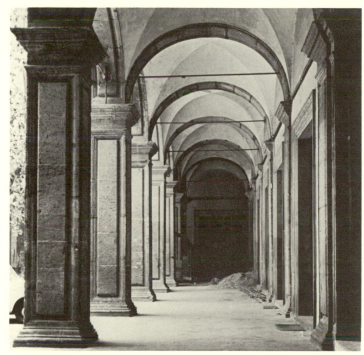

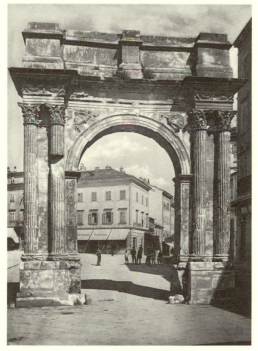

PLATE 155. Corridor of courtyard, Orsini di Gravina palace, Naples, Mormando, begun 1513 (Roberto Pane)

PLATE 156. Arco dei Sergi, Pola, 25–10 B.C. (Photo Alinari)

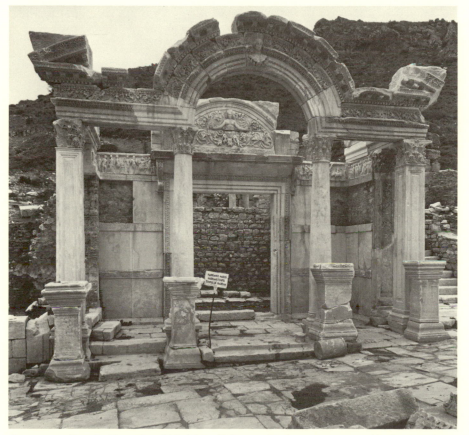

PLATE 157. Porch, Temple of Hadrian, Ephesus, Turkey, c. A.D. 65 (A. F. Kersting, London)

158

159

160

PLATE 158. Stele of Panaitios, 111 B.C. (National Archaeological Museum, Athens)

PLATE 159. Window in Genoa, Francisco de Hollanda, *Os desenhos das Antiguallas*, c. 1540

PLATE 160. Model fireplace, Serlio, bk. IV, 1537

PLATE 161. Reconstruction, seaside facade, Diocletian's palace, Split, c. 300 (after Hébrard)

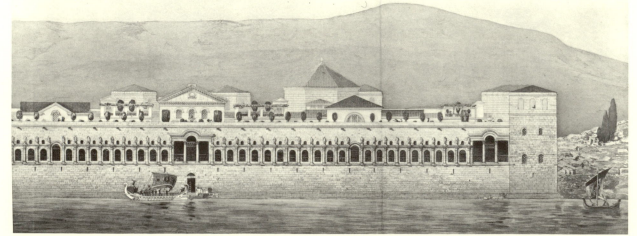

161

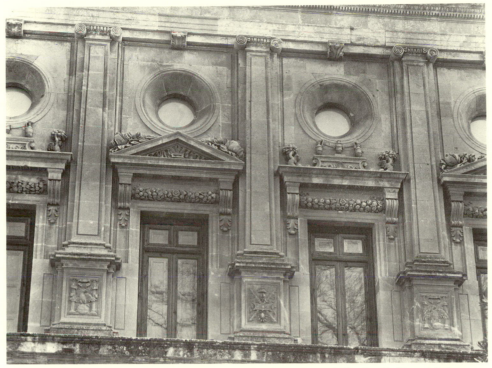

PLATE 162. Main-story windows, west facade, palace of Charles V (Foto Mas)

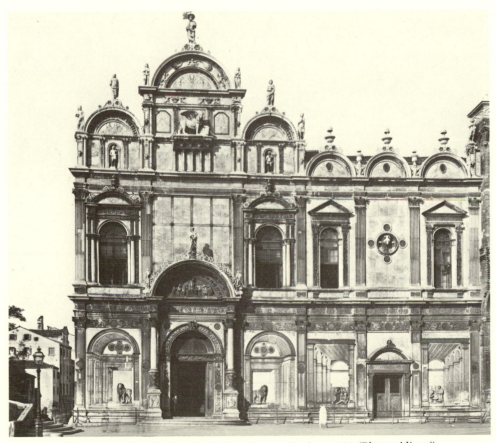

PLATE 163. Facade, Scuola di San Marco, Venice, 1488 (Photo Alinari)

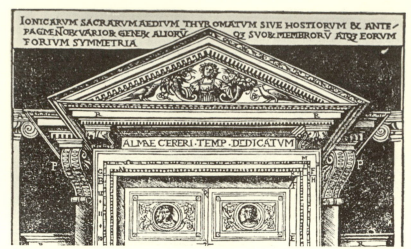

PLATE 164. *Ceres*, pediment of model door, Cesariano, 1521 translation of Vitruvius

PLATE 165. Project for stone frontispiece for the Cancelleria, Rome, (Uffizi A188), Antonio da Sangallo the Younger, 1517 (Gab. Fotografico Sopraintendenza Beni Artistici e Storici di Firenze)

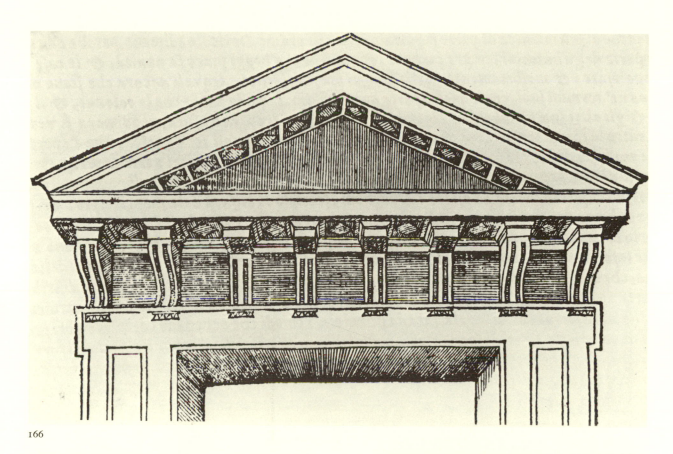

166

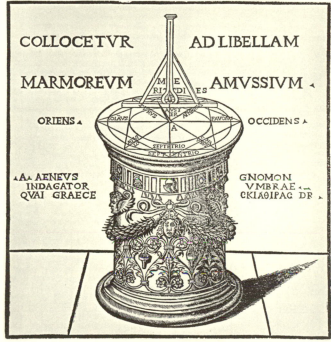

167

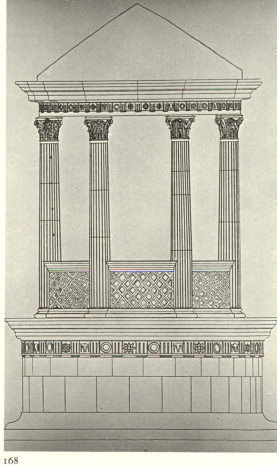

PLATE 166. Triglyph pediment of doorway, Serlio, bk. IV, 1537

PLATE 167. Sun dial, Cesariano, 1521 translation of Vitruvius

PLATE 168. Elevation of round temple, upper level, Sanctuary of Fortuna, Palestrina (Furio Fasola)

PLATE 169. *Holy Family with Saints*, Giulio Romano, c. 1523, Santa Maria dell'Anima, Rome (Photo Alinari)

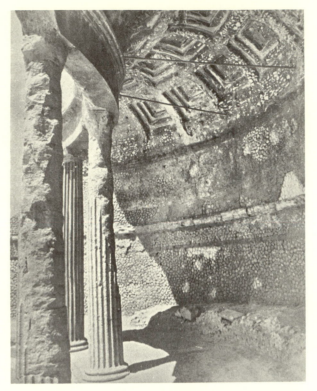

PLATE 170. Annular vault, seventh level, Sanctuary of Fortuna, Palestrina (Giorgio Gullini)

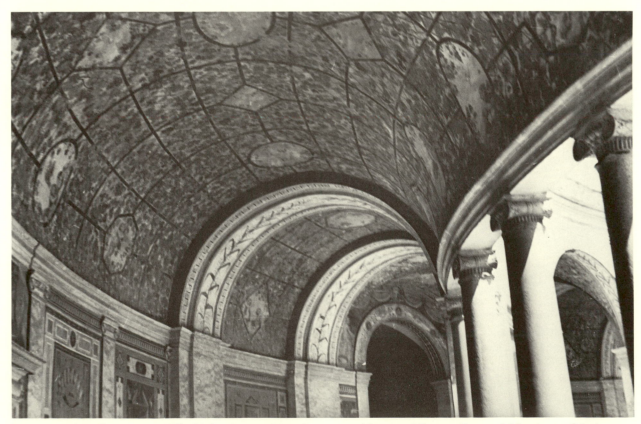

PLATE 171. Annular portico, Villa Giulia, Rome, Vignola, c. 1550 (Conway Library, Courtauld Institute of Art)

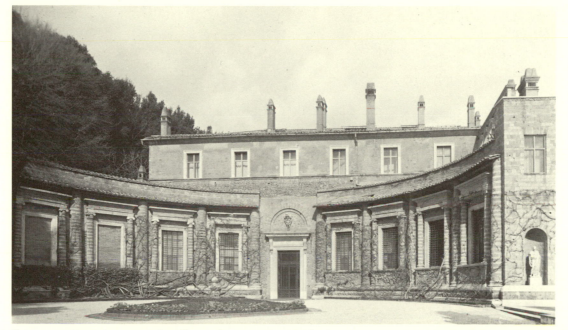

PLATE 172. Round courtyard, Villa Madama, Rome, Raphael, c. 1519 (Fototeca, Bibliotheca Hertziana, Rome)

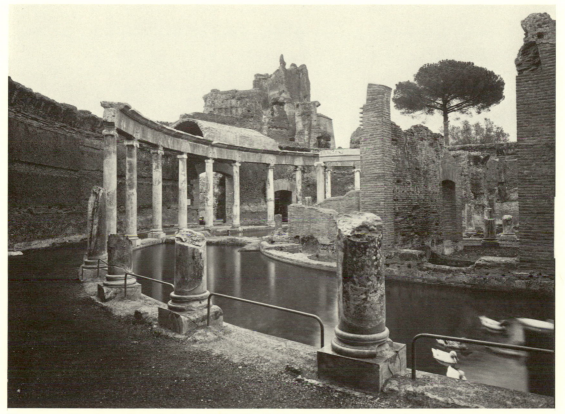

PLATE 173. Circular casino, Hadrian's Villa, Tivoli (Gabinetto Fotografico Nazionale, Rome)